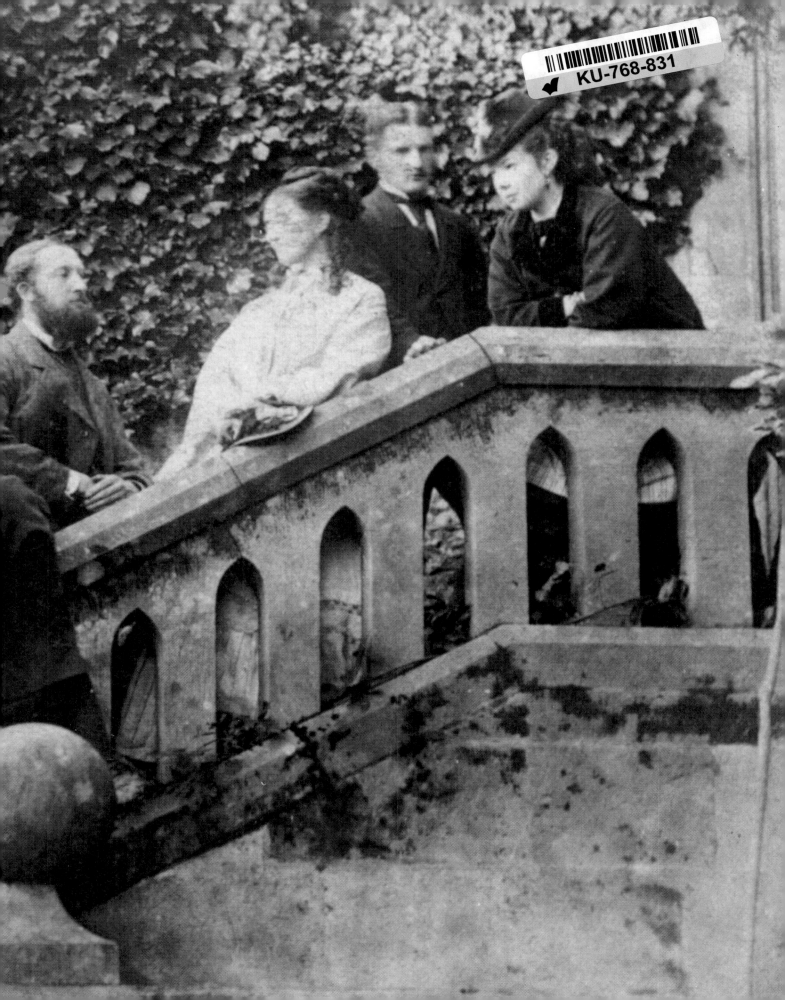

An Illustrated History of the
Water Colour Society of Ireland

The Silent Companion

Fanny W. Currey

An Illustrated History of the Water Colour Society of Ireland

The Silent Companion

Patricia Butler

Antique Collectors' Club

To all those who enjoy the company of their
Silent Companion.

British Library Cataloguing-in-Publication Data:
A catalogue record for this book is available from the British Library.

FSC Mixed Sources
Product group from well-managed
forests, and other controlled sources
www.fsc.org Cert no. SGS-COC-003563
© 1996 Forest Stewardship Council

Printed in China for
Antique Collectors' Club Ltd., Woodbridge, Suffolk, IP12 4SD

The Antique Collectors' Club

Formed in 1966, the Antique Collectors' Club is now a world-renowned publisher of top quality books for the collector. It also publishes the only independently-run monthly antiques magazine, Antique Collecting, which rose quickly from humble beginnings to a network of worldwide subscribers.

The magazine, whose motto is For Collectors–By Collectors–About Collecting, is aimed at collectors interested in widening their knowledge of antiques both by increasing their awareness of quality and by discussion of the factors influencing prices.

Subscription to Antique Collecting is open to anyone interested in antiques and subscribers receive ten issues a year. Well-illustrated articles deal with practical aspects of collecting and provide numerous tips on prices, features of value, investment potential, fakes and forgeries. Offers of related books at special reduced prices are also available only to subscribers.

In response to the enormous demand for information on 'what to pay', ACC introduced in 1968 the famous price guide series. The first title, *The Price Guide to Antique Furniture* (since renamed *British Antique Furniture: Price Guide and Reasons for Values*), is still in constant demand. Since those pioneering days, ACC has gone from strength to strength, publishing many of today's standard works of reference on all things antique and collectable, from Tiaras to 20th Century Ceramic Designers in Britain.

Not only has ACC continued to cater strongly for its original audience, it has also branched out to produce excellent titles on many subjects including art reference, architecture, garden design, gardens, and textiles. All ACC's publications are available through bookshops worldwide and a catalogue is available free of charge from the addresses below.

For further information please contact:

ANTIQUE COLLECTORS' CLUB
www.antiquecollectorsclub.com

Sandy Lane, Old Martlesham, Woodbridge, Suffolk IP12 4SD, UK
Tel: 01394 389950 Fax: 01394 389999
Email: info@antique-acc.com
or
ACC Distribution, 6 West 18th Street, Suite 4B, New York, NY 10011, USA
Tel: 212 645 1111 Fax: 212 989 3205
Email: sales@antiquecc.com

Contents

Abbreviations used in the Text 8

Acknowledgements 10

Author's Preface 12

Foreword 13

Chapter I - An Introduction to the Water Colour Society of Ireland 14

Chapter II - The Early Use of Watercolour 18

Chapter III - The Influence of the Royal Dublin Society's Drawing Schools 32

Chapter IV - Watercolour Enters the Public Domain 49

Chapter V - The Status and Training of Women Artists in 19th Century Ireland 62

Chapter VI - The Role of Sketching Clubs and Drawing Societies in 19th Century Ireland 79

Chapter VII - *'Every Lady Her Own Drawing Master'* The Founder Members of the 89
 Watercolour Society of Ireland

Chapter VIII - Early Exhibitions (1871-1878) 118

Chapter IX - Establishing a Public Indentity – Exhibitions in Cork, Dublin and Belfast 136

Chapter X - The 'Exhibition' Watercolour (1880-1920) 160

Chapter XI - Down to Business 188

Chapter XII - W.C.S.I. Landscape Painters 218

Chapter XIII - W.C.S.I. Figure and Portrait Painters 242

Chapter XIV - W.C.S.I. Flower, Still Life and Garden Scene Painters 263

Chapter XV - W.C.S.I. Etchers and Illustrators 282

Chapter XVI - W.C.S.I. Watercolourists Abroad 297

Chapter XVII - W.C.S.I. Stained Glass Artists 308

Chapter XVIII - W.C.S.I. Military Painters 314

Appendix I – List of Presidents/Chairmen, Secretaries and Treasurers of 317
 the Water Colour Society of Ireland from 1921 to 2009

Appendix II - Index of the Water Colour Society of Ireland 318
 Commitee, Trustees and Members 2010

Appendix III - Chemical Developments – Brushes – Camera Obscura – Paper 319

Glossary of Technical Terms – Drawing Media – Printing Techniques 322

Endnotes 324

Bibliography 328

Index 338

Abbreviations used in the Text

ADS Amateur Drawing Society
ANCA Associate, National College of Art
ANWS Associate, New Society of Painters in Watercolours
AOWS Associate, ('Old') Society of Painters in Watercolours
ARBA Associate of the Royal Society of British Artists
AJ Art Journal
ARA Associate, Royal Academy
ARE Associate, Royal Society of Painter-Etchers and Engravers
ARHA Associate, Royal Hibernian Academy
ARI Associate, Royal Institute of Painters in Watercolour
ARIBA Associate, Royal Institute of British Architects
ARWS Associate, Royal Society of Painters in Watercolour

BL British Library
BLO Bodleian Library, Oxford University
BM British Museum
Bart. Baronet
BAS Belfast Art Society
BC British Columbia
BI British Institution, 1806-1867
BMAG Belfast Museum and Art Gallery
BSC Belfast Sketching Club

CBE Commander of the Order of the British Empire
CH Companions of Honour
Co. County
CSIA Centre for the Study of Irish Art, N.G.I.

DAC Dublin Art Club
D.D. Doctor of Divinity
DCG Dublin City Gallery, the Hugh Lane
DMSA Dublin Metropolitan School of Art (1877-1936)
DSC Dublin Sketching Club (later The Dublin Painting and Sketching Club)

ESB Electricity Supply Board

FAS Fine Art Society, London
FBA Federation of British Artists
FNCI Friends of the National Collections of Ireland
FRCA Fellow, Royal College of Art
FRE Fellow, Royal Society of Painter-Etchers and Engravers

FRCSI Fellow, Royal College of Surgeons in Ireland
FRIAI Fellow, Royal Institute of the Architects of Ireland
FRIBA Fellow, Royal Institute of British Architects.
FRS Fellow, the Royal Society
FSA Fellow, the Society of Antiquaries

GG Grosvenor Gallery, New Bond Street, London

HEICS Hon. East India Company Service
HRA Hon. Member, Royal Academy of Arts
HRCA Hon. Royal Cambrian Academy, Manchester (if an artist studied at the RCA, this refers to the Royal College of Art, London).
HRHA Honorary member, Royal Hibernian Academy, Dublin
HRSA Honorary Royal Scottish Academician

IADS Irish Amateur Drawing Society
ILN *Illustrated London News*
IFAS Irish Fine Art Society
IWM Imperial War Museum

KCIE Knight Commander of the Indian Empire
KCVO Knight Commander of the Royal Victorian Order

Litt D Doctor of Letters
LL.D Doctor of Laws

MA Master of Arts
MB Bachelor of Medicine (*Medicinal Baccalaureus*)
MBE Member of the Order of the British Empire
MD Doctor of Medicine
MFH Master of Foxhounds
MRIA Member, Royal Irish Academy

NCA National College of Art (1936-1971)
NCAD National College of Art and Design
NEAC New English Art Club
NG National Gallery, London
NGI National Gallery of Ireland
NLI National Library of Ireland
NPC National Portrait Collection
NPG National Portrait Gallery, London
NWS New Society of Painters in Miniature and Watercolour, founded 1832.

OBE Officer of the Order of the British Empire

OM	Order of Merit		RSMA	Royal Society of Marine Artists
OPW	Office of Public Works		RSPP	Royal Society of Portrait Painters
OWS	Old Watercolour Society; see RWS		RSW	Member, Royal Scottish Watercolour Society
			RUA	Royal Ulster Academy of Arts or Academician
PhD	Doctor of Philosophy		RWS	Member, Royal Watercolour Society
PRA	President of the Royal Academy of Arts			(1804, Society formed as 'Associated for the
				Purposes of Establishing an Annual Exhibition of
QSC	Queenstown Sketch Club			Painters in Watercolours'; 1805, Society of Painters
				in Watercolours; 1812, Society of Painters in Oil
RA	Royal Academy of Arts			and Watercolours; 1820, Society of Painters in
RAM	Royal Academy of Music			Watercolour; 1881, Royal Watercolour Society –
RBA	Royal Society of British Artists			all previous incarnations known collectively as
RCA	Royal College of Art			the Old Watercolour Society, 'OWS'.)
RCI	Royal Cork Institution			
RDS	Royal Dublin Society		SSA	Society of Scottish Artists
RE	Member, Royal Society of Painter-Etchers		SWA	Society of Women Artists
	and Engravers (Society renamed in 1992, Royal		SWE	Member, Society of Wood Engravers
	Society of Painter-Printmakers.)			
Rev.	Reverend		TCD	Trinity College, Dublin
RHA	Royal Hibernian Academy or Academician		TD	Teachta Dala
RI	Royal Institute of Painters in Watercolours			
	(originally known as New Society of Painters in		UAA	Ulster Academy of Arts
	Water Colours, founded 1831).		UCC	University College, Cork
RIA	Royal Irish Academy		UCD	University College, Dublin
RIAM	Royal Irish Academy of Music		UM	Ulster Museum
RIBA	Royal Institute of British Architects		UWS	Ulster Watercolour Society
RMS	Royal Society of Miniature Painters			
ROI	Royal Institute of Oil Painters		V&A	Victoria and Albert Museum
RSA	Royal Scottish Academy or Academician			
RSAI	Royal Society of Antiquaries of Ireland		WCSI	Water Colour Society of Ireland

Acknowledgements

Prior to his election as W.C.S.I. President on 24 May, 1999, George McCaw together with a number of W.C.S.I. committee members, including Past President James Nolan, recommended that a history of the Water Colour Society of Ireland should be recorded. The project was set in motion when the Society approached me in 2007 to see if I might like to attempt to tackle it. I am most grateful to them, and the W.C.S.I. Publications Committee consisting of George McCaw, P.P.W.C.S.I., Nancy Larchet, P.P.W.C.S.I., Vincent Lambe, P.W.C.S.I., Dr. Patricia McCabe, Pauline Scott and the W.C.S.I. officers and general committee who provided me with this opportunity to record the Society's history. I would like to express my appreciation for their splendid co-operation and advice. Together with members of the Society, I also wish to acknowledge with gratitude the support of Lochlann Quinn, Chairman of the Board of Governors and Guardians of the National Gallery of Ireland and his wife, Brenda; without their encouragement the publication of this book would not have been possible. A special word of thanks to Dr. Andrew Tierney who furnished academic support in the early stages of this book and to professional photographer, Mark Boland, for his outstanding photography. Dedication and hard work coupled with a sense of humour was supplied by Louisa Yorke, editor, and her team at Antique Collectors' Club Ltd., my grateful thanks to them all.

Generous help has been forthcoming from numerous sources and I do hope I have listed them all. Please forgive me if there are any omissions.

Institutions:
Ireland
The Water Colour Society of Ireland Permanent National Collection, The University of Limerick; The National Gallery of Ireland; The National Library of Ireland; The National Library of Ireland Photographic Archive; The National College of Art and Design; The National Botanic Gardens; Ulster Museum; Ulster Museum Picture Library; Royal Irish Academy; National College of Art and Design; The Dublin Art Gallery, the Hug h Lane; The Crawford Art Gallery, Cork; The Geological Survey of Ireland; The Irish Architectural Archive; The Limerick City Gallery of Art; The Dental Hospital; The United Arts Club, Dublin; South County Tipperary Museum, Clonmel, Co. Tipperary; Armagh County Museum; Office of Public Works, Waterford City Council; NIVAL, (National Irish Visual Arts Library); Friends of The National Collections of Ireland; Dun Laoghaire Rathdown County Council; The Irish Museum of Modern Art.

U.K.
The Royal Watercolour Society; Trustees of the Royal Institute of Painters in Water Colours; Reading Museum; The Fine Art Society, London; Courtauld Institute/Witt Library; The Betjeman Society; Sotheby's Picture Library; The British Library; City of York Art Gallery; British Museum; Victoria & Albert Museum; Tate Britain; Royal Institute of British Architects; Winsor & Newton Museum; Manchester University; The Royal Academy of Arts; The Royal Society of Arts; National Portrait Gallery; Royal Library, Windsor Castle; Bristol City Museums and Art Gallery; Syndics of the Fitzwilliam Museum, Cambridge; Country Life Archives; National Army Museum, Chelsea; the Guildhall Library, Corporation of London; Leeds Museums and Galleries, (City Art Gallery); Usher Gallery, Lincolnshire; Arbroath Art Gallery, Scotland.

Rest of the world
Mildura Arts Centre, Mildura, Victoria, Australia; Musée Groeninge, Bruges, Belgium; Abbey Library of St. Gall, St. Gallen, Switzerland; Humanities Research Centre, University of Texas; Mellon Bank Corporation, Pittsburgh; Yale Centre for British Art, Paul Mellon Collection; Fine Arts Museum of San Francisco; Musée D'Orsay, Paris; Guernsey Museums & Galleries; Cathedral of Saint Paul, St. Paul, Minnesota; Musées Royaux des Beaux-Arts de Belgique; British Columbia Archives, Canada.

Commercial Galleries/Fine Art Auctioneers:
The Gorry Gallery; Karen Reihill Fine Art; The Jorgensen Fine Art Gallery; Whyte's; James Adam & Sons; The Oriel Gallery; The Brock Gallery; The Coloured Rain Art Gallery; The Butler Gallery.

Private Collections/Collectors and Others:
The Marquis of Salisbury; The Lady Fitzwalter; Sir Nicholas Bacon; Janet Woodard; Dr. and Mrs Michael Purser; Dr. and Mrs John O'Grady; Adrian FitzGerald, Knight of Kerry; Ciáran MacGonigal; Francis Gillespie; Sarah Tilson; the Rt. Reverend Dr. B. Beare, Dean of Lismore; Peter Dowd, Lismore Cathedral; the Rt. Reverend John Morrison, Dean of Kildare; Dermot Edwards; Neville Currey; Ken Dunne; the Duke and Duchess of Devonshire; Roderick Trench; Emily Villiers-Stuart; Christian and Andrea Jameson; Dr. and Mrs Michael Purser; Dr. and Mrs John O'Grady; Philip Lecane; Miss Nancy Sandars; Fenella Tillier; Sir Richard Keane; Julia Keane; George and Maureen McCaw; Mr and Mrs David Addey; Mr and Mrs Keith Addey; Dr. Bruce Arnold; Elizabeth Mackeown; Gordon T. Ledbetter; Mr and Mrs F. Trench; Faith Frankland; Desmond Calverley Oulton; Anthony O'Brien; Ernest Mallie; Ann M. Stewart; Stephen Connolly; David Sheehy; Selina Guinness; Dr. and Mrs J. Cogan; Graham Wynne; Keith and Betty Addey; Jane Addey; Brian Cudmore Dixon; Mr and Mrs J. Jameson; Karen Reihill; Phyllis Gibney; Sheila Cuthbert Larchet; Dr. Patrick N. Wyse Jackson; Peter and Petronelle Clifton Brown; Brian and Michelle

Whelan; the late Dr. Theo Snoddy; Dr. John Turpin; Grahame Laver; Dr. Mary Lowe; Dr. David Poole; Igor Cusack; Caroline Bayly Scallon; Desmond Bayly; Anthony O'Brien; Mrs A. Hamilton; Lucy Deedes; Diana Finning; Mr & Mrs Graham Crisp; Elizabeth Tottenham; Anthony G. Simpson; Ann Porter; Mr and Mrs Nigel Cathcart; Mr & Mrs Philip Wingfield; the late Beatrice Somerville-Large; Deirdre Richards; John Kirwan; Mr & Mrs Aubrey Flegg; Rev. Canon B.Y. Fryday; Shirley Armstrong-Duffy; Mr & Mrs Philip Jacob; Dr. Nicola Figgis; Patricia McGloughlin, Hon. Secretary, Dublin Painting and Sketching Club; Geraldine O'Connor, Hon. Secretary, Friends of the National Collections of Ireland; Richard and Sandra Craik-White; Diana Watson; Deirdre Richards; Dr. Patrick N. Wyse Jackson; Philip Mackeown; Anne Pollard; Declan Mallon; the late Dr. Theo Snoddy; Dr. A.P.W. Malcomson; Mr and Mrs Aubrey Flegg; Margaret Donovan; the late Nellie Ó Cleirígh; Veronica Rowe; Rosemary Brown; Dr. A.P.W. Malcomson; Eugene F. Dennis; Niamh O'Sullivan; Margaret Rossiter; Igor Cusack; Margaret Williams; John McKenna; Dr. Andrew Tierney; Belinda Jacob; the late Rosemary Macaulay; Mrs John Bush; the late Dr. Philip Smyly; Pat Mayes; Pamela Bush; Jim O'Callaghan; Leonora Dand; Rosemary Brown; Ann Simmons; Sara Bourke O'Gorman; Mrs S. Rowntree; Sheila O'Neill; Graham Wynne; Gráinne Yeats; the late Robert Porter; Kitty Nolan; Adam Lynch Orpen; Pamela Robinson; Kieran Heffernan; William Ellis; Eugene Dennis; Kevin Dwyer; Geraldine Hone; Dr. Barbara Linsley; Desmond Calverley Oulton and all generous donors to the original Book Fund set up in 1987 by the Water Colour Society of Ireland.

Professional Staff:
Raymond Keaveney, Director, N.G.I.; Marie McFeely, Rights & Reproductions Officer, N.G.I.; Dr Brendan Rooney, Administrator, Centre for the Study of Irish Art, N.G.I; Donal Maguire, Assistant, Centre for the Study of Irish Art, N.G.I; Leah Benson, Archivist, N.G.I; Anne Hodge, Curator, Prints & Drawings, N.G.I; Niamh MacNally, Assistant Curator, Prints & Drawings, N.G.I; Andrew Moore, N.G.I. Library; Dr. Charles Noble, Keeper of the Devonshire Collection, Chatsworth; Diane P. Naylor, Photo Librarian, Chatsworth; Andrew Peppitt, Archivist, The Devonshire Collection, Chatsworth; Dennis Nevin, Agent, Lismore Castle; Michael Penn-Ruddock, Agent, (now retired), Lismore Castle; Caitlin Doherty, Arts Administrator, Lismore Castle Arts; Robin Harcourt Williams, Librarian and Archivist, Hatfield House; David Griffin, Director and staff, Irish Architectural Archive, Dublin; Aongus O hAonghusa, Director, (now retired) N.L.I.; Honora Faul, Assistant Keeper, Department of Prints & Drawings, and staff, N.L.I; James and Thérese Gorry, Directors, The Gorry Gallery, Dublin; Thomas Flynn, Archivist, Cathedral of St. Paul, Minnesota; Dr Bruce Davies, Curator, Craigdarroch Castle Historical Museum Society; Dr. Peter Murray, Director, Crawford Art Gallery, Cork; Dawn Williams, Exhibitions Officer, Crawford Art Gallery; Eddie Murphy, Librarian, Donna Romano, N.C.A.D; Dr. Yvonne Davis, Visual Arts Administrator, University. of Limerick; Dr. Julian Bowron, Arts Manager, Mildura Arts Centre; Irene Stevenson, Library Department, Irish Times; Ib Jorgensen, Director and staff, Jorgensen Fine Art, Dublin; Katherine Marshall, Picture Library, Sotheby's, London; Ian Whyte, Director and staff, Whyte's Fine Art, Dublin; James O'Halloran, Managing Director, David Britton, Director and staff, James Adam & Sons, Dublin; Mark Nulty, Director, The Oriel Gallery, Dublin; Seán Kissane, Curator of Exhibitions, IMMA; Pádraic E. Moore, Exhibitions Curator, Dublin City Gallery, the Hugh Lane; Liz Forster, Dublin City Gallery, the Hugh Lane; Jessica O'Donnell, Curator, The Dublin City Gallery, the Hugh Lane; Simon Fenwick, Archivist, Royal Watercolour Society; Siobhán O'Reilly, Care of Collections & Exhibitions, Limerick City Gallery of Art; Dr. Edward M. Walsh, Past President of the University of Limerick; Professor Dr. Patrick F. Doran, University of Limerick; Anthony Costine, Greyfriars Municipal Art Gallery, Waterford; Julia Walsh, Documentation Officer, South Tipperary County Museum, Clonmel; Professor Kenneth McConkey; Petra Schnabel, Deputy Librarian, R.I.A.; Mrs Marian Healy, Principal, Alexandra School and College, Dublin; Aileen Ivory, Librarian, Alexandra College Library, Dublin; Patrick T. Murphy, Director, R.H.A.; Elizabeth M. Kirwan, Assistant Keeper 1, N.L.I; Michel Draguet, General Director, Musées royaux des Beaux-Arts de Belgique, Bruxelles; Dr. Peter Wyse-Jackson, Director, National Botanic Gardens, Dublin; Alex. Caccamo, Librarian, National Botanic Gardens; Colette Edwards, Library, National Botanic Gardens; Karen Gibson, Management Services, Department of the Taoiseach; Cathy Doyle, Corporate Service Manager, The Dental Hospital, Dublin; Victoria Browne, Castletown House, Co. Kildare; Dr. Raymond Refaussé, Librarian, R.C.B. Library, Dublin; Dr. Susan Hood, Archivist, R.C.B. Library, Dublin; Dr. Julian Campbell, Senior Lecturer, Crawford College of Art and Design, Cork; Michael O'Connor, Waterford Heritage Services, Waterford; Andrea Fredericksen, Curator, U.C.L. Art Collections, London; Mary Houlihan, Heritage Officer, The Lismore Heritage Centre, Lismore; the staff, Friends' Historical Library, Rathfarnham, Co. Dublin; Noelle Dowling, Diocesan Archivist, Dublin Diocesan Archives, Archbishop's House Dublin; Donal Brady, County Librarian, Waterford Co. Council; Mike McCann, Royal Ulster Academy of Arts; Joanne Rothwell, Archivist, Dungarvan County Library, Co. Waterford; Thomas King, County Librarian, Library Headquarters, Carlow Town; Carol Graham, President, Royal Ulster Academy of Arts; Anna O'Sullivan, Director, Butler Gallery, Kilkenny; Aoife Lyons, Collections Manager, Butler Gallery, Kilkenny; Martin C. Donnelly, Director, Coloured Rain Gallery, Templepatrick, Co. Down; Martyn Anglesea, Keeper of Fine Art, Ulster Museum; Michelle Ashmore, Ulster Museum Picture Library, Cultra, Holywood, Co. Down; Dermot Mulligan, Curator, Carlow County Museum; Dr. John Killen, Deputy Librarian, The Linen Hall Library, Belfast; Christina Kennedy, Senior Curator: Head of Collections, IMMA; Michael N. O'Connor, Waterford Heritage Services; Marie McMahon, Curator, South Tipperary County Museum; Patrick Bourne, Director, Fine Art Society, London; Petra Coffey, Consultant, Archives, Irish Geological Heritage & Archives Programme, Irish Geological Survey; Diane Leeman, Tour Service Officer, Civic Buildings, Belfast; Erica Loane, University of Limerick; Eoin Stephenson, University of Limerick; Irene Murphy, Secretary, The United Arts Club, Dublin; Emily Kitchin, A.P. Watt Ltd., London; Alan Brindle, A.R.P.S.; Edwin Davison, Davison & Associates Ltd., Dublin.

Author's Preface

At the beginning, there was very little or nothing in the form of a continuous narrative with which to shape and form a history of the W.C.S.I. and no known notes relating to the circumstances of its birth and origin. Instead, I have had to rely largely on press cuttings from the early period and, after December 1921, on extracts from the Society's minutes. The quantity of available biographical information was unequally distributed among members and in some cases the record was a complete blank. I would like to express my gratitude for much valued assistance received from friends and strangers alike to whom I applied for information and their generosity in both furnishing facts and helping to revise some of the biographies.

As will be seen, I did not confine this history to a bare account of W.C.S.I. proceedings but rather tried to place its record as forming an integral part of the history of watercolour painting and the art world in general in Ireland. During the course of the Society's history, membership has included some of the most distinguished and influential names in Irish art who, in many cases, rose to the front rank in their field not only in Ireland but abroad. They, and the many gifted amateur artists, knew exactly what they wanted to express and possessed the emotional strength, armed with considerable technical expertise, and the courage and conviction to carry it out. We salute their contribution and those of succeeding generations. No doubt the seven indefatigable Foundation Members who gathered on the steps of Lismore Castle, Co. Waterford in November 1870 would be delighted to find their descendants are still thriving and striving to live up to their ideals.

Patricia Butler, May 2010

Foreword by the President of the Water Colour Society of Ireland
Vincent Lambe

It is appropriate that the Water Colour Society of Ireland, whose history stretches back 140 years to 1870, should have a book such as this written about it. On behalf of the Society I wish to congratulate Patricia Butler and express our sincere gratitude to her for taking on the enormous task. This beautiful publication, brilliantly researched and written by Patricia, along with her wonderful choice of illustrations, makes for the definitive record of the W.C.S.I. *The Silent Companion* firmly establishes the importance of the W.C.S.I. in a national and international context. It will be an invaluable source of reference to both amateur and professional artists, students and historians, and will give much pleasure to anyone with even a passing interest in the art of watercolour.

Over the years the Society has attracted to membership the most talented artists working in watercolour and the associated media of drawing and fine art print-making. The annual exhibition has gone from strength to strength and is recognised as the largest and finest exhibition of its kind in Ireland, and a highlight of the social calendar. The Society is proud to acknowledge the contribution made by past and present members, many of whom have achieved international recognition. In past years the Society has included many well known Irish artists, among whom were:

Rose Barton, Mildred Anne Butler, Helen Colvill, Phoebe Donovan, Percy French, Brigid Ganly, Letitia Hamilton, Fr. Jack Hanlon, Wilfred J. Haughton, Paul Henry, Evie Hone, Mainie Jellett, Maurice MacGonigal, Kitty Wilmer O'Brien, Bea Orpen, Richard Caulfeild Orpen, Sir William Orpen, Walter Osborne, Sarah Purser and countless others.

Watercolour painting is now well established as a serious artistic medium equal to oils for exhibitions. Since its foundation in 1870, the Society has been noted for its superb exhibits under many traditional headings and remains so to this day. Over the years it has also kept pace with modern trends. With membership now at 139, and with new artists coming on board every couple of years, I am delighted to see fresh approaches, freer styles and abstract images also being exhibited in our annual shows. The Society continues to be honoured by its association with the University of Limerick where the National Collection of the W.C.S.I. was founded in September 1993. This exhibition, which is on permanent view to the public, came about as a result of an approach by the then W.C.S.I. president James Nolan R.H.A., to Dr. Edward Walsh, then president of the University, with the view to displaying the collection. In 2009 the University published a full colour book of the collection.

On behalf of the W.C.S.I., I would like to say a very special thank you to Patricia Butler for her excellent work, and to past president and now trustee and honorary member of the Society, George McCaw, whose inspiration it was to publish a history of the Society, and for his very generous sponsorship and dedication in bringing it to fruition. Thanks also to Nancy Larchet and Pat McCabe for their continued involvement and contribution in making this publication possible.

Vincent Lambe
April 2010

Chapter I

An Introduction to the
Water Colour Society of Ireland

The period since the formation of the Water Colour Society of Ireland in 1870 has witnessed both dramatic developments in the field of watercolour and the participation in the Society's exhibitions of some of Ireland's most distinguished and influential artists: Sir William N. M. Orpen, R.A., R.I., H.R.H.A.; Sarah H. Purser, R.H.A.; Walter F. Osborne, R.H.A.; Paul Henry, R.H.A.; Mainie H. Jellett; Wilfred J. Haughton, P.P.R.U.A., F.R.S.A., P.U.W.S.; Tom Carr, H.R.H.A., R.U.A., R.W.S., O.B.E, and many more. Throughout the Society's history both professional and enthusiastic amateurs explored the full range of the medium and were quick to adopt a wealth of technical innovations that proclaimed the use of watercolour as an attractive, challenging, saleable and thoroughly modern medium.

At the beginning of the nineteenth century, watercolour was used largely for teaching purposes in the Royal Dublin Society's School of Landscape and Ornament. Painting in this medium had always been looked upon as a vital practical skill which allowed useful knowledge in innumerable areas to be recorded and disseminated. Enthusiasm for the work of 'modern' British watercolourists was led by Masters of the School of Landscape and Ornament such as father and son, Henry Brocas, Senior (c.1762-1837) and Henry Brocas, Junior (c.1798-1873). Both artists encouraged members of the R.D.S. to actively pursue and purchase works by well known English watercolourists such as Peter De Wint, O.W.S. (1784-1849) for teaching and technical purposes in the R.D.S. Schools. By studying and copying the work of many of the founders of the great nineteenth century British watercolour tradition, Irish students were introduced and encouraged to adopt many of their technical methods and styles. These influences were later to surface and be reflected in W.C.S.I. exhibitions.

From a social point of view, painting in watercolour was regarded as a useful accomplishment which not only provided an innocent pastime for young men and women but also acted as a signifier of social distinction. In Dublin, despite the growing popularity of the medium at the beginning of the nineteenth century, the Royal Hibernian Academy continued to banish the majority of watercolours to a back room offering little or no opportunity for favourable display. It would appear practitioners in watercolour were considered, both in medium and subject matter, less worthy of recognition than traditional painters in oil.

In Ireland during the early decades of the nineteenth century, women artists in particular found no readily available outlet for exhibiting their talents. It was not until the last thirty years or so of the nineteenth century that a structure and a means of channelling artistic creativity in the medium of watercolour was set in place which provided gifted artists working in this area with an opportunity to market their work. This was largely due to the establishment of the various sketching clubs and amateur drawing societies which began to make their appearance throughout the country with increasing alacrity. In due course, this movement was to culminate in the formation of the Water Colour Society of Ireland, who held their first exhibition under their new title in the Leinster Hall, 35 Molesworth Street, Dublin on Monday, 11 March, 1889.

In November 1870 in Lismore, Co. Waterford a group of enterprising

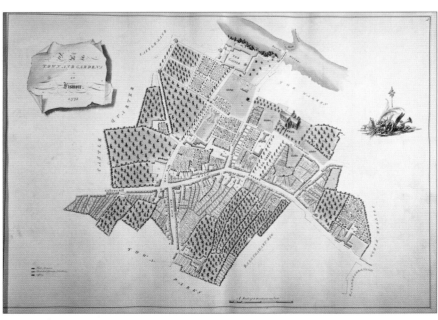

Bernard Scalé (c.1760-1787) 'A General Survey of the Manor of Lismore' from an album entitled *The Manor of Lismore County Waterford 1773*, watercolour.

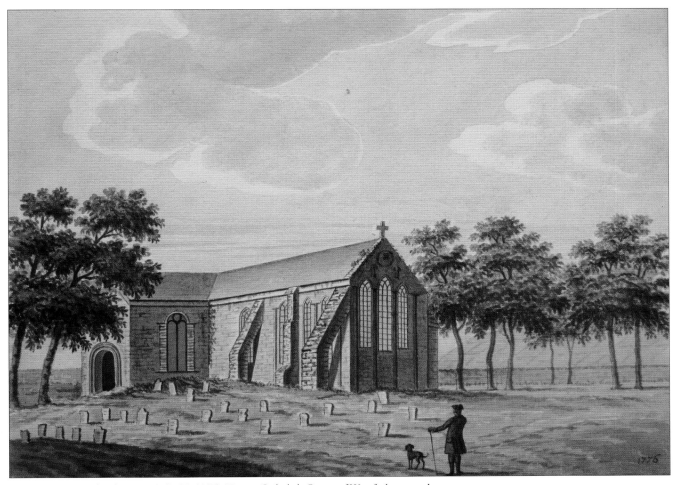

Gabriel Beranger (1729-1817) *Lismore Cathedral, County of Waterford*, watercolour.

talented, amateur women artists emerged, determined to market their work and to make it available to the public. In that year, this band of enthusiastic young painters consisting of Harriet Edith Keane (1847-1920), Frances Annie Keane (1849-1917), Frances 'Fanny' Wilmot Currey (1848-1917), Baroness Pauline 'Polly' Harriet Prochazka (1842-1930), Henrietta Sophia Phipps (1841-1903), and Anna Frances 'Fanny' Musgrave (d.1918) founded the Amateur Drawing Society for the 'mutual improvement in painting and drawing and the cultivation of a taste for art'.[1] The Society, whose membership was available to both men and women, offered women in particular a rare opportunity to exert an executive as well as a passive role. Those who were anxious to establish an independent, professional identity were free to pursue this goal and to exploit its full potential. The group would appear to have imposed no strict jury system and membership was based largely on invitation and through a network of social contacts.

It is interesting to note that when one looks at press comments in relation to the Society's early exhibitions held in Lismore, Clonmel, Carlow and elsewhere, these public displays were generally restricted to practitioners from the upper and middle classes. Furthermore, it would appear that, to some degree, press commentators judged the exhibits more on the artist's social position than on any true artistic merit. The increasingly popular and influential *Art Journal* had noted in 1861 how difficult it was for art critics to produce sophisticated and well informed art criticism for a newly emerging, wealthy, yet uninformed middle class audience. Art reviewers were accused of employing '...an unintelligible jargon [which] was substituted for knowledge, and the amount of technical slang was taken as the standard critical acumen.'[2] It would appear art criticism printed in the local press was not underpinned by any deep sense of scholarship that might strive to provide the reader with a well balanced, authoritative and fair account of an exhibition. Indeed, the role of the art critic was to underline the artist's membership of the grouping to which he or she belonged or to which they aspired to belong. As time went on, early reviews of the Society's exhibitions by newspapers (particularly ones local to the exhibition in question) became increasingly more flattering with critical, unbiased opinion difficult to trace. Perhaps it

should be remembered that a newspaper's editorial opinion was linked to local political, agricultural and economic interests.

The first exhibition mounted by the Society opened on 10 May, 1871 in the Courthouse (known today as the Lismore Heritage Centre), Lismore, Co. Waterford. The architect, John Carr of York (1723-1807), had provided designs for the fifth Duke of Devonshire for a new Sessions House, Lismore in 1799. It is not clear if Carr's design was executed but the existing building, which resembles one of his park lodges blown up on a much larger scale, may be the work of John Carr. There were over one hundred works on view. The press were forced to acknowledge: 'We were not at all aware that there was so much talent…'[3]

For their second exhibition, which took place in the market town of Clonmel, Co. Tipperary and opened on 23 October, 1871, the committee appeared keen to educate both their members and the general public. An impressive private art loan collection was placed on view consisting of a number of eigteenth century portraits and landscapes by Dutch, Scottish and English artists. The catalogue for the third exhibition held in Carlow in May 1872 – and for which the group now included the word 'Irish' in their title, becoming the Irish Amateur Drawing Society – lists the work of forty-five exhibitors with the inclusion of not only 121 watercolours but also a substantial number of oils and drawings. Members were able to choose from an extraordinarily wide-ranging number of categories which included such subjects as 'Illumination' (class 5) and 'Etching from Nature' (class 6). It would appear women artists were no longer to be confined to 'the graceful and feminine department of fruit and flowers'.[4]

Early catalogues reveal the committee appeared to have exercised little or no control over their members' production. For the Society's tenth exhibition, which opened in Dublin on 12 March, 1877, a record number of entries were accepted and hung (544 exhibits), the women outnumbering the men by ninety-nine to thirteen! The number of classes also showed a dramatic increase having risen from eight to seventeen with landscape, as always, being the most dominant and popular theme. The Society was one of the earliest organized art groups in Ireland to champion this subject, members working in a wide variety of styles which tended to hover between innovation and tradition. To judge from catalogue titles, subject matter ranged from rustic, sublime, pastoral and topographical to epic according to talents and tastes, the majority of painters helping to sustain and keep alive the solid academic tradition.

From around the 1930s onwards distinguished W.C.S.I. members such as Mainie Jellett, Evie Hone, Norah McGuinness, May Guinness, Nano Reid, Ralph Cusack, Basil Rákóczi and their followers helped to generate and sustain an exciting approach to this ever popular subject with their introduction of cubism, surrealism, symbolism and abstraction. The various movements promoted by these painters and their admirers helped to contribute to the creation of a stimulating art circle within and without the boundaries of the W.C.S.I., which supported and

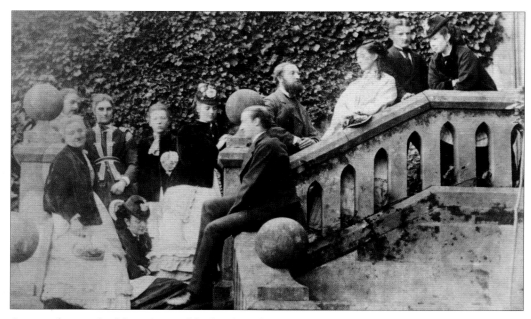

A group photograph of the majority of the founders of the Amateur Drawing Society photographed on the steps of Lismore Castle, Lismore, Co. Waterford, dated December 1870. These include: founder, Henrietta Sophia Phipps (1841-1903) (extreme left); exhibitor, Edith Osborne (1845-1926) (later Lady Edith Blake) (standing third left); founder, Frances Wilmot Currey (1848-1917); founder, Harriet Edith Keane (1847-1920); exhibitor, Grace Osborne, (1848-1926) (later the tenth Duchess of St. Albans); founder, The Baroness Pauline Prochozka (1842-1930) (standing extreme right); founder, Frances Annie Keane (1849-1917) (seated on steps).

Helen Sophia O'Hara, H.B.A.S. (1846-1920) *On the Blackwater Meadow, Lismore,* watercolour. Signed with monogram initials, also inscribed on verso.

sustained a balance between the solid, academic tradition and the visionary. This not merely applied itself to the area of landscape but as, will be shown in the second section of this book, was equally alive in a wide variety of other attractive subject areas.

A third change of title was introduced for the Society's Dublin exhibition held in March 1878 – the Irish Fine Art Society. Unfortunately, no catalogues relating to this particular year appear to have survived and therefore it is impossible to establish a reason for this change. In late September 1878, members began exhibiting in Cork, and from 1878 until around 1885 an exhibition was mounted each autumn in that city followed by a spring exhibition held in Dublin.

It is worth noting at this point that the Society's catalogue collection relating to the early period of its history is incomplete, with the following catalogues being missing: May 1871 (Lismore) and October

1871 (Clonmel); 1873 to 1876; 1878; 1881; 1884-1888; 1890-1891; 1894; 1896; 1903; 1907. In relation to the Society's minutes, none are available before the year 1921.

Fourteen years after the group's formation, it was felt there should be a society specifically to represent the watercolourists, 'Ireland should have such a society and The Irish Fine Art Society…seems…the nucleus on which to form it…'[5] Art historian W.G. Strickland adds weight to this statement by pointing out 'the Society had in its ranks most of the water-colour painters in Ireland'.[6] Therefore, it comes as no surprise when, in March 1889, the title of Water Colour Society of Ireland was officially adopted for the group's exhibition. Two years later it was decided provincial exhibitions should be discontinued and an annual spring exhibition was to be held each year in Dublin.

The Society's spring exhibitions were held in the Leinster Lecture Hall, 35, Molesworth Street, Dublin from c.1874

onwards with, on average, two exhibitions held per year, one in the provinces and one in Dublin. The Dublin exhibitions being held variously at: The Hall, 35 Dawson Street between 1913-1916 and 1921-1923 (when it was called the Engineer's Hall); and at Mills' Hall, Merrion Row from 1917-1920 and 1924-1944. The exhibitions then returned to 35, Molesworth Street until 1976 when the annual exhibition was transferred to the Hugh Lane Municipal Gallery, Parnell Square, (now known as the Dublin City Gallery, the Hugh Lane) until 1980. It then moved to the Bank of Ireland Exhibition Hall, Baggot Street between 1981-1989 and to thence to the Royal Hibernian Academy, Ely Place between 1990-1996. In 1997 the exhibition was transfered to the Chester Beatty Building, Dublin Castle, and in 1998 it was held in the R.D.S. Ballsbridge, Dublin. From 1999 to the present day, members hold their highly successful annual exhibitions in the Concourse, the County Hall, Dun Laoghaire, Co. Dublin.

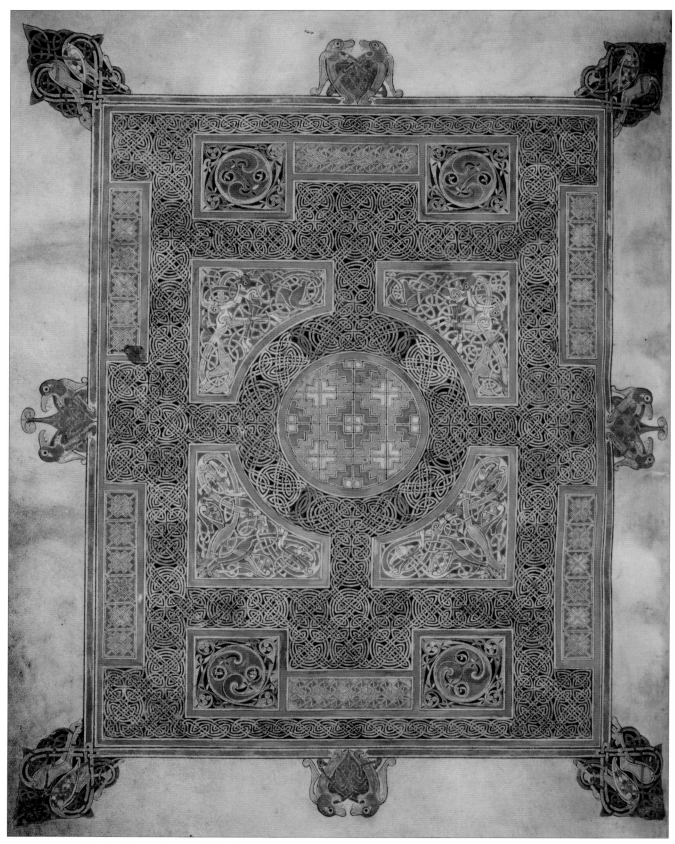

The Lindisfarne Gospels, St. Mark, carpet page.

Chapter II

The Early Use of Watercolour

The distinguished history of the use of watercolour and its associated media provides sound evidence for the fact that it was not until comparatively recently that this versatile medium was employed to produce works of art for display on walls, or for sale from public exhibitions. In the past, the potential of watercolour to illuminate manuscripts, produce miniature portraits, colour maps, decorate documents and books was explored and frequently exploited to the full, characterised by the medium's suitability for small scale work.

The origins and roots of this attractive substance and its associates may be found in the pages of early medieval illuminated book painting. Works such as the *Book of Dimma*, a pocket gospel book, and the well-known *Book of Kells* were produced during the brilliant and creative period stretching between 650–800 AD. In the majority of cases, water was used as the carrying vehicle for the writing material. The origins relating to the period colour pigments are to be found in vegetable, mineral and animal substances. Period pigments may be divided into four loose categories: mineral pigments from ground rocks; earth pigments from ground clays; dye pigments created from plant/animal products; and alchemist pigments, which are derived from a chemical process such as corrosion or burning together with a binding material. Glair, gum Arabic or egg white were the most frequently used binders in period book illumination and were mixed with a wide variety of pigments. Several of the substances used to make the pigments were not available in Europe, and it took a long journey along difficult and dangerous international trade routes to source them.

The creators of one of the greatest masterpieces of medieval European book painting were aware of this in the closing years of the seventh century. The Lindisfarne Gospels dating from about 710 have survived complete and virtually unscathed. They were produced at Lindisfarne (Holy Island), an island community lying close to the coast of Northumberland which was founded by Irish monks around 635. The manuscript, known for its conceptual and technical innovations and for the presentation of both Old English and Latin text, was probably made in honour of the translation of the relics of St. Cuthbert, who had died in 687. According to a colophon

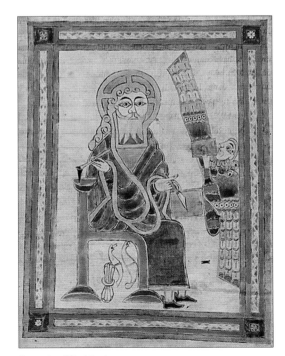

Portrait of St. Matthew.

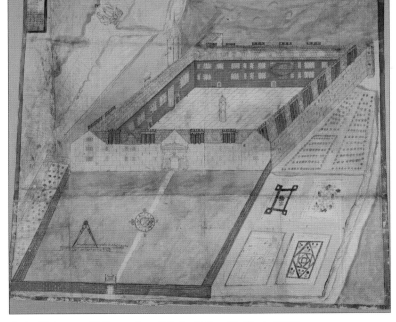

Artist Unknown *Bird's-eye view of Trinity College, Dublin.* (c.1600)

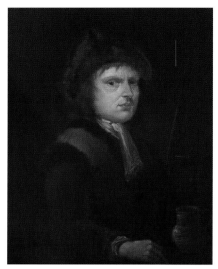

Francis Place (1647-1728) *Self-Portrait*
Francis Place spent the year 1698 travelling
and sketching in Ireland.

which was added at a later date, this
medieval masterpiece was largely the
work of the scribe and illuminator
Eadfrith, Bishop of Lindisfarne. The
earliest binding was provided by
Ethilwald, who succeeded him in 721.
The majority of the pages, made from
well-prepared, good quality vellum, are
virtually unadorned and devoted
entirely to the written text. This was
written in iron gall (sulphate of iron
and oak apples) and mixed with a
binding medium of gum Arabic-based
watercolour resulting in a brownish

tint. The principal decoration is to be
found in the fifteen spectacular pages
which mark major divisions in the
book. Each of the four gospels,
Matthew, Mark, Luke and John, is
introduced by three grand illuminated
pages. The first contains a miniature
which represents a symbolic repre-
sentation of the relevant evangelist; this
is followed by a page devoted to pure
decoration, opposite a page on which
the relevant opening words of the text
are written out in decorated capitals
beginning with a splendid initial one.
With its intricate decoration executed
in soft colours combined with
complicated patterns made up of birds
and beasts, these pages display a wide
range of pigments drawn from
vegetable, mineral and animal sources
found both locally and through trade
connections established with the
Continent. One of the most exotic
pigments to be identified is an ultra-
marine blue derived from lapis lazuli
and available only from Badakshan.
The binding medium applicable to the
majority of these pigments was simple:
egg white mixed with a little warm
water.

The origins of miniature painting
originated in gouache and watercolour
painting on vellum; and each of the
four gospels contained in the
Lindesfarne Gospels is introduced by a
portrait miniature. Thus the art of
portrait miniature acts as a vital link

between the medieval art of book
painting and later work in watercolour.
Portrait miniatures, first known as
limnings, from the Latin *illuminare*
meaning to illuminate, were executed
by miniators. This term, like the later
word 'miniature', is derived from the
Latin *minium*, red lead, a pigment
frequently employed in the outline of
the attractive capital letters which
decorate this medieval book painting.
The portrait miniature of St. Matthew
(illustrated here) taken from the Saint-
Gall Gospel, believed to date from the
eighth or ninth century, is from a lost
Irish Gospel Book and is one of several
Irish miniatures to be found in the
Abbey of Saint-Gall, established as a
monastery in the eighth century and
set in the hills above Lake Constance,
Switzerland. On verso are magical
charms written partly in Old Irish. As
can be seen, the two figures are
employed merely as a form of
decoration with little attempt being
made to produce an accurate sense of
draughtsmanship. These small paintings
or limnings were also known as
'paintings in little'. It was not until the
seventeenth century that the term
'miniature' began to be applied by
extension to all types of illustration in
manuscripts.

As the centuries progressed illumi-
nators using watercolour or associated
media decorated documents, bibles and
books with designs which included

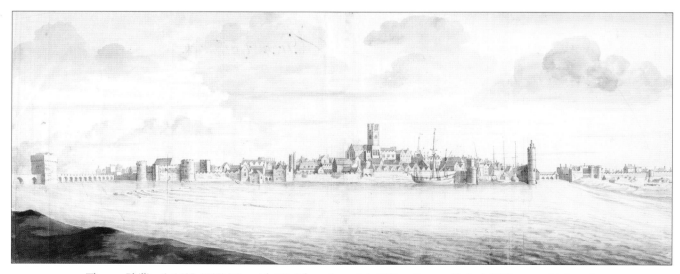

Thomas Phillips (c.1635-1693) 'Limerick City' from the artist's *Military Survey of Ireland 1685*, pen and ink wash
with slight colour.

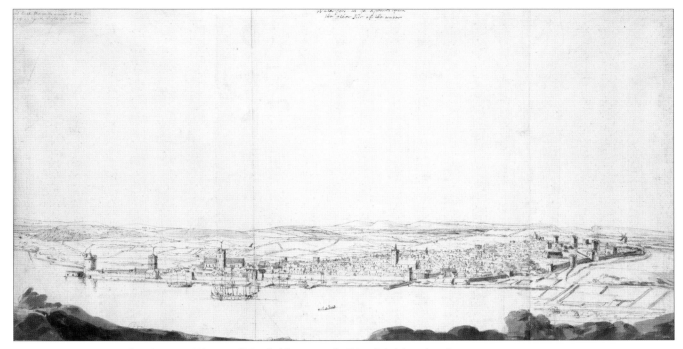

Francis Place (1647-1728) *View of Waterford from across the River Suir*, ink and wash.

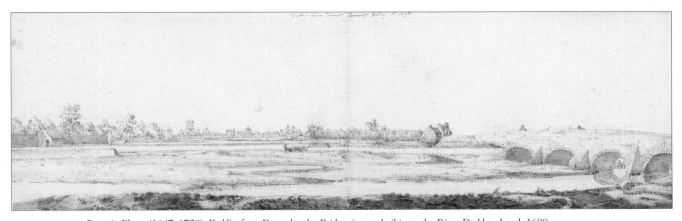

Francis Place (1647-1728) *Dublin from Donnybrooke Bridge, (now rebuilt), on the River Dodder,* dated: 1698.

representations or likenesses of persons. There came a point when these portrait miniatures were separated from the sanctity and security of the bound book and transferred into a portrait miniature, a separate object in its own right. When this happened in Ireland has never been firmly established. There is little evidence to suggest that miniatures were painted much before the seventeenth century.

Like his medieval predecessors, the early miniator or limner preferred gouache, grinding down his colours,

which included a white pigment, and mixing them with a solution of powdered gum Arabic, sometimes adding sugar and egg white, the entire mixture being dissolved in warm water. The majority of limners appeared to prefer this medium, known as gouache or 'body colour', an offshoot of pure watercolour, in preference to oil. A wide variety of supports were employed ranging from vellum to playing cards on which to execute the flattering portrait. Towards the end of the seventeenth century, the

introduction of ivory as a foundation on which to float watercolour provided the limner with certain advantages over vellum. Ivory used as a base imparted a delicacy and natural transparency in relation to the flesh colours. This may be seen in Horace Hone's, A.R.A. (1756-1825) charming and attractive eighteenth century portrait miniature of actress, Mrs. Sarah Siddons, where the artist floats watercolour lightly and delicately over an ivory surface in order to achieve a warmth and delicacy which no other

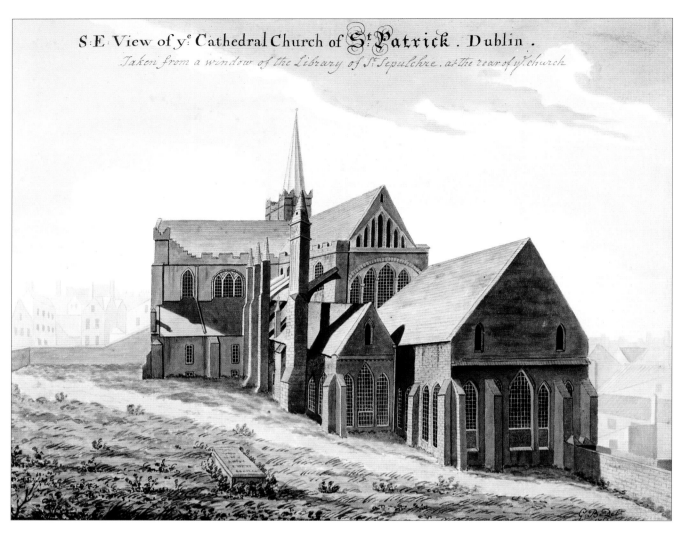

S.E. View of yͤ Cathedral Church of St. Patrick. Dublin.

Taken from a window of the Library of St. Sepulchre. at the rear of yͤ church

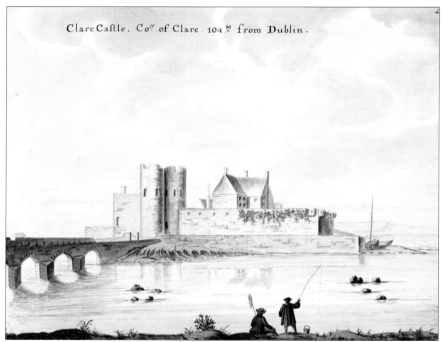

Clare Castle. Coᵗʸ of Clare. 104 ᴹ from Dublin.

Gabriel Beranger (c.1730-1817) 'S.E. View of ye Cathedral Church of St. Patrick. Dublin. Taken from a window of the Library of St. Sepulchure. At the rear of church' (1766) from *A Collection of Drawings of the principal Antique Buildings of Ireland Designed on ye spot, and collected by G. Beranger, Vol. I.*

Gabriel Beranger (c.1730-1817) 'Clare Castle, Co. of Clare. 104ᴹ from Dublin' from *A Collection of Drawings of the principal Antique Buildings of Ireland Designed on ye spot, and collected by G Beranger, Vol. I.*

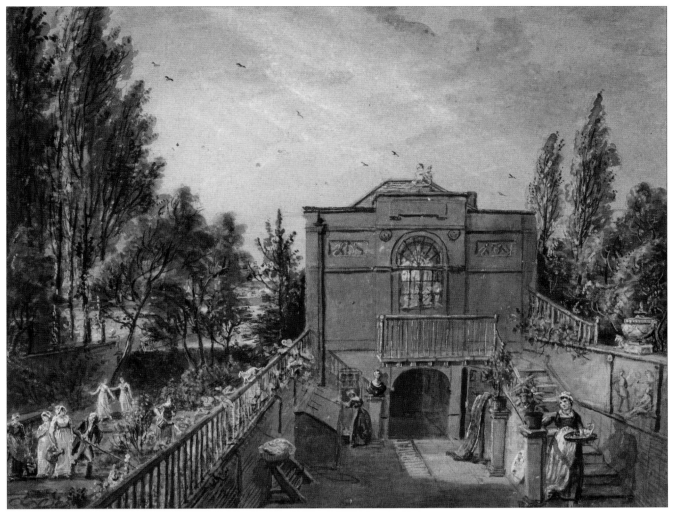

Paul Sandby, R.A. (c.1730-1809) *The artist's studio, 4 St. George's Row, Bayswater, London c. 1800*, watercolour and body colour.
From 1772 onwards, Paul Sandby lived at 4, St. George's Row, Bayswater until his death. Involved in the formation of the Society of Artists (1760) eight years later he became a founder member of the Royal Academy

foundation was capable of producing.

One of the areas traditionally associated with watercolour is topography. In the strictest sense, topography means the portraiture of places, the topographer's task being primarily to gather information and, in doing so, to produce a drawing which records the view for posterity. The topographical watercolourist was a literal transcriber from nature with little or no opportunity to introduce his personal interpretation of the scene before him. Unlike the artist who painted the ideal landscape and who was free to manipulate his material for aesthetic purposes, the topographer was confined to recording landscape in

simple graphic language intended to show the lie of the land, the size and layouts of cities, buildings and ports, (in many cases the information being part of a military survey). It was not until the mid-eighteenth century that the topographical watercolour began to develop into a more expressive and significant branch of landscape painting.

Characteristic of the early watercolour school in the seventeenth and eighteenth centuries was the tinted drawing, a simple topographical drawing outlined with a pen, shaded in grey, and finished with washes of local colour. Hand-colouring by teams of colourists was unknown during this

period and artists had to rely on pigments such as they could obtain or manufacture for themselves. Some of the earliest examples of topographical wash drawings in Ireland were known as 'views' or 'prospects' and date from the seventeenth century. Topographical watercolourists emerged from widely varying backgrounds and included military engineer Thomas Phillips (c.1635-1693) whose coloured washes greatly enlivened the topographical scene. Another example was inveterate traveller and social recorder, Thomas Dineley, (or Dingley) (c.1664-1695) who was described by his friends as being 'very ingenious with the pen'.[1]

Perhaps the most outstanding

23

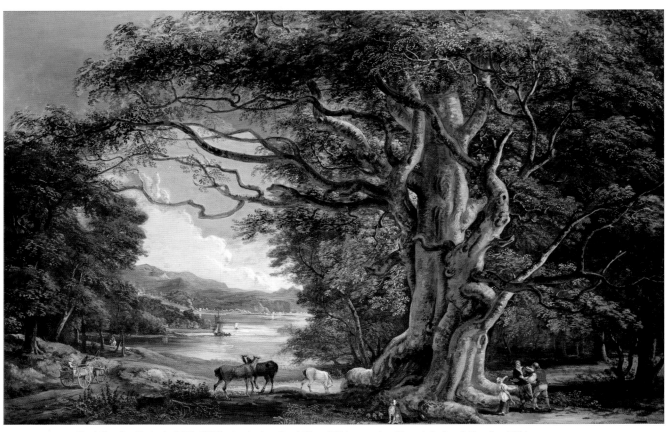

Paul Sandby R.A. (c.1730-1809) *An Ancient Beech Tree, 1794*, gouache. Signed & dated: Sandby 1794.

member of this early group of pioneers was Francis Place (1647-1728) He was to devote the greater part of his life to topography. His ability to record scenes with extraordinary accuracy gave his work a particular historical importance, combining as it did topographical and aesthetic interest. Place, born in Dinsdale, Durham in 1647, arrived in Drogheda in 1698 to spend a year travelling, sketching and visiting such places as Dublin, Kilkenny and Waterford. His fascinating 1698 panorama *Dublin from Donnybrooke Bridge on the River Dodder* was executed with a high degree of accuracy in both ink and watercolour and reveals a wealth of detail, much of which is still relevant to this day. Included are such buildings as the spires of the two cathedrals, Christ Church and St. Patrick's; the old Tholsel (built from 1676 onwards); the old Four Courts; and a collection of churches including St. Michael and All Angels together with St. Audoen's.

The medium of watercolour was particularly suitable for sketching and making finished drawings 'on the spot' due to it being a highly portable medium when compared to oil. The eighteenth century saw many antiquarians employing professional watercolourists either to realise their own sketches or to record topographical drawings of Irish antiquities. The demand for antiquarian art was being accelerated by the foundation of such societies as the Dublin Philosophical Society, the Royal Dublin Society and the Hibernian Antiquarian Society. These enthusiastic groups, many of whose members were leading antiquarians, encouraged the development and exploration of antiquarian interests throughout Ireland. In a less obvious way they encouraged the use of watercolour as a vital means of disseminating a wide range of antiquarian subject matter.

Gabriel Beranger (c.1730-1817) was part of this large and enthusiastic band

of both amateur and professional topographers who from time to time were employed by several leaders of the Irish antiquarian movement throughout the 1770s and 1780s, including Ireland's Chief Engineer and Surveyor, General Charles Vallancey (c.1726-1812). Beranger's attractive topographical view of Clare Castle, executed in watercolour, is based on an original drawing by Vallancey and shows the castle built on an island linked to the mainland by a bridge.

Beranger's recordings in watercolour provide a vital insight into the state of historic buildings in eighteenth century Ireland, including Dublin, as may be seen from his illustration of St. Patrick's Cathedral dating from c.1766 where he succeeds in rearranging the view to suit his needs: 'According to your order, I went with Mr Brien to Patrick's church, and fixed the view on the side of St Patrick's Close to be taken, supposing all the houses to be removed, facilitate the operation'.[2]

Factors such as the publisher's demand for the 'recorded' view or prospect 'drawn on the spot' led to a constant demand for topographical material executed largely through the versatile medium of watercolour. Artists, at the request of their publishers or patrons, undertook journeys both at home and abroad, the results being expressed in print form using a wide variety of technical methods. This included engraving, a popular and prestigious reproductive technique and ideal for converting the original topographical drawing into print as illustrated here.

Commissions were given by publishers to artists for a full range of subject matter, together with illustrations to popular literature or the classics. The choice of subject and their specific treatment was determined by commercial men whose livelihood depended on their understanding of the print market and its constantly changing demands. Again, watercolour was the key medium.

Development of the aquatint in England in the 1770s was led by influential English watercolourist and foundation member of the Royal Academy, Paul Sandby (c.1730-1809) who succeeded in providing a technique which was tonal rather than linear (See Appendix for full technical definition). Aquatint was particularly effective in reproducing the effect of watercolour washes, and as a result became a distinct and positive form of encouragement for the watercolourist and his publisher.

Artists rarely reproduced their own work. This task was normally undertaken by a specialist. The publisher co-ordinated the efforts of a team, including: someone to execute the aquatint; another to produce a soft ground etching for the lines; a third party to print the plate, and a team of colourists to complete the work. A collaboration between Waterford-born artist, Thomas Sautelle Roberts, R.H.A. (1760-1826) and engraver A. Courcell, may be seen here in this superb colour aquatint dating from c.1803 entitled *A Scene in the Dargle, near the Moss House, County of Wicklow*.

The second half of the eighteenth

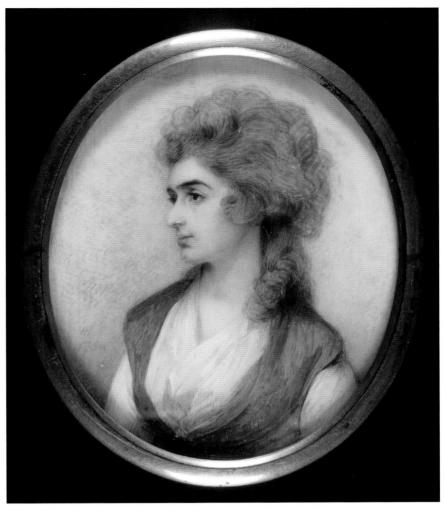

Horace Hone, A.R.A. (1756-1825) *Mrs. Sarah Siddons (1755-1831),* actress, for an engraving, 1785. Signed: HH 1784. Inscribed and signed on verso: 'Painted in Dublin by Horace Hone ARA 1784'.
COURTESY OF THE NATIONAL GALLERY OF IRELAND

century witnessed an almost constant succession of publications being produced which contained views of interest throughout Britain and Ireland. Amongst them was Thomas Milton's *A Collection of Select Views from the Different Seats of the Nobility & Gentry in the Kingdom of Ireland* in which the engravings were based 'on original drawings by the best masters' – as it states on the title page – and executed in watercolour, pen and/or ink. Not all the plates are dated, but the dates on those which are extend from 1785 to 1793. A substantial number of these views are pure landscape subjects with not a building in sight.

James Malton (c.1766-1803) together with his brother, Thomas Malton, the younger (1748-1804), represent the

architectural element in the illustration of their time. James Malton's *A Picturesque and Descriptive view of the City of Dublin displayed in a series of the most interesting scenes taken in the year 1791* was one of the earliest books to be produced containing colour aquatints. The plates were worked from watercolour drawings executed by Malton, twenty-five being reproduced in etching and aquatint, with (unusually for the period) the work being carried out by the artist himself.

Tradition associates the use of watercolour with surveying and map-making: map-making originally having much in common with topographical drawing. Until the early nineteenth century, specifically before the introduction of contours in maps,

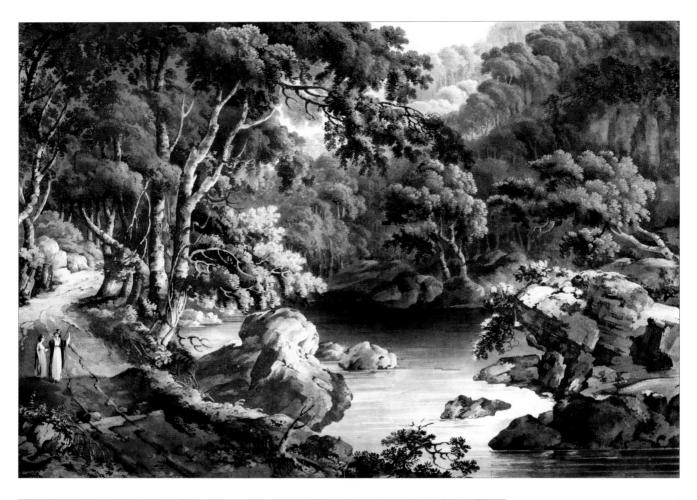

Thomas Sautelle Roberts, R.H.A. (1760-1826) *A Scene in the Dargle, near the Moss House, County of Wicklow c. 1803*, aquatint (coloured). Drawn by Thomas Sautelle Roberts. Engraved by A. Courcell. Published by Le Petit, 18, Henry Street, Dublin.

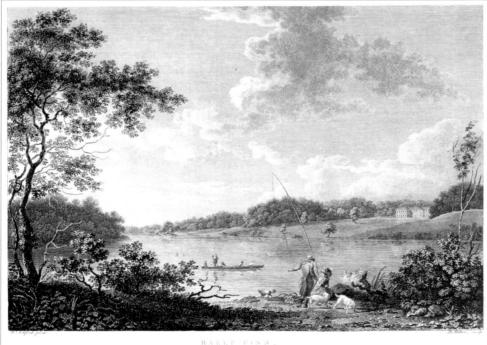

Engraving after William Ashford, P.R.H.A. (1746-1824) *Bally Finn, Queen's County* (now Co. Laois). Publ. March 1st, 1787 by Thos. Milton London.

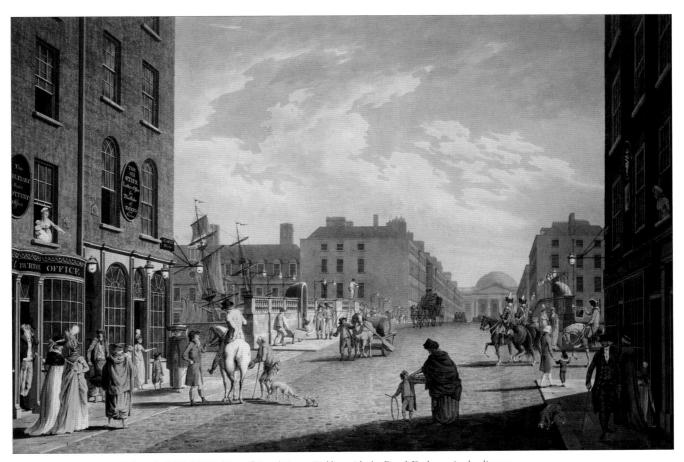

James Malton (c.1766-1803) *View of Capel Street, Dublin, with the Royal Exchange in the distance.*

artistic skills were required to depict and translate the surveyor's process into finished maps. Topographers were trained to sketch the relief of the land. It was the task of the artist to draw perspective views relating to the lie of the land and then apply them to the basic outlines on the surveyor's final map by the application of thin washes of colour. Frequently, these maps were not merely ground plans, but were dotted with representations of objects of interest with no attempt being made at continuous perspective. From this came the transition to the kind of bird's-eye view which may be seen in a wash drawing dating from the reign of Elizabeth I (illustrated p.19). This view (artist unknown) of Trinity College, Dublin, was executed around c.1600 for Lord Burghley who, as Secretary of State, was responsible to the Queen for the foundation of the College in 1592.

Light colour washes define the general layout of 'A General Survey of the Manor of Lismore' (illustrated p.14) taken from an eighteenth-century album entitled *The Manor of Lismore, County Waterford, 1773* by land surveyor, topographer and valuer of estates in Ireland, Bernard Scalé, who was known to have been working from Lower Abbey Street, Dublin between c.1760 to 1787.

It was not until the nineteenth century when these attractive but woefully inaccurate maps of an earlier epoch gave way to precision and portrayal. During this period, the Royal Dublin Society Schools was providing training for young draughtsmen who were eventually to become employed in the Ordnance Survey office. In the Society's Schools watercolour was the principal medium for colouring maps and recording drawings of Irish antiquities.

George Victor du Noyer (1817-1869) was a keen geologist, surveyor, watercolourist and compulsive sketcher. Having worked for the Ordnance Survey Memoir Scheme between 1835 and 1842, in October 1848 Du Noyer became a temporary assistant geologist with the Geological Survey of Ireland (founded 1 April, 1845). Thereafter he made numerous geological and archaeological recordings throughout his travels around Ireland, including his well known and reliable Field-Sheets. These show bands of watercolour being used to convey the distribution of a wide variety of geological formations. Here in his portrayal of the rock structure at Ballyboyle Head, Co. Waterford, dating from 1863, Du Noyer displays his aptitude and ability to use watercolour in a highly skilled and accurate way. Today, despite the onset of photography, it is interesting to note that watercolour is frequently employed by

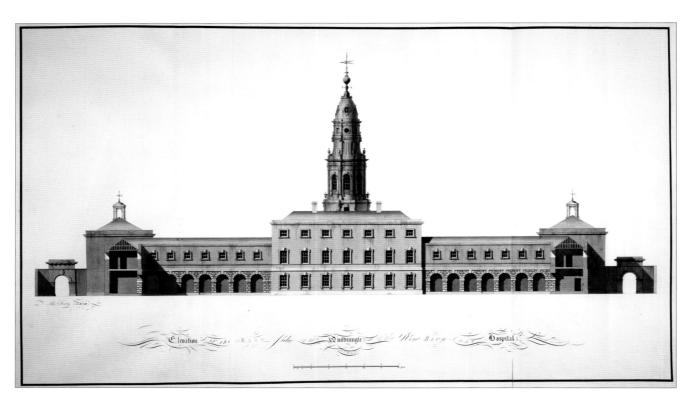

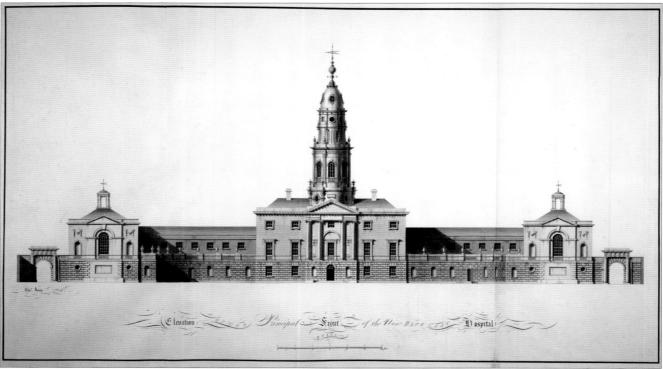

Thomas Ivory (c.1732–1786) Elevations of the Principal Front and the Quadrangle of the New Blue-Coat Hospital
Dublin from *Plans, Elevations and Sections, of The New Blue-Coat Hospital, Dublin, 1776.*

how to finish one end of The Parlour
next the Salloon

Robert Adam (1728-1792) 'Original design for Lord Bective's Eating Parlor or The Great Room, Headfort House, Kells, County Meath', watercolour and pencil.
COURTESY OF BRIDGEMAN ART LIBRARY

field archaeologists to record their informed response to objects discovered on site.

A fascinating element of the broader picture in relation to the use of watercolour is to be found in the field of architectural drawings and perspectives, the medium frequently producing attractive images with a high public profile but one which is rarely considered in watercolour studies.

The genre had its origins in the eighteenth century in the ill defined boundaries which existed between

artist and architect. The Royal Academy's first Professor of Architecture, Thomas Sandby, R.A. (1721-1798) who was a surveyor, topographical artist and architect, encouraged his students to portray buildings in a similar manner to the 'Landskip Painters' with great attention being paid to light and shade. In Dublin, the School of Architectural Drawing was established on 1 March, 1764 by the Dublin Society, its principal aim being 'to teach twenty boys of a proper age and properly qualified, the principles of Geometry

and the Elements of Architecture, and the Rules of perspective...'[3] In the School, plans and elevations were executed in the strict topographical watercolour tradition. A strong emphasis was placed on draughtsmanship, with no attempt being made to learn about actual building construction, materials or indeed creative design. This came later when the young student architect found employment working for a practicing architect.

The School's first Master of Drawing in Architecture, Thomas Ivory (c.1732-

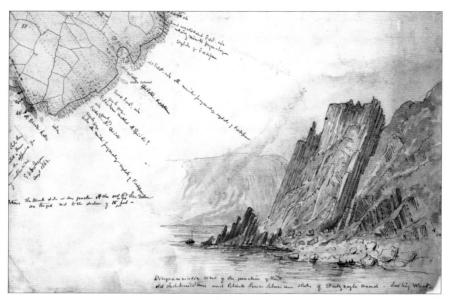

George Victor du Noyer (1817-1869) *Diagrammatic view of the rock structure at Ballyboyle Head, County Waterford 1863*. Detail from George Victor du Noyer's Field-Sheet.

1786) was born in Cork and began his working life as an apprentice carpenter. He then worked as a gunstock maker in Dublin and is believed to have received instruction in drawing from the Myers (or Meyers) family of architects. Thomas Ivory was considered to be amongst the best draughtsmen of Dublin architecture during this period and in the words of architectural historian, Dr. Edward McParland, '[his] draughtsmanship was superb...'[4]

This standard of draughtsmanship may be seen in Ivory's series of watercolour drawings *Plans, Elevations and Sections of The New Blue-Coat Hospital, Dublin* published in 1776 (in Blackhall Place, this building is now the home of the Incorporated Law Society). Described by McParland as amongst 'the loveliest architectural drawings produced in Ireland in the eighteenth century', Thomas Ivory was awarded the high profile commission as a result of a competition held in Dublin in 1773.[5] Executed in watercolour, the architect's plans, elevations and sections demonstrate how the medium might be used in a powerful and imaginative way, the architect pushing his ideas to the limit in order to woo his clients. Ivory's drawing 'The Elevation of the Principal Front of the New Blue Coat Hospital, Dublin' (illustrated here)

demonstrates a strictly utilitarian style in which line predominates. Watercolour enumerates every architectural detail. The use of colour helps to define spatial relationships, whilst the pictorial qualities of the building are captured in gradations of light and shade forming an essential and integral part of the design.

The use of a more pictorial alternative and the addition of a landscape setting for exterior views was pioneered by architects Robert Adam (1728-1792) and Sir William Chambers (1723-1797). Adam's *The Works in Architecture of Robert and James Adam* (1778) also included for the first time a new conception of the interior perspective view executed largely in watercolour. Robert Adam's perspectives of both exteriors and interiors for *Lord Bective's Eating Parlor (or the Great Room), Headfort House, Kells, County Meath* are reproduced in both pen and watercolour. Great attention is given to decorative detail, whilst colour enhances and helps to stimulate the imagination of the client at the same time contributing to the entire design process.

Architect William Henry Lynn (1829-1915), born in St. John's Point, Co. Down, was very much part of the High Victorian era and was responsible

for some of the finest buildings in nineteenth century Ireland. Employing the medium of watercolour and possessing a natural painting ability, Lynn could set off his designs to their best advantage and if necessary disguise certain weak points. This may be seen in his competition drawing for the Carlisle Bridge, Dublin dated 1862 for which *The Irish Builder* noted shrewdly 'nothing practical has been done since 1846'.[6] Here Lynn enhances his ink and watercolour design by placing it in a cityscape complete with overcast sky in order to provide a more realistic concept, and presumably to make it more easily understood by his clients. However, despite Lynn's drawings for this two-arch stone bridge being recognised as being the best in the competition, designs which would 'materially enhance the appearance of this most prominent part of the city, and form a handsome link between its first thoroughfares', the authorities rejected them.[7]

Gifted architect, designer and W.C.S.I. exhibitor, Raymond McGrath, R.H.A. (1903-1977) displays his ability to capture a quiet twentieth century Dublin city scene in watercolour as seen here in his *The Ivory Tower, Dublin Castle* (1941). McGrath's skill in employing the medium was described in the August 1943 issue of *Commentary* by its art critic, Theodore Goodman, as possessing 'a freshness of vision... combined with a fine technique...'; in Goodman's view, this could only be achieved by a 'master of his medium'.[8] McGrath's compositions display a feeling for line and simplicity, combined with a sense of light, space and elegance. His skilfully employed colour washes define, enhance and succeed in emphasising spatial relationships.

The sheer diversity and richness of the watercolour domain was contained in a wide range of practices as mentioned and illustrated here. Throughout the eighteenth century and well into the nineteenth century, an independent, professional identity for many practitioners in this versatile medium was to become one of the principal aims for watercolour artists.

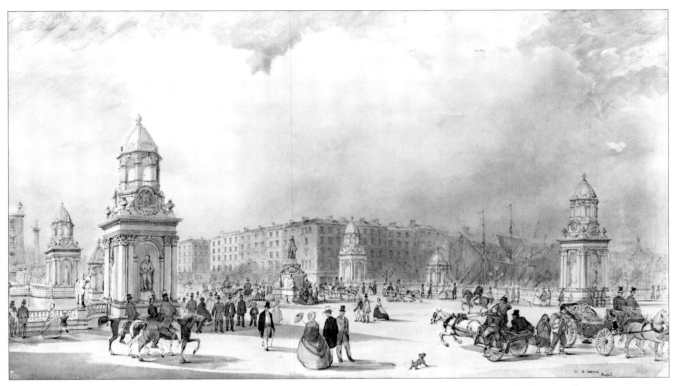

William Henry Lynn (1829-1915) *A Competition Drawing: Proposed Carlisle Bridge, Dublin, 1862,* ink and watercolour.

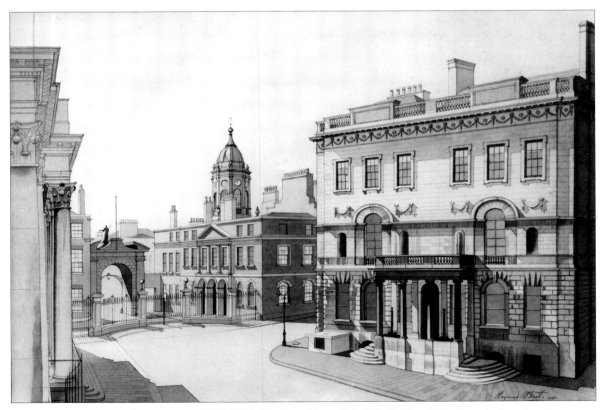

Raymond McGrath, P.P.R.H.A. (1903-1977) *The Ivory Tower, Cork Hill, Dublin, 1941.* General view showing Newcomen's Bank and Castle Gate, Dublin, pen, ink and watercolour. Signed 'Raymond McGrath, 1941'.

Chapter III

The Influence of the Royal Dublin Society's Drawing Schools

It is interesting to note that the National College of Art and Design in Dublin has its roots in the 'little academy or school of drawing and painting' established by Co. Waterford-born, Robert West (d.1770) in George's Lane (now South George's Street) around 1740.[1] The involvement of the Dublin Society (founded 1731, 'Royal' since 1821, abbrev. R.D.S.) with West's school is believed to date from 1746, with the Dublin Society's takeover occuring around 1750. Through their appointed Fine Arts Committee, the R.D.S. controlled the Schools of Figure Drawing, Architectural Drawing, Landscape and Ornament, together with the School of Modelling. The committee's approach to art education had always been essentially a functional and commerical one. The chief objectives were to prepare young tradesmen for a life as craftsmen in the City of Dublin. This realistic approach was combined with the European ideas of practical instruction. Part-time teaching was provided in such areas as figure drawing, drawing of animals, flowers and ornament and was combined with training in the relevant workshops .

The role of the Drawing Schools was to teach the technical skills and to combine this with an ability to understand stylistic conventions. As teaching was on a part-time basis, pupils were free to receive further practical training in the relevant workshops outside the Schools.

In 1877, the Drawing Schools were placed under the South Kensington system and became known as the School of Design. Together with their Committee of Fine Arts, the R.D.S. surrendered control in relation to its four schools and the name was changed to the Dublin Metropolitan School of Art (D.M.S.A.) and based in Kildare Street. It was here at the D.M.S.A. that countless future members of the W.C.S.I. were to receive their art training.

In 1936, the D.M.S.A. was reformed by the Department of Education and the title changed to The National College of Art. The inter-war years saw portrait and figure painter Seán Keating, R.H.A. (1889-1977) appointed as Professor of Painting, (on a part-time basis only) beginning in October 1937. He was joined during the same period by a future member of

the W.C.S.I. Maurice MacGonigal, R.H.A. (1900-1979), who acted as Assistant Professor of Painting. He again was appointed on a part-time basis. The latter believed in a practical approach to instruction in the field of art education: 'The art schools do not claim the almighty power to create the artist. They can only help – they give him his craftsmanship'.[2] Both men did not oppress their students with rigid rules but rather transmitted the belief that painting was synonymous with the learning of a new craft skill. It is interesting to note that both adopted two quite different starting points in relation to teaching . Keating taught through drawing, MacGonigal through painting. 'MacGonigal was a wonderful teacher: quite exceptional, but Keating was poor as a teacher. There was a division between Mac's students and Keating's students... Keating would take charcoal or paint and do his own painting on top'.[3] Amongst the many students later to become W.C.S.I. members who benefited from MacGonigal and Keating's tuition in the D.M.S.A. were Phoebe Donovan (Seán Keating only); Ruth Brandt, A.R.H.A.; Bea Orpen, H.R.H.A.

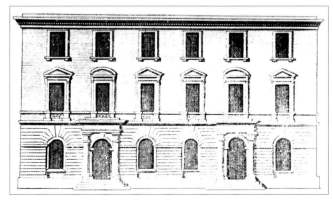

The Dublin Society's House, Grafton Street, Dublin, *The Gentleman's Magazine,* May, 1786.
PRIVATE COLLECTION

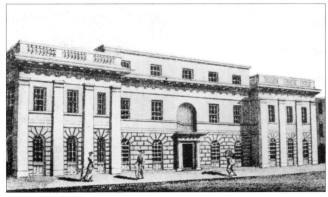

The Dublin Society's House, Hawkins Street, Dublin, 1801.
PRIVATE COLLECTION

James Henry Brocas (c.1790–1846) *Entrance to Dublin Society house Sept 20 1818*, pencil on paper. The main entrance
to the Dublin Society (later the Royal Dublin Society) from the forecourt looking down Molesworth Street, Dublin.

(Seán Keating); Rose Brigid Ganly, H.R.H.A. (Seán Keating); Arthur Gibney; Tom Nisbet, R.H.A.; Harry Kernoff, R.H.A. (Seán Keating).

From the beginning the medium of watercolour formed a vital and necessary part of the curriculum in the R.D.S. Drawing Schools. Pastel drawing together with watercolour and its associate, body colour or gouache, had always been linked to the Drawing Schools, particularly in the area of design. There the creation of patterns for the textile designer and the pattern drawer were executed largely in gouache, this being easier to control than pure watercolour; it could also serve to increase the fineness of detail and was capable of creating a more forceful contrast when required.

In the Society's Drawing Schools employment of the medium had always been looked upon as a vital, practical skill which allowed useful knowledge in innumerable areas to be recorded and disseminated. In order to raise the standard of pattern drawing for industrial purposes, students were encouraged to execute their designs largely through watercolour. As far back as 5 December, 1782, a student of the Dublin Society's School of Landscape and Ornament, Henry Graham, together with fellow artist, George Cowan, had submitted a range of specimen watercolour paints for Dublin Society members' approval. A silver palette had been awarded to Graham 'as a mark of the Society's approbation of his product' his invention being described as 'a Box of Water colours prepared by him in imitation of those invented by Messrs Reeves of London; the said Colours

From the *First Volume of the Instructions Given in the Drawing School established by The Dublin Society* (1769). Publisher: Alex. McCulloh, Henry Street, Dublin.

Photograph of William Orpen's Life Class, Dublin Metropolitan School of Art, c.1911.

Maurice McGonigal R.H.A. (1900-1979) *The Artist's Studio (The Dublin Metropolitan School of Art)* c.1935, oil on linen. Signed: 'Maccongail'. Here the artist imagines his friends, artists and writers have called to see him in the D.M.S.A. They are shown in the Life Room. Left to right: Harry Kernoff; F.R. Higgins (seated); Frank O'Connor; Sean O'Sullivan (seated foreground with drawing board), Seán Keating (seated at his easel), the school cat, Ernest Hayes; Michael de Burca.

appearing rather superior to those invented by Messrs Reeves'.[4]

As far back as 1787, the Dublin Society's School of Landscape and Ornament had provided opportunities for students to receive instruction relating to landscape painting which was intended as a decorative art form relating to interior decoration, woven and printed fabrics, or for the decoration of ceramics. The method of instruction was largely by copying using a wide variety of media which included watercolour. Students were encouraged to copy engravings found in books of ornament, landscape prints and drawings and to draw plant forms from nature. It was not until July 1872 that the idea of conducting classes out of doors was introduced for the study of landscape (*en plein air*).

A remarkable school of Irish landscape painters had emerged in the previous century which has been identified and surveyed by Professor Anne Crookshank and the Knight of Glin. Amongst them were George Barret, Senior, Thomas Roberts, James Forrester, Solomon Delane, and Robert Carver. Irish landscape paintings from this period reveal a striving after Italianate landscape effects combined with the influence of Dutch naturalistic sources which emerged as a type of 'Irish picturesque'. It is obvious that these influences stemmed from drawings which were available for students to copy in the Dublin Society's School of Landscape and Ornament. As Dr. Turpin points out, 'What the School did provide was an awareness of the modes and conventions of the European (primarily 17th century) landscape painting tradition as mediated by the French, and thus gave young Irish artists a framework of received artistic convention within which to place their own direct personal experience of the Irish countryside'.[5]

The acquisition of landscape drawings, particularly those which formed part of the English 'picturesque' tradition, was actively pursued by Royal Dublin Society members who purchased them for teaching purposes in the Society's School of Landscape and Ornament. In this way, many elements of the English watercolour school and tradition were transferred and introduced to Irish students. They became an integral part of their style and technique, and these influences were to surface throughout annual exhibitions organised by the W.C.S.I. down through the years.

Enthusiasm for pictures by modern British watercolourists was led by Masters of the School of Landscape and Ornament, father and son, Henry Brocas, (c.1762–1837), and Henry Brocas, Junior (c.1798–1873). Evidence for this may be found in the Dublin Society's teaching collection of Old Master and modern drawings. In 1966, 163 sheets of drawings from this collection were placed in the National Gallery of Ireland. Subject matter consisted of mythological and religious, examples of ornamental art, figure drawings, and landscapes in the classical, picturesque and topographical traditions. Many of these drawings had been purchased by members of the Dublin Society as examples for their pupils to

John Linnell (1792–1882) Detail from *John Varley (1778–1842)* c.1810.
English watercolourist and visitor to Ireland, John Varley, O.W.S. (1778–1842) together with his brother, Cornelius (1781–1873), were popular and influential drawing masters, their work being purchased by the Royal Dublin Society for teaching purposes in the Drawing Society Schools. John Varley published a number of drawing manuals, such as *A Treatise on the Principles of Landscape Drawing*, 1816–21.

copy in the Drawing Schools and included figure drawing together with landscape and ornamental drawing. Amongst the collection was a substantial number of contemporary watercolours and drawings by both Irish and English artists including several leading English watercolourists and founder members of the O.W.S, Francis Nicholson, O.W.S., (1753–1844) and John Varley O.W.S., (1778–1842) and Cornelius Varley (1781–1873).

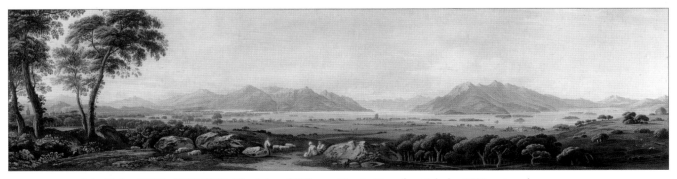

John Varley O.W.S. (1778–1842) *The Lakes of Killarney, County Kerry from Aghadoe,* 1826, watercolour on paper.
Signed: 'J. Varley, 1826'.
COURTESY OF THE NATIONAL GALLERY OF IRELAND

General Guide to the Art Collections. Illustrated Catalogue of Water-Colour & Oil Paintings, Chalk & Pencil Drawings Etc., by A. McGoogan, Dublin, 1915.
This guide was published by the Department of Agriculture and Technical Instruction in 1920; the Preface, however, is dated April 1915. The author, Archibald McGoogan (1860-1931), was a landscape and portrait painter and a keen photographer. He worked in the art section of the National Museum of Science and Art for more than forty years.

Other work by influential English watercolourists discovered in the Society's teaching collection were by drawing master, Samuel Prout, O.W.S. (1783-1852), and Copley Fielding, (1787-1855), the latter being President of the O.W.S. from 1831 until his death in 1855. English watercolourist and

member of the O.W.S. Peter De Wint (1784-1849) had the distinction of having eight of his watercolours purchased by the Royal Dublin Society in 1843. A step towards purchasing examples of this artist's work had been taken at the Dublin Society's Committee meeting held that year on 22 June. Member Charles Montgomery was requested to 'have the goodness to expend to the amount of £30 in the purchase of drawings for the Schools'.[6] This resulted in Montgomery informing the Dublin Society a month later that he had purchased eight drawings from De Wint. The artist wrote to the Dublin Society 'detailing the precise object of each and accepted the sum voted, namely £30., in lieu of the price for them viz. £16. 18s. 0d.' and requesting that 'the difference be considered his present to the Society'.[7] It would appear the choice of De Wint had been actively promoted by R.D.S. member Charles Montgomery, who himself is listed in Harriet De Wint's Sale Records (1827-1849) as owning three landscapes by this artist. The Society also thought highly of De Wint's work and 'it is reasonable to assume that his [De Wint's] method was taught in the school of landscape and ornament'.[8] It is therefore worth considering what constituted this influential English watercolourist's style and approach to his work.

At the age of eighteen, Peter De Wint had been introduced by John Varley O.W.S. (1778-1842) to painter and collector, Dr. Thomas Monro (1759-1833), whose collection of watercolours included a number by watercolourist, Thomas Girtin (1775-1802). De Wint had an opportunity to study the work of this talented artist who was to became one of the most influential English watercolourists in the first ten years or so of the nineteenth century.

It was Girtin who was largely responsible for transforming the tinted drawing into pure watercolour and abandoning the classical, Claudean framework. He did away with the careful outlines and grey washes of his predecessors together with the neat precision of the topographical school.

Details were suggested by the use of shorthand dots with effects being gained by broad massing of form and light. The emphasis lay on free brushwork, using rough, absorbent cartridge paper and creating an atmospheric impression of the scene.

De Wint became one of Girtin's closest followers as expressed in his *The Thames at Windsor* (watercolour over graphite, illustrated here) which demonstrates the use of strong, broad brushwork, with broken-brush stippling being applied to the leaves of the dominant tree on the left. Rich, lush colour tonal washes flood the foreground. Essentially an outdoor painter and revelling in the realities of the English countryside, De Wint's interpretation of landscape is summed up by 'plough-boy' poet John Clare who, in a letter to the artist in 1829 stated 'nothing would appear so valuable to me as one of those rough sketches, taken in the fields, that breathe the living freshness of open air … where the blending & greens & greys that a flat bit of scenery on a few inches of paper appear so many miles'.[9]

De Wint's series of four pencil and watercolour drawings (c.1846) purchased by the Royal Dublin Society on 9 November, 1843 formed part of the original Society's teaching collection and are highly informative. They depict *A River in a Rocky Gorge* in four stages of completion and in the artist's own words are 'illustrative of the method it is desirable to secure in bringing a drawing of a sketch gradually and uniformly towards a conclusion'.[10] In all four studies, the foreground is but a casual suggestion with the main masses being created by employing layers of wash. White highlights are added to breathe life into the rushing waters with foliage being carefully delineated in realistic detail. In sketches such as these, De Wint frequently left the sky untouched. Another drawing by the same artist suggests how the watercolourist should tackle an abstract shape. The full title of the watercolour is *Blot, such as the artist is recommended to make before commencing the picture, in order to try out all the qualities of light and shade, as well as the proportions of warm and cool colours.*

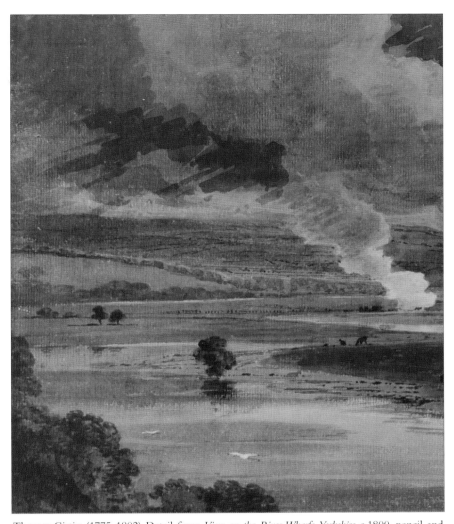

Thomas Girtin (1775-1802) Detail from *View on the River Wharfe, Yorkshire* c.1800, pencil and watercolour. Thomas Girtin was one of the great masters of British watercolour painting and, with J.M.W. Turner, led the revolution in watercolour technique at the beginning of the nineteenth century extending the medium well beyond its previous range. This atmospheric watercolour reveals detail reduced to the absolute minimum with broad and simplified effects predominating. PRIVATE COLLECTION

In 1848 the Dublin Society purchased a further four drawings by this artist for the sum of £30. The Chairman of the Fine Arts Committee, R.D.S. wrote to De Wint;

'I anticipate much good to the students in the Schools from the drawings you propose to make. The beautiful art of painting in watercolour, which has made such rapid progress in England in the last fifty years, has, I regret to say, not made an equal advance in this country which I attribute in a great measure to the want of a good mode of instruction. The boys in these Schools show a great deal of talent and the vicinity of Dublin affords within a few hours many subjects which, for beauty and variety, ought in themselves to create a task for landscape painting.'[11]

Following in the Girtin tradition, Samuel Prout's watercolours and several of his publications also formed part of the curriculum in the Society's School of Landscape and Ornament. A watercolour and pencil drawing of *The Temple of Pallas, Rome* by pupil William Brocas, R.H.A. (c.1794–1868) is a direct copy taken from Samuel Prout's *Sketches in France, Switzerland and Italy*. Watercolours largely executed in the

Peter De Wint, O.W.S. (1784-1849)
Self-Portrait.
English watercolourist, Peter De Wint, had the distinction of having eight of his watercolours purchased by the Royal Dublin Society in 1843 for teaching purposes in the Drawing Schools

COURTESY OF THE COLLECTION: ART AND
ARCHAEOLOGY IN LINCOLNSHIRE
(THE USHER GALLERY)

Peter De Wint O.W.S. (1784-1849) Above: detail from *The Thames at Windsor*, watercolour over graphite. Below: *The Thames at Windsor.* COURTESY OF THE ROYAL WATERCOLOUR SOCIETY

picturesque tradition were represented in the collection and included the work of a number of popular and successful watercolourists and drawing masters, John Varley, (two picturesque views of *The River Dee, near Llangollen, Wales* and *A Shepherd Resting in a Classical Landscape*), Francis Nicholson (*Views in Yorkshire, Cheshire and Somerset*) and Anthony Vandyke Copley Fielding, (*Ships off Dover, Kent and Moonlit Lake*). Other artists represented were Paul Sandby (*A Castle by a Lake*); Nicholas Pocock, (a marine view); Hugh William 'Grecian' Williams, (Scottish and Welsh views); and Richard Cooper, the younger (*A Ruined Castle on a Hill*). The work of these influential English water-colourists gave students in the Dublin Societys' Schools an opportunity to become aware of stylistic conventions outside Ireland. This in turn had a direct relevance in relation to the development of watercolour and landscape painting in Ireland.

Seven of the of watercolour views (now in the National Gallery of Ireland) which formed part of the

(a)

(b)

(c)

(d)

Peter De Wint, O.W.S. (1784-1849) (a) *A River in a Rocky Gorge*, wash on paper; (b) *River in a Rocky Gorge*, pencil and watercolour on paper; (c) *A River in a Rocky Gorge*, watercolour on paper; (d) *A River in a Rocky Gorge*, watercolour with white highlights on paper.

Society's teaching collection proclaim the fact that Irish landscape watercolourist and pupil in the Dublin Society's School of Landscape and Ornament around 1770, John Henry Campbell (1757-1828), was influenced by the picturesque interpretation of landscape as laid down in the Dublin Society's schools. Described by Strickland thus 'as an artist he ranks high among contemporary Irish painters in water-colour', Campbell's landscape watercolours, set largely in counties Wicklow and Dublin, reveal the influence of English watercolourist and drawing master, William Payne (c.1760-c.1830).[12] The latter succeeded in creating a technique which was

Samuel Prout, O.W.S. (1783-1852) *The Doge's Palace and the Grand Canal, Venice* c.1830, watercolour.
Drawing master and watercolourist, Samuel Prout's publications were highly successful and in the R.D.S. Drawing Schools.

William Brocas, R.H.A. (c.1794-1868) *The Temple of Pallas, Rome (after Samuel Prout)*, watercolour and pencil.

easily accessible to impart and employed a tint known as Payne's grey. This consisted of a mixture of Prussian blue, lake and yellow ochre; it appears to have been the basis for the majority of his work and marks the artist out from his contemporaries. Another principal characteristic was a standardized scallop-shaped method of rendering branches and foliage. This, together with the use of Payne's grey, is evident in Campbell's attractive watercolour *Ringsend and Irishtown from the Grand Canal, Dublin* (illustrated here) which succeeds by a skilful use of undulating line in creating an atmosphere of relaxation in what is primarily a topographical work. This is particularly evident in the decorative detail of the large foreground tree. The colour is controlled yet delicately varied to enhance the charm of the whole design. It is interesting to note that the artist painted this view when

the villages of Ringsend and Irishtown were still a unit, and a short distance from the centre of the city of Dublin.

Born in 1757 to English parents, Campbell's family had moved to Dublin, his father becoming a partner with the King's printer, Graisbery. He married a 'Miss Beaufort … of Herefordshire'.[13] From an early age he encouraged his son, John Henry, to train in the Dublin Society Schools. In 1802 John Henry Campbell contributed (from an address in Harold's Cross, Dublin) two views of the river Dargle, Co. Wicklow to an exhibition organised by the Society of Artists of Ireland held in Parliament House, College Green, Dublin. A painter in both watercolour and oil, Campbell is best known for his watercolours and is listed as contributing to the Opening Exhibition of the R.H.A. held in 1826 where he exhibited a moonlit scene. Two years later, he again exhibited in the R.H.A.

six views in all, five of which were set in Co. Wicklow. Campbell appears to have concentrated largely on painting picturesque views in watercolour which related to scenes in and around Dublin including Dun Laoghaire, Rathmines and Rathgar, and of views set in Co. Wicklow. Several landscape watercolours are also known to exist of counties Westmeath, Down and Kildare, together with a view of *Virginia, Co. Cavan,* now in the Victoria & Albert Museum, London, (illustrated here).

The romantic picturesque style of landscape favoured by Dublin Society pupil, Francis Danby, A.R.A. (1793-1861) reveals itself in the latter part of the career of this gifted and original painter. During the 1798 rebellion Danby's family had moved to Dublin from Co. Wexford. After the death of his father in 1807, he began his art training in the Dublin Society Schools, completing his studies in 1813. There

William Cuming, P.R.H.A. (1769-1852)
Artist, John Henry Campbell (1757-1828)
PRIVATE COLLECTION

John Henry Campbell (1757-1828) *Ringsend and Irishtown from the Grand Canal, Dublin,* 1809, watercolour. Signed: 'J H Campbell 1809'.
This watercolour was acquired by the Royal Dublin Society for teaching purposes in their Drawing Schools. COURTESY OF THE NATIONAL GALLERY OF IRELAND

he made friends with two young landscape painters, James Arthur O'Connor (1792-1841) and George Petrie with whom he was to remain on good terms throughout his life.

Lacking patronage and needing to complete his education, Danby, together with Petrie and O'Connor, set out for London during the first week of June 1813. Shortly afterwards, Danby ran out of cash and was reduced to walking to Bristol. He decided to remain there, no doubt being attracted by a lucrative and ready market for his watercolours and eked out a living by giving lessons in drawing. Here he painted watercolours such as *The Avon at Clifton.* This is an open composition, and with the use of strong, dark colouring and creates a mood of romantic contemplation combined with an accurate rendering of topographical detail. *On the Avon, near Bristol* is almost Turneresque in feeling, with many of the scenic devices being deliberately borrowed from English watercolourists John Sell Cotman, (1782-1842) a close friend and admirer of Girtin, and Joseph Mallord William Turner R.A. (1775-1851). Danby's pencil and watercolour *View near Killarney* executed c.1817 (illustrated here) demonstrates his enthusiasm for the seventeenth-century classical

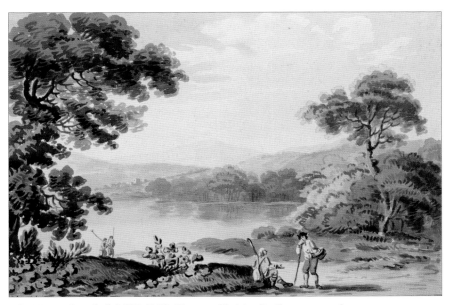

John Henry Campbell (1757-1828) *View near Virginia, Co. Cavan,* watercolour on paper.
COURTESY OF THE VICTORIA AND ALBERT MUSEUM / THE BRIDGEMAN ART LIBRARY

landscape tradition and in particular the influence of Claude.

In 1824 the artist moved from Bristol to London. Visits to Norway and Scotland around 1825 heightened his interest in the grandiose effects of sublime nature, as is clearly shown in

two watercolours dating from this period, *Cascade in Norway* and *Lake in Norway.* Both are recollections of places of elegiac grandeur seen on his travels portrayed with meticulously wrought surfaces and possessing a high degree of intensity.

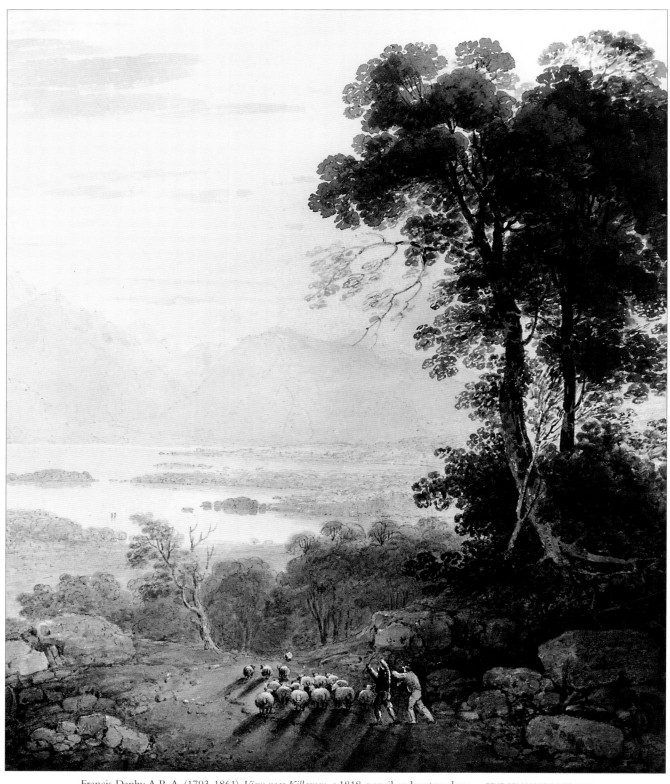

Francis Danby, A.R.A. (1793–1861) *View near Killarney,* c.1818, pencil and watercolour. BRIDGEMAN ART LIBRARY

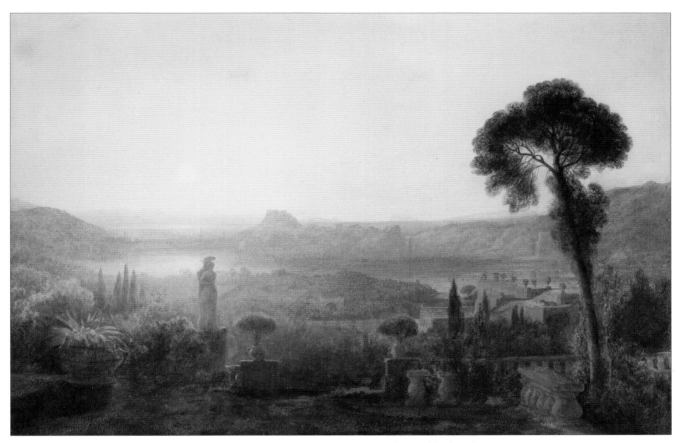

Francis Danby, A.R.A. (1793-1861) *An Ancient Garden*,1834, watercolour and body colour.

In 1825 Francis Danby was elected A.R.A. and was John Constable's chief rival for full status as an academician in 1829, being defeated by just one vote. In London his popularity was high during this period and was believed to be even greater than that of Constable. After his separation from his wife and subsequent departure for Paris in 1829, with another woman, Helen Evans, Danby's career took a downward turn. He remained on the Continent for ten years, travelling and living both in France and Switzerland, continuing to paint and draw. He supported himself and his growing family by the sale of watercolour drawings through the aid of kind friends such as Domenic Colnaghi (1790-1879) and the watercolour painter, George Fennel Robson, (1788-1833) a Past President of the O.W.S. (1819-20). By 1838 he had decided to move back to London. On his return, Danby quietly set about reconstructing his broken career,

exhibiting once again at the Academy and in Ireland at the R.H.A. from 1844 till 1846 and at the Cork exhibition in 1852. Just six years before his death, the artist had the satisfaction of seeing his painting entitled *The Evening Gun* (now in the National Gallery of Canada, Ottawa) hung in the 1855 Paris Exposition. It caused a sensation attracting the eye of poet and novelist Theophile Gautier who remarked: 'No one has better expressed the solemn grandeur of the ocean'.[14] Danby's pencil and sepia drawing is an illustration for his long and lost poem *Cristna* and makes a fascinating comparison with a watercolour and body colour dating from 1834, entitled *Ancient Garden* (illustrated here). The latter shows the gentle harmony of man and nature, the effects of soft light and purity of colouring coupled with an aerial delicacy and demonstrates how mood can dominate a simple classical view depicted largely in watercolour.

George Petrie P.R.H.A., LL.D., (1790-1866) was a close friend of Francis Danby and had been one of his travelling companions on their journey to London in 1813. Son of Dublin-born miniature painter, James Petrie (1750-1819), he became a distinguished pupil at the Dublin Society's Schools and in 1805, at the age of fourteen, was awarded a silver medal. He assisted his father in the field of miniature painting but soon turned to landscape in watercolour making his first sketching tour in Co. Wicklow in 1808. This was followed two years later by a tour through Wales.

Petrie made many sketching tours of Ireland, his graceful watercolour drawings being translated into print and enhancing publications including Reverend G.N. Wright's *Ireland Illustrated* (1828-39) and J.N. Brewer's *The Beauties of Ireland* (1825-26). In the view of his biographer, Dr. Peter Murray, 'Petrie's achievement within the watercolour

James Petrie (1750-1819) *Portrait of George Petrie, P.R.H.A., LL.D. (1790-1866)*, watercolour on ivory.

tradition was to blend the topographical styles of Francis Place, Wenceslaus Hollar and Paul Sandby with the new emotional sensibility of the Romantic era'.[15] It was Petrie who managed to convey the landscape and ancient historic sites of Ireland in a Romantic way but at the same time did not seek to abandon his feeling for draughtsmanship, precision and delicacy contained within the strict topographical tradition. In the view of Murray, Petrie's style was rooted in Girtin and John Varley and painters such as Royal academicians, George Barret, Senior and Richard Wilson (1714-1782).

George Petrie became the first watercolour painter to become a full member of the R.H.A. in 1828. In the view of Stewart Blacker (1813-1881), who was largely instrumental in

founding the Royal Irish Art Union this artist was considered to be 'a water-colourist' of the highest standard.[16] An extraordinarily accomplished man in many fields, Petrie was an archaeologist, musician and man of letters, making a valuable contribution to the R.I.A. Among the many manuscripts he secured for the Academy were the *Annals of the Four Masters* and the *Book of the Dun Cow*. Between 1835 and 1842 he was head of the topographical and historical department of the Ordnance Survey of Ireland and collected valuable material on the antiquities, place names and local history of various counties in Ireland. Possessing a deep interest in Irish music, he gathered together a large collection of Irish airs, some of which he published in 1855 as *The Petrie*

Cromlech at Killiney, County of Dublin from Thomas Kitson Cromwell's *Excursions through Ireland, 1820-21*, Vol. II, engraving after George Petrie (1790-1866).

Collection of the Native Music in Ireland.

Like Petrie, Sir Frederic William Burton, R.H.A., R.W.S., R.S.A. (1816-1900) 'confined himself solely to watercolour and to chalk, never exhibiting in oil'.[17] Indeed, it was said that the smell of oil paint offended him. Born into an artistic family, Burton's father was an amateur painter, and had enrolled his son at the Royal Dublin Society Schools in 1826 where the young artist had the opportunity to study under landscape painter, Henry Brocas Senior and figure painter, Robert Lucius West, R.H.A. The latter, besides being a fine draughtsman, was also an enthusiastic art historian and encouraged his young students to pursue both the practical and the academic arts. This, together with his lifelong friendship with Petrie, encouraged Burton's interest in Irish archaeological studies. Later in life, Burton became a founding member of the Archaeological Society of Ireland and was elected Fellow of the Society of Archaeologists in 1863. Petrie did not, however, influence Burton's technique, or style; as Strickland remarks, 'Even in his earlier drawings, Burton shows a perception and sense of colour much beyond Petrie's limited range.'[18]

In 1832, when Burton was sixteen,

George Petrie, P.R.H.A., LL.D. (1790-1866) *Dun Aengus Fort, Inismore, Aran Islands* c.1827.
COURTESY OF THE NATIONAL GALLERY OF IRELAND

he exhibited for the first time at the R.H.A., a religious work. In the early part of his career, he tended to specialise in painting portraits in watercolour and miniature; his miniature style being influenced by miniature painters, John Comerford (c.1776-1832) and Samuel Lover (1797-1868).

Travelling in Ireland, particularly in the west and frequently in the company of Petrie, Burton recorded landscape in watercolour – *The Upper End of Lough Corrib, Co. Galway* and *In Joyce's Country* (Connemara, Co. Galway). During this period, the growing feeling of 'national identity' was beginning to emerge and the young student was obviously keen to portray peasant life in a sympathetic

Sir Frederic William Burton , R.H.A., R.W.S., R.S.A. (1816-1900) *Self-Portrait*, pencil.
Burton was Director of the National Gallery, London from 1874-1894.
COURTESY OF THE NATIONAL GALLERY OF IRELAND

Sir Frederic William Burton R.H.A., R.W.S., R.S.A. (1816-1900) *The Dream*, c.1861, watercolour, bodycolour and gum over graphite on card.
© YALE CENTER FOR BRITISH ART, PAUL MELLON FUND, USA / BRIDGEMAN ART LIBRARY

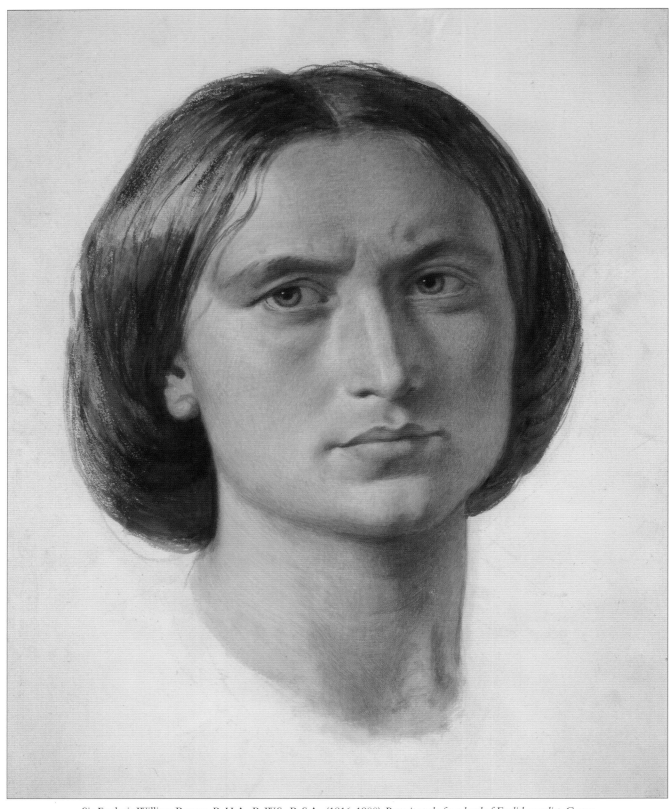

Sir Frederic William Burton, R.H.A., R.W.S., R.S.A., (1816-1900) *Portrait study for a head of English novelist, George Eliot*, watercolour and black chalk.
George Eliot and the artist were friends, Burton describing her as 'fascinating and brilliant, with a wonderful charm in her conversation and a great sense of humour, her eyes though not beautiful, filling with beautiful expression as she talked.' (Gregory, 1974, p.147).

Receipt for archaeologist and artist, Margaret McNair Stoke's (1832-1900) purchase of Sir Frederic William Burton's *Helellil and Hildebrand* or *The Meeting on the Turret Stairs* from art dealers, Agnew's, London in 1898.

COURTESY OF THE NATIONAL GALLERY OF IRELAND

way. This is conveyed in the artist's *The Aran Fisherman's Drowned Child* an important historical recording of an actual event which took place prior to the Famine period. The watercolour was exhibited at the R.H.A. in 1841 and the R.A. the following year. In 1843 the Royal Irish Art Union had the work engraved and it became popular and well known on both sides of the Irish Sea.

Burton belonged to many societies including the Royal Irish Art Union, and was a member of the Irish Academy of Science, Antiquities and Belles Lettres. He was also a member of the Zoological Society. Energetic and enthusiastic, he designed a seal for St Columba's College, Rathfarnham, Co. Dublin which was accepted; also Grecian heads for the Bank of Ireland notes. Devoting a good deal of his time to portraiture, both in chalks and watercolours, he produced in the 1840s such delightful works as a full-length study in watercolour of Helen Faucit as Antigone (1849), and one of Annie Callwell, painted a year earlier, showing a young girl seated on a bank in a sunny, woodland glade surrounded by tall trees and flowers. Attracted by early Celtic art, he revealed these influences in a series of designs and sketches executed in ink and pencil for the Mace in the Royal College of Physicians, Ireland in 1850.

Burton did not confine his many activities to Ireland but paid several visits in the 1840s to Germany and eventually, at the invitation of King Maximillian II of Bavaria decided to reside there from 1851. His task was to

Sir Frederic William Burton, R.H.A., R.W.S., R.S.A. (1816-1900) *Helellil and Hildebrand* or *The Meeting on the Turret Stairs*, 1864, watercolour with white highlights on paper. Signed: '*FWB 1864*'.

COURTESY OF THE NATIONAL GALLERY OF IRELAND

Henry Jamyn Brooks *Private View of the Old Masters Exhibition, Royal Academy, London*, 1889, oil.
This work contains sixty-six figures including Sir Frederic William Burton (fifth from left). Also included are Sir
John Everett Millais, Sir Edward Burne-Jones, Henry Edward Doyle, Sir William Quiller Orchardson (1832-1910),
Mervyn Wingfield, 7th Viscount Powerscourt (1836-1904), John Ruskin (1819-1900) and William Ewart Gladstone
(1809-1898). © NATIONAL PORTRAIT GALLERY, LONDON

paint and copy works of art in the collection accumulated by Ludwig I. Originally, he had intended to stay for two years but in fact he remained there for seven years. Energetic as ever, he spent a great deal of his time sketching and painting in watercolour: architectural studies, landscape and peasant life.

In 1858, Burton decided to return and settle permanently in London. There, he became familiar with Pre-Raphaelite painting and the growing popularity of the Pre-Raphaelite movement. His friends included John Ruskin, Holman Hunt, Burne-Jones, Dante and Gabriel Rossetti. Under their influence, Burton began to use a richer palette and look towards medieval subject matter expressed in Faust's *First Sight of Marguerita* (1857) which he exhibited and the O.W.S. in May, 1857.

His masterpiece *Hellelil and Hildebrand: The Meeting on the Turret Stairs* exhibited at the O.W.S. in 1864 relates to a subject taken from a Danish ballad translated by the artist's friend, philologist and Celtic scholar, Dr. Whitley Stokes (1763-1845). This romantic tale of the ill-fated relationship between Hellelil and one of her twelve personal bodyguards, the Prince of Engelland, is portrayed here in this brilliant rich watercolour with white highlights on paper and reveals the influence of the Pre-Raphaelites. English novelist George Eliot (1819-1880), a dear friend whom Burton greatly admired, described this work in a letter, 'The subject might have been made the most vulgar thing in the world – the artist has raised it to the highest pitch of refined emotion'.[19]

At the age of fifty-eight, Burton was appointed Director of the National Gallery, London by Mr. Gladstone. He was the Gallery's third director and the last to have powers over the trustees with regard to the purchase of pictures. Unfortunately his new post offered him little or no time for his favourite pursuit, 'I hoped and had been assured by Boxall [his predecessor] I would have time to go on with painting, but I've never been able to touch a brush…'[20] Determined to improve the National Gallery's collection of Old Masters, he was able to make a considerable number of worthwhile acquisitions, and some at remarkably low prices; in 1882, for example, he acquired Tintoretto's *Christ Washing his Disciple's Feet* for £157 10s. Other purchases included Leonardo's *Virgin of the Rocks*, and the National Gallery's first Vermeer. In the words of Homan Potterton, former Director of the National Gallery of Ireland, 'It is difficult to fault his judgement in the pictures that he bought for the Gallery…'[21] On his retirement in 1894, Burton was knighted and returned to Ireland, settling in Kingstown (now Dun Laoghaire) on the outskirts of Dublin.

Chapter IV

Watercolour Enters the Public Domain

In order to understand the roots from which the Amateur Drawing Society sprang, it is necessary to look briefly at the historical background in relation to painting in Ireland. In particular, it is worth examining the unique difficulties encountered until around the mid-nineteenth century in exhibiting, presenting and selling watercolours to the public on an ongoing basis.

Throughout the eighteenth century and well into the nineteenth, oil painting remained the most significant form of art, particularly in the field of history painting where it was considered to be the apex of the artistic hierarchy. The first tentative steps towards shifting the medium into the public domain had been undertaken in England in the middle decades of the eighteenth century. This quickened in pace with the foundation of the Royal Academy of Arts (London) in 1768. However, this did little to improve the position of the practitioner who specialised in the delicate art of watercolour. Specialists in this area felt their medium was being neglected and under-rated. The Royal Academy did not pay sufficient attention to 'paintings in water colours' banishing them to the 'Lower Rooms'.[1] In fact, the Royal Academy's first President, Sir Joshua Reynolds, had endorsed this in his famous discourses in which it was made clear that he did not place the medium of watercolour on a particularly high level. During this period, it was impossible for an artist working in watercolours to be elected to the R.A. Until 1810, Academy laws forbade membership to those 'who only exhibit Drawings' – water-colourist Francis Towne (1740-1816) sought election on no less than ten occasions![2] From a commercial point of view, the Royal Academy in the late

John Henry Foley (1818-1874) of Dublin *Sir Joshua Reynolds, P.R.A. (1723-1792)*, marble.
© TATE, LONDON 2010

Sir John Gilbert, R.A., P.R.W.S. (1817-1897) *The Hanging Committee of the Water Colour Society* 1876, pen and ink and graphite.
COURTESY OF THE R.W.S.

eighteenth century placed little emphasis on selling works, whether in oil or any other medium. If a watercolourist was to succeed and his or her work to be taken seriously, he would have to look elsewhere for a suitable exhibition venue. A century later, this was to be one of the principal reasons behind the establishment of the Amateur Drawing Society.

On a practical level, the problems relating to hanging watercolours successfully at the Royal Academy's annual exhibitions was proving difficult. Submitted to harsh lighting levels, hung between windows or placed in dark rooms along with the sculpture collection, they were frequently over-looked and took their place amongst oils of inferior standard. Crowded hanging standards prevailed. A 'ceiling' arrangement was frequently used, proving disastrous for the works of art on view as it allowed no space between each work: paintings were clustered together and hung close to the ceiling. This cluttered and overcrowded arrangement allowed no space in which to admire individual talent and was to be almost continually ridiculed throughout the nineteenth century.

Prior to the foundation of the R.A., the Society of Artists founded in London in 1760 had given painters the freedom to hold annual exhibitions open to the public and to sell their paintings. Irish artists were anxious to have a similar opportunity rather than to rely on direct patronage as an outlet for their work.

It was in England, however, where the first society dedicated to watercolours was to be established. In 1804, the first Society of Painters in Water Colour (often referred to as the Old Water Colour Society or 'O.W.S.') was formed for 'the Purpose of Establishing an Annual Exhibition of

Thomas Rowlandson (1756-1827) *The Exhibition 'Stare Case', the Royal Academy of Arts, Somerset House, London.* c. 1800, watercolour with pen and ink over graphite on woven paper.

Thomas Sautelle Roberts, R.H.A. (1760-1826) *View from Glencree towards Powerscourt and the Great and Little Sugar Loafs*, watercolour. This watercolour formed part of a solo exhibition of watercolours executed by the artist in January 1802, at Parliament House, College Green, Dublin. It is believed to be among the first solo exhibition of watercolours held by an artist in Dublin.

determined to seek a separate identity. It was agreed that the O.W.S. should establish itself as a joint stock company, with each of the members taking a share of its profits based on their original investment. It was also agreed that every effort should be made to attract the buying public at exhibitions, which were to be held on an annual basis. Many of these ideas were later to be echoed by the Amateur Drawing Society in Ireland, particularly the basic need to sell and exhibit work on a commercial basis.

The inaugural exhibition of the Society began on 22 April, 1805. Artists had been asked to mark with a star any works they wished to sell. Public reaction was positive. By the close of the exhibition, 11,542 visitors had filed through the exhibition rooms off Grosvenor Square and sales had been highly satisfactory.

During the next few years the group expanded creating fellow exhibitors or associate members. However, in 1832, a society calling itself the 'New Society of Painters in Miniature and Watercolour' emerged and the original group became more familiarly known as the O.W.S. The first woman to be admitted to full membership was Anne Frances Byrne, O.W.S. (1775-1837) in 1809. A clause was added to the

Paintings in Water Colours'.[3] It is interesting to consider some of the reasons behind the O.W.S.'s formation, as several of them can be equally applied to the need for the establishment of the Water Colour Society in Ireland in the closing decades of the nineteenth century.

On Friday, 30 November, 1804 the founders of the O.W.S. met in the Stratford coffee house in Oxford Street, London. Amongst the group were popular drawing masters and influential English watercolourists, brothers John and Cornelius Varley, together with Joshua Cristall and Francis Nicholson. It is interesting to note that although George Barret, the younger (1767-1842), (who would publish his pamphlet entitled *The Theory and Practice of Water Colour Painting* in 1840) is frequently mentioned as being one of the founders, his name is not recorded in the minutes of the first meeting of the O.W.S.

Several of the essential features established by members set a precedent and were to be copied later in Ireland. This first gathering of specialist practitioners saw a group anxious to balance the development of a market for watercolour and at the same time provide an exhibition space for the selling of their work on an organised, ongoing, commercial basis. Grievances relating to their treatment by the Royal Academy made English watercolourists

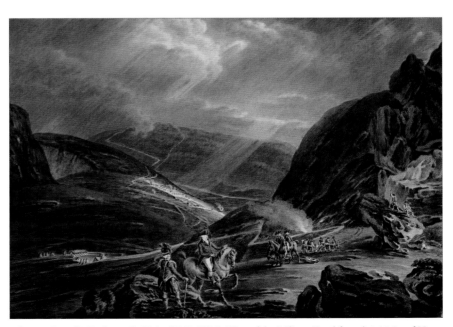

Thomas Sautelle Roberts, R.H.A. (1760-1826) *View of the Military Road from the vicinity of Upper Lough Bray*, watercolour. Signed and dated '1802'.

'The Society hopes (as this is the first attempt towards establishing an Annual Exhibition) every Artist will contribute to so desirable a purpose by sending some of his performances'.[5] Founders included well known artists such as Gabriel Beranger, Jonathan Fisher (active 1763-1809), and Robert Hunter (c.1715/20-c.1803). Sculptors and architects were also invited to exhibit with the result that the total number of entries for the first exhibition reached eighty-eight. The exhibition was so successful that a subscription fund was opened. With this money and an encouraging grant from Parliament awarded two years later, the Society of Artists in Ireland was able to complete the building of an exhibition room in William Street, Dublin and to hold their second exhibition on 10 March, 1766.

In 1774, a group of painters known as the Academy of Artists, Dublin broke away from the Society and for the next two years held separate exhibitions in Napper's Great Room, George's Street. The two groups reunited again to hold exhibitions in 1777 and 1780 (the Society of Artists in Ireland, Dublin) with 214 works on display. The catalogues, although incomplete, reveal that numerous portraits and landscapes in oils, watercolour, and some portraits in chalk were exhibited. Other areas included miniature, still-life, historical and mythological scenes, together with special sections devoted to archi-tectural drawings and sculpture. In the short time between 1765-1780, the total number of exhibits (excluding the missing catalogues) reached 1,242. The exhibition mounted in 1780 was the last to be held in the William Street premises, and Strickland records that 'the Society of Artists ceased to exist'.[6]

Following an interval of around twenty years in which no public art exhibition was held in Dublin, in 1800 the Artists of Dublin succeeded in forming themselves into the Society of the Artists of Ireland. In May of that year, they held a small exhibition in a room lent to them by the print-sellers Allen's sited in Dame Street. This involved twenty-seven artists showing 143 pieces between them. The following year the group managed to

Frontispiece to a *Catalogue of Pictures by Ancient Masters exhibited by permission of the Proprietors for the Improvement of the Fine Arts in Ireland* for the Royal Irish Institution's first exhibition, held in Dublin, July 1814. COURTESY OF THE NATIONAL LIBRARY OF IRELAND

Society's rules: 'No paintings of flowers (Miss Byrne's excepted) shall in future be admitted into the Exhibition'.[4] In 1850 the O.W.S. ejected women from full membership, banishing them first into a ladies section in 1851 and then confining them to associate membership from 1860 to 1890. In that year, the Society experienced a decline in membership and it was decided that women should be permitted to vote for the election of members and associates and to attend general meetings. Women were not allowed to participate in other business matters relating to the Society until 1923. Over the course of its history the

Society has changed its title on a number of occasions. In 1881 it was renamed the Royal Watercolour Society, the name it still proudly carries today, and is housed at the Bankside Gallery, London.

The earliest known group exhibition directly relating to works by Irish painters held in Ireland opened in Dublin on the 12 February, 1765. Anxious to promote a climate in which art might flourish, the Society of Artists in Ireland mounted and sold their works from Napper's Great Room, in George's Lane. Advertise-ments had been placed in *Faulkner's Journal* well in advance of the event:

The Royal Hibernian Academy, Abbey Street, Lower, Dublin. Elevation of principal façade by Francis Johnston. A classical three-storey, four-bay paid for by Johnston at a personal cost of £14,000; the foundation stone was laid on 29 April, 1824 and the work completed in 1826. The builder was Edward Carolin. It was largely destroyed by fire in 1916. PRIVATE COLLECTION

watercolours being 'landscapes… chiefly executed for His Excellency the Lord Lieutenant and The Rt. Hon. Charles Abbot'.[9] The exhibition began on Wednesday 13 January, 1802 in Parliament House, College Green, Dublin with an admission charge of one shilling. On view were 'striking and valuable pieces – the scenes are mostly chosen amongst the more infrequented parts of County Wicklow' together with the artist's 'designs of the Dargle Scenery'.[10]

For the majority of painters the need to exhibit their work became acute. Due to a lack of a suitable and permanent venue for exhibitions, the Society of Artists in all its varying forms became to a large degree dependant on the goodwill of the Dublin Society, where they made use of the Dublin Society's newly built house in Hawkins Street for their exhibitions from 1809 until 1817, with

secure a room in Parliament House, College Green, where portraiture appears to have dominated. An unknown diarist recorded in his journal dated 6 July, 1801, 'This year consists in the figure line almost entirely of portraits, in fact [the artists] have not leisure for any other branch of study'.[7] In 1802, the Society of the Artists of Ireland were again successful in mounting an exhibition in the same venue. However, in 1803 the premises became unavailable and there was no exhibition until the following year when members moved back once more to the 'small gallery at Allen's'.[8]

Exhibitions of works by Irish artists continued despite a number of changes of venues, titles and divisions within the Society of the Artists of Ireland: Irish Society of Artists (1812); Society of Artists of the City of Dublin (1813); Hibernian Society of Artists, Dublin (1814). This was until the establishment of the Royal Hibernian Academy in 1823.

The Act of Union in 1800 had a significant effect on the arts in Ireland; it resulted in many important patrons disappearing, followed by a fall-off in commissions. Despite this, landscape artist Thomas Sautelle Roberts held a solo exhibition consisting of forty

John Comerford (1770?-1832) *William Ashford, P.R.H.A. (1746-1824)*, watercolour on ivory.
COURTESY OF THE NATIONAL GALLERY OF IRELAND

PRIZE MEDAL.

ROYAL IRISH ART UNION.

1843.

Prize medal of the Royal Irish Art Union, 1843. Designed by architect, Francis Johnston (1760-1829). *Royal Irish Art Union Report 1843*. Published: Dublin 1844.

painter, Sir Martin Archer Shee R.A. (1769-1850). On the advice of the Attorney-General, the Solicitor General, and following a consultation with Sir Thomas Lawrence and the Viceroy, Earl Talbot, in 1821 it was decided to grant a Charter of Incorporation to the artists that would ensure their independence of all other art institutions. Two years later the Royal Irish Institution lent their support by paying a fee of £300 in order to complete the process, and the artists were in turn provided with a Deed of Charter. The establishment of the Royal Hibernian Academy of Painting, Sculpture and Architecture

had been accomplished.

The object of the RHA, as stated in the preface of their catalogue relating to their first exhibition in 1826, was 'the promotion of the Fine Arts in Ireland'.[11] This was to be achieved through an annual public exhibition and 'principally by the communication of instruction in painting, sculpture and architecture to those who may be desirous of the same, and whom the Academy may think eligible for this purpose'.[12]

In 1823 the first election of Academicians took place with William Ashford, Thomas Sautelle Roberts and William Cuming being elected to

the Society of Artists in Ireland holding a further exhibition at the venue in 1819. It was largely due to a lack of structure and dependence on the Dublin Society that members felt there should be a national academy, one which might be independent of any institution and would have a clear, well defined constitution.

Support came from the Royal Irish Institution, founded in 1813 primarily for the purpose of encouraging the arts in Ireland by mounting loan exhibitions from abroad, which it was felt would educate and improve the standard of Irish art. The inaugural exhibition opened in July 1814 and is believed to be the first exhibition of works on loan to be held in Ireland. It featured the work of Old Masters such as Rubens, van Dyck, Guercino, Poussin, Titian, Veronese, Carracci, Ostade and Cuyp. Two prominent members of the R.A. in London lent their support, Sir Thomas Lawrence R.A. (1769-1830) and Dublin-born

Michael Angelo Hayes (1820-1877) submitted five 'prize outlines' or designs illustrating the ballad of *Savourneen Deelish* which were in turn lithographed by J.H. Lynch. These were published for members of the Royal Irish Art Union in 1846 and presented in addition to the annual engraving.

The Royal Irish Art Union ballot and prize distribution which took place in the theatre of the Royal Dublin Society on 29 August, 1843. From the *Illustrated London News*. COURTESY OF THE NATIONAL LIBRARY OF IRELAND

appoint them. It was agreed William Ashford should be the first president (1823-24). He died shortly after taking office and was succeeded by the architect Francis Johnston, who purchased a site in Abbey Street, Lower on which to erect a suitable building. A classical three-storey, four-bay edifice was built on the site by Edward Carolin. The total cost of £14,000 was generously met by Johnston himself. The new R.H.A. building contained exhibition rooms, drawing schools, a council room and apartments for the Keeper.

The inaugural exhibition of the R.H.A., which included a special section devoted to 'Architectural and Water Colour Drawings', opened in the completed building named Academy House in 1826.[13] Seventy artists and twenty-one amateurs participated, including eleven female artists. It was not until 1878 that the first woman, Margaret Allen, was elected to 'honorary' membership only.

Photograph of Walter G. Strickland (1850-1928), author, registrar and Acting Director of the National Gallery of Ireland, taken c.1906.
In 1910, rules and regulations of the Art Union of Ireland specifically relating to the W.C.S.I. were revised. The Art Union became known as the W.C.S.I Art Union. The Committee of Management relating to the W.C.S.I. Art Union comprised nine members and included Walter G. Strickland representing the National Gallery of Ireland.

COURTESY OF THE NATIONAL GALLERY OF IRELAND

John Hogan (1800–1858) *The Drunken Faun*, 1826, plaster original. COURTESY OF THE CRAWFORD ART GALLERY, CORK

The R.H.A. Schools formed part of the new building and consisted of two top-lit exhibition galleries. When not required for annual exhibitions, the galleries were used as teaching studios. There was a room set aside for casts of antique sculpture and, as already mentioned, living quarters for the Keeper, an elected academician. He was placed in charge of the two basic schools or classes: the antique school and the life school. Throughout the nineteenth century, the schools appear to have suffered from a lack of government funding. Dr. John Turpin maintains that: 'In reality, the Government had not integrated the Academy into its projections for future Irish art education'.[14] However, despite a number of drawbacks, Turpin believes: 'In the 1870s and 1880s the R.H.A. schools were at their most influential in providing a basic education in painting for Irish people seeking a career as artists'.[15]

The problems in relation to the hanging of watercolours which applied to the Royal Academy in London might equally well be applied to the R.H.A. in Dublin. There, despite the growing popularity of the medium in the nineteenth century, exhibits in watercolour were confined to a back room offering little or no opportunity for favourable display. When oils and watercolours were exhibited together many watercolourists claimed that this was detrimental to their medium. It was felt delicate works in watercolour suffered from comparison with large and brightly coloured canvases. A viewpoint would appear to be adopted that practitioners in watercolour, whether male or female, were considered, both in medium and subject matter, less worthy of recognition than traditional painters in oil.

In Ireland, the second half of the nineteenth century saw the growth of responsibility for national cultural provision flowering when public enthusiasm for the visual arts was high. However, as far back as 1840 the Royal Irish Art Union had made it clear that their society was being established for the 'Encouragement of the Fine Arts in Ireland by the Purchase of Works of Living Artists exhibited in the metropolis [Dublin]'.[16] A committee of twenty-one subscribers who had been selected at a general meeting of members were required to 'Select and Purchase at the Exhibition of the R.H.A., such Works of Art as are creditable to the talent and genius of the country, and, at the close of the season, these Prizes are distributed by lot among the Subscribers, one chance being allowed for one pound…'[17]

An attractive incentive was offered to each member – a free engraving after a work by a living Irish artist and published exclusively for the R.I.A.U. In the Union's first annual report it was recommended that there should be a restriction imposed on purchase of works by non-resident and foreign artists. Preference should be given to works painted for exhibition in Ireland and within the year, the objective being to encourage resident artists. As a result a considerable incentive was now being provided for Irish artists, both amateur and professional, who were fortunate enough to have their works hung in R.H.A. exhibitions. In April 1840 the R.I.A.U. could boast of having over 1,000 members on their books and had raised £1,235 in

The arrival of the Lord Lieutenant, 3rd Earl of Saint Germans, at the Irish Industrial Exhibition, Leinster Lawn, 1853, line engraving.

subscriptions. The positive influence exercised by the Union in their financial ability to purchase works of art and distribute them by lot as prizes to subscribers was reflected in increased sales and attendance at R.H.A. exhibitions. However, by the early 1850s the scene was changing – the effects of the famine coupled with a shortage of funding and a ruling in 1844 by the Lord Commissioners of the Treasury stating that art unions were illegal resulted in the collapse of the R.I.A.U by September 1859.

Many of the ideas contained in the structure of the R.I.A.U. and other similar art unions in Ireland were to be incorporated into the Art Union of Ireland (1858) founded under the auspices of the Irish Institution. Again, ticket-holders were eligible for a draw in which prizes worth between £5 and £50 were awarded specifically for the purchase of paintings in annual exhibitions. As a result, the 1860s saw a new stimulus being given towards the acquisition of paintings which was to have a direct relevance in relation to the success of exhibitions run by the Amateur Drawing Society. From the late 1880s onwards, the Society, in cooperation with the Art Union of Ireland, was to offer similar incentives and encouragement to their members

An exhibit from the Irish Industrial Exhibition, 1853, described as '*A metallic bedstead ... of peculiar excellence*' by R.W. Winfield of Birmingham in *Art Journal*, 1853.

Attributed to Thomas Alfred Jones, *George Archibald Taylor* (d.1854)
In his will, Captain George Archibald Taylor stated he was anxious that his bequest of watercolours should be used 'in such a manner as they may deem fit for the encouragement of Irish art'.

Letter to George Francis Mulvany, Director of the National Gallery of Ireland informing him of a bequest left to the gallery by Captain A. Taylor for the promotion of art in Ireland (1856).

at their annual exhibitions. In 1910 rules and regulations of the Art Union of Ireland specifically relating to the Water Colour Society of Ireland were revised. The Art Union became known as the Water Colour Society of Ireland Art Union, the head office being based at 35, Molesworth Street, Dublin. The committee of management relating to the W.C.S.I. Art Union (1910) comprised nine members including Walter George Strickland, Major George Webb, Sir John G. Barton and W. H. Hillyard. One of its specific aims was 'the promotion and development of Amateur Art in Ireland and the spread of artistic taste throughout the provinces by means of Exhibitions and Art Union Drawings.[18] Works of art in the following media were awarded in

prizes: 'Painting in Water colours, Etchings, Sepia, Chalk, pastel, Pen & Ink and Pencil drawings: Paintings on China, modelling and Wood Carving'.[19] This form of raising funds and offering encouragement to W.C.S.I. members was to continue until 1951.

The year 1853 marked 'the commencement of a new era in the history of Ireland…' as the Irish Industrial Exhibition, housed in an elegant exhibition building and built along the lines of the Crystal Palace in London, was located beside the Royal Dublin Society's premises.[20] The site extended to six-and-a-half acres and was located between Merrion Square and Kildare Street. Railway magnate William Dargan, who had already

made a substantial offer of £20,000 towards mounting the exhibition, insisted that there should be a well lit fine arts court as, like so many Victorians, he firmly believed that art fulfilled an important social need. Around 1,023 paintings were on view and included examples of the work of Old Masters – including Veronese, Correggio, Rubens, Rembrandt, Poussin, Reynolds, Canaletto – the majority being on loan from Irish collections. Heads of state, including Queen Victoria and Léopold I, King of the Belgians, contributed a small number of important works, together with ones from France, Prussia and Holland. Contemporary paintings and watercolours were also on view, amongst them J.M.W. Turner's *Italian*

James Mahon(e)y. A.R.H.A., A.N.W.S. (c.1810-1879) *The Second Visit by Queen Victoria and Prince Albert to the Fine Art Hall, the Irish Industrial Exhibition, Dublin, 1853,* pencil and watercolour with white highlights.

Landscape (1803) (cat. no. 842). The public's response to this great exhibition was remarkable: 589,372 visitors paid at the door whilst 366,923 visitors held season tickets.

The interest generated by the Irish Industrial Exhibition highlighted the fact that Ireland still had no permanent collection and confirmed yet again the need for a permanent gallery in which to house collections. At the close of the exhibition in November 1853 many felt it was necessary 'to prepare the way for the establishment of a permanent Public Gallery in Dublin'.[21] In January 1854, the Irish Institution was established 'for the promotion of Art in Ireland by the formation of a permanent exhibition in Dublin and eventually of an Irish National

Gallery'.[22] The aim of the Institution was to hold annual exhibitions of works of Old Masters lent largely from Irish collections in various venues in Dublin, and to acquire as many pictures as possible for a permanent gallery. The Institution organised six exhibitions in Dublin between 1854 and 1859, the majority were held in the R.H.A. galleries. Considerable public interest and awareness was aroused, particularly in relation to the idea of establishing a national gallery for Ireland. By 1863 the Institution found itself being dissolved, its mission having been successfully completed. The following year on 30 January, and under the directorship of George Francis Mulvany (1808–69), the National Gallery of Ireland opened its

doors to the public. Lit by gaslight, it was the first public gallery in Europe to have the facilities to open after dark. It allowed visitors to view displays of baroque altarpieces, plaster casts, copies of Old Masters and a room set aside specifically for the display of watercolours. This was yet another indicator that the cultural climate in Ireland relating to art and, in particular, towards the medium of watercolour was beginning to change.

Shortly after its inception in 1854, the Irish Institution had been fortunate in being the recipient of a gift presented by a Captain George Archibald Taylor, Mespil Parade, Dublin. In Taylor's will he bequeathed eighty watercolours to the Institution mainly by Irish and English artists: among them works by

The Opening of the National Gallery of Ireland by the Lord Lieutenant, 7th Earl of Carlisle on 30th January, 1864.
From *Illustrated London News,* 13 February, 1864.　　　COURTESY OF THE NATIONAL GALLERY OF IRELAND

watercolourists William Callow, George Howse, Joseph Clayton Bentley and James Mahoney. Later, these works were exhibited for the first time in the Institution's second exhibition held in 1854 and were to form the basis for the National Gallery of Ireland's collection of drawings, watercolours and miniatures.

Included amongst Taylor's bequest was a small collection of splendid watercolours executed by Irish artist, James Mahoney, A.R.H.A., A.N.W.S. (c. 1810-1879). He had undertaken to record Queen Victoria and Prince Alberts' four successive visits made during the eighteenth week to the Irish Industrial Exhibition. These watercolours reinforce and symbolize the optimism of the exhibition organisers: a new age of industry and art was about to dawn, 'the industrialist and artist foretold

of better days for Ireland'.[23]

Mahoney's watercolour (illustrated p.59) depicts the second royal visit to the great exhibition. Queen Victoria and Prince Albert stand on a dais in the centre, their sons, both dressed in kilts, are depicted in the foreground and to their right are members of the R.H.A. The welcoming party hold scrolls. Paintings by British, Irish and European artists hang on one wall of the great exhibition hall whilst works by German, French and Belgian artists adorn the other. Several identifiable sculptures are seen for example sited to the right is *The Drunken Faun* by Co. Waterford-born sculptor, John Hogan (1800-1858) (illustrated p.56).

The second Great Dublin International Exhibition of Arts and Manufactures opened on 9th May 1865 in the grounds and buildings at

Earlsfort Terrace, Dublin, now the site of the National Concert Hall. A journalist of the time commented: 'The greatest attraction is, without doubt … the fine art galleries. These contain collections that for variety, beauty and excellence have never been equalled by similar exhibitions.'[24]

This exhibition attracted almost one million visitors during a six-month period. They were provided with an opportunity to view works by Masaccio, Botticelli, Giorgione, Titian, van Dyck, Rembrandt and Romney, together with many other examples of Old Masters drawn from the Spanish, Italian, French and English schools. Engravings and architectural drawings, together with 137 watercolours, were on view. The latter entitled 'Paintings in Water Colours' was confined to a single room 'off the south corridor' and

was organised by a member of the Fine Art Committee which included Sir John Joscelyn Coghill. Later, in 1877, Coghill was to become a committee member of the Irish Amateur Drawing Society. Another fellow member of the Fine Art Committee was distinguished amateur architect, landscape and figure painter, Sir George Frederick Hodson, H.R.H.A. (1806-1888),a member of the Society of Painters in Watercolours. In 1882, Hodson, like Coghill, was also invited to join the ranks of the Irish Fine Art Society as one of their two Trustees. Both past and contemporary leading British watercolourists were represented, including teacher and artist, Paul Jacob Naftel, R.W.S. (1817-1891). As will be seen, Naftel became influential in shaping the styles of several distinguished W.C.S.I members. Watercolours by Sir Frederic W. Burton, Holman Hunt, George Victor Du Noyer, Samuel Prout, Thomas Charles Leeson Rowbotham, and other examples from both British and foreign schools were also on view. It is interesting to note that there was just one female exhibitor brave enough to submit a landscape watercolour, *Pont Aberglaslyn, North Wales*. J.M.W. Turner's work was once again on view; his *On the Rhine* succeeded in captivating and arousing considerable public attention.

Featured among the section devoted to watercolours was a work by Peter de Wint O.W.S., *Landscape and Cattle*, lent by the South Kensington Museum, London. As far back as 1813, De Wint had seen five of his watercolours included in an exhibition organised by the Society of Artists of the City of Dublin. As already discussed in the previous chapter, this artist's approach to the medium both in technique and style was to play an important and influential role in the evolution of the stylistic conventions of the Irish watercolour tradition in the Royal Dublin Society's School of Landscape and Ornament.

In April 1858, in order to try and rectify mounting financial and other problems at the R.H.A., a revised constitution had been introduced. In a Government report drawn up by Norman Macleod, assistant secretary of

An invitation to the ceremonial laying of the foundation stone of the National Gallery of Ireland, Leinster Lawn, Dublin on 29 January, 1859. COURTESY OF THE NATIONAL GALLERY OF IRELAND

the Department of Science and Art at South Kensington, and submitted in December 1857, it was recommended that the number of Academicians be increased, as the current limited number encouraged mismanagement. Absenteeism was widespread and many members did not take the time to exhibit. It was also recommended that, as the Royal Dublin Society was providing a similar education, the R.H.A.'s schools covering life classes and antiquity should be abolished. The Academicians responded to the report and, by April 1858, had agreed to draw up a new charter based on the recommendations put forward by Macleod. The following year a draft constitution was submitted to the Lord Lieutenant, the main point being a recommended increase in the number of members from fourteen to thirty, and a recommendation that architects be included in the R.H.A.'s membership. As Strickland points out in his summary of the Academy's history:

'From the time of its foundation to the present day [1912] the Academy has struggled against adverse circumstances, partly from the neglect and apathy of the public and partly from the difficulty which was found in filling the ranks of the Academicians with artists who could paint. The history of art in Ireland…

shows that young artists of talent and ambition would not remain where there was no outlet for showing their powers, but emigrated to London. The Academy had often to elect as members of its body artists whose qualifications were of the smallest, and it is not surprising therefore, that at some period of its existence its exhibitions failed to enlist the support of the public.'[25]

The last thirty years of the nineteenth century saw a structure and a means of channelling artistic creativity being set in place which began to provide gifted artists, both amateur and professional, with an opportunity in Ireland to market and exhibit their work in a variety of mediums. This was largely due to the establishment of various sketching clubs and drawing societies which began to make their appearance throughout the country. An integral part of this movement was the establishment of the Amateur Drawing Society founded in November 1870. In due course, this small, local drawing society was to emerge as the Water Colour Society of Ireland. It proved to be a remarkably successful forum for the amateur watercolourist throughout the nineteenth century, a tradition which has been successfully maintained to the present day.

Chapter V

The Status and Training of Women Artists in 19th Century Ireland

Before the latter part of the nineteenth century, women in these islands had little opportunity to establish their reputations in the field of art. The only areas that appear to have been open to them were the delicate arts of miniature and landscape painting. The applied arts, in which women often excelled and which were considered appropriate handicrafts for them during the first half of the nineteenth century, included needlework, crochet, and flower arrangement. However, these activities were frowned upon by the art institutions of the day and considered to be inferior to pure art. No matter how skilled women might become in these subjects, the majority of female practitioners were nearly always looked upon as mere amateurs.

The Amateur Drawing Society was founded for the 'mutual improvement in painting and drawing and the cultivation of a taste for art'; and, as previously discussed, was the inspiration of six enthusiastic amateur women artists.[1] Therefore it is interesting to examine the role and position of the 'amateur' and 'professional' artist living in Ireland around the time of the Society's foundation, and the roles that some of these women went on to play in wider Irish society championing the cause of women working in the craft industries.

A professional painter managed to live by selling his or her work or services, whereas the amateur had to be sufficiently educated to enjoy a wide

Edward Francis Burney (1760-1848) *An Elegant Establishment for Young Ladies*, c.1805, watercolour. In this caricature, artist Edward Francis Burney implies that women's education in deportment, dress, dance and music is self-indulgent and superficial and the only accomplishment thought necessary by society for a career devoted to marriage and motherhood.

range of intellectual and cultural interests and to enjoy painting largely for pleasure and for the sheer love of art. In general, the amateur artist had to come from a certain class which was fortunate enough to enjoy a considerable amount of leisure and to belong to a social position in which drawing and painting were regarded as normal recreational occupations for members of either sex. Adequate tuition in painting had to be made easily available and the necessary materials simple, undemanding and readily accessible.

The contribution made by (male) amateur artists in Ireland to public exhibitions would appear to be high if one looks at, for example, the Society of Artists in Ireland 1765-1789, or if one glances through early R.H.A. catalogues. There would appear to have been no restrictions on curtailing the percentage of works submitted by non-professionals represented in these public exhibitions. In an exhibition in Limerick in 1821, for example, the word 'amateur' is clearly mentioned in the title: 'Catalogue of Paintings Exhibiting and several fine works, by the Old Masters and a Collection of Pictures by the Artists & Amateurs of Limerick'. The first exhibition of the Society of Native and Resident Artists held in Cork in 1835 saw the inclusion of a cross-section of both amateur and professional artists participating. However, the absence of participation by women is particularly noticeable, with only three female artists coming forward to exhibit their work: Mrs H. Stewart, Mrs W. Connell and Miss Fitzgerald. Two years earlier, in 1833, an exhibition arranged by the Society for Promotion of the Fine Arts in the South of Ireland, with leading English watercolourists Francis Nicholson, O.W.S. (1753-1844) and Copley Fielding P.O.W.S. (1787-1855) acting as Honorary Members, witnessed just two brave amateur female artists presenting their compositions for public approval: Lady Deane and Miss McCarthy.

If a woman was to establish a reputation as an artist, either on a professional or amateur basis, it was necessary to have an opportunity to

A Vocation Missed - Mr Brown: *'Look here Maria – Look at the Young Lady's Light Touch!'* Mrs Brown: *'Eh! What a Hand for Pastry!'* COURTESY OF THE NATIONAL LIBRARY OF IRELAND

train and to exhibit her work to the public. From the teaching perspective, the Royal Dublin Society had offered encouragement to women almost from its inception in 1731. The Society's premiums or prizes were open to both men and women. Evidence for this may be found in the award of a premium of £25 in 1740 to Susannah Drury, (fl. 1733-70) (sister of Dublin miniature painter, Franklin Drury) for her gouache drawings of the Giant's Causeway.

In 1746 the Society announced premiums were being awarded 'to the boy or girl, under fifteen years old, who should produce the best drawings, performed by him or her in 1745 £5', and, 'to such boys and girls, under fifteen years old, who shall produce the best patterns made by them in 1745, for damask or printed linens…£6.'[2] Around 1760, the Society's attitude towards admitting girls as pupils began to waver when it was made clear that 'the two girls who learn to draw from Mr. Manning having been two years with him be dismissed.'[3] From around 1762 onwards the situation appears to have deteriorated, leaving a lack of opportunity for formal art training for female artists in Ireland who wished to practice as painters.

One of the ways in which a woman might become a professional artist was

if she was fortunate enough to belong to a family of painters. Artist Mary Anne Hunter, daughter of one of the foremost portraitists in Dublin in the 1750s, Robert Hunter (c.1715/20-c.1803), married another portrait painter, John Trotter (d.1792). Two of their children also became artists. The other alternative was to train in the numerous private drawing schools which flourished in Dublin in both the eighteenth and nineteenth centuries (as discussed in Chapter III).

In eighteenth-century Dublin several private drawing schools were run by French-trained artists. French painter, Charles Praval (d.1789) described himself as 'drawing-master at Mr. Kearns, glover, Dame Street, late draftsmn to Mr. Banks during his expedition round the world'.[4] Whilst on a less exalted level, Edward Purcell (fl. 1812-1831) wished the world to know that he 'proposes giving instruction at 73 Aungier Street. Has taught many of the best families in England.'[5] Further afield, George Gaven (fl.1756-75) established himself as a drawing master 'and resided in Queen Street, Oxmantown'.[6] Later in the nineteenth century there was an opportunity to avail of instruction by post: a Miss C.M. Hill of Mount Rivers, Carrigaline, Co. Cork advertised 'drawing by corres-

Susanna Drury (fl.1733-1770) *The East Prospect of the Giant's Causeway* c.1739, gouache on vellum.

pondence, oil and colours. Terms £1 1s per quarter. Reference to pupils'.[7] However, in many people's views, becoming a drawing master was 'one of those unattractive fates which awaits the failed artist, along with the 'hackney likeness-taker, [the] copier … or pattern-drawer to young ladies'.[8]

Eighteenth-century educationalists Maria and Richard Lovell Edgeworth adopted a similar view and felt many drawing masters and mistresses were

Maria Edgeworth (1767-1849) writing in the library, Edgeworthstown, Co. Roscommon, watercolour and pencil on paper. Dated 25 April, 1848, artist unknown.

Cover of *Simple Lessons in Water-Color Painting: Landscape* by Vere Foster. Published London, Glasgow, Edinburgh & Dublin, 1884.

SIMPLE · LESSONS · IN

LANDSCAPE

WATER · COLOR · PAINTING ·

David Cox, O.W.S. (1783-1859) from *The Young Artist's Companion or Drawing-Book of Studies and Landscape Embellishment comprising a great variety of the most picturesque objects required in the various compositions of Landscape Scenery. Arranged as progressive lessons*, London, 1825.

either lazy, incompetent or incapable of providing any meaningful tuition: 'It is seldom found that those who can communicate their knowledge the best … possess the most, especially if this knowledge be that of the artist'.[9]

Until well into the second half of the eighteenth century, the method of instruction employed by drawing masters was based upon example with a fairly wide choice of media ranging from pencil, chalk to pen and wash. These were introduced more or less in that order to the pupil. It was not until later in the century that students were encouraged to complete their work by adding a tint. The end of the era saw the introduction of the manipulation of colour washes and brushwork being introduced at an early stage. The nineteenth century was well advanced by the time linear draughtsmanship

was finally dispensed with in favour of painting in pure watercolour, and when drawing masters felt they could take their pupils out of doors *en plein air* and provide lessons from nature.

By the end of the first decade of the nineteenth century, drawing manuals were becoming highly popular. However, in many cases these were often little more than colouring books offering instruction on how to mix various pigments, together with outline drawings waiting to be blocked in my the increasingly enthusiastic lady watercolourist. Armies of amateurs ensured a rapid rise in the market that supplied these manuals along with prints and papier-mâché objects to paint together, and drawings available to trace and copy.

Towards the end of the century, educationalist, philanthropist and first

President of the Irish National Teachers' Organisation, Vere Foster, published a series of drawing and copy books amounting to twelve in all which provided lessons in the art of watercolour painting. These covered such topics as 'outline' (in his view the most important part of the lesson) and 'colouring'. These manuals were distributed widely throughout Ireland. However, perhaps it should be remembered that these methods of encouragement tended to provide a somewhat negative perception in relation to the notion of artistic amateurism.

In 1877 the R.D.S. Schools were placed under the South Kensington system and became known as the Dublin School of Design in connection with the Royal Dublin Society (see Chapter III). Emphasis was now to

Photograph taken at the Waterford School of Art, 1907. PRIVATE COLLECTION

'Lady Students at the National Gallery' from *Illustrated London News*, 21 November, 1885, p.534. COURTESY OF THE NATIONAL LIBRARY OF IRELAND

be placed on the education of designers for applied rather than fine art. It was felt women in particular possessed a certain aptitude for design and this artform was therefore considered to be a suitable occupation. Female recruitment was rapid with substantial numbers being admitted on a regular basis. The introduction of evening classes by the R.D.S. was now being made available to female students and proved to be popular. The schools' daily timetable were extended with instruction continuing to be offered in the four foundation subjects – figure drawing, modelling, ornament and architecture. In addition, classes in watercolour and associated media were also available, together with the drawing of ornament, plants and flowers, all of which attracted substantial numbers of female students.

Unlike most of their male counterparts, it would appear the majority of women came from middle-class families, and were largely Protestant. By 1851, 170 women were on the roll who, between them, in that year alone, were awarded eighteen of the forty-two premiums. It is interesting to note that many of these

female students during this period intended to become teachers (sixty-nine), designers (ten) and artists (five). The rest remained undecided.

But art training for women was not merely confined to the Government Schools of Design based in Cork, Belfast and Dublin. In Waterford, the School of Art had re-opened in 1881. Originally known as the School of Practical Art and Design, it had begun life on 1 October, 1852, with 146 pupils on its books, including eighty-three females. Several were governesses who were admitted at a reduced rate to all classes. After a number of years, the School was forced to close, only to be re-established in 1881 under the Department of Agriculture and Technical Instruction and became part of the Waterford Central Technical Institute. A wide range of courses were on offer to both men and women, including drawing from the antique and from life, general design, painting modelling. Craft courses ranged from leatherwork, embroidery, crochet, wood-carving, enamelling, stencilling, lettering, poster work, plate metalwork, painting and decorating.

From the beginning, the Royal

Hibernian Academy allowed women to exhibit, as may be seen from their inaugural exhibition held in 1826. By 1881 there were eighty-five women registered as artists, but they were excluded from actual membership of the Academy. A concession had been granted in 1878 when the first woman, Margaret Allen, H.R.H.A. (1832-1914) was elected to 'honorary' membership only of the organisation. Allen had begun her association with the R.H.A. by exhibiting two untitled portraits in 1853. Between 1853 and 1894, this artist exhibited fifty-two works. In the view of Derville Murphy, 'Margaret was the first female artist to tackle the politically motivated subjects.'[10]

By the early 1890s the Department of Science and Art was keen to admit women to the R.H.A. Schools. Following a motion proposed by leading R.H.A. academician and a distinguished member of the W.C.S.I., Walter Frederick Osborne, R.H.A. (1859-1903) the concession was granted and women were finally admitted in 1893.

Another factor favouring the admission of women to the R.H.A. Schools may have been the fact that

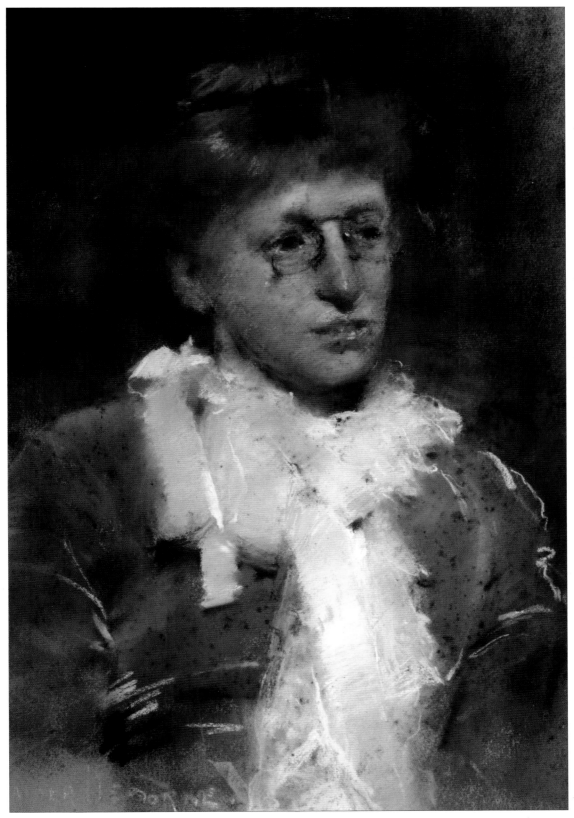

Walter Frederick Osborne, R.H.A. (1859-1903) *Portrait of a Lady, Sarah Henrietta Purser, R.H.A. (1848-1943)*, pastel.
W.C.S.I. exhibitor, Sarah Purser had the distinction of being the first female artist to be elected a full member of the
R.H.A. in 1924. This portrait was exhibited in the Dublin Sketching Club exhibition, December 1887 as *Portrait of a
Lady* (cat. No. 107).

Sir Martin Archer Shee, P.R.A. (1769-1850) *Self-portrait,* 1794. Born in Dublin, Sir Martin Archer Shee was elected President of the Royal Academy on 25 January, 1830. He served as President of the R.A. from 1830-1850. © NATIONAL PORTRAIT GALLERY, LONDON

Dr. Edith Œnone Somerville (1858-1949) *Student at Colarossi's Studio,* pencil on paper. COURTESY OF THE CRAWFORD ART GALLERY, CORK

the Academy was having difficulties in attracting male students. However, the decision to admit the 'fair sex' was to have a devastating effect. According to the Secretary, Stephen Catterson-Smith, Junior (1849-1912), there was an immediate dropping-off in attendance by male students who were not keen to work alongside their female counterparts. The general feeling was that female students were the daughters of the wealthy middle class who did not need to work, and therefore their devotion to art should not be taken seriously, and on the other hand, the men were there to train in order to earn a living. This general climate and attitude towards women and their training, and particularly in

the field of election, persisted until 1923 when the rules were changed to allow female artists to be elected as Associate Members. Distinguished artist, philanthropist and W.C.S.I. member, Sarah Purser, who had four works accepted for the R.H.A. exhibition on 6 February, 1872, had the distinction of being elected a full member in 1924, the first woman to be honoured by this venerable institution.

In London, the Female School of Art and Design had opened in 1843 as a branch of the Government Schools of Design. However, it seems art training being offered in this School became an excuse for not allowing women to train in the Royal Academy Schools. If one did not avail of this government-

run opportunity or were not content to be taught privately, women had to undergo a certain degree of ridicule as depicted here in *Lady Students at the National Gallery.*

From the point of view of earning a living from the arts, the possibilities for the lady artist in the first half of the nineteenth century in Ireland were distinctly limited. Teaching was the principal outlet which struggled to satisfy the need of the ever-growing number of enthusiastic amateurs who required instruction in drawing, and later in the art of watercolours. However, society adopted the view that once the artist crossed the boundary between the relative respectability of being a painter to

Jefferson Davis Chalfant (1856-1931) *Atelier at the Académie Julian* 1891, oil on wood panel.
The paintings and drawings are tacked to the wall. Charcoal studies ('academies') hang together in horizontal rows high on the back wall below skylights brightly lit by the windows. Portraits are hung at a higher level. Full-colour figure paintings of draped and undraped models cover the side wall. Models stand on wooden platforms high above the students. COURTESY OF FINE ARTS MUSEUMS OF SAN FRANCISCO, GIFT OF MR AND MRS JOHN D. ROCKEFELLER III

become a mere drawing mistress or master, he or she occupied an inferior social position and one that would appear to have been look down upon. Sir Martin Archer Shee declared from the lofty pinnacle of the Royal Academy that the drawing master or mistress 'want the instruction he pretends to give to others', and that 'an incapacity to learn his art, has made him a teacher of it'.[11]

At the other end of the social scale, a young girl was encouraged by her family to become mistress of the polite accomplishments and proficient in the arts. From childhood, drawing would have been part of the basic curriculum taught in the schoolroom by her governess. When adult, many women

continued to draw and paint for pleasure. Watercolour was the ideal and fashionable medium. Why was this? Mary Ward's *Robert Elsmere* (1888) provides a clue: 'I informed her…that you had given up water-colour and meant to try oils and she told me to implore you not to, because water-colour is so much more lady-like than oils.'[12] Beyond having a civilising effect on society, and expressing her exquisite taste in both dress and in the furnishings of her house, a lady artist was expected to have just enough skill to paint a portrait or landscape in watercolour. Expertise coupled with the idea of developing one's talent and becoming an independent artist in her own right was not encouraged. Women

who were brave enough to adopt the qualities which defined the artist – self-reliance and independence coupled with competitiveness – were frowned upon and rejected. Art reviews relating to the early and mid- nineteenth century even went so far as to warn that ambitious, aspiring young women artists ran the risk of 'unsexing' themselves! The Rt. Hon. Charles Kendal Bushe, a friend of Maria Edgeworth held the view that painter, Letitia Bushe (fl. 1731-57):

'... had a rare and enchanting gift as an artist, which, even in those days, when young ladies of quality were immured in the padded cell of the amateur, could scarce have failed to make its mark. In her time there were

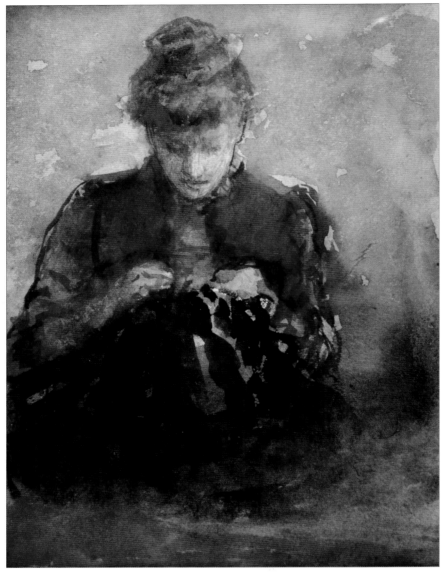

Attributed to Louise Breslau (1856-1927) *Darning Socks – Artist Sarah Purser (1848-1943) in Paris,* watercolour and pencil.

PRIVATE COLLECTION. REPRODUCED BY KIND PERMISSION

few women who gave even a moment's thought to the possibilities of individual life as an artist, however aware they might be – must have been – of the gifts they possessed.'[13]

Women who came from good families were not encouraged to distinguish themselves as professional painters:

'...a lady may seek notoriety as a rider, a huntress, or a flirt in the ball-room or promenade, without committing any flagrant breach of propriety. She may attract every eye by the style and extravagance of her dress, provided always she be duly chaperoned. And she may share the manly triumph of the hunting field, and be in at the death...but woe be to her if Nature has been unkind enough to weight her with any extra portion of artistic talent, and with it the fatal desire to cultivate the same beyond that point which has been determined as the extreme limit of feminine indulgence, or ladylike development. The moment she dares to cross that Rubicon which separates so widely the professional artist from the fashionable amateur, she forgets...her social position, and is henceforth barely tolerated.'[14]

Like their predecessors, female artists in the nineteenth century were placed in a difficult position. Caught between motherhood and looking after their husbands, families and homes, they often struggled against the strict limitations placed on them by the social category of being feminine. Offered no encouragement by society to become professional or skilled amateur artists, they found themselves with no ready, easily available outlet for exhibiting their talents. By the mid-nineteenth century, however, some change in relation to the position of women in society was beginning to take place. In England the Matrimonial Causes Act 1857 saw the rights of women both in marriage and divorce being enhanced. This legislation authorized secular divorce for the first time, defining marriage as based on contract rather than sacrament. Under the provisions of the new law, a husband could be ordered to pay maintenance to his divorced or separated wife. In 1870, and again 1882, a woman's position was further strengthened through the Married Women's Property Acts, which permitted a wife to retain her property and her own earnings. Further protection was enshrined in the Matrimonial Causes Act of 1884 when a woman was no longer looked upon as being a 'chattel' but rather as an independent and separate person in her own right.

The London art scene saw the Society of Female Artists established around 1855. This gave women artists an opportunity to exhibit their work to the public. The first annual exhibition held in London in 1857 saw 149 women exhibiting a total of 358 works; some exhibitors went so far as to conceal their true identities for fear of social recrimination. As standards improved and access for women to avail of a professional art training became more open, the Society changed its name to the Society of Lady Artists (1869). It was now in a position to offer full membership to professional lady artists whilst also encouraging amateurs to exhibit. The last year of the century saw the Society adopt a new name: the Society of

Women Artists. From Ireland, many distinguished W.C.S.I. painters joined its ranks, including Frances Wilmot Currey, Rose Barton, Lilla Perry and Lady Elizabeth S. Butler.

Some young Irish women were fortunate enough to have the opportunity to obtain their art training abroad. This brought fresh benefits, opening up new horizons both socially and artistically. From around 1870 onwards, a popular move for an ambitious and aspiring young lady artist was to take up an academic arts training in Paris. Together with many other nationalities, young Irish painters began to flock to the city. Again, future W.C.S.I. members were evident: Frances Wilmot Currey, Sarah H. Purser, Rose Barton, Edith Somerville and May Guinness; these and other women excited by art, in love with their freedom and highly committed to their work, began to avail of this unique and adventurous opportunity.

In the mid-nineteenth century, Paris had undergone dramatic change. The rebuilding of the city by Baron Haussman and Napoleon III in the 1850s and 1860s had succeeded in physically transforming the city. A new mix of writers, artists, and the new bourgeoisie were gathering in the parks, streets, cafes and restaurants. The Second Empire had collapsed in 1870 and the establishment of the Third Republic in 1875 began to produce a more democratically-based middle class culture. More opportunities were being offered for artists to exhibit their work, with venues ranging from the official Salon to the Union des Femmes Artistes. The city offered women painters an opportunity to train on an equal footing with male students. However, unlike her male counterpart, the young female artist was not allowed access to the major art school, l'Ecole des Beaux Arts; that is, until 1897.

The atelier system was widespread throughout the city and open to everyone. Académie Julian, founded by Rodolphe Julian in 1868 welcomed foreign students, including Irish pupils, both male and female, in its many rented ateliers. Until the end of the nineteenth century, most classes were single-sex. On

A selection of exhibits which included a crescent mirror hand-carved by Irish Amateur Drawing Society member, Elizabeth O'Grady, Kilballyowen, Bruff, Co. Limerick. These exhibits formed part of the Home Arts and Industries Association exhibition held at the Royal Albert Hall, London, 1892. Illustrated in *The Queen*, 25 June, 1892, p.1061.

payment of a modest fee, weekly criticism and a nude model was provided, with instruction generally being offered by a roster of visiting professional teachers, including professors from the Ecole des Beaux-Arts.

A young Irish art student, Frederick Carter writing of his experiences in one of the ateliers 'off the rue Fromentin' in Paris provides a flavour of the atmosphere:

'Inside the school was an atmosphere of rich warmth, with a vast cold light falling from wide top windows, high in the roof overhead. The place really was huge; a great barn in size, a real atelier de peinture, a workshop. The upper part of the plaster walls was covered with unframed canvases, unframed oil paintings of the posed model which had gained awards and honours. Below were chalk studies and small pochade copositions in oil. But from a height of about one's waist line to chest a strip round the whole wall was covered with a mass of palette scrapings, a belt of cereous pigment, spotted and splotched by every colour that the merchants sell…I was snuffing the odour of mixed oil and turpentine and acrid tobacco-smoke of the painting studio.'[15]

In the classes, the level of instruction combined with the freedom students enjoyed ensured each artist had ample opportunity to develop his or her own individual style. Both men and women were prepared for competition in the professional art world and to meet the challenges that lay ahead.

In Ireland, art education for women was beginning to open up new horizons and possibilities. Apart from the R.D.S. Drawing Schools, the Queen's Institute for the Training and Employment of Educated Women (founded 1861) offered their students classes in the applied art: lithography, painting photographs, wood-engraving, illuminated painting, and painting on china. The latter was to become a particularly popular subject featuring in the Irish Amateur Drawing Society's exhibitions from around 1877 until the late 1880s and attracting members such as Alma Barton (1877), Miss F. Tottenham (1877 & 1879), Helen O'Hara (1879), Lady Plunket, Miss O'Doherty, Kathleen Newport (1879), L. Perry (1882), Jane Taylor, Maud Faulkner, Florence L. Pike, C.E. Montizambert (1889) and Elizabeth M. Farmar (1893). Training for both male and

Over-mantle carved in the Celtic style. This is believed to be the work of two founders of the W.C.S.I., sisters Harriet and Frances Keane. It was made for their home, Glenshelane, Co. Waterford.

female students took place in a number of academies, including the City of Dublin Technical Schools, Kevin Street, which opened its doors on 10 October, 1887. Here instruction was offered in engraving, etching, lithography and wood-carving.

Wood-carving was to become particularly popular and widespread during the late decades of the nineteenth century; it held a strong appeal for no less than five founder members of the Amateur Drawing Society – Baroness Pauline Prochazka, Anna Frances Musgrave, Frances Wilmot Currey and the Keane sisters – and a small number of other Society members. These included: Mrs R. Bagwell (1877), Miss H. Perrin, (1877, 1883), Amy F. Gorman (1882), K. Bagenal (1882), M. Newton (1883), Amy F. Gorman (1883), Mrs J. McCalmont (1883), Florence L. Pike (1883), Lillie Colles (1883) and Elizabeth M. Farmar (1893). Through-

out the 1870s and 1880s members exhibited their wood-carving entries with the Society on a regular basis. These consisted largely of decorated screens and tables, together with carved picture frames. It is interesting to see how this craft form was established in Ireland. In 1886 the Home Arts and Industries Association (founded in 1884) established a number of art-carving schools throughout Ireland with support received from the Irish Association for Promoting the Training and Employment of Women (founded 4 June, 1883). The Association's social and artistic objectives, apart from fostering and promoting cottage industries, (particularly in isolated rural areas) also included marketing and exhibiting on a commercial basis examples of wood-carving both at home and abroad. Particular emphasis was placed on the sale, held each year and organised by the Home Arts and Industries Association in the Royal Albert Hall, London.

Members were encouraged to arrange classes, to instruct their pupils, exchange designs and to hold a yearly exhibition. One of the principal organisers was the Hon. Emmeline Plunket, an illustrator and writer of children's books and an exhibitor throughout the 1870s with the Amateur Drawing Society. A talented wood-carver and teacher, she also conducted classes in the Dublin area.

The Edinburgh International Exhibition held in 1886 saw a strong representation of Irish industries which included examples of wood-carving. In the same year, the Countess of Aberdeen together with a number of representatives from leading Anglo-Irish families, including Lady Keane (mother of Harriet and Frances Keane), came together to form the Irish Industries Association. Their principal objectives were to promote the manufacture and export of lace and to encourage the craft of wood-

View from the Lace Studio, Glenshelane House, Co. Waterford, home of Harriet and Edith Keane. PRIVATE COLLECTION

Cover of the illustrated journal *The Woman's World*, July 1888, edited by Oscar Wilde in which an article written by Harriet Edith Keane appeared entitled 'Lace-making in Ireland'. © BRITISH LIBRARY

VENETIAN POINT.
(Made by Miss Keane's Workers, Cappoquin.)

An example of Venetian point lace made by 'Miss Keane's [Frances Annie Keane] workers' at Cappoquin, Co. Waterford. Illustrated in *The Woman's World*, July 1888. The photograph was used to illustrate her sister, Harriet Edith Keane's article 'Lace-making in Ireland'.
COURTESY OF THE NATIONAL LIBRARY OF IRELAND

Borders of raised needlepoint lace. The style of this needlepoint lace is based upon that of the Venetian lace (sometimes called rose point) of the seventeenth century. 'Miss Keane' of Cappoquin House, Co. Waterford entered an example of this type of lace-making in the section entitled 'Irish Reproductions of Old Laces', Dublin Exhibition of Arts Industries and Manufactures and Loan Museum of Works of Art held at Earlsfort Terrace, Dublin in 1872.
COURTESY OF THE NATIONAL LIBRARY OF IRELAND

Photograph of the Countess of Aberdeen (1857-1939). 'Miss Keane' was also a member of the committee entitled New Patterns for the Use of Irish Lace Makers established in 1884 in order to encourage new designs in the field of lace-making. The Countess of Aberdeen together with the Duke of Devonshire were both members. Lady Aberdeen offered her own financial support in order to establish an organising centre in Dublin. This co-ordinated lace-making in many rural convents in Ireland.

COURTESY OF THE NATIONAL LIBRARY OF IRELAND

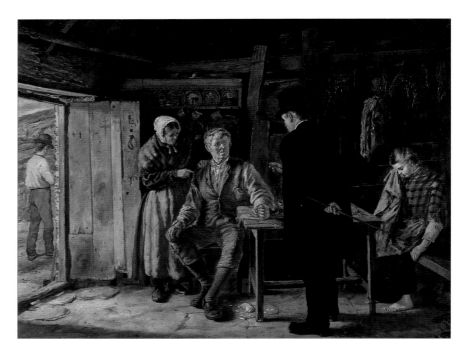

James Brenan, R.H.A. (1837-1907) *Committee of Inspection,* 1877, oil.

COURTESY OF THE CRAWFORD ART GALLERY, CORK

carving. By 1888 classes founded by the Home Arts and Industries Association had succeeded in establishing, according to Mrs M. Power Lawler (a Government Inspector of Lace), classes in wood-carving in no less than twenty-three counties throughout Ireland, together with five in Dublin. Classes were open to both men and women: 'The teachers in most cases appear to have been interested amateurs, hailing usually from the nearest big house, and often from the local rectory.'[16]

One of the most talented designers and wood-carvers was Madam Elizabeth O'Grady from Kilballyowen, Bruff, Co. Limerick, who, as early as 1877 had contributed a portrait to the Irish Amateur Drawing Society's tenth exhibition held in Dublin in March 1877. She displayed two examples of wood-carving in the Irish Fine Art Society's exhibition – an Irish cross and

a carved picture frame – and made similar contributions to subsequent exhibitions. Madam O'Grady's exceptional skills appear to have extended to Celtic ornamentation. This may be seen in a number of illustrations published in *The Queen*, which appeared in 1891 and 1892.[17]

In 1882 and 1883 Anna Frances Musgrave is listed as exhibiting a flower screen in the Irish Fine Art Society's annual exhibition held in Dublin. Ten years later, in 1892, Musgrave again submitted a hand-carved piece: a three-fold table screen to the Society's thirty-seventh exhibition. From time to time, Frances Wilmot Currey also exhibited in this area: her hand-carved screen formed part of the Society's thirteenth exhibition held in Dublin in March 1879. A handsome overmantle, the work of Harriet and Frances Keane sisters and carved in the Celtic style (illustrated here), demonstrates a high degree of skill in the field of Celtic ornamentation.

As already mentioned, one of the principal aims of the Irish Industries Association was not only to promote wood-carving but also to encourage the lace industry in Ireland. Harriet

Keane and her sister, Frances, had an interest in lacemaking and both set out to extend their reputations far beyond the limited confines of what were considered 'appropriate handicrafts'.

The tradition of muslin embroidery and point lacemaking had been established in the Keane sisters' local village of Cappoquin since the 1850s. At the local school, the craft of lacemaking was taught to local girls and young boys by the Sisters of Mercy who lived in the nearby convent of St. Theresa. The lace school at Cappoquin was mentioned in the first of two lectures delivered by Alan S. Cole, Science and Art Department, South Kensington, London in February 1884 entitled 'The Irish Art of Lace-Making'. Cole is quoted as saying that the lace school established at Cappoquin was well known for needlepoint.[18] By 1888 the school was employing around twelve employees with Miss Keane acting as their patron. In the same year, an article written by Harriet E. Keane entitled 'Lace-making in Ireland' appeared in the illustrated journal, *The Woman's World* edited by Oscar Wilde. It provides an insight into teaching methods and mentions that in 1868:

'Miss Keane began to teach lacemaking at Cappoquin, Co. Waterford… In Cappoquin one or two women had a slight knowledge of point lace stitches, probably derived from Youghal, only sixteen miles distant. Miss Keane and one of the women unravelled some old Venetian rose point, and so learnt the method of working. Only Venetian laces and the finest kinds of Reticella are made at this school.'[19]

The Edinburgh International Exhibition of 1886, Women's Industries Section, saw 'Miss Keane's Schools, Cappoquin, Co. Waterford' actively participating and submitting a number of copies of both Greek lace and Rose point.[20] Two years earlier, in 1884, a 'Miss Keane' is mentioned as becoming a member of a committee, entitled 'New patterns for the use of Irish Lace Makers'.[21] The group was spearheaded by the indefatigable Lady Aberdeen (née Ishbel Marjoribanks) (1857-1939), ardent Liberal and active suffragist, who later became President of the International Council of Women. The committee numbered amongst its ranks the Marchioness of Londonderry, the Duke of Devonshire, Vere Foster, the Duchess of St. Albans (née Grace Osborne) and Louisa Anne, Marchioness of Waterford. The aims of the committee included money prizes being offered for the production of designs, a guarantee of payment to workers for orders already placed, and an undertaking to exhibit specimens of lace in Dublin, Cork, London, Dublin and Belfast. A subscription fund was opened which ran for three years, and amongst the subscribers was Lady Keane.

Non-profit making concerns such as the Irish Lace Depot were taken over by Lady Aberdeen around 1892, together with the Irish Industries Association. The latter had been established in 1886 by Lady Aberdeen in order 'to try and organize, co-ordinate, collect, supervise, develop, publicize and market the work of the many scattered industries, to provide teachers and designs appropriate to changing fashions, to run industrial schools and to supplement the work of isolated single, philanthropic exertions, while ensuring workers were given a

Photograph of a group of lace workers. c.1900. COURTESY OF THE NATIONAL LIBRARY OF IRELAND

fair price.'[22] The association included cottage crafts together with a number of independent groups and provided women, particularly those living in rural areas, with much-needed employment. It also helped to improve sales facilities for lacemaking centres, both large and small throughout Ireland. However, organised support was badly needed, as highlighted in a report in *The Irish Builder* in July 1883. It noted that despite producing a wide variety of laces in these centres, only eight now remained, including Cappoquin, Co. Waterford.[23]

In 1893 an 'Irish industrial village' organised by Lady Aberdeen formed part of the Irish Industries Association exhibit at the World's Columbian Exposition, Chicago (the Chicago World Fair). Anxious to promote Irish industries in the United States, Lady Aberdeen assured her followers she had enlisted 'the flower of [Irish] maidenhood who had competed eagerly for the privilege of going to Chicago.'[24] Amongst them, the Official Guide mentions that 'Miss Keane will show specimens of all manner of cottage industries and not only lace and embroideries of many kinds but hosiery and under-cloth woollens…'[25]

The Royal Irish School of Art Needlework (1882-1915) exhibited on a regular basis with the Irish Industries Association. Many of the exhibits were the work of Baroness Pauline Prochazka, who acted as the efficient manageress and artistic director/designer of the School for twelve years from 1886.

The School had been established by the Vicereine, Katrine, Countess Cowper (then Lady Lieutenant of Ireland) and was run on a similar basis to that of its counterpart in London, producing a wide range of both costume and domestic embroidery. In 1888 the *Lady's Pictorial* commended 'the good work done by the Royal Irish School of Art Needlework in educating and developing artistic taste in embroidery.'[26] The School's initial location was in Molesworth Street and a move to 23, Clare Street, Dublin ensured it retained a position on the south-side of the River Liffey, close to Dawson Street with its milliners and dressmakers. In its early years, one of the primary objectives of the School was to provide suitable employment for indigent gentlewomen, art needlework providing them with 'means of earning a livelihood'.[27] The school, under

Frontispiece of a catalogue for the Royal Irish School of Art Needlework, Dublin. PRIVATE COLLECTION

Sketches from the Irish Exhibition held at Devonshire House, Picadilly, London, June 1888, organized under the auspices of the Royal Irish School of Art Needlework, Clare Street, Dublin. Artistic Director, Baroness Pauline H. Prochazka (from *The Building News,* 22 June, 1888. p.891). COURTESY OF THE NATIONAL LIBRARY OF IRELAND

Prochazka's efficient guidance, sent nine entries to Lady Aberdeen's Irish Exhibition at the Edinburgh International Exhibition in 1886. The Baroness also played an active role in the administrative side relating to this exhibition. She served as a member of the General Committee and was responsible for running a stall to represent Irish Women's Industries, together with Lady Keane from Cappoquin and other women drawn from well known Anglo-Irish families living in diffierent parts of Ireland. In 1888 the Irish Exhibition, held in the auspicious surroundings of Devonshire House, Piccadilly, London was organized by Prochazka and her team

from the Royal Irish School of Art Needlework, Dublin. The exhibition, held in June, not only included fine examples of Irish needlework and lace but, according to *The Building News,* 'a good show of oak work'.[28]

The first exhibition of the Arts and Crafts Society of Ireland was held in the Royal University Buildings, Earlsfort Terrace, Dublin in 1895. This provided the public with an opportunity to view a loan collection by members of the English Arts and Crafts Society including work by stained glass artist and craftsman, Christopher W. Whall (1849-1924), and decorative artist, John Hungerford Pollen (1820-1902). From the Clare Street premises

and with the assistance of four workers from the School, Prochazka exhibited a silk embroidered chasuble in the exhibition (later to be worn by Archbishop John Ireland, St. Paul, Minnesota, U.S.A.). In 1893 this magnificent vestment (illustrated here) had been placed on display in the Art and Handicraft section of the Women's Building at the Chicago World Fair. Lady Aberdeen, one of the principal forces behind the exhibition illustrated Prochazka's contribution as part of her essay 'Why Should We Encourage Irish Industries?' in the accompanying catalogue.[29]

On several occasions the Baroness was invited to give lectures relating to

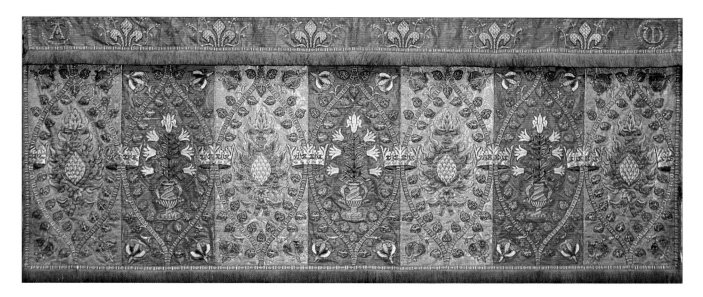

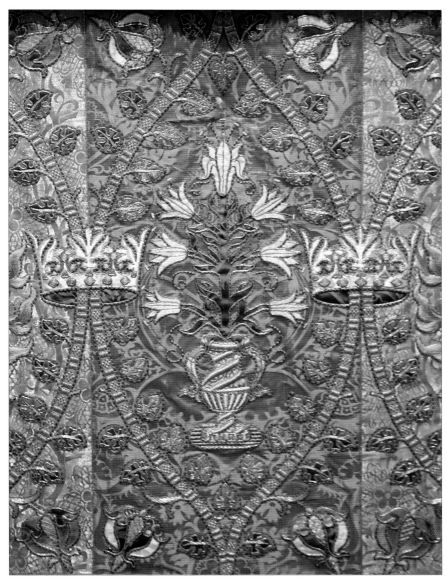

Rose-red and gold frontal for the high altar, Kildare Cathedral, 1897-98, executed by the Royal Irish School of Art Needlework, Dublin and based on a design by Scottish church architect, Sir Ninian Comper (1864-1960).

For around twelve years, Baroness Pauline Prochazka acted as manageress and artistic director of the Royal Irish School of Art Needlework. On several occasions she was invited to give lectures relating to 'Art Needlework' at their exhibition rooms in Westland Row, Dublin.

Cover of *The Arts & Crafts Society of Ireland Catalogue of the First Exhibition*, 1895, Royal University Buildings, Earlsfort Terrace, Dublin.

The cover and headpiece was designed by W.C.S.I. Member, Richard F. Caulfeild Orpen R.H.A., F.R.I.A. (1863-1938). R.F. Caulfeild Orpen was a founder and the first secretary of the Arts and Crafts Society of Ireland. He was also a long-standing and distinguished member of the W.C.S.I. and was elected Chairman of the Society in February 1934.

Silk embroidered chasuble, from the Royal Irish School of Art Needlework, Clare Street, Dublin designed and made for His Grace, Archbishop John Ireland, (born Kilkenny, 1838-1918) St. Paul, Minnesota.

Baroness Pauline Prochazka, with the assistance of four workers from the Royal Irish School of Art Needlework, was responsible for the execution of this magnificent chasuble which was exhibited at the World's Columbian Exposition, Chicago (the Chicago World Fair) in 1893.

'Art Needlework' at the School's exhibition rooms located in Westland Row, Dublin. She also found time to lecture on the same subject outside the capital. On Friday, 21 May, 1886 an art exhibition was held in the local parochial hall, Mallow, Co. Cork. The local paper recorded 'a large audience of ladies assembled to hear an address on "Needlework" which the Baroness Prochaska had kindly consented to deliver. Her ladyship treated her subject in admirable style, and the excellent and useful lecture which she delivered was listened to with the greatest attention and appreciation'.[30]

By the end of the nineteenth century, the expanded area of the applied arts had become a fashionable and acceptable pursuit for women, with a number of distinguished members drawn from the ranks of the Amateur Drawing Society playing an active and leading role. However, women artists had seen little real improvement in relation to exhibiting their art work in Ireland on a public basis, or in becoming independent, professional artists accepted by Irish art institutions and placed on an equal footing with men. With the growth of sketching clubs and drawing societies throughout Ireland and, in particular, the establishment of the Amateur Drawing Society in 1870, the position did indeed begin to improve.

Chapter VI

The Role of Sketching Clubs and Drawing Societies in 19th Century Ireland

In Ireland, the establishment of sketching clubs, together with both amateur and professional drawing societies, set in motion a tradition that has lasted to the present day. The Amateur Drawing Society was, in its early years, small and largely comprised of amateur female painters. The formation of the Society was part of the growing momentum of sketching clubs and exhibition societies which were beginning to spread throughout Ireland. This may have stemmed from England where in the second half of the nineteenth century a dramatic rise had taken place in relation to the number of sketching clubs and societies being established. Members, ranging from the keen amateur to the distinguished professional, were anxious to form themselves into groups for mutual encouragement and 'to encourage sketching from nature and Original compositions'.[1]

The sketching club or drawing society served a number of functions. It offered the artist working in a relatively unacceptable medium such as water-colour an opportunity to exhibit his or her work. The club/society also

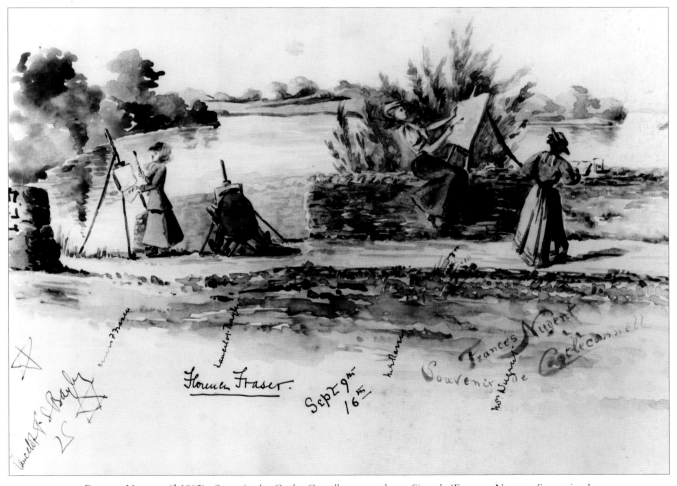

Frances Nugent (fl.1905) *Souvenir de Castle Connell,* watercolour. Signed: 'Frances Nugent Souvenir de Castleconnell,' dated: 'Sept. 9th 16th 1905'. A page from the autograph album of Mary Elizabeth Massy depicting Miss Florence Fraser, Mr Lancelot Bayly (member, W.C.S.I), Mrs Massy and Mrs Frances Nugent sketching on the banks of the river Shannon, Co. Limerick. COURTESY OF THE IRISH ARCHITECTURAL ARCHIVE, DUBLIN

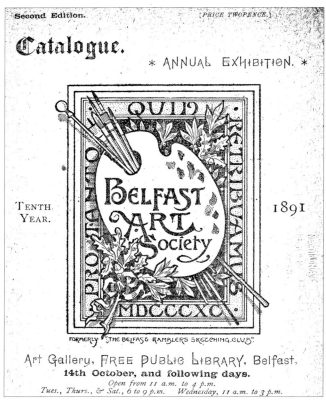

Cover of the catalogue for the Belfast Art Society's tenth annual exhibition, October 1891.

Ernest E. Taylor (1863-1907), *Portrait of John Vinycomb, M.R.I.A. (1833-1928),* oil, 1892. Illuminator and heraldic designer, John Vinycomb was President of the Belfast Ramblers' Sketching Club in 1879, and of the newly-formed Belfast Art Society in 1890; he was also President of the Ulster Arts Club founded in 1902.

provided a congenial, sympathetic environment in which paintings might be purchased and admired. In many cases, there was no jury present to pass judgment. Societies also offered amateur painters, particularly women, valuable opportunities and facilities. Women would appear to have found clubs and exhibition societies more welcoming than the rather austere surroundings of the R.H.A. or the R.A. Public exhibition space was now available to artists who had access to new patrons and an opportunity to meet a circle of like-minded people. Members enjoyed shared activities such as sketching from nature, together with convivial excursions to the countryside.

The formation of a society formalised the practice and brought artists together who enjoyed shared mutual interests. It also helped to ensure that public exhibitions of members' work was held at least once a year. Societies such as the Fine Art Society provided a venue for sparkling and fashionable *conversaziones*, balls, lectures and other various aspects of art and culture.

From their inception, several Irish societies offered open membership to both professionals and amateurs. This would appear to have been the case in relation to the Amateur Drawing Society where, at the beginning, there was little or no control being exercised in relation to the numbers admitted. This tended to weaken standards and led to a range of problems – congested hanging, little or no control being placed on the number of works exhibited by an individual member, financial and media difficulties.

Despite these drawbacks, art societies and sketching clubs blossomed throughout Ireland and appear to have been largely promoted by women. In the latter part of the nineteenth century, Belfast saw the birth of the Belfast Sketching Club, later to become known as the Belfast Ramblers' Sketching Club. This club was eventually to lead to the formation of the Belfast Art Society, which encouraged the appreciation and development of the visual arts in the city between 1890 and 1930. In 1930 the society changed its name to the Ulster Academy of Artists, and was allocated a royal prefix in 1950.

The first meeting of the Belfast Sketching Club was held in July 1864, the objective being nothing less than 'the artistic improvement of its members'.[2] Membership of this somewhat select group was not allowed to exceed sixteen members. For a period, the club foundered but was revived in the spring of 1879 and renamed the Belfast Ramblers' Sketching Club.

Under its President, illuminator and heraldic designer, John Vinycomb, M.R.I.A. (1833-1928), monthly meetings were arranged at which members discussed and criticised each others' work. Their first exhibition was held in the autumn of 1881 when they joined forces with the Belfast School of Art Sketching Club. This had been formed in 1872 by twelve female students at the school for the purpose of studying landscape and figure subjects from nature. Two years later, a rival club was established in the same school by the students who attended the evening classes and this would appear to have been more organised. It had rules, regulations and officers, and an elected honorary secretary. Their objective was studying from nature with sketching expeditions being organised in and around Belfast.

In the club's joint exhibition with the Belfast Ramblers' Sketching Club held in 1884, new members included marine, landscape and genre painter Anthony Carey Stannus (1830-1919), who, shortly afterwards, agreed to

Photograph of Queenstown (now Cobh), Co. Cork, c.1880, the home of the Queenstown Sketch Club. COURTESY OF THE NATIONAL LIBRARY OF IRELAND

become their president. It was largely due to his efforts that the Club managed to obtain clubrooms at 55, Donegal Place, Belfast. A highly successful exhibition comprised of around 300 works was held on the premises opening on 10 November, 1885. Also included were a sizeable number of paintings by members drawn from the ranks of the Irish Fine

The Queenstown Sketch Club Rules. PRIVATE COLLECTION

Landscape and figure painter, Beatrice Edith Gubbins (1878-1944), 1898. Gubbins was a member of the Irish Fine Art Society and Hon. Secretary of the Queenstown Sketch Club c.1900. PRIVATE COLLECTION

Marjorie Hariette French (1887-1972) *Cuskinny (interior)*, watercolour.
Cuskinny, Queenstown, Co. Cork, was the home of artist Marjorie Hariette French (1887-1972), a member of the Queenstown Sketch Club and also an exhibitor with the W.C.S.I. from 1908-1911.
PRIVATE COLLECTION

T. Scully, *The Club at Work*. From a catalogue of the Dublin Sketching Club Annual Exhibition, 1888. The Dublin Sketching Club, founded on 20 October, 1874, is still thriving and is known today as The Dublin Painting and Sketching Club.
COURTESY OF THE NATIONAL LIBRARY OF IRELAND

Art Society. The local press, fully supportive of the Club's efforts, declared: 'the show of pictures will compare favourably with the work done by any local sketching club in the kingdom.'[3] In 1890, the Club changed its name to the Belfast Art Society, and was proud of having developed from a small membership base into a large, ever expanding membership.

In the south of Ireland, the strict rules relating to the Queenstown Sketch Club were preserved (until recently) at the home of the Club's Honorary Secretary, Beatrice Edith Gubbins (1878-1944). Her home, Dunkathel House, built in the Palladian manner, was acquired by the Wise Gubbins family around 1870 and overlooks the River Lee at Glanmire, a few miles from the city of Cork. A much travelled artist and a frequent exhibitor with the Irish Fine Art Society, Beatrice Gubbins ran a tight ship. The Society's Rule No. 3 mentions that all sketches 'must be strictly original and not done under the supervision of a master. They may be executed in any medium except oil, and must be signed with a pseudonym'. In order to protect themselves from critical attack either by fellow members or outsiders 'Votes and criticisms [are] to be signed with pseudonym' (Rule 7). Gubbins (together with other members of the Club) frequently inscribed their work using pseudonyms. In the case of Gubbins, 'Greyhound', 'Benjamin' and 'Jessamine' appear to have been popular. Subscriptions and fines imposed by the Club went towards paying a 'Professional Critic, to subscribe to the Studio, to pay current Expenses and to give Prizes to those who have received most votes.' (Rule 9).[4]

In the capital, the Dublin Sketching Club was to embrace many members of the Irish Fine Art Society. It was largely the brainchild of an enthusiastic amateur artist and well known Dublin dentist, William Booth Pearsall, F.R.C.S.I., H.R.H.A. (1845-1913). The Club, founded on 20 October, 1874 stated amongst its many objectives 'the bringing togetherArtists, Amateurs, and others interested in Art, the holding [of]

Ye Artist & Ye Critic. Cover of the catalogue for the Dublin Sketching Club Annual Exhibition, 1885.

Cover of the catalogue for the Dublin Sketching Club Annual Exhibition, 1884.

Public Exhibitions, the encouraging of Art of all kinds, especially painting, Sketching, Drawing, Modelling, Pottery, Photography…'[5] It is still thriving today holding annual exhibitions and is known as the Dublin Painting and Sketching Club.

Further aims are provided in more detail in a catalogue dating from 1901: 'The Club aims to be a Sketching Club where meetings are arranged for Conversation, for study from Models, for Illustration Work, Sketches, Lantern Exhibitions and Social Events. During the summer, Sketching Parties work out of doors, direct from Nature, many interesting places being visited.'[6]

Founder members were President, (and W.C.S.I. exhibitor 1909-17) landscape and cattle painter, Alfred Grey, R.H.A., (1845-1926), Vice President, Augustus Burke, R.H.A.,

together with William Booth Pearsall, who acted as both Hon. Secretary and Hon. Treasurer. The Committee consisted of Abraham 'Bram' Stoker, (author of *Dracula*); T.A. Jones, P.R.H.A. (Chairman); John Todhunter, M.D.; J.E. Rogers, A.R.H.A.; C.E. Fitzgerald, M.B.; Thomas U. Young, and John Woodhouse, A.R.H.A. For the first year of the Club's existence, membership was confined to founder members only which made for a somewhat restricted group. The following year it was decided to throw the club open '…to the gentlemen painters of the city'.[7] Amongst those who enjoyed the weekly 'sketching outings' was Nathaniel Hone, the younger, R.H.A. (1831-1917) who had returned from Barbizon to live in Ireland. In 1876 the Club accepted applications for membership from

several well known Academicians including Dr. James Butler Moore (a future President of the R.H.A.); John Butler Yeats, R.H.A. (1839-1922); and Bartholomew Colles Watkins, R.H.A. (1833-1891). They were followed later by members of the W.C.S.I. including Richard Caulfeild Orpen, R.H.A. (1863-1938); Walter F. Osborne, R.H.A. (1859-1903); Percy French (1854-1920); and Sarah Purser, R.H.A.

At the beginning, members met indoors to draw and paint, but due to the inadequacy of the gas lighting soon opted for weekly outings. At their 1884 exhibition held in the Leinster Hall, Molesworth Street, Dublin, the Club staked a place in the city's art history by succeeding in bringing the first one-man loan exhibition of 'modern' paintings to be exhibited in Dublin in the late nineteenth century. In this

case, the artist was American-born James Abbott MacNeill Whistler (1834-1903). The idea had been the brainchild of the Hon. Frederick Lawless, (1847-1929) an Irish sculptor who, whilst living in London during the 1880s, had become a friend of Whistler's. Lawless returned to Dublin in February 1884 and, together with Dublin Sketching Club members, William Booth Pearsall and John Butler Yeats, helped to organise the American painter's Dublin exhibition. The Club issued a formal invitation to Whistler in London on 10 November, 1884. The artist responded immediately by sending twenty-six works to Dublin for the exhibition due to open on 1 December, 1884. These included his famous pieces *Arrangements in Grey and Black: No. 1 Portrait of my Mother (Mrs George Washington Whistler)*, and *Arrangement in*

Photograph of Abraham 'Bram' Stoker (1847-1912), taken in 1906. Stoker was a novelist, (author of *Dracula*), a theatre manager and a founder member of the Dublin Sketching Club.

Grey and Black, No. 2, Portrait of Thomas Carlyle (which had hung in the Paris Salon that year), a couple of *Nocturnes*, and *Portrait of Lady Meux*, together with eight small watercolours. Whistler's substantial contribution was hung as a group and separated from works executed by club members. This attracted criticism not only from members themselves but the press. *The Irish Times* felt: 'The exhibition ought to be one thing or the other. It ought to be a loan exhibition pure and simple, or an exhibition of the year's club work.'[8]

Whistler's celebrated court case with Ruskin held in 1878 had aroused curiosity in art circles around the world. The fact that his work should be placed on show in Dublin in the surroundings of a relatively conservative art society was bound to trigger a hostile reaction. In the early

Sarah Henrietta Purser, H.R.H.A. (1848-1943) *William Booth Pearsall, F.R.C.S.I., H.R.H.A. (1845-1913)*, oil on canvas. William Booth Pearsall was a specialist in dentistry, instrumental in founding the Dublin Dental Hospital and a founder of the Dublin Sketching Club. He exhibited many works at the R.H.A. and the R.A. between 1872 and 1912. This portrait was exhibited in the R.H.A. in 1884.

COURTESY OF THE DENTAL HOSPITAL, DUBLIN

William Booth Pearsall, F.R.C.S.I., H.R.H.A. (1845-1913) *On the Liffey*, etching on copper. This 'club sketch' was executed in two hours at the Working Meetings of the Club, Sixth Season, (1879-80), from a catalogue of the Dublin Sketching Club entitled *Club Sketches and Studies. The Fifth Annual Exhibition of Sketches and Studies November 1st, 1880* held at Messrs. Cranfield & Company's Gallery, 115 Grafton Street, Dublin.

PRIVATE COLLECTION

'Spy' *James Abbott McNeill Whistler* from *Vanity Fair*, 12 January, 1878.

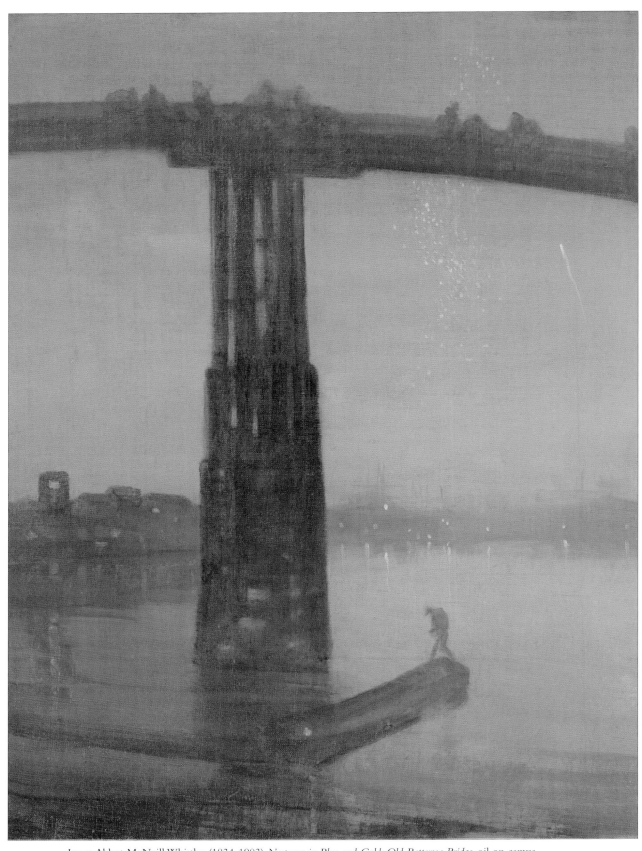

James Abbot McNeill Whistler (1834-1903) *Nocturne in Blue and Gold: Old Battersea Bridge*, oil on canvas.

Beatrice Elvery (1883-1970) *The Opening Ceremony of the new premises of the United Arts Club, Dublin, 7 December 1910*. In this cartoon the artist Beatrice Elvery (later Lady Glenlavy) is shown first on the left (seated), with Ellen Duncan (seated on the artist's left), founder in 1907 of the United Arts Club, Dublin reading the *Athenaeum*. The portrait above the chimneypiece is of Dermod O'Brien, P.R.H.A. by Strang.

1880s, Whistler's work was being heavily criticised by some conservative critics who considered his paintings to be mere studies or sketches and lacking in clarity and legibility, the basic qualities on which watercolours had formerly been judged. However, Whistler's tonal and atmospheric landscape compositions, his ability to transmit information relating to the physical world by both sensuous pictorial and abstract means, was now beginning to cause a revolution in the art world. Whistler had no reservations about openly proclaiming the fact that his paintings were, in the first instance, related to the arrangement of line and colour; everything else was secondary. This was considered to be a direct attack on a culture that sought to

establish narratives rich in moral values and which proclaimed what was considered to be, at the time, proper behaviour.

Whistler's early *Nocturne in Blue and Gold: Old Battersea Bridge* (illustrated) may be seen as the artist's rejection to the explicit moralising of much to be found in Victorian art during this period and was first exhibited in 1877. The painting displays a surface made up of gentle atmospheric tones with dots of colour being applied to indicate the presence of lights. In a letter to Fantin Latour dated 30 September, 1868, the artist states:

'The same colour ought to be…embroidered on the canvas, that is to say, the same colour ought to appear in the picture continually here and

there, in the same that a thread appears in an embroidery, and so should all the others… in this way, the whole will form a harmony. Look how well the Japanese understood this. They never look for the contrast on the contrary, they're after repetition.'[9]

William Booth Pearsall, acting as Whistler's agent in Dublin, remarked: 'the whole of Dublin was convulsed and many went to Molesworth Street to see the exhibition who rarely went to see anything of the kind'; and that Whistler appeared to have been pleased 'not only with the purchase of his pictures, but with the commotion that the exhibition caused.'[10] Furthermore, Whistler's works continued to be criticised unfavourably by *The Irish Times,* and this in turn led to a raging

controversy in the pages of the newspaper with the 'whole of Dublin [being] convulsed'.[11]

At the beginning, the Dublin Sketching Club appears to have been an all male society: 'Lady Artists' were permitted to send their work to Club exhibitions but were not allowed to participate in Club activities; that is until 1885 when lady artists were finally admitted providing that '[they] shall have no voice in the management of the club and no power to attend a meeting'.[12]

Two years after the formation of the Amateur Drawing Society, a group of ladies, under the firm guidance of a Miss Deane (fl.1847–74), had 'started the Ladies' Sketching Club. At that time the R.H.A. was the only public exhibition held in Dublin and the need for a smaller exhibition where Amateurs and Tyros in Art could exhibit their work, was felt as a growing necessity with the rapidly increasing taste amongst all classes for Drawing and Painting'.[13] The following year, they permitted the gentlemen to join them and changed the title of the club to the Dublin Amateur and Artists' Society. However, management of the Society still remained firmly in the hands of the ladies. In 1874, R.H.A. exhibitor and later member of the Irish Amateur Drawing and the Fine Art Society, Mary Kate Benson succeeded Miss Deane as secretary for a further three years, the group becoming known as 'Miss Benson's Society'. However by 18 October, 1878 the Secretary of the Dublin Sketching Club, A.B. Wynne, was being forced to record:

'Your committee notice with regret the extinction of an art society which for many years held its art exhibitions in the Leinster Hall…As the result of conversations amongst the members of that society and our own, a committee of each society was appointed to consider the question of their amalgamation with us. Your committee believe that a considerable number have signified their intention of joining the Sketching Club, some have done so already. During the last week a formal resolution was passed at a specially summoned meeting of the Dublin Amateur and Artists Society

Poster for the first exhibition of the Modern Sketch Club held in The Modern Gallery, 175 Bond Street, London, January, 1903.
PRIVATE COLLECTION

confirming the amalgamation.'[14]

In 1892 a breakaway branch formed themselves into what was known as the Dublin Art Club. This survived for only three years. It was not until ten years after its demise that the United Arts Club was founded in 1907. The idea was to establish a club 'combining the usual advantages of a social club, open to both ladies and gentlemen, with features of special interest to workers in Arts, in Music and in Literature'.[15] Many distinguished figures in Irish cultural life have belonged to this colourful club, including W.C.S.I. members Percy French, Beatrice Moss Elvery (later Lady Glenavy), and Sir William Orpen. Other members included Pádraic and

Mary Column, Lord Longford, Michael MacLiammoir, Casimir and Constance Markieviez, Lennox Robinson, Jack Butler Yeats, Bernard Shaw, and James Stephens.

The establishment of these sketching clubs and drawing societies, which began to make their appearance with increasing alacrity throughout the country in the closing decades of the nineteenth century, provided gifted artists, particularly women with an opportunity, however limited, to exhibit their work. Women artists now had a public platform and an opportunity to achieve recognition both from a professional and amateur standpoint.

Chapter VII
'Every Lady Her Own Drawing Master' The Founder Members of the Water Colour Society of Ireland

Today, the visitor to Lismore is impressed by the architectural dominance of Lismore Castle counter-balanced by the beauty of the cathedral church of the diocese named after its founder, St. Carthage. Travelling on the main road from Cappoquin to Lismore, the view of the elegant cathedral spire may be seen emerging from the trees surrounding the town. The indefatigable and often highly critical recorder, William Makepeace Thackeray, on a visit to Lismore in 1842 was enchanted and noted in his *Irish Sketch-Book*, 'The graceful spire of Lismore church, the prettiest I have seen in, or, I think, out of Ireland.'[1]

It was here in this historic town of Lismore that the founders of the Amateur Drawing Society gathered in November, 1870 to unite themselves into an associated body for the 'mutual improvement in painting and drawing and the cultivation of a taste for art'.[2] The six artists and founder members were drawn from the surrounding areas and counties. They were: Harriet Edith Keane (1847-1920), Frances Annie Keane (1849-1917), Frances 'Fanny' Wilmot Currey (1848-1917), Baroness Pauline Harriet Prochazka (1842-1930), Henrietta Sophia Phipps, (1841-1903) and Anna Frances 'Fanny' Musgrave (1853-1918).

One of the principal motives behind the foundation of the Society would appear to have been dissatisfaction with the condition in which watercolours and drawings were hung and displayed in both public and private exhibitions held throughout Ireland and Great Britain. The group also required an independent space in which to hang and exhibit their work. From the beginning, the Society sought to accommodate those artists who were not receiving recognition from official societies and who wished to have a new outlet in which to display their work in a wide range of media, including oil, and to create an environment in which to attract patrons. In the coming years, members were to prove remarkable for their talent and determination in securing a venue, establishing a market and making their output available to the public, setting up exhibitions, and in many cases managing to earn a living from their work. The Society also offered women, in particular, a rare opportunity to exert an executive role.

'There was something very attractive and impressive in her curious, plain face, full of intellect, and devilry, and good fellowship too.'[3] This was Edith Somerville's description of her friend and relative, and founder of the Amateur Drawing Society, Frances Wilmot Currey. The latter was considerably older than Somerville when they encountered one another for the first time. 'Rider to hounds, salmon-fisher, woodcock-shooter, organist, suffrage speaker, agitator in all the main relations of life'.[4] It would appear from Somerville's description that she was somewhat in awe of her relative's achievements. This is not surprising since by the late 1880s Currey had succeeded in establishing herself as one of the few professional members of the Society – a professional watercolourist. A reviewer

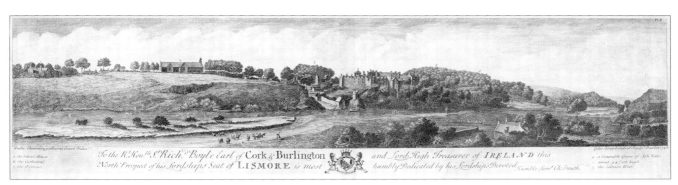

Engraving of North Prospect, Lismore, 1746, 'To the Rt. Honble. Richd. Boyle, Earl of Cork & Burlington and Lord High Treasurer of Ireland, this North Prospect of his Lordship's seat of Lismore is ... dedicated ... Antho: Chearnley ... Published Dublin, 1746' from C. Smith's *History of Waterford*. On the left may be seen (a) The School House, (b) St. Carthage's Cathedral, (c) Lismore Castle, and (d) the Salmon Weir.

COURTESY OF THE NATIONAL LIBRARY OF IRELAND

commenting on her work in relation to the second exhibition mounted by the Society under their new title, the Water Colour Society of Ireland, held in Belfast in the autumn of 1889, commented on the fact that Frances Wilmot Currey '...could not be considered an Amateur in any sense of the word save one, that she is not dependent upon the pursuit of Art for a livelihood'.[5]

Frances Wilmot Currey was the daughter of Francis Edmond Currey (1814-1896) and Anna Matilda (née Hamilton). Her mother was the third and youngest daughter of Alexander Hamilton, Rector of Thomastown, Co. Kilkenny. Francis Edmond Currey, a Cambridge-trained lawyer and a fine amateur photographer, served as resident head agent to both the sixth and seventh Dukes of Devonshire for over forty years at Lismore Castle. He took an active part in local affairs serving as a local magistrate and Poor Law guardian in Co. Waterford, whilst holding directorships and share-holdings in a number of railway companies and other local enterprises.

The Currey family had been intimately involved with the Dukes of Devonshire for several generations. Benjamin Currey (1786-1848), Old Palace Yard, Westminster, one of the clerks at the table of the House of Lords, was a well known London solicitor and a senior partner in Messrs Currey & Co, Agents and Legal Advisers to the Dukes of Devonshire. In 1827 he was formally appointed Auditor in relation to the Duke of Devonshire's legal affairs and held this position until his retirement in 1848. In 1839 his nephew, Francis Edmond Currey, was appointed resident agent in Ireland at Lismore Castle; a post he

Sir Edward Burne-Jones, (1833-1898). Stained glass window, St. Carthage's Cathedral, North Mall, Lismore, Co. Waterford. This stained glass window depicts the allegorical characters of Justice and Humility. Designed by Pre-Raphaelite artist, Sir Edward Burne-Jones, and made by his friend, designer and craftsman, William Morris (1834-1896), the window is dedicated to Francis Edmond Currey, father of Frances Wilmot Currey.

held from 1839 to 1881 and from 1883 to 1885. Copious correspondence exists between the 7th Duke of Devonshire and Francis Currey in relation to the day-to-day management of his Irish estates.[6]

Frances Wilmot Currey was born in Lismore Castle on 30 May, 1848, and baptised a year later on 16 September. Educated privately, Currey was taught by her governesses in the agent's wing (the east wing). However, part of her art training took place in London under the highly successful and influential Guernsey-born drawing master, Paul Jacob Naftel, R.W.S. (1817-1891). Influenced by such well-known English watercolourists as David Cox, Senior, O.W.S. (1783-1859), who, in his late period, achieved a freedom and atmospheric effect in his painting which was considered by many to be a direct forerunner of Impressionism, Naftel closely followed Cox's style excelling in 'atmospheric' effects, laying emphasis on scudding cloud formations, water and wind-swept landscapes as seen here in his

Frances Wilmot Currey (1848-1917) *View of Lismore Castle, Lismore, County Waterford*, watercolour. Signed and dated '1895'.

watercolour of *Brecqhou, Guernsey and Herm from Sark 1888*. Naftel washed his colours on to thick rough paper.

It is thought Currey became Naftel's pupil when the artist decided to leave Guernsey for good in 1870 and settled with his family at No. 4, St. Stephen's Square, Bayswater, London. This was to

be the Naftel's family home for the next thirteen years. Later, in 1883, when Naftel moved to a house in Chelsea, with its first floor north-facing studio, many eager young artists, including Rose Barton and Mildred Anne Butler, descended from Ireland keen to learn from this gifted teacher.

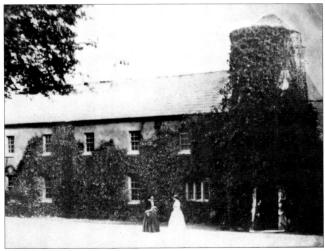

Photograph of the East Wing (the Agent's wing), Lismore Castle, Co. Waterford, attributed to Francis Edmond Currey (1814-1896). Agent to both the sixth and seventh Dukes of Devonshire, his daughter, Frances Wilmot Currey, was one of the founders of the Amateur Drawing Society and lived in this part of Lismore Castle during the early part of her life.

Photograph of William Cavendish, second Earl of Burlington and seventh Duke of Devonshire (1808-1891). The Duke took a keen interest in his Irish estates and copious correspondence exists between himself and his head agent at Lismore Castle, Francis Edmond Currey.

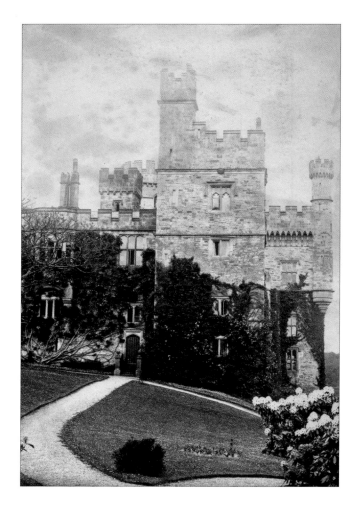

Photograph. of Frances Wilmot Currey (1848-1917) and her brother, Chetwode Hamilton Currey (1846-1883). Attributed to Francis Edmond Currey (1814-1896). PRIVATE COLLECTION

Photograph of Lismore Castle from the gardens, attributed to Francis Edmond Currey (1814-1896).

Naftel's influence, and in particular his liking and appreciation for the work of David Cox, would appear to have been an important factor in Currey's development. Indeed, she acknowledges this early on in her career. Exhibiting at the Irish Fine Art Society's thirteenth exhibition, held at 35, Molesworth Street, in March 1879, it is clear from the somewhat lengthy catalogue title *Old church and graveyard, at Bettwys-y-Coed, N. Wales*, that the artist had spent some time in North Wales and, in particular, Bettwys-y-Coed: 'It is situated in a valley in Carnarvonshire, on the banks of the Ilugwy, close to the picturesque bridge of Pont-y-Pair, and not far from its junction with the river Conway. The scenery is unusually varied and beautiful, and it has long been chosen as the favourite rendezvous of English landscape painters in the summer and autumn months.'[7] For many years, each autumn David Cox had made this

Photograph of Frances Wilmot Currey (1848-1917), one of the main motivators behind the Amateur Drawing Society.

PRIVATE COLLECTION

district his headquarters, firmly believing that Bettwys-y-Coed 'was of all others the place for good and impressive subjects, and he never lost sight of this.'[8]

Currey also spent some time in Paris at the Académie Julian. There, her teachers and professors included Tony Robert-Fleury (1837-1912) and Pierre-Auguste Cot (1837-1883) who provided her with a conservative academic training, the emphasis being on preparing students to enter the Ecole des Beaux-Arts, to exhibit at the official Salon and to compete for the Prix de Rome. At the same time, the individual talent and originality of students was not ignored. Separate ateliers (or occasionally mixed) for both men and women offered courses in drawing, painting and sculpture. The strong demand from women students in particular for a strict art academic training was particularly noticeable during this period. Académie Julian

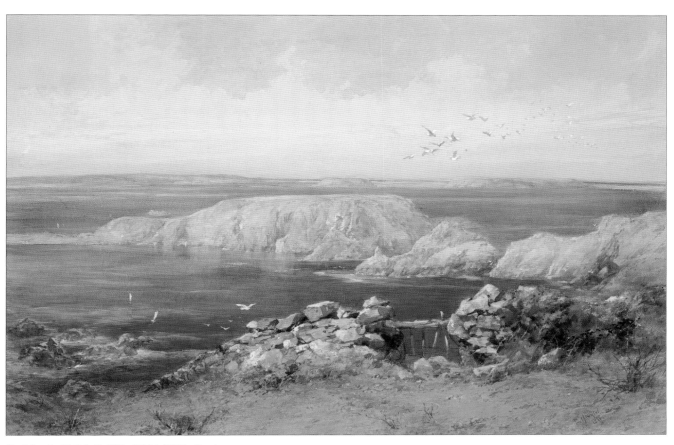

Paul Jacob Naftel, R.W.S. (1817–1891) *Brecqhou,
Guernsey and Herm from Sark* 1888, watercolour.

Thomas Mogford (1809–1868) *Portrait of Paul
Naftel. R.W.S. (1817-1891)*, watercolour.

Photograph of David Cox. O.W.S. (1783-1859), watercolourist, teacher and author.
In the last twenty or so years of his life, David Cox achieved a freedom and atmospheric effect in his painting which was considered by many to be a direct forerunner of Impressionism. The artist considered his late work to be 'the work of the mind, which I consider very far before portraits of places'.
PRIVATE COLLECTION

thus opened its doors to foreign students who did not have to pass the rigorous entrance exam demanded by Ecole des Beaux-Arts but could begin their training immediately. Students such as Frances Currey were free to leave or to stay as long as they wished. Catalogue titles provide evidence that Currey also spent time sketching and copying in the Louvre: *Prince Charles Afterwards Charles II*, sketched in the Louvre from van Dyck's picture, is but one example, and was shown in the tenth exhibition of the Society, held in Dublin on 12 March, 1877.

Currey's richly detailed watercolour *A Bazaar in Tangier*, dating from 1887 and illustrated here, was exhibited at the Royal Academy in 1888 (cat. no. 1167) and demonstrates this artist's superb control of the medium. A brilliantly fresh comment on the exotic world of North Africa, and in particular the painter's visit to Morocco; she combines clear, bright, fresh colours with careful modelling and precision to produce an outstanding tour de force on a relatively modest scale. Nineteen works by this artist were hung at the R.A. during the period 1881-1897.

The opening of the Waterford, Dungarvan and Lismore railway on 12 August, 1878, succeeded in making transportation of works of art throughout both Ireland and Great Britain much more straightforward. Keen to promote and market her work professionally, Currey began to contribute paintings, both in oil and watercolour, to a substantial number of societies and galleries throughout the United Kingdom, despatching her paintings by rail to London. These included the Royal Institute of Painters in Water Colours (19 works), the Royal Academy (20), the Fine Art Society (6), the Society of Women Artists (29), the Royal Institute of Oil Painters (12), the Grosvenor Gallery (8), the Dudley Gallery (22), the New Gallery (14), and the Royal Society of British Artists (3). Further afield, this artist's work was also to be seen in the Walker Art Gallery, Liverpool (11), the Manchester City Art Gallery (8), Glasgow Institute of Fine Arts (1), and the Royal Society of Artists Birmingham (4).

In 1877 Currey exhibited for the first time at the R.H.A. (*A View near Ischl, Austria*) and continued exhibiting there until 1896, contributing a total of twenty-one pictures. These included many views in and around Lismore. Her delightful watercolour *A Stile in Brittany,* painted in the early 1880s, was exhibited at the R.H.A. in 1882 and succeeds in raising an everyday Breton subject to a high level. From time to time, this painter also contributed flower pieces to R.H.A. exhibitions, which often attracted comments in the

Photograph of Rodolphe Julian (1839-1907), founder of Académie Julian, Paris, from *The Sketch*, June 1893. PRIVATE COLLECTION

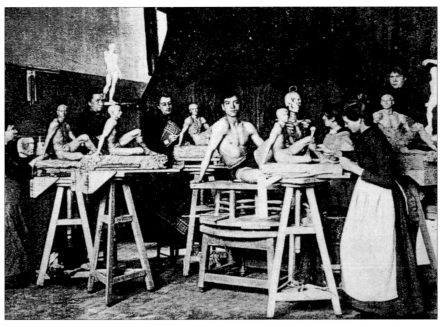

Photograph of the women's anatomical studio at Académie Julian (5 rue de Berri, Paris) from *The Sketch*, June, 1893. COURTESY OF THE NATIONAL LIBRARY OF IRELAND

Photograph of Frances Wilmot Currey's studio, The Mall House, Lismore, Co. Waterford, (external view), attributed to her father, Francis Edmond Currey. (1814-1896).

and, in particular, bulbs in her walled garden in Lismore. She became a professional daffodil bulb grower and was one of the earliest of Ireland's internationally famous daffodil breeders.

In her later years, the artist spent several weeks every summer at the old barracks near the Gap on the Lismore-Clogheen road. Here, she would paint, fish in the Oon-a-Shad river, and shoot grouse. For many years Currey was a reliable organist playing in St. Carthage's Cathedral. She also managed to find the time to lecture on one of her favourite topics, market gardening. *The Queen* noted in November 1891: 'The Horticultural classroom at Alexandra College was unusually crowded on the 18th [November] when Miss Frances Currey delivered her lecture on "Market Gardening" to a packed room which included the curator of the Botanic Garden, Trinity College, Dublin, Burbidge.'[10]

press. *The Daily Express* in March 1895 noted that 'another well-known lady artist Miss Fanny Currey, has an excellent study of roses...one of the best pieces of flower painting in the gallery.'[9] Currey's ownership of the Warren Nursery, Lismore resulted in her cultivating a wide range of plants

As a journalist she also expounded on the same subject ('Market Gardening for Ladies') under the rather prim title:

Photographs of the interior of Frances Wilmot Currey's studio, The Mall House, Lismore, Co. Waterford, attributed to her father, Francis Edmond Currey.

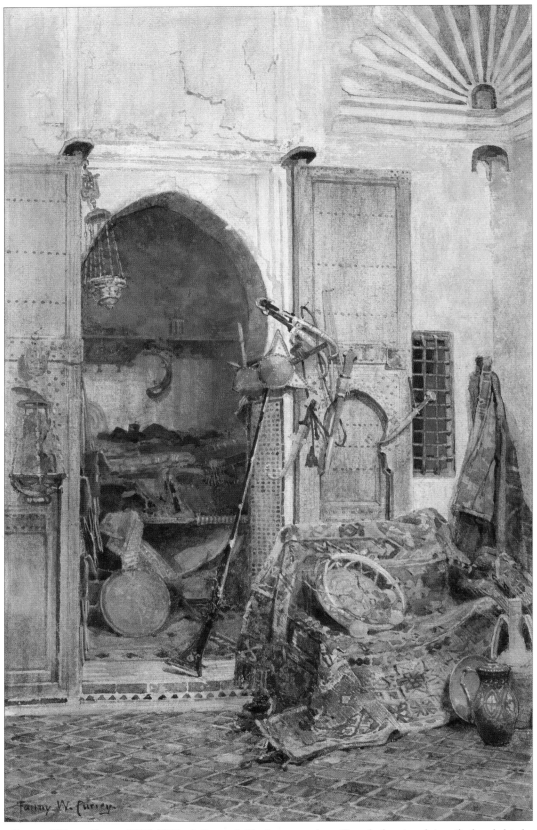

Frances Wilmot Currey (1848-1917) *A Bazaar in Tangier*, watercolour. Signed, also signed, inscribed and dated '1887' on verso. Exhibited at the Royal Academy, London, 1888. (cat. no. 1167).

'Pursuits for Gentlewomen'.[11] However, in a letter to Edith Somerville, Martin Ross does not appear to have thought too highly of Fanny's ability in the field of journalism: 'I am sure she is a good judge, though the only specimen I have seen of her style (Journalistic) is very poor as far as literary brilliancy goes.'[12]

An amusing story related by Edith Somerville in *Wheel-Tracks* recalls how a project was begun in connection with a new drainage system at Lismore. It was decided by the authorities to dig a drain through the centre of Currey's walled-in garden of her house in the town, which, if carried out, would destroy the well cultivated and highly prized daffodil bulbs. A notice was served on the owner and Currey lodged a protest but without success. Undeterred, she produced a gun and shot rooks on the wing before seating herself on her garden wall armed with a rifle and plenty of ammunition. Needless to say, the plan never materialised!

Following her father's retirement, he came to live with his daughter in The Mall House. During the last ten years or so of her life, Frances Wilmot

Frances Wilmot Currey (1848-1917) *Study of a dead bird.*

Currey was cared for by family relatives in her own home. She died on 30 March, 1917 and was buried in the family grave in the graveyard surrounding Lismore Cathedral.

A close friend of Frances Wilmot Currey and a fellow founder member of the Amateur Drawing Society was the Baroness Pauline 'Polly' Harriet Prochazka. Daughter of Colonel Baron Ottocar Prochazka, who later became Field Marshal commanding the Austrian forces at the ill-fated Battle of Sadowa in 1866; and Leopoldine, who

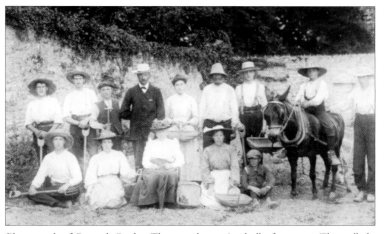

Photograph of Currey's Garden. The team harvesting bulbs for export. The walled-in garden was in Lower Church Lane, Lismore Co. Waterford.

Cover of the Warren Gardens catalogue (1907). Despatched from The Warren Gardens, Lismore, Co. Waterford by Miss F.W. Currey.

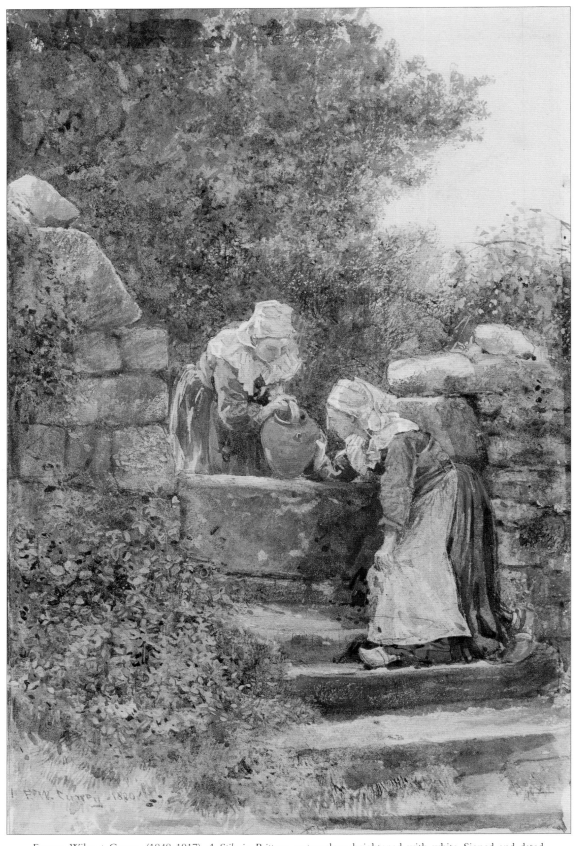

Frances Wilmot Currey (1848-1917) *A Stile in Brittany*, watercolour heightened with white. Signed and dated '1880'. Exhibited: R.H.A. 1882. (cat. no. 529).

Photograph of the Baroness Pauline 'Polly' Harriet Prochazka (1842-1930), a founder member of the Amateur Drawing Society.
COURTESY OF
THE MARQUIS OF SALISBURY, HATFIELD HOUSE

Photograph of the Dromana Gateway which spans the river Finisk, and is the entrance to Dromana, Co. Waterford, home of Baroness Pauline Prochazka. The gateway is considered to be the only example of the Brighton Pavilion taste to be found in Ireland. PRIVATE COLLECTION

Photograph of the drawing room, Dromana, Co. Waterford.
REPRODUCED COURTESY OF THE NATIONAL LIBRARY OF IRELAND

was the daughter of Austrian, Pauline Theresia d'Ott and Captain Leopold Gersch (who had married in Vienna in 1814). Pauline Prochazka's grandmother, Pauline Theresia d'Ott (already the mother of two children from her first marriage) married for the second time in London in 1826. Her new husband was Henry Villiers-Stuart (1803-1874), (later Lord Stuart de Decies, Dromana, Cappoquin, Co. Waterford). They had two children, Henry Windsor Villiers-Stuart and Pauline Villiers-Stuart. The latter was later to marry Sir Charles F. Wheeler Cuffe, Leyrath, Kilkenny. Her daughter, Leopoldine (from Lady Stuart de Decies' first marriage to Captain Gersch) captivated Austrian Colonel Baron Prochazka's heart when they met at the Emperor's court in Prague c.1840. They married and had two children, a son, Harry (1845-1904) and Pauline Harriet 'Polly' (1842-1930), the latter being born in Prague. At the age of five, Pauline Prochazka left Bohemia for good and was brought up entirely in Ireland.

Dromana lies not far from Lismore and was the home of Pauline Prochazka's grandmother, Lady Stuart de Decies. It occupies a spectacular setting rising steeply from a ledge of rock high above one of the most beautiful stretches of the estuary of the river Blackwater. A spectacular Hindu-Gothic gateway, thought to be the only example in Ireland of the Brighton Pavilion taste, is found at the northern

Photograph of Leyrath, Co. Kilkenny. In 1861, Sir Charles F. Wheeler Cuffe, 2nd Bart., married Pauline Villiers-Stuart, daughter of Lord Stuart de Decies, Dromana, Co. Waterford. The main western block was rebuilt on a larger scale in a rich Italianate style; the architect was John McCurdy (c.1824-1885). COURTESY OF DAVISON & ASSOCIATES LTD.

Photograph of the entrance hall and elegant staircase at Leyrath, Co. Kilkenny, home of the Wheeler Cuffe family. When Lady Wheeler Cuffe died in 1895, Baroness Pauline Prochazka moved to Leyrath to act as Sir Charles Wheeler Cuffe's housekeeper and to assist with the management of the estate. COURTESY OF DAVISON & ASSOCIATES LTD.

end of the demesne spanning the river Finisk. In her late teens Pauline Prochazka with her 'very twinkling eyes', who had become a keen amateur artist having been taught by her governesses, spent many happy holidays at Dromana with her grandmother painting in the surrounding countryside, gardens and house.[13] She also spent several summers at Leyrath on the outskirts of Kilkenny staying with her relatives, Sir Charles and Lady Wheeler Cuffe.

Leyrath (originally a castle) had been acquired by the Wheeler family in the seventeenth century and by 1826 was a simple two-storey house with two wings. In 1861 it was transformed at considerable expense into a house which was on a similar scale to Dromana. In that same year, Sir Charles F. Wheeler Cuffe, married Pauline Villiers-Stuart. The latter's family did not regard Leyrath as being sufficiently grand enough for their daughter, and so an architect, John McCurdy (c.1824 -1885), was employed by the Wheeler-Cuffe family to rebuild the main western block on a larger scale and in a rich Italianate style. He also carried out other alterations and additions. One of the major similarities to Dromana is the elegant imperial wooden staircase with ornate cast-iron balustrades, as illustrated here. When Lady Wheeler Cuffe died in 1895, Pauline Prochazka moved to Leyrath and acted as Sir Charles' housekeeper and later ran the estate; he described her as his 'half-niece by marriage'.[14] Following the death of Sir Charles in January 1915, she continued to live at Leyrath, managing the house and running the farm until the return from the Far East of Sir Otway and Lady Wheeler Cuffe in around 1921. Whilst living at Leyrath, the Baroness found ample scope for her many talents.

For around twelve years, Prochazka acted as the efficient manageress and artistic director/designer of the Royal Irish School of Art Needlework, Dublin beginning in 1886 (see pp.75-78).

In relation to her painting, Prochazka appears to have been largely self-taught, early training being provided by her governesses. From the

Baroness Pauline Prochazka (1842–1930) *The Beech Walk, Dromana*, watercolour, pencil and gouache.

Baroness Pauline Prochazka (1842-1930) *The River Road*, watercolour and pencil. Inscribed on verso: 'Original Sketch Class 3 Pauline H. Prochazka'
The River Blackwater runs beside the winding road. Dromana, home of the artist, is seen in the far distance on the right perched high above the river. PRIVATE COLLECTION

Leeson Rowbotham (1823-1875) (elected a member of the New Society of Painters in Watercolours, N.W.S., in 1851), and his father, Thomas (1783-1853), who, in 1872, had collaborated with his son to publish the influential *The Art of Painting in Water-Colours*.

Prochazka's historical recording in watercolour of *Laying the foundation stone of Ring Agricultural College*, c.1876, which was included in the W.C.S.I.'s 150th exhibition and illustrated here reveals the influence of both these artists – the broad panoramic view, the vivid touches of colour on the costumes of the somewhat stylised figures who throng the mid-distance. Groups have gathered together to record the laying of the foundation stone for an agricultural college at Ring, Co. Waterford, on land owned by the Villiers-Stuart family. Henry Villiers-Stuart, the artist's relative, was keen to improve the welfare of his tenants and anxious to establish an agricultural college in Co. Waterford. Later, in 1882, he was to be responsible for introducing the Labourers' Cottages and Allotments Bill into parliament. This was to result in the erection of labourers' houses throughout the country. During the nineteenth century, this Irish speaking area (part of the Villiers-Stuart's estates on the coast of Waterford) was densely populated and had serious housing and public health problems. Sadly, the college building was never roofed and did not open its doors to students. In 1909 the ruined building was given by the Villiers-Stuart family to the Irish College Committee on satisfactory terms. Later, it was converted into the Irish College that expanded to become the present Coláiste na Rinne.

Titles of Prochazka's works exhibited with the Society provide evidence that she was a keen traveller: *Doorway of the Church Heilige Krtuz Monastery* (1877); *The Lazzaretto Vecchio, at Livons, Italy* (1877); *The Avenue to the King's House, Jamaica* (1925); *Sunset on the Danube, Komara, Hungary* (1926); *The Blue Mountains, from Port Royal, Jamaica* (1926). Possibly due to her many commitments, Prochazka was not a consistent contributor throughout her life to the Society's exhibitions but she

beginning, this artist was closely involved with the Amateur Drawing Society's activities. As early as October 1871 her work in the 'Illumination' class at the second exhibition mounted by the Society in Clonmel attracted the reviewer's attention. There, Prochazka carried off the principal award for 'one of the finest works ever seen – a collection of orchids and butterflies painted on a gold ground.'[15] *The Irish Times* noted that in

connection with the Irish Amateur Drawing Society's exhibition that opened on Friday, 2 April, 1875, the Baroness had received a commendation for architecture, first prize being awarded to a Miss Emily Newton. A catalogue entry for the following year, *Villa Carlotta, Como after Rowbotham*, reveals that Prochazka was aware of the work of leading Dublin-born landscape and marine watercolourists, Thomas Charles

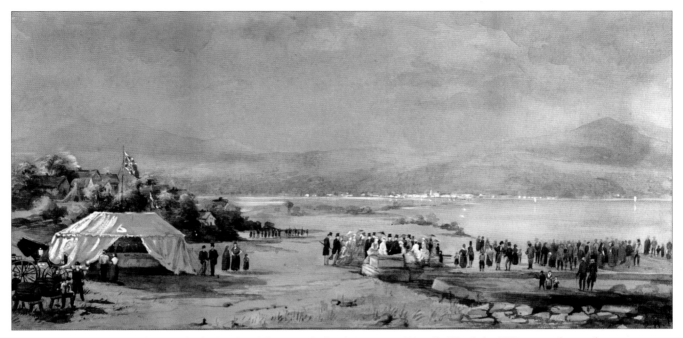

Baroness Pauline Prochazka (1842-1930) *Laying the foundation stone – Ring, Co. Waterford* c.1876, watercolour and gouache. This work records the laying of the foundation stone of an agricultural college at Ring, Co. Waterford on land owned by the Villiers-Stuart family. The roof of the college building was not completed and therefore the building was unable to open its doors to students. In 1909 the ruined structure was given by Henry Charles Villiers-Stuart to the Irish College Committee. It was converted into an Irish College which expanded to become the present Coláiste na Rinne.

did exhibit between the years 1924-27, and again in 1927 at the Belfast Art Society.

In the late 1870s the craze for painting in either oil or watercolour on terracotta and china was becoming highly fashionable. The Irish Fine Art Society's thirteenth exhibition (held at 35, Molesworth Street, Dublin and opening on 10 March, 1879) lists Prochazka exhibiting six items relating to this every growing popular pursuit.

During the First World War, Prochazka was a keen participant in the area of charitable works, and is listed together with Lady Waterford and others in the local newspaper *The Kilkenny People* as providing clothing for the men of the Royal Irish Regiment fighting at the front. For many years, the Baroness had risen at 5 a.m. in all weathers in order to direct a coffee stall held every fair day in Kilkenny town. She knew that farmers coming early to the fair found only the public houses open to refresh them and she was determined to provide an alternative.

Prochazka's intelligence and keen interest in modern day affairs was undiminished until her death in a Kilkenny nursing home in April, 1930. 'In true Molly Keane manner, [she] died of a stroke brought on by dancing a waltz to the tune of the "Blue Danube" being played on a gramophone'.[16]

Along the banks of the River Blackwater and within sight of Dromana lies Tourin, home of Anna Frances Musgrave. Anna Frances, like Currey and Prochazka, is also mentioned by Strickland as being one of the founder members of the Society; she is, however, perhaps the most obscure figure. Anna Frances Musgrave is listed as being present with her family at the first exhibition organised by the Amateur Drawing Society in the Courthouse, Lismore, which opened on 10 May, 1871. According to *The Irish Times* this consisted of few exhibitors: 'Only about a dozen members'.[17] Due to the committee's decision not to print any catalogues, it is uncertain as to whether Musgrave, the youngest founder member of the Society, did in fact exhibit. However, her work caught the attention of the press at the Society's second exhibition (October, 1871) held in Clonmel. Musgrave is mentioned as being one of the principal participants in the art class 'Studies from Nature and Figures, Originals and Copies', Anna Frances Musgrave was awarded first prize for her study of trees, the reviewer admiring the 'high professional skill of the exhibition'.[18]

Musgrave's aptitude when it came to painting flowers was noted in March 1875, when the Society held their exhibition at the Leinster Lecture Hall, Molesworth Street, *The Irish Times* commenting on the 'Flower Painting' class: 'It is splendidly represented ...Miss Musgrave's Cyclamens, Asters, and Christmas Roses... and are very cleverly painted on toned paper.'[19]

It would appear from the catalogues that this artist was not a long-term or consistent exhibitor. As far as can be ascertained, on only two occasions does Musgrave's name appear as being a member of the committee: at the Society's tenth exhibition, held in

March 1877; and the thirteenth, held in March 1879.

Two entries which provide evidence that this artist travelled both in France and Italy are mentioned in relation to the tenth exhibition *Annecy, Savoy* and *Bellagio, Lake of Como*. In 1880 evidence of a journey to Scotland is supplied by one of her contributions, *View in the Kyles of Bute,* whilst a further two entries are recorded for 1883, one of them being *Cromarty Bay – from Altyre.* Her interest in wood-carving is evident, a hand-carved, decorated screen being her handiwork in the same year (catalogue number 438). In 1892 Musgrave's name appears again: two exhibits: *Cesarino near Sorrento*, together with a three-fold table screen.

Anna Frances Musgrave's family connections with Ireland may be traced back to the early part of the

Views of the gardens at Tourin, Co. Waterford (2009) REPRODUCED BY KIND PERMISSION

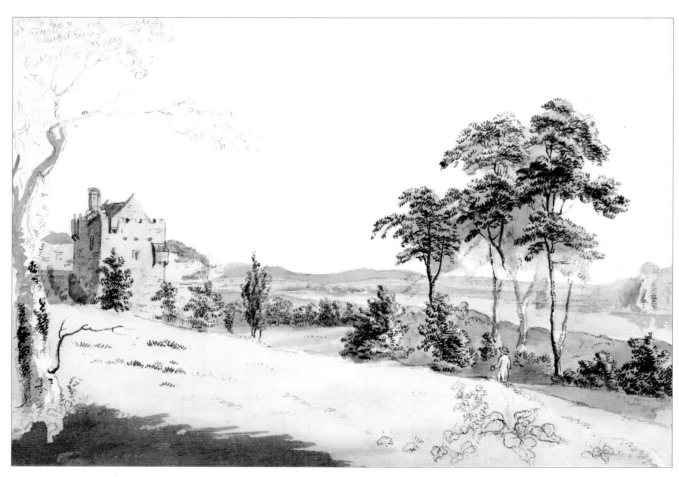

Attributed to William Ashford, P.R.H.A., (1747-1824), *View of the Tourin Castle,* pen, pencil, ink and watercolour. This seventeenth century tower house, known as Tourin Castle, is located close to Tourin Quay by the River Blackwater, Co. Waterford, and forms part of the estate surrounding the home of a founder of the Amateur Drawing Society, Anna Frances Musgrave (1853-1918). COURTESY OF THE NATIONAL LIBRARY OF IRELAND

Photograph of Tourin, Co. Waterford, c.1880. Home of a founder of the Amateur Drawing Society, Anna Frances Musgrave.

eighteenth century when a Christopher Musgrave, son of Richard Musgrave, of Yortley, a village in West Yorkshire married an Irish heiress and settled in Ireland. In 1782, their eldest son, Richard, born about 1757, achieved distinction and a separate baronetcy. In 1801 he published his well known *Memoirs of the Different Rebellions in Ireland* which contained maps and plans and largely dealt with the Insurrection of 1798. The Irish branch of the Musgrave family continued to live in Ireland; the Co. Waterford branch settling at Salterbridge on the outskirts of Cappoquin along the banks of the River Blackwater. Sir Richard's brother, Christopher, described as 'of Tourin' lived downstream on the other side of the same river.[20]

Anna Frances Musgrave was the

Photograph of Anna Frances Musgrave (1853-1918).

Photograph of Sir Richard John Musgrave, 5th Bart. (1850-1930), brother of Anna Frances Musgrave, standing at the door of their family home, Tourin, Co. Waterford.

daughter of the fourth baronet, Sir Richard Musgrave (1820-1874), and Frances Mary (d.1895) (née Ashton Yates). Her parents had married on 30 April, 1845. As Lord Lieutenant for Co. Waterford, her father had taken an active and keen interest in local affairs and became involved in trying to establish a canal connecting Cappoquin to Fermoy. Sir Richard was also anxious to see steamers on the Blackwater, which would connect Youghal to Cappoquin. Anna Frances together with her three sisters, Florence Sophia (known as 'Margaret'), Edith Melesina Lovett, and Maria, along with her brother, Richard John, lived on the outskirts of Cappoquin in the family's handsome, square two-storey Italianate house, Tourin. Built around 1840, it is thought to be a design by architect, Abraham Denny (1820-1892); the name derived from the nearby seventeenth-century tower house known as Tourin Castle.

Tourin was at the heart of the family's 8,000 acre estate. Frances Anna's brother, Richard, assumed the title in 1874, becoming the 5th Baronet when he was just twenty-four years old. He appears to have had little interest in the management of the family's estate and preferred instead to spend his time in Canada enjoying the fishing on Vancouver Island and leaving his mother to deal with any difficulties that might arise in relation to running his Irish affairs.

On 23 September 1891, Sir Richard married in spectacular style. His bride was an attractive and wealthy Canadian heiress, Jessie Sophia Dunsmuir, sixth daughter of a coal baron and railway tycoon, and one of the richest and most powerful men in British Columbia, the Hon. Robert Dunsmuir of Victoria, a member of the Legislative Council of Victoria, B.C. When the newly married couple returned to Tourin, it was the Dunsmuirs' financial injection into the Musgrave estate that saw a new wing being added to the family home and an extravagant lifestyle being adopted which included thirteen live-in servants. The family also acquired a large and comfortable London townhouse, 63, Cadogan Gardens in the heart of fashionable Chelsea.

Frequent visitors to Tourin from Newtown Anner, Clonmel, included Edith Bernal Osborne, (1845-1926) later to become a well known botanical artist in her own right, (Lady Edith Blake), together with her sister, Grace, an amateur artist and exhibitor with the Irish Amateur Drawing Society, (1872). Another visitor, also from Clonmel was Harriette Bagwell from Marlfield House sited on the outskirts of the town. Harriette was the daughter of Philip Jocelyn Newton, Dunleckney Manor, Bagenalstown, Co. Carlow, and had married Richard Bagwell on 9 January, 1873, five years after he had been appointed High Sheriff of Tipperary. An exhibitor with the Society in 1872, Harriette Bagwell became instrumental in establishing a thriving local cottage industry, Marlfield Cottage Industries, on her family's estate. It would appear that the three girls received drawing lessons in the early 1870s at Tourin. Harriette records in an entry to a visitors' book, dated 29 January, 1873, that she 'found this house [Tourin] comfortable... Drawing lessons given gratis' and with an eye on the practical mentions 'the beds are good'.[21] A number of witty pen and ink sketches by a frequent visitor to Tourin, artist and later committee member of the Society, Philip Chenevix Trench (1849-1911), decorate several pages of the Visitors' Book including *A race for Life or The Turkeys Revenge (on New years day)*, dated 3 January, 1880. These are similar in style to Grace and Edith Osborne's and Frances Wilmot Currey's amusing decorated envelopes discovered in the 1970s.[22]

It is not known just when Anna Frances and her sister, Florence, decided to leave Tourin but it may have been after Sir Richard's marriage in 1891. The sisters settled into life in London living at 63, Cadogan Gardens. It is possible that they may also have rented a country cottage in Devon in the early years of the twentieth century. Both appear to have spent a large part of their lives travelling in Europe and returned on a fairly frequent basis to Ireland. During the First World War, on 25 September, 1918, the sisters arrived at Tourin for a holiday. On 10 October, 1918, they

The signatures of *Frances Musgrave* (Anna Frances Musgrave) and her sister *Florence S. Musgrave* (Florence Sophia Musgrave) in the Visitors' Book, Tourin, Co. Waterford, (January, 1873-June 1902). PRIVATE COLLECTION

Photograph by Dr. William Despard Hemphill (1816-1902)
The Artist (1866) This may be a portrait of botanical artist, Edith Bernal Osborne later Lady Edith Blake (1845-1926) aged 21 years who lived at Newton Anner, Clonmel, Co. Tipperary. She was a frequent visitor to Tourin, Co. Waterford, home of the Musgrave family.
REPRODUCED BY KIND PERMISSION OF THE SOUTH TIPPERARY COUNTY MUSEUM

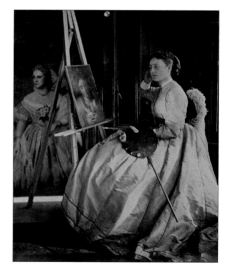

Torpedoed! The R.M.S. Leinster *Disaster*
The R.M.S. *Leinster* was bound for Holyhead, N. Wales on 10 October, 1918. It was carrying over 700 passengers when the ship was torpedoed twice, with three minutes between each hit. Only 256 people were rescued. Tragically, Anna Frances Musgrave, together with her sister, Florence Sophia, were both drowned.

COURTESY OF PHILIP LECANE, AUTHOR OF 'TORPEDOED! THE R.M.S. LEINSTER DISASTER' (2005)

The gravestone of the Musgrave sisters, Anna Frances (1853-1918) and Florence Sophia (d.1918), in Affane graveyard, near Cappoquin, Co. Waterford. The inscription reads: *In loving memory of Fanny and Florence Musgrave drowned in R.M.S. Leinster sunk by Germans.*

began their return journey to London and boarded the R.M.S. Leinster at Kingstown bound for Holyhead. The boat belonged to the City of Dublin Steam Packet Company and was carrying passengers, mail and military personnel between Ireland and Wales. It had no convoy protection, relying entirely on speed to escape much of the U-boat activity found in the Irish Sea during this period. Close to the Kish Bank, the vessel was attacked by a German submarine UB-123. It was carrying over 700 passengers. The ship was torpedoed twice, with three minute intervals between each hit. 501 people lost their lives with, tragically, both Musgrave sisters being listed amongst the casualties.

After a burial service held in St. Anne's church, Cappoquin, Co. Waterford on 16 October, the sisters were laid to rest in the Musgrave family burial plot in nearby Affane graveyard, close to the river Blackwater and their family home. Today, flanked on either side by their parents, their brother and his wife, a simple cross marks their grave. The inscription reads: 'In loving memory of Fanny and Florence Musgrave drowned in R.M.S. Leinster sunk by Germans'.

'Oaklands is a big plain house on a steepish hillside. There are fine trees in the park and it used to have a rookery, and there is a St. Patrick's Well which has been refurbished and restored...My grandfather said it always was home to him, and he loved the large rooms and heavy doors.'[23] This description of the three-storey late eighteenth century house and demesne, which stands about two miles from the town of Clonmel, Co. Tipperary, was kindly provided by Nancy K. Sandars, a direct descendant of Henrietta Sophia Phipps. Phipps was, together with Currey, Prochazka, Musgrave and the Keane sisters, one of the founders of the Amateur Drawing Society who had gathered together in Lismore in November, 1870.

Henrietta's parents, Colonel and Mrs Pownoll Phipps, came to live at Oaklands, Clonmel in 1836, two years after their marriage. The previous year, the couple had taken a lease on Oaklands largely in order to be near his wife's elder sister, Lady Osborne, who lived nearby at Newtown Anner. Colonel Pownoll Phipps, (1780-1858) K.C., H.E.I.C.S., had been married twice before and had spent almost thirty years in the Indian army. In Ireland, he became a magistrate and Poor Law guardian and was to play an active part in the affairs of Clonmel and surrounding districts. During the famine, he was appointed a Director of famine relief. His wife, Anna (née Smith) (1808-1898), born in Rochester, Kent, was the grand-daughter of the Reverend James Ramsay (1733-1789), surgeon and abolitionist, whose work for the emancipation of slaves in the West Indies was one of the principal factors which induced William Wilberforce to take up their cause. Anna's father, Major Smith (Royal Marines) married one of the Reverend James Ramsay's three daughters.

Henrietta Sophia (known in the family as 'Hetta') was born on 13 September, 1841 at Oaklands: 'My mother was confined of twins, a boy and a girl. As the little boy was very ill, both babies were baptized in the drawing room privately on October 8 by our rector, the Reverend Richard Maunsell. The little boy was named

Philip Chenevix-Trench (1849-1911) *Sport on the Blackwater*, from the Visitors' Book, Tourin, Co. Waterford.

PRIVATE COLLECTION

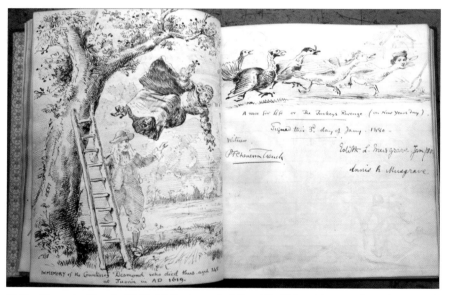

Philip Chenevix-Trench (1849-1911) *A race for Life or The Turkeys' Revenge,* from the Visitors' Book, Tourin, Co. Waterford..

PRIVATE COLLECTION

Robert Constantine, and the little girl Henrietta Sophia, after my father's two former wives. The little boy died the next day, and was buried in Abbey Churchyard...'[24] Two of Henrietta's brothers also survived. The eldest, Pownoll William Phipps (1853-1903), following his education at Rugby and Oxford, entered the Church of England and eventually became Rector of Chalfont St. Giles, Buckinghamshire. Henrietta's second brother, Ramsay Weston Phipps, (1838-1923), joined the Royal Artillery in 1852 when he was just fourteen years-old and was commissioned at the age of seventeen. In that year (1855), he went out to the

Crimean War and, according to his descendant, Nancy Sandars, was armed with nothing less than 'dried herbs and vegetables from Fortnum and Mason'.[25] Whilst in the Royal Artillery, Henrietta's brother became a keen architectural draughtsman, his drawings of machinery being necessary for gunnery work prior to the arrival of photography.

Henrietta's childhood spent at Oaklands would appear to have been happy and secure judging by her brother's account:

'Our nursery was the room at the end of the lobby, looking down the drive... The water for the house was supplied by a water cart drawn by a mule which also drew the market cart... Our life was regular. In the morning, my father used to be in the library...when the coachman, came to the window from one of the cottages at the gate, my father gave orders for the day... The coachman drove my mother into town or to visits...the car used to stop at the brow of the hill, and my mother and Henrietta began shrieking for things they had left behind...'[26]

Outside the high walls of Oaklands, life in the 1840s was turbulent:

'When I first went to school, the country was in a state of rebellion. Driving to Waterford, we came on what I thought were numerous camps, and Pownoll talks of meeting cars of soldiers to prevent the rebels breaking down bridges. We had a guard of 12 men in the village who went to Church armed; every night you heard shots. I believe farmers letting off their guns at night to show they had guns. Once we had a rehearsal of an attack on the town, the cavalry on outpost, then retiring into the barracks, the infantry then manning the barrack walls, then cavalry charging.'[27]

Grace and Edith Bernal Osborne, both talented amateur artists lived at nearby Newtown Anner, Clonmel. Their father, Ralph Bernal M.P. (1808?-1882), was to become a noted speaker in the House of Commons, Secretary to the Admiralty and stood for a number of parliamentary constituencies. He became one of the great wits of the House of Commons and, like Henrietta's father, played a

leading role on relief committees in the town of Clonmel. Catherine Osborne, his wife as a 'rather lonely young bride was recommended to take drawing lessons, hiring prints from Bianconi who had a small shop in Clonmel.'[28] She also encouraged her two daughters to draw and paint, inviting artists such as English lithographer and watercolourist, Thomas Shotter Boys, N.W.S. (1803-1874), to stay at Newtown Anner. Henrietta frequently visited and stayed at Newtown Anner where she availed of the opportunity to learn to paint and draw with her cousins. She may also have received some art training from her governess and from her brother, Pownoll. After he left Rugby and before going up to Oxford, Pownoll William Phipps spent sometime in Truro, Cornwall (1853-54). There he took lessons from landscape and coastal painter, James George Philp, R.I. (1816-1885), who

Photograph of Henrietta Sophia Phipps (1841-1903), a founder of the Amateur Drawing Society. PRIVATE COLLECTION

lived at Falmouth. A member of the Royal Institute of Painters in Watercolours, Philp provided Henrietta's brother with 'a taste for painting and those few lessons have proved a real blessing to me all my life'.[29] It is possible he may have passed some of his art training on to his younger sister. Henrietta's appreciation of painting was encouraged by her father and she frequently accompanied him on visits to art exhibitions. He had always been interested in art and:

'...derived the greatest possible interest and amusement from an Art Exhibition [Clonmel] which was held...in connection with the South Kensington Museum. Colonel Pownol Phipps lent pictures, marbles and many Indian curiosities. My father was on the committee, and took a leading part in all the arrangements, his knowledge and taste qualifying him especially for such duties...In October, 1858, the Art

Attributed to Henrietta Sophia Phipps (1841-1903) *The Gardens at Newtown Anner, Clonmel, Co. Tipperary,* watercolour. Signed: 'HP'.
PRIVATE COLLECTION

Colonel Pownoll Phipps (1780-1858) *View from drawing room Oaklands 24 August, 1891*, watercolour and pencil, (from a sketchbook). The artist, Colonel Pownoll Phipps, was the father of Henrietta Sophia Phipps (1841-1903), a founder of the Amateur Drawing Society.

PRIVATE COLLECTION

Exhibition was closed and my father was asked to preside and speak...'[30]

At the age of ten, mother and daughter had the unique experience of visiting the Great Exhibition (1851) housed in the Crystal Palace and located in Hyde Park, London.

Henrietta's brother, Pownoll, procured lodgings for them at 13, Burton Street. Following the opening on 1 May, 1851 by Queen Victoria and Prince Albert, the *Art Journal* wrote: 'Forming the centre of the entire building rise the gigantic fountain, the culminating

point of view from every quarter of the building.... We have here the Indian Court, Africa, Canada, the West Indies, the Cape of Good Hope, the Medieval Court and the English Sculpture Court...'[31] In the view of many, the Great Exhibition, one of the defining points of the nineteenth century, succeeded in fulfilling its aims: for the purposes of exhibition, of competition and of encouragement. The Phipps family were among the six million visitors to the exhibition; something which must have left considerable impression on their young daughter.

Intrepid travellers, mother and daughter journeyed extensively around Europe throughout the 1860s, visiting France, Austria and Bavaria. The winter of 1861-2 was spent in Florence staying at the Palazzo Bruciato with the Osborne girls, Grace and Edith, and their mother. Strolling through the art galleries, Henrietta had ample opportunity to view for herself the work of the great masters.

The Phipps family were present at the first exhibition mounted by the Amateur Drawing Society, held in Lismore in May 1871. The Society's second exhibition, held in October

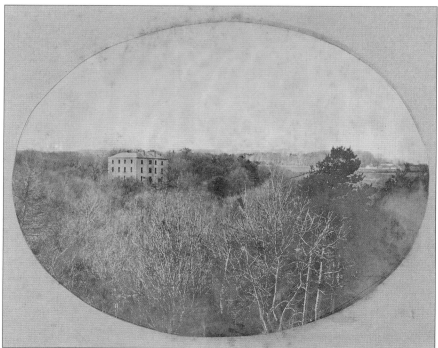

Colonel Pownoll Phipps (1780-1858) *Oaklands from Salisbury Road Clonmel 18 August 1892*, watercolour and pencil, (from a sketchbook).
Oaklands was the family home of HenriettaSophia Phipps. PRIVATE COLLECTION

Frontispiece from The official catalogue for The Clonmel Art Exhibition, 1858. Works of Decorative Art from the Government Museum, South Kensington, London were exhibited in Clonmel, 1858. REPRODUCED BY KIND PERMISSION OF THE SOUTH TIPPERARY COUNTY MUSEUM, CLONMEL, TIPPERARY

Le Pavillon de Flore, Tuileries c. 1830. Artist: Thomas Shotter Boys, N.W.S. (103-1874). Medium: Watercolour, pen and brown ink. This watercolour was engraved in chromolithography by Boys for *Picturesque Architecture in Paris, Ghent, Antwerp, Rouen* etc., 1839, Pl. xx1. Note: Watercolourist, engraver and itinerant drawing-master, Thomas Shotter Boys was a regular visitor to Newtown Anner, Clonmel Co. Tipperary, home of amateur artists, Grace Osborne and her sister, Edith. Founders of The Amateur Drawing Society (later W.C.S.I.), Frances Wilmot Currey together with Henrietta S. Phipps were close friends of the family and were frequent visitors to Newtown Anner. There they would have had an opportunity to meet the artist, Thomas Shotter Boys, N.W.S. COURTESY OF THE SYNDICS OF THE FITZWILLIAM MUSEUM, CAMBRIDGE

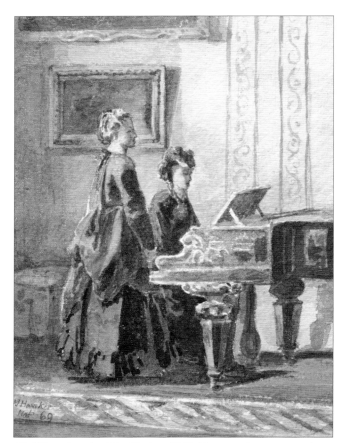

Henrietta Sophia Phipps (1841-1903) *Portrait of Anna Phipps (née Smith) (1808-1898)*, oil. The sitter is the mother of Henrietta Phipps. This portrait is undated but it is thought to have been executed prior to 1885 when the artist married Lt. Colonel William Francis Smith.

PRIVATE COLLECTION

H Phipps done by Mrs Hawber 1869 Newtown Anner, watercolour, gouache and pencil. COURTESY OF THE MARQUIS OF SALISBURY, HATFIELD HOUSE

1871 in Clonmel, saw Henrietta being listed as a successful participant. *The Clonmel Chronicle* noted that an oil portrait executed by her was 'admirably painted, it was deservedly commended'.[32] However, after this date there is, as far as can be ascertained, no further mention of Phipp's participation in exhibitions organised by the Society.

On 9 November, 1885 Henrietta Phipps married Lt. Colonel William Francis Smith of Dublin and Co. Mayo. The service, conducted by her brother, Pownoll, took place in the Abbey Church, (the Franciscan Friary) Mitchell Street, Clonmel. Her husband was a widower and an elderly militia officer whom she and her mother had met on a visit to the seaside town of Bray, Co. Wicklow. Despite the death of her sister-in-law the previous month, and protests by her immediate

family that the wedding should be postponed, the marriage between Henrietta Phipps and Colonel Smith went ahead in the presence of many well known local families – the Bagwells from Marlfield, the Moores of Summerhill, and the Rialls of Annerville. Henrietta and her husband continued to live at Oaklands until 1894. The artist died at Kingstown, Co. Dublin in 1903.

Two sisters, Harriet Edith and Frances Annie Keane (the latter generally referred to in W.C.S.I catalogues and minutes as 'Miss Keane'), became closely involved with Henrietta Sophia Phipps and the other three founders in establishing the Amateur Drawing Society. They were the daughters, together with their sister, Laura Ellen Flora, of Sir John Henry Keane, 3rd Bart (1816-1881), Cappoquin House, Cappoquin, Co.

Waterford and his first wife, Laura (née Keatinge). The latter was the eldest daughter of the Rt. Hon. Richard Keating, whom Sir John had married on 10 July, 1844. Apart from their three daughters, the Keanes also had two sons, George Wilfred and Richard Francis Keane (1845-1892), a civil engineer who was later to become High Sheriff for Co. Waterford and who eventually succeeded to the title. Richard F. Keane was anxious to make efforts to improve the employment situation in the town of Cappoquin and surrounding areas. With the arrival of the Waterford, Dungarvan and Lismore Railway Company (the first train passing through Cappoquin in August 1878) he was encouraged to establish a foundry and implements works with the support of his cousin, Frederick H. Keane, a mechanical engineer. Within a period of nine

years, the workforce had reached seventy. In July 1872, Richard F. Keane married Adelaide Sidney, the only surviving daughter of John Vance, M.P. His wife, like his two sisters, Harriet Edith and Frances Annie, was also an artist and a member of the Irish Amateur Drawing Society.

The Keane family have lived in Co. Waterford for over two hundred years and are descended from a George Keane (ÓCathain, anglicised to ÓCahan) who originally came from Co. Derry. The ÓCahans fought for James II at the Battle of the Boyne and after the final defeat of James's forces at Aughrim, Co. Galway, the ÓCahan lands were confiscated by William III. The family found themselves banned from government service until George ÓCahan changed his name to Keane and became a Protestant. He later worked as a lawyer in the service of the government.

Cappoquin House, the family seat and home to the Keane sisters during the early part of their lives was built c.1779 on the site of a Fitzgerald castle. The house, surrounded by its beautiful gardens, commands magnificent views over the River Blackwater and the town of Cappoquin. The original house was tragically burnt down in 1923. The architect responsible for the rebuilding, which began in 1924 was Richard Caulfeild Orpen (1863-1938), brother of Sir William Orpen and a long-standing and distinguished member of the W.C.S.I. With the help of local craftsmen, the fine eighteenth century interiors were painstakingly reproduced from the original moulds. The original entrance to the house was transformed into the garden front, and the main entrance established through the courtyard at the rear of the house.

From the beginning both Harriet and Frances were actively engaged in running the newly formed Amateur Drawing Society and both served on the committee. However, it would appear that throughout her life, and unlike her sister, Frances Annie Keane's involvement with the Society was to be largely administrative. She agreed to act as Hon. Secretary for the first exhibition which opened on 10 May, 1871 in the Sessions House, Main Street, Lismore and held this position until 1878 when her role was taken over by artist, Philip H. Bagenal. Both sisters were probably self-taught but it is thought they received a certain amount of tuition from relatives and from their governesses whilst also following the well worn path of learning from copying paintings and using drawing books. This is noticeable in the Society's catalogue entries for 1872 (the third exhibition, held in Carlow). Two of Harriet Edith Keane's views painted in Scotland are attributed to being 'after Harper': *Early Morning, Loch Katrine* and *Woodcutter's Hut in the Trossachs.* English painter and

Colonel Ramsay Weston Phipps, R.A. (1838-1923) *The drawing room at Oaklands*, pencil.
The drawing is believed to have been executed in 1861 when Henretta was twenty and living at Oaklands, Clonmel. The artist, Henrietta's brother, Ramsay Weston Phipps, R.A., second son of Colonel Pownoll Phipps, was a keen architectural draughtsman; his drawings, especially those of machinery, were necessary for gunnery work before photography. PRIVATE COLLECTION

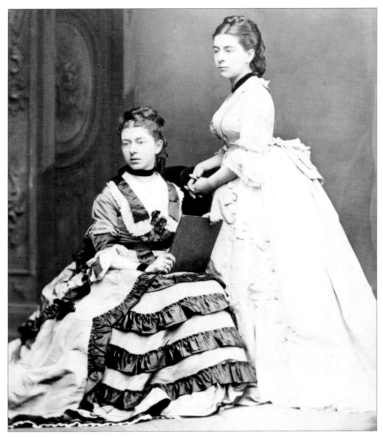

author, Henry Andrew Harper (1835-1900), had travelled extensively in the Holy Land and the Near East. His work was particularly popular in London from the early 1870s onwards when a number of exhibitions were held at the Fine Art Society; and one at the premises of fine art dealers Agnew's in 1872 entitled 'Palestine, Egypt and Nubia', which the Keane sisters may well have seen.

As early as 1872, a 'Miss Keane of Cappoquin House', is listed as being an exhibitor in the Dublin Exhibition of Arts, Industries and Manufactures but not as a painter. A number of entries had been accepted in the Irish Reproductions of Old Laces section from a Miss Keane. The catalogue relating to the Cork Industrial Exhibition, July 1883, under the title 'Lace-Medals' awarded 'E.H Keane of Glenshelane, Cappoquin, a medal for lace, a facsimile of Venetian point lace cuffs and Venetian point'.[33] The second entry in this section of the catalogue mentions the Industrial School, Mercy Convent, Cappoquin, Co. Waterford.

When the sisters moved from Cappoquin House to nearby Glenshelane (it is thought in the late 1860s), they established a small, local lace-making studio and provided private lessons in the kitchen of their new home. Mary Power Lawlor, Government Inspector of Lace in her preface to accompany The Irish Exhibition held at Olympia, London, 1888 (Sir Francis H. Keane was one of

Sepia portrait by Chancellor, Lower Sackville Street, Dublin of Harriet Edith Keane (1847-1920) and her sister, Frances Annie Keane (1849-1917), who, together with Frances Wilmot Currey, Henrietta Sophia Phipps, the Baroness Pauline Prochazka and Anna Frances Musgrave, founded the Amateur Drawing Society in November 1870. PRIVATE COLLECTION

Cappoquin House, Co. Waterford. A handsome two-storey building originally dating from c.1779, it faces the town of Cappoquin. The house was burnt down in 1923 and afterwards completely rebuilt. The fine eighteenth century interiors with decorative plasterwork were splendidly restored by local craftsmen. The architect responsible for the rebuilding was Richard Francis Caulfeild Orpen, R.H.A., F.R.I.A.I. (1863-1938), a keen and enthusiastic member and exhibitor with the W.C.S.I., and brother of W.C.S.I. member and distinguished painter, Sir William Orpen (1878-1931). REPRODUCED BY KIND PERMISSION

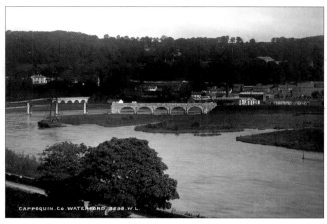

Photograph of a view of Cappoquin and the river Blackwater, Co. Waterford c.1880. Cappoquin House, the Keane sisters' family home, may be glimpsed through the trees, upper right, overlooking the town.
COURTESY OF THE NATIONAL LIBRARY OF IRELAND

View of Glenshelane House and gardens, Co. Waterford, the home of two of the founders of Harriet Edith Keane (1847-1920) and her sister, Frances Annie Keane (1849-1917), in the late nineteenth century.
REPRODUCED BY KIND PERMISSION

the patrons listed in the accompanying catalogue), states, 'Cappoquin started in 1868 by Miss Keane of Glenshelane, Cappoquin, Co. Waterford'.[34] Glenshelane had been built by the Keane family around 1820 in the simple late Georgian 'cottage' style, and was used by the family as a shooting-lodge. When Harriet and Frances moved there, the house was renovated and enlarged. Both sisters appear to have been keen gardeners and set about transforming the land surrounding the house into an attractive garden where their skill can still be seen today.

It would appear that the Keane

The Keane family coat of arms, motto: *Felix demulcta mitis* ('The stroked cat is gentle').

sisters' firm commitment and dedicated enthusiasm to the craft of lace-making and to creating local employment resulted in a reduction of participation when it came to exhibiting their work in Society's exhibitions. Harriet Edith Keane did not exhibit on a regular basis and it is interesting to note that her work was shown on only six occasions, firstly in 1872, when seven of her paintings were hung in the Society's third exhibition (mounted in Carlow). Her name does not appear again until 1877 when six works, including a view of her home, Glenshelane, placed on view.

The Cork Industrial Exhibition,

Entrance to the gardens, Cappoquin House, Co. Waterford. REPRODUCED BY KIND PERMISSION

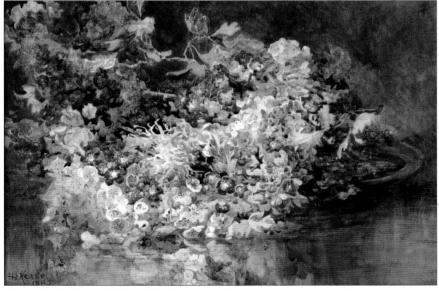

Harriet Edith Keane (1847-1920) *From the Garden,* watercolour and pencil. Signed and dated (bottom left) 'H.E. Keane 1885'.
PRIVATE COLLECTION

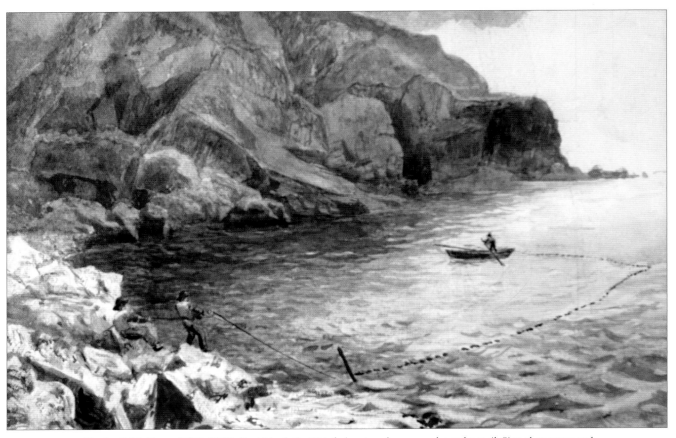

Harriet Edith Keane (1847-1920) *Goat Island, Co. Waterford*, watercolour, gouache and pencil. Signed on verso and dated '1920', the year of the artist's death. PRIVATE COLLECTION

which opened in July 1883, saw two of Harriet Edith Keane's entries hung alongside paintings by Sir T.A. Jones, P.R.H.A. and Catterson Smith, R.H.A. in the Gallery of Modern Painting housed in the western gallery of the Concert Hall. The total number of paintings amounted to 324. In November of the same year the Society organised their own exhibition in the city. It was noted by the Cork Examiner: 'Miss F. Keane played the piano...at the Assembly Rooms...and acquitted herself with much success.'[35] Harriet Edith Keane is also listed as being a participant in the Society's thirty-second exhibition (Dublin, March 1889).

As a result of both sisters being so heavily involved in many aspects of life – wood-carving, lace-making, and gardening – it would appear that attention shifted away from the categories of 'art' and 'artist'. Unlike Frances Wilmot Currey, who succeeded in transforming herself into a professional artist, the two Keane sisters, with so many interests occupying their lives, were not in a position to become full-time professional artists in their own right. They did, however, succeed in leaving a legacy of attractive, charming, delicate watercolours and also found the time to play a leading administrative role in establishing the forerunner for the Water Colour Society of Ireland.

Mahlstick. Inscription: 'Presented by the Society to Miss Frances Wilmot Currey'.
Frances Wilmot Currey became Secretary of the Society in 1880. By 1893, she had been replaced by Robert Clayton Browne, Sandbrook, Tullow, Co. Carlow. She continued as a W.C.S.I. committee member until 1906. PRIVATE COLLECTION

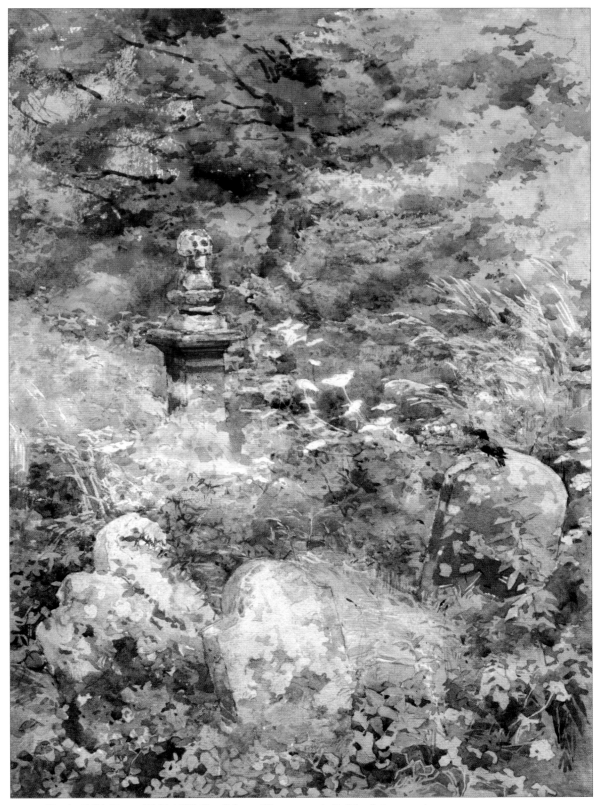

Harriet Edith Keane (1847–1920) Detail from *Affane graveyard, Co. Waterford*, watercolour.
Delicately painted in neutral tones, this work evokes the quiet stillness of an old graveyard overgrown with a tangle of grass and flowering weeds. Affane graveyard is the burial ground of the Keane and Musgrave families. The work was included in an exhibition of watercolours organised by the W.C.S.I. and the N.G.I. to celebrate the 150th W.C.S.I. Exhibition in 2004. PRIVATE COLLECTION

Early Exhibitions (1871–1878)

The first exhibition to be organised by the newly formed Amateur Drawing Society was held in May 1871. This took place in what was then known as the Courthouse, (now known as the Lismore Heritage Centre), a building sited in a prominent position on the main street, Lismore, Co. Waterford. Architect, John Carr of York submitted designs for a new courthouse, (Sessions House) for the Duke of Devonshire in 1799. The building was to include a market hall on the ground floor for the weighing of corn and potatoes, as well as a number of small rooms for male and female prisoners together with accommodation for the clerk of the peace and jurymen. It is not clear if

Carr's design was executed but as pointed out by author and biographer, Brian Wragg, the building resembled one of Carr's park lodges blown up on a larger scale and therefore the design may be the work of this York architect.[1]

Sited in a pivotal position on the main street, the stone building consisted of two storeys with a central pedimented pavilion and lower wings. The Courthouse was lit by a round-headed window in a shallow receiving arch. The Italianate clock tower was added later. The building was partially damaged during the War of Independence and was rebuilt shortly afterwards.

The Society's decision to provide an

Photograph of James Brenan, R.H.A. (1837-1907). Brenan was appointed Headmaster of the Cork School of Art in 1860 and held the post until 1889 when he was appointed Headmaster of the Dublin Metropolitan School of Art. He was invited to judge the first exhibition held by the Amateur Drawing Society, which opened on May 10, 1871 in The Courhouse, (now known as the Heritage Centre), Main Street, Lismore, Co. Waterford.
PRIVATE COLLECTION

independent exhibition space for its first and subsequent exhibitions came at a significant time in Irish Victorian exhibition history. In the nineteenth century, chartered bodies such as the R.H.A. tended to stress acknowledgement of public taste over their own artists' personal ideas and interests. It would appear sales dictated taste. The main body of Academicians elected male artist members first as an Associate Member, then if successful elected them as Full Members. This was not to be the case with the Amateur Drawing Society. Here, there was no jury system which might discourage young talent. It would appear that artists were allowed to join the Society based on invitation and

CHRONICLE, TIPPERARY

THE FIRST EXHIBITION

OF THE

Amateur Drawing Society's Pictures

WILL BE HELD IN THE COURT-HOUSE, LISMORE.

It will be open from the 10th to the 24th of May, from One to Six o'clock daily—Saturday, the 13th, and Sundays excepted.

Ticket of Admission during whole time } 1s. 0d.
of Exhibition }
Single Entrance...................... 0s. 6d.
Honorary Members and Members of the Society free.
FRANCES KEANE, Hon. Sec.
May 1, 1871.

Advertisement from *The Clonmel Chronicle, Tipperary Express & Advertiser*, Wednesday evening, 10 May, 1871 announcing the first exhibition of the Amateur Drawing Society (later to become known as the Water Colour Society of Ireland) to be held in the Courthouse, Lismore, Co. Waterford from 10 May until 24 May, 1871. COURTESY OF THE NATIONAL LIBRARY OF IRELAND

largely through their own social contacts. From the beginning, restrictions appear to have been imposed on the number of works a keen amateur might exhibit 'three pictures worthy of being received' each member agreeing in advance to support the annual or half-yearly exhibitions.[2] For their first exhibition mounted in the Lismore Courthouse, an executive committee was formed consisting of Miss Harriet Edith Keane, the Baroness Pauline Prochazka, Miss Frances Annie Keane, (Hon. Secretary), Miss Henrietta Phipps, and Miss Frances Wilmot Currey. There was no mention by *The Clonmel Chronicle* (who covered the event) of Anna Frances Musgrave from nearby Tourin, Cappoquin being a member of the group despite the fact that she is listed as being one of the founders by Strickland. The founders' objectives were high. 'The society was started by a few ladies with the extremely laudable object of mutual improvement in those studies, and of cultivating a general taste for Art.'[3] It would appear that the group was setting out to be a showcase for individual talent.

The first exhibition organised by the Society opened on 10 May, 1871, and was set to continue until 24 May. A discreet advertisement appeared on the opening day in *The Clonmel Chronicle* and stated: 'The First Exhibition of the Amateur Drawing Society's Pictures will be held in the Courthouse, Lismore. It will be open from the 10th to the 24th of May, from one to six o'clock daily – Saturday, the 13th and Sunday excepted.' Open to the general public, a two-tier system of admission was being offered. For one shilling, one could visit during 'the whole time of the exhibition' or pay sixpence for 'Single Entrance'.[4] Members of the Society were to be admitted free and according to *The Irish Times*, this consisted of 'only about a dozen members'.[5] No catalogue, according to this paper, was printed.

Despite the low membership, there were over 100 works on view with only three rejections by the small selection committee which consisted of the Misses Keane and Frances Currey. The 'well-filled' screens had been erected to accommodate the works of participants in all six classes. These were Class 1. Oil Colour Original; Class 2. Oil Colour Copies; Class 3. Water Colour Originals; Class 4. Water Colour Copies; Class 5. Illumination; and Class 6. Etching in Chalk and Sepia. Head Master of the Cork School of Art, (1860-1889), and a past student of both the R.D.S. School of Design and the R.H.A. School, James Brenan, R.HA. (1837-1907) 'Ireland's most distinguished art

Harriet Edith Keane (1847-1920) *Into the bluebell glade*, watercolour, signed: 'HE Keane'. The work was exhibited in the Irish Fine Art Society's ninteenth exhibition (cat. no. 112) held in 1882. PRIVATE COLLECTION

A view of the main street, Lismore, Co. Waterford taken in the second half of the nineteenth century.
This photograph is attributed to Francis Edmond Currey (1814-1896), a keen photographer who established a studio in Lismore Castle whilst serving as resident agent to both the sixth and seventh Dukes of Devonshire. The first exhibition organised by the Amateur Drawing Society (later W.C.S.I.) was held in the Lismore Courthouse (now the Lismore Heritage Centre) which may be seen on the left complete with bell tower.

educationalist of the 19th century' was assigned the task of judging all six classes.[6]

The opening attracted a large and 'very fashionable attendance'.[7] Co. Waterford families included The Hon. Mr and Mrs Windsor Villiers-Stuart from nearby Dromana; Frances Currey's parents and her brother, Chetwode, from Lismore Castle; the Lloyds from Strancally Castle, Knockanore; Miss More Smyth, Monatrea House, Whitechurch; Sir John and Lady Keane, Cappoquin House; Sir Richard and Lady Musgrave, their daughters and son, Richard, from Tourin; Mr and Mrs R. Moore Maxwell, Moore Hill; Mrs King, Fort William, Lismore; the Fitzgeralds from Tivoli; the Misses Chearnley, Salterbridge; Lady Nugent and her daughters from Cloncoskraine, Dungarvan; and Lord and Lady

Hastings, Whitechurch House, Cappagh. Co. Cork, was represented by the French family and their daughter, Phoebe, from Cuskinny, near Queenstown (now known as Cobh). Also present from the south was Mrs Charles Wise from Anngrove, Carrigtwohill. Co. Tipperary families included Grace Osborne from Newtown Anner; the Misses Quinn from Rochestown, Cahir, (birthplace of W.C.S.I. Member, Rose Barton, R.W.S.); Mr H.A. Blake, Tipperary; T. Butler-Stoney, Portland Park, Lorrha; and in Co. Kilkenny, Sir Charles Wheeler Cuffe, Leyrath, together with the Newton family from Dunleckney Manor, Bagenalstown, Co. Carlow.

From the beginning, the emphasis and interest seemed to gravitate towards the watercolour classes with no entries being received for Class I (Oil Colour Original). Oil Colour

Copies (Class II) did succeed in attracting support with first prize being awarded to Butler-Stoney who based his entry on an original work in the Fitzwilliam Museum, Cambridge by English painter, Frederick Goodall, R.A. (1822-1904). The latter had visited Ireland in 1844 in the company of O.W.S. members, Francis Topham, O.W.S. (1808-1877), and Alfred Downing Fripp, O.W.S., R.W.S. (1822-1895). During his Irish visit, Goodall recorded a range of popular, largely romantic, rustic scenes. (later, a trip to Egypt was to transform his style). In 1862 the Fitzwilliam Museum, Cambridge was presented with two oils executed by Frederick Goodall, one of which dated from the painter's visit to this country in 1844 (*Cottage Interior*).

Frances Currey's entry (also in Class II) was executed in a soft, painterly

style and based on a copy from an oil by Italian painter, Correggio (1494 or 1489-1534). The artist was awarded highly commended. The third class, Water Colour Originals, attracted a substantial number of participants and was 'one of the most interesting features of the exhibition'.[8] A 'Miss Homan' received first prize for her 'well known view of the Thames from Richmond Terrace'.[9] Grace Osborne from Newtown Anner, Clonmel, Co. Tipperary exhibited two moonlit

scenes together with a view in Greece which was considered by the reviewer to be 'one of the most pleasing pictures of its class in the entire collection'.[10]

A problem arose in the fourth section, Water Colour Copies, which had attracted a substantial number of entries of 'considerable merit'.[11] This posed a dilemma for Judge, James Brenan who decided to award no less than three First Prizes 'to three pictures of equal excellence, but different styles'.[12] Miss Chearnley from nearby

Salterbridge, Cappoquin was one of the recipients. Her entry was based on a work by English watercolourist, Myles Birket Foster, R.W.S. (1825-1899), an artist who enjoyed a high reputation amongst painters during his lifetime, and continues to do so to this day. Emily Bagwell from Marlfield, near Clonmel was also a prize winner for a watercolour entitled, *On Lago Maggiore after E. Richardson*. The title reveals that, like many of her fellow members in the Society, Emily Bagwell was aware of what was happening in the watercolour societies in England. Watercolourist, Edward M. Richardson, A.N.W.S. (1810-1874) was a frequent exhibitor at the New Society of Painters in Watercolours from 1846 onwards and was elected a full member in 1859.

Frances Wilmot Currey was again successful and was awarded third first prize for her landscape watercolour 'after a French master'.[13] The two local competitors in Class 5, Illumination, included yet again the indefatigable Miss Currey together with Baroness Pauline Prochaska who had submitted no less than six pieces, two of which illustrated the Siege of Corinth. According to *The Clonmel Chronicle* these were 'really magnificent specimens...the imitation of jewellery, the flower painting on a golden ground...the delicate tracery of the initial letters all displayed a degree of perfect manipulation rarely excelled'.[14] In this particular class, Miss Currey had been more modest and had confined herself to submitting two octavo pages based on a missal which the paper noted were 'evidently the result of much patient labour'.[15] The final class, Etching in Chalk, included work by Mary Gough, Miss P. French, Miss L. Power and Frances Currey's brother, Chetwode. Miss Phoebe French was awarded first prize.

The local press, summing up the first exhibition, concluded, 'this Art Exhibition is well calculated to serve a useful purpose in leading others to emulate this very laudable example...We were not at all aware that there was so much talent...'[16] However, the exhibition was forced to close several days earlier than expected

Harriet Edith Keane (1847-1920), a founder member of the Amateur Drawing Society and an active participant in their first exhibition, which opened on 10 May, 1871.

PRIVATE COLLECTION

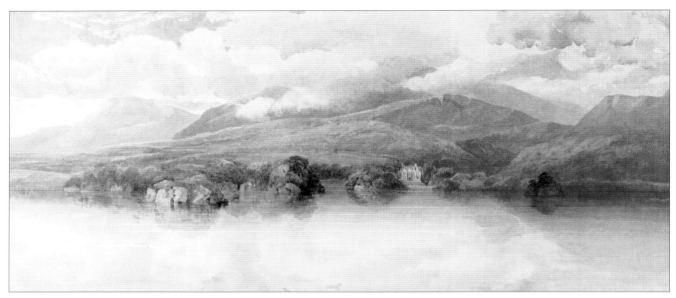

Mary Herbert (1817-1893) *Muckross from the Lower Lake*, watercolour and pencil.

Watercolourist, Mary Herbert exhibited on a number of occasions with the Amateur Drawing Society and was related by marriage to two of the Society's founders, Harriet Edith Keane and Frances Annie Keane. Muckross House, Killarney, Co. Kerry is celebrated for its lakeshore location. In 1843, W.M. Thackeray commented on 'the most wonderful rich views it commanded of the lakes' (*The Irish Sketch-Book*, 1843). In this watercolour, the artist paints the house from across the Lower Lake, Killarney, perhaps from one of the many islands. PRIVATE COLLECTION

Frances Wilmot Currey (1848-1917) *The West Gate, Clonmel, Co. Tipperary on market day, 1889.* The Amateur Drawing Society's second exhibition took place in Clonmel opening on 23 October, 1871. PRIVATE COLLECTION

owing to the courthouse being required.

The second exhibition mounted by the Society would appear to have been once again a lavish and fashionable affair and succeeded in attracting a wider cross-section of the public. *The Clonmel Chronicle* under the title 'Amateur Drawing Society' again provided a small, discreet advance notice on August 12, 1871 stating that 'it has been suggested that our School of Art now being newly decorated, might perhaps, be procured for the purposes of the exhibition that the second exhibition.'[17]

The Clonmel School of Art, housed in the Mechanics' Institute, was sited on the eastern side of Anglesea Street, a largely residential area in the town of Clonmel. The Institute had been opened by Charles Bianconi, Mayor of Clonmel and President of the Mechanics' Institute on 2 April, 1845. During this period, a mechanic was an artisan or workman who used a machine in his everyday employment. Supported by the business community of Clonmel, the Mechanics Institute was largely for the benefit of the working class and was the only large educational establishment which was non-denominational, its founders being determined that it should be 'a neutral ground where creed and class could meet.'[18] The Institute provided day and evening classes in science, art and the practical skills and was fortunate to possess a well stocked library, lecture theatre and a hall for exhibitions. In October, 1854, a School of Art was established in the same building under the Science and Art Department (the South Kensington system). Opened by local landowner, Ralph Bernal Osborne, (1808?-1882) from nearby Newtown Anner, who later became M.P for Waterford City (1870-1874), the school was under the direction of 'the talented Master of the School of Art, Mr. Healy'.[19] In 1858 Healy had been successful in mounting a wide-ranging exhibition entitled 'The Museum of Art' in the School of Art, Clonmel exhibiting works on loan from the Government Museum, South Kensington, London.

It may have been the intention of

Photograph of Anglesea Street, Clonmel, Co. Tipperary. The Mechanics' Institute may be seen on the left in which the second exhibition of the Amateur Drawing Society opened on 23 October, 1871. COURTESY OF THE SOUTH TIPPERARY COUNTY MUSEUM, CLONMEL, CO. TIPPERARY

Mrs A. Riall *A Collection of Flowers*, watercolour. Signed 'Mrs A. Riall'. The artist was an early exhibitor taking part in the second exhibition mounted by the Amateur Drawing Society held in the Mechanics' Institute, Clonmel, Co. Tipperary which opened on 23 October, 1871.
REPRODUCED BY KIND PERMISSION OF THE MARQUESS OF SALISBURY, HATFIELD HOUSE

the Mechanics' Institute committee that by allowing the Amateur Drawing Society to hold their second exhibition in one of their art rooms, they not only

gave their students an opportunity to observe what was going on in the world of painting but also hoped in time to provide the town of Clonmel

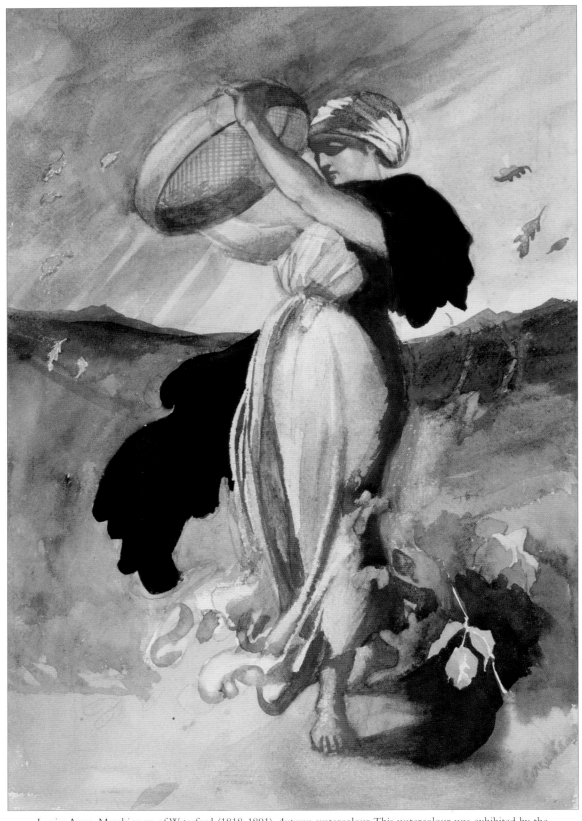

Louisa Anne, Marchioness of Waterford (1818-1891) *Autumn*, watercolour. This watercolour was exhibited by the artist in the second exhibition organised by the Amateur Drawing Society. *The Clonmel Chronicle, Tipperary Express & Advertiser* commented: 'The figure of a girl winnowing is a decidedly artistic gem …'

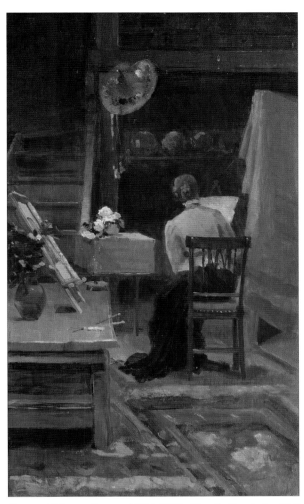

Frances Wilmot Currey (1848-1917) *The Studio at the Mall House, Lismore, Co. Waterford*, oil on wood. The artist portrayed is probably Helen Sophia O'Hara, H.B.A.S. (1846-1920), a friend of Frances Wilmot Currey, and an active member and keen exhibitor with the Society.

COURTESY OF THE GORRY GALLERY, DUBLIN

Alfred, Count D'Orsay, (1801-1852) *Ralph Bernal Osborne (1808-1882)* 1846, engraving. The reputation of Ralph Bernal Osborne, M.P. for Waterford City, 1870-1874, and father of watercolourist and exhibitor, Grace Osborne (later tenth Duchess of St. Albans) rested on his wit and force as a speaker, Disraeli describing him as 'the chartered libertine of debate'. In October 1854, he was invited to open a School of Art in Clonmel, Co. Tipperary housed in the Mechanics' Institute, Anglesea Street, Clonmel. It was in this building that the Amateur Drawing Society mounted their second exhibition in October, 1871.

© NATIONAL PORTRAIT GALLERY, LONDON

with 'a properly constructed gallery'.[20]

The exhibition opened on 23 October in the 'spacious room which the Mechanics Institute has kindly placed at the services of a kindred society for the development of Fine arts…'[21] It remained open to the public until 31 October, 1871.[22] Visitors were permitted to attend between one and five p.m. each day. Admission was charged at one shilling per ticket. (This admission charge may have been derived and based on the Royal Academy's entrance fee which was fixed at the same rate during this period). Season tickets were also issued and allowed entrance during the entire period of the exhibition at a cost of 2 shillings and 6 pence. Members of the Clonmel School of Art and the Amateur Drawing Society were granted free admission. A catalogue was prepared and *The Clonmel Chronicle* informed its readers this would be issued 'on Tuesday'.[23] Robert Edwin Lyne, M.R.I.A., F.R.G.S. (1863-1888), who had been appointed Headmaster of the Royal Dublin Society's Drawing Schools in 1863 agreed to act as judge. However, he was replaced at a later stage by distinguished portrait painter and a past President of the R.H.A., Stephen Catterson Smith, the Elder (1806-1872).

There was an overwhelming and enthusiastic response to the com- mittee's appeal for potential exhibits. Paintings were not only arriving in Bianconi's horse-drawn cars but also by train. As far back as 1852 the town had seen extensive railway con- struction taking place and this had resulted in a line being established between Limerick and Clonmel. The 'zealous' Hon. Secretary, Miss Keane, was hard at work while the Misses Currey, Bagwell and Phipps had been 'actively engaged in securing and arranging the various pictures for competition' and this had resulted in entries 'hourly arriving'.[24] *The Clonmel Chronicle* felt sure that despite 'a certain amount of mediocrity' there was 'an amount of genius and high artistic

Robert Lowe Stopford (1813-1898) *Kilnap railway viaduct, near Cork,* watercolour; the viaduct was designed by Sir John Macneill and built in c.1849 by William Dargan (1799-1867). Transportation of large-scale works of art provided a daunting challenge for the W.C.S.I. committee. However, the situation was eased by a nineteenth century railway system which provided a relatively easy and efficient method of transporting works of art for exhibition.

Stephen Catterson Smith, P.R.H.A., the elder (1806-1872) *Self-Portrait,* coloured chalks on paper. A prolific and popular portrait painter, Stephen Catterson Smith, the elder, succeeded George Petrie as President of the R.H.A. on 7 March, 1859, a post he held for seven years. He was elected again on 17 October, 1868. He replaced Robert Edwin Lyne (d.1889) as judge for the Clonmel Exhibition (October 1871) organised by the Amateur Drawing Society. COURTESY OF THE NATIONAL GALLERY OF IRELAND

feeling that does honour to the amateur circles of Ireland. Some of the pictures should occupy the foremost rank at any Royal Academy'.[25]

The opening was a glittering and elegant affair with a substantial number of local families being represented. Included were the Phipps, Keane, Currey, Riall, Barton, Grubb, Bagwell, Musgrave, Villiers-Stuart, Butler-Stoney, Battersby, Maguire, Barton and Chearnly families, together with watercolourist, Louisa Anne, Marchioness of Waterford, Curraghmore, Co. Waterford; the Duke of Manchester; the Countess of Donoughmore, and Baroness Pauline H. Prochazka. Also present at the opening was Edward A. Frazer, Master of the Clonmel School of Art together with a

smattering of officers from the Royal Artillery based in Clonmel and Cahir.

The daughters of Ralph Bernal Osborne, amateur artists, Grace (who was later to marry the tenth Duke of St. Albans in 1874) together with her sister, Edith (later Lady Edith Blake), were also present. Their family lent part of their substantial and impressive art collection from their home, Newtown Anner, Clonmel for the occasion, which added an extra dimension. The Newtown Anner loan collection was particularly rich in seventeenth and eighteenth century portraits and included two by Allan Ramsay (1713-1784), one by Joseph Wright of Derby (1734-1797) and a portrait of a French Marshall by Nicolas de Langillière (1656-1746), together

Lord Frederic Leighton, P.R.A., R.W.S. (1830-1896) *Portrait of Grace Osborne*, oil. Grace Osborne (1848-1926) later became the tenth Duchess of St Albans. COURTESY OF THE MARQUIS OF SALISBURY, HATFIELD HOUSE

Photograph of Newtown Anner, Clonmel, Co. Tipperary.

Photograph of the Drawing Room, Newtown Anner, Clonmel, Co. Tipperary, home of the Osborne family. This photograph by Dr. William Despard Hemphill (1816-1902) dating from c. 1864 was awarded 1st prize and Gold Medal, Amateur Photographic Association, 1864, and two Prize Medals, 1865, International Exhibition, Earlsfort Terrace, Dublin.

Sir Francis Grant, P.R.A. (1803-1878) *Louisa Anne, Marchioness of Waterford (1819-1891)*, oil on canvas. The sitter was present at the second exhibition organised by the Amateur Drawing Society and held in the Mechanics' Institute, Clonmel, in October 1871. This artist is listed as exhibiting two works in the March–April, 1882 (the nineteenth exhibition) held at 35, Molesworth Street, Dublin. She exhibited a further work in 1899 and was frequently recorded as being present at openings of exhibitions organised by the Society down through the years.

with an 'Italianate' landscape by Flemish painter, Aelbert Cuyp (1620-1691). Here was an opportunity for the public to view works by established artists and a chance to raise general artistic awareness.

Despite the weather being 'rather unpropitious' during the week, visitors to the exhibition were undeterred: Clonmel was 'literally …en fete…'[26] Hours of admission had to be extended to include Thursday, Friday and Saturday openings between 7.30 and 9.30 p.m. and also throughout the day. Attendance figures were recorded on the fourth (129) and fifth day (108). It is interesting to note that the admission charge of one shilling to the exhibition allowed for greater social diversity, and would have attracted a wide range from the highest social strata to the lower middle class. It probably included craftsmen, highly skilled craftsmen and artisans.

Unfortunately, no record appears to have survived relating to how many exhibits were on actual display. The collection was divided into seven classes (an increase of one compared with the first exhibition) and in several cases, these classes were subdivided: 1. Oils; 2. Oil Copies; 3. Watercolour Studies; 4. Watercolour Copies; 5. Class Illumination; 6. Etching from Nature and Copies; 7. Class Animals in either Oil or Watercolour. Caterson Smith, who judged all seven sections, later remarked that in Class 3, Watercolour Studies, 'This is decidedly the best class, there are some drawing in this class which are worthy of a place in any exhibition in the kingdom'.[27] He awarded second prize to Frances Wilmot Currey for 'a set of charming studies…The only objection to these drawings is their size'.[28] A Society founder, Henrietta Phipps, was successful in Class 2, Oil Copies, being awarded second place for her portrait of a lady which the press noted was 'admirably painted…Two other works of almost equal merit were shown by Miss Phipps – an excellent copy of Madame du Barri and a head of the Madonna, the latter being well drawn and effectively coloured.'[29]

During the Clonmel exhibition, a grand ball and supper took place at the Courthouse, on Tuesday evening,

IRISH AMATEUR DRAWING SOCIETY.

THE THIRD EXHIBITION will be held in the CLUB-HOUSE, CARLOW.

IT WILL OPEN ON THE 10th OF MAY, AND REMAIN OPEN UNTIL 18th MAY, From Eleven o'Clock to Six o'Clock each Day.

Entrance Tickets, 1s. each. Season Tickets to admit during the whole time of exhibition, 2s. 6d. Catalogues to be had at the door, 6d. each.

Advertisement placed in *The Carlow Sentinel*, 4 May, 1872 announcing the Irish Amateur Drawing Society's third exhibition, which ran from 10-18 May, 1872.
COURTESY OF THE NATIONAL LIBRARY OF IRELAND

Sarah Henrietta Purser, R.H.A. (1849-1953) *Seated male nude*, charcoal on paper. Sarah Purser's association with the Irish Fine Art Society began as early as 1880 when she submitted a number of portraits and flower studies.
COURTESY OF THE NATIONAL GALLERY OF IRELAND

October 24th, 'The assembly rooms were beautifully decorated for the occasion - Mr. Bagwell sending from his own conservatory some beautiful shrubs to adorn the place'.[30] The interior was festooned 'with garlands of evergreens and flowers', and according to *The Clonmel Chronicle*, 'it was carried out with great taste.'[31] Festivities began at ten p.m. Seven stewards ushered the glittering crowds towards dancing and supper which was served in the Grand Jury room with 'every delicacy of the season being provided in first class style.'[32] This included iced champagne and 'other wines of excellent vintage'.[33] Amongst those present were the Duke and Duchess of Manchester, the Marquis and Marchioness of Waterford, Lady Hester Carew, the Misses Trayer, Mr De la Poer M.P., Mr W. Riall, Miss Riall and Miss Quinn from Annerville, Mr. Charles Grubb from Caher Abbey, the Misses de Burgh from Knocklofty, Mrs and the Misses Osborne, the Countess of

Sir Robert Ponsonby Staples, Bart., R.B.A. (1853-1943) *Portrait of William Percy French (1854-1920)*, watercolour; signed.
Musician, watercolourist and illustrator, William Percy French began exhibiting with the Irish Amateur Drawing Society (later to become known as the W.C.S.I.) as early as 1872.

Donoughmore, Miss Currey, Mr de la Poer M.P. and many other friends and supporters. Dancing continued, under the direction of Mr Power's 'effective' quadrille band until five in the morning, the party being brought to a close with an elegant 'cotillon' − a ballroom dance resembling a quadrille.

It was probably due to the great success of the Society's first two exhibitions that the following spring on Friday, 10 May, a further exhibition opened in Carlow. The Society had added 'Irish' to their title and were now to become known as the Irish Amateur Drawing Society. It was announced that this, the third exhibition, would remain open from eleven o'clock to six p.m. each day closing on Saturday, 18 May.

The exhibition was held in a popular and fashionable venue known as the Club-House, Carlow, which is sited at the junction of Dublin Street and Court Place opposite the Carlow courthouse. It was originally built as a hotel and at a later stage transformed

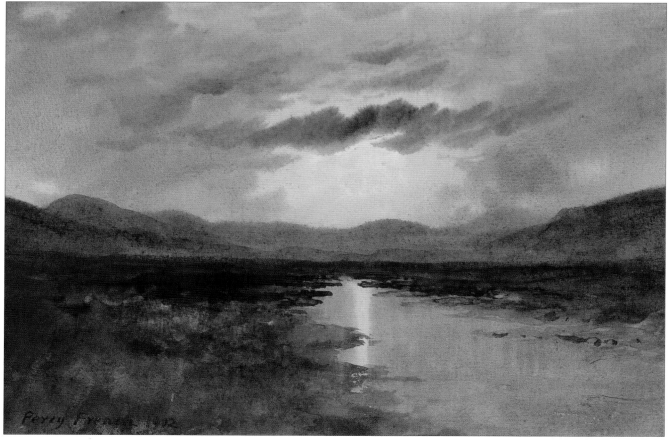

William Percy French (1854-1920) *Sunset Reflections*, watercolour. COURTESY OF THE ORIEL GALLERY, DUBLIN

The Club-House, sited at the junction of Dublin Street and Courtplace, Carlow in which the third exhibition organised by the Irish Amateur Drawing Society opened on Friday, 10 May, 1872. This building later became the first offices of the Irish Sugar Co.

Photograph of Dunleckney Manor, Bagnalstown, Co. Carlow, built c.1835-40, designed by Daniel Robertson (d.1849), the home of P.J. Newton who assisted with the third exhibition organised by the Society which took place in the County Club-House, Carlow. The exhibition ran from Friday, 10 May until Saturday, May 18, 1872.

Sir John Fiennes Twisleton Crampton, 2nd Bart. (1805-1886) *The Sea Beach*, watercolour.
Sir John F.T. Crampton was one of the judges at the Carlow exhibition in May 1872. The elder son of Sir Philip Crampton, an eminent Dublin surgeon-general, Sir John F.T. Crampton gave forty-eight years of his life to the diplomatic service. He married Victoire Balfe (1837-1871), singer and daughter of composer, Michael Balfe. The Crampton family home was at 14, Merrion Square, Dublin where a pear tree grew in the basement, a detail used by James Joyce in *Finnegans Wake* 'so insulated as Crampton's'.

Cover of the tenth exhibition of the Irish Amateur Drawing Society, which opened on March 12, 1877.

View of Molesworth Street, Dublin. The Leinster Lecture Hall, No. 35, is shown on the right. A terraced three-bay, three-storey over basement red brick town house built around 1840. It is currently in use as the Spanish Embassy. The W.C.S.I. held the majority of their exhibitions here from c.1875 onwards.

into a clubhouse. In the 1870s it possessed a large ballroom and over ten bedrooms and stables fit for 'seventeen carriages and cars, an omnibus and a hearse for two or four horses…'[34] During this period, the building is listed as belonging to a George Wilson who seems to have spent a good deal of his life encouraging 'the sporting bloods of Carlow and neighbouring counties' to gather under his roof.[35]

The Club-House had been converted into a 'very passable picture gallery'.[36] Oils were hung in the 'glass anti-room', chalk drawings to the right of the entrance to the club room, whilst to the left, the vast majority of watercolours occupied the entire length of the wall. Screens were erected in the centre of the room on which pencil drawings, etchings, and illuminations were shown off to best advantage. These were arranged 'with exquisite taste and great judgement', and were under the personal supervision of the energetic committee; Miss Frances A. Keane, Miss Keane (Hon. Secretary), Miss Currey, Baroness Pauline Prochazka, all ably assisted by exhibitor, Miss Emily Newton. The ladies also had the support of two male members of the Society: Emily's father, P.J. Newton, from Dunleckney Manor, Bagenalstown, Co. Carlow; and Robert Browne, Browne's Hill, Carlow. Prices, relating to works of art ranged from around fifteen shillings to £12 12 0d.

The number of members, women in particular, was growing at a rapid pace. Women's abilities, rights and opportunities were of vital concern during this period. This new, independent art group, the Irish Amateur Drawing Society was now beginning to play an important role in providing these 'lady artists' with recognition for their talents. Many were attracted to the aristocratic glamour of the Society. Amateurs such as Louisa Anne, Marchioness of Waterford and others who exhibited later strengthened the aristocratic ethos conveyed by the group. This was further enhanced when the Society began to enjoy Royal patronage. Prince Arthur, 1st Duke of Connaught and Strathearn (1850-1942), seventh of the nine children of Queen Victoria and Prince Albert, agreed to act as the Society's patron around 1879. This attracted public attention and provided an added impetus to the Society's prominence and prestige. In an age when there was a strong emphasis on balls, guests lists, dinner parties, the opening of the

Photograph of portrait and landscape painter, Charles Grey, R.H.A. (c.1808-1892) a judge at the Irish Amateur Drawing Society's third exhibition, Carlow, May 1872.

PRIVATE COLLECTION

Harriet Edith Keane (1847-1920) *Emily Newton* (d.1912), watercolour. Inscribed on verso in pencil 'For Lady Eleanor Keane'.

A friend of the Irish Amateur Drawing Society committee members, Harriet and Frances Keane, Emily Newton, from Dunleckney Manor, Bagenalstown, Co. Carlow began exhibiting with the Society in May 1872, (the third exhibition). She continued to exhibit largely Italian, German, Irish and Scottish views together with a small number of portraits and interiors until 1906 under her married name, Trant.

PRIVATE COLLECTION

Society's exhibitions was beginning to become an important social event which allowed members to mingle with other painters and potential patrons. Participating in the more fundamental purpose of art and enjoying the nature of the aesthetic experience also added to the appeal of joining. The third exhibition, held in Carlow, saw a substantial female entry; 231 works were exhibited, all were numbered, and all were catalogued. No details exist as to how this exhibition was hung but one can only assume that with such a large entry, congestion was the order of the day! Paintings hung at or near eye level would have been difficult to adopt due to the sheer number of works submitted and on view.

There was a slight increase in the number of classes, eight rather than seven as seen in the Clonmel exhibition held in the autumn the previous year. Flower painting was added to class no. 4, whilst a new section was created for chalk drawings in class no. 6. A special prize (not part of any category) was awarded in either oil or watercolour for a subject or a theme, in this case, 'Solitude'. In the Original Water Colours section, forty-three items were listed as being the work of, amongst others: Lady Louisa Egerton, Mrs Trayer, E. Bagwell, D. Graham, F.W. Currey, Miss S. Tottenham, Miss C. Bushe, K. Ruttledge, Mrs Nixon, A. Holman, H. Graves, M. Perrin, C. Montizambert, E. Gaisford, J. Haughton, Hon. E. Plunket, I. Charnley, P. Alcock, and Mrs de Montmorency. In the Water Colour Copies section there was a substantial entry amounting to 121, seventy-eight being direct copies of other artists' works. A number of additional names had been added to the list including Mrs Elrington, E. Ryland, K. Bagenal, T. Chearnley, P. Maguire, I. King, Mrs Vesey, H. Newton, T. King, H. Ruttledge, A Drew, C. Bennett, Baroness Prochazka, R. Barton, T. Rothwell and E. Izod. The judges were diplomat and amateur watercolour painter, Sir John Fiennes T. Crampton, (1805-1886) and portrait and landscape painter, Charles Grey, R.H.A. (c.1808-1892), whose patrons included Lord Powerscourt and Lord Londonderry. They spent all of Thursday, 9 May examining the exhibits and in their summing up urged members 'to contribute in increasing numbers' but noted 'that copies, particularly from chromo-lithographs, may decrease in a corresponding degree'.[37]

Helen Sophia O'Hara, H.B.A.S. (1846-1920), *View from the Barracks, above Lismore, Co. Waterford*, watercolour. Signed:'Helen O'Hara'. Landscape and seascape painter, Helen S. O'Hara began exhibiting with the Irish Amateur Drawing Society (later W.C.S.I.) in 1877, and from then until 1913 exhibited well over one hundred works.

<div align="right">PRIVATE COLLECTION</div>

Photograph of Sir John Joscelyn Coghill, Bart. Painter, distinguished amateur photographer, founder member and President (1855-6) of the Dublin Photographic Society (founded 1854). He became a member of the Irish Amateur Drawing Society's committee for their tenth exhibition which opened in Dublin on 12 March, 1877. He exhibited with the Society in 1877 ,'79, '82 and '83.

<div align="right">PRIVATE COLLECTION</div>

By 1875 the Society's membership had progressed, according to *The Irish Times* from 'consisting of about a dozen members: now numbers a hundred and twenty two members'.[38] In March of that year, the Society held their exhibition in Dublin in The Leinster Lecture Hall, 35, Molesworth Street, Dublin. The building dating from c.1840 is a handsome three-bay, three-storey-over-basement red brick townhouse. The street front contains a blind arcade of rusticated granite to ground floor and the entire site is surrounded by wrought iron railings. The newly appointed judges, Thomas A. Jones P.R.H.A., A. Burke, R.H.A. and Bartholomew Colles Watkins, R.H.A., in their report relating to the Society's exhibition of 1875 noted:'The average excellence of the works submitted to our judgement by the I.A.D.S. for the season of 1875 is considerably higher than that of former years... The number of copies in oils and water-colours has considerably decreased, and we congratulate the society on the fact that original studies form the leading features in the present exhibition...'[39] They were particularly impressed by the number of water-colour sketches and drawings exhibited under the title 'Illustrations'.[40]

Membership continued to rise and the following year reached around 150. The exhibition, held once again in Molesworth Street was open daily from eleven until six o'clock and the

Photograph of Philip Chenevix Trench (1849-1911), grandson of Richard Chenevix Trench, Archbishop of Dublin and instigator of the Oxford English Dictionary. Born in Ghazeepore on 7 June, 1849 (his father was in the Bengal Civil Service at the time), Philip Chenevix Trench was a graduate of Christ Church, Oxford and a Fellow of the Surveyor's Institute. In 1882, he married Frances Angel Reeves, only daughter of Robert Reeves of Dublin. Philip Chenevix Trench began exhibiting with the Irish Amateur Drawing Society at their annual exhibition held in Dublin on 12 March, 1877. He took an active part in the Society's administrative affairs becoming a committee member and, together with Lord Ardilaun, a trustee. PRIVATE COLLECTION

watercolour) comprised sections nine and ten. Studies of flowers and still-life in both media were allocated to classes 11 and 12. Chalks and pastels were allocated two classes (13 and 14); whilst etchings, sepia and pencil drawings were again divided into two classes, copies and originals (15 and 16). The popularity of etching was steadily increasing; four years later this enthusiasm was to attain new heights when influential publication *The Athenaeum* (1881) went so far as to demand that this skill should be awarded a 'separate field for display'.[43] In class 17 the theme subject was 'Reflections'. Entries had exceeded all expectations and amounted to 544 with no increase in prices being particularly noticeable. The committee consisted of two male additions, distinguished amateur photographer and founder member and (later President) of the Dublin Photographic Society, Sir John Joscelyn Coghill, Bart., and Philip H. Bagenal, the latter acting as Secretary. The Misses Keane, Frances Musgrave, Frances Currey, and Miss Vance (only daughter of John Vance M.P.) formed the remainder of the committee.

The number of female entries was astonishing. The ladies outnumbered the men by ninety-nine to thirteen! There appears to have been no control relating to the number of entries each artist might submit, with Frances Currey topping the list by exhibiting no less than twenty-two works.

In 1878 the Irish Amateur Drawing Society changed its title once again and became known as the Irish Fine Art Society. As far as is known, no catalogues relating to the Society's activities have survived from this early period. From 1878 until 1885, and again in 1895 (with the exception of 1880 when the Society held one exhibition only that year, their fifteenth, in March at 35, Molesworth Street, Dublin), an exhibition was organised each autumn in Cork and a spring exhibition held in Dublin. As the Society formed a strong exhibition link with the city of Cork during this period, the next chapter will consider the background in relation to art training being offered in that city during the second half of the nineteenth century.

'large number of persons [who] have visited the exhibition … must be very encouraging to its members.'[41] The Society found themselves being congratulated by the press '…This is the third display that has taken place in Dublin and is extremely interesting… From small beginnings-half a dozen vague rules, a couple of dozen members, and a tiny exhibition in a corner of the courthouse at Lismore-the society has spread far and wide, till it can boast of some hundred and fifty

members and an annual exhibition.'[42]

The tenth exhibition was held once again in Dublin (no venue given in the catalogue) and opened on March 12, 1877. The number of classes showed a dramatic increase having risen from eight to seventeen. Both the oil and watercolour sections were now subdivided into, in each case, four distinct groups: Copies of figures and landscapes and originals in both media occupied classes one to eight. Studies and copies of animals, (oil and

Establishing a Public Identity – Exhibitions in Cork, Dublin and Belfast

During the nineteenth century, the city of Cork possessed a flourishing and enterprising artistic community. Wealth had been generated largely by the export trade in agricultural produce, the harbour being of prime importance. The city's municipal council was dominated to a great extent by a commercial merchant class who, in turn exercised a strong influence on Cork's cultural life.

The founding of the Cork Society for Promoting the Fine Arts had taken place as far back as 1815. Largely philanthropic in outlook, it set out to improve the standard of 'taste' in society and with this in mind 'The First Munster Exhibition' was held in the city in 1815. This consisted of original pictures in oil and watercolours, pencilling and crayons, and included both amateur and professional painters.

A few years later, in 1818, a collection of casts from the antique which had been selected under the care of the celebrated Canova and presented by Pope Pius VII to the then Prince Regent, later King George IV, was presented by the latter to the Society. In 1832 the Royal Cork Institution moved to the Old Custom House, (erected 1724) Nelson Place (now known as Emmet Place). The R.C.I. brought with them their important collection of sculpture casts together with a collection of books and scientific instruments. Art lectures conducted by the Institution were also transferred to the Old Custom House which became a 'fledgling' School of Art.[1] The School flourished and was eventually incorporated into the Government Schools of Design system and became known as the Cork School of Design. It opened on 7 January, 1850. Attendance figures reveal that numbers varied at the beginning

from 200 to 150 and consisted of both female and male students mainly 'of the mechanic and artisan classes, and the females of governesses, teachers, japanners, and girls engaged in embroidery and lace schools.'[2] Classes included embroidery, lace enamelling and japanning. The School was supported by an annual grant from Cork Corporation amounting to £200, and a further £500 from the government, which was later reduced to £450, the legality of this use of public money having been questioned. In 1854 both corporation and parliament grants were finally withdrawn leaving the School dependent on students' fees. Unable to survive, the School closed its doors, only to reopen on 8 January, 1856 – Cork being the first city in Ireland to set an example by voluntarily charging themselves a rate of one half penny in the pound towards the revival and support of their design school.

Four years earlier, a section devoted to fine art was included in 'The Cork National Exhibition'. This exhibition, which originated as the Munster exhibition, became so large that an extension, known as the Southern Hall, had to be added to the Cork Exchange Hall. The Cork School of Design was well represented, 'the occasion afforded a fitting opportunity of displaying the imitative and creative genius of our countrymen in the highest walks of art...'[3]

By 1856 attendance in the School was placed on a firm footing. In that year, 245 male and 95 female students were registered and the public freely admitted to view both the art and sculpture galleries. From the beginning, a separate morning class had been established 'for the ladies' instruction being offered in 'Drawing outline from the flat'.[4] However, this

influx of middle-class female students tended, in the view of Dr Peter Murray to derail the School of Design 'from its original intentions'.[5] By 1857 the annual awards ceremony had become one of the most sought after events in Cork's social and cultural diary: 'The number of ladies present was very large and the attendance was exceedingly fashionable...'[6] Subjects taught in the school now included mechanical drawing, carving, gilding, photography, lithography etc., with the emphasis being placed on the practical, students being encouraged to learn a trade or craft. In 1860 James Brenan took up his appointment as headmaster. During his twenty-nine years in office, the School flourished.

At the beginning of the 1880s, the old building (The Old Custom House) was remodelled, and a spacious School of Art together with an art gallery extension was added. A distiller, William H. Crawford, generously donated £20,000 towards the cost. It was opened by the Prince and Princess of Wales in 1884 and renamed the Crawford Municipal School of Art. This successful amalgamation of an eighteenth with a late-nineteenth century building is known today as the Crawford Art Gallery.

One of the contributing factors which may have influenced and persuaded the committee of the Irish Fine Art Society to hold their twelfth (1878) and subsequent autumn exhibitions in Cork was the energy and commitment of artist, administrator and educator, James Brenan, R.H.A. (1837-1907), whose name has already been mentioned here. He had been invited by the Amateur Drawing Society to judge their first exhibition held in the Courthouse, Lismore which opened on 10 May, 1871. Brenan, born in Dublin, trained in

Lady Kate Dobbin (1865-1955) *Eason's Hill, St. Anne's Shandon, Cork*, watercolour. Lady Kate Dobbin, flower and landscape painter, studied at the Crawford Municipal School of Art from 1891-95 and was a regular contributor to the W.C.S.I. and the R.H.A. COURTESY OF THE CRAWFORD ART GALLERY, CORK. PRESENTED BY MR ALFRED DOBBIN, 1955

Robert Lowe Stopford (1813-1898) *Crosshaven, Co. Cork,* watercolour.

both the R.H.A. and R.D.S. Schools, and worked in London assisting Owen Jones and Matthew Digby Wyatt in the decoration of the Pompeian and Roman Courts in the Crystal Palace. Returning to Dublin, he taught at the Dublin Society Schools. However, in order to further his art education, he returned to London, this time to become a student in the training college at South Kensington. After several short periods of being placed in charge of art schools in Liverpool, Taunton and Yarmouth, Brenan was appointed Headmaster of the Cork School of Art at the age of only twenty-three. He was to serve for a period of twenty-nine years, retiring in June 1889. Later that year he became headmaster of the Dublin Metro-politan School of Art.

Brenan had taken up his post in Cork as a man firmly committed to trying to improve the position of women in Irish society and, in the view of Dr. John Turpin, he was anxious 'to promote design for local industry, improve art teaching, and raise the level of taste in society'.[7] Brenan held strong views in relation to the connection between art training and the promotion and development of economic self-reliance. Throughout his life, he was interested in the application of art to industries. In connection with this, he encouraged home industry, in particular the promotion of lace-making as a source of income for women living in rural areas. He was to be successful in establishing classes in lace -making, crochet and embroidery in centres such as Killarney, Kenmare, and Kinsale

It was against this background and under their new title, the Irish Fine Art Society, that members began preparing for their exhibition to be opened on 27 September, 1878 in the Rotunda saloon of the Opera House located on Nelson (now Emmet) Place, Cork. Designed by Sir John Benson (1812-1874), the building, known as the Athenaeum, was altered and extended when it was rebuilt on this site, having served as the main exhibition hall for the 1852 National Exhibition, Cork. This elegant colonnaded structure was later to be remodelled as the Munster Hall and eventually became known as the Opera House (tragically destroyed by fire in 1955). Erected on its new site, (Nelson Street) the Athenaeum possessed considerable charm. It was completed by early 1855. A classical façade faced the river, (the north front), whilst the west and east ends of the building were adorned with semi-circular facades. The main entrance was sited at the eastern end. The interior was one of grandeur, particularly in relation to design and vastness of proportion. The lofty and spacious rotunda was elevated above the main hall and lit by a glazed roof, supported by a double row of fluted Corinthian columns. Small gas jets inserted into the dome and extending along the cornice ensured sufficient artificial

lighting was provided for this vast space.

The building belonged to the trustees of the Royal Cork Institution who had raised sufficient funds for its removal to Nelson Place. It was to be used for the promotion of literature, science and the fine arts. The official opening by the Lord Lieutenant, the Earl of Carlisle accompanied by the Mayor, Sir John Gordon, the Earl of Bandon (Lord President of the County) together with a gathering of clergy, local officials and dignitaries was a splendid occasion and took place on 22 May, 1855. An appreciation of the building's merits was given by a local antiquarian and noted orator, Dr. Charles Yelverton Haines who described it as: 'a really beautiful hall…this fine Rotunda with its brilliant coronet of light coruscating

beneath that lofty dome.'[8] By the early 1870s, the Athenaeum, devoted to 'the successful mastery of art, science, and literature' was found to be somewhat limited in its ability to meet these claims and a decision was made to remodel, in particular the interior in order to provide for greater flexibility.[9] After considerable alterations had taken place, the building opened in 1872 and became known as the Munster Hall. Three years later, and following the closure of the Theatre Royal, Cork, the Munster Hall became the only available principal performing venue in the city. Purchased by the Theatre Royal and Opera House Company, it was decided that the Munster Hall should be extensively remodelled with a gallery, balconies and a much improved stage being added in order to make it suitable for

theatrical productions. The Munster Hall now became known as the Opera House and opened to the public on 17 September, 1877. The *Cork Examiner* informed its readers that the new rotunda saloon was a 'great acquisition, as it is available not only as a "Foyer" for refreshment and promenade, but also for balls, small chamber concerts and bazaars, while the top of the dome being of glass, the lighting is perfect even during the day.'[10]

It was here in late September 1878 that the Irish Fine Art Society held their twelfth exhibition. The *Cork Examiner* was on hand to report on events: 'The rotunda has been transformed for the while into a tastefully arranged art gallery. It is structurally well suited for such a purpose, but the addition of a handsome carpet, caused the room to

Samuel McDonnell (fl.1857) (copy after Robert Lowe Stopford) *View of Cork Opera House* (former Athenaeum, former Munster Hall), watercolour. Dated: 'Aug.8th, 1857'.
From 1878 until 1884, with the exception of 1880, the Irish Fine Art Society mounted one autumn exhibition per year in Cork. These were held in the Rotunda Saloon of the Athenaeum until 1881, when, in November of that year, they moved to the Assembly Rooms, South Mall, Cork. COURTESY OF THE CRAWFORD ART GALLERY, CORK

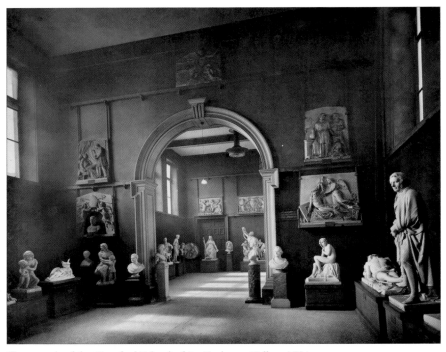

Photograph of the Crawford School of Art Sculpture Gallery, 1884.

wear a very unusual appearance. There are over two hundred pictures in the collection, beside a collection of china, painted most beautifully. The water colours are, of course, more numerous and of greater merit than the oils…'[11] The work of local artists was singled out for special mention: Mrs Sharman Crawford and Miss Lily Tanner. Rose Barton's two pictures, *Dead Game* and *Pheasants,* were described by the paper as being 'by far the best pictures in the collection'.[12] A further account appeared in the same paper a few days later. A large number of visitors attended and many pictures had been sold: Mary K. Benson's (1842-1921) *Evening on Caragh Lake, Co. Kerry* and Miss Currey's 'remarkably good pictures' were considered, by far, to be 'the best…in the collection'.[13] However, not all works were of a similar high standard. A portrait, reputed to resemble Joan of Arc, was described somewhat amusingly as

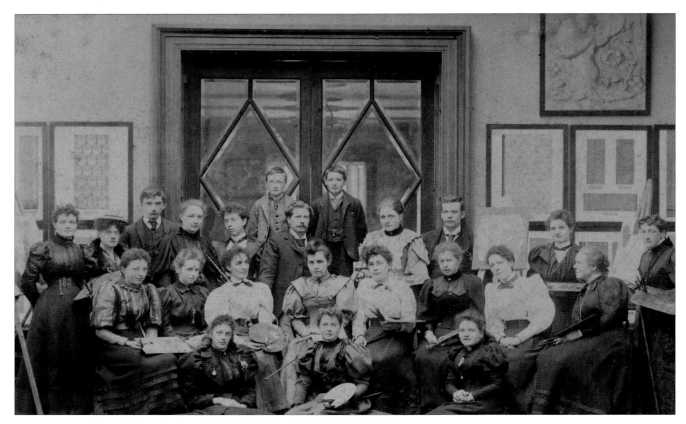

Gibson Gallery Students *Students at the Crawford School of Art* c.1885.

Mary Reeves (fl.1877-1907) *Ballycotton Bay* 1892, watercolour. Signed 'M. Reeves 1892 Ballycotton Bay'. The artist exhibited with the Irish Amateur Drawing Society in 1877, the Irish Fine Art Society in 1879, 1882 and 1883, and the W.C.S.I. in 1889. COURTESY OF THE CRAWFORD ART GALLERY, CORK

resembling some 'bilious young person, with a very discontented expression of face'.[14] Painter and member of the R.H.A, Philip H. Bagenal, appears to have replaced Harriet Edith Keane in her role as 'the almost indefatigable secretary'.[15] The *Cork Examiner* felt the exhibition had been well attended and lived up to expectations. Despite being 'the production of amateurs, it promises well for the future of Fine Art in Ireland. While some of the pictures exhibited are palpably the work of amateurs, others approach very near in style that may be called 'professional'.[16]

The Society's spring exhibition, the thirteenth, returned to Dublin and was held in the usual venue, the Leinster Lecture Hall, 35, Molesworth Street, with its 'handsome blind arcade of rusticated granite'.[17] The exhibition

opened on 10 March, 1879. Arthur, 1st Duke of Connaught, again agreed to act as patron, which was certain to enhance the Society's social cachet. A number of committee changes had taken place: Rose Barton, and Robert Clayton-Brown, Junior were appointed together with a new secretary, Leslie Wingfield who replaced Philip H. Bagenal.

Members returned to Cork at the end of October, 1879 in order to hang their exhibition which was once again held in the rotunda saloon, of the Opera House. The Society's committee had expanded and comprised a wide slice of south of Ireland artistic life – the Misses Keane, Mary Reeves, of Tramore, Douglas, Cork (R.H.A. exhibitor 1877 to 1906); Mrs Sharman Crawford, Lota Lodge, Cork; Miss J. Longfield, Longueville House, Mallow,

(exhibitor R.H.A. 1881-1883); Miss Frances Currey; Rose Barton; Sir John Joscelyn Coghill, and James Penrose were all represented. It is interesting to read that the drawing of prizes in association with the Art Union of Ireland is mentioned by the *Cork Examiner* for the first time.[18]

The Art Union of Ireland had been established under the auspices of the Irish Institution, the objective being the encouragement of Irish art by purchasing works exhibited each year in the R.H.A. and elsewhere. 'The distinctive feature of this Art-Union is that the entire subscription, less the working expenses, is allocated in prizes of money, which must be expended in the purchase of pictures or other works of art exhibited in the Academy for the year.'[19] When applied to the Irish Fine Art Society, it took the form of a

John Gilbert (1834-1915) *The Pigeon House, Dublin* 1913, watercolour. Signed 'J Gilbert 1913 Pigeon House Dublin'. Illuminator, topographical artist and portrait painter, John Gilbert was born in England; he later settled in Cork city and ran an art shop at 120 Patrick Street. He organised the first ceramic exhibition in Cork in 1880 followed by another the following year.

sweepstake with paintings being distributed as prizes. Each subscriber of one shilling and upwards was entitled to one chance for every shilling subscribed or twelve chances for ten shillings etc. The total amount received was expended in the payment of pictures selected by the prizewinners from amongst those hanging in the exhibition. A certain percentage of the monies received was withheld for the purpose of defraying the necessary expenses incurred in mounting the exhibition. The draw took place in the rotunda and appears to have generated a good deal of support. The Society's well attended exhibition continued for three weeks and appears to have been highly successful and, it was noted, 'many red stars are to be observed on the pictures'.[20]

At their Dublin (March 1880) outing held once again in the Leinster Lecture Hall, there was a notably wide price range. Helen Colvill's sketch was set at a mere sixteen shillings (cat. no. 217) whilst George J. Knox's watercolour *A Street in St. Malo* (cat no. 65) was listed as being £26 55 shillings.[21] The exhibition was not divided into sections and the number of entries was substantial, amounting to 522. Newcomers included distinguished artist, Sarah Purser, and Maud Naftel, A.R.W.S. (1856-1890), (only daughter of drawing master and artist, Paul Naftel). Frances Wilmot Currey was, for the first time, listed as Secretary of the Society, a post she was to retain for around the next ten years.

For their Cork exhibition, due to open on 7 November, 1881 members

decided to move to a new venue, the Cork Assembly Rooms sited on the South Mall 'amidst the terrible political and social excitement'.[22] The previous year, the first ceramic exhibition ever to be held in Cork had taken place in the same venue. Stylishly laid out, it consisted of paintings on porcelain and terracotta, both in oils and watercolours with subject matter relating to historical works, still-life, and landscape. This area of painting was beginning to take hold and appealed particularly to women. It is interesting to note that entries relating to this form of decorative art had begun to appear in the Society's catalogues as far back as 1877 when a 'Miss F. Tottenham' is listed as exhibiting no less than six 'decorations' on china for the tenth exhibition (see p.71).

Sir George Frederick Hodson, 3rd Bart., (1806-1888) *Elevation of Offices at Holybrooke House, Bray, Co. Wicklow*, 1836 ink and wash. Inscribed 'Offices No 1 Holybrooke May 26-36 GFH'.

Hodson lived at Holybrooke House, a Tudor Revival house on the outskirts of Bray, designed by William Vitruvius Morrison and completed in 1835. He was appointed a trustee of the Irish Fine Art Society together with Viscount Powerscourt, K.P. in 1882. A keen amateur artist and architect, he exhibited a number of landscapes and figure subjects in the R.H.A. In 1871 he was appointed an Hon. Member.

COURTESY OF THE IRISH ARCHITECTURAL ARCHIVE, DUBLIN

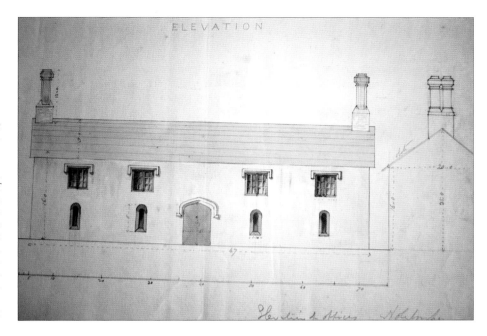

Anthony Wysard *Caricature of the Duke of Connaught, with his son, Prince Arthur, and his grandson, Alastair Arthur, 2nd Duke of Connaught*, pencil and gouache.

Left to right: Alastair Arthur, 2nd Duke of Connaught and Strathearn (1914-1943); Arthur, 1st Duke of Connaught and Strathearn (1850-1942); Prince Arthur Frederick Patrick Albert (1883-1938).

© NATIONAL PORTRAIT GALLERY, LONDON

Prize certificates of the Art Union of Ireland dated 12 May, 1859.

The venue for the Society's November exhibition was the Assembly Rooms built in 1860 to a design by architect and antiquary, Richard Rolt Brash.(1818-1876). A fine hall and suitable for mounting exhibitions, it ran to a length of 98 feet and possessed a width of 45 feet. It was lit from the sides and at the ends by semi-circular headed windows. The organisation was placed in the capable hands of exhibition organiser and R.H.A. exhibitor, John Gilbert (1834-1915), who, in the view of the *Cork Examiner* felt certain 'nothing will be left undone'.[23] A landscape and portrait painter, he specialised in illuminated addresses. Gilbert, born in England, had settled in Cork city where he ran an art shop at 120 Patrick Street. In 1880 he organised (with help from members of the Irish Fine Art Society) the first ceramic exhibition, which had

attracted a substantial entry. Several students from the Cork School of Art had been permitted to submit exhibits to the Irish Fine Art Society's November 1881 exhibition, the *Cork Examiner* (mentioning no names) commenting on one entry in particular.[24]

During the coming week, the evening of 15 November was to be set aside for a 'full-dress *conversazione*' complete with music and song, which was certain to enliven the Cork social scene. Following the conclusion of the *conversazione*, it was arranged that the annual drawing of prizes awarded by the Art Union should then take place. The closure of this, the Society's eighteenth exhibition, was followed by a second exhibition in the same building of the ever increasing popular art form of 'ceramic painting'. This was organised once again by the ever

efficient John Gilbert with certificates being offered for 'excellence of amateur work'.[25]

The following spring, for the Society's nineteenth Dublin exhibition, two trustees were appointed; both came from County Wicklow – Viscount Powerscourt, K.P., and Sir George Frederick Hodson, 3rd Bt., (1806-1888), Holybrooke House, Bray, Co. Wicklow. The latter was a keen amateur artist, an Honorary Member of the R.H.A. and a man who had served on the Fine Arts Committee in connection with The Dublin International Exhibition of Arts and Manufactures held at Earlsfort Terrace, Dublin in 1865. The Duke of Connaught continued to act as the Society's Patron.

A substantial entry, amounting to 444 exhibits were on display. The exhibition was opened by the Lord Lieutenant and Countess Spencer on Thursday, 1 March, 1883 in the Leinster Lecture Hall. Included were works by, amongst others Bingham McGuinness, A.R.H.A., Lady Ardilaun, Sir J.J. Coghill, Mary Reeves, Harriet C. Bruce, Alexander Williams, Helen O'Hara, A.B. Wyne, Captain Irwin, Charles A. Lodder, Cassandra Hill, Rose Barton, Louisa Anne, Marchioness of Waterford. Frances Wilmot Currey, 'the energetic Secretary of the Society' had no less than seventeen entries accepted for this, the twentieth exhibition.[26]

As a result of the high number of pictures submitted, accepted and exhibited by Currey, an aggressive attack was mounted by William Booth Pearsall, one of the principal founders of the Dublin Sketching Club in the pages of the *Daily Express* [Dublin]:

'In her figure subjects Miss Currey is grotesque – utterly wanting in that living grace or vigour one is apt to expect in such work, and there is a Japanese enjoyment of ugliness and monstrosity in her pictures of figures… We are sorry to find fault with Miss Currey's work, but so many of the members endeavour to imitate her methods of work and choice of study that we wish to warn them against painting anything that they do not really see and understand in nature.'[27]

Sarah H. Purser, R.H.A. (1848-1943) *Francis Carmichael Purser (1876-1935)*, pastel. Signed and dated 'SPurser. 1891.'
This is a portrait of the artist's nephew. Sarah H. Purser began exhibiting with the Irish Fine Art Society as early as 1880.
PRIVATE COLLECTION

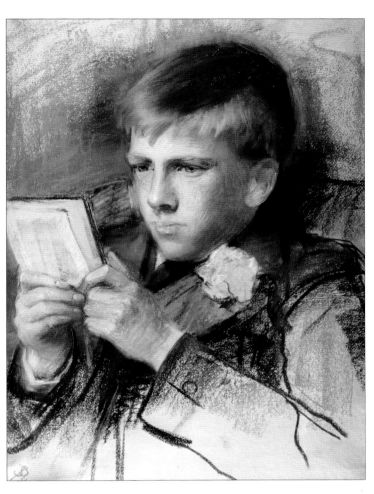

Bingham McGuinness, R.H.A. (1849-1928) *At the quayside*, watercolour. COURTESY OF THE GORRY GALLERY, DUBLIN

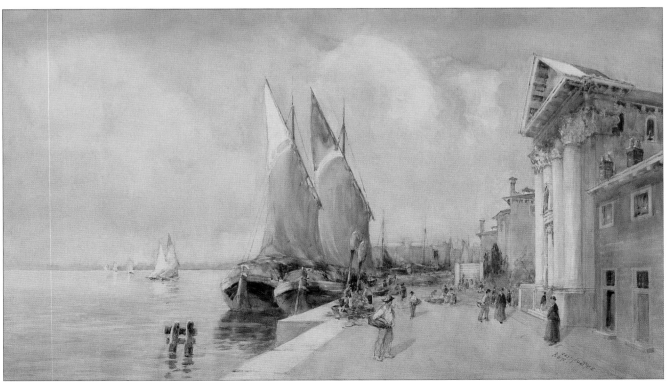

'The Grosvenor Gallery of Fine Art, 135-137 New Bond Street' *Illustrated London News*, May 5, 1877.

During its fourteen-year lifespan, the gallery exerted a formative influence on Victorian taste and culture. Several members of the W.C.S.I. exhibited their work here including Frances Wilmot Currey, Rose M. Barton, R.W.S., Mildred Anne Butler, R.W.S., and Louisa Anne, Marchioness of Waterford, encouraged by the gallery's co-founders, Sir Coutts Lindsay and Blanche, Lady Lindsay.

COURTESY OF THE NATIONAL LIBRARY OF IRELAND

'Music and Aesthetics' from *Punch,* 16 February, 1878.

COURTESY OF THE NATIONAL LIBRARY OF IRELAND

Photograph of landscape painter and illustrator, Edith Anna Œnone Somerville (1858-1949) (astride) who began exhibiting with the Irish Amateur Drawing Society in 1883; with Hildegarde Coghill (1867-?) and their dogs, including an Irish water spaniel, on the beach at the west end of the harbour, Castletownsend, Co. Cork (c.1893-1896).

Photograph of Sir Egerton Bushe Coghill (1853-1921) 5th Bart., and Herbert Baxter painting *en plein air.*

Egerton Bushe Coghill, born in Castletownshend, Co. Cork, was the second son of Sir Joscelyn Coghill, Bart., and his wife, the Hon. Katherine Frances, daughter of John Plunket, 3rd Baron Plunket. He studied engineering but soon abandoned this in favour of becoming a painter. After receiving some art training in Dusseldorf, he spent four years at Académie Julian, Paris and on occasions painted at Barbizon, on the edge of the Forest of Fontaineblue. Following his marriage to Hildegarde Somerville, sister of Edith Somerville, he spent the majority of his life in Castletownshend, Co. Cork, later exhibiting with the R.H.A. and the Irish Fine Art Society.

William Giles Baxter (1856-1888) 'Fashion Fancies by Miss Sloper' from *Ally Sloper's Half-Holiday*, 17 May, 1884.

Rose M. Barton, R.W.S. (1856-1929) *St. Patrick's Close, Dublin 1881*, watercolour on paper. Signed 'Rose Barton/1881'. This watercolour was first exhibited in the Irish Fine Art Society's March 1888 exhibition held in the Leinster Hall, 35, Molesworth Street, Dublin. The artist was described by the *Daily Express* (Dublin), as 'a rising artist whose progress during the last two years has been remarkable' (12 March, 1888, p.3, col. 1).

This newspaper also carried letters from several readers criticising the standards of selection currently being adopted by the Irish Fine Art Society. In a letter to the editor signed 'A Member' and dated 16 March, 1883, the writer expressed the view that the affairs of the Society were being conducted in an unsatisfactory manner:

'The general members are allowed no voice or representation; they are mere contributors to the funds, with the privilege of sending in pictures which are indiscriminately rejected.'[28]

It was felt by a number of members that rejection did not appear to be governed by any particular standards or indeed lack of space. In one particular case:

'I find that in the present exhibition there are no less than 17 pictures by one member of the committee…'[29] It was clear to the writer of the letter that the committee, in the selection of pictures, did not apply the same standards to themselves as they did to other members. The suggestion was made that the machinery used in the selection of members was not the same as that which applied to the selection of pictures for exhibition. In all, a total of ninety members of the Society were not represented in the exhibition. The letter concluded by stating that it was hoped the situation would improve otherwise members must consider whether or not there was a case for forming a 'Dublin Grosvenor Gallery'.

This drew a heated response from Philip Chenevix Trench, a long-

standing committee member who was later to become a trustee of the Society. In a letter to the Editor, (the *Daily Express*, Dublin) dated 26 March, 1883 he made the Society's position clear:

'Any member's work accepted by the judges is invariably hung …In the election of members they try to choose only those who show apparent ability to produce work fit for exhibition, but cannot insure their pictures being always hung afterwards. To select the works for exhibition, the committee …being in competition themselves entrust the choice to the most competent judges they can procure (not members of the Society) such as R.H.A. academicians, who decide on the merits, out of the total numbers sent in, what shall be hung, and also give general advice as to the arrangement of "the line". The committee have no voice in the matter themselves, their pictures being equally liable to rejection.'[30]

He defended the rights of committee members to submit a larger entry of work compared with that submitted by ordinary members. His reasons were based on the fact that the committee 'give more time, work harder, and thus keep pace with the general standard of merit…'[31] The

Edith Somerville (1858-1949) *The End of Glen Aar* 1927, oil. Signed 'E.O. Somerville'.
PRIVATE COLLECTION

editor of the paper, in an effort to diffuse the situation 'wished the society every success' but could not resist adding 'even though from the correspondence which has been going on in our paper, there appears to have been some distrust exhibited by the

members that they were not done justice to by the committee'.

In Cork, the Industrial and Fine Art Exhibition opened in July 1883 and, until it closed on Saturday, 13 October succeeded in attracting around 10,000 people. It was a reflection of the

Helen Sophia O'Hara, H.B.A.S. (1846-1920) *A Summer Sea*, watercolour. Signed with monogram and inscribed on reverse. For the Society's exhibition held under their new title 'the Water Colour Society', the committee, which included Helen O'Hara, expanded from twelve to fifteen with 302 exhibits being listed in the catalogue.

COURTESY OF THE GORRY GALLERY, DUBLIN

Photograph of Helen Sophia O'Hara (1846-1920) by Lafayette, from *The Lady of the House* [Dublin], 14 May, 1892 p.2.
Helen O'Hara began exhibiting with the Irish Fine Art Society in 1877 and continued almost without a break until 1913.
COURTESY OF THE NATIONAL LIBRARY OF IRELAND

G. Grenville Manton *A conversazione at the Royal Academy, London 1891*, watercolour.
Sitters include Dame (Alice) Ellen Terry (1847-1928), Sir William Quiller Orchardson (1832-1910), Sir Henry
Irving (1838-1905), Sir John Everett Millais, 1st Bart. (1829-1896), Sir Lawrence Alma-Tadema (1836-1912), Baron
Leighton (1830-1896), Sir Edward Coley Burne-Jones, 1st Bart. (1833-1898), and various unknown male and
female sitters. © NATIONAL PORTRAIT GALLERY, LONDON

prosperity and optimism which was helping towards providing the city with a first class art school and gallery. James Brenan was placed in charge of the Fine Art Section for the exhibition, which amounted to over 800 entries. Landscape watercolours were on display from a number of Irish artists including the gifted Henry Albert Hartland and John Drummond (both former Cork School of Art students) together with Robert Lowe Stopford and Irish Fine Art Society member, Joseph Poole Addey.

The situation with regard to female participation had changed dramatically since 1865 when just one brave lady artist was represented in the watercolour section at The Dublin

International Exhibition. The year 1883 saw a substantial female entry and included a number of representatives from the Irish Fine Art Society – Helen O'Hara, Harriet Edith Keane, Frances Currey, Mary Reeves, Miss Longfield, Sarah Purser and Rose Barton – who proudly came forward to exhibit their work. In fact, oils and watercolours were so numerous they not only occupied the Gallery of Modern Painting but were also hung in the western gallery of the Concert Hall.

A special room was set aside for a loan collection from South Kensington which saw a cross-section of Old Masters placed on view to the public. Amongst them were works by Sir Peter

Lely, Maclise, Poussin, Rubens and van Dyck. Several years later, in a report, Brenan remarked on 'the educational value of such a collection [which] was very great, and the interest displayed in it by the crowds of visitors was most gratifying.'[32] In the area of watercolour, a loan collection included works by Sir Fredric William Burton, Edwin Hayes, Cattermole, Prout, Maclise, Nicholas Grogan and Erskine Nicholl. This allowed the public an opportunity to view the work of leading Irish and English nineteenth century watercolourists at firsthand for themselves.

Notwithstanding the success of the Industrial and Fine Art exhibition, the Irish Fine Art Society returned to the Assembly Rooms for their annual

outing in November of that year. The review which appeared in the *Cork Examiner* on 15 November, 1883 was critical of the lighting: 'The paintings are hung in the best manner possible under the circumstances, but it is to be regretted that the light is not all that could be desired'.[33] The reviewer also noted that 'a versatility of style and subject ... is especially noticeable in the case of painters of the gentler sex'. There was a special mention relating to Sarah Purser's entry, 'the figures are exceedingly well drawn'. Amongst the many participants were Alexander Williams, R.H.A. Frances Wilmot Currey, Helen O'Hara, Jennie Hackett, Miss Swan, Ida Lee, Mr. John Gilbert and Captain Hodder, R.H. On Saturday, 17 November, the band of the 20th Hussars was invited to play. This helped to attract a large audience and it was noted with satisfaction '... the pictures...are being rapidly disposed of'.

During the exhibition on Wednesday, 21 November a recital was organised by the Society and held in the large hall of the Assembly Rooms. A number of amateur vocalists, all members of the Irish Fine Art Society, contributed to the 'well selected programme'. Amongst them, Mrs Longfield, Miss Davidson and Miss Colthurst who made up a 'brilliant combination of amateur talent'.[34] Not to be outdone, Messrs Forest, Creagh and Marks were the male vocalists with Mr Creagh managing to score an encore with his rendering of *Golden Love*. Frances Keane and Mrs Edwin Hall played a number of piano solos 'in which they acquitted themselves with much success'.[35]

An amusing account of a typical *conversazione* and recital organised by the Irish Fine Art Society is to be found in the scrapbook of the Dublin Sketching Club:

'The experiment which latterly has been tried of combining music with one or more distractions, such as promenading, or more recently still, of serving it up with tobacco smoke accompaniment is not one which we can conscientiously commend...The performers, perfectly au fait with their own music, are too much disposed to

Photograph of Theresa Susey Helen Vane-Tempest-Stewart, Marchioness of Londonderry (1856-1919) who, together with her husband, the 6th Marquis of Londonderry, the Lord Lieutenant, opened the Society's first exhibition held under their new title, the Water Colour Society of Ireland on Monday, 11 March, 1889 at 3 p.m. in the Leinster Hall, 35, Molesworth Street, Dublin. Photograph by Lafayette, c.1886. © NATIONAL PORTRAIT GALLERY, LONDON

overrate the intelligence of the audience. In many cases these have no idea of what is being sung or who is singing it. Thus one old lady was perceived nodding her head in time with the somewhat rococo rhythm of "Should he upbraid" - once the joy of our mothers! - she being unconscious that it was not a song of Tosti to which she was listening.'[36]

Frequently, the press commented on what the ladies wore to these fashionable, much sought after social events. The *Daily Express* (Dublin)

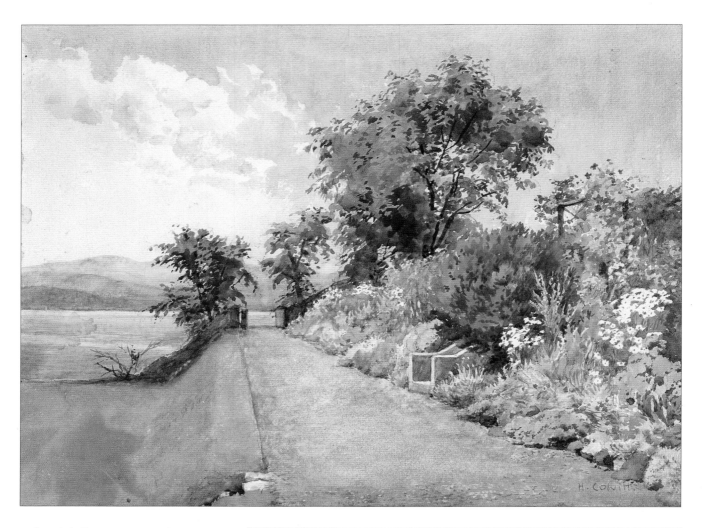

Helen Colvill (1845-1953) *The garden at Roxboro, Howth, Co. Dublin*, watercolour. Helen Colvill exhibited with the Society for the first time at their exhibition held in the Leinster Hall, 35, Molesworth Street, Dublin, in March 1880. A prolific W.C.S.I. exhibitor, in the 1930s she moved from Coolock House to Holywell Cottage, Howth, Co. Dublin.

COURTESY OF THE GORRY GALLERY, DUBLIN

W.S. Welch, steel engraving from a photograph. *Gardener's Chronicle*, 11 November, 1893 (p.589).
Two men in a punt on the pond in Trinity College Botanic Gardens, Ballsbridge, Dublin in the summer of 1893. Frederick Burbidge, Curator, Trinity College Botanic Garden (1879-1905) is seen standing in the punt. Also a botanical artist, Burbidge delivered a talk relating to botanical art during the Society's annual exhibition held under their new title, the Water Colour Society of Ireland, on 20 March, 1889.

COURTESY OF THE NATIONAL LIBRARY OF IRELAND

noted that at the *conversazione* held in the Leinster Hall in conjunction with their March 1896 Dublin exhibition saw Miss Rose Barton attired in an 'artistic' gown of pale blue brocade, trimmed with sable, whilst Viscountess Glenworth was arrayed in cream silk with a pale blue belt studded with sequins. Lady Sankey wore a smart shaded velvet gown toning from olive to yellow, whilst a less subdued Mrs Longfield was spotted sporting pink feathers in her hair![37]

'The scene was brilliantly lighted and decorated with refined taste so that the pictures were seen under the best possible conditions…The enjoyment of the company was much heightened by musical contributions from a number of gifted amateurs… The following was the programme of the musical entertainment: - Duet, piano and violin, Viscountess Glentworth and Miss Burke-Irwin; song, Mr. Darcy; song, Miss Longfield; song, Miss Webber; song, Mr. Scott; duet, piano and violin, Viscountess Glentworth and Miss Burke-Irwin; song, Miss Longfield; song, Mr Darcy.'[38]

For their twenty-third exhibition, The *Daily Express* (Dublin) provides an interesting insight into the methods in relation to hanging works adopted by the Society. 'The judges appointed by the committtee …kindly consented to give up nearly a whole day to selecting the pictures to be hung, and, we are informed, went through them twice in the first place, to make sure no good picture should be inadvertently rejected, and, secondly, to mark by a number, 1,2,3 or 4, the relative positions the accepted pictures bore to one another and the order of their hanging – in this way carrying out the procedure of the Salon in Paris. They thus greatly relieved the Hanging Committee of responsibility in the selection of places for the pictures, and largely contributed to the general effect.'[39]

By December 1884, largely due to the generosity of benefactor, William Horatio Crawford (1812-1888), Cork had a magnificent new home in which to house their School of Art. The building had doubled its size and provided for the first time purpose-

Photograph of the view of the Central Library, (originally known as the Free Public Library), Royal Avenue, Belfast. Architect: W.H. Lynn (1829-1915). Builders: H. & J. Martin.
Executed in Dumfries red sandstone on a black granite base, it is French in style with horizontal ground floor rustications and a delicately proportioned order above. It was here, in the new and impressive art galleries on the top floor, that the Water Colour Society of Ireland held their second exhibition under their new title in the autumn of 1889.

Belfast Free Public Library: The Art Gallery (the title was changed on 16 July, 1890 when it became known as The Art Gallery and Museum). Housed on the top floor, exhibitions were staged in three rooms, and it was in these galleries the W.C.S.I. held their second exhibition under their new title in the autumn of 1889. Photograph from *A Museum in Belfast* by Noel Nesbitt.

153

built galleries for exhibitions of sculpture and painting as well as studios for teaching art. Beside this building, the autumn exhibition of the Irish Fine Art Society went ahead in the Round Room of the Theatre Royal (the Opera House) in November of that year and was opened by the Lord Mayor on Friday, 14 November, 1884. The *Cork Examiner* reminded its readers that the Society had begun as a:

'...small amateur society, [and] year by year improved both in the class of its exhibits and the strength of its numbers. Most of the original members have gained in power and experience, and the society has also enlisted a strong body of professional recruits, so that it counts now among its members many names well known in art, not only in Ireland, but in England and elsewhere.'[40]

Two works (portraits of children) by the President of the Royal Hibernian Academy, Sir Thomas Alfred Jones, P.R.H.A. (1823-93) were on view, together with a collection of oils and watercolours by, amongst others Alexander Williams, R.H.A., Sir John Joscelyn Coghill, Arland A. Ussher, Dora Carpenter, W. Hyde Perrott, Mr and Mrs Dawson Borrer, Mr. A. Butler, and Edith Somerville, Helen O'Hara, Frances Currey, Maud J. Peel, Mildred Anne Butler, and Rose Barton, the latter being described by the *Cork Examiner* as 'that promising young artist'.[41]

In the opinion of the reviewer, the Society's twenty-fourth exhibition had maintained 'fair average of excellence'.[42] He felt landscape, as a study, 'occupied a large amount of attention in a Society so largely composed of amateurs. The exhibition looks bright and complete as far as it goes. What, with Mr Bagenal's red carpets, the high art curtains across the ugly doors at the end of the Leinster Lecture Hall, and the tolerably successful hanging of the pictures, an air of comfort is given to the room…' However, he felt 'the work of arrangement still requires a good deal of attention from the committee of the Society before it can be pronounced satisfactory.' He went on to note shrewdly: 'much of the injustice …we pointed out in former years has been obviated, still it is easy to see that is of considerable advantage to an exhibitor to be a member of the committee.'[43]

The last exhibition to take place under the title of the Irish Fine Art Society was opened by the Lord Lieutenant and the Marchioness of Londonderry on 12 March, 1888 in the Dublin venue, the Leinster Hall, 35, Molesworth Street, with Frances Wilmot Currey presiding as Secretary. The press commented on the fact that work in watercolour was:

'a branch of pictorial art which the R.H.A. surprisingly did not appreciate at its proper value, and it must be admitted that much credit is due to the Fine Art Society for the steady persistence with which, year after year …they have afforded the public an opportunity of studying the production of our best native artists in watercolour…and thereby assist in developing talent.'[44]

According to the *Daily Express* (Dublin) the catalogue contained 328 works. The depression, which had begun to seriously affect sales at R.H.A's exhibitions during this period appeared to have had little effect in Molesworth Street. Several new names were mentioned as having contributed in both oil and watercolour – Johnston J. Ingles, Mrs Webb Robinson, the Countess of Bantry, the Misses Crookshank, Buller, Pollard, Colquhoun, Hill, Blaker and Clara Irwin. Rose Barton's watercolour, *St. Patrick's Close*, Dublin was given a special mention: 'a rising artist whose progress during the last two years has been remarkable'.[45] While *The Irish Times* noted that 'the artist's work forms a charming feature of the exhibition'.[46] It was noted Miss Currey had submitted a 'limited number of her productions'.[47]

By the spring of 1889 it had been decided to change the title of the Irish Fine Art Society to the Water Colour Society of Ireland. For some years it had been noted that the watercolour element of this society has been growing in interest. At exhibitions the number of oils had been gradually receding, the space being occupied by the growing attraction of watercolour painting and collecting:

'This may be accounted for by the fact that many of its members can procure places for their oil pictures at the R.H.A. where their watercolours, unless good enough to secure a position in the limited space allotted to them in the front room, are relegated

Harry Furniss (1854-1925) 'A Strictly Private View' from *Punch*, 3 May, 1890.

to the back, and do not show to such advantage…. This tendency is, we believe, on the increase, and seems to point to the time having arrived when, with a little help, the Fine Art might be reformed into "The Water Colour Society of Ireland". Ireland should have such a society, and the Fine Art, many of whose members compete for and gain places in the London and Paris galleries seem, especially if it could secure the recognition and help of the R.H.A., the nucleus on which to form it. Such a society once established, and sanctioned by the public, would soon draw recruits and lead to a greater development of watercolour art in Ireland.'[48]

The first exhibition held under the Society's new title 'The Water Colour Society of Ireland', was opened on Monday, March 11, 1889 at 3 p.m. in the Leinster Lecture Hall, by the Lord Lieutenant and his wife, the Marchioness of Londonderry. The committee (including the Patron and Trustee) had been expanded from twelve to fifteen and comprised Miss Keane, Miss H.E. Keane, Miss R. Barton, Robert Clayton Browne, Esq., Miss H. O'Hara, Miss May Manning, P.C. Trench, Miss H.K. Lynch, General Sankey, Arland A. Ussher, Miss Mildred A Butler; and Secretary, Miss F.W. Currey, Lismore Castle. As in previous years, the Society's Patron, the Duke of Connaught and Trustee, Viscount Powerscourt, remained the same. The catalogue listed 302 exhibits but provides no indication as to medium so it is impossible to say whether or not watercolours predominated.

The press appeared to have been in favour of limiting the exhibition to watercolour only. The *Daily Express* (Dublin) commented that this would ensure that the Society 'will in that respect stand [apart] from the R.H.A., the Arts Club and The Dublin Sketching Club' and this 'would ensure that there was an evenness in the collection which was not visible in former ones, owing…to the difficulty of avoiding rough contrasts when oil paintings and watercolour drawings have to be hung together'.[49] *The Irish Times* once again reminded readers:

'…the society had begun in a small

Cover of the catalogue for the fiftieth exhibition of the W.C.S.I., held in February 1904 at the Leinster Lecture Hall, 35, Molesworth Street, Dublin.

COURTESY OF THE NATIONAL LIBRARY OF IRELAND

way, the Irish Fine Art Society was founded by a comparatively small number of cultivated and enthusiastic artists – amateurs and professionals – who saw that the time had come when an opportunity ought to be provided for the encouragement and development of a widespread general talent, to which (though strongly marked) little attention had hitherto been paid…Year after demonstrated the growth of artistic power, until at length the society found itself in a position to look forward to a solid future. It now is known as "The Water-Colour Society of Ireland" and it has earned that proud title by real merit.'[50]

For the occasion, the Leinster Hall was 'charmingly draped in a coloured material that harmonizes very agreeably with the gold frames'.[51] The

collection, 'a remarkably good one' and the best that has yet been seen in Dublin, saw a substantial number of entries – Frances Currey submitted no less than fourteen pictures.[52] Despite such enthusiasm, *The Irish Times* felt it was justified: 'Miss Fanny Currey has stood by the Society since its beginning, and it is with satisfaction that we notice some fourteen of her able works amongst its treasures.'[53] Helen O'Hara was just as enthusiastic as her friend, but her enthusiasm generated the opposite effect and only succeeded in arousing hostile criticism from the *Daily Express* (Dublin): 'Miss O'Hara has a habit of repeating herself from time to time…Some of the sea pieces remind us forcibly of predecessors…' and Rose Barton's watercolours, in particular *Trafalgar*

Photograph of military painter, Lady Elizabeth Southerden Butler, R.I. (1846-1933) painting in her studio at Dover Castle, c.1898.
The artist exhibited with the W.C.S.I. from 1908 until 1932 and was a member of the committee.
COURTESY OF THE NATIONAL ARMY MUSEUM, LONDON

Poole Addey, Mr Grierson, A.R. Wynne, Dr. Boyd, Mr. Gilchrist, Mr Colomb, Bingham M'Guinness, F.G. Coleridge and Lord Massy. Amongst the women artists were the Misses Webb, Boyer, Stronge, A. Currey, M.A. Butler, Arland Ussher, Bailward, Oniton, Reeves, J. Longfield, Celia Culverwell, Morgan, Guinness, Pollard, Helen Colvil, Harvey, Morgan, Henrietta K. Lynch, Nicholson, Macauley, Peel, Keogh, Trant, Katherine Fairholm and the Marchioness of Waterford.

The autumn of 1889 saw the Society travelling north to Belfast to hold their thirty-fourth exhibition in the Art Gallery housed on the top floor of the newly completed Belfast Free Public Library sited on Royal Avenue. In October the previous year, Queen Victoria had elevated the town of Belfast to the status of city. It had already begun to overtake Dublin in terms of population and industrial and commercial success. The development of industries such as linen, rope-making, engineering, ship-building and tobacco had all contributed to a rapidly expanding population.

The art scene was also thriving. In 1870 a new School of Design had opened in the city and was connected with South Kensington. It remained in existence for a period of thirty-six years and like its predecessors was open to both men and women. The objectives of the new institution were very similar to other schools of design throughout the island but Belfast succeeded in offering a broader curriculum. Under Tomas Mitchner Lindsay, headmaster, and George Trobridge, second master, the School appears to have been highly successful. Two years after its foundation, it was ranked fourth in the United Kingdom and achieved outstanding successes throughout the 1890s, obtaining a substantial number of scholarships to the South Kensington School (the Royal College of Art). Under Trobridge's headmastership drawing from the antique together with anatomy life classes were introduced, which ensured that the School was not only a School of Design but also a School of Fine Art.

Square, was singled out for praise: 'a masterly study of a well known and picturesque part of London'.[54] Paul Naftel's study of *Pitlochrie* did not strike the reviewer as being up to his usual standard, whilst his daughter, Maud's, watercolours obviously appealed and were described as nothing less than 'delicious'. Both Dublin papers urged their readers to visit the exhibition, *The Irish Times* felt that by doing so visitors would be doing nothing less than 'encouraging the aims and promoting the interest of the whole artistic community of Ireland'.[55]

The popularity of flower painting was beginning to increase as indicated by the high entry in this section for the exhibition. During the exhibition members were provided with a lecture entitled 'Flowers and Leaves in Art' (delivered on the evening of 20 March) by Frederick W.T. Burbidge (1847-1905), Curator of the Trinity College Botanic Garden and a botanical artist.

Landscape once again appears to have dominated, with submissions being received from such male artists as Alexander Williams, Edwin Hayes, General Sankey, Edward Eagle, Joseph

During the last decade of the nineteenth century, the city benefited from the economic boom with major public buildings such as the City Hall, Donegal Square and the Free Public Library (now known as The Central Library) being erected. The architect appointed to design the latter was County Down-born, William Henry Lynn, who had already completed the library of Queen's College (1865-8), and Belfast Castle (1868-70) along with several other major commissions. Described by architect, author and illustrator, Jeremy Williams, as a building which had been inspired by Louis XV1-style 'if a trifle self consciously', the Free Public Library was executed in Dumfries red sandstone on a black granite base.[56] It possesses a horizontally rusticated ground floor, Corinthian piano nobile and garlanded attic. Inside a suitably processional staircase with wrought iron balustrades leads to a splendid domed reference library. On the top floor, three well lit rooms were set aside in which exhibitions were to be staged. This was known as the Art Gallery (subsequently changed on 16 July, 1890 to become known as the Art Gallery and Museum). The floor was described by *The Northern Whig* as follows:

'To the left side [of the main staircase] there is an ante-room (thirty feet by twenty feet) and opening from it a picture gallery, or lecture-room (thirty feet by forty-four feet) and there is also on the left a large room suitable for an art museum. These room are lighted from the roof... the internal arrangements are likely to afford convenience in every department.'[57]

On the morning of Saturday, 13 October, 1888, dense crowds had thronged Royal Avenue, 'flags and banners and a handsome crimson cloth cover[ing[the platform. At 11.30 a.m. dashing dark brown horses drew the State carriage (on loan from Dublin Castle) entered the yard and shortly afterwards, one hundred men of the Gordon Highlanders accompanied by their band took up a position on the platform.'[58] 'In the presence of a large and brilliant assemblage…'[59] The library was opened by the Lord Lieutenant, the Marquis of Londonderry accompanied by his wife. 'The art gallery is undoubtedly the most attractive portion of the building, and contains the finest collection of art ever seen in Belfast…'[60] The bookless walls were lined with contributions relating to the loan exhibition. Over one hundred lenders had contributed 780 paintings and sculptures together with ten cases of antiquities, books and manuscripts and a printed catalogue which were on display, all having been assembled together in the space of around five weeks! Works by members of the Belfast Ramblers' Sketching Club occupied the south and east sides of Room C and the corridors much to the chagrin of one reviewer who remarked that 'So fine are these works that one may inquire why they do not occupy a more dignified position…'[61]

It was in these new and impressive art galleries on the top floor of the Free Public Library that members of the Water Colour Society of Ireland gathered to hang their second exhibition under their new title in the autumn of 1889. This consisted of around 350 pictures. Apart from watercolours, oils had been accepted together with several exhibits of decorative art and wood-carving. Before a large and fashionable gathering, which included the Bishop of Down, Connor and Dromore (Dr. Reeves), the Lord Mayor of Belfast and Chairman of the Library Committee, Sir Edward Porter Cowan, (himself a keen art collector), the Lord Lieutenant of County Antrim, and 'numerous ladies', Lady Cowan, wife of Belfast's Lord Mayor opened the exhibition. In her speech she mentioned that this was the first exhibition by the Society to take place in Belfast, and she hoped it would not be the last as she believed the exhibition to be far better than those held in Dublin or Cork!

The press, however, did not hold the same opinion. Under the title 'The Water Colour Society of Ireland's Belfast exhibition' one reviewer commented on the fact that the 'oil paintings and pastels form a by no means unimportant portion of the works exhibited, and it is somewhat difficult to see how this new departure can be reconciled with the title and aims of the association…'[62] The same paper went on to suggest that perhaps in their spring exhibition scheduled to take place again in Belfast, 'it will be found possible to limit the exhibits to work in water colour, or, at most, to make an exception only in favour of pastels, for there are in Dublin so many exhibitions open to painters in oil that there is scarcely any need for another mixed collection to be put on show, and there is ample room for one in which the water colour artists may have it all their own way.'[63]

Special mention was made of 'the gifted secretary to the society who will scarcely need to be assured that her contributions to the present exhibition are of a high order. Miss Currey cannot be considered as an amateur in any sense of the word save one, that she is not dependent upon the pursuit of art for a livelihood, and therefore the recent pungent objections to the general body of amateurs to which one of our clever young professional artists gave utterance cannot be taken as applying in any way to her'.[64]

Helen O'Hara's sea studies came in for some amusing comments: '[These] are at once so masculine and so poetical. If at times we feel that there is somewhat too close a relationship between these masterly delineations of rolling waves fuming and fretting against the broken rocks, it is simply because we have been surfeited with the sweets of art…'[65] The reviewer assured readers that Miss O'Hara should find many patrons in Belfast.

Other contributors to the W.C.S.I. Exhibition included the President of the Belfast Ramblers' Sketching Club, Anthony Carey Stannus, Mildred Anne Butler and Sarah Purser. The latter's portraits, in particular, attracted praise, Professor Purser being considered a 'fine likeness'.[66] The paper concluded by stating 'There are scores of works in the collection which deserve notice, but as this is necessarily a brief record rather than a study in detail, we can only hope that the Belfast public will not fail to find them and to enjoy them as they deserve to be enjoyed'.[67]

The following year, in November, for the Society's thirty-fifth exhibition, members had obviously taken the advice offered by Lady Cowan and returned again to the Free Public Library. Encouraged by the Curator of the art gallery, James F. Johnson, there were no less than 369 exhibits on view which included seventy-six oil paintings. A private view was held on 6 November, the day before the official opening, the arrangements being '…admirably carried out by Miss Currie, Mr A. Ussher, Mr Philip C. Trench, and Miss O'Hara…'; furthermore, *The Irish Times* hoped 'it would be greatly to the advantage of art in the North if this exhibition could be held here annually.'[68]

This was not to be the case. From 1891 onwards, it would appear that provincial exhibitions were largely discontinued, with the exception of a visit to Cork in November 1895, when members showed their work in the Crawford Municipal Schools of Science and Art. Instead, an annual Spring Exhibition was held in Dublin where the emphasis was placed on exhibiting watercolours only.

The opening of the March 1892 exhibition was not without amusement. The Lord Lieutenant's wife visited the exhibition on the Opening Day at 2.30 p.m. only to find that several of the pictures which she would have liked to have bought had already been purchased. A complaint to her husband resulted in a hand-written letter from the Lord Lieutenant, Lord Langford being despatched the next day from Dublin Castle to the Society's Secretary:

'If anyone should have had the right to have had the first selection, that right should have been reserved for them [the Lord Lieutenant and his wife]. Use is made of their name and of their presence for furthering the ends of the Exhibition and this is the way they are treated.'[69]

Employing as much diplomacy, tact and skill as he could muster, W.C.S.I. Committee member and Trustee, Philip Chenevix Trench replied the next day on behalf of both the Secretary and the Committee. He apologised for the fact that Their Excellencies were disappointed in not being able to purchase the pictures they most desired but pointed out that there were many hidden difficulties. It had always been the custom of the Society to allow members to buy a season ticket which enabled them to view on the morning of the opening and early in the afternoon prior to the opening at 3 p.m. During this period, many pictures had been 'starred'. In the Society's view, they were following the custom of the R.A., the R.W.S., the Royal Institute and the Dudley Gallery. In the case of the latter, as Chenevix Trench made clear, a 'Private View' was offered to the Queen, gallery members and friends. Determined to stand his ground, he continued 'We are aware that Their Excellencies formal opening is of great value to the Society and highly appreciate their kindness in coming, and are prepared to do anything we can to meet their wishes, but it must not be at the expense of our Artist Members, or habitual buyers who had stood by us from year to year, and made the Society what it is.'[70]

In response, a curt reply was received from the Lord Lieutenant. He did not wish to trouble the committee any further but stated that Her Excellency was never given the option of a private view. They had been treated in a shabby fashion and offered nothing by the Society in return.[71] In an effort to calm troubled waters, the Secretary of the Society responded pointing out that the previous year he had, in fact, suggested that there should be a Private View but due to a 'multitude of his duties' this had been overlooked: 'I am sorry that I did not act on an idea which did occur to me of purchasing *Haste to the Levee* myself in case His Excellency might fancy it as I felt sure that, even if not bought in the morning, some one would have purchased it…'[72] No response was forthcoming from The Castle and there the matter rested.

In order to accommodate the ever increasing number of entries, February 1903 saw the Society providing, for their forty-ninth exhibition, two screens on wheels. These had been 'constructed from a plan approved by The Royal Water Colour Society'.[73] The Society's financial state was now healthy, and it was therefore decided that the Art Union Funds should be added to by the 'accumulating funds of the Society, one prize of £15, two of £10 and others of smaller amount'.

It is interesting to note that throughout the closing decades of the nineteenth and well into the twentieth century, the number of exhibits accepted from both professional and amateur artists and placed on view at W.C.S.I. annual exhibitions tended to remain high and numbered, on average, 300-400 per exhibition. According to the press attendance was also good. This was in stark contrast to the R.H.A. where, since the second half of the nineteenth century, visitors to exhibitions had dropped from 28,480 (1874-85) to 7,967 (1894-1905). For the W.C.S.I.'s fiftieth exhibition, in February 1904, entries reached an all time high with 445 works on view. In the same year, and in an effort to streamline certain areas relating to administration, the Society published their own Rule Book. Rule 3 stated clearly that the number of members 'will not exceed 250'. From now on, no more than one exhibition was to be held each year in Dublin. Works of art eligible for exhibition would include only watercolours, etchings, sepia, chalk, pastel, pen and ink and pencil drawings, paintings on china (burnt in) together with modelling and wood-carving. In order to assist with the transportation and storage of members pictures, the Society appointed agents both in London and Dublin. Their task was to receive and store all pictures without cases, and, if the exhibits were not removed within a week after the closure of the Society's exhibition, a charge would be made.

Despite what *The Irish Times* described as 'prevailing conditions' being difficult in Dublin from 1916 onwards, the W.C.S.I. still continued to hold annual exhibitions (not all received a review) without a break, exhibiting on average a total of 300 pictures per year until well into the 1930s.

Clara Irwin (1853-1921) *Scotch Street, Armagh* c.1910, watercolour. Signed 'Clara Irwin'. Clara Irwin, daughter of John Robert Irwin, Carnagh House, Castleblayney, Co. Monaghan was a prolific exhibitor and committee member of the W.C.S.I., contributing 170 works (both townscape and landscape) to W.C.S.I. exhibitions between 1892-1921. Also a member of the Belfast Art Society from 1894, her interest in Armagh has provided an important series of topographical watercolours which capture the character of the town between 1880-1910. The scene depicted here shows the view up Scotch Street towards the cathedral on the hill. The horse's head on the building to the left denotes a saddler's shop, while the sign hanging above the doorway opposite is the entrance to a public house, The Prussian Arms.

Chapter X

The 'Exhibition' Watercolour (1880-1920)

W.C.S.I. MEMBERS: ROSE MARY BARTON, R.W.S., (1856-1929);
MILDRED ANNE BUTLER, R.W.S., H.B.A.S. (1858-1941);
JOSEPH POOLE ADDEY (1852-1922)

In Ireland, the organization of painters in watercolour into an exhibiting society – the W.C.S.I. – was to have a sizeable impact upon watercolour technique. The medium might never have evolved beyond the eighteenth-century tinted drawing had practitioners specialising in this area not been forced to compete and hang their works beside large oils in such venerable institutions as the R.H.A. or the R.A. Watercolours, generally small in size, fragile drawings or miniatures were crushed by the overwhelming presence of large, substantial canvasses which tended to relate to historical subjects, landscapes, portraits or genre executed in oil. There had to be another way in which artists specialising in the delicate art of watercolour might hold their own with the best that oil painters were capable of producing. This was one of the main reasons why watercolourists were forced to strengthen their technique in the nineteenth century. In order to attract the public's attention,

Sydney Smirke, R.A. (1798-1877) *Perspective of Proposed Design of Interior of Gallery 111, Burlington House, London, 1866-'67*, pencil, pen and ink, and watercolour.
It was in these R.A. galleries that W.C.S.I. members Rose Mary Barton, R.W.S. (1856-1929), Mildred Anne Butler, R.W.S., H.B.A.S. (1858-1941), Joseph Poole Addey (1852-1922) and other distinguished members of the W.C.S.I. exhibited their work from the 1890s onwards. COURTESY OF THE ROYAL ACADEMY OF ARTS, LONDON

Charles West Cope R.A. (1811–1890) *The Council of the Royal Academy Selecting Pictures for the R.A. Exhibition, 1876,*
oil. COURTESY OF THE ROYAL ACADEMY OF ARTS, LONDON

they had to devise methods relating to this fragile medium that would stand alongside the richness and power of oils.

The solution lay in developments in the field of technical achievement.

Almost from the beginning of the nineteenth century a wide range of colours were being made available to the artist, largely due to scientific and industrial discoveries – magenta, cobalt violet, manganese violet, yellow, viridian green and ultramarine. The introduction of new white pigments, Permanent White (1831) and Chinese White (1834), mixed with a variety of pigments created opaque colours of an even texture which resulted in a rich and wide variety of tonal range and gave rise to what was and is still known today as 'body colour' or 'gouache'. This consistency was thicker than pure watercolour and made it easier for the artist to manipulate and interpret intricate detail.

A late nineteenth century exhibition watercolour frame. PRIVATE COLLECTION

From the beginning, the use of body colour was a constant source of controversy in the art world. This opaque colour was seen as the great distinguishing feature which separated the previous generation of water-colourists from many nineteenth century practitioners. Influential teacher and watercolourist, James Duffield Harding, O.W.S. (1797-1863), author of *The Principles and Practice of Art* published in 1845 painted in both body colour and also in 'pure' colour washes. He maintained that body colour, and particularly Chinese white, precluded the need to resort to the 'bungling practice' of scraping or sponging out in order to achieve highlights. Many of Harding's views were adopted by his pupil, painter, poet and social reformer, John Ruskin, (1819-1900) who remained convinced throughout his life that 'the greatest things to be done in art must be done in dead colour' (i.e. body colour).[1]

Artists now no longer created slim pen and ink outlines, slowly and laboriously building up thin washes of watercolour on sheets of pure white paper to produce luminous, translucent

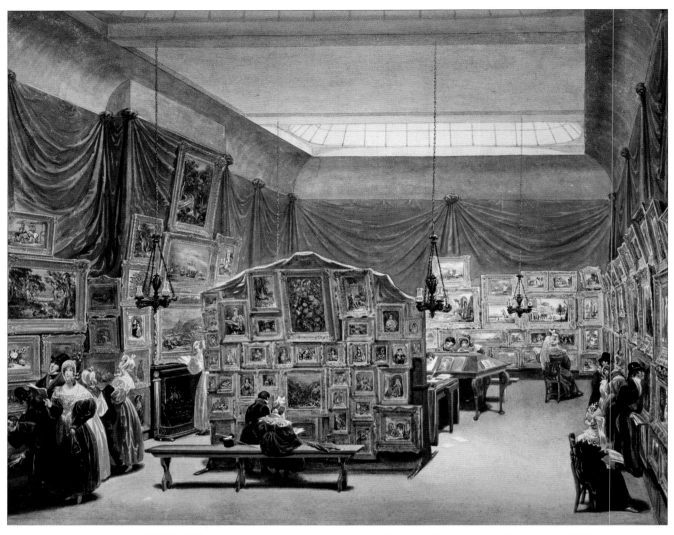

George Scharf (1788-1860) *Interior of the gallery of the New Society of Painters in Water-Colours, Old Bond Street 1834*, watercolour over pencil. Signed and dated 'G. Scharf Pinxt. 1834'. Note the hanging scheme combined with the richness of the dark, carefully arranged, heavy red draperies. The closely hung watercolours are framed in gesso frames complete with ornate baroque motifs. Viewed in a diffused light, the scene was one of richness and opulence and was independent of the actual watercolours themselves.

effects. Now by employing body colour the watercolourist was able to load colour to a full impasto, to identify every dot by stippling and was at liberty to introduce a wide range of techniques. One of the greatest exponents, J. M. W. Turner, R.A. (1775-1851) devised simple methods such as stopping-out, sponging, scraping, rubbing, or simply wiping, cutting or scraping away colour with a knife or fingernail to expose the white paper underneath. These methods were now to become common features in nineteenth-century watercolour painting.

The quality of paper was also improving. In 1808 Ackermann was able to offer around eight different types of paper to their customers, which included wove and cartridge, vellum and rough surface paper, the latter's flecks and irregularities adding a subtle texture to the finished work. Many watercolourists now borrowed techniques from painters in oil. In order to achieve deep tones and colour and to avoid any loss of transparency, they applied a glaze over successive layers of transparent colour. This modulated bright tones and succeeded

in creating a soft, atmospheric quality.

The taste for substantial, large gold frames combined with a plain gilt slip surrounding the watercolour began to gather momentum. From around 1880 onwards this type of frame came to dominate the watercolour exhibition, the gold slip gradually becoming more broad and mat-like. The popularity of these types of frames lasted well into the twentieth century. A gallery hung with watercolours encased in these impressive, solid frames could hold its own 'as powerfully as pictures in oils'.[2]

In the Victorian era there emerged

W.C.S.I. exhibitor, Rose Mary Barton, R.W.S. (1856-1929) from *The Lady of the House,* 15 January, 1896.

Rose Mary Barton R.W.S. (1856-1929) *Child with a White Cap*, watercolour and body colour over graphite. Signed 'Rose Barton'. Miss Rose Barton was elected an Associate of the Royal Society of Painters in Water-Colours in 1893 and attained full membership in 1911. This simple, uncluttered composition was the artist's Diploma work. The artist had already been exhibiting with the Water Colour Society of Ireland (known then as The Irish Amateur Drawing Society) from as early as May 1872. (Carlow).

two distinct types of watercolour: the finished work prepared by artists for the purpose of exhibition (the 'exhibition watercolour') and the preparatory study or sketch. The finished watercolour for public exhibition was frequently worked on for a considerable period of time by the artist, was generally large in scale and capable of holding its own with works in oil. On this work rested the painter's professional/public reputation.

An exhibition watercolour entitled *Child with a White Cap* earned W.C.S.I. artist Rose Mary Barton her diploma from the Royal Watercolour Society. This work not only represents Barton's love for the world of children but demonstrates her painterly virtuosity and ability to render a wide variety of textures. Like English watercolourist, John Varley (who was one of the first to introduce the combination), Barton unites body colour (white pigments) here with pure watercolour. A strong interest in texture – brick, moss and stone is supported by the broad use of the brush. Employing a mixture of wet-in-wet and dry brushwork, the stone wall is loosely conveyed in the background whilst body colour is used to reinforce the various areas of moss, and graphite acts as a guide for the figure.

Rose Mary Barton R.W.S. (1856-1929) *The Garden, St. Anne's Clontarf, Dublin 1900*, watercolour and body colour. Signed 'Rose Barton 1900'. This watercolour was exhibited in the R.W.S. annual exhibition under the title *The Yew Hedge at St. Anne's Clontarf* (cat. no. 168) held in December 1900. *The Ladies Field,* reviewing the exhibition, noted the watercolour was 'the largest, a picture of the curiously-cut yew hedges in Lady Ardilaun's Garden at St. Annes and occupies one of the places of honour.' (*The Ladies Field,* December 1900). This work also appeared in J. Crampton Walker's *Irish Life and Landscape* (1926, p.99).

Augustus Edwin John (1878-1961) *Portrait of Jacques-Emile Blanche 1921.*
Both Rose M. Barton, R.W.S. (1856-1929), and Jacques-Emile Blanche (1861-1942) were pupils of Henri Gervex (1852-1929) in Paris during the same period. A painter of eminent writers, artists and musicians and a well known figure in artistic and society circles, Jacques-Emile Blanche was closely associated with Manet and Degas. A friend of Oscar Wilde, both he and Wilde shared many friends including Sickert, Beardsley and Rothenstein. PRIVATE COLLECTION

A relaxed and uncluttered work, Barton places the child's cap at the centre of the composition, the left arm controls the child's balance, her right hand is busy exploring. The artist cleverly does not allow the viewer to see the face of the child but the position of the body conveys to the spectator the little girl's excitement on the eve of her new discovery. This watercolour adorned the cover of *The Glory of Watercolour – The Royal Watercolour Society's Diploma Collection* published in 1987. Accepted as Barton's diploma work, it resulted in this Anglo-Irish painter being elected A.R.W.S. in 1893 and a full member of the Royal Watercolour Society in 1911. The artist was to maintain her links with this Society throughout her life.

Barton contributed a total of 121 works to W.C.S.I. annual exhibitions. The painter's connection with the Society began in the spring of 1872. In May of that year, aged sixteen, Barton exhibited in the 'Water Colour Copies' section at the Society's third exhibition held in the Club -House, Carlow. Her name caught the reviewer's eye at the ninth exhibition organised (March 1876) when *The Irish Times* described her work entitled *St John and the Lamb (after Murillo)*, which had been entered in the Water Colour Copies Class (figures) as 'a very careful picture' and well deserving of first prize.[3] Barton also succeeded in being awarded first prize in two further classes in the same exhibition – Studies from still-life in oils and water colours, and Studies of animals in oils and watercolours. October 1878 saw this artist exhibiting at the Society's twelfth exhibition held

in the Round Room of the Athenaeum (Theatre Royal), in Cork. The *Cork Examiner* was quick to spot her talent: '*Dead Game* and *Pheasants* by Miss Rose Barton are by far the best pictures in the collection.'[4] Unlike many of her contemporaries, throughout Rose Barton's career her pictures continued to attract press coverage. In March 1888 at the Society's Dublin exhibition the *Daily Express* (Dublin) noted that here was a rising artist 'whose progress during the last two years has been remarkable. Her paintings are excellent *No. 105 St. Patrick's Close* …is painted with great vigour and fidelity …her position in the world of art is secure.'[5] By March 1879 Barton had been elected to the Irish Fine Art Society's committee and supported the exhibition by exhibiting a total of four pictures together with a screen.

Barton was a professional artist who came from a wealthy and privileged background. She was one of those good watercolourists whom critics recognised during her lifetime, an artist who consistently produced, sold, exhibited widely and worked hard to earn a living from painting. Professional in her approach, she exhibited for the first time at the R.H.A. in 1878 and three years later submitted four entries to the Dublin Art Club. Anxious to establish herself as a professional artist, Barton around 1880 also began to market and exhibit her work in London in the small, commercial fashionable galleries which centred in or around New Bond Street, Piccadilly and Pall Mall.

Throughout the 1880s and '90s, Rose Barton was successful in having her work accepted and hung in the thriving Dudley Gallery which had been established in 1864. The gallery, which became known as the Dudley Art Society in 1883, possessed a membership of around 150 members and was open to painters both in watercolour and oil. Unlike many other galleries, it managed to extract a sizeable seventy-five per cent commission on sales. Sited in Piccadilly and confined to one room located inside the larger Egyptian Hall, the gallery had been established to serve as

Rose M. Barton, R.W.S. (1856-1929) *Going to the Levee at Dublin Castle* 1897, watercolour. Signed 'Rose Barton 1897'. This watercolour relates to an important series of social events, the 'Castle season' which generally began in February each year and ended around St. Patrick's Day (17 March). The scene shows the carriages turning from Dame Street into Cork Hill to enter the Castle Yard under the Gateway of Justice This work was exhibited by the artist at the W.C.S.I. exhibition held in 1897 (cat. no. 314.) COURTESY OF THE NATIONAL GALLERY OF IRELAND

Photograph of W.C.S.I. member, Rose M. Barton, R.W.S. (1856-1929) seated at her writing desk.

Rose Barton, R.W.S. (1856-1929) *View of Lismore Castle from across the River Blackwater, County Waterford* 1900, pencil and watercolour heightened with body colour. Signed and dated.

a direct rival to the R.A. Despite cramped surroundings and crowded hanging conditions, it succeeded in mounting a wide variety of exhibitions each year including a spring exhibition specialising largely in watercolour, a black and white show and a winter exhibition which was confined to oil only.

In 1884 Rose Barton's work was hung in the Royal Academy for the first time (*Paraquet*). The artist now began to gain financially from the sale of her attractive, atmospheric, largely exhibition watercolours; growing in confidence, the painter continued to promote and exhibit her work both in Ireland and London. In February–March 1893, sixty views of London together with a number of coastal scenes, the work of a 'Miss Barton', was hung in the Japanese Gallery located at 28, New Bond Street.

Examples of Barton's work were also on view in the fashionable Grosvenor Gallery which had been established in the same street (Nos. 135-137) in 1877. Its co-founders were Sir Coutts Lindsay (1824-1913) and Lady Blanche Lindsay (1844-1912). The couple's 'palace of art' was 'much more than an elite enclave, for Sir Coutts Lindsay was a visionary whose notion of artistic integrity, museum amenities, audience needs, and aesthetic display ally him more with the modern-day museum director than with a Victorian counterpart'.[6] During its fourteen-year lifespan, this gallery exerted a formative influence on Victorian contemporary taste and culture with the owners anxious to promote the work of contemporary artists. Many W.C.S.I. members were encouraged to exhibit here, including Frances Wilmot Currey, the Marchioness of Waterford, and Mildred Anne Butler

As far back as 1880, Barton's work had been accepted for an exhibition organised by the Society of Lady Artists, founded around 1855. One of the Society's principal objectives was to strive to obtain critical acclaim from the male-dominated art world, and to shift the emphasis away from the R.A. In 1886 Barton became an Associate and throughout her career sought to maintain close links with this group

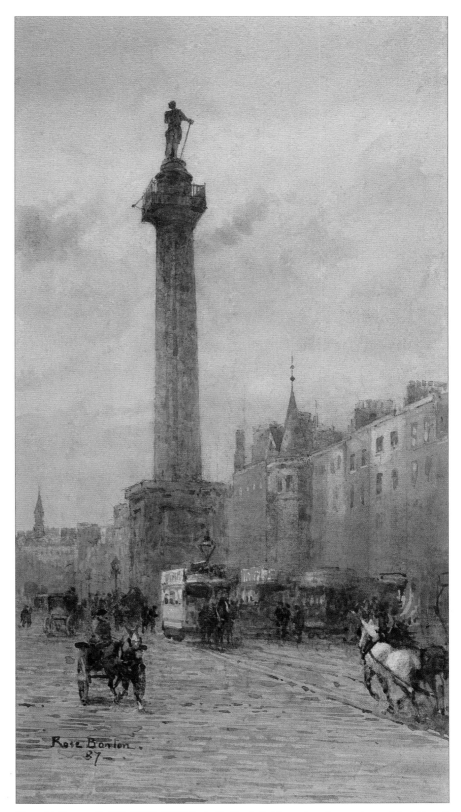

Rose M. Barton, R.W.S. (1856-1929) *Sackville Street, Dublin*, watercolour and pencil heightened with white.
COURTESY OF THE GORRY GALLERY, DUBLIN

Photograph of New Bond Street, London around 1885.

exhibiting a total of twenty works.

Like her cousin Edith Somerville, Rose Barton was also a talented illustrator contributing to *Picturesque Dublin Old and New* by Frances A. Gerrard (the pseudonym of Geraldine Fitzgerald). In June 1898 the Clifford Gallery, which had moved from Piccadilly to the Haymarket and was the brainchild of art dealer, print-seller and colourist, C.E. Clifford, exhibited a number of watercolour drawings/ illustrations of London by Rose Barton. Later, many were to be incorporated into Barton's well known *Familiar London* (1904) which the artist both wrote and illustrated.

Around the turn of the century, the English press began to take note of this gifted female artist from Ireland. *The Ladies Field* commented in December, 1900:

'Among the women artists who claim membership of the Society [R.W.S.] the greatest prominence has been given by the hanging committee to the work of Miss Rose Barton…And it is only fair to say that Miss Barton deserves the excellent positions which have been allotted to her drawings…The largest, a picture of

the curiously-cut yew hedges in Lady Ardilaun's Garden at St. Anne's occupies one of the places of honour.'[7]

On her death, *The Times* described Rose Barton as:

'An artist of some considerable ability, Miss Barton was a well-known figure in art circles in Dublin before she took up residence in London some years ago. She achieved most distinction in the production of watercolours, many of her pictures being highly praised by leading authorities in both Dublin and London.'[8]

The second of two daughters of solicitor, Augustine Barton of Rochestown, Co. Tipperary, and Elizabeth Riall, Rose Mary Barton (together with her sister, Emily Alma) was educated privately at home by a German governess who instructed the girls in drawing and music. She also received further art training from a Miss Jane Underwood of Herbert Place 'a well known teacher in Dublin circles'.[9]

Following the death of her father, Barton travelled to Brussels with her mother and sister. There she participated in both painting and

drawing classes before going on to Geneva. In the late 1870s, Barton was in London studying under landscape painter Paul Naftel. In the 1880s she moved to Paris and became a student of watercolourist, illustrator, and fashionable teacher, Henri Gervex (1852-1929). Born in Paris, Gervex had studied at the Ecole des Beaux-Arts under Alexandre Cabanel (1823-1889). His fellow pupils included Jules Bastien-Lepage (1848-1884) and Henri A.G. Regnault (1843-1871). An artist who broke with the official Salon to become a founder-member of the Societé Nationale des Beaux-Arts, Gervex's work adopted the appearance of the Impressionist style without quite understanding its essence. Whilst in Paris, Barton may also have seen the work of her fellow student and Gervex's most notable pupil, namely Jacque Emile Blanche (1861-1942) whose somewhat subdued Impressionistic colouring is similar to her own. It was in France that many of the characteristics, such as the obvious influence of Impressionism, a liking for bright colours, love of *plein air* sketching combined with a skill at depicting commonplace everyday subjects began to make themselves felt in this painter's work and were to remain with Barton for the remainder of her career. Other influences such as Turner and Whistler were also to play their part.

A watercolourist, fascinated by both London and Dublin, Rose Barton captured both cities in atmospheric street scenes: 'the blue-grey fog that turns the end of a London street, as you look down it, into mystery and beauty that give to the present a tinge of the uncertainty of the future, and throw a halo of poetry over the most commonplace homes…'[10] Her ability to employ watercolour in order to portray the damp and atmospheric winters of Dublin is beautifully demonstrated here in *Going to the Levee at Dublin Castle*, which was exhibited in the W.C.S.I.'s annual exhibition held in 1897. Here the artist succeeds in handling the wide variety of textures, the road surface, carriage, ironwork and building together with the crowds of people with consummate skill.

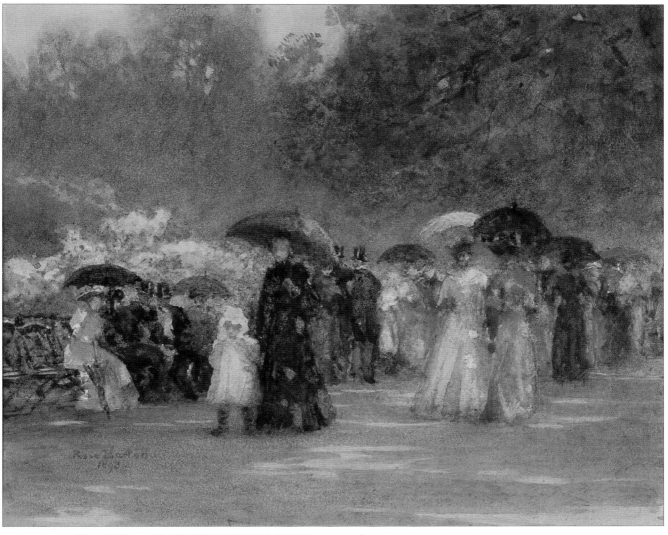

Rose M. Barton, R.W.S (1856-1929) *Hyde Park, May*, watercolour.

An indication of Barton's working methods can be gleaned from a letter dated 12 March, 1922 which was found attached to her exhibition watercolour entitled *Here we dance, Lubin, Lubin* executed in 1897. (This work was exhibited in four major exhibitions including the W.C.S.I., 1898). It read:

'I am pleased you have got "Lubin, Lubin" I had the first idea for it in an old sketchbook which I will send you if I can find it. I think I must have begun it in 1897. I went down to Kensington for a fortnight….And I painted it here. I expect I put it away I often do for some years…'[11]

As art historian Rebecca Rowe has pointed out, Barton composed quick, lightening sketches on the spot, out of doors, full of detail and frequently in colour. She then used these sketches to produce the finished watercolour in her studio. In the view of Rowe, Barton was not strictly a *plein air* painter, although many of her watercolours possess an atmospheric *plein air* quality with their loose brushwork and soft outlines.

The latter part of Barton's life was largely spent in London, sketching, painting and contributing work to a number of exhibitions, including a small collection of three watercolours which were included in the loan collection of pictures exhibited in the Corporation of London Art Gallery in 1904. She loved entertaining her Irish relatives when they came to stay: '…they can recall the kindly old lady, who entertained them in her untidy artist's flat, which they used to visit on their way back to school, having travelled over from Ireland…'[12] She also found time to become involved in helping to organise, together with W.G. Strickland, George Russell 'A.E.' Count Markiewicz and others such prestigious exhibitions as the Watts Memorial. This exhibition, held in the R.H.A. in March 1906, was to honour one of the last grand allegorical history painters of the day, George Frederic Watts, O.M., R.A., H.R.C.A. (1817-

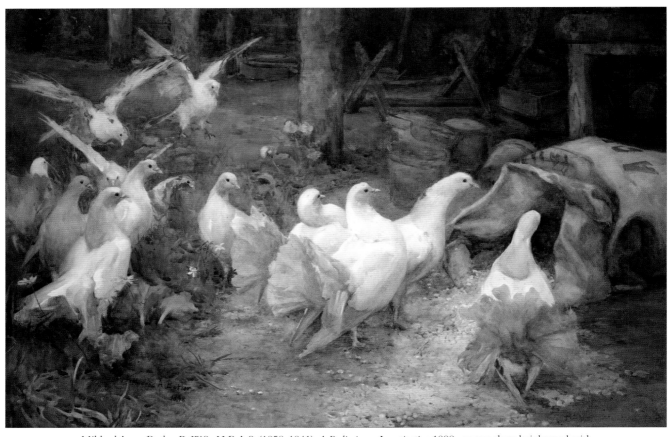

Mildred Anne Butler, R.W.S., H.B.A.S. (1858-1941) *A Preliminary Investigation* 1898., watercolour heightened with body colour. Signed and dated: Mildred A. Butler 1898. This exhibition watercolour was exhibited in the Royal Academy, London in 1899 (cat. no. 1116). COURTESY OF THE NATIONAL GALLERY OF IRELAND

Mildred Anne Butler, R.W.S., H.B.A.S. (1858-1941) 'Study for A Preliminary Investigation' c.1898, black chalk on paper. COURTESY OF THE NATIONAL GALLERY OF IRELAND

Sir Alfred Munnings, P.R.A. (1878-1959) *Kilkenny Horse Fair* 1922, oil. Sir Alfred Munnings was, like Mildred Anne Butler, a pupil of William Frank Calderon's R.O.I. (1865-1943) School of Animal Painting (1894-1916). This was the artist's Diploma Work accepted by the R.A. in 1925. COURTESY OF THE ROYAL ACADEMY OF ARTS, LONDON

1904) and succeeded in drawing large crowds.

Barton died in her London home, 79, Park Mansions, Knightsbridge on 10 October, 1929. Four weeks later the committee of the W.C.S.I. recorded the death of one of its most distinguished members:

'Its sense of the great loss the Society has suffered in the death of Miss Rose Barton, R.W.S. one of its oldest and most valued members. Miss Barton, who was an artist of very exceptional ability and had her works shown annually in the Exhibition of the

Royal Water Colour Society in Pall Mall and at our own Exhibition here and they have always commanded admiration owing to their excellent composition and charming colour.'[13]

At the Society's meeting held in April 1930, it was decided that a memorial exhibition of Rose Barton's work should be held, the majority of watercolours being lent by her relative, the late Major MacCalmont and other members of her family. Again, in 1970, this artist was honoured when her watercolour, *Going to the Levee* (illustrated here) was included in the

W.C.S.I. Centenary exhibition.

W.C.S.I. member, Mildred Anne Butler's, R.W.S., H.B.A.S. (1858-1941) *A Preliminary Investigation*, is a splendid example of a Victorian exhibition watercolour, large in scale, and designed to be framed in a heavy gilt frame and displayed as if it were a work in oil. (A preliminary study for this work, executed in black chalk, is in the N.G.I. dating from c.1898 and illustrated here). This large-scale work was exhibited at the Royal Academy in 1899. Ambitious in technique, Butler combines watercolour heightened

with white to illustrate her subject. The doves tentatively approach an open bag of corn, probably planted by the artist herself for the unsuspecting birds in order to give the painter an opportunity to study the group at firsthand. Birds and animals were this artist's forte. Butler had the ability to capture their endearing and often humorous personalities with great skill as demonstrated here.

Mildred Anne Butler's earliest spirited sketches date from around 1878 and would appear to have been influenced by her father, Captain Henry Butler, (1805-1881) a grandson of the eleventh Viscount Mountgarret. He was born at Kilmurry, on the outskirts of Thomastown, Co. Kilkenny and after graduating with a first class honours degree from Trinity College, Dublin was commissioned into the 27th or Inniskilling Regiment of Foot in May 1827. Whilst travelling with his troops in Southern Africa in the 1830s, he recorded what he saw in a wide variety of styles which ranged from caricature to the strangely exotic seen in his series of illustrated hunting scenes, *South African Sketches* published by Ackermans, London (1841). Considered to be 'an excellent draughtsman and amateur artist', his watercolours, together with a number of black and white drawings form a unique record of the landscapes, social circumstances and peoples of Southern Africa and today may be seen in the Africana Museum, Johannesburg. On his return to the rural peace and tranquillity of Co. Kilkenny, Butler's interest in art appears to have left a lasting impression on his young daughter.

Anxious to receive art training, Mildred Anne Butler enrolled at the Westminster School of Art, London, located at 18, Tufton Street in Westminster, where it formed part of the old Architectural Museum. During this period the School was under the enlightened headmastership of Frederick Brown (1851-1941). He had trained at the National Art Training School, London (later Royal College of Art) and had become weary of the mechanical teaching methods then dominant in Britain. As headmaster at the Westminster School of Art (1877-

92) he was inspired by Alphonse Legross's (1837-1911) reforms which Legross had begun to introduce following his appointment as Professor at the Slade School of Art (1876). Brown taught his students basic observational and analytical skills whilst encouraging them to develop their individual style, all of which Butler was to keen to absorb and develop from the beginning in her career.

The artist's first journey to Europe appears to have taken place in 1885. Travelling in the company of a relation, Lady French, Butler journeyed through France and the Swiss lakes on her way to Italy. These early Swiss and Italian views reveal the influence of teacher, Paul Jacob Naftel. The artist always maintained that Naftel was highly influential and indeed central to her development. This Guernsey-born artist and gifted teacher closely followed the style of David Cox washing his colours vigorously onto thick 'rough' paper, and achieving atmospheric effects by laying emphasis on scudding cloud formations, water and wind-swept landscapes. Like her teacher, Butler was an assiduous chronicler of detail, as early drawings reveal. However, it would appear the guidance offered by Naftel was informal and took the form of letters, the young art student despatching a portfolio of drawings and watercolours each month which her teacher assessed and then returned. Butler's interest in animal painting led her, in 1894, to the studio of Founder and Principal of a School of Animal Painting (1894-1916), William Frank Calderon R.O.I. (1865-1943) who was to number amongst his students, distinguished sporting artists, Lionel D.R. Edwards, R.I.., R.C.A. (1878-1966) and Sir Alfred Munnings P.R.A. (1878-1959). Butler remained in the school for one term and watercolours such as *A Preliminary Investigation* executed four years later (mentioned above) are probably a result of Calderon's influence and tuition.

Like many of her contemporaries both in England and Ireland, Butler was drawn to the artistic colonies that began to become fashionable both in

France and England in the late 1860s and '70s. One of the most important was established in the small fishing village of Newlyn in the early 1880s which lay close to Penzance, Cornwall. In the summer of 1894, and in the company of painter and member of the W.C.S.I., May Guinness, Butler served the final phase of her apprenticeship in the studio of Realist painter, Norman Garstin (1847-1926) in the little fishing village of Newlyn. The following summer she returned for a further two months. A number of Irish painters who later became members of the W.C.S.I. studied under Garstin at the Newlyn School. Therefore it is worth looking at what this Co. Limerick-born painter set out to achieve in Cornwall in the closing decades of the nineteenth century.

Born in the Old Parsonage, Caherconlish, Co Limerick in 1847, Norman Garstin studied engineering and architecture. Somewhat late in life, he turned to painting:

'I met a painter sportsman who seriously advised me to take up Art as a profession. After a lot of thought I was determined to have a good try and so started for Antwerp, in which Academy I studied for a couple of years under Charles Verlat,The last six months of my stay in Belgium I painted in the country with Theodore Verstraete.'[14]

After travels in Brittany, the south of France, Italy, Morocco and Spain, Garstin finally settled in Newlyn in 1886. Kind, modest and self-critical, this 'distinguished looking Irishman whose delightful wit and fine artistic insight soon began to charm us'.[15] He settled down both to paint and to teach. Together with Irish artist and teacher, Stanhope Forbes, R.A. (1857-1947) who was already well established in this Cornish fishing village, the two Irish painters found themselves united in their common hostility to academic art and both shared a commitment to *plein air* painting and Realism. They began introducing *plein air* subjects and French methods into England. 'The plein artists were then in the ascendant. Millet and Manet with their palettes of revolt, and Lepage with less of revolt, but with a very clear open-air eye. The

direct inspiration of nature was the creed of the way, and a feeling of reaction from academic traditions, and studio work as opposed to work on the spot, actuated most of the students.'[16] Whenever possible, classes were held out of doors, on 'the fine days when the students pitch their easels in a glade of the Meadow, shaded and sheltered by overhanging trees.'[17] Painting *plein air* was considered to be the most binding principle of the Newlyn artists but as Garstin amusingly remarked: 'Your work cannot really be good unless you have caught a cold doing it.'[18]

From 1899 Garstin, in order to help supplement his income, began to take parties of art students on study trips abroad in the summer – what he called his 'tutorials'. Garstin and Forbes' love of unusual perspectives and viewpoints from chimney pots to coastlines or sloping streets appear to have provided Butler with a new and somewhat unconventional approach to landscape. This is expressed in the artist's *A View Across Rooftops to Newlyn Harbour* (?) *Cornwall* (inscribed on verso '1894'), an aspect of her teacher's influence which was to remain with this artist for the rest of her painting career.

Butler's watercolour relating to Newlyn Harbour depicts angular rooftops in the foreground that become the main focus of the work. Unusual perspectives and Butler's ability to concentrate on one point of the composition, paint it in detail and reduce the remaining part of the work to a somewhat generalised form, became hallmarks of this artist's mature style and were probably 'a result of her two sessions with Garstin'.[19]

Throughout her life, this artist's subject matter remained simple, unsentimental and combined with broad washes and use of strong colour; she displayed a natural gift for understanding the distribution of light and shade. Following in her teacher's footsteps, Butler was a keen advocate of *plein air* painting. However, a sizeable proportion of her work was carried out in the studio from detailed notes that had already been recorded on the spot together with small drawings. The artist made full scale charcoal cartoons

Sir John Lavery, R.A., R.S.A., R.H.A. (1856-1941) 'Sketch for A Pupil of Mine', oil on panel. Artists' colonies became a feature towards the end of the nineteenth century; painting *en plein air* becoming one of the binding principles of Newlyn artists such as W.C.S.I. members, Mildred Anne Butler and May Guinness. COURTESY OF THE FINE ART SOCIETY, LONDON

for her large scale watercolours, and when painting animals frequently relied on stuffed specimens, photographs or her own acute powers of observation.

Like Barton, Butler was an efficient businesswoman and kept careful records of her exhibitions, purchasers, and criticisms. She exhibited on a regular basis in London from 1882 onwards and in 1889 had two works accepted for the Royal Academy. By 1891, her work was steadily gaining recognition in London. *The Queen* commented on her composition

entitled *Out in the Open* and hung in the 1891 R.A. exhibition:

'Both animals and landscape in this picture are full of that nature of which Miss Butler delights…working under the able instruction of Mr Naftel, and so rapidly improved that she has been an exhibitor at the R.A., the Institute and is now an Associate of the Lady Artists' Society'.[20]

Throughout the 1890s (with the exception of 1897) this professional artist succeeded in having her paintings accepted and hung in the Royal Academy. Like Barton, Butler was also

Mildred Anne Butler, R.W.S., H.B.A.S. (1858-1941) *A View Across Rooftops to Newlyn Harbour(?) Cornwall,* watercolour on board. Inscription (on verso) '1894'.

COURTESY OF THE NATIONAL GALLERY OF IRELAND

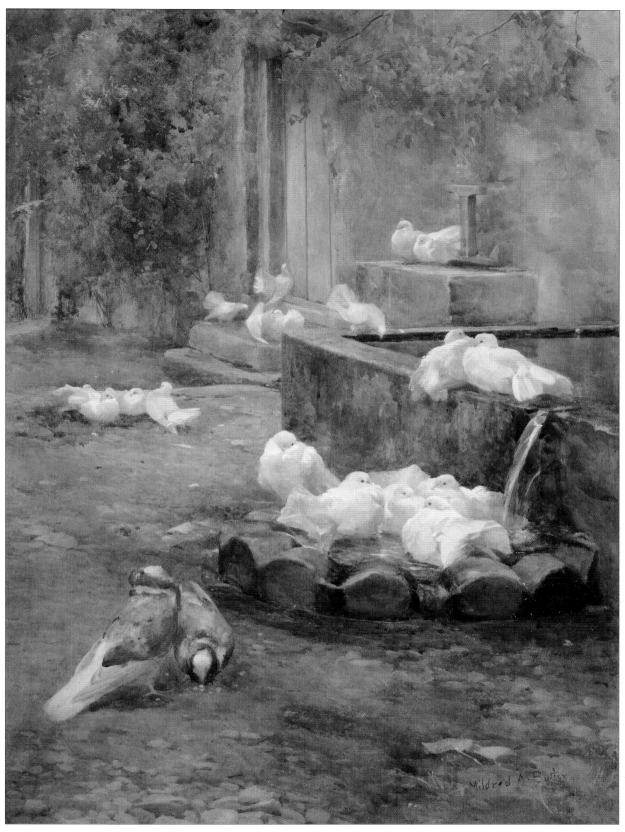

Mildred Anne Butler, R.W.S., H.B.A.S. (1858-1941) *The Morning Bath*, watercolour. This exhibition watercolour hung in the Royal Academy exhibition, 1896. In the same year, the artist was elected an Associate of the R.W.S. (February, 1896).

Photograph of Mildred Anne Butler, R.W.S., H.B.A.S. (1858-1941) painting in the foreground, with her family home, Kilmurry, Co. Kilkenny in the background.

a member of The Society of Lady Artists. In 1893, the artist was invited to contribute to a portfolio of drawings presented by the Society to Princess May (later Queen Mary) to celebrate her forthcoming marriage to the Duke of York. Together with Barton and other selected members of the R.W.S., Butler was also invited to present a picture to Edward VII to commemorate the first year of his reign. Later, in 1910, his wife, Queen Alexandra, purchased one of the artist's watercolours.

A hard worker and efficient businesswoman, Butler also exhibited as far afield as Japan (1921), and in London at the Dudley Gallery, (from 1888), the R.W.S., the New Gallery and the Fine Art Society, New Bond Street. The latter, according to their advertisement which appeared in the pages of a publication entitled *Year's Art*, (1899) edited by writer, art dealer, and a director of the Fine Art Society, Marcus Bourne Huish aimed:

'to present a constant succession of Exhibitions … held at the Rooms of The Fine Art Society, Bond Street, entrance 5s., free to purchasers, undertakes engravings and etchings portraits, employs special staff in departments of frame-making and mount-cutting: Excellent workmanship and novelty of design are specially aimed at.'[21]

Mildred Anne Butler's paintings were also to be seen in Liverpool at the Walker Art Gallery, the Belfast Art Society beginning in 1893, and the R.H.A. where she contributed a total of five works commencing in 1891. In February 1896 the artist was elected an Associate of the R.W.S. In the same year (1896) Butler had the satisfaction of seeing her watercolour entitled *The Morning Bath* purchased by the Chantrey Bequest at the Royal Academy exhibition. Later, this work became part of the Tate Gallery Collection. Despite this artist's professional reputation gaining ground, she was not elected a full member of the R.W.S. until 1937, four years before her death.

Mildred Anne Butler's paintings did not attract nearly as much attention in either the Irish or English press as that of her friend and contemporary, Rose M. Barton. The *Daily Express* (Dublin) lists Butler as being a member of the W.C.S.I. committee for the first exhibition held under the Irish Fine Art Society's new title, the W.C.S.I. in March, 1889 and held in the Leinster Lecture Hall, 35, Molesworth Street, Dublin. The paper, commenting on her work noted: '*Following the Plough* No.61 is excellent', adding 'Miss Butler therefore proves her claim to be considered a true artist'.[22] The *Belfast Newsletter* was more restrained and described her 'very clever treatment of a difficult and unpicturesque subject…'[23] And in November two years later mentions her 'proficiency in the composition of catchy subjects'.[24]

The painter's links with the Irish Fine Art Society begun as early as 1880 when she exhibited three pictures, two being animal studies – *Study of Teal* and *Stable Companions* in their fifteenth exhibition held at 35, Molesworth Street, Dublin in March of that year. Until 1938, just three years before her death and almost without a break, this artist contributed over 250 paintings to the Society's annual exhibitions, sending on average three entries per year. Subject matter ranged from landscape, garden scenes, animals, birds and flowers.

Butler is listed as a W.C.S.I. committee member for the first time in conjunction with the Society's first exhibition held under its new title of the Water Colour Society of Ireland in March 1889. A regular attendant at W.C.S.I. committee meetings, in 1922 she was forced to write to the Secretary of the committee (A.V. Montgomery) to explain that she was finding it difficult to attend their meetings. However, the Society did not forget her: in their annual exhibition which opened on the 15th April, 1931 (238 exhibits) one screen was reserved for 'Miss Mildred Butler's Pictures'.[25]

Increasing difficulties due to arthritis and the war had curtailed the artist's travels. Now annual summer holidays were spent at nearby Tramore, Co. Waterford. Butler's subject matter tended to became more 'local', as the artist began to concentrate on painting in the demesne and gardens surrounding her home, Kilmurry, near Thomastown, Co. Kilkenny. There, surrounded by the beeches: 'great domes of ruby purple some of them,

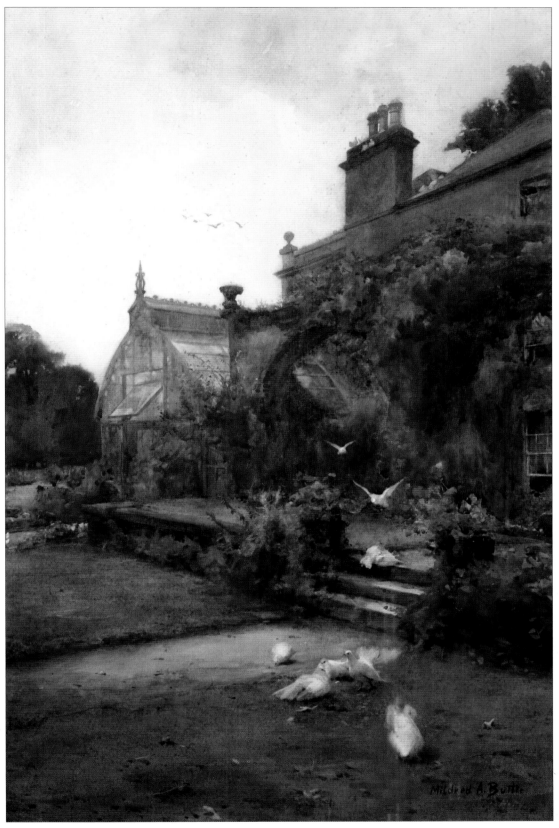

Mildred Anne Butler, R.W.S., H.B.A.S. (1858-1941) *Doves outside the conservatory, Kilmurry, Thomastown, Co. Kilkenny,* pencil and watercolour heightened with body colour. Signed 'Mildred A. Butler' (lower right).

Joseph Poole Addey (1852-1922) *Self-Portrait* PRIVATE COLLECTION

but most where of the delicate shimmering green that is the lovely coming out dress in which they greet the summer, and in their thin shade, the wild bluebells where spreading like blue air between the grey trunks', the artist spent the remaining years of her life.[26] The three acres of gardens surrounding the house which had been cultivated so skilfully by her sister, Isabel ('Issy') are recorded in Butler's flower paintings and gardens scenes which, during her lifetime began to become increasingly popular. Her well known exhibition watercolour, *The Lilac Phlox, Kilmurry, Co. Kilkenny* now in the N.G.I., was hung in both the W.C.S.I.'s exhibition held in 1913 and in the Royal Watercolour Society the previous year.

Mildred Anne Butler died at Kilmurry, which had been her home for the greater part of her life on 11th October, 1941. A professional painter, 'she possessed the ability to make good pictures out of simple and indeed trivial material; and all

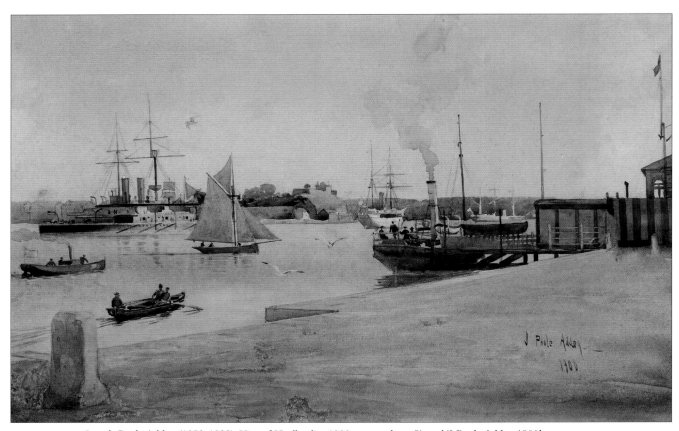

Joseph Poole Addey (1852-1922) *View of Haulbowline* 1900, watercolour. Signed 'J Poole Addey 1900'.

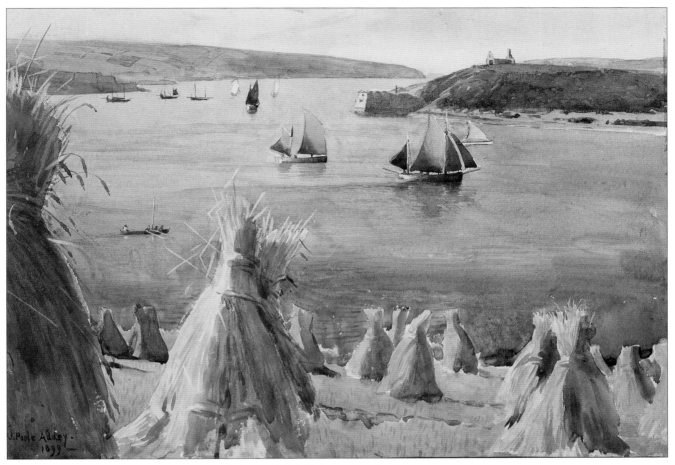

Joseph Poole Addey (1852-1922) *A View of Cork Harbour*, watercolour.

her…contributions are extremely interesting and even beautiful, although there is not a shred of story, anecdote, incident or an atom of pathos beyond that which always attends really artistic representations of homely nature…These pictures command attention by the massing and breadth of their chiaroscuro, and the solid way in which they have been handled.'[27]

Joseph Poole Addey (1852-1922) was a prolific and long standing contributor to the W.C.S.I. beginning in March, 1889. He also contributed works to many other art societies both in Dublin, Belfast, London and Liverpool. The Poole family were Quakers from Northamptonshire and had established themselves in Co. Wexford as early as 1649. Four generations later, descendants Jacob and Mary Poole, farmers and extensive

landowners, had settled at Taghmon, (Growtown) Co. Wexford. Jacob Poole, grandfather of artist Joseph Poole Addey, was by all accounts 'an unassuming scholar and nature-lover'.[28] He became interested in the manners, customs and strange dialect of the Baronies of Forth and Bargy, Co. Wexford, an area of some 40,000 statute acres which between them supported a population of around 37,000 people. Jacob Poole compiled a glossary (or mini dictionary) relating to the vocabulary and phrases which he found amongst the people living there. He and his wife, Mary Poole, had six children, one of whom, Eliza 'Lizzie', (1818-1886) married Cork draper, George Addey, a son of Robert and Sarah Addey. Lizzie, a poetess of some competence, was a cousin of Dublin printer Richard Davis Webb (1805-72), a man who had played a decisive

role in the anti-slavery movement.

Joseph Poole Addey was the son of George and Lizzie Addey and was born in Dublin on 11 November, 1852. However, according to Dr. Theo Snoddy, this painter has always been regarded as 'of Cork'.[29] Addey was educated at Newtown School, Waterford between 1862-67. In 1869 he is recorded as receiving a prize at the Cork School of Design. Unlike Barton and Butler, it would appear this artist did not study abroad. In 1872, Addey received further training in the National Art Training school, South Kensington. This had been established as the Government School of Design in Somerset House, London in 1837, and with the move to South Kensington in 1853, the school became known as the National Art Training School, the main emphasis being placed on training new teachers

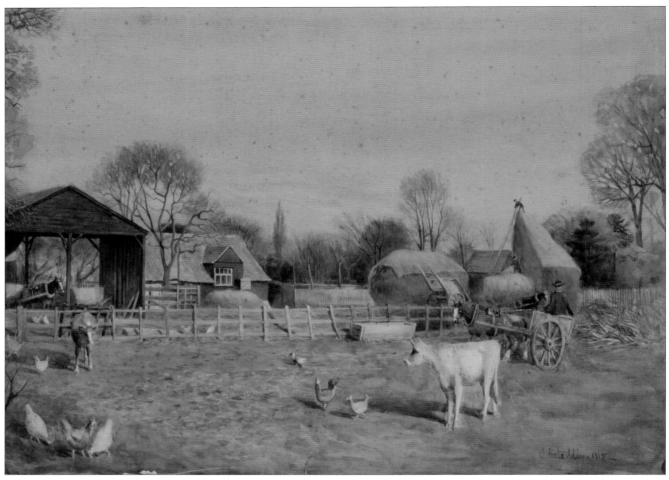

Joseph Poole Addey (1852-1922) *A farmyard scene*, watercolour. According to Michael Holland, writing in the *Cork Historical and Archaeological Society Journal* (1943), Addey painted throughout the 1880s 'admirable pictures of rustic life farmyard scenes with their adjuncts of fowl and fodder'.　　　　PRIVATE COLLECTION

Joseph Poole Addey (1852-1922) *The River Dodder, near Rathfarnam, Co. Dublin* 1910, watercolour over pencil. Signed and dated and inscribed on verso 'J Poole Addey 1910'. The artist knew this area well as he regularly accompanied members of the Dublin Sketching Club on outings which included the banks of the River Dodder. Before joining the staff of the Slade School of Fine Art, London in 1914, Joseph Poole Addey had been placed in charge of the Dublin Metropolitan School of Art's landscape sketching classes and each year during the summer term these were held out of doors at Rathfarnam Castle, Co. Dublin.

COURTESY OF THE BROCK GALLERY,
BLACKROCK, CO. DUBLIN

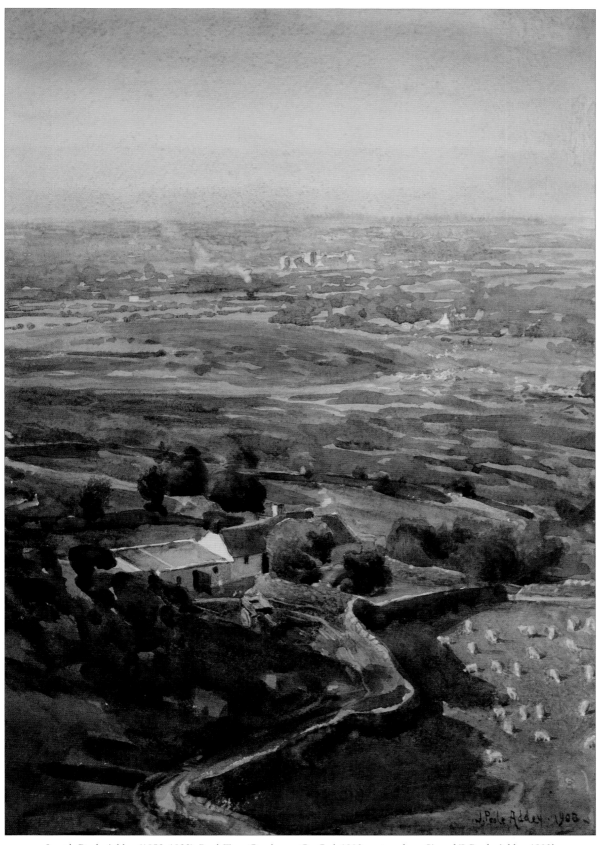

Joseph Poole Addey (1852–1922) *Beech Trees, Crosshaven, Co. Cork* 1903, watercolour. Signed 'J. Poole Addey 1903'.

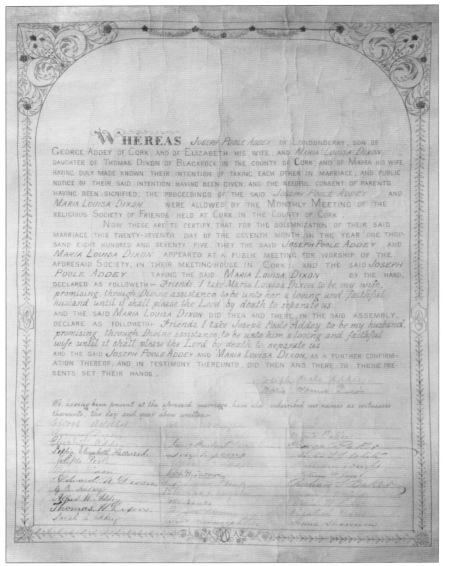

Marriage Certificate of the artists, Joseph Poole Addey (1852-1922) and Maria Louisa Dixon (1855-1907). The couple were married on 27 July, 1875 in The Meeting House, Cork

PRIVATE COLLECTION

from 1877 until 1914, a total of 134 works. Early exhibits sent from his home 1, Clarendon Street, Derry, included landscapes of Donegal, Antrim and Cork, together with a small number of portraits. At the Cork Industrial and Fine Art Exhibition, 1883 over 800 works were on display with Poole Addey's landscape water-colours being singled out for special mention by the *Cork Examiner*.[30]

The artist's work also caught the eye of the *Daily Express* (Dublin) when he contributed to the W.C.S.I.'s exhibition held at the Leinster Lecture Hall, 35, Molesworth Street, Dublin under the Society's new title in March 1889. His landscape *Rocky Sheane, Co. Wicklow* received favourable comment. Addey's portraits also attracted attention. At the Society's forty-second exhibition held in Dublin, which received a substantial entry amounting to 399 exhibits and included 100 artists, Addey's portrait of Percy French was noted as 'represent[ing] his subject with great boldness and fidelity in facial likeness and expression'.[31] Spanning a period of over thirty years (1889-1921), Joseph

Henry Tonks (1862-1937) *Self-Portrait* , pencil on paper.
Joseph Poole Addey was succeeded by Tonks as a teacher of perspective at the renowned Slade School of Art, London.

COURTESY OF
THE NATIONAL PORTRAIT GALLERY, LONDON

and becoming a focus for national art education, design playing a vital part in the curriculum. Addey's qualifications as a teacher were to be put to good use when he returned to Ireland.

On 27 July, 1875, in the Meeting House, Cork, Joseph Poole Addey married fellow artist, Maria Louisa Dixon, (1855-1907), one of twelve children and the eldest daughter of Thomas Henry Dixon (1817-1882) and his second wife, Maria Dixon, (1829-1916) (née Keville) of Northcliffe House, Blackrock, Co. Cork. Shortly after his marriage, Addey took up his appointment as the

Londonderry School of Art's first headmaster. The School of Art was located in Ship Quay Street and had been founded under the Science and Art Department, South Kensington by a committee of subscribers in 1874. Addey retained this post until a year after the death of his mother, Eliza Poole, in Cork in 1886.

Almost from the beginning of his teaching career, Addey was a keen and enthusiastic exhibitor contributing a flower piece to the Royal Academy in 1897. He was also a consistent and long-standing contributor to R.H.A. exhibiting, almost without a break,

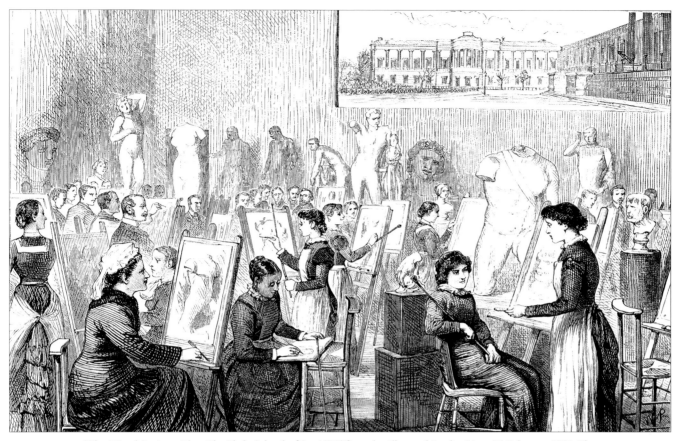

'The Mixed Antique Class, The Slade School of Art 1881' from the *Illustrated London News*, 26 February, 1881. The Slade School was founded as part of London University in 1871. It offered practical instruction to both men and women in the field of art, rather than providing lectures intended for a general audience (as at University College London and colleges at Oxford and Cambridge). It was here Irish artist and W.C.S.I. member, Joseph Poole Addey (1852-1922) taught perspective from 1914-1918.

Poole Addey would appear to have contributed over 140 watercolours to the W.C.S.I.'s annual exhibitions.

After he left Londonderry, Addey, together with his wife, artist and W.C.S.I. exhibitor, Maria Louisa (née Dixon), spent some time painting in Co. Wicklow – Avondale, Glendalough and the surrounding areas of the River Dargle. Both landscapes and portraits were despatched for exhibition from either Lake Cottage, Glendalough or 60, Frankfort Avenue, Rathgar. By 1894, Addey had moved to Cork, living at 1, Park Villas, Victoria Road, Cork; and by 1 May 1898, the artist was back in Dublin. The minute book belonging to the Dublin Sketching Club dated 1898 states: 'Mr Joseph P. Addey has kindly promised to attend as many of the Excursions as possible, and to give hints and advice on Sketching to any of the members who may wish

for such assistance.'[32]

The first outing took place on Saturday, 7 May, 1898 departing from Merrion Row by wagonette for the Furry Glen, Phoenix Park. Addey regularly accompanied members on Club outings during the summer of 1898 to places such as the Bride's Glen, Loughlinstown, Howth, Kingstown, and other picturesque sketching spots in Co. Dublin, offering advice on the technical aspects of drawing and watercolour painting. According to Snoddy the artist 'could not comprehend how anyone would be unable to copy accurately, with pencil, a simple object'.[33] By the end of the summer, the excursions (eleven in all) held under Addey's supervision appear to have lost much of their appeal. It was suggested at the Club's autumn A.G.M, somewhat amusingly: 'We intend, if we are alive, to appeal to their

stomachs next year by providing picnic teas instead with, we hope, better results.'[34]

Addey's graceful exhibition watercolour entitled *Is it Sound, or Fragrance, or Vision?* formed part of the R.H.A. 1902 exhibition. It shows a young woman seated on an elegant chaise longue placed against a Chinese screen and 'is one of the first examples in Ireland of the then fashionable chinoiserie'.[35] The sitter holds a collection of flowers in her left hand. A guitar, gaily decorated with ribbons, rests lightly against the chaise longue and is supported by the young woman's right hand. Addey's abilities as a fine draughtsman, coupled with his love of bright colour and his fascination with texture, all help to convey to the viewer that emphasis is being placed here on charm rather than on high moral grandeur. At the

Joseph Poole Addey (1852-1922) *A 'Kerry' Belle (or Woman in a White Dress)* 1904, watercolour. *A 'Kerry' Belle* was exhibited in the Guildhall Exhibition of Works by Irish Painters, London, 1904 organised by Sir Hugh Lane.

COURTESY OF KEITH ADDEY.
PHOTOGRAPH COURTESY OF JANE ADDEY.

Joseph Poole Addey (1852-1922) 'Surveying the Bogside' and 'Foyle Street', pen and ink drawings from Keith Robertson's *Miss Ferryquay's Grand Tour with her cousin from Scotland being an account of Londonderry* (1887).

COURTESY OF THE NATIONAL LIBRARY OF IRELAND

Joseph Poole Addey (1852-1922) *Portrait of Maria Louisa Addey (1855-1907)* 1898. The sitter (the artist's wife) began exhibiting with the W.C.S.I. at their thirty-second exhibition, held in March 1889. She contributed largely flowers and still-life works. PRIVATE COLLECTION. PHOTOGRAPH BY ALAN BRINDLE, F.R.P.S.

same time there is a pervasive feeling of pensiveness engendered by the realization that all pleasure is transitory, captured in the sitter's somewhat sad, melancholy expression.

This feeling of melancholy is inherent in Flemish painter, Antoine (Jean) Watteau's (1684-1721) paintings, his work gaining a good deal of currency in the nineteenth century thanks to various contemporary writers and artists including none

other than Turner. In 1822 this artist had exhibited a painting entitled *What you Will*, which was described by the painter himself as 'a whimsical attempt at a Watteau'. Simplicity and idealization of the antique was being replaced by a fashion for the fanciful and frivolous. Watteau appealed to nineteenth century readers of fashions and domestic magazines. In the view of art historian and author Dr. Anita Brookner, Watteau became the

advocate and representative of aristocratic taste, and many 'Watteau' touches, usually mass-produced, were introduced in the 1840s into the bourgeois home. The influence of Watteau may be seen in the pose of the girl's head, depicted here in Addey's watercolour, which is similar to several drawings by this Flemish painter together with the introduction of the guitar, a favourite instrument found in much of Watteau's work.

Joseph Poole Addey (1852-1922) *Is it Sound, or Fragrance, or Vision?* 1902, watercolour on card. Signed and dated.
This watercolour was exhibited in the R.H.A. in 1902 (cat. no. 153) COURTESY OF THE GORRY GALLERY, DUBLIN

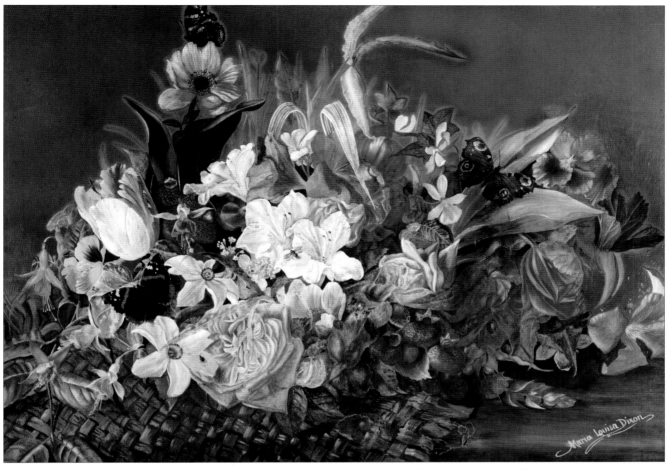

Maria Louisa Dixon (1855-1907) *A collection of garden flowers, insects and butterflies*, watercolour. Signed 'Maria Louisa Dixon'. The artist began exhibiting with the W.C.S.I. under her married name, Maria Louisa Addey, in March 1889, contributing three flower studies, and again in March 1893. PRIVATE COLLECTION

In 1904, Sir Hugh Lane (1875-1915) invited Joseph Poole Addey to contribute to the prestigious exhibition of works by Irish painters held at the Guildhall Art Gallery, London. Addey's charming, attractive exhibition portrait executed in watercolour and entitled *Kerry Belle* (illustrated here) was exhibited in Gallery IV, alongside works by Irish painters including George Barret Senior, Thomas Danby, Hugh Douglas Hamilton, Adam Buck and William Mulready.

It may have been Addey's hard-won experience gained from acting as tutor to members of the Dublin Sketching Club on their outings which saw him placed in charge of the Dublin Metropolitan School of Art's landscape sketching classes held during the summer term at Rathfarnham Castle, on the outskirts of Dublin. Until he moved to England, Addey taught landscape painting *en plein air* to students of the D.M.S.A. during the years 1905 to 1909 (with the exception of 1908).

By 1914, the artist had moved to Kingston-on-Thames from Surbiton, Surrey and was invited to join the staff of the renowned Slade School of Fine Art, London. The Slade, established in 1871, offered practical instruction in the field of art, the first professor being Neoclassicist, Sir Edward Poynter (1836-1919). He founded the School's tradition of drawing from the nude thereby placing emphasis on the study of the live model. He was succeeded by Frederick Brown (1851-1941) who, assisted by Henry Tonks (1862-1937), a leading anatomist, carried on the tradition. They were successful in steering the School through one of its most brilliant periods (1892-1918) and helping to produce artists such as Sir William Orpen Augustus John, Paul Nash, Ben Nicholson, and Stanley Spencer. By 1912, perspective had become an obligatory constituent of the Art School's Diploma. Joseph Poole Addey was invited to assist with this subject from 1914-15. He stayed on until 1917-18 when the course continued under the direction of Professor Henry Tonks.

Joseph Poole Addey died on 18 October, 1922 in London. In the view of Crookshank and Glin, 'He deserves to be better-known'.[36]

Jack Butler Yeats, R.H.A. (1871–1957) *The Country Shop*, ink and watercolour on card. Signed '*JACK B. YEATS*'. This image featured on the cover of the Water Colour Society of Ireland Centenary Exhibition Catalogue.

Chapter XI

Down to Business

At the Water Colour Society of Ireland's sixtieth exhibition held in February 1915 in the Mills' Hall, Merrion Row, Dublin, stringent efforts were made to tighten up the running and management of the Society. The committee comprised of Rose M. Barton, R.W.S., The Hon. Lady Ross of Bladensburgh, Helen S. O'Hara, H.B.A.S., Bingham McGuinness, R.H.A., Miss H.K. Lynch, Helen Colvill, Lady Elizabeth Butler, R.I., Mildred Anne Butler, A.R.W.S., Clara Irwin, Captain Neville R. Wilkinson, A.R.E., R.M.S., K.C.V.O., Richard Caulfeild Orpen, B.A., F.R.I.A.I., Archibald V. Montgomery and Secretary, W.H. Hillyard. At this meeting, it was decided to issue a small handbook of rules governing the Society's activities together with the names and addresses of members.

Rule number one stated that the Society was to be known as 'The Water Colour Society of Ireland'. An exhibition and sale of watercolour paintings and works of art was to be held once a year in Dublin. However, there was also provision to hold, from time to time provincial exhibitions, Rule No. 16 stating, 'There may... if occasion arises, be held provincial Exhibitions, due notice of date and place being given to Members'.

Works of art eligible for each annual exhibition might also include, apart from watercolours, etchings, sepia, chalk, pastel, pen and ink, pencil drawings together with paintings on china (burnt in), modelling and wood carving. The rules also stated that the Committee of Management must consist of at least twelve ladies or gentlemen and that the number of members must not be allowed to exceed 250. New members should be admitted to fill vacancies on the list by signing an agreement to abide by the Society's rules. Subscriptions and entrance fees were fixed at ten shillings per member and any member who 'shall be in arrear in payment of their subscription for two consecutive years shall cease to be a member of the Society. No works were to be hung for exhibition unless the entrance fee and the first year's subscription had been paid in advance.'

Restrictions were to be placed on the number of entries: 'No member shall submit for exhibition more than six Works of Art during each year' (Rule 6). An attempt at price control was also set in place: 'No price less than £2 2s. 0d. will be entered in the Catalogue for any Picture'. Members were left in no doubt as to how they should hang their work: 'All pictures must be entirely the work of the Member exhibiting, and not have been previously exhibited in Dublin. Frames and inside mounts must be rectangular,

Photograph of Sir Nevile Rodwell Wilkinson A.R.E., R.M.S., K.C.V.O. (1869-1940), W.C.S.I. member, designer, illustrator, etcher and miniature craft-worker, who exhibited several of the designs relating to his unique creation, Titania's Palace, in the W.C.S.I. Annual Exhibition held in 1922 and 1927. (Note the fairy standing on the sitter's left shoulder!)　PRIVATE COLLECTION

gold, plain white or black. Preference is given to gold mounts as the space for white is limited. N.B. Oval, circles, Oxford frames, and photographs are inadmissible. Each drawing must be framed separately'. Rule 12 provided further guidance: 'Previous to each Exhibition a form will be sent to Members, with spaces for the insertion of the particulars of the works to be exhibited, and corresponding labels, one of which must be gummed on the back of the picture, and the other so arranged as to hang over its face...' Rules governing conditions of sale included the Society taking five per cent on the sale of all pictures and works of art was also introduced.

In the future, the Management Committee was to have the power to

Cover of the Water Colour Society of Ireland Rules and Terms of Reference, dated 1915.

Attributed to W.C.S.I. member, Gertrude Villiers-Stuart (1878-199?) M.B.E. *A fountain in the palace gardens, Tangiers, Morocco*, watercolour. The artist owned a house, Dar el Quas, Tangiers and spent a considerable period of her life painting in Morocco.

William Crampton Gore, R.H.A. (1871-1946) *An Eastern Scene* 1904, watercolour, gouache and pencil. Signed and dated 'W.G. 1904'.

William Crampton Gore, R.H.A. (1871-1946). Preliminary drawing for *An Eastern Scene*.

Edward J. Rogers (1872-1938) *Portrait of Alexander Williams, R.H.A. (1846-1930)*, pastel. W.C.S.I. member, landscape and marine painter, Alexander Williams, began exhibiting with the Irish Fine Art Society in March–April 1883 (the twentieth exhibition) held at 35, Molesworth St., Dublin. This portrait was exhibited in the 1923 W.C.S.I. annual exhibition. The artist, Edward J. Rogers, exhibited with the W.C.S.I. from 1921-1936. PRIVATE COLLECTION

Nathaniel Hone, the Younger, R.H.A. (1831-1917) *Dinghies on a Normandy Beach* c.1868, pencil and watercolour. At the suggestion of W.C.S.I. committee member, Sir Neville R. Wilkinson and supported by the efforts of R.H.A. President, Dermod O'Brien, eighteen watercolours and sketches by Nataniel Hone, the Younger were placed on screens and exhibited at the Water Colour Society of Ireland annual exhibition held in 1925 in the Mills Hall, Merrion Row, Dublin. COURTESY OF THE NATIONAL GALLERY OF IRELAND

Edouard Brandon (1831-97) *Portrait of Nathaniel Hone, the Younger*, oil on canvas. Signed 'Ed. Brandon, 1870'.
COURTESY OF THE NATIONAL GALLERY OF IRELAND

Walter Frederick Osborne, R.H.A. (1859-1903) *Sculptor against his sculpture of Orpheus and Eurydice*, watercolour of John Hughes, R.H.A. (1865-1941). Inscribed 'This is my portrait by Walter Osborne. One of the last pictures he painted. Presented by me to Lucy Stoker, May 1903. John Hughes.' This watercolour was exhibited in the W.C.S.I. Centenary Exhibition in 1970. It was also on view in the Irish International Exhibition, 1907 and in 'Drawings from the National Gallery of Ireland', Wildenstein London/New York, 1967.

Photograph of Gertrude Gwendoline Villiers-Stuart M.B.E. (1878-199?) taken at Dromana, Co. Waterford, her childhood home. A cousin of a founder of the Amateur Drawing Society, Baroness Pauline Prochazka, Gertrude Villiers-Stuart was a prolific watercolourist and began exhibiting with the W.C.S.I. in February 1904. In 1914, she married Sir Basil Scott, Chief Justice of the High Court of Bombay (1908-1919). In 1954, she was awarded an M.B.E.

decide or reject 'a work which they may consider to be below the standard of merit of the exhibition or not within its scope' (Rule 14). It had also been decided to appoint a London agent, a Mr. Johnson of 62A, Westborne Grove, Bayswater. He was to be responsible for handling, receiving and storing pictures on behalf of members at a cost of one shilling per month. Any surplus funds arising from the Society's activities were to be invested in the hands of the Trustees (The Rt. Hon. The Earl of Mayo, K.P., and Archibald V. Montgomery) for 'the furtherance of Art and the interests of the Society'. Other rules drawn up included 'Any member intending to withdraw from the Society must give notice in writing to the Secretary on or before December 15 of their intention to do so' (Rule No. 8), and 'Works sent in for Exhibition cannot be removed on any pretext whatever until the close of the Exhibition' (Rule No. 15).

In October 1924, committee member Sir Neville Rodwell Wilkinson proposed that loan pictures should be exhibited at the annual exhibition with screens provided for such exhibits.[1] The following year, eighteen watercolours and sketches by landscape painter, Nathaniel Hone, R.H.A. were exhibited at the Society's annual exhibition held in the Mills' Hall, Merrion Row, Dublin. This was largely due to the efforts of the President of the R.H.A., Dermod O'Brien, P.R.H.A. (1865-1945). At a committee meeting held on 19 November, 1925 at 66, Merrion Square, the issue was

Sir Frank Brangwyn, R.A., R.W.S., R.B.A., Hon.V.P.R.S.M.A. (1867-1956) *Self-Portrait*. Brangwyn was an artist, designer and distinguished W.C.S.I member. MUSEA BRUGGE © LUKAS-ART IN FLANDERS VZW

Sir Frank Brangwyn. R.A., R.W.S., R.B.A., Hon.V.P.R.S.M.A. (1867-1956) *Santa Maria from the street* 1907, copper etching.
© READING MUSEUM SERVICE (READING BOROUGH COUNCIL)

raised once again as to how many pictures each member might submit. Henrietta Lynch proposed, seconded by Helen Colvill, that the rule limiting exhibitors to six pictures should be altered. The figure was set at eight.

At their committee meeting held on Tuesday, 19 October, 1926, members were anxious to make their views known in relation to the plight of the Hugh Lane pictures. A letter by W.C.S.I. committee member Lucius O'Callaghan was read to the committee in which he urged members to take steps with regard to the request for the return of the paintings to Ireland. Following a lengthy debate, Richard Caulfeild Orpen tabled a motion which read: 'The Committee of the Water Colour Society of Ireland intensely desiring the restoration of the Lane Pictures to Ireland would respectfully ask the Government of Saorstát Eireann to use every available means to attend this end.'[2]

Photograph of landscape painter, Lilla M.. Bagwell (1888-1974), (later Mrs John Perry) Marlfield, Clonmel, Co. Tipperary c.1909. A prolific and consistent exhibitor with the Water Colour Society of Ireland from 1916-1970 inclusive, she exhibited almost one hundred works. PRIVATE COLLECTION

In conjunction with their 1932 exhibition, which opened on April 9th, the committee hosted a reception at which drawings by the Keeper of Prints & Drawings, Victoria & Albert Museum, London Martin Hardie (1875-1952) were placed on display.

At their meeting held 27 November, 1934 'The question of the Art Union was carefully considered and it was felt…it might be wise to abandon it altogether.'[3] However, the following year, in February, the matter was again under discussion and it was decided that the Art Union should continue.[4]

The payment of a Secretary for the Society is mentioned for the first time in the minutes relating to a special meeting of the committee summoned by Richard Caulfeild Orpen on 22nd October, 1936 and held at 13, South Frederick Street, Dublin. After the vacancy caused by the death of Mrs Pilkington on 24 August, 1936 it was

John Butler Yeats, R.H.A. (1839-1922) *Sir Hugh Lane (1875-1915)*, pencil on paper. Signed and dated 'August 1905 J B Yeats'. At a W.C.S.I. committee meeting held on Tuesday, 19 October, 1926 members were anxious to make their views known in relation to the plight of the Hugh Lane pictures: 'The Committee of the Water Colour Society of Ireland intensely desiring the restoration of the Lane Pictures to Ireland would respectfully ask the Government of Saorstát Eireann to use every available means to attend this end.'

Richard Francis Caulfeild Orpen, R.H.A., F.R.I.A.I. (1863-1938) *Laecoön* 1910, watercolour and pencil. Signed 'R C Orpen'; inscribed on verso 'In the little wood. Rollington Farm, Corfe, Dorset, August 1910'. This work was exhibited in the R.H.A. in 1911 (cat. no. 461). In relation to art, Laecoön is the subject of a well known marble group in the Vatican depicting father and sons in their death-agony. The group was exhibited in the palace of Titus and was said by Pliny to have surpassed all other works of painting and sculpture.

Headpiece designed by W.C.S.I. member, Richard Caulfeild Orpen, RHA, F.R.I.A.I. (1863-1938) for the Arts & Crafts Society of Ireland's first exhibition held in 1895 and used in their catalogue. Architect, landscape painter and cartoonist, Richard Caulfeild Orpen was a founder and first secretary of the Arts & Crafts Society of Ireland. A brother of Sir William Orpen, Richard Caulfeild Orpen was a staunch supporter of the W.C.S.I. and exhibited from 1908-1936. He played an active part in the Society's affairs serving on the committee from 1922 to 1933 and facilitated members by allowing them to hold W.C.S.I. meetings in his office, 13, South Frederick Street, Dublin. Appointed President, W.C.S.I., February 1934.

decided that landscape and figure painter, Mrs. Eileen Florence Beatrice Reid (née Oulton) (1894-1981) should be appointed Secretary of the Society at a salary of £40 per annum.[5] This was a post she was to hold for a period of thirty-six years, retiring on 21 February, 1972.

An indication as to how the finances of the Society were faring was given at a committee meeting held on Thursday, 10 December, 1936. The exhibition that ran between 21 April and 16 May, 1936 produced the following results:

'Proceeds from door £22. 14. 0d.
Pictures Sales £70. 10. 6d.
Including £9 Art Union
Expenses of Exhibition £60. 14. 7d.'

Once again, the number of entries sent in by members was under discussion at the 1938 committee meeting (11 November, 1938). Abstract and figure painter, Mainie Jellet (1897-1944) suggested that this should be reduced. Major Goff proposed limiting entries to four only. This was approved and the resolution passed. At a further meeting held six years later, the number was again reduced to two entries only. [6]

Down through the years, the Society invited many well known artists and 'personalities' to open their yearly exhibitions, including the President of the R.H.A., Dermod O'Brien (1940); artist, Jack Butler Yeats, R.H.A. (1941); poet, writer and broadcaster, Sir John Betjeman (1943); Director of the N.G.I., Thomas McGreevy (1947); William Howard, 8th Earl of Wicklow (1948); President of the R.H.A., Séan Keating (1951); art historian, lecturer, writer and Professor of Art History, Trinity College Dublin, Anne Crookshank (1966 & 1980); writer and fisherman, T.C. Kingsmill Moore (1946); author and *Irish Times* critic, Terence De Vere White (1952); Dr. Sheehy Skeffington (1954); author and playwright, Ulick O'Connor (1970) (the Centenary exhibition); publisher, book designer and printer, Liam Miller (1978); Director, N.G.I., Homan Potterton (1982); President of the R.H.A., Thomas Ryan (1984); Head of

Enthusiastic lady members of the W.C.S.I. Standing: Lily Williams, A.R.H.A. (1874-1940); Lady Glenavy, (née Beatrice Elvery, Mrs Campbell), R.H.A. (1881-1970); Frances 'Cissie' Beckett (1880-1951); Estalla Solomons, H.R.H.A. (1882-1968); Dorothy Kay (née Elvery); seated: Frida Perrott (fl.1899-1946). COURTESY OF THE NATIONAL LIBRARY OF IRELAND

Sir William Orpen R.A., R.I., H.R.H.A. (1878-1931) *Sowing New Seed for the Board of Agriculture and Technical Instruction for Ireland*, oil. This painting was exhibited in the W.C.S.I. annual exhibition held in 1913 under the title *Sowing the seed of evolution for the Board of Agriculture* (cat. no. 365).
COURTESY OF THE MILDURA ARTS CENTRE, MILDURA, VICTORIA, AUSTRALIA

Sir William Orpen. R.A., R.I., H.R.H.A. (1878-1931) *It's a Big Job* 'S.P. with Philippa', pencil.
COURTESY OF THE NATIONAL GALLERY OF IRELAND

Lady Charlotte Isabel Wheeler Cuffe (née Williams) 1867-1967) *Ani Sakan, Maymyo, Burma*, watercolour.
Botanical artist and inveterate traveller, Lady Charlotte Wheeler Cuffe was elected a member of the W.C.S.I. on Friday, 14 March, 1924 shortly after her return to Ireland. She exhibited with the Society until 1933.
COURTESY OF THE NATIONAL BOTANIC GARDENS, GLASNEVIN, DUBLIN

Photograph of W.C.S.I. landscape painter, Lancelot F.S. Bayly (1868-1952) taken in the garden of his home, Bayly Farm, Co. Tipperary. The artist exhibited more than one hundred annual works at the W.C.S.I. annual exhibitions from 1910 to 1934. He is first mentioned as being a member of the W.C.S.I. Committee in February 1922.
PRIVATE COLLECTION

Above left: Moyra A. Barry (1885-1960) *Self-Portrait*, oil. Signed 'M.B.' Flower piece and landscape painter, Moyra A. Barry was elected a member of the W.C.S.I. on 4 March, 1938 and exhibited a total of fifty-nine works, flowers being the dominant theme, until a year before her death on 2 February, 1960.

COURTESY OF THE NATIONAL GALLERY OF IRELAND

Above right: Margaret Crilley (1888-1961) *Portrait of Harry Clarke, RHA (1889-1931)* c.1914, pencil on board.
This portrait was drawn by Harry Clarke's future wife, Margaret Crilley, shortly after they became engaged. During this period Harry Clarke exhibited *The Lady of Decoration*, a design for a calendar, in the annual W.C.S.I. exhibition held in 1915 (illustrated on p.291).

PRIVATE COLLECTION

Grahame Laver (b.1930) *Sir John Betjeman (1906-1984)*, oil. Poet, writer and broadcaster, Sir John Betjeman opened the W.C.S.I. annual exhibition on 29 March, 1943. PRIVATE COLLECTION © GRAHAME LAVER

18 FITZWILLIAM SQUARE, DUBLIN.

March 20th 1941

Dear Miss Reid

I thank yourself and the Committee of the Water Colour Society of Ireland for their asking me to open the Exhibition at 3.30 P.M. on Monday April 28th next, and I will have much pleasure in doing so

Yours sincerely

Jack. B. Yeats

Letter of acceptance dated 20 March, 1941 from Jack Butler Yeats, R.H.A. (1871-1957) to W.C.S.I. Secretary, Mrs Eileen Reid in relation to the opening of the Water Colour Society of Ireland's annual exhibition to be held on Monday, 28 April, 1941 at 3.30 p.m. in the Mills' Hall, Merrion Row, Dublin.

Mainie Jellett (1897-1944) Studies for a section of mural decoration, 1938, oil.

The artist exhibited her three small, preliminary studies, two of which are illustrated here, at the W.C.S.I.'s eighty-fourth annual exhibition (1938; cat. nos: 65, 72 and 84). These formed part of the preparatory work for the two final murals, each measuring 10 x 80 feet and depicting various aspects of Irish industrial, cultural and rural life. They were exhibited at The Glasgow Exhibition which opened in May 1938.

Photograph of Varnishing Day at the Royal Hibernian Academy Summer Exhibition, held in the D.M.S.A., 1933. Left to Right: Dermod O'Brien P.R.H.A. and standing behind him wearing a hat and glasses, W.C.S.I. member Mainie Jellett; next to Dermod O'Brien, future President of the W.C.S.I. Kitty Wilmer (O'Brien's future daughter-in-law); behind her, W.C.S.I. member, Brigid O'Brien (née Ganly); Maurice MacGonigal, R.H.A.; behind him Frank McKelvey; Oliver Sheppard; Arthur Power; behind them W.C.S.I. member, Howard Knee.

the National College of Art and Design, art historian and lecturer, Professor Dr. John Turpin, (1985); Professor of the History of Art, University College Dublin, Alistair Rowan (1986); auctioneer and fine art lecturer, Brian Coyle (1987 & 1994); Lord Mayor of Dublin, Dr. Carmencita Hederman (1988); Director of the N.G.I. Raymond Keaveney (1989); lecturer, author and Curator, British Collections, N.G.I., Adrian Le Harivel (1991); musician and director, R.I.A.M. Dr. John O'Conor (1992); Former President, Institute of Chartered Accountants of Ireland, Dr. Margaret Downes (1993); United States Ambassador to Ireland, Jean Kennedy Smith, (1995); President of Ireland, Mary Robinson (1996); Chairman, Office of Public Works, Barry Murphy (1997); President of the R.D.S. Liam Connell (1998); author, art historian, journalist and critic, Dr. Bruce Arnold (1999).

Mainie Jellett (1897-1944) *Horses*, watercolour, gouache and pencil.

Hilda van Stockum (1908-2006) *Evie Hone at work in her studio*, oil. Signed 'HVS'. Stained glass and landscape artist, Evie Hone, H. R.H.A. exhibited a total of forty-three works with the Water Colour Society of Ireland between 1931 and 1946.

The Evie Hone Memorial Exhibition held in The Great Hall, (now the Concert Hall) Earlsfort Terrace, University College, Dublin, from 29 July-5 September, 1958. In the distance may be seen the cartoon for the great East Window, Eton College Chapel, Berkshire which the painter worked on between 1949 and 1952. The cartoon was bequeathed to Maynooth College, Co. Kildare by the artist.

Cover Black & White Artists' Society of Ireland. Catalogue of the Third Exhibition, April, 1916 held in The Hall, 8, Merrion Row, Dublin and organised by W.C.S.I. member, J. Crampton Walker, A.R.H.A. (1890-1942).

Due to the Mills' Hall, Merrion Row, Dublin being unavailable for the annual exhibition in 1945, the possibility of finding a suitable venue was under discussion at the 6 October, 1944 meeting held at 19 Upper Mount Street.[7] Chairman and secretary, Major Nolan Ferrall, together with committee members, the Misses Hamilton, Miss Davidson, Major T.C. Goff and the Misses Colvill, Davidson and Boyd put forward suggestions which included using the gallery of the National College of Art, the Dublin Painters' Gallery, St. Stephen's Green or the Oak Room in the Mansion House. At their next meeting in December 1944 members decided to opt for the Dublin Painters' Gallery 'although… small'.[8] It was decided that due to lack of space in which to hang the 9-28 April, 1945 exhibition this should be on a 'much smaller scale and to limit the number of works submitted by any one member to 2 only.' It was also decided that 'under the circumstances no new members could be elected at present'.[9] Helen Colvill acting as Secretary provided an account of the somewhat sombre proceedings relating to the opening of the reduced in size exhibition which opened in the Dublin Painters' Gallery for the first time in April 1945:

'The 1945 Exhibition was opened in

Anne Yeats (1919-2001) *At the Easel*, pen on paper. This artist exhibited with the W.C.S.I. in 1947 (cat. no. 19 *Donegal Fisherman,* cat. 20 *The Minaun Rock* and cat. 22 *The Old Woman*). From an early age, Anne Yeats, daughter of William Butler Yeats, pursued an artistic career. She trained at the R.H.A. Schools under Maurice MacGonigal and landscape, portrait and figure painter, Henry C.W. Tisdall (1861-1954). She became a stage designer and assistant to Tanya Moseiwitch, Abbey Theatre, Dublin and spent some time at the Paul Collin School of Theatre Design, Paris before returning to the Abbey as chief designer, designing costumes and sets for some of her father's plays. She was also a designer for plays by Austin Clarke and George Bernard Shaw. In the forties, Anne Yeats decided to become a painter but also continued for some time as a freelance designer.

the Gallery, 78 Stephen's Green on Monday, April 9th by Lady Maffey who made an excellent short speech. The invitations for the Opening had been considerably cut down owing to the small size of the Gallery. In spite of this, the Gallery was crowded to capacity. The number of visitors throughout the 3 weeks of the

Exhibition was excellent and sales were correspondingly good. On Friday, April the 20th a small "At Home" was held which took the form of a private view. The Committee and some of the members acting as Hosts and Hostesses invited their friends and during the afternoon ices and wafer biscuits were served and seemed to be much

Lilian Lucy Davidson ARHA (1879-1954) *Seagulls*, watercolour, gouache and pencil. Signed with monogram lower left.
PRIVATE COLLECTION

Photograph of Florence Josephine Pielou (née Gillespie) (1884-1959). A figure, portrait and landscape painter, who exhibited a total of ninety-three works with the W.C.S.I. between 1928 and 1951.
PRIVATE COLLECTION

appreciated by the guests. The Art Union Draw took place on Thursday, April 26th. The sale of tickets provided for seven prizes.'[10]

In November, the venue for the following year (1946) was once again the subject of debate. The Dublin Painters' Gallery was not available, and therefore it was felt that the C.M.S. Hall in Molesworth Street should be secured which was larger and would allow 'for more pictures and better hanging'.[11] This was agreed. The exhibition opened on the premises on Monday, 20 May and closed on 8 June, 1946.

The list of applicants who wished to become members of the Society was now beginning to cause problems. In 1948 a substantial number of potential candidates had sent in work to be judged by the committee. According to the minutes, the standard was not met and only five artists were elected. There were nine rejections. A year later, the work of seven potential candidates was examined and only two were invited to join the Society.

For the first time, a small loss was recorded in the minutes for 1954. At their next meeting held on 14th December that year, despite the

shortfall, and mounting expenses, it was decided that the annual subscription (15 shillings) should not be raised to £1. However, a year later the committee was forced to change their decision, and it was increased to £1. Despite the financial situation being somewhat difficult, it was unanimously agreed at their next meeting that a bonus of £25 should be awarded to the Secretary, Mrs Eileen Reid who had been appointed in 1936. The annual subscription was raised again in 1968 to 30/-d.

For the Society's 1958 exhibition, the committee felt members should be encouraged to send in more entries relating to Black & White drawings in the hope that this would 'form a group of this type of art'.[12] It was agreed that assistance for the Society might be sought from the Arts Council 'and it was proposed by Mr. Alan Hope that a letter should be sent to the Secretary of the Arts Council asking for their help in making some improvements to the Hall [C.M.S.] in our presentation of the Annual Exhibition.'[13] Shortly

Photograph of Kitty Wilmer O'Brien, R.H.A. (1910-1982) taken by her son, Anthony O'Brien, in her home in Herbert Park, Dublin, 1981. Kitty Wilmer O'Brien joined the W.C.S.I. in 1950 and became a regular exhibitor contributing over seventy works (landscapes together with two portraits only) between 1950 and 1978; she was elected President of the W.C.S.I. on 15 January, 1962. PRIVATE COLLECTION

Artist unknown *Portrait of Eileen Reid (née Oulton) (1894-1981)*. The sitter, a landscape and figure painter, was elected Secretary of the W.C.S.I. on 10 December, 1936 and gave a total of thirty-six years service to the Society, retiring in February 1972.

afterwards, it was announced that a gift of one hundred pounds had been left to the Society by an anonymous donor. It was decided that this money should be used to improve conditions in the C.M.S. Hall in relation to annual exhibitions.

Landscape and portrait painter, Kitty Wilmer O'Brien, R.H.A. (1910-1982) was elected President of the Society on 15 January, 1962. At the age of sixteen she had entered the R.H.A. Schools and received prizes for both competition painting and drawing. Awarded the Taylor Scholarship in 1933, the young artist was able to study at the Slade School of Fine Art. Kitty Wilmer also spent two non-consecutive years studying in the D.M.S.A. In 1936 she married Dr. Brendan O'Brien, son of her former tutor, Dermod O'Brien. A regular exhibitor at the R.HA., Kitty Wilmer O'Brien was elected A.R.H.A. in 1968 and became a full member in 1976. Her association with the W.C.S.I. began in 1950 when she exhibited two portraits and was to continue until 1978. During this period the artist contributed over seventy works to the Society's annual exhibitions.

As W.C.S.I. President, Kitty Wilmer O'Brien was to become well known for her outstanding contribution to the Society which she achieved by raising standards and introducing to members the work and reputation of international artists. Two years after her election as President, she suggested at the Society's committee meeting (held January, 1964) that a number of painters of international renown might be approached to see whether they would be willing to participate in the 1964 annual W.C.S.I. exhibition. These included English abstract painter and designer, John Egerton Piper, C.H. (1903-1992) and eminent British artist and sculptor, Henry Spencer Moore, O.M., C.H., F.B.A. (1898-1986), together with several leading Irish artists (who were not identified).

At 19, Upper Mount Street, on 8 December, 1969, the committee began to make plans for their Centenary Exhibition to be held the following year 1970). This consisted of: President, Mrs Kitty Wilmer O'Brien, A.R.H.A.; Trustee, Geoffrey Wynne; Miss Phoebe Donovan; Mrs W. Griffith; Tom Nisbet, Esq., R.H.A.; Caroline Scally; Miss M. Stokes; Mrs C.E.F. Trench; Miss A.S. King-Harman; Miss Palm Skerrett; Gerald Donnelly, Esq.; Mrs. Chris Reid; Gerald Bruen, Esq.; and Secretary, Mrs Eileen Reid. The exhibition was to be held in the usual venue i.e. the C.M.S. Hall and it was

Phoebe Donovan (1902-1998) *Portrait of Elizabeth Rivers* (1903-1964) pastel portrait dating from c.1946 of Donovan's friend and fellow W.C.S.I. exhibitor, wood-engraver, figure painter and illustrator, Elizabeth Rivers. This portrait was exhibited in the Elizabeth Rivers' Memorial Exhibition held in the Municipal Gallery of Modern Art, (now known as The Dublin City Gallery, the Hugh Lane) Parnell Square, Dublin in February 1966. PRIVATE COLLECTION

Hard at Work! Photograph of Symbolist and Expressionist painter, W.C.S.I. member, Basil Rákóczi (1908-1979). PRIVATE COLLECTION

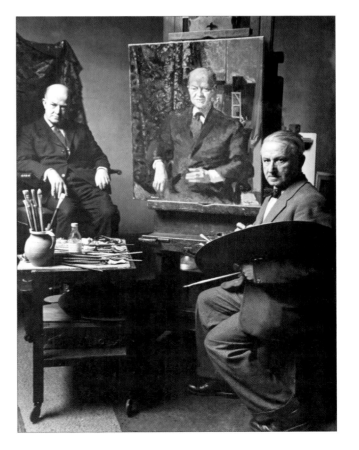

Photograph of Maurice MacGonigal, P.P.R.H.A., R.A., H.R.S.A. (1900-79) painting a portrait of theatre director, Frank Dermody. The finished portrait was exhibited in the R.H.A. in 1960 (cat. no. 107).
 COURTESY OF LENSMEN PHOTOGRAPHIC AGENCY

A lively discussion! Photograph of George Campbell, R.H.A., R.U.A. (1917-1979), landscape, still-life, figure painter and stained glass artist, who was elected a member of the W.C.S.I. on 14 December, 1954.

PRIVATE COLLECTION

Tom Carr, H.R.H.A., R.U.A., R.W.S., O.B.E. *The Art Class* 1965. Signed 'T. Carr '65.' Honorary membership of the W.C.S.I. was offered to watercolourist Tom Carr in 1986, who accepted 'with great pleasure'.

COURTESY OF THE NATIONAL LIBRARY OF IRELAND

agreed that a good quality catalogue with a new design for the cover 'should be produced for this Exhibition'. It was also decided that author, art historian and journalist, Bruce Arnold (later Dr.) should be approached to see if he might consider writing a short article for the centenary catalogue relating to the history of watercolour painting and the Society's involvement in it. W.C.S.I. President, Mrs Kitty Wilmer O'Brien suggested 'loan works of some distinguished past members should be exhibited on a special screen.' These works of art were to be borrowed from the National Gallery of Ireland and Municipal Gallery of Modern Art (now known as The Dublin City Gallery, The Hugh Lane). Members were in agreement. It was therefore decided that Mr (later Dr.) James White (Director, N.G.I.) and Miss Eithne Waldron, Curator, Municipal Gallery of Modern Art should be

approached to see if works might be borrowed for the occasion.

At their next meeting, the date for the Centenary Exhibition was finally agreed and fixed to open on 27 May, 1970. It was announced that permission relating to loan works of art had been granted by both the National Gallery of Ireland and the Municipal Gallery of Modern Art. 'It was decided not to borrow special screens to hang the Loan Exhibition but to reserve a portion of the wall in the centre of the hall for these pictures. For the Centenary Catalogue, it was decided that a reproduction in Black & White of Jack B. Yeat's "Village Shop" should make an attractive cover for the Catalogue.'[14]

Mounting costs of running the Society and the annual exhibition led to yet another rise in the subscription which was now set at £2 (1972). At their next exhibition to be held in May

of the following year, it was decided not to hold the Art Union Draw 'owing to the difficulty of selling sufficient tickets to provide Prizes of increased value'.

At a previous committee meeting held on 21 February, 1972, Mrs Eileen Reid, Secretary had indicated that she wished to retire from her position having served as Secretary of the Society for thirty-six years. At the next meeting, it was proposed that Ciarán MacGonigal, (son of Maurice MacGonigal, a P.P. R.H.A.) should be offered the post as Secretary of the Society. This was agreed and members recommended that the Secretary's salary should be increased from £40 per year to £80 'provided that Mr. MacGonigal would be responsible for all the secretarial work and would be there in person to look after the Exhibition for the 3 weeks and also to be at the Hall to receive pictures…'[15]

'En plein air'. Photograph of Anne Margaret 'Nano' Reid (1900-1981), landscape, portrait and figure painter, elected a member of the W.C.S.I. on Monday, 17 April, 1939.

COURTESY OF THE NATIONAL LIBRARY OF IRELAND

Photograph of James Nolan, R.H.A., A.N.C.A. seated in front of his self-portrait entitled *The Singapore Hat* chosen to represent Ireland in the prestigious Master Painters of the Twentieth Century Self-Portrait Collection, Uffizi Gallery, Florence. A major contributor to the Society's progress, James Nolan served as President of the W.C.S.I. from 1981 to 1994. COURTESY OF THE NATIONAL GALLERY OF IRELAND

In January 1974, an indication of the Society's finances was provided by the new Secretary, Ciarán MacGonigal who stated: '385 catalogues were sold to the value of £19.25, 530 members of the public had paid to see the Exhibition (1973) at a cost of £26.50. The Exhibition cost the Society £181.37 approx... membership fees yielded £145.50, leaving an excess of £20.37 over income'.[16]

At their meeting in January 1974, it was announced this would be the last year when the C.M.S. Hall was free for W.C.S.I. Exhibitions. An alternative venue would have to be found. It was decided to approach the Exhibition Hall, Bank of Ireland, Baggot Street,

the Hugh Lane Municipal Gallery and the R.H.A. Gallagher Gallery to see if it might be possible to hold the Society's annual exhibition in one of these venues. Members agreed that no works might be hung in the annual exhibition without subscriptions being paid in advance by each exhibitor. From 1975 until 1980, the W.C.S.I. annual exhibition was held in the Hugh Lane Municipal Gallery, (now known as The Dublin City Gallery, The Hugh Lane) Parnell Square, Dublin. An entrance fee relating to those artists who had been newly elected to join the W.C.S.I. was introduced in 1983 and the figure agreed by the committee was £10.00.

Subscriptions were raised to £7.50.

James Nolan, R.H.A., A.N.C.A., was elected as a member of the Society in 1974 and was to serve with distinction as President from 1981 to 1994. Born in Dublin, the painter studied Fine Art at St. Martins College of Art, London and at N.C.A.D. under Seán Keating, R.H.A. and Maurice MacGonigal, R.H.A. He graduated in Fine Art (Painting) in 1958, and taught Fine Art at N.C.A.D. from 1959 to 1977. At the end of that year, he left to take up painting as a full-time career. Specialising in landscape and figurative painting, Nolan was elected an Associate of the Royal Hibernian Academy in 1969, and served as

Keeper from 1978 to 1988. Appointed a Trustee of the National Self-Portrait Collection, University of Limerick from its inception in 1981 to 1988, Nolan was also a member of the Board of Governors and Guardians of the N.G.I. from 1984 to 1993.

W.C.S.I. Committee member, George McCaw, who had been elected a member of the Society in December 1958, replaced Dorothy Glynn as W.C.S.I. Hon. Secretary in February 1984 He was to hold this position for the next fifteen years. During this period, George McCaw succeeded in raising the profile of the Society and contributed to its current success on many levels. Related to the painter, Louis Werner (d.1901) who exhibited a number of portraits at the R.H.A. from 1860 to 1899, George McCaw studied architecture at the University of Cambridge School of Architecture and at Edinburgh College of Art. Between 1957 and 1980, he worked first as an assistant and then as a partner in the established firm of McDonnell & Dixon, Architects, Ely Place, Dublin. He left in 1980 in order to set up his own private practice in Clonskeagh, Dublin.

At the 1984 W.C.S.I. committee meeting, it was agreed that artists Arthur Armstrong, Professor John F. Kelly, Ruth Brandt, Carey Clarke, Niccolo Carraciolo, Arthur Gibney, Janet McGloughlin Minch and Eric Patton should be invited to join the Society and exhibit their work at the annual exhibition to be held in the Exhibition Hall, Bank of Ireland, Baggot Street in June of that year.[17] The question of raising the commission on sale of paintings to twenty-five per cent was also under review. Many members had objected to this but 'following a vote it was agreed to let the decision stand for this year (1984) but that the situation would be reviewed next year.'[18] At the Society's next meeting held in November 1984, it was announced that Niccolo Carraciolo, Ruth Brandt, Carey Clarke, Arthur Gibney, Arthur Armstrong and Eric Patton had been duly elected. At this meeting, it was also announced that advertisements in the catalogue had produced over £200.00 in revenue.

It was also proposed at this meeting that members should receive an Annual Newsletter. It was agreed that a draft copy should be produced for approval at the next meeting. 1985 was the first year, (and the 131st year of the Society) when an Annual Newsletter was sent to Members by the Hon. Secretary, George McCaw. It stated: 'At the start of this year [January, 1985] there are a total of 107 Members registered ... Of these 73 are in the Dublin area, 15 are in other parts of Leinster, 6 are in Munster, 3 are in Connaught and 8 are in Ulster. We have one member in London and one in Paris.'[19]

Honorary membership of the Society had been offered to distinguished landscape and figure painter, Tom Carr, H.R.H.A.,, R.U.A., R.W.S., O.B.E. (1909-1999) who had exhibited with the W.C.S.I. in 1983. He accepted with great pleasure.[20] It was also agreed that Honorary membership should also be extended to Irish born and international painter, sculptor, printmaker, designer and illustrator, Louis Le Brocquy.[21]

In 1987, Hon. Secretary, George McCaw initiated the idea of holding summer outings for members to places of interest. This became a popular annual event. An outing was discussed at the January, 1987 meeting and arrangements were made for members to visit the Ulster Watercolour Society's (formed in 1976) annual exhibition held that year in the Bell Gallery, Belfast on 6 June, 1987.[22] This was followed by a luncheon party in the Ulster Museum and a conducted tour of the museum's watercolour collection provided by Martyn Anglesea, Assistant Keeper, Department of Art, Ulster Museum.

During the following years, visits were paid during the summer to a wide variety of venues throughout Ireland including the Salesian College, Ballinakill, Durrow and Kilkenny Castle, Limerick University, Glenstal Abbey, Monaghan County Museum, the Tyrone Guthrie Centre, Carlingford, Warrenpoint and the Mourne mountains, Trim Heritage Centre and Castle, Ballinlough Castle near Delvin, Co. Meath, the Father Murphy Centre, Boolavogue, County Wexford and the collection of work of W.C.S.I. member, the late Phoebe Donovan (1902-1998) on display in her home, Ballymore, Camolin, Co. Wexford.

When elected President of the W.C.S.I. in 1981, James Nolan was surprised to find that despite a long and distinguished history, the Society had not produced a logo or emblem with which to identify itself. In order

A group of W.C.S.I. members visit the Ulster Watercolour Society (founded 1976) exhibition held in October 1997. W.C.S.I. ARCHIVES / NATIONAL GALLERY OF IRELAND

to raise the image of the Society, members, including the President, were invited to submit a design for this. James Nolan's interpretation was adopted. In a letter to the author, the artist relates how he arrived at his design:

'After much consideration and the rejection of the pragmatic and obvious, I was left with two choices: Minerva and St. Luke. Both had long been adopted by the academies in one form or another: Minerva appears on the coat of arms of the R.H.A., holding a spear in one hand and a wreath of laurels in the other…St. Luke was, according to tradition the painter of the first Christian icons…I chose St. Luke because tradition proclaims him as an artist and long associated with the medieval guilds.'[23]

A designer who had trained in N.C.A.D. and been a prize winner (jewellery) in the National Design competition, (1966) Una de Blacam (née Craddock) was commissioned by the Society to execute the President's

Some W.C.S.I. members and members of the committee, 1988.
Front Row: L-R, W.C.S.I. President and Trustee, James Nolan, R.H.A., A.N.C.A.; Chris Reid; Pamela Leonard.
Back Row: L-R, Palm Skerrett; W.C.S.I. Trustee, Myra Maguire; Patricia Kilroy; Rosemary O'Reilly; Hon. Treasurer, Brian K. Reilly, F.C.A.

The W.C.S.I. President's Medallion. Designer, Una de Blacam (née Craddock). The three-dimensional design is in gold, and based on the W.C.S.I. logo designed by W.C.S.I. President, James Nolan, R.H.A., A.N.C.A.; it was enclosed in an undulating silver surround, suggesting a wave, and suspended from a green (later blue) silk ribbon.

design for the medallion in three-dimensional form. This was made from a piece of gold, a family heirloom which had been generously donated by W.C.S.I. President James Nolan. The gold logo was enclosed in a gentle undulating silver surround, suggesting a wave and suspended from a silk ribbon.

In 1986, for the first time for many years, a social event was held in the home of member, Patricia Kilroy, and her husband. Thirty people attended and a small profit was realized.

Accounts for the year ending 31 October, 1986 showed a marked improvement. Total sales at the annual exhibition (1986) were £4,448.00 (37 pictures) as against £4,420.00 (40 pictures) in 1985. During 1986, generous donations had been received by the Society's President towards compiling a History of the Society (the 'Book Fund') and towards the purchase of a suitable Presidential medallion.[24]

The idea of publishing the full names and addresses of exhibiting members in the annual W.C.S.I. exhibition catalogue was revised again in 1986 with 175 paintings being accepted for the Society's Annual Exhibition. In the same year, it was also decided by the committee that all new

applicants applying for membership should, from now on submit a short C.V. together with examples of their work. The following year the Committee agreed that the Annual Subscription should be raised to £10.[25]

During the second week of the Annual Exhibition (1987) held in the Exhibition Hall, Bank of Ireland, Baggot Street, Dublin the President of Ireland, Dr. Patrick Hillery honoured the Society by paying a visit to the exhibition. He was provided with a tour of members' exhibits by the Society's President, James Nolan, R.H.A., A.N.C.A. and the Hon. Secretary, George McCaw.

In 1987, the Society's President, James Nolan was anxious to see a revision of the Rules of the Society being set in place. He was 'keen that as many of the old rules that were applicable now should be retained. The Secretary … read a revised terms of reference, relating to the Officers of the Society and subject to some revisions that was agreed in principle. It was felt that a combination of these and the Old Rules should be drawn up to form the basis of the new Rules to be submitted for approval to a general meeting to be held next autumn.'[26] As

a result, the committee decided to undertake a revision of the Society's Rules and Terms of Reference during that year. It was also reported that during 1987, Ann M. Stewart, Librarian, National Gallery of Ireland had begun work on compiling information from available W.C.S.I. exhibition catalogues belonging to the Society. It was intended that these should help to provide information on which the history of the Society would eventually be written. No official documentation/archives relating to the W.C.S.I. activities were known prior to 1921 and therefore the catalogues, although incomplete were of particular relevance and importance.

At a W.C.S.I. General Meeting held in Buswell's Hotel, Molesworth Street, Dublin, 2 on Tuesday, 9 February, 1988 present were: President, James Nolan, R.H.A., A. N.C.A. and Hon. Secretary, George McCaw. Committee: Brian Reilly, Myra Maguire, Pamela Leonard, Palm Skerrett, Lillias Mitchell, Pat McCabe, Pauline Scott, Desmond McLoughlin, Kay Doyle, Vivienne Baldwin, Edythe Flood, Patrick Muldowney, Josephine Scott, Pauline Doyle and Ann Whelehan. Under discussion was the Society's Rules and Terms of Reference which was subject to the following amendments (as already circulated to all members). These were proposed for adoption by Pamela Leonard and seconded by Myra Maguire. They were passed unanimously.

A. Hon. Secretary Terms of Reference 2 was altered to read as follows:

'All the correspondence connected with the business of the Society shall be directed through the Hon. Secretary'.

B. Hon. Secretary Terms of Reference 9 was altered to read as follows:

'The Hon. Secretary shall receive fair remuneration and expenses at the discretion of the Committee.'

C. Hon. Treasurer Terms of Reference 6 was altered to read as follows:

'The Hon. Treasurer shall receive fair remuneration and expenses at the discretion of the Committee.'

D. The following additional item No. 10 was added to Committee Terms of Reference:

'The Committee is empowered in special circumstances to elect to Honorary Membership persons deemed to be suitable.'

E. Rule No. 8 was altered to read as follows:

'The Works of Art eligible for the Exhibition of the Water Colour Society of Ireland shall consist of Paintings in Water Colours, Gouache, Etchings, Sepia, Chalk, pastel, Pen and Ink and Pencil Drawings and Fine Art Prints.'[27]

In response to an invitation issued by the President of the University of Limerick, Dr. Edward Walsh to W.C.S.I. President, James Nolan and members, the Society agreed their summer outing in 1988 should be to the Hunt Museum and the National Self-Portrait Collection, Limerick.

At their meeting held on 6 April, 1989, it was confirmed that the Society's annual exhibition that year would be held at the R.H.A. Gallagher Gallery, Ely Place, Dublin (4-16 September inclusive) and not in the usual venue, the Exhibition Hall, Bank of Ireland, Baggot Street, Dublin. This was unavailable due to alterations being carried out to the exhibition area. In order to meet expenditure costs, the annual subscription was raised to £15.

The 136th exhibition (1989) 'has been an outstanding success...For the first time a private Press Reception was held prior to the main Opening Ceremony ...107 pictures to the value of £22,356.00 were sold. Increased publicity and being open for 2 weekends certainly helped to achieve record sales in addition to the overall high standard of exhibits.'[28]

In conjunction with their Annual Exhibition (1992) held for a fourth year in the R.H.A. Gallagher Gallery, Ely Place, Dublin there was a new departure during the exhibition when a free lunchtime lecture on watercolours was delivered by the Director of the R.H.A., Ciarán MacGonigal. This was attended by over 100 people.[29]

In the Society's Newsletter dated 15 December, 1989, it was announced that:

'An agreement has now been signed

General view of the Permanent National Collection of the Water Colour Society of Ireland, University of Limerick. PHOTOGRAPH BY EOIN STEPHENSON, UNIVERSITY OF LIMERICK

with Limerick University for the housing of a permanent Collection from the Society in their new Foundation Building just completed. To form the Collection each member is being invited to present one fully framed painting for which the University will pay an honorarium fee of £100.00 plus cost of framing. As this Collection will be on view to the public, the Committee hope that members will be keen to support the scheme with a work of good quality…'[30]

In 1989, the President of the W.C.S.I., James Nolan, R.H.A., A.N.C.A. held discussions with the President of the University of Limerick, Dr. Edward M. Walsh, in conjunction with the idea of establishing a Permanent National Collection of the Water Colour Society of Ireland. Each member of the Water Colour Society of Ireland was invited to donate a representative work to this collection. It was hoped that from time to time, the collection would also be augmented by the acquisition of works by deceased Irish painters/members of the Society. On 8 March, 1990 in a letter to James Nolan, Dr. Edward M. Walsh stated it would 'be necessary to identify a building in which the special environmental conditions necessary for such an important collection could be provided'.[31] He went on to mention that he was hopeful that it might be possible to make suitable provision for the Collection within a new £9m Research and Exhibition complex 'which we are designing and intend to fund privately through the new University of Limerick Foundation'. In collaboration with the architects and the Chairman of the Foundation, Dr. Walsh felt there was the possibility of designing certain circulation areas within the new building which would meet the special requirements for a watercolour collection. It was en-visaged that a work by each member of the Water Colour Society of Ireland would be placed on public exhibition and 'the University would provide the necessary support to ensure that the Collection would be cared for and developed over the years ahead'.

Photograph taken at the opening of the Permanent National Collection of the Water Colour Society of Ireland, Foundation Building, University of Limerick on Saturday, 25 September, 1993. W.C.S.I. President, James Nolan, R.H.A., A.N.C.A.; Mr. Willie O'Dea, TD., Minister of State at the Department of Justice; Dr. Edward M. Walsh, President, University of Limerick and Mr. George McCaw, Hon. Secretary W.C.S. I.

W.C.S.I. ARCHIVES / NATIONAL GALLERY OF IRELAND

Amongst the various clauses eventually agreed upon and contained in the agreement drawn up between The Water Colour Society of Ireland and the University of Limerick were the following:

'The Society shall provide the Curator, at least annually, with (a) a list of current Members of The Society, (b) a list of new Members of The Society admitted since the previous list was provided.' (7)

'The Curator shall make an annual report to The Water Colour Society of Ireland on the state of The Collection.' (8)

'The University shall house, care for and maintain The Collection in accordance with the general policies and procedures that apply to the art collection that is the policy of The University.' (10)

'No work in The Collection shall be disposed of.' (12)

'The University shall bear the cost of housing and maintaining The Collection.' (15)

'The University shall receive any revenues or royalties that may arise from The Collection.'(16)

'The University of Limerick shall be the permanent home of The Collection.' (17)

'In the event of any matter arising between the two parties which cannot be resolved by mutual agreement, it shall be decided upon conclusively by a person or persons acceptable to both parties.' (19)

In general, W.C.S.I. members were enthusiastic about the idea of establishing a Permanent National Collection sited on the University of Limerick campus provided a number of points in the draft agreement could be agreed upon by both parties. In a letter dated 25 May, 1990, Dr. Edward Walsh mentioned he had briefed members of the board and, in principle

W.C.S.I. President, James Nolan, R.H.A., A.N.C.A. presenting a female portrait study (untitled) (pencil on paper) by W.C.S.I past member Maurice MacGonigal, P.P. R.H.A. (1900-1979) for inclusion in the W.C.S.I. Permament (later National) Collection, University of Limerick. Also present are Dr Edward M. Walsh, President, University of Limerick and his wife, Stephanie.

W.C.S.I. ARCHIVES / NATIONAL GALLERY OF IRELAND

they were in favour of the idea. Dr. Walsh stated he hoped to be in a position to bring the matter before the Governing Body for their approval on 28 June of that year (1990). Meanwhile, Professor Dr. Patrick F. Doran, Dean of Humanities had been appointed Curator of the Permanent National Collection of the Water Colour Society of Ireland, University of Limerick and was being kept informed by Dr. Walsh of progress to date.

On September 27th, 1993 after much discussion and revision of the agreement, the Permanent National Collection of the Water Colour Society of Ireland was established which comprised the work of both professional and non-professional artists/members of the Society. It was officially opened in the University of Limerick's newly constructed Foundation Building. A large party of members travelled down for the occasion and were given a warm welcome by University President, Dr. Edward Walsh and his staff.

The opening ceremony was performed by Mr. Willie O'Dea, T.D., Minister of State, Department of Justice and took place in the University Concert Hall which forms part of the new building. The President of the W.C.S.I., James Nolan, addressed those present and mentioned in his speech the distinguished history of the W.C.S.I. and how so many prominent artists including Nathaniel Hone, the younger, Sir William Orpen, Harry Clarke, Evie Hone, Kitty Wilmer O'Brien and many more had all contributed to the Society's ongoing success, standard and reputation. He paid a warm tribute to the:

'...initiative and vision of Dr. Edward Walsh, Dr. Patrick Doran and to Erica Loane, the latter being responsible for the research and high quality illustrated catalogue which accompanied the collection. This was produced by the University of Limerick under her guidance.'[32]

He concluded:

'The Society is proud and honoured to have a presence in these august surroundings and confident that as the collection expands by drawing on the past and with the support of future members, it will become a valued part of our European heritage.'[33]

At the ceremony, both the W.C.S.I. President and the Hon. Secretary, George McCaw, were presented with cut-glass momentos as a tribute to mark their outstanding contributions. Following the launch, the audience was invited to enjoy a concert presented by London Winds in the University Concert Hall.

It was noted that out of a total of 111 W.C.S.I. members (in 1993), ninety-eight had responded to the invitation to exhibit their work in the Permanent National Collection of the W.C.S.I. It was hoped that in future, works by former members would be added whenever possible. All newly elected W.C.S.I. members were expected to donate a selected work to the Permanent National Collection.

Since 1993, the Society has elected sixty new members. By 2009, this had resulted in a total of 168 works being placed on view in the Permanent National Collection of the W.C.S.I. The exhibition had expanded rapidly since its inauguration in the early 1990s and it was decided in 2009 that a section should also be housed in the splendid Bourn Vincent gallery which forms part of the Foundation building, University of Limerick. The exhibition, accompanied by an illustrated catalogue, is open to the public all year round.

In 1989, the Society on the recommendation of W.C.S.I. members, Brian and Kay Doyle, appointed a professional public relations consultant, Sandra McDowell, who had been a public practitioner since 1978 and a director of a leading PR consultancy firm in Ireland. Later, in 1993 McDowell was to establish her own private practice. Her task was to raise the profile of the Society and to be responsible for handling promotional campaigns for W.C.S.I. annual exhibitions. She was also requested to look after publicity in relation to new incoming presidencies. Sandra McDowell continues to undertake these tasks on behalf of the W.C.S.I. and has succeeded in raising the Society's public profile which, in turn, has encouraged new applicants to seek membership.

President James Nolan retired in 1994:

'...after thirteen years of dedicated and devoted service to the Society. James's Presidency was significant for the growth in the membership of the Society, the opening of our Permanent collection in the University of Limerick, the design of the Society's motif and the very generous gift of a gold medallion for our Presidential chain of Office.'[34]

As mentioned by the Hon Secretary, George A. McCaw in his Newsletter, James Nolan had generously presented to the Society a gold presidential medal which was to be worn by the President of the Water Colour Society of Ireland on all formal occasions. A general vote of thanks and appreciation was expressed by the W.C.S.I. committee at their meeting held in January 1994 to James Nolan for his unique and outstanding contribution to the work of the Society.

James Nolan was succeeded by Kay Doyle, A.N.C.A. for a five-year term, her nomination being proposed by the outgoing President, seconded by Edythe Flood and confirmed at the same meeting (January 1994.) Kay Doyle had joined the Society in 1982. Six years later, she was elected to its committee. After graduating from N.C.A.D., she began her art career in Paris and four years later returned to Dublin. Kay Doyle exhibited on a regular basis with the R.H.A., W.C.S.I., and the Royal Ulster Academy. Her work formed part of many international exhibitions including the 17th International Art Exhibition held in the Metropolitan Museum, Tokyo. As the new President of the W.C.S.I., Kay Doyle agreed 'to foster the growth of the Society and to encourage public interest in Irish watercolour painting.'[35]

At the beginning of 1994, the Society had 116 members, with seventy-eight residing in the Dublin area, twenty in parts of Leinster, four in Connaught, six in Ulster, two members in England, and one in Paris. The Annual Exhibition (1994) had been highly successful with 103 paintings

W.C.S.I. member and President, the late Kay Doyle, A.N.C.A. (1931-2009) at the R.H.A. Gallagher Gallery, W.C.S.I. Annual Exhibition, 1992. Photograph by Jack McManus, *Irish Times*, 4 November, 1992. COURTESY OF THE IRISH TIMES, DUBLIN

being sold. Proceeds from sales had amounted to £25,075.

In 1995, the Hon. Treasurer, Brian K. Reilly, compiled and issued (with assistance from his secretary, Rosemary Macaulay) the definitive *W.C.S.I. Exhibition List 1872-1994*. Valuable research relating to past W.C.S.I. catalogues had been provided by N.G.I. librarian, Ann M. Stewart. The W.C.S.I. exhibition list listed 24,000 works by 1,200 artists and provided details, year by year, of the names and

addresses of all known artists who had participated in the Society's exhibitions, titles of their works shown, together with prices. The list was compiled in alphabetical sequence by artist's surname. This publication is a valuable source of reference both for the Society and future researchers, and helps considerably to enhance the Society's past history and current public profile. It is hoped that from time to time additional updates will be added to the exhibition list.

Outside Slaney House, University of Limerick, July 1995:
Back row: James Nolan, R.H.A., A.N.C.A.; W.C.S.I committee member, Liam O'Herlihy; W.C.S.I. Hon. Treasurer, Brian K. Reilly, F.C.A.; Dr. Patrick Doran, Dean of Humanities and Curator of the W.C.S.I. Permanent (later National) Collection, University of Limerick; W.C.S.I. Hon. Secretary, George McCaw.
Front row: Dr. Anne Sadlier, University of Limerick; W.C.S.I. President, Kay Doyle, A.N.C.A.; Dr. Edward M. Walsh, President, University of Limerick; W.C.S.I. committee members, Nancy Larchet, Pamela Leonard. W.C.S.I. ARCHIVES / NATIONAL GALLERY OF IRELAND

The W.C.S.I. Annual Exhibition held in the R.H.A. Gallagher Gallery, Ely Place, Dublin, November, 1993. Gemma Maughan chatting to W.C.S.I. member, Anne Whelehan. Photograph by Eric Luke. COURTESY OF THE IRISH TIMES

At a W.C.S.I. committee meeting held in April 1996 there was a lively debate in relation to entrance fee charges being made for W.C.S.I. annual exhibitions with opposing views being put forward. It was agreed that for the current year (1996), there should be a general entrance fee levied amounting to £1, with reduced charges for OAPs, students, children and groups.

On December 10, 1996 the Society's Annual exhibition (142nd) was held for the sixth year in the R.H.A. and opened by the President of Ireland, Mary Robinson. The President, accompanied by her husband,

Nicholas, was introduced to W.C.S.I. committee members and provided with a conducted tour of the exhibition by W.C.S.I. President, Kay Doyle. On behalf of the Society, Kay Doyle presented the President with a bound copy of *The W.C.S.I. Exhibition List 1872-1994*. Out of a total of 207 paintings for sale, 101 were sold at a cost of £28,309.00.

The following year, the Society moved the Annual Exhibition to the Clock Tower, Dublin Castle. This was opened by the Chairman of the Board of Works, Barry Murphy.[36]

For the first time, a 'Studio evening' was launched in 1997 with nine W.C.S.I. members participating: James Flack, Berthold Dunne, John Freeney, Eleanor Harbison, Vincent Lambe, Anna Marie Leavey, Desmond McLoughlin, Nina Patterson and Pamela Leonard, A.N.C.A. who demonstrated their skills to an enthusiastic audience. Distinguished academician, Thomas Ryan, P.P.R.H.A., H.R.A. H.R.S.A. drew a large crowd to this Sunday demonstration.

A spring outing was arranged in 1998 when members visited Lismore Castle, and the Lismore Heritage Centre based in the Courthouse, Lismore. A lecture relating to early Irish watercolours was organised by the administrators of the Lismore Arts Centre, Dromroe, Cappoquin, Co. Waterford, Patricia Martin and Susan Wingfield. The talk was given by

Cover of the *Water Colour Society of Ireland Exhibition List, 1872-1994* compiled by W.C.S.I. Hon. Treasurer, Brian K. Reilly, F.C.A. and published in 1994.

W.C.S.I. member, the late Brian K. Reilly, F.C.A who served as W.C.S.I. Hon Treasurer from 1982-1996. He compiled and issued, with assistance from Rosemary Macaulay and members of the W.C.S.I committee (1993-1994), the *W.C.S.I Exhibition List 1872-1994* (Dublin, 1994). Original research by Ann M. Stewart, Librarian.

The President of Ireland, Mary Robinson, viewing the W.C.S.I. exhibition with the President of the W.C.S.I., Kay Doyle, A.N.C.A. President Robinson opened the 142nd Annual Exhibition of the society on Tuesday, 10 December, 1996 held in the R.H.A. Gallagher Gallery, Ely Place, Dublin. COURTESY OF FENNELL PHOTOGRAPHY

Desmond FitzGerald, Knight of Glin and Professor Anne Crookshank in the Courthouse, Lismore It was in this building that the Amateur Drawing Society mounted its first exhibition in May 1871. A commemorative exhi- bition consisting of forty-seven paintings by fifteen artists largely relating to the first exhibition were on display to the public.

During 1998, apart from the Annual exhibition, an exhibition by W.C.S.I. members was also held at the '75' Gallery, O'Connell Street, Limerick and again the following April, the theme being 'The Way of Nature'. The exhibition was opened on Sunday, 25 April by John Hunt, Director of the Hunt Museum, Limerick. Due to lack of space, the gallery was forced to limit the number of paintings to between sixty and seventy works.

The Permanent National Collection of the W.C.S.I. Limerick had been continuing to grow and the total number of exhibited works in 1998 reached 128. In that year, it was agreed that the honorarium payment to W.C.S.I. Exhibitors be raised from £100 to £150.[37]

President Mary Robinson opens the W.C.S.I. 142nd Annual exhibition, Tuesday, 10 December, 1996. W.C.S.I. Committee members Pauline Scott; James Nolan, R.HA., A.N.C.A.; Nancy Larchet; the President of Ireland, Mary Robinson; W.C.S.I. Hon. Treasurer, Brian K. Doyle; W.C.S.I. President, Kay Doyle; W.C.S.I. Hon. Secretary, George McCaw; Desmond McLoughlin and Pamela Leonard. COURTESY OF FENNELL PHOTOGRAPHY

In October, 1998, distinguished artist, Neil Shawcross, R.U.A. from Hillsborough, Co. Down was invited to become an Honorary member. His acceptance and subsequent exhibit of work which formed part of the Annual Exhibition, 1998 held in the Royal Dublin Society, Ballsbridge, Dublin

George McCaw elected President of the Water Colour Society of Ireland, 24 May, 1999.

was greatly appreciated by members. In memory of highly respected W.C.S.I. committee member, flower, landscape and portrait painter, the late Phoebe Donovan, (elected an Honorary member, 1987) a memorial panel exhibiting six of her works was also on display.

Due to a new exhibition policy, the R.H.A. Gallagher Gallery was not available for hire in 1999 and neither was the R.D.S. Instead the Annual Exhibition was held for the first time in the Concourse, County Hall, Dun Laoghaire, Co. Dublin from 28 September-14 October, 1999. Art historian, writer, and journalist, Dr. Bruce Arnold opened the exhibition.

In that year, (1999) Kay Doyle, A.N.C.A. retired as W.C.S.I. President. Her contribution together with that of her husband, Brian, to the Society had been immense, with many important changes taking place. Among the major ones was the introduction of a Selection Committee for the Society's Annual Exhibition; the re-introduction of exhibitions in centres outside Dublin (in addition to the Annual Exhibition held in Dublin); the introduction of painting demonstrations by members during the exhibition; sponsorship and sponsored

prizes for the Annual Exhibition; the complete revision and updating of the Society's Rules together with Terms of Reference (approved at a General Meeting held on 7th July, 1998); and the codification and documentation of the Society's exhibition requirements and procedures.

George McCaw, elected to the Society in 1959, had served as Honorary Secretary for fifteen years. During his term of office innovations

A Century of Watercolours A lecture given on Saturday, 25 April, 1998 by Professor Anne Crookshank and Desmond Fitzgerald, Knight of Glin in the Lismore Heritage Centre, Lismore, Co. Waterford. In the same venue, on Wednesday evening, 10 May, 1871, members of the Amateur Drawing Society (now known as the Water Colour Society of Ireland) held their first exhibition.

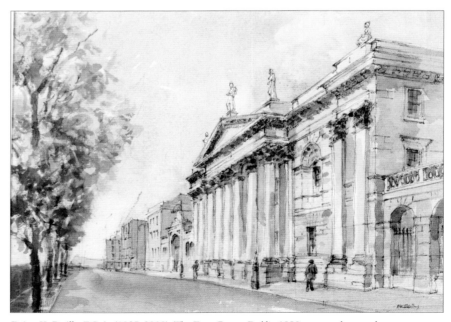

Brian K. Reilly. F.C.A. (1925-2008) *The Four Courts, Dublin* 1990, watercolour and pen on paper. Signed 'BK Reilly'. The late Brian K. Reilly studied part-time at the N.C.A.D. Dublin and St. Martin's School, London. He exhibited his work in both public and commercial galleries and made a distinguished contribution to the W.C.S.I. serving as Hon. Treasure from 1982 until February 2002.

Nancy Larchet elected President of the Water Colour Society of Ireland, 5 June, 2002.

had included the Society's annual summer outing and the newsletter. Drawing on the loyal support and encouragement of his wife, Maureen, he agreed to serve as President of the Society. He was nominated by W.C.S.I. members, Liam O'Herlihy, and seconded by Desmond McLoughlin at a W.C.S.I. meeting held on 24 May, 1999. Pauline Scott was elected Honorary Secretary, while Brian Doyle, F.C.A continued to act as Hon. Treasurer of the Society.

In accepting the position of President, George McCaw stated that he looked forward to continuing the work of the Society, one of his goals being the commissioning of an illustrated history of the Society to follow on from Brian Reilly's publication *Water Colour Society of Ireland Exhibition List, 1872-1994*.

By the year 2000, membership of the Society had reached 116. There was a surplus in the accounts, and at their Annual Exhibition that year, 255 exhibits were on show. It was decided to close the membership until 2002 when the position would again come under review.

In May 2000 a Procedures Manual (extending to eighty-five pages) for the running of the Society was introduced. This document had been initiated and assembled under the supervision of

Kay and Brian Doyle. Agreement with the Officers and Committee, the objectives of the Manual which, it was stressed, should be used as a working document were as follows:

'(a) To keep a record of current practice in all of the activities of the Society.

(b) To encourage constant review and updating of these practices.

(c) To facilitate regular improvement in "How we do things".

(d) To provide a reference document of "What was done last year".'

Under the guidance of W.C.S.I. committee member, Nancy Larchet and Hon. Secretary, Pauline Scott, thirty-eight paintings by W.C.S.I. members were placed on display in the corridors of the Regional Hospital,

Waterford in November 2000. The exhibition, which opened on Friday, 23 November, 2000 was held in aid of the Waterford Healing Trust which promotes the idea of bringing art into the hospital. It raised considerable interest and support.

Following a proposal put forward by Desmond McLoughlin, supported by Pauline Scott and Nancy Larchet, it was suggested that former W.C.S.I. President, James Nolan, former Treasurer, Brian K. Reilly, and former President, Kay Doyle, should be conferred with Honorary Membership of the W.C.S.I.

To commemorate and celebrate their achievements, an awards ceremony was held in the Royal Dublin Society's Members' Club on Wednesday, 25 July, 2000. In the presence of twenty invited guests, which included the W.C.S.I. Committee, and Myra Maguire (a W.C.S.I. Trustee), Honorary Life Membership was bestowed upon Kay Doyle, James Nolan, and Brian Reilly,

W.C.S.I. members' work on display at The Concourse, County Hall, Dun Laoghaire, Co. Dublin. The Water Colour Society of Ireland began holding their annual exhibitions in this venue in September 1999.

to honour their outstanding contributions to the Society over many years. Illuminated scrolls were presented outlining their achievements.

At a W.C.S.I. committee meeting held on Thursday, 14 February, 2002 at the United Arts Club, 3 Upper Fitzwilliam Street, Brian Doyle stood down as Hon. Treasurer. It was proposed that Dr. Thomas Wilson be co-opted to the position in advance of a triennial General Meeting to be held on 8 May, 2002. This was agreed. Dr. Wilson's links with the Society had begun thirty years earlier when he began exhibiting in 1972. His father, Dr. T.G. Wilson, also an artist had been a consistent contributor to W.C.S.I. exhibitions throughout the 1960s exhibiting a number of Greek, Italian and Irish views.

In a letter to W.C.S.I. committee member, Nancy Larchet, dated 20 April, 2002, the President of the W.C.S.I. George McCaw outlined his reason for wishing to step down after a term of three years: 'I feel that a new President should be elected every three years so as to give all those worthy of the office [an opportunity] to get a chance.'[38] At a committee meeting held

Vincent Lambe, current President of the Water Colour Society of Ireland.

on 5 June, 2002 Nancy Larchet, who had served with commitment on the W.C.S.I. committee since 1993 and, together with Kay Doyle, had developed the public relations and promotional aspect of the Society's Annual Exhibitions was duly elected President.

Nancy Larchet, who studied at University College, Galway, U.C.D. and N.C.A.D. had exhibited for the first time in 1972 and later at the Mall Galleries, London between 1977 and 1979. A member of the Dublin Painting and Sketching Club, the European Association of Water Colours and the Pastel Society of Ireland, she exhibited for the first time with the W.C.S.I. in 1983. A frequent exhibitor at the R.H.A., and the Royal Ulster Academy, her work has been shown in many countries including France, Italy, Spain and Hungary.

As incoming President, Nancy Larchet paid tribute to retiring President George McCaw for his unstinting dedication to the Society over so many years. He agreed to continue to serve on the W.C.S.I. committee. Later, in 2005, George McCaw was conferred with Honorary Membership of the Society.

The idea of commemorating the 150th Exhibition of the W.C.S.I. with an exhibition to be held in the National Gallery of Ireland was put forward at a committee meeting held in June 2003 by President Nancy Larchet. She had approached the Director of the N.G.I., Raymond

Cover of the Water Colour Society of Ireland's 150th Exhibition Catalogue (2004). A celebratory display of paintings by distinguished past members held (by kind permission) in the Prints and Drawings Gallery, National Gallery of Ireland, Dublin 6 October-12 December, 2004. W.C.S.I. ARCHIVES / NATIONAL GALLERY OF IRELAND

Susan Sex, *Hybrid Dactylorhiza*. Poster for the W.C.S.I. 150th Exhibition held in The Concourse, County Hall, Dun Laoghaire, Co. Dublin, 27 September-9 October, 2004.

W.C.S.I. ARCHIVES / NATIONAL GALLERY OF IRELAND

Keaveney and the Curator of Prints and Drawings, N.G.I., Anne Hodge and both were interested in the idea. At their next meeting, it was announced, the National Gallery of Ireland in conjunction with the W.C.S.I. had agreed to present an exhibition of watercolours on behalf of past members and founders of the Society. This was to celebrate and coincide with the Society's 150th exhibition. The exhibition was to be held in the Print Room, N.G.I by kind permission in the autumn of 2004. Approximately forty-five works were to be placed on display. Further details were provided at the W.C.S.I. February meeting when it was stated that the search for suitable paintings was ongoing and the final selection would be made by Anne Hodge, Curator of Prints & Drawings, N.G.I. The exhibition opened on Tuesday, 5 October and continued until 12 December, 2004. It was generously sponsored by John Larchet, proprietor, Australian Premium Wine collection, and was accompanied by a well researched and illustrated catalogue.[39] Director of the N.G.I., Raymond Keaveney, kindly provided the preface. Patricia Butler, art historian, lecturer and author of *Three Hundred Years of Irish Watercolours and Drawings* was invited to write the foreword. Biographical entries were provided by Curator, Prints & Drawings, N.G.I., Anne Hodge, and her assistant, Niamh MacNally. The exhibition attracted a wide audience, aroused curiosity and succeeded in raising the profile of the Society.

The 150th exhibition of W.C.S.I. members' works opened in the Concourse, County Hall, Dun Laoghaire, Co. Dublin on Sunday, 26 September, 2004 and closed on Saturday, 9 October. It had been highly successful with ninety-six members participating and was supported by generous sponsors, James Adam Salesroom, Citroën Dun Loghaire, DART Suburban Rail, D. O'Sullivan (Graphic Supplies) Ltd., Amárach Consulting and Whyte's Auctioneers. Due to pressure for membership, it was decided this should remain closed until 2006.

At a celebration W.C.S.I. lunch organised by the Hon. Secretary,

W.C.S.I. Committee 2009. Back row, left to right: Valerie 'Moffy' Empey; W.C.S.I. Assistant Secretary, Ann Mina; Rosita Manahan; Jim Doolan; Jayne Barry; Thomas Wilson; Ann O'Clery; Grania Langrishe; W.C.S.I. Assistant Treasurer, Angela Shivnen; W.C.S.I. Hon. Secretary, Pat McCabe.
Front row, left to right: Ivor Coburn; Gráinne Dowling; W.C.S.I. President, Vincent Lambe; W.C.S.I Hon. Treasuer; Pauline Doyle; Muriel Byrne Goggin.

Fox in the Snow by W.C.S.I member, Terence O'Connell, catches the attention of Eoghan Clarke (3) and Leah Deverell (5) from Dun Laoghaire, and Ginnie, a young English pointer, at a preview of the Water Colour Society of Ireland's annual exhibition, October 2001 held in The Concourse, County Hall, Dun Laoghaire. COURTESY OF THE IRISH TIMES

Pauline Scott and held at the Mansion House, Dawson Street on Saturday, 30 October, 2004 members congratulated themselves on two well organised and well received exhibitions by the public held during the year: the 150th National Gallery of Ireland exhibition

and the Annual 150th Exhibition.

By 2009, membership stood at 134 members. From a firm base and a healthy position, the Water Colour Society of Ireland could now look forward to the future with an eager optimism.

Water Colour Society of Ireland
Landscape Members

Alexander Williams R.H.A.
Claude Hayes, R.I., R.O.I.
William Percy French
Florence Agnes Ross
Paul Henry R.H.A.
Edith Gladys Wynne
Stella Noel Frost
Flora Hippisley Mitchell (Mrs William Jameson)
Frank McKelvey R.H.A., R.U.A.
Maurice MacGonigal P.P.R.H.A.,R.A., H.R.S.A.
Norah McGuinness H.R.H.A., D.Litt.

George Pennefather & Helen Pennefather
Basil Ivan Rákóczi
Tom Nisbet R.H.A.
Kitty Wilmer O'Brien R.H.A., U.W.A.
Tom Carr H.R.H.A., R.U.A., R.W.S., O.B.E.
Ralph Desmond Athanasius Cusack
Patricia Wallace (Mrs Griffith)
Gerard Dillon
Wilfred James Haughton P.P. R.U.A., F.R.S.A.,
 P.U.W.S.

ALEXANDER WILLIAMS, R.H.A. (1846-1930)

Honorary Secretary of the Dublin Sketching Club for over fifty years, landscape and marine painter Alexander Williams was at the centre of Dublin art circles throughout his life. He is first recorded as participating in the Irish Fine Art Society's twentieth exhibition held at 35, Molesworth Street, Dublin in the spring of 1883. Fourteen of his landscapes were on view and so began an almost continuous association with the Society.

A prolific artist, Williams appears to have had no difficulty in marketing and selling his work. During the Lord Lieutenant George Cadogan's seven-year term in office as viceroy in Ireland (1895-1902), the Cadogan family purchased some of Williams' work each year at the W.C.S.I. annual exhibitions, until by the time they left Ireland in 1902 they had assembled a substantial collection.During his lifetime, this artist exhibited no less than 191 known landscape works in W.CS.I. annual exhibitions. Forty-one featured his beloved Achill Island, Co. Mayo. He is quoted as saying, 'Achill Island has had for me an ineffaceable charm and my friends tell me I paint it as if I thoroughly loved it.'[1]

William's Achill watercolours are markedly different from his large-scale detailed exhibition pieces which were executed in both oil and watercolour and were major public statements of his art. He exhibited no fewer than 450 works at the R.H.A. between 1870-1930. William's watercolour executed in the picturesque style and depicting *Dugort, Achill Island, Co. Mayo with Slievemore* in the background (illustrated here) contains none of the fussiness combined with overt attention to detail which are found in his large exhibition-type watercolours. In the artist's own opinion, he did not consider himself to be a fully trained artist and regretted that 'his formal art education was limited to drawing at night school at the R.D.S.'[2]

Born in Monaghan on 21 April, 1846 Alexander Williams was the son of William Williams, hatter, Laurence Street, Drogheda, Co. Louth and was educated at Drogheda Grammar School. In 1860 the family moved to Dublin where William Williams established a hat shop in Westmoreland Street. At the age of fifteen he became his father's apprentice. From early childhood, Williams had always been a keen naturalist, sketcher and painter, and once the family were established in Dublin, he managed to find the time to attend drawing classes in the evenings at the R.D.S. In 1866 his father's

premises in Westmoreland Street were destroyed by fire and, being under-insured, the business failed. Short of money, Alexander, together with his brother, Edward, began to earn a living as taxidermists. The brothers founded a natural history studio in Dublin and subsequently several of their works were purchased by the Natural History Museum. During this period Williams was enjoying several careers, including appearing in public as a ventriloquist and as a much sought after singer. He became a member of the choir of the Chapel Royal, Dublin Castle, and was also a member of the Dublin Glee and Madrigal Union Quartet. Later he became a soloist in the choirs of both Christ Church Cathedral and St. Patrick's Cathedral, Dublin. However, in the view of his grandnephew, Gordon T. Ledbetter, 'Alec's ability to sing – he combined singing with painting for many years – probably detracted from his final reputation as an artist.'[3]

The artist visited Achill for the first time in September, 1873 and subsequently wrote, 'All to me was so new and inexpressibly wild and romantic … writing to my father I said I had found a part of Ireland where there was an immense field for the activities of an artist, and that I intended to make it peculiarly my own.'[4]

Alexander Williams, R.H.A. (1846-1930) *Dugort Bay, Achill Island, Co. Mayo with Slievemore in the background;* original title: *Cabins on the beach at Dugort Bay, Achill Island,* watercolour over graphite. Signed lower left, transcribed inscriptions on verso. PRIVATE COLLECTION, IMAGE COURTESY OF WHYTE'S

Williams returned year after year to Achill. Eventually in May, 1899 he was successful in obtaining a lease of three acres of land together with a ruined cottage at Bleanaskill, Atlantic Drive, Achill Sound. And on September 17, 1910, after successfully converting the ruined cottage into a comfortable two-storey house, and transforming the holding by planting hundreds of trees and shrubs, he proudly noted in his diary, 'This is a red letter day in the history of Bleanaskill Lodge, for today, after years of waiting and many disappointments we occupy our house for the first time.'[5]

An article entitled: 'Fifty Years of Irish Painting' appeared in the *Capuchin Annual,* in 1949. The author, Thomas MacGreevy recorded his thoughts on Williams thus: 'A more popular painter of those days, Alexander Williams, would be almost forgotten now, were it not that his feeling for the picturesque in nature, overstated in his large canvases, is expressed effortlessly in some of his smaller works, which, as a consequence retain, unexpectedly after all the years of eclipse, a touch of something very like genuine lyrical quality.'[6]

CLAUDE HAYES R.I., ROI., (1852-1922)

Irish landscape and portrait painter Claude Hayes was described by Martin Hardie, (1875-1952) art historian, author and Keeper of Prints and Drawings, Victoria & Albert Museum, London as 'one of the supreme watercolour painters'.[7] It would appear Hayes had no difficulty in adopting the same principles and open-air breezy style seen in the work of David Cox, Thomas Collier and William Charles Estall, in order to produce water-colours of outstanding simplicity. This is well illustrated here in the work *A Showery Day,* framed in a heavy, ornate 'exhibition' gilt frame, and which hung in the R.A. in 1899.

For watercolours on a large scale, Hayes made many small sketches *en plein air* completing the work in his studio. Determined to retain the brilliance and bloom of the surface of his composition, he avidly applied large washes, with the support, whether paper or card, being placed almost bolt upright on the easel. This resulted in colour running rapidly down the paper. Having carefully worked out the

entire composition well in advance, he began to add detail, applying short, decisive, confident strokes.

Following Cox and Colliers' technique, Hayes aimed at a high quality of texture in his work, and made sure that the support reflected light through the washes. This succeeded in adding a purity and strength of tone not obtainable by any other means.

Son of marine painter, Edwin Hayes, R.H.A., R.I., R.O.I. (1819-1904), Claude was born in Dublin. Despite the young boy showing from an early age a love of drawing, his father was determined that his son should not follow him, but rather enter the world of business – something his offspring was equally determined he would not do. A clash of wills ensued and the young Claude ran away to sea, becoming involved in the Abyssinian expedition during 1867-68. Before returning to London, Hayes spent a winter in the United States, earning a living by selling his drawings. Back in England, the young student studied at Heatherley's Academy and spent a further three years at the Royal Academy Schools. He completed his art training in Antwerp by studying

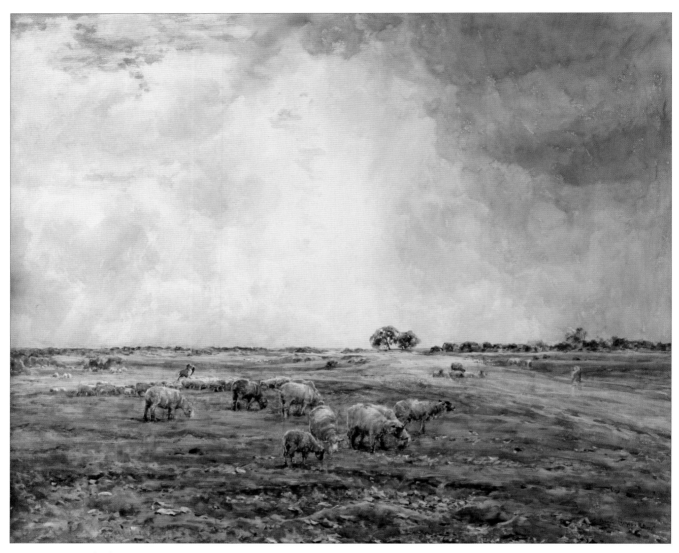

Claude Hayes, R.I., R.O.I. (1852-1922) *A Showery Day* 1895, watercolour heightened with white. Signed and dated '1895'. This exhibition watercolour was exhibited in the Royal Academy, London in 1899 (cat. no. 436).

PRIVATE COLLECTION

under well known Belgian teacher and Realist painter, Charles Verlat (1824-1890). As Hayes' career progressed, he appears to have abandonned portraiture and the medium of oil in favour of watercolour and landscape painting. In 1884 this artist exhibited for the first time at the Institute of Painters in Water Colours. Two years later, Hayes was elected an R.I. Also a participant in the Cork Industrial Exhibition, this artist took part in the Irish Exhibition held in London in 1888. In 1904 Sir Hugh Lane included two watercolours by Hayes (*The River Stour* and *The Road to Portsmouth*) in the prestigious Guildhall Exhibition of Works by Irish Painters.

Claude Hayes' association with the W.C.S.I. began in 1901 when he exhibited two works, *Near the Farm* and *On the Wey, Surrey*. The following year, 1902, he showed two further landscapes, *The Old Bridge* and *A Surrey Pastoral*; and in 1908 he exhibited the work *Scanty Pasturage*. The artist appears to have been reluctant to sever his links with Ireland and submitted a further two watercolours to the Irish International Exhibition, Dublin held in 1907. In 1909 Hayes took part in the Belfast Art Society's twenty-eighth annual exhibition held in their usual venue, the Belfast Free Public Library.

Hayes is listed as an 'Artist Exhibiting by Special Invitation' and submitted two landscape watercolours *Haymaking in Dorset* and *A Pastoral Scene*.[8] The following year, he was listed as being an Honorary Member of the Society.

Towards the end of his life, Hayes tended to paint in a higher tonality than before. However, due to ill health and lack of money, the artist began to turn out hasty and indifferent work. Hardie feels this artist 'never quite received the recognition which he deserves', but at his best, Claude Hayes' watercolours were admirable for their freshness of colour, fluidity and response to atmosphere.[9]

WILLIAM PERCY FRENCH
(1854–1920)

'Percy French was a man of diverse talents, the archetype of the gifted all-rounder who seems to be virtually extinct in our own specialised age. As a watercolourist he was prolific, fluent, and generally good without storming the heights. He was much more than an amateur artist.'[10]

So wrote Brian Fallon, art critic of the *Irish Times,* reviewing an exhibition of this artist's work in 1982. French spent a total of eight years in Trinity College, Dublin: 'they were obviously afraid that if I stayed at Trinity much longer I might apply for a pension.'[11] In his first year in College, the young student entered two watercolours in an exhibition organised by the Irish Amateur Drawing Society in 1872, the two entries being sent from St John's Wood, London. The artist continued his association with the Society until 1910, submitting a total of sixty-eight works in all.

French understood what was essential to the composition of a good picture, his style being well suited to the depiction of the beauties of the Irish open countryside, dominated by sky and filled with light effects. He rarely introduced figures into his landscape compositions, preferring instead to capture the fleeting atmospheric conditions of his beloved Midlands or the west of Ireland. The mood and essential forces of nature are beautifully and expressively conveyed here in his landscape entitled *In the West* dating from 1912. The artist succeeds in capturing the ever changing western light which falls on the calm, still water of the bog, light always playing a major role in this painter's work.

Born at Cloonyquin House on the outskirts of Elphin, Co. Roscommon, his family having lived for many generations in the county. His mother was the daughter of the Reverend William Percy; his father, Christopher French, was a Doctor of Law. Their son was educated at an English prep school, Kirk Langley, and later at Windermere College, Foyle College,

and Trinity College. He graduated with a degree in civil engineering in 1881 and took up his appointment with the Board of Works in Cavan as surveyor of drains. During Percy French's seven-year appointment, the artist had ample opportunity to paint and sketch throughout the county, in the midlands and west of Ireland.

When the Board reduced its staff and the artist lost his capital in an unwise investment, French turned his hand to journalism. He became editor of the *Jarvey,* a weekly comic paper. Sadly, this venture did not succeed. Never at a loss, French joined his friend Dr. Collisson and began to write and produce musical comedy, staging *The Knights of the Road* at the Queen's Theatre, Dublin. The partnership between French and Collisson led to a long and successful career as a songwriter and entertainer, which included tours of the United States, Canada, England and the West Indies. In 1890, the artist moved to London. In 1907, he held a joint exhibition with Claude Hayes, Mildred A. Butler, and Bingham McGuinness, at the new Dudley Gallery.

As he said himself, 'I was born a boy and have remained one ever since. Friends and relatives often urge me to grow up and take an interest in politics, whiskey, race meetings, foreign securities, poor rates, options and other things that men talk about, but no – I am still the small boy messing about with a paint-box, or amusing myself with pencil and paper while fogies of forty determine the Kaiser's next move'.[12]

Following his death at the home of his cousin and friend, Canon J.B. Richardson at Formby, Lancashire on 24 January, 1920, the *Irish Times* paid tribute to his unique talents:

'He contributed much to the joy of life and wherever he went he shed about him an atmosphere of goodwill. He possessed rare gifts of art and humour-an art apparently slight and effortless, yet beautiful and by no means superficial in its simplicity; a humour free from burlesque, which never consciously hurt the most sensitive soul, Percy French's nature was as simple as a child's.'[13]

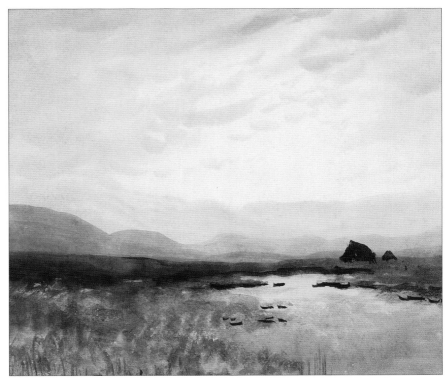

William Percy French (1854-1920) *In the West* 1912, watercolour. Signed and dated '1912'.

COURTESY OF THE GORRY GALLERY, DUBLIN

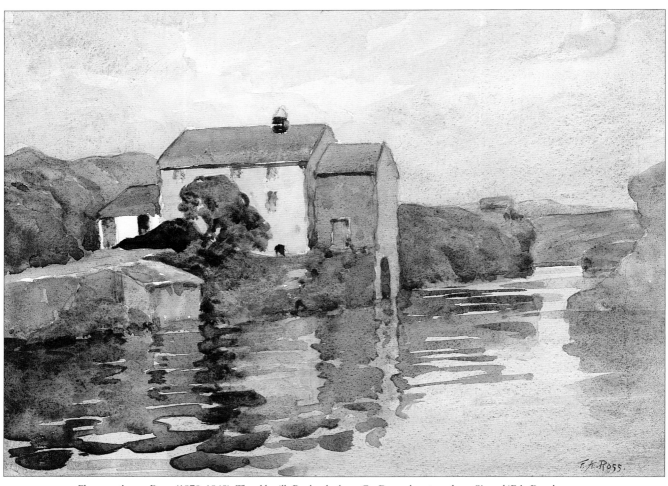

Florence Agnes Ross (1870–1949) *The old mill, Bunbeg harbour, Co. Donegal,* watercolour. Signed 'F.A. Ross'.

FLORENCE AGNES ROSS (1870–1949)

In his autobiography, playwright John Millington Synge wrote: 'When I was about ten my real affections and imagination acted together in a friendship with a girl of my own age who was our neighbour... She was, I think, a very pleasant-featured child and must have had an excellent character as for years I do not remember a single quarrel...She was handy with her pencil and on wet days we used to draw animals from Vere Foster's copy books with great assiduity.'[14]

It is thought that the little girl Synge was referring to was Florence Agnes Ross, a cousin of the playwright who came to make her home at 3, Orwell Park, Rathgar, Dublin with her grandmother, Mrs Anne Traill. Meanwhile, next door, number 4 was occupied by Mrs Traill's newly widowed daughter, Mrs Kathleen Synge and her family. The two cousins formed a firm friendship. Recalling the summer of 1882, when he and Florence spent their days exploring and wandering through the demesne of nearby Rathfarnham Castle, Synge wrote: 'I was passionately drawn to nature and was now busy in the study of birds – a matter which I afterwards carried a good way. She took fire at my enthusiasm and we devoted a great deal of our spare time to observation and reading books on ornithology.' Both cousins enjoyed natural history and together compiled a nature notebook. In 1891, and after the death of her mother, Florence went to live with the Synge family who were now living in Crosthwaite Park, Kingstown (Dun Laoghaire). The following summer, the Synges, including Florence, spent the first of many happy summers at Castle Kevin, Co. Wicklow. Here Florence and her companion, another future W.C.S.I. exhibitor, Cherrie Matheson, spent many happy hours sketching and exploring.

In 1895, Florence left Ireland and travelled to Tonga in the Friendly Islands to keep house for her brother, a doctor and his family. Away from Ireland for eleven years, she had the opportunity to visit New Zealand, Australia and the Argentine. On her return to Ireland in 1906, Florence Ross appears to have devoted her time to watercolour painting, often in the company of her cousin, Elizabeth Synge, visiting the Blasket Islands to sketch the 'King's House' (on the Great

Blasket) in which her cousin, J.M. Synge, had stayed. As reflected in her contributions to W.C.S.I. exhibitions, which began in 1927 and continued, with the exception of one year (1937) until a year before her death, landscapes by this artist included scenes in counties Donegal, Antrim, Waterford, Galway, Dublin, Connemara, Kerry and Mayo. However, the majority of exhibits relate to scenes in Co. Wicklow where the artist ran a sketching club in the Glendasan glen, close to Glenmacnass.

Ross exhibited ten pictures in an exhibition entitled 'Aonach na Nodlag' held in the Mansion House, Dublin and opened by Eamon De Valera, T.D. on Friday, 11 December 1931. Florence Ross was also represented in the 'Oireachtas Art Exhibition' held the following year. In 1933, she began exhibiting with the Dublin Sketching Club. She also exhibited with the Belfast Art Society and held a number of solo shows at 35, Molesworth Street, Dublin. The scene illustrated here, executed in loose washes of evenly laid colour, is of the *Old Mill, Bunbeg, Co. Donegal*. The mill was originally built as a corn mill in 1840 and is now a guesthouse. It overlooks an attractive little harbour at the mouth of the Clady river.

PAUL HENRY R.H.A. (1876–1958)

In 1919 Paul Henry moved to Dublin and was on the eve of becoming, in the view of his biographer, Dr. S.B. Kennedy, 'one of the most important painters, and arguably the most influential landscapist, to work in Ireland in the twentieth century'.[15] The following year, the artist submitted two drawings to the W.C.S.I. exhibition held in the Mills Hall, Merrion Row, Dublin: *The Storm* and *The North Downs*. Henry's art training had not been merely confined to his native Belfast: around 1898, he travelled to Paris to study at Académie Julian, Paris where he became a pupil of academician Jean-Paul Laurens (1838-1921).

'After some months I heard that Whistler had opened a new studio in Paris where he was to give lessons. This was almost too good to be true, and I did not rest until Stephen Haweis and I had located it, interviewed the Massier and enrolled ourselves as pupils of "The Master", as we call him.'[16]

Whistler always maintained that he did not attempt to thwart a student's individuality, but rather tried to encourage it, 'I do not teach Art but I teach the scientific application of paint and brushes'.[17] In order to become a student in Whistler's Academie Carmen, it was necessary to abandon all former teaching methods unless they corresponded with the great master's. One had to learn to become an observer, setting down the points in direct, simple terms. The artist had to draw on a limited palette employing harmonious muted tones, as expressed in Henry's atmospheric *The Lake of the Tears of the Sorrowing Women*, executed around 1915-6. The influence of Whistler was now becoming more dominant in Henry's work, the artist dispensing almost completely with figures and tending to concentrate instead on painting pure landscape. As Dr. Kennedy notes, 'the influence of this great American artist [Whistler] lingered in his [Paul Henry's] work till relatively late in his career'.[18]

Henry's great skill 'in coaxing from the medium [charcoal] the tenderest effects of which it was capable' continued throughout his carer and is demonstrated here in this fine charcoal drawing of *The Grand Canal Dock,*

Paul Henry, R.H.A. (1876-1958) *The Grand Canal Dock, Ringsend, Dublin* 1928, charcoal. Signed 'PAUL HENRY'.

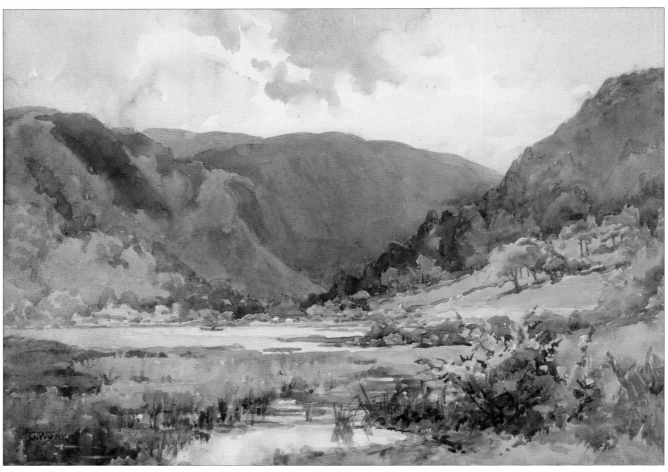

Edith Gladys Wynne (1876-1968) *The Lower Lake, Glendalough, Co. Wicklow,* watercolour. Signed lower left 'G. Wynne'. Inscribed on verso.

Ringsend, Dublin, an industrial landscape, unusual for this artist.[19] Here the artist makes full use of the grain of the paper by rubbing the charcoal heavily into it for dark tones and applying less pressure for the pale tones. The picture plane itself is divided into two distinct sections. The upper is dominated by the upward thrust of the two smoking chimneys (known in Dublin as the Tramway Twins) which also serve to link the two sections. Sky dominates the upper section whilst a lack of clear detail and absence of figures is noticeable in the lower section.

Seán O'Faolain in his foreword to *An Irish Portrait,* the painter's autobiography noticed how this Irish artist had fallen under the spell of the American painter:

'The influence of Whistler is apparent. He acknowledges it gene- rously in these pages. But the term misleads if it implies some sort of facile recording, or makes us forget that no man can receive or record any impression out of proportion to his own impressionability, his devotion, his patience and his love. This book is the story of a loving apprenticeship as long as life itself'.[20]

EDITH GLADYS WYNNE (1876-1968)

Gladys Wynne's contribution to Society exhibitions was substantial: she showed a total of 147 works at W.C.S.I. exhibitions between the years 1902 and 1968. Landscapes included views in counties Kerry, Limerick, Waterford, Armagh, Donegal, and Tipperary.

Wynne also painted in Kent, Somerset and Hereford and, in the early part of her career, travelled to Switzerland and Germany. As a young artist, Wynne began exhibiting at the R.H.A. as early as 1899, submitting two flower studies; she also exhibited two paintings at the Munster-Connaught Exhibition in Limerick in 1906: *Hawthorn* and *On the Shore of Lough Derg.* Throughout her painting career, this artist was also an active and energetic participant in exhibitions mounted by the Dublin Sketching Club and the Belfast Art Society.

Gladys Wynne was born at Holywood, Co. Down on 29 June, 1876; the youngest of six children of the Reverend George Rupert Wynne and Ellen, daughter of the Reverend George Sidney Smith, D.D., F.T.C.D. Wynne's childhood was spent living in

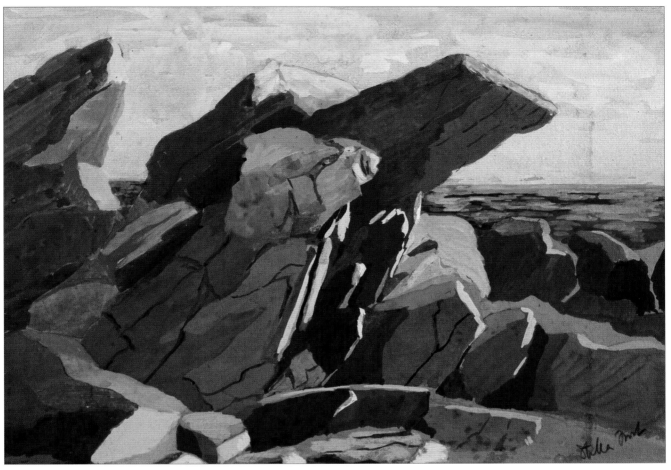

Stella Noel Frost (1890–1962) *Achill Rocks I*, c.1954, watercolour. This watercolour was exhibited in the Water Colour Society of Ireland's annual exhibition held in 1954 (cat. no. 4).

various rectories in the south of Ireland including Woodlawn, Killarney, Co. Kerry and St. Michael's Rectory, 12 Barrington Street, Limerick. Her father became Archdeacon of Aghadoe in 1885. He was the author of several published religious works and papers and considered to be something of a mystic, 'some thought him more suited for study than the parish, but he was an excellent pastor.'[21] He encouraged his daughter to pursue her art training abroad, both in Florence and Rome, and later in Somerset and Scotland.

In 1909, Wynne moved to Glendalough, near Rathdrum, Co. Wicklow and settled there for the rest of her life, first at The Lodge and later at Lake Cottage, down by the lower lake. She was close to her cousins, the artistic Wynne sisters, who ran Avoca Weavers. Many of Gladys Wynne's watercolours depict views of her beloved Glendalough, such as *In the Mine Valley, Glenda Lough* (W.C.S.I. 1904), *Between the Lakes, Glenda Lough* (1914) *Evening on the River, Glenda Lough* (1947) or *Early Spring, Glenda Lough* (1961). Wynne's early water-colours display a strong sense of feeling for space coupled with a confident grasp of colour and light as seen in the example illustrated here, *The Lower Lake, Glendalough*. (This may have been exhibited in W.C.S.I. Annual ex-hibition, 1912, cat. 198) Later work tended to lose its sense of freedom and spontaneity, becoming more tight and concise. Frequently painting in the company of her aunt, Edith Wynne (exhibited W.C.S.I., 1909-1913) from nearby Tigroney House, and a friend, Constance Rochford, from Kilcoursey, Greystones, Co. Wicklow – also a W.C.S.I. exhibitor (1895-1942) – Wynne entertained a number of artists in her cottage by the lake shore including Mainie Jellett and Mildred Anne Butler. A keen musician, she played the organ in St. John's Church, Laragh every Sunday for over fifty years. Gladys Wynne died at her home in Glendalough on 24 March, 1968.

STELLA NOEL FROST (1890-1962)

On Tuesday, 5 April, 1932, the W.C.S.I. hanging committee examined pictures sent by six potential members; included amongst the hopeful applicants was a 'Miss Frost'. Her watercolours were accepted, and Stella Frost was duly elected a member of the Society.[22] During the period

Flora Hippisley Mitchell (1890-1973) *The Brazen Head Hotel, Dublin, No. 20 Bridge Street, Dublin*, watercolour and ink. Illustration for *Vanishing Dublin*, 1904, p.45. Signed 'Flora H. Mitchell'.

COURTESY OF THE NATIONAL GALLERY OF IRELAND

care of private gardens.

Frost spent many holidays in Achill, Co. Mayo painting with her friend Mainie Jellett and staying at Keel West, Doagh. After joining The Society of Dublin Painters in 1935 the artist held what is considered to be her first one-woman show exhibiting paintings of the Balearic Islands and Yugoslavia.

In 1957, Stella Frost edited a tribute to her two close friends, Evie Hone and Mainie Jellett. She wrote:

'Few people have been fortunate enough, as I have, to make pilgrimages with Evie Hone to the great cathedrals of Chartres, Le Mans and Bourges, and to spend intensive weeks with her in Paris visiting the modern stained glass workers, and exhibitions of painting, tapestry and sculpture.'[24]

In 1955, the artist became a member of the committee responsible for organising a memorial exhibition held in U.C.D. Earlsfort Terrace, 1958 in honour of Evie Hone. H.R.H.A. Stella Frost was buried in the Church of Ireland graveyard at Tallaght, Co. Dublin.

FLORA HIPPISLEY MITCHELL (1890-1973). (Mrs William Jameson)

A meticulous worker, Flora Mitchell's technique appears to have lasted throughout her life. She would first make a small pencil sketch on site; returning to base, the artist then created a larger sketch, followed by carefully tracing the outline in Indian ink. The final task was to block in with watercolour.[25] Later on in her career, Flora Mitchell resorted to a camera to record the scene and worked from the photograph at home. Born at Omaha, Nebraska, the artist was the daughter of Arthur J.C. Mitchell, managing director of the Anglo-American Cattle company. Due to difficulties encountered by the Sioux Indian Rising, the family came to Ireland. Flora's father was offred a position in the Dublin-based distillery, William Jameson & Co., which he accepted. In 1930, Flora married William Jameson, forty years her senior and the great-grandson of the distillery's founder.

1932–1959, this artist exhibited a total of sixty-three landscapes with the W.C.S.I., her subject matter ranging from landscape scenes in Bosnia, Mallorca and Dalmatia to the hills and coastline of Achill Island. *Achill Rocks I*, (illustrated here) is characterized by a strong modernist sense of structure, and succeeds in capturing the uniquely decorative aspect of this island's rock formations. It was exhibited together with the artist's second watercolour, *Achill Rocks II* in the W.C.S.I. Exhibition held in Dublin in 1954, the last year in which this painter exhibited with the Society. She also contributed work to The Dublin Painters (1939-

1944) and the Irish Exhibition of Living Art between 1943-1959.

Stella Noel Frost was the daughter of the Rector of Foulsham, Norfolk, the Reverend Charles H. Frost. She was born at 23 Francis Road, Edgbaston, Birmingham. When she came to live in Dublin, Frost opened a school for lady gardeners from her home Hazelbrook, Terenure Road West. Gardening Schools were popular during the early decades of the twentieth century with 'the practical side predominat[ing] over the theoretical.'[23] The training offered to women allowed them to choose a career from three main branches: teaching in schools; lecturing; or taking

Between 1906 and 1908 Mitchell attended Princess Helena College, Ealing, London. A gifted student, she was the recipient of many art prizes and went on to be a student at the Dublin Metropolitan School of Art in 1910.

During the First World War, Flora Mitchell was involved in voluntary war work in Dublin and in 1918 became involved in Voluntary Aid Detachment in England. A year later, she decided to leave for Canada to take up a private teaching post. One of her earliest known contributions to the publishing world was made in 1929, when two of her illustrations were accepted for *A Book of Dublin* (1929, Corporation of Dublin).

Despite submitting three exhibits per year to annual W.C.S.I. exhibitions held in 1935 and 1936, there is no mention of her election to the society in the W.C.S.I. minutes. When Mitchell returned to exhibiting with the W.C.S.I. after an interval of twenty-seven years (from 1963 until a year before her death), again there seems to be no record of her election.

Vanishing Dublin by Flora H. Mitchell,

published in 1966 and described as 'an eloquent record of the passing scene, a remarkable re-creation of the Dublin of an older day', contained fifty watercolour drawings of the Irish capital, including *The Brazen Head Hotel* (illustrated here) located at 20, Bridge Street, Dublin.[26] The publication, with its depiction of all the charming little courts and alleyways, has become a valuable record of Dublin's past. Each watercolour was 'accompanied by a short commentary, often including an amusing anecdote, a snippet of history or of local tradition, or a note of conversations with dustmen and hucksters'.[27] However, as the *Irish Independent* pointed out this artist was 'less sure when she includes humans in the foreground of her work'.[28]

Flora Mitchell held a number of solo exhibitions in Dublin in the fifties, including one in 1957 when her close friend, Mabel Henry, (née Young, 1889-1974), second wife of artist Paul Henry, helped to organise and hang the exhibition. The artist also held a one-woman show at the Upper Grosvenor Galleries, London in 1969 entitled

'London, Yesterday and Today'.

As has been pointed out, Mitchell's watercolours are not always of the highest quality but they do serve as an important record of Dublin in the late 1960s, a time of great change in the city. The National Gallery of Ireland has a substantial collection of her watercolours of Dublin and a number of sketches of other locations, including views of London and landscapes painted in the west of Ireland.

FRANK McKELVEY, R.H.A., R.U.A., (1895-1974).

Belfast-born landscape and portrait painter Frank McKelvey began exhibiting with the W.C.S.I. in 1919. The artist submitted, on an intermittent basis between 1919 and 1962, a total of fifteen works which largely related to scenes in Donegal, Antrim and Co. Dublin. As a young painter, McKelvey had admired the work of landscape artists Richard Wilson, Corot, Constable and Harpignies together with the Pre-Raphaelites. He

Frank McKelvey, R.H.A., R.U.A. (1895-1974) *Loading the Turf* 1922, watercolour. Signed and dated.

had also studied Ruskin's *Modern Painters* and approved of many of the ideas put forward therein. However, as his biographer, Dr. S.B. Kennedy has pointed out, 'He was not consumed by any inflexible theory, but rather was stimulated by a number of viewpoints'.[29] In Kennedy's view, this painter's career contained no dramatic change of direction. With his superb mastery of technique and an enquiring mind, McKelvey's output remained vigorous and fresh throughout his life, despite some landscape subject matter being, from time to time, somewhat repetitive.

In the twenties and thirties J. Humbert Craig R.H.A. (1877-1944), Paul Henry and McKelvey, together with some of their lesser known contemporaries, helped to forge what was considered to represent an Irish School of Painting. *The Studio* looked upon this 'distinct group' as the best landscape painters in the North, 'Their landscapes, though by no means emotional, are always most obviously sincere, closely observed, firmly and cleanly handled'.[30] In Kennedy's opinion, the artist had 'a sharp eye and [he] could, with apparent ease, penetrate the essentials of his subject and set it down with a matching exactitude'; but it is felt 'McKelvey lacked the originality to define a notion of the landscape'.[31]

McKelvey's ability to capture evening light falling over vast expenses of low, level estuaries or plains was one of the major characteristics of this artist's work as seen in his watercolour, *Loading the Turf*. In an *Appreciation*, the *Irish Times* noted that 'With [his] death, it said, Irish art has suffered a major blow... He was a perfectionist who loved his art and gave his all to it. For this we should be eternally grateful, because his living and his loving have enriched our lives immeasurably'.[32]

MAURICE MacGONIGAL, P.P.R.H.A., R.A., H.R.S.A. (1900-1979)

A distinguished artist, Maurice MacGonigal did not exhibit with the W.C.S.I. in the early part of his career, but rather, according to his son, Ciarán, contributed five or six watercolour drawings each year to the R.H.A. from 1924 until 1951. From an early age the medium appears to have attracted this artist, as expressed in his *Prisoners on the Roof, Kilmainham* painted in 1923, or seen in his preparatory cartoons for stained glass work. MacGonigal was elected a member of the W.C.S.I. in February 1973 and for the nest six years, until his death in 1979, contributed seven works to W.C.S.I. annual exhibitions. These included views of Kerry, Connemara and Dublin.

An example of a painter who possessed an acute sense of the Irish reality, basking in the silence of Kerry or Connemara, in the green-and-grey countryside and in the enormity of the skies, is captured here in MacGonigal's interpretation of Mount Brandon (illustrated) seen shrouded in heavy rain clouds. Here the fleeting atmospheric conditions are conveyed using Impressionistic brushwork in order to create an animated surface throughout. This watercolour demonstrates the painter's belief in the requirement to place the human element in the landscape. The artist was once known to remark: 'I'm not interested in nature in the raw – whatever man has worked and scraped and put together–that's what interests me. I've never been convinced that one can do without the human in art.'[33]

As a young man, MacGonigal appears to have been anxious to achieve a progressive approach to his art but as his career progressed, he became more of an academic painter, rooted to a large extent in the academic tradition and little influenced by Modernist trends. In the 1930s and 40s, Maurice MacGonigal and Sean Keating became central figures in the movement which sought to establish a distinct and 'national' identity in painting. MacGonigal in an R.T.E. interview given around 1972 reveals one of the most important aspects of his work:

'There was an attempt, there is an attempt to be aware of the contribution the artist should make to Ireland but I don't know that people pay much attention to that now. In my time there was a little. We did think that we were doing something to create a new Ireland.'[34]

As early as 1958 Arland Ussher had observed in *The Dublin Magazine* that MacGonigal had displayed 'a consistent striving to get at [to] grips with the Irish scene. He has never been lured away by the exotic blandishments of Southern Europe.'[35]

Born in Dublin in January, 1900, MacGonigal was educated by the Christian Brothers, Synge Street, Dublin before becoming an apprentice in the stained glass studios of his cousin, Harry Clarke, R.H.A. (1889-1931) in North Frederick Street, Dublin. As a young man, MacGonigal joined the first Na Fianna Eireann, was interned, but later released. Afterwards he received both the War of Independence Medal and the Military Service Medal and Bar.

In the early 1920s, MacGonigal attended evening classes in the Dublin Metropolitan School of Art and studied under Keating, Sleator, Tuohy and Clarke. Later he was awarded a scholarship which enabled him to continue his studies by day from 1923-26. Further funds for his art studies came when he was awarded the Taylor Art Scholarship. He also studied for a short time in Holland and won both the silver medal for landscape and the bronze medal for drawing in the Tailteann exhibition of 1928. Three years earlier, this artist had begun to exhibit at the R.H.A., his interest having transferred from stained glass to painting. In 1937 when the Dublin Metropolitan School of Art became the National College of Art, MacGonigal was appointed Assistant Professor of Painting. In 1954 he succeeded Seán Keating as Professor. MacGonigal ended his thirty-two years as a teacher when he resigned in protest from the College in 1969, railing against what he considered to be 'the erosion of the professional authority of the college'.[36] In his view, this was being undermined by student unrest.

Culminating in his fifteen-year presidency of the Academy, Maurice MacGonigal's links with the R.H.A. were long and distinguished: in 1931 he was appointed A.R.H.A. and two years later attained full membership; Keeper from 1936 to 1939, returning again to act in that capacity from 1950

Maurice MacGonigal, P.P.R.H.A., R.A., H.R.S.A. (1900-1979) *Clouds over Mount Brandon, Co. Kerry and the stony beach of Feothanach, Co. Kerry* 1973, graphite and watercolour. Signed 'Mac Gonigal 73'.

until 1961; Professor of Painting from 1947 to 1978, and, finally, President from 1962. In an appreciation, *Irish Times* art critic Brian Fallon wrote:

'...after his retirement from the College of Art...he seemed to find a second wind. Possibly the emancipation from teaching chores had a lot to do with it but he blossomed into a kind of Indian summer as an artist, and the public responded to this. MacGonigal's best painting, to my mind, was done in his late sixties and early seventies. And compared to the stagnation into which artists sink at that age, it was a notable achievement.'[37]

Maurice MacGonigal was buried with his palette and brushes in Gorteen cemetery, Roundstone, Co. Galway.

NORAH McGUINNESS, H.R.H.A., D.Litt. (1901-1980)

Apart from a flurry of activity in the early years as a member of the W.C.S.I., Norah McGuinness would not appear to have taken an active part in the Society's administrative affairs. On Monday, 16 February, 1942, the W.C.S.I. Committee (consisting of Chairman, Major Nolan Ferrall, Miss Boyd, Miss M. Jellett, Miss D. Blackham, Major Goff, Mr. F.G. Hicks and Mrs E. Reid) met to consider the election of two members, one of whom was Norah McGuinness. The latter was successful. Two years later, on 28 January, 1944, Norah McGuinness was elected to the hanging committee, which consisted of Letitia and Eva Hamilton, F.G. Hicks, Miss H. Colvill and Miss Boyd. On 6 October, 1944, the artist was invited to become a member of the W.C.S.I. committee. After this date, references to her contribution to the Society appear to cease and one can only suppose that, as Norah McGuinness had been a founder member of the Irish Exhibition of Living Art, becoming its President in 1944, her energies were being diverted

elsewhere. Nevertheless, having begun exhibiting with the W.C.S.I. in 1942, Norah McGuinness went on to exhibit around sixty works at their annual exhibitions until her death in 1980. Titles range from views in counties Waterford, Wicklow, Dublin, Donegal, Limerick, Mayo and also include a number of French and Italian scenes.

Norah McGuinness trained at the Dublin Metropolitan School of Art under portrait and figure painter, Patrick Tuohy, R.H.A. (1894-1930), designer, enameller and metalworker, Percy Oswald Reeves (1870-1967) and stained glass artist, Harry Clarke, R.H.A. ((1889-1931) The latter was to have a considerable influence on her work as an illustrator during this artist's early days in college. Whilst in London in 1923 or 1924, Norah McGuinness had the opportunity to view an exhibition of Impressionist and Post-Impressionist paintings and she always maintained throughout her life that they had had a profound impact on her artistic

Norah McGuinness, H.R.H.A., D.Litt. (1901-1980) *The Four Willows,* watercolour and ink.

development. After her marriage in 1925 to Geoffrey Phibbs (better known as Geoffrey Taylor), Norah McGuinness began to produce set designs and costumes for plays both at the Abbey and the Peacock. Her marriage broke up in 1929 and, following the advice of her friend Mainie Jellett, she travelled to Paris. There she studied at the Académie Montparnasse under André Lhote (1885-1962), whose own work demonstrated Cubist mannerisms in a wide range of subject matter, including landscape, and who aimed to teach students the theories underpinning Cubism. Norah McGuinness remained there for almost two years. In the view of Professor Anne Crookshank, whilst this painter was in Paris:

'… her style changed considerably. Colour became steadily more important to her and, as her favourite mediums in the thirties were watercolour and gouache, line became less vital. She was thinking more in blocks of tone values than in outline. Norah McGuinness went to Paris as an artist with several years of work behind her. She seems therefore to have been less immediately affected by her teacher than one might expect and instead one finds in different drawings a great variety of influences, Braque, Lurcat and Dufy as well as Lhote … by the time she is exhibiting in London from 1932 onwards her own personal style has been evolved.[38]

An artist whose style was essentially joyous, decorative, free-flowing and spontaneous, McGuinness enjoyed painting on site throughout the thirties and forties, frequently employing watercolour or gouache in which to record her compositions. She made full use of rich colours and heavy outlines which reveal the influences of contemporary artists such as Henri Matisse (1869-1954) and Maurice Vlaminck (1876-1958). However, her work would appear to reveal little of the cubist influences as laid down by her teacher, André Lhote. As Dr. S.B. Kennedy has pointed out:

'Norah McGuinness' treatment of landscape in general was as a breath of fresh air to Irish painting at this time, and those who were weary of the conventional scene of purple mountains and white cottages welcomed the freshness of her observation, her use of medium, mood and form. Yet paradoxically there is on occasions a tinge of melancholy about her paintings; but this may be seen as a metaphor for the times, for Norah McGuinness always reacted spontaneously to things around her.'[39]

Elected an honorary member of the R.H.A. in 1957, she resigned in 1969. In 1973, she received an honorary degree, Doctor of Literature from Trinity College, Dublin.

George R.S. Pennefather (1905-1967) *Silver Willow* 1950, watercolour. Signed 'George Pennefather 1950'.

GEORGE RICHARD SEYMOUR PENNEFATHER (1905-1967) and HELEN PENNEFATHER (fl.1939-1946)

George Pennefather, together with his second wife and cousin, artist Helen, daughter of Gerald Pennefather of Australia, were both admitted as members of the W.C.S.I. at a committee meeting held in the Mills Hall, Merrion Row, Dublin on Monday, 17 April, 1939. George Pennefather thus began an association with the Society (1939-54) during which time he exhibited a total of thirty-five works. Helen Pennefather exhibited twenty-five works with the Society between 1939 and 1946. Despite being consistent exhibitors, the couple do not appear from the minutes to have taken an active part in running the Society's affairs.

Self-taught, George and his wife,

Helen, explored Ireland in a caravan, the fruits of their travels being reflected in many of their W.C.S.I. watercolours: *A Slaney pool in Spring* (exhibited 1941), *Stream in the Comeragh Mountains, Co. Waterford*, (1946), *The Blackwater Gorge* (1954). George Pennefather's watercolour *Silver Willow*, executed in 1950 and illustrated here, expresses his manner of painting in this medium: rapid, vivacious, full of moving, swirling colour and shifting light that succeeds in capturing the silver willow by the side of the water.

The couple settled in Kilkenny in the 1940s, as the arts correspondent for the *Kilkenny People* later reported, 'It was during the war and George and Helen Pennefather came to the city, loved it and settled in a caravan on the Freshford road'.[40] In 1943, during his stay in the city, George Pennefather founded the Society for the Encouragement of Art in Kilkenny

(SEAK), later to become known as The Kilkenny Art Gallery Society. One of the principal aims was to achieve a municipal art gallery for the city of Kilkenny. Both George and Helen felt there was very little in the area of visual art on display and this was particularly regrettable for young artists. By involving a group of friends, persuading them to paint, and also borrowing from various private and public sources and accepting gifts, the Pennefathers achieved their goal. Before they left Kilkenny in 1946 they had succeeded in forming the basis of a municipal collection.

In 1955 George Pennefather travelled to Australia remaining there for a year. He exhibited his work in Sydney, Melbourne, Perth and Brisbane. On his return, he showed his work in the Imperial Hotel, Cork, consisting of both Irish and Australian landscapes. A studio sale was held on 12

May, 1998 in the National Concert Hall, Earlsfort Terrace, Dublin. George Pennefather died at the age of sixty-one. In a tribute paid to him by fellow artist and W.C.S.I. member, Tom Nisbet wrote:

'He was not an average man. ….everything he did seemed to be that shade more than ordinary. He flew his own aircraft at a time when people ran out of their houses to see one. He had a dance band…he founded an engineering works, he designed and built a model hydroelectric plant for his estate, ran a poultry farm, painted watercolours better than average and wrote a book on the subject…He was a skilled photographer and could talk exhaustively on a wide variety of subjects from music to magic…'[41]

A critic remarking on Helen's work at the 1942 R.H.A. exhibition commented: 'Among the water-colourists, the outstanding figure is Helen Pennefather whose *Rainy Morning* and *Sunlit Road* are exquisite examples of the proper use of the medium – direct attack with a full brush, and perfect appreciation of atmosphere.'[42]

BASIL IVAN RAKOCZI (1908-1979)

On 1 April, 1941, at 19 Upper Mount Street, the W.C.S.I. committee met to judge the works of two candidates for membership. At that meeting, it was decided to postpone the election of Basil Rákóczi until he submitted further work. Despite this, Rákóczi began to exhibit with the Society in that year. He continued to do so for the next ten years submitting a total of thirty-four works which included a number of scenes in Achill and Arran..

Born on 31 May, 1908, at Cheyne Walk, Chelsea, Basil Rákóczi's father, Ivan, was Hungarian: a violinist, artist and composer; his mother, Charlotte May Dobbey, an artist's model, was the daughter of an Irish seaman who came from Co. Cork and decided to settle in Kent. Proud of his Hungarian and Irish origins, Basil Rákóczi's childhood was spent between England and France. He received his education at the Jesuit College of St. Francis Xavier in Brighton; his formal art training took place at the Brighton School of Art and later at the Académie de la Grande Chaumière, Paris. Some years later, Rákóczi studied with the Russian born French artist and sculptor, Ossip Zadkine (1890-1967).

Before turning to painting and psychology, in the late 1920s, Rákóczi worked as a commercial artist and interior decorator. Around 1933 he founded the Society for Creative Psychology based at his home 8, Fitzroy Street, London aiming to create a methodology in psychology attuned to what they termed 'the natural rhythm of life'.[43] It was at one of the society's meetings that he met landscape and figure painter Kenneth Hall (1913-46). They became good friends and together visited a number of European countries on painting expeditions absorbing developments in art, including Surrealism. Both began to experiment with psychoanalytic techniques and, in painting, based their imagery on the outcome of their experiments. This resulted in what they called 'Subjective' painting, 'a manner which is close to Surrealism but which owes much to his [Rákóczi's] studies in psychoanalysis.'[44] In 1935 he and Kenneth Hall, both being part of the Bloomsbury Group of artists and intelluectuals, began to encourage a move from academicism to modernism, their 'Subjective Art' movement gathering force.

As World War II approached Basil Rákóczi, Kenneth Hall and a small group of friends decided to live in Ireland. In the summer of 1939, they rented a cottage close to Delphi, Co. Mayo overlooking Killary harbour before eventually settling in Dublin the following year.

During the six years the artist spent in Ireland, two different strands are to be found in Basil Rákóczi's work: a representational manner of painting in the 1940s, together with his Subjective works, which, as already mentioned, were rooted to a large extent in his studies in psychoanalysis. These Subjective paintings attempted to approach Surrealism with all its complex, component elements and subject matter and tended to rely on a type of allegory of life or dream. An emphasis was placed on line, with colour being considered less important than form and shape.

In Dublin during the 1940s, there was strong opposition towards efforts to convey modern principles in art. Rákóczi and Kenneth Hall began to breathe new life into the somewhat conservative artistic community. Subjective Art became a strong influencing force and, together with its multi-disciplinary ethos, which embraced philosophy, literature music and poetry, they attracted a small, loyal group of supporters known as The White Stag Group. Amongst them was architect Patrick Scott, composer/ musician Brian Boydell, artist Dorothy Vanston and a number of W.C.S.I. members including Mainie Jellett, Ralph Cusack, Dorothy Blackham, Evie Hone and Nano Reid.

A major event took place in the lives of Rákóczi, Hall and their followers when, in January, 1944 at 6, Lower Baggot Street they staged the 'Exhibition of Subjective Art'. This exhibition was mounted just four months after the first Irish Exhibition of Living Art and both exhibitions did much to encourage artists who were interested in an exciting avant-garde approach to Irish painting. A book by Rákóczi entitled *Three Painters: Basil Rákóczi, Kenneth Hall, Patrick Scott* (1945, Dublin: At the Sign of the Three Candles) was published a year later and ensured the work of the White Stag artists was brought to a wider audience. Rákóczi's watercolour *Group of Men* depicts local men going about their business and dates from his early representational period, shortly after his arrival in the west of Ireland. It is nearer to his illustrative work, combining bold pen and ink lines with delicate washes of watercolour. In a review of his friend's exhibition of watercolours written in 1942, Kenneth Hall remarked:

'He has achieved a very considerable mastery in this medium; while exhibiting those qualities, such as delicate colouring, fluidity, lightness and spontaneity of handling, most generally considered attributes of a

Basil Ivan Rákóczi (1908-1979) *Group of Men*, watercolour, pen and ink.

good watercolour, he has added to them a variety and originality of texture and by the use of an ink line, a formalised sense of design to be found seldom in the work of other artists.'[45]

Rákóczi returned to London in 1946 and eventually settled in Paris, his work becoming more Cubist in outlook. The 1960s saw the artist reverting to his earlier style of Subjective Art. He did not sever his links with his friends in Ireland but held a number of one-man shows in Dublin between 1948 and 1954. He also continued to send works until 1951 to W.C.S.I. annual exhibitions. Titles included: *Keel, Achill* (1941), *Arrangement in a Dream* (1941), *Two Friends with an Antelope* (1943), *Cottages, Carna* (1944), *Aran Islanders* (1945), *The Yellow House* (1946), *Boat*

Building Villefranche (1948), *The Harbour, St. Jean* (1949), and *Flowers* (1950). Rákóczi also contributed to the R.H.A. until 1952, and the Irish Exhibition of Living Art until 1960.

TOM NISBET R.H.A. (1909-2001)

Although Tom Nisbet's election to the W.C.S.I. took place on 18 May, 1948, he did not, in fact begin to exhibit with the Society until 1979. He continued without a break until 1994, submitting a total of thirty-nine works.

In a foreword to a sale of the artist's work held in November 2006, Thomas Ryan, P.P.R.H.A and long-standing member of the W.C.S.I. described Tom Nisbet as being that rare phenomenon,

a popular artist:

'In truth, not many actually knew Tom, he was quite a shy person, it was his work they liked. And that came in two forms: in his pictures and in his inimitable letters in *The Irish Times*. Both carried the distinctive imprint of his vision; in his watercolours that showed the quiet of canal paths and the leafy suburbs of the south side. His letters were clever comment on topics of the day or someone's misdemeanour that often opened in a stringent mode but, more often, ended in a guffaw.'[46]

Born in Belfast on 16 December, 1909, Tom Nisbet's father, Alexander, repaired and tuned pianos and was a capable pianist fortunate enough to possess the gift of perfect pitch. Anxious to become an artist, Tom briefly attended evening classes at the

Tom Nisbet, R.H.A. (1909-2001) *River Avonmore, Co. Wicklow* 1993, watercolour. Signed 'Tom Nisbet'.

College of Art, Belfast in 1931. In that same year, Tom Nisbet decided to move to Dublin. In order to support himself, he worked as a van driver transporting motor parts backwards and forward to the West of Ireland while attending night classes from 1931-34 at the Dublin Metropolitan School of Art. There he became a student of Seán Keating and Maurice MacGonigal.

During the war years, Nisbet was employed as a scene painter for the Theatre Royal while pursuing his own career as an artist. In 1944, he married Kathleen Byrne and founded the Grafton Gallery in Harry Street in the same year, 'to afford a venue for as yet unrecognised painters (self included) and operated it for twenty-seven years with a degree of financial success and other inestimable rewards'.[47] Amongst the many painters who benefited from his wit, encouragement and support were Colin Middleton, Arthur Armstrong, George Campbell, Harry Kernoff, Kitty Wilmer O'Brien and Fergus O'Ryan. Brendan Behan, Patrick Kavanagh and Brian O'Nolan were regular visitors. The gallery was sold in 1971 and, rather than seek alternative premises, Nisbet decided to base himself in a studio he had built for himself in the garden of his home in Clonskeagh.

Elected an Associate of the R.H.A. in 1950, he became a full member in 1962. His work was exhibited widely; South Africa, Australia, the United States, Canada and Britain, and yet Nesbit rarely travelled abroad, with the exception of a visit to Paris in 1939.

For many years he was a regular correspondent to the letters page of *The Irish Times* offering lively commentaries on topical subjects. A keen composer of limericks, his efforts were rewarded in advertisements for Irish Sweepstakes and Odearest mattresses.

A regular contributor to The Dublin Painting and Sketching Club and numerous group shows, he managed to find the time to develop a practice in pastel portraits of children. As well as specialising in watercolour views of south side Dublin, he also greatly enjoyed the bird life of the countryside and painting peaceful river scenes, as illustrated here: A *study of myself sketching by the River Avonmore, Co. Wicklow*. A distinguished and popular member of the W.C.S.I., Tom Nesbit died on 12 May, 2001 at St. Vincent's Hospital, Dublin.

Kitty Wilmer O'Brien, R.H.A., U.W.S. (1910-1982). *Tullabawn Strand, Co. Mayo* c.1965, gouache on black board. Initialled 'KWOB' lower right.　　　　PRIVATE COLLECTION. PHOTOGRAPH COURTESY OF ANTHONY O'BRIEN

KITTY WILMER O'BRIEN, R.H.A. (1910-1982)

Kitty Wilmer O'Brien served as President of the W.C.S.I. for nineteen years between 1962-81, but the story begins with her election to the W.C.S.I. on Friday, 13 January, 1950 at a committee meeting held at 19, Upper Mount Street, Dublin. Wilmer O'Brien's first contribution in 1950 was a pair of portraits: *Miss Amanda Pringle* and *Miss Gemma Pringle*. During the next thirty-one years, this artist contributed to W.C.S.I. annual exhibitions a total of seventy-four landscape works recorded in Counties Mayo, Galway, Connemara and Clare. In 1953, Wilmer O'Brien was elected to the W.C.S.I. committee. Her election as President of the Society took place at a

meeting held on 15 January, 1962. She was proposed by Geoffrey Wynne, and seconded by Phoebe Donovan.

As President of the W.C.S.I. Kitty Wilmer O'Brien set out 'to work to improve its standards by persuading as many good watercolourists as possible to join and succeeded to a very great extent.'[48] Active in so many aspects of Dublin art life, including the United Arts Club, the Friends of the National Collections, the Dublin Painters, and a regular contributor to Oireachtas art exhibitions, Kitty Wilmer O'Brien was able, through her influential connections, to attract many painters and personalities to the Society's ranks. She also played a leading role in organising plans for the W.C.S.I. Centenary Exhibition held in 1970.

As a young girl, all Pamela Kathleen

Helen Wilmer had wanted to do was go to art school. Her determination overcame all opposition and she entered the R.H.A. Schools at the age of sixteen, one of her tutors being Dermod O'Brien R.H.A. (1865-1945), who was eventually to become her father-in-law. In 1931 she was awarded prizes for both drawing and competition painting. Two years later she was the recipient of the Taylor Art Scholarship and, on the strength of this, then went to London to study at the Slade School of Fine Art. Two of her works were accepted for exhibition by the R.H.A. in 1933 and '34 and a further six in 1935. The following year she married '...Dr. Brendan O'Brien and they travelled to Dresden where she spent days in the magnificent gallery, the Zwinger. In the modern art gallery she received perhaps

her most important stimulus – a still life by Van Gogh. On the return journey she stayed briefly in London and there, at an exhibition of French art, saw three more of his pictures. His colour and brush work had a lasting influence on her.'[49]

A painter who occasionally painted portraits, landscape appears to have been this artists favourite subject. Each summer was spent in the wilds of Connemara and West Mayo where she painted on hardboard and in latter years primed black. Painting in gouache, largely for the sake of speed and occasionally employing pure watercolour, Wilmer O'Brien also worked in pastel.[50] In order to prevent herself from getting wet whilst painting, she designed a van with wide windows from which she could paint with ease whilst her husband fished.[51] Fortunate to spend the year 1950 studying in Paris under André Lhote (1885-1962), she was awarded the Douglas Hyde Gold Medal at the Oireachtas exhibition in 1964, elected an Associate Member of the R.H.A 1968, Kitty Wilmer O'Brien appointed a full member in 1976.

The artist's gouache composition *Tullabawn Strand* painted around 1963 captures the vastness of the west with its fleeting effects of light and shade scudding across sea, sand and sky. The artist's vibrant, confident style had progressed from the somewhat strict academic studies of her early career to the expressionistic brushwork of the 1960s as illustrated here. She sought to capture nature as she saw it, 'often cold, bleak, raw and beautiful'.[52]

She retired as President of the W.S.C.I. in 1981, a year before her death. In the words of P.P.W.C.S.I., James Nolan R.H.A., A.N.C.A. Kitty Wilmer O'Brien, both as President of The Water Colour Society of Ireland and a member of the Royal Hibernian Academy:

'…lent the dignity of her presence, enthusiasm and the devotion of most of a lifetime. She took her responsibilities very seriously and was reliable and concerned for the wellbeing of the Fine Arts, serving on councils and committees and ever ready to advise or help when called upon. She moved through life with a natural dignity, and lent a touch of colour to a sombre world.'[53]

TOM CARR. H.R.H.A., R.U.A., R.W.S., O.B.E. (1909-1999)

At a 1970 exhibition of watercolours held in the David Hendriks Gallery, Dublin Brian Fallon described Tom Carr's work: 'This show is entirely in watercolour…big pictures as watercolour goes, but there is no suggestion of them being blown up beyond their style and content. They are also courageously and unfashionably traditional in theme. Almost all are landscapes, with a few studies of flowers or reeds…there is freshness, brilliance, lyricism and superb technique…On the strength of this exhibition he is, quite definitely, the outstanding watercolourist in this country.'[54]

In recognition of his distinguished contribution to the W.C.S.I., Tom Carr was offered Honorary membership of the Society in October 1986 and accepted. In 1983 he had exhibited two works *Tractor Tracks* and *Nine Crows* in the W.C.S.I. annual exhibition and, that same year, the artist was honoured by the Arts Councils in both Belfast and Dublin when a major retrospective of his work was held in the Ulster Museum, Belfast and in the Douglas Hyde Gallery, Trinity College, Dublin; 162 works were on display and covered a fifty-year period.

As a young man, born in Belfast in 1909, the son of a stockbroker, Tom Carr had always admired the work of Claude, Degas, Corot and Sickert and these influences never deserted him. He flirted briefly with nonrepresentational art but soon returned to painting people sitting on beaches, dogs at the seaside, children playing or the landscape of his beloved Co. Down. His art training had begun at school at Oundle, Northamptonshire where he was taught by Belfast-born painter and wood engraver, E.M. O'Rorke Dickey (1894-1977) together with art master Christopher Perkins; the latter taking the boy on a painting exhibition to the south of France. Carr was also encouraged to paint by his maternal grandfather, John Hughes Workman, a watercolourist who frequently took his grand-son on sketching expeditions along the banks of the river Lagan.

In 1927 Carr enrolled at the Slade School of Fine Art under Professor Henry Tonks and Wilson Steer (1860-1942) and was awarded a scholarship. Two years later he left the Slade for Italy and lived for six months in artist Aubrey Waterfield's (1874-1944) medieval castle at Settignano not far from Florence. There, he not only had ample opportunity to paint but also to visit such places as Villa I Tatti, home of American connoisseur and art historian, Bernard Berenson. The latter's niece invited Carr to see Berenson's collection and to join wild parties which the painter recalled, somewhat ruefully, 'just stopped short of throwing darts at the Duccios'. Carr also availed of the opportunity to study at the British School in Rome.

The 1930s saw the young artist exhibiting with the Euston Road group (formed in 1937) and becoming friendly with leading British painters Victor Pasmore (b.1908), Sir William Coldstream, (1908-87) and Claude Rogers (1907-79). The group's main aim was to advocate a move away from modernist styles to a more straightforward naturalism – ideas that affected Carr for the rest of his life. As he said himself: 'There wasn't a future in representational painting – and we had no religious feelings to express'.[55]

Shortly before the outbreak of the Second World War, Carr moved back to Ulster, settling in Newcastle, Co. Down with his family. He worked as an official war artist, painting scenes in factories, making flying boats and parachutes. The North of Ireland was to become his principal subject matter which he recorded in both oil and watercolour. The artist had a life-long commitment to the latter, firmly believing that '…watercolour is a medium that doesn't do to be blown away across a field or suddenly dried by a blazing sun, or wet by a shower of rain'.[56] Carr possessed the ability to explore and develop the scope of the medium to its full potential without losing its characteristic purity, as illustrated here in his watercolour entitled *The Lagan, winter landscape.*

Several of Carr's paintings were shown in Dublin in 1939 and a year later the artist had his work accepted

Tom Carr, H.R.H.A., R.U.A., R.W.S., O.B.E. (1909-1999) *The Lagan, winter landscape* 1969, watercolour.

for exhibition at the R.H.A. Persuaded by his friend, landscape and figure painter, John Luke R.U.A. (1906-1975), to teach part-time in the Belfast College of Art, Carr laid special emphasis on life drawing. In 1995, after the death of his wife, he moved to Norfolk, England. The B.B.C. film devoted to this painter's work entitled *Sunshine in a Room* was shown in 1996. Tom Carr died on 17 February, 1999.

RALPH DESMOND ATHANASIUS CUSACK (1912–1965)

Painter and stage designer Ralph Cusack was elected to the W.C.S.I. on 10 March, 1941 by committee members Alice Boyd (who acted as Chairman in the absence of A.V.

Montgomery), Mainie Jellett (a cousin of the artist), Lilian Davidson, Eva Hamilton, Major Nolan Ferrall, Dorothy Blackham, Mrs E.H. Reid and Major Crosbie Goff. Ralph D.A. Cusack exhibited a total of ten works in W.C.S.I. exhibitions from 4, Balbriggan Road, Skerries, Co. Dublin until 1943.

Born at Portmarnock, Co. Dublin, son of banker Major Roy J.R. Cusack and educated at Charterhouse, Cusack read economics at Cambridge where he took a degree in 1934. For health reasons and being 'small of build and dapper of bearing' the painter went to live at Mentone in the south of France in 'the last villa on French territory with only one house between his and Port St. Louis which, over river and rocky gorge, leads to Italy'.[58] Largely self-taught, Cusack began to take his

painting seriously, exhibiting at the Salon de Monaco in 1937 and from 1938 for four successive years exhibiting his work at the Exposition Annuel de la Société des Amis des Arts, Mentone. He also took the opportunity to act with the local drama group and designed stage sets for them. As the outbreak of war seemed inevitable, and taking into consideration the dangerous location of his villa, Cusack decided to return to Ireland in May 1939.

A friend of Basil Rákóczi and Kenneth Hall, Cusack began contributing to their White Stag group exhibitions from February 1941. He also participated in the Contemporary Irish Artists exhibition held in the Great Southern Hotel, Galway in April 1942, and contributed three works to the annual W.C.S.I. exhibition held the same year: *The Conservatory, To the*

Ralph Desmond Athanasius Cusack (1912-1965) *Stream through Kerry Wood* 1941, oil. PRIVATE COLLECTION

Banks, and *A Dingle Bay Farm*. However, as Dr. S.B. Kennedy has noted: 'His style as a painter developed rapidly until about 1942 or '43 but thereafter, it remained static, and from the late 1940s he painted hardly at all.'[58] Stephen Rynne commenting in *The Leader* on Cusack's first one-man show held at the Dublin Painters' Gallery, 7 St. Stephen's Green, Dublin in 1940 described the artist's work as 'Clever statements, clever technique, and versatility'.[59] Six years later well known Dublin art critic, Edward Sheehy, writing in *The Dublin Magazine,* felt that 'he has a very fine sense of design, a good sense of colour, but his draughtsmanship is weak, hesitating and ineffective...Some of his watercolours are fresh charming and original in their simplicity.'[60]

From the beginning an emphasis on line and pattern combined with a feeling for colour is evident and is illustrated here in Cusack's *Stream through Kerry Wood* painted in 1941 which possesses a gentle, Surrealist quality. From around 1943 the artist began to turn increasingly towards landscape and would appear to have been influenced by English painter, designer and book illustrator, Paul Nash (1889-1946). One of the most individual British artists of this period, Nash's deep, imaginative response to the English countryside coupled with his fascination with European modernism, and Surrealism in particular, had a profound influence on Cusack.

In the view of Dr. S.B. Kennedy: 'Overall, as a painter Cusack lacked a sense of purpose. It is said that he did not think highly of his work and in his semi-autobiography, *Book Cadenza: An Excursion* (1958) he did not even mention his painting. With a little restraint and a sense of purpose, Cusack could have been one of the most interesting and influential painters of his generation in Ireland.'[61]

PATRICIA WALLACE (Mrs Patricia Griffith) (1913-1973)

Between the years 1938-1966 Patricia Griffith exhibited forty-nine works with the W.C.S.I. under both her maiden and married names. **S**he was elected as a member of the Society on 4 March, 1938. The artist's election to the W.C.S.I. committee took place at a meeting held on 6 October, 1944 at 19, Upper Mount Street, together with Norah McGuinness and Harriet Kirkwood. Griffith's art training had begun early in life at Howell's School, Denbigh, North Wales. On her return to Dublin, she enrolled as a pupil at the R.H.A. Schools, completing her training in London at the Slade School of Fine Art. There she met Bea Orpen and the two painters became lifelong friends.

In the mid-1930s Patricia Wallace was employed by a friend, Jennifer Davidson, as a scene painter for the Torch Theatre. Later, in April 1940, Griffith began exhibiting with The White Stag Group alongside Basil Rákóczi, Mainie Jellett, Kenneth Hall and others. Her work was again on view with the same group in an exhibition held at 30, Upper Mount Street in February, 1941. A year later Griffith held her first solo exhibition at the Dublin Painters' Gallery, 7, St. Stephen's Green.

When she and her husband, William A. Griffith, went to live and run the Old Head Hotel, Louisburgh, Co. Mayo, the painter found another outlet for her artistic flair, namely designing interiors, creating large pictures from pieces of tweed, and painting. During this period in the early 1940s, Patricia Wallace sent a number of paintings from her west of Ireland address to the W.C.S.I. exhibitions: *Boy by the Sea, Snow, Clew Bay, 'Roonah Quay'*; the majority of her work being devoted to landscape in the west. Also included were a small number of child portraits. She obviously enjoyed painting children and set out to capture their characters, frequently including in these portraits scenes from the children's lives or their hobbies.

This artist's favourite medium appears to have been gouache as illustrated here in *The Haggard*, where she employs individual dashes of stark colour, vigorously applying it throughout the composition. The artist cleverly incorporates the brown paper, using it as an additional colour and making sure it becomes an integral part of her composition.

GERARD DILLON (1916-1971)

In an extract from Gerard Dillon's own introduction to his exhibtion *Gerard Dillon A Retrospective Exhibition 1916-1971*, the artist wrote: 'I was born and brought up in Belfast and always wanted to paint but had to 'work' as art didn't mean work to my people as it didn't to most of the people in Belfast when I was growing up. So I was sent to serve my time as a house-painter that was not bad at all for at least I learned to be familiar with brushes and paint but it became a bit boring having to cover large spaces with the one colour only, when my hand was itching to draw and compose'.[65]

Dillon's life was devoted to the purpose of picture making. He records

Patricia Wallace (Mrs Patricia Griffith) 1913-1917 *The Haggard*, gouache. Signed 'PAT WALLACE'.

stories in his paintings that may not possess an exact anecdotal meaning but always contain a symbolic idea. Concern for human situations gave his work, including collages, a literary content which he related in a wide variety of media such as gouache and watercolour. Inspired by the distinctive rocky landscape of Connemara, *The Yellow Field* depicts the rhythm of life through the rhythm of colour: in a landscape flattened by the artist, animals, a lone figure, small stone walls, a bare field, cottages are all collected and brought together within the frame. Imbued with vigour and movement, they contain that curious quality of delight which is this painter's unique gift in the transubstantiation of life into art.

A self-taught artist, Dillon left Belfast for London in 1934 where his work varied from painter and decorator to night porter and art teacher. He made frequent visits to Ireland, particularly Connemara where in the company of fellow artist and W.C.S.I. exhibitor, George Campbell both found inspiration in the West of Ireland landscape. The war years were spent in

Belfast and Dublin. Dillon's first one man show was held in Dublin in February, 1941 at the Country Shop, St. Stephen's Green and was opened by Mainie Jellett from whom he received constant encouragement.

Two years later, having been elected at a W.C.S.I. committee meeting held at 19, Upper Mount Street on 8 March, three of Dillon's works were included for the first time in the W.C.S.I. annual exhibition: *Rooftops*, *People on the Roadside* and *Cyclists–as Dublin appears to me*. He continued to exhibit with the Society until 1945 showing ten works in all. A keen exhibitor and hard worker, this artist's work was included in major exhibitions: Pittsburg International (1958), Guggenheim International, New York (1958) and Marzotto International, Rome (1961 and 1963).

A long-standing exhibitor and member of the committee of the Irish Exhibition of Living Art, Dillon was also a regular contributor to R.H.A. exhibitions until the year of his death, particularly in the field of watercolour. His work never lost its childlike spontaneity, charm and playfulness.

WILFRED JAMES HAUGHTON P.P.R.U.A., F.R.S.A., P.U.W.S. (1921-1999)

'I have often wondered how much an artist's place of birth affects his attitude to life, and what effect this may have on what he eventually paints. It is true to say that many acknowledged Masters, seeking fresh challenges and pastures new, have gone far a field for inspiration, but as often as not, have returned to the area in which they were born and have painted there for the rest of their lives.'[66]

Wilfred James Haughton, a distinguished landscape artist was fortunate to spend his early years in a countryside environment. In the future, this was to exert a considerable influence on his life as a painter. Born in 1921 at Hillmount, Cullybackey, Co. Antrim, Haughton was brought up in the Victorian mould and was expected to become proficient in music, singing, literature and painting. However, his participation in the latter was delayed for a number of years while he served during World War II with the Royal Air Force. A self-taught artist, Haughton had always enjoyed drawing

Gerard Dillon (1916-1971) *The Yellow Field*, gouache, ink and crayon. Signed 'Gerard Dillon'.

Wilfred James Haughton P.P. R.U.A., F.R.S.A., P.U.W.S. (1921-1999) *Approaching Storm* 1994, pastel on colour paper.
COURTESY OF THE COLOURED RAIN ART GALLERY, TEMPLEPATRICK, NORTHERN IRELAND

and sketching from an early age but had little opportunity or time to become a full-time art student. Due to his business activities, he had to delay full-time participation in painting. However, this did not prevent him from becoming involved from the age of twenty-five with the Royal Ulster Academy.

Haughton's involvement with the W.C.S.I. began three years later when at a committee meeting held on Monday, 23 May, 1949, he was 'unanimously elected and his work accepted for the Exhibition'.[67] His first year exhibiting with the Society saw the artist presenting two works. This was followed by a total of fifty three landscapes until 1993, many of them centring around the immediate area where he lived in Co. Antrim, a landscape which provided ample scope for this developing artist.

Haughton's involvement in his many teaching activities at Art Clubs (e.g. the Coleraine Art Society) and Technical Colleges (Larne) throughout the North of Ireland together with his contribution to the Royal Ulster Academy of which he was President (1964-1970) ensured that his 'staggering technical ability and a great sympathy with the general countryside' was conveyed to many.[68] In the latter part of his life, Haughton was instrumental in the formation of The Ulster Watercolour Society (1976) and was elected its first President.

The artist wrote: 'One of the great problems when working on your own is to assess the quality of your painting. It is so easy to accept praise from relations or close friends, which may or may not mean anything at all. So often they seem to regard one's efforts as 'a hobby' and something to be praised whether or not the standard is good, and in many cases they are not qualified to judge.'[69]

An Approaching Storm (illustrated) is captured in the menacing, threatening sky. In the foreground, three cattle head for shelter. The artist in his book entitled *Brush Aside* described how he set about depicting cattle in a rural landscape:

'[They] may need only a touch of two of juicy paint, but a knowledge and understanding of them is essential to enable the artist to place those touches just right. I have spent many hours following them round country fields until their portrayal has become almost second nature. Definition that appears simple is so often the culmination of knowledge and feeling built up over years of observation and even then there is always something more to learn and absorb.'[70]

Wilfred Haughton died at his home, 17, Dromana Lane, Cullybackey, Co. Antrim on 17th December, 1999.

Chapter XIII

Water Colour Society of Ireland
Figure and Portrait Painters

Louisa, Marchioness of Waterford
Sarah Purser, R.H.A.
Josephine Webb
Walter Osborne, R.H.A.
Clare Marsh
Eva Hamilton
Harriet Townshend
Sir William Orpen, R.A., R.I., H.R.H.A.

Lilian Davidson, A.R.H.A.
Jessie Douglas
Eileen Reid
Mary 'Mainie' Jellett
Anne 'Nano' Reid
Harry Kernoff, R.H.A.
Brigid Ganly, H.R.H.A.

LOUISA ANNE, MARCHIONESS OF WATERFORD (1818-1891)

Born into a distinguished family, a correspondent of the Pre-Raphaelites and John Ruskin, Lady Waterford was acknowledged within her own lifetime as a watercolourist of exceptional talent and ability. Lady Waterford was a friend of several of the founders of The Amateur Drawing Society, including Baroness Pauline Prochazka and Frances Wilmot Currey, and was related to sisters Harriet and Frances Keane. Throughout Lady Waterford's life she corresponded with several supporters of the Society, including the Osborne family from Newtown Anner, Clonmel. An exhibitor almost from its inception, Lady Waterford is mentioned by the local press as being present and taking part in the Society's second exhibition which opened in the Mechanics' Institute, Clonmel on 23 October, 1871. Her contribution, 'Three crayons…one - the figure of Christ with a reed - is singularly clever…so well worked out…'[1] Her work was also represented in the Society's nineteenth exhibition held under their new title the Irish Fine Art Society, in March-April 1882) in Dublin. The artist submitted two

works, *The Sower,* together with a child study, *A Birthday Queen.*

After her husband's death, Lady Waterford chose to live in England and did not contribute to the Society on a regular basis. Nevertheless, the artist did not sever her links completely, and exhibited two child portraits at their twentieth exhibition held in Dublin in March/April 1883. As late as 1889 – two years before her death – Lady Waterford's name appears once again in the Society's catalogue in relation to their thirty-second exhibition (held under the title the Water Colour Society of Ireland) when she exhibited *Sketch of a Child.*

The second daughter of the British ambassador to the recently restored court of Louis XVIII, Sir Charles Stuart, she was born in Paris in 1818. At the age of six she returned to England, and for four years the family lived at Bure (part of the family estate at Highcliffe) near Christchurch on the south coast of Dorset. After her father's re-appointment as Ambassador to France, she and her family returned to Paris, bringing with them the family governess, Miss Hyriott. It was she who continually encouraged the young girl to draw and paint. Louisa, now aged ten, was 'already devoted to her paint boxes' and, according to

friends, capable of copying a family portrait by Reynolds with a certain degree of skill and accuracy.[2]

In the year of her sister Charlotte's marriage to Charles Canning (who was later to become Governor General and first viceroy of India), Lady Waterford was presented at Court. An outstandingly beautiful girl, she was described by painter and poet Dante Gabriel Rossetti as being 'an excellent artist and would have been really great…if not born such a swell and such a stunner'.[3] During this period Lady Waterford had the distinction of being painted by many leading artists – George Frederic Watts, Sir Edwin Landseer, Swinton and Sir Francis Grant. At that famous Victorian romantic folly, the Eglinton Tournament, held at Eglinton Castle, Ayrshire, she met the third Marquis of Waterford, whom she married in 1841. Shortly afterwards, the young couple left for Curraghmore, Lord Waterford's estate near Portlaw, Co. Waterford. There, Lady Waterford set about trying to improve the living and working conditions of the tenants on the estate and started a local industry for the manufacture of woollen goods organising a 'Curraghmore Cothing Club' which provided employment for around thirty local women. Plans for

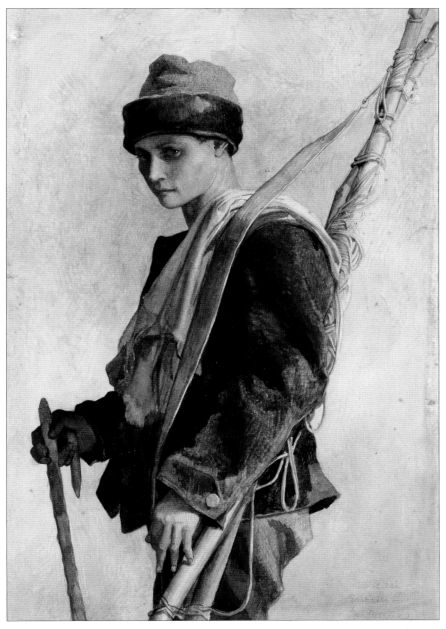

Louisa Anne, Marchioness of Waterford (1818-1891) *Pietro Ricci, a Fisherman of Sospello near Menton*, watercolour.

knife to almost an extent as you would scratch out a mistake in a word; it is better of course not to have much to do after the operation, or one is liable to blots and holes and other catastrophes. But the knife, lightly used, helps in reforming the work exceedingly when it is done.'[4] Due to a deterioration in her health, in February 1858 she and her mother travelled abroad. Her sketch books record their visits to Verona, Venice, Mantua and Menton. The portrait, illustrated here entitled *Pietro Ricci. A Fisherman of Sospello near Menton* is thought to date from this period. Tightly construed, it reveals a number of influences including Pre-Raphaelitism with its bright colouring, high finish, devotion to detail and careful brushwork.

In the winter of 1858-59 Lord Waterford was killed in a riding accident at Corbally, Carrick on Suir, not far from Curraghmore. His young wife, childless and with her sister far away in India, moved from Ireland to Ford Castle in Northumberland. There she undertook the task of designing and executing large murals for the local village school, which took her twenty-one years to complete. The murals were executed in both watercolour and gouache: comprising scenes from the Bible and using local school children and their families as models, they demonstrate the artist's mastery in handling figures, particularly children, who are conveyed with great tenderness and charm.

This cycle of remarkable frescoes captured the attention of the art world, including Edward Burne-Jones, George Frederic Watts and Sir Edwin Landseer. Ruskin was less enthusiastic: 'He condemned my frescoes and has certainly spirited me on to do better'.[5] In the autumn of 1890, Lady Waterford's health began to decline. After several weeks of being confined to bed, she died on 12 May, 1891. Buried at Ford, a simple recumbent cross designed by Watts marks her grave. A year after Lady Waterford's death, an exhibition of her work was held at 8, Carlton House Terrace, London where over three hundred examples of her work were exhibited together with several of her sketchbooks.

the building of two local churches was decided upon with designs for the stained glass windows being drawn up by Lady Waterford. She also found time to paint and sketch, frequently in the company of her friend Grace Palliser of Derryluskin, Co. Tipperary.

Attracted to the Pre-Raphaelite movement, in the summer of 1853 Lady Waterford paid a visit to Holman Hunt's studio at 5 Prospect Place, Cheyne Walk, London. She also met John Ruskin for the first time. Ruskin suggested that she should take lessons in drawing from Rossetti, although Rossetti then declined to offer instruction. Nevertheless her work improved steadily. Ruskin remained scant with his praise insisting that it lay within her power to practise and persevere more. He advised 'that the pen drawings may be softened with the

SARAH HENRIETTA PURSER, R.H.A. (1848-1943)

Born in Kingstown, Co. Dublin on 22 March, 1848, Sarah Henrietta Purser was one of two daughters and nine sons of Benjamin Purser, a flour miller of Dungarvan, Co. Waterford, and Anne Mallet. Her childhood was spent in Dungarvan, and her education was at the Institution Evangélique de Montmirail, near Neuchatel in Switzerland (1861-63). When her father's business failed, his daughter was determined to earn her own living and resolved to try and support herself by becoming a professional artist. In February 1872 Purser had four works accepted at the R.H.A. exhibition: *Nell Connery, Coming from Mass, Taking a rest, An old salt* and *Still life*. In 1875 the R.D.S. awarded her a certificate in a new area of interest, still-life, and confirmed a family tradition that she did attend the D.M.S.A. in Kildare Street. Despite receiving Distinction in examinations held by the Royal Dublin Society Drawing Schools in that year, the artist was none too happy with the instruction she was receiving, and with the R.H.A. Schools still excluding female students, Purser turned to the few art institutions which accepted women during the 1870s.

In 1878 she decided to set out for Paris to continue her art training at the Académie Julian, Avenue des Ternes. The atelier provided studio facilities and access to academic artists, such as Tony Robert Fleury (1837-1912); the academy was described by Irish critic and writer, George Moore (1852-1933) as teaching the 'grammar of art, perspective, anatomy and *la jambe qui porte*', Fleury's teaching being considered by many to be dull and lacking in inspiration.[6] Purser received training in charcoal, chalks, oil and also pastels; the young student admiring, in particular, the naturalism of the *en plein air* painting and portraiture of Jules Bastien-Lepage (1848-84), together with the work of Puvis de Chavannes (1824-1898) and Degas (1834-1917). After six months Purser returned to Dublin and rented a little studio on the top floor of 2, Leinster Street.

Pursers' associations with the Irish

Sarah Henrietta Purser, R.H.A. (1848-1943)
Portrait of William Butler Yeats, pastel.
This portrait was exhibited in the Water Colour Society of Ireland's exhibition held 1899 (cat. no. 222). Although the sitter and the artist disagreed on several occasions, Yeats sought the artist's permission in 1935 to have this portrait reproduced in his projected autobiography.
COURTESY OF THE DUBLIN CITY GALLERY, THE HUGH LANE

Fine Art Society began as early as 1880 when she submitted a number of portraits and flower studies: *The Winter Nosegay, A Pink Dress, Letizia, A Charcoal Head*.

A year later, the artist had two paintings accepted by the R.H.A. The *Daily Express,* reviewing the Irish Fine Art Society's exhibition commented, 'Miss Purser is…without a rival in power and method of oil painting…cat. 189 *A Pink Dress* and 201 *Head of an Old Man* shows the advantages to be gained by earnest study under proper direction in Paris. We congratulate Miss Purser on her earnestness and perseverance and we hope she will continue to keep working in the same artistic spirit.'[7]

Purser's *Study in the open air* formed part of the W.C.S.I. exhibition held at 35, Molesworth Street, Dublin in March-April, 1882. A half-length of a young girl seated in a garden, wearing a hat and holding a dog-daisy, in the view

of Dr. John O'Grady, 'conveys an outdoor atmosphere with economy and restraint; an unpretentious picture and a good one, it breaks new stylistic ground for Purser, having a strength and vision closer to Degas than to the fashionable mode of earlier works'.[8] The painter's name had been mentioned in a number of press reviews relating to the Society's exhibitions as early as 1880. In 1899 she had five portraits accepted for the W.C.S.I's annual exhibition, including her pastel of *William Butler Yeats* (illustrated here) and described by her biographer as follows: 'Purser seized the essentials of the man and the poet, the eager thrust of head, sensitive face, mobile lips, and – behind pince-nez – the eyes narrowed on his inner vision.'[9] Along with the portrait of Yeats, Purser also exhibited *Miss Maud Gonne, Miss Eva Gore Booth, J.E. Goeghegan,* and *Mrs H. Stokes*. These portraits demonstrate her academic competence coupled with a sound draughtsmanship and her ability to capture a likeness: qualities which established her reputation in the field of portraiture not only in Ireland but also in Britain. As time went on, the painter's work became increasingly fresh and impressionistic; her palette brightened through the second decade of the twentieth century, as seen in her portrait of *Roger Casement–sketch* (1914) (oil) now in the N.G.I. In 1891 Sarah Purser was elected an Honorary Academician by the R.H.A., an institution which was still exclusively male in membership; in 1924, at the age of seventy-six, she had the distinction of becoming the first woman to be admitted to full membership.

With her exceptional energy and intelligence, Sarah Purser, 'grande dame of Dublin Society', was always in the forefront of Irish intellectual activities playing a vital role in Irish cultural life.[10] Her '2nd Tuesdays', her 'days of wrath' held in her home, Mespil House, Dublin became a salon frequented by artists, writers, politicians, visionaries and revolutionaries.[11] She and Sir John Purser Griffith were responsible for setting up and financing the Purser Griffith Scholarship and History of Art lectures, which still continue to this day in T.C.D. and U.C.D. In 1903 she founded and financed An Túr Gloine

(Tower of Glass) at 24, Pembroke Street in order to further the ideal of national self-sufficiency in stained glass. In 1914 she was appointed to the board of the N.G.I. Largely responsible for the foundation of the Friends of the National Collections of Ireland in 1924, she later persuaded the Irish government to transform Charlemont House into a Municipal Gallery of Modern Art which opened in 1933. At the age of seventy-five Purser set about arranging and organising a solo exhibition of her work. Sarah Purser died on Saturday, 7 August, 1943 in her home, Mespil House. She was buried three days later 'and as it was the second Tuesday of the month her friends felt she would be deriving merriment from entertaining them so appositely on her final day of wrath.'[12]

JOSEPHINE WEBB (1853-1924)

Josephine Webb was a consistent exhibitor with the W.C.S.I. from 1892 until 1902 exhibiting a total of fifty-one portraits and landscapes. The W.C.S.I. catalogue lists not only Irish and British scenes but also landscapes painted around Rambouillet and Seine-et-Oise, France. Described by *The Studio* as being '...really charming water-colour sketches of French and Irish scenery. They include some clever line and wash drawings, something after the matter of Caldecott's work, and three interesting studies in charcoal, with a wash of colour suggestive of the work of the early water colourists. Miss Webb's method is very rapid and direct, and in her French sketches she has managed to convey the emphatic effect of brilliant sunshine very cleverly.'[13] Throughout the 1880s and '90s Webb also exhibited a number of portraits in the R.H.A. beginning in 1880 with a portrait of *Sir John Barrington D.L., Lord Mayor 1865, 1879*.

Born in Dublin, Josephine Webb was part of a large Quaker family, her father being Thomas Webb of Thomas Webb & Co., 'boot and shoe manufactory; tailoring and gentlemen's general outfitting warehouse'.[14] Josephine Webb entered Alexandra College, Earlsfort Terrace, Dublin in 1868; in 1871 she

Josephine Webb (1853-1924) *Portrait of Dora Mary Sigerson (Mrs Shorter) (1866-1918)*, pastel. The sitter, a poetess and journalist, was born at 17, Richmond Hill, Dublin, 16 August, 1866, eldest daughter of Dr. George Sigerson, surgeon and Gaelic scholar. Her mother, Hester, was a successful novelist. The Sigerson family were deeply involved in the Gaelic Revival. Dora Sigerson was a member of the National Literary Society and contributed poems, reviews and article to Irish periodicals. Her first book *Verses* appeared in 1893. In 1896 she married journalist, Clement Shorter, editor of the *Illustrated London News*, and settled in England. COURTESY OF THE NATIONAL GALLERY OF IRELAND

entered the Queen's Institute and College at 25, Molesworth Street, and in 1875 was awarded two silver medals for drawing. Three years later the young art student was in Paris studying at the Académie Julian under Tony Robert Fleury whom she found handsome, dark and rather interesting. In another letter to her mother, the artist described Monsieur Julian: 'a quiet, low sized, tolerable stout little man, comes into the room without any fuss, has a pleasant face and dark cropped beard; his hair is beginning to get a little grey and is cropped very short'.[15]

On her return to her native city in 1879, Webb rented a studio at 5, Grafton Street and began exhibiting at the R.H.A. for the first time, moving in 1885 to a new studio at 13, Nassau Street. She returned to Paris in 1887, spending a month at Julian's, and a year later visited Holland. In 1892 a substantial number of entries, nine in all, were sent from a new address, 69, St. Stephen's Green, to her first annual W.C.S.I. exhibition. Part of a lively group of painters and writers, Josephine Webb was a friend of both John Butler Yeats R.H.A. and his son,

245

Jack B. Yeats R.H.A. A hard worker, the artist continued to exhibit throughout her life and held a one-woman show at the Leinster Lecture Hall in 1904 followed by another in 1908 at 122a, St. Stephen's Green. An exhibitor at the Dublin Arts Club from 1892 onwards, she also participated in the Oireachtas Art Exhibition in 1907.

Just after the First World War, Josephine Webb presented her informal pastel portrait of poetess, *Dora Sigerson (Mrs Shorter)* to the National Gallery of Ireland. It is considered to be an excellent likeness judging by contemporary photographs and portraits. The artist captures the melancholy quality of the sitter – a quality which is often prevalent in Miss Sigerson's poetry as she expresses a sadness and desolation intensified by what she considered to be her exile in England.

Webb's exhibition work appears to have been largely confined to Ireland but she did exhibit one portrait, *Boy and Bubble,* at the Royal Society of British Artists in London in 1892. A year before her death, the artist organised an exhibition of her paintings in her studio at 122a, St Stephen's Green.

An artist who moved in a lively circle of artists and writers, her studio 'on the green' was a gathering place for all interested in art, music and literature. Josephine Webb died on 3rd November, 1924.

WALTER FREDERICK OSBORNE, R.H.A. (1859-1903)

According to the artist's biographer, the late Dr Jeanne Sheehy, from around 1889 onwards, Walter Osborne began to devote himself seriously to portrait painting. Prior to this, he had concentrated on painting relatives and friends and, as far as is known, his first serious commission was a portrait of *Dr. Anthony H. Corley,* a work exhibited in the R.H.A. in 1889. Thomas Bodkin, having viewed this portrait, considered somewhat scathingly that the artist was 'wasting his talent in immortalising the people of reputation, rank, or fashion in Dublin'.[16] As time would prove, not

everyone agreed. Yeats, in a letter to Lady Gregory, noted, 'Dublin can't support more than one portrait painter - now it is Walter Osborne'.[17]

The second son of Anne Jane Woods and William Osborne (1823-1902) artist and animal painter, Walter Frederick Osborne was born in Dublin on 17 June, 1859, into a comfortable middle class family who lived at 5, Castlewood Avenue, Rathmines. In 1876 the young painter attended the R.H.A. Schools and in his first year succeeded in being awarded four of the seven annual prizes. He went on to win two successive Taylor Scholarships – in 1879 and 1880 – and succeeded in gaining the principal prize amounting to £50 the following year. It was suggested that, as the artist was obviously an outstanding student, he should continue his studies at a different school of art, and so Osborne settled on Antwerp. He enrolled at the Académie Royale des Beaux Arts and became a member of the *natuur* class (painting and drawing from life) conducted by animal painter, and Professor of Painting, Charles Verlat (1824-1890). The Academy encouraged a vigorous handling of paint coupled with a bold use of colour, with emphasis being placed on speed of execution. When he had completed his training, Osborne travelled to Brittany working around Pont Aven, Dinan and Quimperlé. He had an attractive personality and had no difficulty in becoming friendly with many artists, in particular Jules Bastien-Lepage (1848-1884), the French naturalist painter who employed the 'square-brush' technique and tended to use a grey, even light in his paintings. He also fell under the influence of *plein air* painters Alexander Stanhope Forbes, R.A, (1857-1947) and Sir George Clausen, R.A., R.W.S., R.I. (1852-1944). In 1884 Osborne moved to England where he was to live for the next eight or nine years, moving from county to county and painting on a regular basis. Each winter he returned to Ireland where he exhibited his work. This included the Dublin Sketching Club (1884, 1885), and, following his election as a full member of the R.H.A. in 1886, at the Dublin Art Club (1886-1892). In 1886 Osborne joined the

ranks of the W.C.S.I. for the first time, exhibiting *The Markets, Bordeaux–A Study*; in 1897 he exhibited *An Old Canal, Amsterdam* and *At Zaandam, Holland.* This was followed in 1899 and 1901 by further submissions.

In the view of Sheehy, Osborne must have looked towards Whistler and the elegant society portraits of John Singer Sargent (1856-1925) for guidance, the latter's influence being seen in the vigorous brushwork which he employed for his own Self Portrait (*A Self-Portrait* signed 'Walter Osborne'). The artist also studied portraits by the great masters – Goya, Velasquez, Reynolds and Gainsborough – but they do not appear to have had a direct influence on his poses, with the exception of Reynolds' mother and child portraits. This is seen in his clever, easy and relaxed portrait of *Mrs Noel Guinness and her daughter Margaret* exhibited at the Royal Academy in 1898 and shown a year later at the R.H.A. Lent by Noel Guinness for the Exposition Universelle, Paris, in 1900, the work received a bronze medal which brought him international recognition as a portrait painter. In the same year, the artist was offered a knighthood by the Lord Lieutenant, but declined.

Osborne would appear to have been more at ease painting his family and friends, as is seen in the delightful portrait (illustrated) of his niece, Violet Stockley, exhibited in the W.C.S.I. exhibition in 1901. Osborne's sister, Violet, had married W.F.P. Stockley and emigrated to Canada in 1892. A year later she died in childbirth. The baby was sent to the painter's parents to be brought up in Ireland. Osborne's decision to return to Dublin from England was influenced by this change in his family's circumstances and the artist appears to have assumed responsibility for the young girl's upbringing. This evocative, tender picture, together with well known pieces *The Dolls' School, The House Builders* and *A Doll's Party* (the latter being exhibited in the W.C.S.I. annual exhibition in 1901), all form part of a successful late group of child portraits executed in water colour and heightened with touches of coloured chalks. All possess enormous charm and appeal.

The school registers of the D.M.S.A.

Walter Frederick Osborne, R.H.A. (1859-1903) *At a Child's Bedside,* watercolour. Signed and dated '1898', also inscribed on verso 'Painted in September, 1898 when Violet was 5 years of age'. The sleeping child, Violet Stockley, was the artist's niece. This watercolour was exhibited in the W.C.S.I. exhibition in 1901. (cat. no. 15) and was also included in the New English Art Club exhibition held in 1899 (cat. no. 30). COURTESY OF THE GORRY GALLERY, DUBLIN

reveal that, shortly after his return to Dublin, Osborne attended the D.M.S.A. for a year between October 1897 and July 1898. Establishing himself as an influential art teacher in Dublin, Osborne was appointed visiting teacher at the R.H.A. Schools. He was well liked and enjoyed an excellent reputation. His early death from double pneumonia on 24 April, 1903, brought to a close the work of Ireland's leading portrait painter. 'As he had always shown a generous temperament, a sense of fun and a spirit of sportsmanship, he left a wide circle of personal friends to whom his charming personality had endeared him'.[18]

A year later, in 1904, at the Guildhall Art Gallery, London Sir Hugh Lane included fourteen pieces by the artist in 'The Exhibition of Works by Irish Painters': works ranging from portraits and landscapes to genre scenes. Walter Osborne's paintings formed the majority of work in an exhibition held in The School of Art, Emmet Place, Cork in June and July, 1935: portraits, landscapes, studies of animals and genre executed both in watercolour and oil were placed on view. The W.C.S.I. also honoured him in 1970 by including his *Portrait of John Hughes, (1865-1941), Sculptor, against his Sculpture of Orpheus and Eurydice* in their Centenary Exhibition (illustrated on p.192).

CLARE MARSH (1875-1923)

A member of an Anglo-Irish family, Clare Marsh was, in the words of her lifelong friend and artist, Mary Swanzy, H.R.H.A. (1882-1978), 'one of a devoted family of brothers and sisters of great good looks and charm, with a background of impecuniosity which did not apparently worry them in spite of a more affluent upbringing. Though finances doubtless caused some anxiety from time to time'.[19] Marsh, one of five children, was born at New Court, Bray, Co. Wicklow in the house belonging to her grandfather, Andrew McCullach, a wine merchant. She met Mary Swanzy in the studio of teacher and landscape/figure painter May Ruth Manning (1853-1930) where both were fortunate enough to be the recipients of excellent and enthusiastic tuition.

Clare Marsh is listed on the D.M.S.A. Index Register as attending during the years 1897-1898, 1900 and 1901-1903. While a student there, Marsh found the time to attend night classes for sculpture under John Hughes R.H.A. (1865-1941) and Oliver Sheppard R.H.A. R.B.S. (1865-1941). She was also a student on a course run by Norman Garstin in Penzance, Cornwall, in 1897.

Clare Marsh (1875-1923) *Portrait of Edward Gibson, 1st Baron Ashbourne* (1837-1913), Lord Chancellor of Ireland (appointed 1885), oil.

imitate a thing directly but rather translate it into the language of painting. The reason why I hoped for good things from you was because I saw you had some inkling of this language …Trying to produce a picture will force you to *think*'.[21]

After John Butler Yeat's departure for America in December 1907, Clare Marsh kept in touch, seeking the artist's help and encouragement, the rich yet delicate texture of her portraits owing not a little to Yeat's work and outlook.

As early as 1896 Clare Marsh began exhibiting with the Dublin Sketching Club. In 1902 she had five entries accepted for exhibition with the W.C.S.I., including two landscapes painted in Scotland: *On the Frith of Forth* and *Evening on the Coast, North Berwick.*

She exhibited for the first time in the R.H.A. in 1900 and continued without a break until 1921; the artist exhibiting portraits, genre scenes, flower paintings and landscape studies. The painter's style revealed an ever increasing tendency towards French Post-Impressionism whilst at the same time never totally deserting the academic world of painting. As Pyle remarks: 'Her approach was typical of a painter trained in Dublin at the beginning of the century, with an eye to the Continent rather than to London'.[22]

Probably due to John Butler Yeat's influence, the young painter was persuaded to visit America in 1912 and stayed with relatives first at White Plains, New York and then at Yeat's boarding house in New York. Her stay was short: after two months Marsh was back in Dublin, and in 1916-19 held the appointment of Professor of Fine Arts at Alexandra College, Earlsfort Terrace, Dublin. She shared a studio with Mary Swanzy in 1920, and the following year was one of seven artists (including Jack Butler Yeats, Paul Henry, Letitia Hamilton and Grace Henry) to participate in the Dublin Painters' Gallery autumn show. In 1923, a year after John Butler Yeats died in New York, Clare Marsh passed away; a painter who 'approached her subject, as her great master [John Butler Yeats] did, in a temper that was unfailingly gracious and often poetic to such a

One of the lasting influences on Marsh's career was portrait painter and illustrator John Butler Yeats R.H.A. (1839-1922), who taught in Manning's studio in the summer of 1898 and painted Marsh's portrait in c.1900. John Butler Yeats built up a long lasting friendship with the artist and, according to art historian, Dr. Hilary Pyle, the work of his son, Jack Butler Yeats is also believed to have been another influencing factor: 'Jack's aligning of greys and lilac in harmonious complement must have had some effect on Clare's work.

Among her studio remains are water-colour sketches of a farmhouse cluster, in misty light, where she attempted a similar relation of tones, and of a pansy in a jug, where she drew together a stronger chunky composition with one predominant colour, a greeny yellow.'[20]

Dr. Pyle suggests the artist would appear to have modelled her approach to portraiture on that of John Butler Yeats, R.H.A. (1839-1922). The latter looked upon this young painter almost like a daughter, his advice being:

'In painting the chief thing is to make oneself think. You must not

degree that one needs to be in a room with even a small Clare Marsh picture for only a very little time before becoming instinctively aware of a sympathetic presence.'[23]

EVA HENRIETTA HAMILTON (1876–1960)

Part of a large family, Eva Henrietta Hamilton was the daughter of Charles Robert Hamilton of Hamwood, Co. Meath and Louisa Brooke of Sumerton, Castleknock, Co. Dublin; she was a cousin of Rose M. Barton R.W.S. Eva Hamilton was born two years before her sister, Letitia, whose work is perhaps better known. Both sisters attended Alexandra College, Dublin and both became students of William Orpen at the D.M.S.A. – Eva attending between October 1907 and July 1908, and again in 1914 to 1915. Eva went on to become a student at the Slade School of Fine Art, London. As a young painter, and in order to earn money, she spent a considerable amount of time copying portraits by her tutor, William Orpen, and from an early age appears to have specialized in this particular genre; it was only in the 1930s that she turned her hand to painting landscape .

It is not known when Eva Hamilton was elected to the W.C.S.I. due to the lack of minutes prior to 1921. The artist began exhibiting with the Society in 1898 and, between then and 1950, showed around ninety-one works at annual WCSI exhibtions. Portraits predominated with only fourteen landscapes being shown, these were largely Irish scenes. In April 1925 she was appointed a member of the W.C.S.I. Hanging Committee, a position she appears to have held until 1932. Later she was co-opted to the W.C.S.I. Committee in place of her sister, Letitia, during the latter's absence from Ireland in December 1940. After Eva Hamilton ceased exhibiting with the Society in 1950, the artist continued to take an active part in its affairs recording for example the minutes for a W.C.S.I. committee meeting held in March, 1951.[24]

Eva Hamilton's early portraits, largely

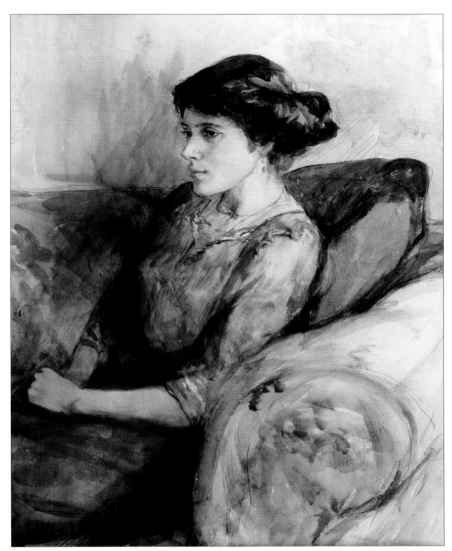

Eva Henrietta Hamilton (1876-1960) *Portrait of Mrs Charles Travers Hamilton*, watercolour and pencil. PRIVATE COLLECTION. REPRODUCED BY KIND PERMISSION

executed in pastel, were small ovals in the eighteenth-century style. Later the influence of William Orpen is seen in both her figure and subject painting, as illustrated here in the portrait of the artist's sister-in-law. Fundamentally academic and full of charm, it possesses little formality, the sitter's face imbued with a softness and delicacy typical of this young portraitist's approach to her sitter. An elegant, handsome woman, Mrs Charles 'Violet' Hamilton is seated on a sofa, her hair arranged in a typical Edwardian upswept style, the artist employing soft colours and being careful to confine detail to the minimum.

Eva was the first of the two sisters to exhibit at the W.C.S.I., showing a

portrait and a figure subject, *An Irish Peasant Girl,* in 1898. In 1904 she returned again to the Society, exhibiting two further portraits, *Miss Ethel Hamilton* and *Miss May Hamilton,* together with two views of Dollymount, Dublin (*Dublin from Dollymount in the evening.* and *The Bridge to the Golf Links, Dollymount*) sent from 40, Lower Dominick Street, Dublin.

Eager to promote her career as a portraitist, the young artist agreed to participate in the prestigious exhibition of Irish painting held in the Guild Hall, London in 1904, which was being organised by Hugh Lane. She submitted a portrait entitled *A Lady in Pink.* She then participated in the Irish

International Exhibition in 1907 with *The Letter, The Moor of Meath* and *Portrait of a Lady*. In 1912 the R.H.A. exhibition was written up in *The Studio*, '…the contributions from resident Dublin painters both in landscape and portraiture…they were remarkable for their high standard of attainment and their variety of interest…Miss Eva Hamilton, who has gained in breadth and fineness of vision, was particularly successful in her interior, *A Bright Morning* with a mother and child looking out across a Dublin street…'[25] Hamilton also exhibited *A Bright Morning* in the exhibition of Irish art held at Whitechapel, London in 1913.

Eva Hamilton was now beginning to gain recognition as a competent portraitist; this was confirmed when, in 1928, Dermod O'Brien, P.P.R.H.A. invited her to participate in a prestigious exhibition of Irish art to be held in the D.M.S.A., together with well established painters such as Richard F. Caulfeild Orpen, R.H.A., Sarah Purser R.H.A., Harry Clarke, R.H.A., and Paul Henry, R.H.A. As far as is known, Eva Hamilton never held solo exhibitions; by 1946, however, the artist had exhibited a total of 121 works at the R.H.A. concluding with a portrait of her sister, Letitia Hamilton, R.H.A.

At the end of the First World War, in which the artist had been actively engaged in philanthropic work, and following the death of her mother in 1922, Eva Hamilton took over the housekeeping for herself and her sisters, which left her little time to devote to her art. When she did find the time, she tended to concentrate on landscape painting. The family having lived in various rented buildings (exhibiting at the R.H.A. between 1904 and 1946, Eva Hamilton is listed as having submitted exhibits from eight different addresses) for a great deal of their lives, in 1946 the sisters moved for the last time to Woodville, a rambling, largely mid-eighteenth century house on the outskirts of Lucan, Co. Dublin. Despite the pressures of keeping house, Eva Hamilton managed to maintain her association with the R.H.A., the Dublin Painters and the W.C.S.I., submitting exhibits to the latter until ten years before her death in 1960.

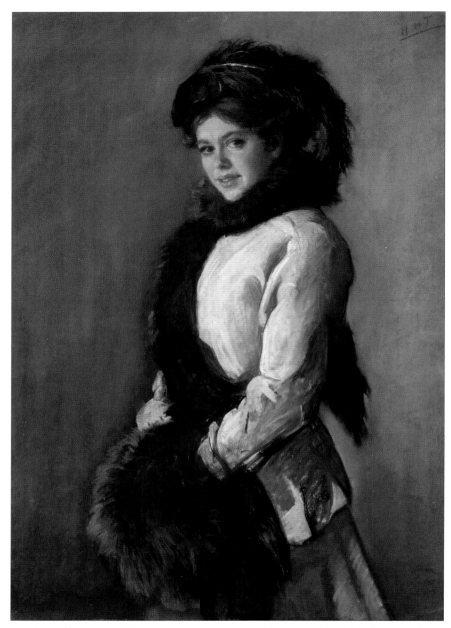

Harriet Hockley Townsend (1877-1941). *Winter*, 1911, pastel. A portrait of Miss Theodosia Townshend, aged nineteen years. Signed with initials 'H.H.T.' Inscribed on label on verso, 'Winter by Miss H H Townshend/Parmerstown Park/Dublin and Miss Theodosia Townshend/aged 19/1911.'
DONATED TO THE CASTLETOWN FOUNDATION BY MRS A. DE DOUZON, 1992; ON LOAN TO THE O.P.W. CASTLETOWN HOUSE, CO. KILDARE. PHOTOGRAPH COURTESY OF DAVISON & ASSOCIATES LTD.

HARRIET HOCKLEY TOWNSHEND (née Weldon) (1877-1941)

Harriet Hockley Townshend began exhibiting portraits and flower pieces with the W.C.S.I. in 1925, having been elected in the same year as Letitia Hamilton, R.H.A. *Winter* (illustrated here), executed in pastel, dates from 1911 and was her first entry hung in the R.H.A. The subject is the artist's stepdaughter, Theodosia Townshend, aged nineteen. It demonstrates the painter's accomplished and confident style. Art historian Wanda Ryan-Smolin describes the piece thus: 'The pose is formal yet the expression on the young woman's face and her dashing costume with ostrich feather

hat lends a lightness and sense of gaiety to the composition…it is clear from the style of this portrait that she was either directly or indirectly influenced by the work of William Orpen who taught at the School [D.M.S.A.] between c.1908 and 1912.'[26]

The artist's early childhood was spent at Forenaghts, Naas, Co. Kildare, the home of her parents, Major-General Walter Weldon, and his second wife, Annie (née Homan Molloy). Their daughter may have received her early art training from her governess. However, it is known that she did enrol for one year in the D.M.S.A. in 1909. She may also have studied for a short period in both Florence and Paris.

On 8 June, 1910, she married Thomas Loftus Uniacke Townshend, land agent, of 7, Palmerston Park, Dublin and began exhibiting under her married name. However, as far back as 1903, she had begun to establish her reputation as a portraitist by exhibiting her work at the R.HA, which included, in 1914, two portraits: *Master Joly Dixon* and *Miss Margaret Silvertop*. It was not until the artist moved to Waverley, Westminster Road, Foxrock, Co. Dublin that her connection with the W.C.S.I. began. A flower piece *Lilac Time* (cat. no. 85) was exhibited in the Society's annual exhibition in 1925, followed two years later by two child portraits. Between 1931 and 1940 this artist exhibited a total of sixteen portraits and five flower pieces with the Society, all of which were executed in pastel. Harriet Hockley Townshend died at her home on 20 August, 1941.

SIR WILLIAM NEWENHAM MONTAGUE ORPEN R.A., R.I., H.R.H.A. (1878-1931)

Dr. John Turpin writes of Orpen: 'As a student in Dublin and London, he took his artistic nourishment from many sources. The tradition of European realism especially Spanish art profoundly influenced him; from this current he absorbed the method of modelling form by tone…the tradition of European classical drawing-notably the example of Ingres. The twin aspects of tone and line were complementary

Sir William Orpen, R.A., R.I., H.R.H.A., (1878-1931) *Seated Nude*, monochrome, wash and pen. Signed in pencil 'William Orpen '99'. This work was exhibited in the Water Colour Society of Ireland's Centenary Exhibition in 1970. PRIVATE COLLECTION. REPRODUCED BY KIND PERMISSION

in his art; colour was usually less important…He is different from his Victorian predecessors in his greater compositional discipline and aesthetic control. Therefore he took what he wanted from contemporary art: Tonks, Whistler, Sickert, Steer, Pryde, Clausen, W. Rothenstein and Augustus John.'[27]

William Orpen was a superb draughtsman and an influential teacher of generations of Irish painters, many being future members of the W.C.S.I. Son of a successful practising solicitor, Arthur Herbert Orpen and his wife, Anne (née Caulfeild), Orpen's childhood home was Oriel, Grove

Avenue, Blackrock, Co. Dublin. From an early age, Orpen possessed a natural talent for drawing. His parents encouraged this, allowing him to enrol at the D.M.S.A. before he had reached his thirteenth birthday. Awarded prize after prize, he then moved to the Slade School of Fine Art – on which *The Studio* noted: 'As regards drawing, he had, indeed, but little to learn when he entered the Slade School…he drew for practice, not for display, to give sureness to his hand and make it a reliable servant to his eye…'[28] As a young and gifted painter, William Orpen realized that his native country could not offer him the

same opportunities for advancement as those open to him in England, and so London became the artist's base. However, between 1902 and 1914 Orpen travelled back to teach part-time at the D.M.S.A. and brought about a revolution in teaching practice in the life class 'disseminat[ing] the Slade approach to a whole generation of Irish Artists'.[29] In 1901, Orpen exhibited at the R.H.A. and became a full member in 1907. In 1910, he became an associate of the Royal Academy, and was elected to full membership in 1919.

The artist exhibited one work under its full title, *Sowing the seed of evolution for the Board of Agriculture* (illustrated on p.195) in the W.C.S.I.'s fifty-ninth exhibition, held in February, 1913 in Dublin; a piece which he sent from 13, Royal Hospital Road, Chelsea. This painting had already been shown at the New English Art Club's winter exhibition, 1913. In this work, the artist expresses his deep frustration spent in years of teaching students in an institution (the D.M.S.A.) which seemed immune to change or progress of any kind. A lack of any real understanding and appreciation relating to the position of the artist and the development of art in Ireland is conveyed with a high degree of cynicism. In Orpen's own words:

'The scene is Dublin Bay, painted from Howth, with Kingstown, Bray and the Sugar Loaf Mountain in the background. The figure in black represents the several heads of the Board of Agriculture and Technical Instruction for Ireland, which board, beside their agricultural and technical duties, have control of the money for, and the management of, art in Ireland. The lady "sowing the seed" represents myself, or any other unfortunate, trying to introduce more modern movements or fresher life and thought to the schools under the board. But anything outside the conventional red tape method is not tolerated by the board. Yet "young Ireland", the children receive it gladly. The lady leaning on the department's arm is the very ordinary departmental wife, who understands nothing, but wishes to be on the safe side, and is afraid perhaps that her husband has not noticed the

"sowing lady" at all. The decayed tree is the department and the single magpie is "bad luck to it".'[30]

During his lifetime Orpen produced intimate and sensitive portraits of many women, including his wife, Grace (née Knewstub), and models, Yvonne Aubicq, Flossie Burnett, Emily Scobel, Lottie Stafford and Vera Hone. An incurable romantic, he had a number of relationships with many beautiful women including the tall and elegant Mrs St. George whose portrait he painted on many occasions. The nude study, illustrated here and exhibited in the W.C.S.I. Exhibition of 1970 may be 'the model he had in the Art School in Dublin, c.1906.'[31] Again, this drawing underlines the artist's supreme powers as a draughtsman. Fluency and spontaneity are firmly underpinned by a core of sound draughtsmanship. Critical of his own work, Orpen produced a substantial number of self-portraits. These, together with professional portraits, represent the bulk of his output and serve as a record of major figures in both English and Irish society at the time.

During the First World War Orpen was appointed official war artist and produced a powerful stream of pictures that revealed the horrors and tragedy of the bloody conflict. For his services he accepted a knighthood in 1918. He returned again to his portrait practice in the 1920s from which he earned substantial sums of money Separated from his family and Ireland and ravaged by drink, he became seriously ill in May 1931. He died on 29 September the same year and was buried in Putney Vale Cemetery.

LILIAN LUCY DAVIDSON, A.R.H.A. (1879-1954)

W.C.S.I. member Lillias Mitchell in a tribute to her friend, Lilian Davidson, a much loved and dedicated teacher, wrote: 'She was very kind and encouraging but always expected each of her pupils to try hard. She herself took no path of ease, but must have taken great satisfaction in seeing her pupils also take their places in the serious art world.'[32]

Born at 7, Fitzwilliam Terrace, Bray, Co. Wicklow on 26 January, 1879, Lilian Davidson was the daughter of Edward Ellice Davidson and Lucy Rising (née Doe); she was their sixth child. Her father was Clerk of Petty Sessions serving in Bray, Enniskerry and Cabinteely, Co. Dublin. She obtained her early art training at the D.M.S.A., entering in October 1894 and remaining there until 1898. In 1895, she is first mentioned as being a prize-winner in the D.M.S.A. Annual Report and List of Prizes.

Lilian Lucy Davidson's association with the W.C.S.I. began in 1912 and continued until 1953, a year before her death. She exhibited each year without fail. Davidson was elected to the W.C.S.I. committee on 20 October, 1932, at a meeting held at 61, Merrion Square, Dublin. From time to time Lilian Davidson was also a member of the Society's Hanging Committee. She remained a W.C.S.I. committee member until 1953.

Evidence that Davidson travelled is revealed in titles relating to many of her watercolours exhibited at the R.H.A. in the early 1920s – *Marchande des Poissons, Bruges* (1922), *A Belgian Battlefield* (1923). She also exhibited at the Dublin Painters, the Oireachtas and Aonach Tailteann. During her forty-one-year period exhibiting with the W.C.S.I. titles included, *Canal from Pont St Boniface, Bruges* (1922), *Fishermen, Rouen* (1923), *In the Flower Market, Brussels* (1924). In the view of art historian/researcher, Katherine Cahill, 'she was a journeyman artist. She earned her living through the sale of exhibited works, private commissions, teaching and the proceeds of her writing'.[33]

It is unfortunate that due to her restricted economic circumstances, Davidson could not afford to spend time abroad where she might have had the opportunity to study and become influenced by the various stylistic movements and,. as a result, her work was 'rooted in the somewhat narrow, Victorian focus of the South Kensington system (as promoted by James Brenan at the D.M.S.A.), aimed at achieving a teaching qualification, and this probably limited her potential as a consequence.'[34]

Lilian Lucy Davidson, A.R.H.A. (1879-1954) *Portrait of Sarah Henrietta Purser, R.H.A.(1848-1943), c.*1920, crayon. Signed 'LD'.
COURTESY OF THE NATIONAL GALLERY OF IRELAND

Her crayon portrait of her older contemporary, Sarah Purser, captures the energy and drive of this indomitable, courageous and generous woman. Competent and academic, Davidson is 'aiming at inventing the mind behind the face'; deriving much from portraitist, John Butler Yeats, and his adoption of the dominant line in order to produce a forceful likeness.[35]

Davidson taught drawing and painting in a number of Dublin schools, including Knockrabo P.N.E.U. (Parents' National Education Union), Dundrum, Wesley College, St. Stephen's Green and even travelled as far afield as Abbeyleix by train each week to teach in Glen Ban P.N.E.U. Boarding School. Classes held at Earlsfort Terrace, Dublin on Saturday mornings were popular and included students Pat Wallace (Griffith), Kitty Wilmer O'Brien, Bea Orpen, and Lilias Mitchell, with Davidson preparing her students for a number of examinations. Frequently, discussion ranged over a wide number of subjects including the theatre: Davidson was one of the founders of the Torch Theatre Company, Capel Street, Dublin and also designed sets, programmes, posters and illustrated books

Regarded as a fine painter, 'she remained firmly in the mainstream of Irish naturalism, using Irish landscape, seascape and genre scenes as her raw material, material she used with remarkable facility...'[36]

JESSIE OGSTON DOUGLAS, H.B.A.S. (fl.1893-1928)

Between 1892 and 1922, Jessie Ogston Douglas exhibiting from 1, Windsor Park Terrace, Lisburn Road, Belfast, exhibited a total of seventy-two works at W.C.S.I. exhibitions including the Society's fiftieth exhibition held in Dublin in February, 1904. Amidst the 445 works on display, her exhibits – a portrait and several landscapes – caught the eye of the press. The *Irish Times* commented: 'Three studies by Miss J.O. Douglas will at once attract attention, not only by the same cleverness of their colour scheme but by the general ability which they display.'[37] A keen portraitist, W.C.S.I. annual exhibitions saw a number of examples of this artist's work on display, e.g. *A Flemish Lacemaker* (1893), *Mandoline Player* (1901), *A Horticulturist* (1911), *The Poppy Girl* (1918), and *The Blue Bandeau* (1921). *Cherry Ripe* (illustrated) is a typical example of the type of portrait this painter was capable of producing. A lively, fresh interpretation of the artist's niece, it depicts the sitter wearing a white blouse and grey gym-slip with bunches of cherries hanging from the young girl's ears. W.C.S.I. landscape titles/exhibits reveal Douglas was an enthusiastic traveller: Donegal, Connemara, Antrim, Holland, the South of England and Normandy.

Little is known about the art training or family background of this painter. *Fáinne an lae*, which provided coverage relating to Feis week in Belfast in May 1898 commented: 'Miss Douglas who has studied in Paris and Italy, and who, besides being a most successful artist herself, has schooled several of our most promising local portrait painters...'[38]

Douglas is mentioned as being a member of the Belfast Art Society in 1892, with three watercolours – *Calvaire, Rue de l'Oei Brittany, Mischief* and *The Lace Maker* – being accepted for exhibition. In the same year she participated for the first time in the W.C.S.I. annual exhibition displaying a flower piece, *Chrysanthemums*. In December 1896, together with Helen O'Hara, William Laird and William Darragh, Jessie Douglas was elected a vice-president of the Belfast Art Society. She exhibited almost every year with the Society until 1914, submitting views of Donegal, France, Holland, England and fancy subject-portraits. Whilst participating in the Belfast Art Society's 1905 exhibition, her work attracted the eye of the

Jessie Ogston Douglas (fl.1893-1928) *Cherry Ripe*, watercolour. Inscription on verso 'painted/by Miss Jessie Douglas/Belfast/A Real Artist!/ The portrait of a niece of hers/a daughter of Dean Seaver'.　COURTESY OF THE TRUSTEES OF THE NATIONAL MUSEUMS, NORTHEN IRELAND

EILEEN FLORENCE BEATRICE REID (née Oulton) (1894-1981)

Eileen Reid was elected a member of the W.C.S.I. at their committee meeting held at 61, Merrion Square, Dublin on Thursday, 20 October, 1932. Two years later in May, her name was proposed by Richard Caulfeild Orpen (seconded by Major Goff) to be invited to join the W.C.S.I. Committee 'and the resolution was passed unanimously.'[40] The Society quickly became part of this artist's life. In 1936, after the vacancy caused by the death of the Hon. Secretary, Mrs Ellice Pilkigton on 24 August of that year, it was decided by the committee that Eileen Reid should be appointed Secretary of the Society for a fee of £40 per annum. She agreed to serve for one year but continued until February 1973, a span of thirty-seven years. Eileen Reid was fortunate to be possessed with an ability to organise exhibitions described by one W.C.S.I. member as being 'triumphs of unobtrusive, benign but firm organisation', and thus she succeeded in guiding the Society through their centenary exhibition held in 1970.[41] Reid also lent works from her own collection for the W.C.S.I. centenary exhibition, including paintings by members Frederick Hicks, Helen Colvill, May Guinness, and Richard Caulfeild Orpen.

Born on 11 February, 1894 at 19, Upper Mount Street, a house that was to become her life-long home, Eileen Reid's (née Oulton) father was a distinguished barrister, George Nugent Oulton. His daughter's early education was at the German school sited nearby in Wellington Place. Reid also studied music at the Royal Irish Academy of Music where she carried off the Coulson Exhibition in 1910 and was awarded a Coulson Academy scholarship the following year. In 1914 she qualified as a music teacher. Music was eventually to become her career and to provide her with an income. Also a keen painter, she enrolled at the D.M.S.A. in October 1908 and remained there until the following summer. Around 1919 she travelled to

reviewer from *The Nationalist* (Dublin):

'The Silk Weaver is a nice little drawing of a cottage interior, discovering a white-bearded weaver at work on his loom of cherry silk. The grey interior and the white-bearded man are Irish, without a doubt; but the cerise-hued fabric (which 'makes' the picture) is foreign. Is this sort of thing legitimate? I very much question it. And I fail to see that any good is to be attained by artists 'forcing' their subjects. The Choir as a bit of colouring has the same defect. The picture is bright and catchy, but there is no motif underlying it...'[39]

A consistent exhibitor, Jessie Douglas was rewarded with honorary membership of the Belfast Art Society together with sculptor and illustrator, Rosamond Praeger, H.R.H.A., R.U.A. (1867-1954) around 1918. Also active in Dublin between 1906 and 1920, Douglas exhibited a total of eight works including a number of portraits in the R.H.A. Douglas' work was also shown at the Royal Institute of Painters in Watercolour, the Society of Women Artists and the Royal Scottish Academy. In 1907 a watercolour entitled *A Donegal Interior* was accepted for the Irish International Exhibition, Dublin. It would appear that Jessie Douglas did not exhibit in the Ulster Academy of Arts as her name does not appear on the lists.

London and enrolled in the R.A. Schools; her progress was rapid and successful and she found herself the recipient of praise from William Orpen, a Dublin friend of the family.

On her return to her native city, the artist enrolled for a further two years at the D.M.S.A. from October 1920 to July 1922. The following year, 1923, she married Hugh C. Reid of Sloane Square, London. The wedding was held on 26 June in her local church, St. Stephen's, Mount Street Crescent, Dublin. A member of the Colonial Service and stationed in Nigeria, Hugh

Reid returned to his post. His bride was due to follow. As she prepared for the long journey south, Eileen Reid received news that her young husband had died of black water fever on 14 February, 1924 at the age of thirty.

Reid's portrait of *The Officer*, illustrated here, is believed to be a study of her relative, Major William Oulton M.C., and dates from 1923. It reveals the influence of Orpen with its instinctive feeling for conveying the character of the sitter combined with a strong sense of draughtsmanship. This portrait was submitted by the artist for

the annual R.A. Schools examinations held in 1923.

Despite the tragedy in her young life, Reid appears to have continued at the R.A. Schools, completing her studies in 1927. Gradually, the artist's interest in painting in oil gave way to watercolours and in turn this led to her involvement with the W.C.S.I. She was a consistent exhibitor with the Society from 1933 until 1942, exhibiting a total of thirty landscapes painted in counties Dublin, Wicklow, Connemara, Kerry and Clare, whilst also painting in England (Berkshire). In order to make a living, however, the young artist turned once again to music: art now becoming somewhat of a hobby. However, her lifelong involvement and generous contribution to the W.C.S.I. was outstanding. To mark this fact, a portrait of Eileen Reid was generously donated to the Society at their Annual Exhibition (the 155th) in September 2009 by her nephew, Desmond Calverley Oulton. It now forms part of the Permanent National Collection of the W.C.S.I., University of Limerick.

As Tom Nisbet R.H.A., a distinguished W.C.S.I. member, recalled in an appreciation of Eileen Reid published in *The Irish Times* in April 1981: 'It was a pleasure to see her and there was always plenty to chat about, and her visits were never prolonged…Eileen seldom spoke of herself, but through her occasional reminiscences I caught glimpses of a lively and lovely young woman, fond of games, swimming, cycling and seriously devoted to music and painting. The last time I left her fireside and stood on the doorstep with her looking at St. Stephen's Church, her beloved "Pepper Pot", floodlit against the blue-black night sky, I felt privileged to have observed a mode of life which transcended tragedy and attained a serenity beyond my understanding.'[42]

MARY HARRIET 'MAINIE' JELLETT (1897-1944)

The artist wrote: 'I studied in Ireland till I was eighteen then went to London and studied under Walter Sickert (first revolution), where for the first time drawing and composition

Eileen Reid (née Oulton) (1894-1981) *Major William Oulton, M.C. 1923*, oil. Signed 'Oulton'. Inscribed and dated on verso. '1923'. The portrait was submitted by the artist for the annual examination at the Royal Academy Schools, London held in 1924.

PRIVATE COLLECTION. COURTESY OF WHYTE'S AUCTIONEERS

came alive to me, and with Sickert's help I began to understand the work of the Old Masters. Sickert being in the direct line of French Impressionist painting was an excellent stepping stone to my next revolution, Paris and Lhote's Studio. This was my first encounter with modern French painting; though I had admired and appreciated it in London and wherever I had come in contact with it, the ideas behind it I had only partially understood.'[43]

Born into a distinguished Dublin family, Mainie Jellett's father was a leading barrister and her mother a gifted musician. She was one of four girls, all of whom were given pet names: Mainie, Bay, Betty and Babbin. Around the age of eleven, Mainie Jellett was allowed to join a class in watercolour painting run by designer, landscape and flower painter, Elizabeth 'Lolly' Corbet Yeats (1868-1940), who had produced several books of instruction relating to brushwork studies. Jellett also spent a short period with portrait painter, Sarah Cecilia Harrison (1863-1941) before trans-ferring to the Merrion Row studio of well known and influential Dublin teacher, landscape and figure painter, Mary Ruth Manning (1853-1930). Manning firmly believed that students who wished to draw also had to learn how to model. Therefore her more senior pupils were encouraged to study modelling at evening classes in the D.M.S.A.. In Manning's studio Mainie Jellett received tuition in basic watercolour technique and on a visit to Wimereux, France at the age of fourteen was already painting avidly in this medium. When she was sixteen, Jellett became a pupil of Norman Garstin, attending his sketching classes in Brittany. As her biographer, Dr. Bruce Arnold, points out: 'Watercolour studies of landscape scenes, cottages, and of grass and sand, offer convincing evidence of her technical advance during that summer.' (1913).[44]

Despite possessing the ability to become a professional musician, Jellett was anxious to devote her life to painting and drawing rather than music. She entered the D.M.S.A. in 1914 and was fortunate to receive one year's training under Orpen. During this period Jellett's work shows his influence 'in the direct and honest treatment of the nude and in the full and satisfying composition of her portraits'.[45] In January 1917 the artist left for London and, shortly after her arrival, met Evie Hone who was to become her life-long friend. Enrolled as a student at the Westminster Art School (1917), Jellett was fortunate to study under gifted teacher and artist, Walter Sickert, who was considered at the time to be one of the most important figures in the art world. For artist Mainie Jellett: 'Sickert remained the main force. His impact is strongly evident in the dated watercolours and oils of 1917 which how rapidly and completely his teaching influenced and changed Mainie's style.'[46]

This free and accomplished watercolour study (illustrated here) of the artist's sister, Betty, caught with her back to the spectator, shows the influence of Sickert. This delightful scene on a warm, sunny summer morning is captured through the window of the family's holiday home at Fintra, Killybegs, Co. Donegal. Jellett here employs a free sense of line stemming directly from French Impressionism coupled with a secure grasp of colour and light; with the tones of the landscape echoed beautifully in the child's hair.

Mainie Jellett returned to the D.M.S.A. for a year in 1919 and the following year was awarded the Taylor Art Prize. In February 1921 she and Evie Hone travelled to Paris to work in the studio of painter, André Lhote. Looking back at this period in her life, the artist wrote: 'With Lhote I learnt how to use natural forms as a starting point towards the creation of form for its own sake; to use colour with the knowledge of its great potential force, and to produce work based on a knowledge of rhythmical form and organic colour, groping towards a conception of a picture being a creative organic whole, but still based on realistic form…'[47]

After working with Lhote for several months over a two-year period, she and Evie Hone decided to pursue the extreme abstraction of Cubism and turned to Albert Gleizes (1881-1953), both becoming Gleize's students. As Madame Roche-Gleizes noted: 'Mainie and Evie were so much his *filles spirituelles* one cannot separate them'.[48] The women travelled to France once or twice a year to study under Gleizes for the next ten years. Their teacher's revolutionary technique Translation and Rotation gave to painting-without-subject a mobile rhythm. Mainie Jellett felt she had 'come to essentials, and though the type of work I had embarked upon would mean years of misunderstanding and walls of prejudice to break through, yet I felt I was on the right track.'[49]

The artist was correct in her assumption of having to do battle with the walls of prejudice: it would appear Dublin was not yet ready to accept her version of modern painting, and in particular artist and critic 'AE' (George Russell). Reviewing Jellett's work in a Dublin exhibition of 1923, he wrote: 'We find… Miss Jellett a late victim to Cubism in some sub-section of this artistic malaria… the sub-human art of Miss Jellett'.[50] But the artist did not bend. Instead, Jellett went on to become 'the Irish missionary of the modern'.[51]

Throughout 1922, Mainie Jellett produced a substantial corpus of pure Cubist canvases. 'It was absolutely in keeping with the artist's rejection of perspective in favour of two-dimensional abstract and semi abstract painting that she should, at the same time, give up the translucent properties of watercolour painting in favour of the opaque properties of gouache. The former is suited to perspective, giving depth by the layering of washes; the latter is not.'[52]

At a W.C.S.I. committee meeting held at 61, Merrion Square on Thursday, 20 November, 1930, amongst the new members proposed and elected were Miss Mainie Jellett and Miss Evie Hone. By 4 March, 1938, Mainie Jellett had become a member of the W.C.S.I. committee and began to take an active part in the Society's affairs, suggesting for example at that meeting that the 'number of entries sent in by members to the exhibition should be reduced in order to improve the hanging'.[53] Three years later, she was elected to the W.C.S.I.

Mary Harriet 'Mainie' Jellett (1897-1944) *Betty at the window–Fintra*, watercolour and pencil. Signed 'M J.'

Hanging Committee. From 1931 until the year of her death in 1944, Mainie Jellett exhibited work every year at the annual W.C.S.I. exhibition. These included views in Cork, Mayo, Dublin and as far afield as Lithuania. In the Society's annual exhibition of 1938, the artist placed on view her three cartoons for the decoration of the Irish Pavilion, Glasgow (illustrated on p.198).

Mainie Jellett died in March 1944 at the age of forty-seven. The writer Elizabeth Bowen provides a moving description of those last few months before her friend's death: 'I saw her last in October 1943 in the quiet back room of the Leeson Street nursing home, where she lay with her bed pulled out under the window. A fire burned in the grate, and brick buildings in October sunshine reflected brightness into the room. The eager generous little girl of my first memories was now a thin woman, in whom the fatigue of illness, mingling with that unlost generosity and eagerness, translated itself into a beauty I cannot forget. The greatness of Mainie Jellett was to be felt in many ways; but not least in her simplicity.'[54] At a W.C.S.I. committee meeting held in March 1944: 'Very deep regret was expressed by all the members present on the death of Miss Mainie Jellett whose loss to the Society as a very active and helpful member of the Committee was a very great and real one.'[55] In a tribute, Dr. Bruce Arnold wrote: 'For over twenty years, between 1922 and her death in 1944, Mainie Jellett was the acknowledged leader of the modern art movement in Ireland. In 1923 she confronted the notoriously conservative Dublin art world with a series of stunningly beautiful, fully abstract paintings, ten years before the first abstract work of Ben Nicholson, Barbara Hepworth or Henry Moore was shown in London. She was greeted with hostility and ridicule. But the force of her personality and her courage imposed respect long before her painting was accepted. Moreover, through her teaching and her public speaking, she opened the way for freedom and experimentation to a whole generation of Irish Artists.'[56]

ANNE MARGARET 'NANO' REID (1900-1981)

'The notable thing about the approach of Nano Reid was that she instinctively avoided the too strong, too near influence of Paris, and began with a pure and firmly realised preoccupation with drawing, with insistence on line and structure... She is outstanding for her draughtsmanship, and her vitality, so often praised, is rarely understood as existing by virtue of this passionate insistence on the structure of her subject…she drew incessantly.'[57]

In the early part of her career, landscape, portrait and figure painter, Nano Reid attempted to earn a living by portrait painting. She found it difficult to continue as inevitably her public demanded flattery and not the true, honest image. In the words of art critic, Edward Sheehy (whose portrait is illustrated) she lacked '… the politer virtues of finish, obvious charm ….[which] has led to some critics to decry her work in favour of painters who are vastly inferior to her in every sense, not that her work is without fault but they are faults of her qualities.'[58] From the 1940s onwards, portraiture was to hold a less dominant position in this artist's work. Instead, Reid tended to concentrate on painting landscape in a lyrical and evocative style.

But the artist did not abandon portraiture altogether: evidence may be found in the penetrating study of art critic, *Edward Sheehy*, believed to date from c.1944, which gives a rapid and vivid insight into the sitter's personality. Conveyed in strong, bold, confident lines, this portrait study demonstrates the artist's fluency of line coupled with her sound sense of draughtsmanship and sensitivity. One of Reid's admirers, artist Patrick Swift (1928-1983) noted: 'She was concerned with the head, its existence as a structure with certain characteristics. She is so much concerned with this that her portraits are inevitably deep studies of character and personality. The head, the face, the lines and feature, contain everything for the painter who understands well enough to put it down'.[59]

Nano Reid (1900-1981) was the daughter of a Drogheda publican, Thomas Reid. A pupil at the Sienna Convent, Drogheda, she entered the D.M.S.A. on a scholarship in October 1919 and studied under the then assistant teacher, portrait and figure painter, Seán Keating, R.H.A (1889-1977). When asked about this period of her life, she recalled '… one long period of drawing, drawing in the life-class and drawing anywhere and anything that helped to explore the possibilities of line.'[60]

Like many of Reid's contemporaries, Harry Clarke R.H.A. who taught in the design room, D.M.S.A. was also a strong influence, both artists sharing a love of rich colour. Reid's friends Northern painters Gerrard Dillon, George Campbell and Dan O'Neill were also to leave a marked impression on her work.

Nano Reid began exhibiting at the R.H.A. in 1925. Her contribution in the early years consisted largely of illustrations of poems including *An Enchanted Nightingale Sits*, inspired by Heinrich Heine's verse. In 1928 Reid was in Paris at la Grande Chaumière, this 'shy, eccentric and fiercely independent artist' enjoying its cosmopolitan atmosphere.[61] A year later, she enrolled at the Central School of Arts and Crafts, London under Bernard Meninsky (1891-1950) and later studied at Chelsea Polytechnic.

In about 1930 Reid returned to Ireland; and n 1934 she held her first one-man show at the Gallery, Stephen's Green, exhibiting landscapes. Shortly afterwards a collection of Irish landscapes by the Belgian artist Marie Howet (1897-1984) were shown in the Gresham Hotel, Dublin. On seeing these paintings for the first time, they had a profound effect on Reid's outlook and attitude towards her art. The Belgian artist's expressionist style became a strong influence on Reid's artistic development. In Reid's view, Howet's art conveyed an interpretation of the feelings they presented to her rather than an impression of the facts the artist had witnessed. This approach fascinated Reid. As Elizabeth Curran says, here was an artist who saw things primarily in terms of line 'as she did herself but who was big enough and possessed of so powerful a sense of

Anne, Margaret 'Nano' Reid (1900-1981) *Edward Sheehy*, c.1944, charcoal. Signed 'Nano Reid'. Edward Sheehy was one of the most influential art critics during the 1930s and '40s in Dublin and was a consistent contributor to *The Dublin Magazine*.　　　PRIVATE COLLECTION

design as to be unfettered by outside influences.'[62]

Writing in *The Studio* in 1937, art critic and artist, Edward A. McGuire noted: 'Her [Nano Reid] respect for essentials with a consequent rejection of distracting trivialities gives her work a quality of clarity and directness. A sound feeling for composition is combined with a sense of design and colour…In her watercolours, she is particularly happy, they are bold and direct colourful statements, clearly and unhaltingly expressed…'[63]

Watercolour obviously appealed to Reid. During the late 1930s and '40s,

she enjoyed working in this medium. This is clearly demonstrated in her one man-show held in Daniel Egan's gallery at St. Stephen's Green, Dublin in 1936 where there was roughly twice the number of watercolours on display (53) as compared with oils (23). Her paintings, particularly those executed in the medium of watercolour, were now beginning to lose the somewhat melancholic, heavy tone and were becoming more lyrical.

In 1939 Nano Reid was elected to membership of the W.C.S.I. at a special meeting held in the Mills Hall, Dublin on Monday, 17 April, together with

George and Helen Pennefather. The artist began exhibiting with the Society in the same year, sending four landscapes – *Eagle Mountain, Dunquin*; *Evening, Ticknock, Boyne, near Slane* and *Boyne, at Ross-na-Ree*. Reid continued to participate on an irregular basis in W.C.S.I. annual exhibitions until 1950 sending a total of thirteen landscapes. Her attractive watercolours, generally painted with a simple use of wash and lively use of brushed-in line, conveyed her ability to see things more in terms of line than colour. They frequently caught the eye of the critic: 'In watercolours she is particularly happy, they are bold and direct colourful statements clearly and unhaltingly expressed'[64]

In 1946, together with artist Frances Kelly, Nano Reid was commissioned to paint twelve large murals for the ballroom of a Georgian-style five-storey building on Harcourt Street, Dublin known as The Four Provinces (later the Television Club). As the headquarters for the Irish Bakers, Confectioners and Allied Workers Union, their president, John Swift intended The Four Provinces building to become a cultural centre for trade unionists and their families. Reid and Kelly's murals depicted scenes from Irish labour history and the trade union movement. In 1988 this building was demolished and the murals tragically destroyed.

Together with Norah McGuinness Reid represented Ireland at the Venice Biennale in 1950. She continued to participate in a number of international exhibitions: Mostra Internazionale di Bianco e Nero, Lugano, 1956; Guggenheim International Award Exhibition, New York, 1960; Twelve Irish Painters organised by An Chomhairle Ealaíon, New York, 1963; and Terzo Biennale Internazionale della Grafica d'Arte. Florence, 1972. Also in 1972, Reid was awarded the Douglas Hyde Gold Medal at the Oireachtas exhibition for the best painting of an Irish historical subject, *Cave of the Firbolg*. This was followed by a major retrospective exhibition organised The Arts Council of Northern Ireland./An Chomhairle Ealaíon/The Arts Council which exhibited 108 of her works over the

winter of 1974-75 at the Municipal Gallery of Modern Art, Parnell Square, Dublin and then at the Ulster Museum. Belfast.

Nano Reid died in Drogheda, Co. Louth on 17 November, 1981. In the view of art historian, the late Dr Jeanne Sheehy, Nano Reid must be considered to be 'the most talented Irish painter of the generation which came to maturity before the first world war…the more one looks at her painting, the more one discovers in it.'[65]

HARRY AARON KERNOFF R.H.A. (1900-1974)

'He painted them all; the famous and the infamous, the great and the insignificant, the pretentious and the humble, the good and the bad, and he loved the "characters".'[66] Kernoff captured his friends and cronies in his own unique manner whether it be in paint or pastel preserving the Dublin of Bloom or Behan with his brush. His style was humane and compassionate. He never considered himself to be a 'studio' painter'. In his own words: '…art is self-expression of an artist's reactions to life in a creative work. Beauty is the artist's conception of Nature in a Rhythmic form, emphasizing his viewpoint with controlled emotion and with perfect balance, like the wavering of a compass-needle…Every picture painted is a fresh problem and a new expression of emotion…I prefer doing a portrait in one sitting, and retain freshness of vision thereby, and avoid a laboured work…'[67]

Harry Kernoff was born in London: his father, Isaac, was a Russian furniture maker, and his mother, Katherine A'brabanelle, a direct descendant of a distinguished Spanish family. The family emigrated to Dublin in 1914 and Harry began working as an apprentice in his father's furniture business. Anxious to become an artist, Kernoff enrolled in the night classes at the D.M.S.A., his fellow students being Maurice MacGonigal and Hilda van Stockum. The latter remembers him as 'a silent gnome' who worked away quietly and did lovely watercolours'.[68] During this period, the School was keen to uphold

Harry Aaron Kernoff, R.H.A. (1900-1974) *Playwright Sean O'Casey (1880-1964)*, 1930, pastel and graphite on brown card. Signed 'KERNOFF 30'.

the academic tradition with a strong emphasis being placed on drawing from life and figure-drawing. Awarded the Taylor Art scholarship in 1923 (first prize in both watercolour and oil painting) and encouraged by his teachers, Seán Keating, Patrick Tuohy, R.H.A. (1894-1930) and Harry Clarke, Kernoff enrolled as a full-time student day student in the D.M.S.A. Shortly afterwards the artist travelled to Paris and spent a month painting and sketching.

Elected a member of the W.C.S.I. at a committee meeting held on Tuesday, 19 November, 1929, Kernoff gave his address as The Studio, Harrington Street, Dublin. A year later the artist began exhibiting with the Society. From 1930 to 1933 he showed scenes set in counties Dublin, Limerick and Kerry. In the view of Edward Sheehy, art critic, writing in the *Dublin Magazine* in 1945: 'His [Kernoff] rural landscapes, particularly in water-colour while competent, approach too near

the precious, a kind of bow to Rathmines, for his particular genius.'[69]

Throughout his life the artist produced illustrations for journals, pamphlets, ballad sheets, books, collections of poems and calendars; he employed a wide variety of media and embraced watercolour, pen and ink. Kernoff proudly exhibited his illustrations at the Arts and Crafts Society of Ireland exhibition held in 1925. A staunch supporter of the R.H.A., Kernoff began exhibiting there in 1926; in 1935 he was elected an Associate Member and became a full member later in the same year. During the 1940s he worked on his portraits of Dublin characters and leading literary figures (published in 1942 under the title *Dublin Poets and Artists)* and produced woodcuts largely in a clear-cut linear style, often dramatic in content.

A self-proclaimed realist throughout his life: 'I am, always was, a realist'.[70] Kernoff died on 25 December, 1974 in the Meath Hospital, Dublin. He was honoured with 'The Harry Kernoff Memorial Exhibition' at The Hugh Lane Municipal Gallery of Modern Art, Parnell Square, Dublin, 14 December, 1976 to 30 January, 1977.

ROSE BRIGID GANLY
H.R.H.A. (née O'Brien)
(1909–2002)

Rose Brigid Ganly, H.R.H.A. was born into a world surrounded by paintings. Her father, portrait, landscape and figure painter, Dermod O'Brien P.R.H.A. (1865–1945) was elected President of the R.HA in the year Rose Brigid was born: a position he held until 1944. During that period the RHA suffered the loss of its premises in the Easter Rising and Dermod O'Brien was determined, in his daughter's words 'to try and keep it [R.H.A.} going and make sure that good standards were maintained because the cachet of being in the academy helped people to get commissions for portraits.'[71] Ganly was one of five children born to Mabel (née Smiley) and Dermod O'Brien, grandson of William Smith

O'Brien, a prominent member of the Irish Republican Brotherhood. Born in Dublin on 29 January, 1909, the artist spent her early childhood on the family farm at Cahirmoyle in Co. Limerick, a place she was to remember with fondness throughout her life. In 1919 the O'Briens moved to 65, Fitzwilliam Square, Dublin. At the age of sixteen the artist took the opportunity to attend the D.M.S.A.. Here the influence of William Orpen prevailed: conveyed through the teaching of Sean Keating and Patrick Tuohy. In Brigid Ganly's own words: 'The first year was devoted to antique drawing, the second to life drawing, the third year to specialised studies in painting, sculpture or crafts.'[72]

Ganly also had the opportunity to study with sculptor Oliver Sheppard (1865-1941) '...in the modelling room. I got on well there and I think he was pleased with my work. He asked me to go in for the Taylor scholarship...I won the prize. I got a lot out of sculpture because he was a very, very good teacher. I went on then from the School of Art to the Hibernian Academy School in Stephen's Green.'[73]

Brigid Ganly excelled at sculpture and won several awards including the Taylor scholarship in 1929 for her allegorical male nude figure entitled *Pity*. She continued her art training at the R.H.A. Schools. Her visiting teachers included Margaret Clarke and Seán O'Sullivan and, from time to

Rose Brigid Ganly, H.R.H.A. (1909–2002) *Self Portrait* c.1935, oil. Signed 'BOB '35'.
COURTESY OF THE NATIONAL SELF PORTRAIT COLLECTION, LIMERICK

261

time, her father. In the introduction to the 1998 'Brigid Ganly Retrospective', Daire O'Connell writes: 'He did not want to overly influence her work but his own *plein air* approach to landscape greatly appealed to her as first and foremost she sought to capture the freshness of nature.'[74]

Brigid Ganly first exhibited at the R.H.A. in 1928 aged nineteen and was elected an Associate in the same year, becoming a full member in 1935. In 1969 she resigned from the R.H.A. She felt strongly that there was little or no opportunity available for young artists to exhibit at the R.H.A. annual exhibitions. She eventually returned in 1982 as an honorary member. The artist had always held strong, open-mined views in relation to the Academy. For example, in 1942 she responded in support of the Academy to an attack on its values by Mainie Jellet in May of that year. [75]However, the following year she had no hesitation in coming forward to criticize the institution's lack of a hanging policy. [76]

On Wednesday, 23 November, 1927, the W.C.S.I. committee elected 'Miss Brigid O'Brien' a member and thus began a long association with the Society.[77] A year later in the Society's annual exhibition, Ganly – exhibiting from 6a Laurel Hill, Upper Glenageary Road, Dun Laoghaire, Co. Dublin – had two of her works hung: *Fitzwilliam Square West* and *Cassis*. Brigid Ganly was to prove a consistent exhibitor with the W.C.S.I. until 1994, exhibiting portraits – including her daughter

Phillida, Master Edward Booth, Miss Emer FitzGerald – and landscapes ranging from scenes in her beloved Co. Limerick to views from as far afield as Greece, Tasmania and Philip Island in the South Pacific.

In 1931 Brigid Ganly received a commission to paint a mural at the Child Welfare Centre, George's Hill, Dublin. This consists of a three-foot high mural painted in oil directly onto the wall and depicts the *Boyhood of Fionn*. In order to develop and learn more about the technique of mural painting, in 1933 the artist studied both fresco and tempera in Rome. The following year she went to Florence where she painted the self-portrait now in the Permanent National Collection of the W.C.S.I., Limerick (illustrated here) which exemplifies the academic virtues of solid draughts-manship and a well thought-out, practised technique. The artist depicts herself pausing briefly to interact with the spectator. The tips of her brushes, the majority of which are held firmly in her right hand, are not visible and are cut off from view, whilst a light palette helps to complement the gentle brushwork. Throughout her painting career, Ganly was to remain essentially a representational artist. This is reflected in some of her best works: portraits of her husband, her children, her father and her friend, author Sheila Pym, whose books and dust jackets she illustrated.

On her return to Dublin from Italy, Ganly received further commissions for murals, the artist employing egg

tempera on canvas – rather than fresco, which she considered to be unsuitable for the Irish climate. In 1936 she married Andrew Ganly, a dental surgeon and writer, and from then on there is a change of emphasis in her work as she shifts from landscapes to portraits and interiors. The previous year the artist held her first solo show at The Dublin Painters' Gallery. Three years later she accepted a substantial commission in egg tempera for an 11 x 8 foot mural depicting the boyhood of St. Columba for the baptistery for All Saints' Church, Blackrock, Co. Dublin.

A visit to Paris in 1951 in the company of her sister-in-law (and future President of the W.C.S.I.) Kitty Wilmer O'Brien, and landscape painter and W.C.S.I. member Anne S. King Harman, saw Ganly studying for a short time in the atelier of Cubist painter André Lhote. Although she absorbed many of Lhote's Modernist principles, the experience does not seem to have fundamentally altered her artistic outlook. Ganly's work is represented in The Permanent National Collection of the W.C.S.I., University of Limerick with a piece entitled *Tall Houses, Clarinda Park, Dun Laoghaire.*

Despite coming from an art background steeped in academicism, Brigid Ganly greatly encouraged young artists to explore a wide range of artistic movements including Expressionism, Conceptual and Cubism. However, she always remained true to her own personal vision based upon direct observation and truth to her subject.

Harry A. Kernoff, R.H.A. (1900-1974) *A Bird Never Flew on One Wing or Alcholics Synonymous*
COURTESY OF THE NATIONAL LIBRARY OF IRELAND

Chapter XIV

Water Colour Society of Ireland Flower, Still Life and Garden Scene Painters

Helen Colvill
May Catherine Guinness
Lady Charlotte Wheeler Cuffe
Kathleen Louisa Rose Marescaux (née Dennis)
Lady Kate Dobbin (née Wise)
Grace Harriet Kirkwood (née Jameson)
Moyra Barry
Caroline M. Scally (née Stein)

John Crampton Walker, A.R.H.A.
Joan Moira Maud Jameson (née Musgrave)
Dorothy Isabel Blackham
Phoebe Donovan
The Reverend Father John 'Jack' Thomas Hanlon
Helen Lillias Mitchell, H.R.H.A.

HELEN COLVILL (1856-1953)

Helen Colvill began exhibiting with The Irish Fine Art Society in 1879 at the age of twenty-three. She maintained an active link with the W.C.S.I. until three years before her death, exhibiting almost without a break for seventy-one years, and establishing a record within the group by submitting a total of 292 exhibits.

A keen and active participant in W.C.S.I. affairs, the first mention of this artist's name occurs at a committee meeting held at 61, Merrion Square on 27 April, 1921, when, together with Miss Henrietta Lynch, Miss Boyd, Sir Neville Wilkinson, Miss Carson and the secretary, W. Montgomery, Helen Colvill is listed as being a committee member. At that meeting Colvill put forward a proposal that for the 1922 and future annual exhibitions an index list of names of exhibitors together with the numbers of pictures 'should be included' in the catalogue.[1] Her proposal was passed. At the Society's next meeting held on 7 February, 1922, the artist undertook 'to select drapery and supervise the painting of the standards'.[2] The following year, Colvill volunteered to help with picture hanging. This would appear to be the standard pattern of this artist's

involvement in the Society's affairs throughout her life: chairing meetings; making suggestions (such as in 1926 extending the number of pictures each member might exhibit from six to eight); serving as a member of the Hanging Committee, and acting from time to time as Secretary. Three years before her death, Helen Colvill tendered her resignation from the W.C.S.I. committee. The artist's letter, which was read to the Society at a meeting held on Friday, 13 January, 1950, stated simply that: 'it was unlikely she would be able to attend future meetings'.[3]

Born on 11 December, 1856, Helen Colvill was the youngest daughter of James Chaigneau Colvill, Coolock House, Co. Dublin. She studied in the studio of landscape and figure painter, Mary Ruth 'May' Manning, and always maintained that she learned the art of watercolour painting from two W.C.S.I. members, Rose Barton and William Bingham McGuinness.

To judge from titles of exhibits submitted by Colvill to W.C.S.I., R.H.A., Dublin Sketching Club, and Belfast Arts Society exhibitions, this artist travelled extensively throughout her life – Germany, England, France, Italy and Spain. Scenes recorded in watercolour provide the evidence:

Orchard at Badenwiler (1895), *April in the Riviera* (1901), *On the Beach, Rapallo* (1901), *Porta Eburnea, Perugia* (1904), *Venice from the Guidecca* (1917), *Market Square, Shrewsbury* (1935), *October Evening, Coolock House* (1932).

In 1892 Helen Colvill left her family home, Coolock House, and moved to Holywell Cottage, Baldoyle, Co. Dublin. The watercolour (illustrated here) expresses her joy in recording the garden surrounding the cottage, which was to be her home for the next forty-five years. A skilful distribution of light and shade brings this corner of the sheltered garden to life. Flowers spill out on to a sun-drenched path, the latter skilfully helping to guide the eye into the distance. Garden views would appear to have formed an important part of this painter's oeuvre throughout her life, evidence for this appearing early on her career.

Helen Colvill, together with her sister, moved to Cloghereen, Baily, Howth in 1937 where she lived until her death at the age of ninety-seven. Colvill's work is represented in the Dublin City Gallery, The Hugh Lane with a piece entitled *The Mall, Armagh, Springtime*. In November/December, 1994, an exhibition of seventy-two watercolours by Helen Colvill's was held in the Gorry Gallery, Dublin.

Helen Colvill (1856-1953) *Garden at Holywell Cottage, Baldoyle, Co. Dublin*, watercolour.

MAY CATHERINE GUINNESS (1863-1955)

May Guinness did not devote herself to the study of art until she was twenty-eight years of age, her mature career extending to around thirty years. In her lifetime the artist succeeded in becoming one of the most exciting and innovative Irish painters of her generation. Daughter of Thomas Hosea Guinness, a solicitor, and Mary Davis of Coolmanna, Co. Carlow, she lived at Tibraden House, Rathfarnham on the outskirts of Dublin and was a member of a large family, all of whom tragically pre-deceased her. May Guinness is recorded as having enrolled at the Dublin Metropolitan School of Art for one year between October 1891 until July 1892. In that same year she joined the W.C.S.I. Two years later she accompanied Mildred Anne Butler to Newlyn, Cornwall, in order to study under Realist painter Norman Garstin. Between 1905 and 1907 Guinness studied in Paris with the Fauvists, the Dutch-born painter and printmaker Kees van Dongen (1877-1968) and Spanish painter Hermenegildo Anglada Camarasa. (1871-1959). A note in the catalogue relating to an exhibition entitled 'Decorative Paintings and Drawings' held in 1920 at the Eldar Gallery, London described the artist's approach to her work:

'Miss May Guinness paints not to represent but to decorate...Her achievement – she has preserved her own individuality, and that through years spent in the Paris studios. More, she has fought for it. Her genius is for colour and design. Under Edwin Scott, the Paris-American, she found her colour being firmly subdued. She broke away. At the old Vitti studio Hermen Anglada, the Spaniard, taught her to pile broken paint on thickly. She broke away from him. She broke away from them all albeit learning all the time, until she found a leader and not a driver - van Dongen.'[4]

'In the early summer of 1917 ... she [May Guinness] arrived to work at the Red Cross hospital at Vadelaincourt in the Meuse valley in north-east France. Hospital no. 12 was located some 15 kilometres from the front at Verdun along La Voie Sacrée, the main supply route for the Allied forces.'[5]

Throughout the First World War May Guinness served with bravery and courage. She was awarded the Croix de Guerre and, at the conclusion of the hostilities, the Medaille de la Reconnaissance Française.

Despite the artist's involvement in the war effort, she did not abandon her

painting. Guinness appears to have adapted without any difficulties to the Post Impressionist world of Paris. Between 1922 and 1925, and as a student of the well known academician of Cubism, André Lhote, she flirted briefly with Cubism, creating bold patterns and stylised forms but using a soft range of colours as seen here in her lyrical *Still Life*. A highly versatile artist, Guinness was also an admirer of the broad decorative style of Matisse, employing bold brushwork, her palette full of bright colours with a strong emphasis on atmosphere and mood, as expressed in *A Religious Procession in Brittany* now in the National Gallery of Ireland.

After 1925 this artist's work becomes joyous, lyrical and in many ways reminiscent of the work of French painter and printmaker, Marie Laurencin (1883-1956) whose work Guinness may well have seen in Paris. However, as the artist commented in 1925: '[I have been through] all the phases, and had now settled down to "stylisation" … the flat and rhythmic arrangements of line and colour.'[6]

Despite her Paris training, May Guinness remained essentially a conservative painter never venturing beyond what she had learned in Paris.

'On her return to Ireland she became the elderly godmother of the Irish Modernists. Mainie Jellett and Fr.

Jack Hanlon (both fellow students of Lhote) joined Evie Hone, her neighbour in Marlay Park, and Mary Swanzy for regular tea parties at her home in St. Thomas, Rathfarnham, where works by Bonnard, Braque, Matisse, Picasso, Dufy and Rouault lined the walls. On her death this collection was left to St. Patrick's Cathedral to raise funds for the repair of its roof; a practical fate that, although lamented by her family, perhaps befits the collection of a painter who had survived the utter devastation…'[7]

This artist's contribution to the W.C.S.I. was substantial, beginning as early as 1892 and continuing until 1951. During that period May Guinness submitted a total of 129 paintings, with, on occasions, up to ten exhibits per year (such as in 1899). These included a small number of portraits together with views in Belgium, France, Brittany, Italy, England. Exhibited Irish views appear to have been confined to counties Donegal and Dublin. As far as is known, this artist took no part in the administration of the W.C.S.I. but rather confined herself to exhibiting almost on a yearly basis (with the exception 1912-1930). A woman who had demonstrated great bravery and courage throughout her life, May Guiness died on 16 July, 1955 at the age of 92.

LADY CHARLOTTE ISABEL WHEELER CUFFE (née Williams) (1867-1967)

Charlotte Isabel Wheeler Cuffe (née Williams) was born in Wimbledon on 24 May, 1867, the daughter of William Williams, a president of the Law Society. Grand-daughter of the Reverend Sir Hercules Langrishe 3rd baronet of Knocktopher Abbey, Thomastown, Co. Kilkenny, her links with Ireland were already well established before she married Otway Fortescue Luke Wheeler Cuffe in 1897. Her husband, a civil engineer, was the nephew and heir to the Leyrath estate sited on the outskirts of Kilkenny, home for the greater part of her life to Baroness Pauline Prochaska,

May Catherine Guinness (1863-1955) *Still Life*, watercolour. Signed 'M. Guinness'.
PRIVATE COLLECTION. REPRODUCED BY KIND PERMISSION

Lady Charlotte Isabel Wheeler Cuffe (née Williams) (1867-1967) *Vanda caerulea* 1903, watercolour and graphite. Inscribed in watercolour 'Vanda caerulea C.W.C. 1903 Thoukyegat Toungoo Feb.'

a founder member of the Amateur Drawing Society.

After her husband had completed his training at the Royal Indian Engineer College, Cooper's Hill, he joined the Indian Public Works Department in October 1889. During the next twenty-four years, Lady Cuffe frequently accompanied him when he travelled to inspect civil engineering works and various new projects, making the trek on pony or on foot. In this way, she had an opportunity to explore many parts of south-eastern Asia which had hitherto lain undiscovered by botanists. She also recorded what she saw, nearly always in pencil and/or pure watercolour, in particular the flora and landscapes of these two continents.

Whilst living at Maymyo, a small hill town north of Rangoon, Lady Cuffe was invited in 1917 to establish a botanical garden. This task she undertook with great delight, writing to Pauline Prochazka, 'I couldn't sleep last night with excitement over it (which was very silly of me).' Undeterred, she managed to convert 150 acres of jungle and virgin marshland into a well ordered garden.

She and her husband returned to live permanently in Ireland in 1921. Lady Cuffe was elected as a W.C.S.I. member at a committee meeting held at Merrion Square in March 1924. Titles of her exhibits at annual W.C.S.I. exhibitions (until 1933) reflect her travels throughout Burma in particular: *North Moat, Mandalay, Burma*

(1924), *A Garden in Mandalay, Burma* (1924), *At the Foot of the Shan Hills, near Mandalay, Burma* (1925), and *The Malihka Valley, Upper Burma* (1927). Whilst she was abroad Lady Cuffe completed several hundred botanical paintings which she presented to the National Botanic Gardens, Glasnevin in 1926. The main collection relates to Burmese orchids dating from 1902 to 1921. There are also portraits of rhododendron and Burmese native plants together with landscapes of both Burma and Ireland.

Orchid *Vanda caerulea* (illustrated here) forms part of a collection of orchid paintings recorded around Toungoo, Burma in 1902. Painted in pure watercolour, she obviously enjoys painting direct from nature in a fairly

flamboyant style with little attention being paid to strict, botanical detail. In a letter to her mother dated 1 March, 1902, Lady Cuffe wrote:

'Here is a blossom of a perfectly lovely violet blue orchid an old Burman has just brought me from a tree up the Thonkyegat stream – I must paint it tomorrow! It grows in long graceful sprays, about a dozen blooms on each, & is either a Vanda or a Saccalabium. I have only once seen it before, & then could not get it.'[8]

Her orchid studies are nearly always depicted in their natural habitats growing as epiphytes on the branches of trees. In several paintings she chose not to emphasize the structure but rather concentrated on the graceful movement of the plant, defined by leaves and stems as they stretched, turned, overlapped and touched. The elegant outlines are carefully infilled with light, modulated washes of colour as illustrated here.

Lady Cuffe's husband, Otway, died in 1935 but she lived into her hundredth year, and died on 8 March, 1967.

KATHLEEN LOUISA ROSE MARESCAUX (née Dennis) (1868-1944)

Portrait and flower painter Kathleen Marescaux was born at Raheenduff House, close to Horetown, Co. Wexford, the second daughter of Major-General James B. Dennis, Newtown House, Kilkenny. She studied art in Bruges in 1888 and spent the following year in Dusseldorf and Heidelberg and was in Florence in 1890. Four years later, she married Lieut. General Marescaux and they had two sons. Her husband had entered the navy in 1873 and rose steadily through the ranks to become a Rear-Admiral in 1913, and serving during the First World War.

Kathleen Marescaux began exhibiting with the W.C.S.I. in 1912. In the same year two of her family portraits, *Captain Gerald Marescaux, Royal Navy* and *Major-Gen. J.B. Dennis, Late Royal Artillery*, were accepted and hung in the R.H.A. Marescaux sent two views of Kilkenny to the 1912 W.C.S.I. annual exhibition, *Old Houses, Kilkenny; Kilkenny Castle and the Nore,* and a scene in Co. Antrim, *Redbay Castle, Co. Antrim.* Thus began a long association with the Society which continued until 1944, the year of her death.

The artist recorded scenes in Brittany, Malta, Scotland and Dorset, which, from around 1929 onwards, tended to include mainly flower pieces. A hard worker and prolific exhibitor, in 1929 she exhibited in the Fine Art Society's gallery in London. In 1936, Marescaux had the distinction of having a flower piece accepted and hung in the annual Royal Academy exhibition – *Belladonna lilies* – a work which had been on view in the R.H.A the previous year. From her home in Kilkenny, Inchiholohan, the artist sent two flower pieces to the Ulster Academy exhibition in 1938 and two years later, in February 1940, exhibited *Dutch Wall, Vase & Daffodils* at the fourth Waterford Art Exhibition. In 1944, just a month before the artist's death, Limerick City held the First Annual Exhibition of Fine Art at The Goodwin Galleries, Limerick. Again, *Dutch Wall, Vase & Daffodils* was included amongst the many distinguished painters who participated, such as fellow W.C.S.I. members, Mainie Jellett, Harry Kernoff, Gerard Dillon, Letitia Hamilton, Father Jack Hanlon, Bea Orpen, Evie Hone, Basil Rákóczi and Caroline Scally.

Kathleen Louisa Rose Marescaux. (née Dennis) (1868-1944) *Begonias*, watercolour, gouache and graphite. Signed 'K. Marescaux'. This work was exhibited in The Water Colour Society of Ireland's Annual exhibition held in 1935 (cat. no.87). PRIVATE COLLECTION

Lady Kate Dobbin (1868-1955) *Gateway*, watercolour. Signed 'K. Dobbin'.

LADY KATE DOBBIN (née Wise) (1868-1955)

Kate Wise was born in Clifton, Bristol, the daughter of a solicitor. After her marriage she spent most of her life living in Cork, becoming the second wife of tobacco manufacturer, merchant and keen amateur artist, Alfred Graham Dobbin J.P. of Cork.

In 1900 her husband was knighted and, in the same year, became High Sheriff of the City of Cork. In 1891 the young artist had enrolled at the Cork School of Art and was awarded certificates and a prize for 'a beautiful monochrome from the cast'.[9] In 1894, a year before her graduation, she began sending work to the R.H.A. from 4, Belgrave Place, Cork: *Still Life Study*; *On the River Lee; The Glen, Ballyvolane,* and *At Corrigaloe.* Lady Dobbin continued to exhibit at the R.H.A until 1947.

It was not until 1899 that this artist began exhibiting with the WCSI, sending four views of Co. Cork from her home at Frankfort, Montenotte, Cork – *Monkstown, Co. Cork*; *Kilcrea Abbey; An Evening Study,* and *Blackrock Castle.* She became a consistent and prolific exhibitor with the W.C.S.I., sending on average three exhibits per year without a break (with the exception of 1905) until 1949 and contributing a total of 138 works. Favourite subject matter included flower pieces (beginning in 1901), garden scenes, landscape views recorded in Cannes, Bath, Bristol, Wales, Scotland, and throughout Ireland (Kerry, Cork, and Connemara) together with a small number of portraits.

In May 1927 Lady Dobbin's work, *Kilbrittain, Co. Cork,* was included in Crampton Walker's 'Exhibition of Irish Artists' at the Fine Art Society in London. This show was organised to bring to the public's attention the publication the previous year of his book, *Irish Life and Landscape,* to which Lady Dobbin had contributed.

Lady Dobbin's style is similar to that of W.C.S.I. members Rose Barton, R.W.S. and Mildred Anne Butler, R.W.S., H.B.A.S. The majority of her work was executed in watercolour where she employed, as demonstrated here in this garden scene, a soft, atmospheric *plein air* quality combined with loose brushwork, soft outlines and a subtle use of colour. By contrast, her flower pieces demonstrate a far greater use of rich colour.

Late in life, and suffering from arthritis, she and her husband gave up their house in Montenotte and took up residence in the Imperial Hotel, Cork. Lady Dobbin continued to paint, exhibiting widely including the Munster Fine Art Club, the R.H.A. and W.C.S.I. She died on 26 February, 1955 in the Victoria Hospital, Cork.

GRACE HARRIET SARA KIRKWOOD (née Jameson) (1882–1953)

At a W.C.S.I. committee meeting held on Friday, 28 January, 1944 at Upper Mount Street, Harriet Kirkwood was elected a member of the Society. At their autumn meeting in the same year she was invited to join the W.C.S.I. committee, together with Norah McGuinness and Patricia Griffith. It would appear from the Society's minutes that Harriet Kirkwood took no active part in committee meetings and indeed did not exhibit with the W.C.S.I. again after 1945.

However, she did became a prominent member in Dublin art circles. Born at Sutton House, Sutton, Co. Dublin, Harriet Jameson was the daughter of the Rt. Hon. Andrew Jameson, P.C. The artist enrolled for a year at the D.M.S.A. beginning in January 1908, returning for a further year in 1919. She also availed of the opportunity to study at the Slade in London. Three years after her marriage in 1910 to Major Thomas William Kirkwood, a director of John Jameson & Co., Harriet was in Moscow studying under Ilya Ivanovich Mashkov (1881–1944). In 1902 the prominent Russian painter had opened his own art school in Moscow, and Thomas Kirkwood, who possessed a gift for languages, had been sent to the city to study Russian.

In 1922 Harriet Kirkwood became a member of the Dublin Painters' based at The Gallery, 7, St Stephen's Green and for a number of years served first as their Hon. Secretary (elected 1930), and then as President (1936). (Dr) James White writing in the *Irish Art Handbook* (1943) described the group as representing around twenty artists who possessed an exciting array of techniques and individual characteristics. In his view 'must considered to be collectively the most competent group in the country…'[10] Harriet Kirkwood was at the centre of this group which included several of her friends: Mainie Jellett Frances Kelly, Patricia Wallace, the Rev. Jack Hanlon and Nano Reid. James White, writing in the same publication, noted that Harriet Kirkwood's work

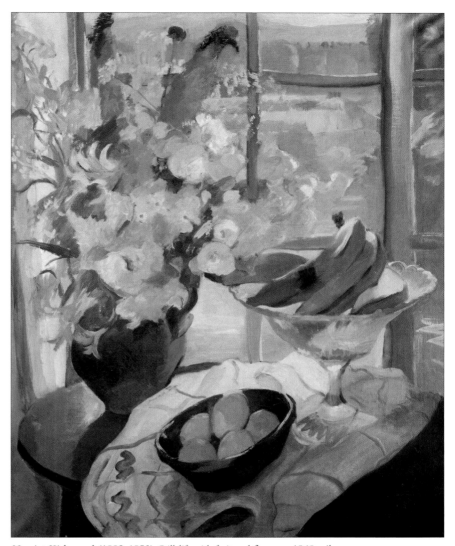

Harriet Kirkwood (1882–1953) *Still-life with fruit and flowers*, c.1940, oil.

'expresses a deep satisfaction in the subtle colour of farm scenes and woodland places. One feels she sits in deep contemplation of the scene until the morning light has cast a faint grey mist over the whole. Perhaps it is this mist that makes her canvases seem so desirable or perhaps the fact that such familiar scenes in the hands of other artists invariably suggest the colours of centuries of pictures which serve rather to soothe than stir our weary minds.'[11]

Kirkwood was persuaded by J. Crampton Walker to participate in the first New Irish Salon held in March, 1923. Her entry *At the Mirror* caught the attention of the *Irish Times* critic who described it as 'a very pleasing portrait'.[12]

In the 1930s, possibly due to the influence of Mainie Jellet and Evie Hone, whose work she greatly admired, Harriet Kirkwood studied in Paris under Cubist painter, André Lhote. However, Lhote does not appear to have had any profound effect on Kirkwood's style. A keen admirer of Cezanne, Augustus John, and above all her Irish contemporaries and friends – Grace Henry, May Guinness Letitia Hamilton and Norah McGuinness – it was instead their approach, style and technique that was to have a lasting influence on Kirkwood's work.

Primarily a landscape and still life painter, the artist's *Still-Life with Fruit and Flowers* was acquired by the National Gallery of Ireland in 1983 (illustrated here) and was painted around 1940. Lyrical in style, the work demonstrates the artist's feeling for light with the choice of colours fresh and delicate, all contributing to the sense of atmosphere. Through her skilful use of light and colour, Kirkwood succeeds in connecting the interior with the landscape, which comprises a view of the Wicklow mountains seen through the window of her house, Collinstown Park, Clondalkin, Co. Dublin.

An exhibitor at the R.H.A. since 1920, Kirkwood was also a regular contributor to the Irish Exhibition of Living Art, beginning with their first exhibition held in 1943 when she contributed two portraits and two landscapes. Two years later the artist exhibited four works in the W.C.S.I. annual exhibition – *Country House*; *Odalisque*; *Sun Bather* and *Winter Trees* – and two further entries the following year: *The Garden* and *At the Window*. Her *View of Howth and Ireland's Eye* was included in the 'Exhibition of Contemporary Irish Painting North America' in 1950.

MOYRA A. BARRY (1885–1960)

Brian Fallon reviewing an exhibition for the *Irish Times* of the late Moyra Barry's work in The Gorry Gallery, Dublin in 1982, noted that it appeared to be this artist's fate 'to be tagged with the label "flower Painter", and in fact flowers were her chief theme. But her range is shown here to have been much wider than that. She was as adept in watercolour as she was in oils…'[13] Also on show in this exhibition was a small collection of self-portraits which included one example revealing a young woman with a wistful, sensitive, vulnerable expression seated beside a brightly coloured canvas. The artist is dressed in a smock with a black scarf tied in a flat bow perched on her forehead. Her delicate features are carefully modelled, whilst the sitter's smock and background are painted in a free and expressive style.

Moyra Barry was educated at the Loreto Convent, George's Street, Dublin. Her early art training took place in the R.H.A. Schools. In 1909 she was awarded the prize for the best drawing from the antique, and for the best composition from a given subject. Further training followed in London at the Slade School of Fine Art between 1911 and 1914, where she was awarded first prize for painting from the cast, and was later awarded the Royal Academy Senior Certificate. She also received a further year's training in the Dublin Metropolitan School of Art between October 1917 and July 1918. Although Barry began contributing to the R.H.A. in 1908, and to the Oireachtas Art Exhibition in 1911 (at which she exhibited two works: *Ros I nGloine* and *Ros Ruadh)* the artist did not hold her first one-man show until 1932. It took place at the Angus Gallery, St. Stephen's Green. She had the distinction of having one of her works purchased by the Thomas Haverty Trust.

Moyra Barry's links with the W.C.S.I. began six years later. Elected at a W.C.S.I. committee meeting held on 4 March, 1938, at Upper Mount Street, the artist began exhibiting in that year with two of her original four entries being devoted to flowers. She exhibited a total of fifty-nine works at W.C.S.I. exhibitions, contributing on a regular basis until a year before her death. Flowers were the dominant theme throughout with the exception of just four landscapes: *Sand Dunes, Clontarf* (1938), *Rocks at Dun Laoghaire* (1939), *View at Clontarf* (1940) and *Road near Dartry* (1940).

Dahlias (illustrated here), purchased by the Crawford Municipal Art Gallery at the Oireachtas Art Exhibition held in 1953, displays the artist's masterly orthodox but visually appealing style. Barry painted flowers directly as she observed them, depicting each petal and leaf whilst employing an exuberance and richness of colour. Here the artist places them in a simple vase set against a plain background and thus ensures the viewer's interest will be in the flowers themselves and not the surroundings.

It would appear that Moyra Barry spent most of her life in Dublin living at 29, Palmerston Road. In the late 1920s she departed for Quito, Ecuador to act as a private tutor in painting and English (a record of her stay was shown as part of an exhibition of her work held in The Gorry Gallery in September 1982). A member of the Dublin Sketching Club, she was a regular exhibitor with them throughout the 1930s; she also contributed to the Dublin Painters in 1934, the Irish Exhibition of Living Art in 1943, and to various Oireachtas art exhibitions over the years. Her work was represented in the 'Exhibition of Contemporary Irish Painting North America' in 1950, and in the Contemporary Irish Art exhibition at Aberystwyth held in 1953.

CAROLINE M. SCALLY (née Stein) (1886–1973)

Caroline Scally's feel for the quirky details, combined with her dexterity when employing watercolour and her obvious sense of colour and lyricism, is well expressed in her watercolour entitled *Cats in the Garden*. This watercolour was exhibited at the W.C.S.I. annual exhibition held in 1951 and in the Memorial Exhibition (W.C.S.I.) in 1976. *The Dublin Magazine,* commenting on her one-man show held in The Dublin Painters' Gallery in 1953, noted: 'a painter of sensitivity. She uses a warm, rather diffuse palette….[her work] is rich, gay and indefinably French'.[14]

Born at 7, Corrig Avenue, Kingstown, Co. Dublin, she was the daughter of engineer, Robert F. Stein. Three years after his daughter's birth, the family moved to Woodview, Merrion Avenue, Blackrock, Co. Dublin. Caroline received her early education at the nearby Dominican Convent, and later attended the English Institute at Nymphenburg near Munich. Determined to be a painter, she enrolled at the Dublin Metropolitan School of Art in October 1905 and remained there for a year, returning again in 1910 for a further three years. Amongst her teachers was

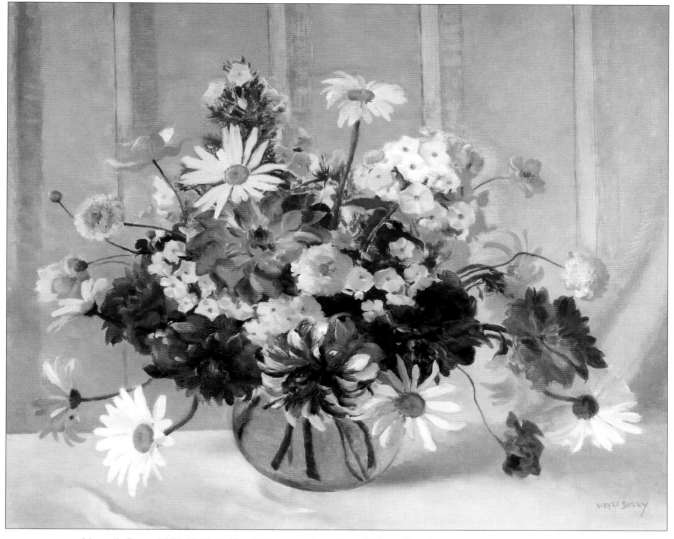

Moyra A. Barry (1885-1960) *Dahlias* 1953, watercolour. Signed 'Moyra Barry'
COURTESY OF THE CORK ART GALLERY, CORK. GIBSON FUND PURCHASE FROM THE OIREACHTAS, 1953

William Orpen. Her fellow students included Sean Keating R.H.A. (1889-1977) and James Sleator R.H.A. (1888-1949), the latter's oil portrait of Caroline Scally now hangs in the N.G.I. Awarded the Taylor Art Scholarship in 1911, the young painter set out for Paris, then moved on to Rome. During this period her subject matter included 'an early interest in landscape and architectural subjects, themes that remained with her throughout her career.'[15]

On her return to Dublin, as mentioned above, she enrolled again at the DMSA, completing her training in 1913. Three entries in the R.H.A.

exhibition held in 1915 sent from Shielmartin Cottage, Baily, Co. Dublin, confirm that this painter was beginning to gain confidence; exhibits included a flower study, a portrait and evidence of travel abroad. The previous year the artist had married a Dublin businessman, Gerald Scally, and appears to have devoted a large part of the rest of her life to bringing up their five children. Although Caroline Scally ceased exhibiting after 1920, she still continued to paint for the next ten years. She held her first one-man show at The Dublin Painters' Gallery in September 1930, her subjects being largely landscapes, still life and flower studies.

Caroline Scally is first recorded as exhibiting with the Society in 1951. There appears to be no record of her election to the W.C.S.I. Titles of her exhibits convey the fact that she concentrated on Irish scenes, which ranged through counties Mayo, Cork, Kerry, and Dublin. Also included amongst her work were several garden scenes. Caroline Scally was part of a circle which included a number of influential women artists who were all members of the W.C.S.I., including Elizabeth Rivers, Joan Jameson, Nano Reid, Harriet Kirkwood, and Norah McGuinness. Scally contributed to the first Irish Exhibition of Living Art in

Caroline M. Scally (née Stein) (1886–1973) *Cats in the Garden*, watercolour. This work was exhibited in the W.C.S.I. Annual Exhibition, 1951 (cat. no. 105) and also included in the W.S.C.I exhibition, 1976 Memorial Section for Caroline Scally, (cat. no. 10).

1943 and again in 1949, after which she exhibited work there every year until 1970 (with the exception of 1952, 1966 and 1967). She also exhibited each year at the W.C.S.I. almost without a break (with the exception of 1957, 1961 and 1967) until two years before her death, and also took an active part in W.C.S.I. affairs, being elected to the committee in March 1958 and serving for a period of around eight years.

Scally's work was represented in the Contemporary Irish Art exhibition held in Aberystwyth in 1953 and two years later the artist held a solo exhibition at The Dublin Painters' Gallery. She was also a regular contributor to R.H.A. exhibitions and by 1958 had exhibited a total of forty-one pictures. Described in 1957 by Arland Ussher as being 'that subtly adventurous painter in a quiet key', Caroline Scally was elected President of the Dublin Painters in 1962.[16] Reviewing the Independent Artists' exhibition held three years later, Brian Fallon declared the 'two painters who stood out by sheer quality' were Dairine Vanston and Caroline Scally. Both are rather sadly underrated, both go their own way and to hell with fashion'.[17] Reviewing the W.C.S.I. annual exhibition five years later, the same critic noted that both Caroline Scally and Sean Keating were the last of Sir William Orpen's pupils still actively painting and exhibiting their own work.[18] Caroline Scally died at her home Weir View, Islandbridge, Dublin on 26 September, 1973.

JOHN CRAMPTON WALKER A.R.H.A. (1890-1942)

It would appear that landscape and flower painter John Crampton Walker possessed a flair for organisation, being responsible for arranging the six exhibitions of the New Irish Salon held annually from 1923 to 1928 in the Mills' Hall, Merrion Row, Dublin. The first exhibition of this new, exciting group of young painters which 'may have been conceived as an Irish equivalent to the New English Art club, that is, as an alternative to the

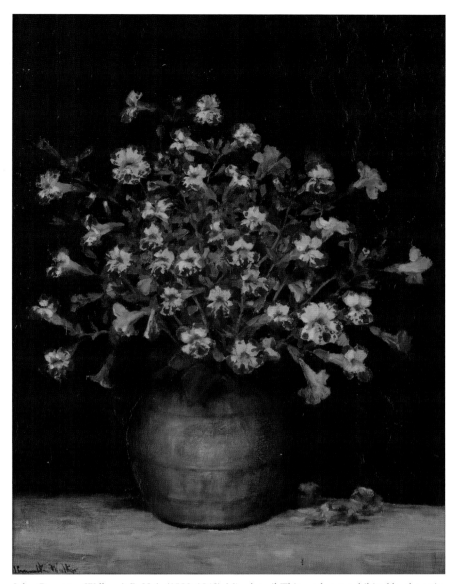

John Crampton Walker, A.R.H.A. (1890-1942) *Mimulus*, oil. This work was exhibited by the artist in Exposition d'art Irlandais, Brussels in 1930. J. Crampton Walker also acted as organising committee secretary for this event. The painting was purchased by the Belgian Government in 1930 and now forms part of the collection of Musées Royaux des Beaux-Arts de Belgique Art Modere, Bruxelles. KMSKB – MRBAB © GRAFISCH BUREAU LEFEVRE, HEULE

Academy exhibitions…'[19] It comprised the work of around sixty artists, the majority being Irish. Two years later, in 1925, Crampton Walker presented no less than 300 exhibits with over 130 artists participating, which aroused considerable interest in Dublin art circles'. The work produced by these innovative Irish Salon painters aroused curiosity, discussion and, in some cases, animosity in art circles. However, it is interesting to note that the organiser, J. Crampton Walker painted throughout

his career in an academic, traditionalist manner as illustrated here, his flower piece *Mimulus* being painted in 1928. This painting was purchased two years later by the Belgian Government.

John Crampton Walker was born at 9, Gardiner Place, Dublin, the eldest son of Garrett William Walker KC, and educated at St. Stephen's Green School, Dublin. According to the Dublin Metropolitan School of Art Register, John Crampton Walker became a student in the school at the

age of eighteen, entering in October 1907 and remaining for one year; he gave his address as 38, Fitzwilliam Square, Dublin. In October 1908 he entered Trinity College, Dublin in order to read medicine. He then returned to the DMSA in 1913 for a further two years study. He had begun exhibiting with the Dublin Sketching Club in 1912 and also found time to establish the Black and White Artists' Society of Ireland in 1913. This comprised William Orpen as President and James Ward as Vice President, and a committee that included Alexander Colles, Charles A. Mills, Richard Francis Caulfeild Orpen and Jack Butler Yeats. Crampton Walker served both as Hon. Secretary and as a member of their Art Union committee. The Black and White Artists' Society's second annual exhibition was held in 1914 in Mills' Hall, 8 Merrion Row and attracted favourable reviews, 'The fine spirit of enthusiasm that pervades the Society has made it a very valuable asset of art in Ireland, and it deserves well at the hands of the public.'[20]

He returned again to the DMSA for a year in October 1918, giving his address as The Studio, 13A Merrion Row. Dr. S.B. Kennedy mentions that this artist also studied in Paris and for a time under landscape painter, Nathaniel Hone, R.H.A. (1831-1917) 'who greatly influenced him.'[21]

Crampton Walker began exhibiting with the W.C.S.I. in 1913. However, despite his organisational abilities, it would appear from the W.C.S.I. minutes that he took no active part in the administration or day-to-day running of the Society's affairs. Until 1927, annual W.C.S.I. exhibitions saw on average two to six contributions by this artist. These consisted largely of town and landscape views in counties Dublin, Galway, Meath, Kerry and the Arran Islands, together with scenes recorded in Cambridge and Sussex. W.C.S.I. lists do not provide evidence of flower pieces being on display. However, entries for the R.H.A. annual exhibitions reveal that Crampton Walker began exhibiting this particular subject matter from as early as 1919 onwards. Flower painting

was obviously something the artist enjoyed. In June 1929 Crampton Walker organised an 'Exhibition of Pictures, Flowers, and West of Ireland landscapes' in Mills' Hall, 8 Merion Row, Dublin, which comprised forty of his own works; he did the same again under a slightly different title in February 1931.

John Crampton Walker was elected an Associate of the R.H.A. in 1931. In 1928 he had helped to organise the 'British Contemporary Flowers' exhibition held at the Fine Art Society gallery in London where his work was already well known. This painter was also one of the principal organisers behind an exhibition of flower and garden pictures held in the Dublin Metropolitan School of Art in 1934, and a further exhibition of Irish landscapes and flower pictures held in The Irish Industries Hall, Ballsbridge in the Spring of 1938.

Crampton Walker's sound organisational abilities saw the realization of the publication of his well known *Irish Life and Landscape* in 1926, which, as editor, he dedicated to his mentor '…the late Nathaniel Hone, RHA, one of Ireland's greatest landscape painters'.[22] The objective was to bring to the attention of the public the works of Ireland's leading twentieth century landscape painters: sixty-seven coloured or black and white reproductions of their work, together with notes, were published. Crampton Walker contributed one work, *Looking towards Glenbeigh, Co. Kerry* (oil), which was well received. *The Dublin Magazine* acknowledged that 'Both editor and publisher deserve great credit for the production of this interesting book…The book has been entirely produced in Ireland, and offers therefore not only a representative collection of the Irish art work of to-day, but an excellent example of Irish book production.'[23]

The following year Crampton Walker organised an 'Exhibition of Irish Artists' at the Fine Art Society, which opened in May 1927, as a sequel to his survey of Irish art. Despite leading an active life which included shooting and croquet, the artist died at the relatively early age of fifty-two.

JOAN MOIRA MAUD JAMESON (née Musgrave) (1892-1953)

Novelist Molly Keane was a life-long friend and neighbour of artist Joan Jameson at Ardmore, Co. Waterford. Drawing on her memories, the novelist recalls: 'Never an early riser, she [Jameson] would wander unwillingly through the garden to her studio, stopping on her way to consider some present planting, or some planting to be, her eye was always right … Arrived at her studio, nearly hidden by fuchsia and hydrangea, she would sigh a little and grow a little pale as she sorted out her paint brushes and looked almost with dislike at the canvas on its easel. Before starting to paint, she was nearly ready to welcome any interruption, whether from her adored children or her, rather frightening, giant dachshund … But, once she had conquered such impediments to concentration, her strength was indefeatable − she painted cautiously. Her brush seemed to be pushing its way as it followed her eye into the canvas.'[24]

Joan Jameson was born in London on 4 October, 1892, the eldest daughter of Jessie Dunsmuir and Sir Richard Musgrave. Her family home was at Tourin, Cappoquin, Co. Waterford (the house having also been home to Anna Frances Musgrave, a founder of the Amateur Drawing Society and a relative of Joan's). Described as one of the prettiest debutantes of the season, 'A Colleen of County Waterford', after her coming out she decided to take art seriously and spent two years (1912-13) at the Academie Julien and the Sorbonne.[25] In February 1916 she exhibited three works at the W.C.S.I. exhibition held at 35, Molesworth Street: two Kerry scenes, *The Boatcove, Derrynane* and *Derrynane, Kerry,* and a view in Venice.

Following her marriage in 1920 to Captain Thomas Jameson, she lived in London until 1929, exhibiting her work in a number of well known London galleries. Following the death of her father, the artist and her husband, together with their two sons, Shane and Julian, decided to move to Tourin.

Joan Moira Maud Jameson (née Musgrave) (1892-1953), *Still Life*, oil.

Joan Jameson held her first one-man show at The Dublin Painters' Gallery, 7 St. Stephen's Green in October/November 1934. The press noted: 'She has a delightful studio at her home, Tourin, Cappoquin, County Waterford… Her technique comprises an interest in design, though she aims at getting the effect from colour rather than from design. Her paintings of landscapes and flowers show a keen intelligence and understanding, while vivid colours used against a dark background show individuality and interest…'[26]

From 1934 Joan Jameson continued to exhibit almost every year with the Dublin Painters and enjoyed identifying with the work, attitude and approach of several members of the society including Evie Hone and Mainie Jellett. Finding herself at the centre of an avant-garde movement in the 1940s, Jameson also participated in the first exhibition of The Irish Exhibition of Living Art in October

1943, sending four exhibits. From then on this artist was a regular exhibitor with the group (1943-1953), her paintings consistently capturing the attention of the critics: Edward Sheehy reviewing the Exhibition of Living Art of 1945 for *The Dublin Magazine* commented: 'Joan Jameson's *Making the Bed* has incisiveness and a well-spaced composition'.[27] The late Dr. James White commenting on the 1951 Jameson exhibition wrote in *The Bell*: 'As in most large exhibitions there are a number of very excellent small pictures of varying types … One particularly notes Joan Jameson's *Mother and Child…*'[28]

Myles na Gcopaleen, grappling with coming to terms with this new innovation in Irish cultural life, namely the Exhibition of Living Art, mentions Joan Jameson's *Sleeping Girl* (1943) and described it as a 'vivid thing of yellows and chromes well up to the level of this artist's best work'. He concludes: 'One cannot deal in the course of a short

article with the very varied and striking exhibits and no person who is interested in art should fail to …Who could be amused by stuff like that? I can only say that I'm damm glad there are no war pictures in this exhibition. It saves one the trouble of calling it a Salon de R.A.F.-U.S.A.'[29]

Irish Times art critic, Brian Fallon commenting on Joan Jameson's work wrote: 'It is in the still life and flower pieces that this artist seem most herself, and most at home'.[30] Jameson's *Still Life* (illustrated here) displays exceptional feeling for colour coupled with fluency of brushwork. Her thorough knowledge of draughtsmanship and loose flowing lines being one of this artist's most attractive and dominant characteristics.

In 1947 Joan Jameson moved to Ardmore, Co. Waterford to live at Rock House. Frequent visitors included her friends Norah McGuinness, Sean O'Sullivan R.H.A. (1906-1964) – a distinguished portrait

Dorothy Isabel Blackham (1896-1975) *Summertime*, watercolour. Signed 'DBLACKHAM'.

painter and member of the R.H.A., and Molly Keane. Many happy evenings were spent playing poker in the nearby Cliff House hotel._'Poker was her game - Her still, small face disclosing nothing ... I dined with them on the night of her death. Until the malaise took over, she was all for a game of poker. No one in my life has ever matched her infinite variety. And, when she died, magic certainly fell from the air, to live on in her pictures. In them, I can still feel the strength of her great understanding and acceptance of everything in life.'[31]

Joan Jameson died on 25 September,

1953 and was buried at Ardmore, Co. Waterford. A headstone, carved by Seámus Murphy R.H.A. (1907-75), carries a palette and brushes. In 1989 a retrospective exhibition of her work was held at the Crawford Municipal Art Gallery, Cork and at the R.H.A. Gallagher Gallery in Dublin.

DOROTHY ISABEL BLACKHAM (1896-1975)

One of the most consistent contributors to W.C.S.I. annual exhibitions was Dorothy Blackham. Elected a

member on Friday, 23 February, 1934, she exhibited no less than 135 works between 1934 and 1974. In Ireland, Blackham seemed particularly drawn to Achill and a substantial number of views were exhibited in successive annual Society exhibitions. Also included were landscapes recorded in counties Waterford, Clare and Donegal, together with a handful of garden scenes:*Snow in the Garden* (1956), *Garden in Rain* (1957) and *Rock Garden* (1969).

Born in Dublin, Dorothy Isabel Blackham's grandfather was T.K Lowry, editor of *The Hamilton Manuscripts,* published in Belfast in 1867. Blackham trained in the R.H.A. Schools and then in London at Goldsmiths' College. From the beginning she appears to have been particularly interested in becoming a linocut artist, later producing woodcuts for her friends the Yeats sisters' Cuala Press She also exhibited woodcuts at the Exhibition of Irish Art held at the D.M.S.A. in Kildare Street in June/July 1932. An active and loyal supporter of the White Stag Group, and a friend of one the founders, Basil Rákóczi, Blackham participated alongside Mainie Jellet, Patricia Wallace and others in one of the Group's earliest Dublin exhibitions held at Upper Mount Street in October 1940. She earned her living teaching art at a number of schools in and around Dublin, including Alexandra College, Earlsfort Terrace and The Hall School, Monkstown.

When Dorothy Blackham and her husband moved to London in 1941, she availed of the opportunity to paint abroad. The artist exhibited watercolours of Holland, Italy, Portugal and France in the W.C.S.I. annual exhibitions. The couple returned to Ireland to live in Donaghadee in 1964. Blackman's watercolours from the early part of her career were largely representational. Frequently she employed unusual compositional devices in order to arouse curiosity and add interest, as illustrated here in the watercolour, *Summertime*; the architecture is realistic, solid and reasonably detailed with a tendency to emphasize strong shapes. This serves to provide a

Phoebe Donovan (1902-1998) *Water Lilies, Lough Derg* 1960, watercolour. Signed 'P.D.'

stable background for the profusion of flowers: a riot of colour on a hot summer's afternoon.

Blackham's interest in linocut remained with her throughout her life. Anna Sheehy writing in *The Bell* (1941) remarked: 'Her name, of recent years, has come to be especially associated with the linocut, in which she has done a great deal of interesting work. She works on a large scale, producing prints three or four times the average size ... one of the few linocut artists here to experiment seriously and effectively with the colour print'

After her death, exhibitions of Blackham's work were held at The Queen's University, Belfast (1976) and

at the Neptune Gallery, South William Street, Dublin (1977). The W.C.S.I. commemorated her contribution to the Society by exhibiting a decorative pencil watercolour with strong emphasis on line – *House Painting in Paddington* – in two of their exhibitions: first in 1976 and secondly in their 150th, held in the National Gallery of Ireland in 2004.

PHOEBE DONOVAN (1902-1998)

A printmaker, flower, landscape and portrait painter, Phoebe Donovan's career spanned most of the twentieth century. She was born at Ballymore,

Camolin, Co. Wexford on 23 February, 1902, the youngest daughter of Richard Donovan. Happy childhood days were spent at Ballymore, learning to ride (she became an accomplished horsewoman) and helping on the farm. This rural setting was later to become the artist's base: a source of inspiration for much of her art work. Her favourite subjects included flowers of every kind, weeds and brambles, lakes, mountains, windswept trees, all of which tend to reveal this painter's basic affinity with the natural world.

Richard Donovan died when his daughter was fourteen years old. From an early age his daughter knew she wanted to be an artist and set about realising her dream in a practical way.

In order to go to art school Phoebe raised money 'by fattening pigs, selling eggs and garden produce and also running a pottery business near Enniscorthy'.[32] Educated at home, Phoebe Donovan later attended the French School, Bray, Co. Wicklow. Her interest in art was increased by joining a local art group in Gorey, Co. Wexford. In 1927 she visited Rome and had the opportunity to enrol for a short period in a private art school. This was followed by a term at Regent Street Polytechnic, London. On her return to Dublin, she enrolled in the Dublin Metropolitan School of Art in October 1927, giving her address as 37, Percy Place, Dublin. She also became a student at the Academy School on St. Stephen's Green. Whilst in Dublin the artist also received tuition from portrait and figure painter, Sean Keating. The young student attended his classes in the morning 'and when the school closed for the afternoon she recalled: "I'd make sure to get locked in so I could keep painting; usually still-life".[33] Donovan participated in the R.H.A. exhibition of 1931 and the following year exhibited with the Dublin Sketching Club.

A year later the artist made enquiries in relation to joining the W.C.S.I. At a meeting held by the Society on 14 April, 1933 the works of Miss Phoebe Donovan were accepted by the Society's hanging committee and hung in the annual exhibition that year. Thus began an association with the W.C.S.I. spanning sixty-one years during which time this painter submitted a total of 149 pictures. Phoebe Donovan was elected to the W.C.S.I. together with Tom Nisbet on Monday, 18 May, 1948. On the suggestion of Kitty Wilmer O'Brien and proposed by Letitia Hamilton, from 23 May, 1954 the artist was elected to serve on the W.C.S.I. committee – a task she undertook with great enthusiasm and loyalty until 1987, after which time she was conferred with honorary membership of the Society.

Armed with 'her determined individuality … unlike Mainie Jellett, Evie Hone, or her friends, Elizabeth Rivers and Nora McGuinness, she didn't really embrace a version of Modernism… an ex-student of Sean Keating….naturalistic observation remained the touchstone of her method, and her approach to portraiture retained his influence. While her experience of plants and animals was garnered at home in Ballymore, the practicalities, as well as the background of country life, formed an important strand of her subject matter.'[34] Phoebe Donovan possessed an extraordinary devotion and dedication to her art: 'Art is a full time job-you just can't live a normal life', she explained, 'I always painted better when I was lonely. Not just alone. Lonely. I put more into it'.[35]

Phoebe Donovan worked from Ballymore, her portraits of adults, children, horses and dogs being much in demand. During the war, the artist took over the running of Carley's Bridge Pottery which lay not far from her home. In 1947 she decided to move to a studio in Dublin and eventually went to live on the top of Dalkey Hill. Late in life, Donovan developed her interest in printwork and lithography. She was enlisted by Liam Miller, Dolmen Press to design book-jackets and this eventually led to her involvement in establishing the Graphic Studio in 1961.

Phoebe Donovan is quoted as saying: 'My aim is to have air around things – when I paint flowers I want to give the impression that they are still alive, still growing.'[36] A review in the *Dublin Magazine* of her one-man show held in spring 1957 seems to confirm her remark, the critic describing her work as possessing a 'greater freshness. Her brushwork is more rough and vigorous; her flowers, one feels are things that have grown and some real air plays around them…'[37] Phoebe Donovan therefore must not be considered to be a strict, botanical portraitist concerned with minute detail but rather as an artist who aimed to convey an atmospheric sense (as illustrated here) where lilies float in their natural setting amongst the calm, still waters of Lough Derg.

In 1991, following a fall, the artist came back to live at Ballymore and spent the last years of her life in a nursing home in Camolin, Co. Wexford. After her death on 11 May, 1998, a memorial panel with six works was displayed at the 1998 W.C.S.I. annual exhibition. In 2001 the Wexford Arts Centre hosted an exhibition of her lithographs. A gallery in the stables of her home, Ballymore, has been restored and a collection of her works placed on display.

THE REVEREND FATHER JOHN 'JACK' THOMAS HANLON (1913-1968)

'Father Jack Hanlon was one of the generation of artists who, following the lead of Evie Hone and Mainie Jellett, brought the brilliancy and lucidity of contemporary French painting into Irish art. His style had much in common with that of Norah McGuinness and like her he was influenced by the work and ideas of the French painter, André Lhote … Though his talent was hardly an original one, it was remarkably pure and consistent, and he will always have an honoured place among the group of pioneers who in the forties were responsible for founding the Living Art Exhibitions and changed the face of Irish painting'.[38]

John Thomas Hanlon was born the first son of James and Kathleen Hanlon of Fortrose, Templeogue, Co. Dublin on 6 May, 1913. He came from a 'comfortable' background; the family home, filled with fine furniture, was surrounded by a beautiful garden. The young boy inherited from his mother a love of flowers and all his life he enjoyed painting them. Together with his two brothers, Desmond and Thomas, he attended Belvedere College, Dublin where art was not part of the school curriculum. In the late 1920s he enrolled as an art student in a studio run by a Miss Henrietta Healy in Molesworth Street. The young student completed his education at University College, Dublin and then embarked on studies for the priesthood at Holy Cross College, Clonliffe and Maynooth College. He was ordained a priest on 18 June, 1939.

Despite the strict surroundings

The Reverend Father John 'Jack' Thomas Hanlon (1913-1968) *Fiery Leaves*. Signed 'JACK P HANLON'.
COURTESY OF THE NATIONAL GALLERY OF IRELAND

imposed upon him by his religious vocation, the artist, encouraged by his mother, continued to pursue his talent as a painter and succeeded in passing the Royal Drawing Society examinations run by the Ablett Studios in London. In 1937 he entered for the Taylor Art Scholarship and Prize, the judges that year being Jack Butler Yeats, Richard Caulfeild Orpen and J.R. Woolway (representing the R.D.S.). Hanlon was awarded two prizes. Two years later he was an exhibitor at the New York World Fair.

Father Jack Hanlon was elected a member of the W.C.S.I. together with artist, Helen Lillias Mitchell H.R.H.A. (1915-2000) at a special meeting of the Society held on Monday, 15 April, 1940. In the W.C.S.I. annual exhibition that year he exhibited four landscapes: *Morning Keel, Keel, In the Woods* and *Road to the Farm*. Between 1940 and 1968 the artist submitted a total of thirty-eight works, largely landscapes, together with a small number of portraits.

Prior to his election to the W.C.S.I.

several of its members exerted an influence on Father Jack Hanlon's approach to his painting (for example, Letitia and Eva Hamilton, and Harriet Kirkwood), but it was Mainie Jellett's work which was to leave a lasting impression. It is thought Jellett introduced him to Cubism and may have persuaded the young artist to study with Cubist painter André Lhote in Paris. In 1922 Lhote had established his own school, Academie Montparnasse, and was a gifted teacher influencing many young painters. Whilst studying with Lhote, Father Jack Hanlon had plenty of opportunity to visit exhibitions of works by Fauvists such as Matisse, Rouault and Dufy. This influence reflects itself particularly noticeably in the painter's use of watercolour. Lhote's version of cubism is demonstrated in Hanlon's approach to line but his interpretation of colour 'owes much more to his own temperament and to the Fauvist idea of pure colour'.[39] When painting in this medium, employing an economic and brisk execution, and a sometimes humorous approach to his subject matter, the artist's love of a light palette coupled with his use of pale colours saw him developing a style that was essentially lyrical and feminine. As demonstrated in the watercolour (illustrated here) entitled *Fiery Leaves,* Hanlon manages to avoid the strictures of pure Cubism and instead lays emphasis on a skilful use of light combined with subtle orchestrations of colour which produces a watercolour cool, refined and uncluttered. Keen to demonstrate his preference for painting on a white ground, 'Hanlon succeeded in introduc[ing] a brilliance of colour …in the 40s and 50s where grey skies and the moist atmosphere made for a certain pensive air in the work of most artists'.[40]

The painter's seven years in a seminary preparing to become a priest were punctuated by summer vacations travelling in Europe where he had ample opportunity to study the works of old and modern masters. He also enjoyed working in the studios of several well known artists in both France and Belgium.

In 1934 Hanlon's work was accepted for exhibition in the R.H.A. Between this date and 1962, Father Jack Hanlon contributed a total of only eight works. A founder member of the Irish Exhibition of Living Art, he was an annual exhibitor and member of the organizing committee until his death in 1968. Hanlon held a number of solo exhibitions with the Victor Waddington Galleries in Dublin beginning in 1941, and continued at the Dawson Gallery, Dublin in 1958, 1962 and 1965. His work was also shown outside Ireland, one-man shows being held in Curaçao, Paris, Brussels and Venezuela. Beginning in 1939 and continuing into the early 1950s, Hanlon also found time to exhibit his work with the Dublin Painters.

During his lifetime Father Jack Hanlon's talent as a painter was recognised. He received the Hallmark International Art Award (1955), the Douglas Hyde Gold Medal at the Oireachtas art exhibition (1962), and the Arts Council Prize (1962). He was a committee member of the Irish Society of Design and Craftwork, the Council of the Friends of the National Collections of Ireland and The Dublin Diocese Commission for Sacred Art and Architecture.

Father Jack Hanlon died on 1 August, 1968 and was buried in Templeogue Cemetery, '…all those who knew him reveal that he was an intensely private man who exercised his priestly role, moved easily in social circles but generally only expressed his innermost feelings through his paintings.'[41]

HELEN LILLIAS MITCHELL H.R.H.A. (1915-2000)

Helen Lillias Mitchell (1915-2000) was elected, together with Father Jack Hanlon, at a special meeting of the W.C.S.I. committee held on Monday, 15 April, 1940. A loyal exhibitor and supporter of the Society, Lillias Mitchell exhibited 119 works, including landscapes (views in Ireland, N. Wales, France, Italy, Barbados) together with a substantial number of flower pieces, between 1940 and 1994. The artist always maintained that painting in watercolour, and in particular the painting of flowers, had given her most of the inspiration for the colours she has used in her textile work.

Helen Lillias Mitchell was born in Dublin in 1916, the youngest child of David and Frances Mitchell. Her grandfather, Robert, had established a poplin weaving business in Brabazon Row in the Liberties, Dublin. Her father was in the retail business and active in the community serving as an Elder of the Presbyterian church. Lillias Mitchell began her education, as did her two brothers (David and Frank), under the care of Great-Aunt Frances Massy-Hewson, who organised a little school in the dining room of Mitchell's home. The artist was introduced to the art of flower painting at an early age. When she was eleven years old, Lillias Mitchell attended painting classes held in Mount Temple School at 3, Palmerston Park where her art teacher was designer, flower and landscape painter, Elizabeth Corbet Yeats (1868-1940), who, her pupil noted 'was never without a brimmed hat while teaching'.[42] Elizabeth C. Yeats was the younger of the two sisters of the poet, William Butler Yeats and painter Jack B. Yeats. In an interview with Sheila Walsh for *The Irish Press* (1979) Lillias Mitchell recalled: 'Louis le Brocquy and his sister, Melanie were in the class… Miss Yeats used a simple approach and we were all given a paint box of primary colours, a paint brush, no pencil or rubber, mark you… She started us off by putting a small branch of a yew tree stuck in a piece of lead in front of us and asked us to look at it for a long time and then try ad draw it. Later we used it to make a little pattern for a bowl.'[43]

At the age of sixteen, Lillias Mitchell became a boarder at Howell's School, Denbigh, North Wales, a school which had a strong tradition of craft teaching. Mitchell studied painting for two years under Dermod O'Brien at the Royal Hibernian Academy Schools (1934-36) as well as taking courses in sculpture in the National College of Art under Professor Friedrich Herkner. She spent a year at the Institut Heubi, where her mother had taught English, and on her return to Dublin was employed as a heraldic painter in the Office of Arms,

Helen Lillias Mitchell, H.R.H.A. (1915-2000) *Snow in My Garden* 1988, watercolour. Signed 'LM'.

Dublin Castle. In 1940 Lillias Mitchell was awarded the Taylor Prize for sculpture for the piece *Saint Patrick overthrowing Cromm Cruach*.

Three years later the artist returned to her school in N. Wales, this time having been invited to teach by headmistress, Cicely Robinson, under the direction of Ella McLeod. At the school she 'found everyone there spinning, dyeing and weaving' due to the enthusiasm of Miss McLeod who, in turn, taught Lillias Mitchell the skill of weaving and also the method of teaching the craft.[44] On her return to Dublin, Mitchell established with a friend, Morfudd Roberts, her own weavers' workshop and school in Lower Mount Street. In 1951 she was invited by the Minister for Education, General Richard Mulcahy, to set up the weaving department in the National College of Art: 'He showed a

great personal interest and used to call occasionally to see us at work'. Lillias Mitchell wrote four books relating to the craft of weaving being determined to keep alive the traditional methods of production. She also established other ways of encouraging the retention of traditional skills. The artist founded the Irish Guild of Spinners, Weavers and Dyers in November 1975. She was also responsible for creating an annual Lillias Mitchell Prize for weaving at the R.D.S. Following her death in January 2000, the artist left sufficient funds for the establishment of The Golden Fleece. The Helen Lillias Mitchell Artistic Fund, the object of which was to assist members of the public in the study of the traditional arts.

Following her retirement from N.C.A.D. in 1980, the artist found she had more time to devote to painting.

Lillias Mitchell had exhibited at the Oireachtas art exhibitions in 1953, '57 and '59, and also contributed to the Irish Exhibition of Living Art in 1963. Her watercolour *Snow in My Garden* (illustrated here) was exhibited at the R.H.A. in 1988 and now forms part of the W.C.S.I.'s Permanent National Collection at the University of Limerick. In relation to painting, this artist drew her inspiration from nature, flowers and landscape: 'You have to feel a lot before you begin a piece of work' – however, always mindful of the practical, she added: 'You have to be disciplined, or you won't get anything done'.[45] A retrospective exhibition of works by Lillias Mitchell was held in the Kennedy Gallery, Harcourt street, Dublin and opened by W.C.S.I. President, Nancy Larchet on 2 March, 1993.

Water Colour Society of Ireland Etchers and Illustrators

Dr. Edith Anna Œnone Somerville
Edward Millington Synge, A.R.E.
Sir Frank Brangwyn, R.S.W., R.A., R.W.S., R.B.A.,
 Hon. V.P.R.S.M.A.
Sir Nevile Rodwell Wilkinson, A.R.E., R.M.S.,
 K.C.V.O.

Myra Kathleen Hughes, A.R.E.
Lady Mabel Marguerite Annesley
Henry Patrick 'Harry' Clarke, R.H.A.
Elizabeth 'Betty' Joyce Rivers
Robert Wyse Jackson
Margaret Mary Stokes

DR. EDITH ANNA ŒNONE SOMERVILLE (1858-1949)

Edith Somerville's links with The Irish Fine Art Society began in March 1882 when she submitted four entries for their nineteenth exhibition, which was held at 35, Molesworth Street. Her family connections with the Society had been established through her grandfather, Sir Josiah Coghill, Bt. The latter's son amateur painter Sir Joscelyn Coghill had been a member of the committee responsible for organising the Society's tenth exhibition, held in Dublin in March 1877. Sir Joscelyn's son, Egerton B. Coghill, married his cousin, Edith Somerville's sister, Hildegarde. A frequent exhibitor with The Irish Fine Art Society and the R.H.A., Egerton Coghill's name, together with that of his sister-in-law, Edith Somerville, frequently appears in exhibition lists in Society catalogues from the 1880s and '90s.

Edith Somerville, Drishane House, Castletownshend, Co. Cork belonged to 'that class George Bernard Shaw call[ed] "downstarts"'.[1] The eldest child of Lieut.-Colonel T.H. Somerville, DL., she was born on the island of Corfu whilst her father was stationed there. Her mother, Adelaide, was the granddaughter of the Lord Chief Justice of Ireland, Charles Kendal Bushe. Somerville's early education was, according to her biographer Gifford Lewis, 'somewhat sketchy'.[2]

The young girl, having succeeded in disposing of a succession of governesses, is recorded as being a student at the age of seventeen for two terms at Alexandra College, Earlsfort Terrace, Dublin in 1875. In order to achieve independence as a self-supporting professional artist, Somerville decided to train abroad. Egerton Coghill, a favourite cousin, was fortunate to have a studio in Dusseldorf. There the young artist spent two terms (1881 and 1882) in the German city where she availed of the opportunity to study music and anatomy whilst also attending life-drawing classes given by a fellow student, Swiss figure and genre painter, Gabriel Emile-Edouard Nicolet (1856-1921) and genre and interior artist, Carl Rudolph Sohn (1845-1908).

In 1884, Somerville decided to take her art training a step further. She again joined Egerton Coghill who by now had moved to Paris. There she began studying under French naturalist painter and printmaker, Pascal-Adolphe-Jean-Dagnan-Bouveret (1852-1929) in the ladylike atmosphere of Colarossi's studio near Étoile. Dagnan-Bouveret had trained at the École des Beaux-Arts and in the ateliers of Alexandre Cabanel (1823-1889) and Jean-Leon Gerome (1824-1904).

In the same year, Somerville renewed her contact with The Irish Fine Art Society, contributing to their Cork exhibition of 1884. A year later she returned to Paris. Dissatisfied with the teaching she had received the previous year, she joined another branch of Académie Colarossi in the Rue de la Grande Chaumière and began to work in a serious, professional atmosphere.

During this period Somerville made humorous drawings of patients at Dr. Pasteur's clinic and her career as an illustrator began to take off. In 1885, *Cassell's Magazine of Art* published her article illustrated with her sketches of life in the studios at Colarossi's .

At home in Castletownshend, Sommerville's life was filled with hunting, picnics, sketching expeditions. In the summer of 1886, she met her cousin, Violet Martin, who used the *nom de plume* 'Martin Ross'. One of their earliest collaborations was the publication of *An Irish Cousin* (1889), a novel with Edith Somerville being responsible for the graphics, and her cousin providing the text. This was to be the pattern for further Somerville and Ross books.

1889 saw Edith Somerville participating for the first time at the R.H.A. Never a prolific exhibitor, between 1889 and 1920 she contributed a small number of French and Irish scenes together with a small collection of illustrations. She continued to visit Paris on a regular basis between 1886 and 1894, enrolling in 1894 at Délacluse's studio. In 1898 she and Violet Ross visited Étaples, the artist's colony near Boulogne, which was a favourite painting area of her beloved cousin, Egerton Coghill. Somerville again returned to Délacluse's in 1899, attending classes in the mornings. The afternoons were spent assisting Whistler's *massier* or head student, American artist, Cyrus Cuneo

Edith Œ Somerville (1858-1949) *G stands for Geese. Look at Gollagher now, And himself in the thick of a Family Row*! To celebrate the fiftieth anniversary of the Water Colour Society of Ireland (1904) Edith Somerville exhibited six illustrations which had appeared the previous year in her book, *Slipper's A.B.C. of Fox Hunting* by E. Œ. Somerville, M.F.H. published by Longmans, Green & Co., London, 1903. COURTESY OF THE NATIONAL LIBRARY OF IRELAND

(1879-1916) to establish an illustration class; this was conducted in the same studio where Whistler himself had taught a class of young female artists.

Throughout the 1890s, Edith was also busily engaged in executing a substantial number of pencil, ink and wash drawings for *Black and White* and *Ladies Pictorial*. During this period, both Violet Ross and herself collaborated to produce four illustrated essays on Paris, *Quartier Latinities*.

From an early age, Edith had been influenced by leading English caricaturist and illustrator John Leech (1817-1864). Born in London, Leech was, according to Thomas Bodkin, the son of a 'gentlemanly Irish landlord' and one of the leading artists working for *Punch* from its foundation in 1841 until his death.[3] He established the gentle, witty tone for the magazine which it would appear influenced Somerville's style. This may be seen in

a collection of original illustrations the artist exhibited with the W.C.S.I. between 1901 and 1926, starting with *The Story of Owld Bocock's Mare*. For the W.C.S.I. fiftieth exhibition (held in The Leinster Lecture Hall, Dublin, February, 1904) six illustrations were on view from *Slipper's A B C of Fox-hunting,* one of which is illustrated here. Other W.C.S.I. exhibits included *The Master of the Whiteboys* (1909), and *"Is that my darling Major Yeats?" enq'd the Job Cook* (1909). This artist's delightful, witty style combined with her strong sense of draughtsmanship demonstrates the influence of John Leech and displays her unique, highly comical view of Irish life. Her pictorial humour was largely aimed at her own class, the treatment of local people always being handled with understanding and sensitivity.

Following her first solo show at the Goupil Gallery, London in 1920, and

subsequent shows at Walker's Gallery, Bond Street, in 1923 and 1927, Somerville embarked on a tour of the United States in 1929. This proved to be highly successful, resulting in three exhibitions being held in that country.

At the age of seventy-four, Trinity College, Dublin conferred on her the degree of Doctorate of Letters. A talented horsewoman, Somerville, together with her brother Aylmer, founded the West Carberry Hounds. A competent musician, this artist will be best remembered for her marvellously humorous view of the life she saw around her. This is perhaps best exemplified in her ever-popular Irish RM stories; these had begun life in 1898 as a monthly series for the *Badminton Magazine* and culminated in the publication of *Some Experiences of an Irish RM*, 1899, a collaboration with Violet Ross which Somerville illustrated. This painter's work was

represented in the first Irish Exhibition of Living art held in 1943. In September 1984 an exhibition of eighty-seven of her pictures went on view in Castletownshend as part of the Somerville and Ross Commemorative Festival, and subsequently at the Crawford Gallery, Cork.

EDWARD MILLINGTON SYNGE A.R.E. (1860-1913)

Born at Malvern on 17 April, 1860, Edward Millington Synge had close family links with Ireland. He was the grandson of Francis Synge of Glanmore Castle, near Ashford, Co. Wicklow, and his father, the Reverend Francis Synge, was Chief Inspector of Schools. Educated at Norwich School, and then at Haileybury, Hertford, Synge entered Trinity College, Cambridge in 1882, graduating with honours in the Classical Tripos. He decided to become a land agent and was placed in charge of estates in both Surrey and Sussex.

Practising etching in his spare time, Synge had always been interested in the technique of copperplate etching, and in 1892 enrolled at the Westminster School of Art under William Mouat Loudan (1868-1925). In his spare time, he travelled to London to receive instruction whilst also benefiting from information and advice provided by distinguished etchers such as Sir Frank Short and Sir Francis Seymour Haden, M.D. P.R.E. (1818-1910). Elected A.R.E in 1898, the following year, Synge exhibited at the Paris Salon and also began contributing to the Royal Academy, continuing until 1911. From 1901 onwards, Synge decided to devote himself entirely to his art career and in 1902 began working in Rome under painter, Ferdinand Sabatte (1874-1940).

In 1906 *Romantic Cities of Provence* by Mona Caird was published and carried illustrations from sketches by distinguished American illustrator and writer, Joseph Pennell (1860-1926), and Edward Millington Synge, who contributed forty-six sketches. The following year the artist visited Spain and, according to his daughter, it was in this country that 'some of his best work

Edward Millington Synge A.R.E. (1860-1913) *Pines, Villa Borghese*, etching, 1903. Signed on plate.

was done'.[4] It was during this period that Synge began to exhibit at the R.H.A. for the first time and between 1907 and 1913 contributed a number of Venetian and Italian scenes including two views of the Villa Borghese, Rome (one of which is illustrated here).

This artist's association with the W.C.S.I. began in 1911 when Synge sent – from Clare Cottage, West Byfleet, Surrey – one work entitled *On the Canal*. During the following two years *Spring in the Cotswolds* (1912), *Macon* (1912), and *Road near Perth* (1913) were shown at W.C.S.I. annual

exhibitions. He also exhibited his work at the Glasgow Institute of the Fine Arts, the Walker Art Gallery, Liverpool, and the R.H.A. and was a keen supporter of the Royal Society of Painter-Etchers and Engravers, exhibiting almost ninety works. He was elected an associate of the Society in 1898. An ability to produce a work full of delicacy coupled with purity of line is demonstrated throughout in Synge's etchings. As his career progressed, his work became considerably richer and was injected with a strong poetic feeling. Towards the end

of his life, Synge tended to carry out the printing processes himself, ably assisted by his wife, Freda.

Following the artist's death on 18 June, 1913, a memorial exhibition of etchings, together with a catalogue which carried a foreword by art historian and artist Martin Hardie, was held in London. According to his daughter, Mrs E.E. Woodhouse, all his plates (numbering around 370) were destroyed and used for munitions during the First World War.

SIR FRANK BRANGWYN, R.A., R.W.S., R.B.A., Hon. V.P.R.S.M.A., R.S.W. (1867-1956)

Guillaume François Brangwyn (known as Frank) was born on 12 May, 1867 at Rue de Vieux Bourg, C 20, No. 24, Bruges, Belgium (now known as 30 Oude Burg). One of six children, his father William Curtis Brangwyn and his Welsh wife, Eleanor Griffiths, moved to London in 1874 where the young boy attended school until 1879. His father worked on a freelance basis as an architect, muralist and in other arts-related craft areas. Frank Brangwyn left school at an early age and it would appear he received no formal art education. Three of the artist's earliest influences were from the Arts and Crafts movement in Europe: writer, designer, artist and socialist, William Morris, (1834-1896); German art dealer, Siegfried 'Samuel' Bing (1838-1905); and progressive architect and designer, Arthur Heygate Mackmurdo (1851-1942). It was largely through the latter's influence that the young artist managed to gain employment in the Queen Square workshops of William Morris in 1882. There he learned about 'enlarging designs, tracing drawings on cloth and drawing them on silk'.[5] Two guiding principles which were to stand Frank Brangwyn in good stead both as an artist and a designer were learned at the feet of Morris and Mackmurdo – the value of drawing from nature combined with a strong work ethic, 'the great thing is to work and work all the time and you will no doubt do something good'.[6]

Travels abroad, particularly to his beloved Venice, during the 1880s and 1890s helped to develop and inspire Brangwyn's output. In 1885, at the age of seventeen, he had submitted an oil (*A Bit on the Esk near Whitby*) to the Royal Academy and was successful. Encouraged by this, but earning little money, the artist rented a studio in Chelsea. A neighbour recalls: 'I remember saving a water-colour with which he was going to light his stove, by giving him an old coat for it; framed, it is now an ornament on my wall.'[7]

The artist's reputation was growing. A member of the R.S.A. (1890), the Royal Institute of Oil Painters (1892), the Munich Secession (1893), the Vienna Secession (1897), a participant at the Paris Salon and in a number of British galleries, Brangwyn began to exhibit his work in Dublin at the W.C.S.I. in 1911. The following year

the *Irish Times* commented: 'A notable feature of this exhibition is the series of black and white etchings lent by Mr Lee Hankey and Mr Frank Brangwyn. These artists have won a reputation for their work, and it is certainly justified by their contributions'.[8] The previous year at the Cork Industrial Exhibition it is thought Brangwyn exhibited his work in Ireland for the first time. The annual W.C.S.I. exhibition of 1911 saw the artist despatching two examples of his work – sent from Temple Lodge, Queen Street, Hammersmith, London – *The Farmyard* (a sketch) and *The Millstream, Montreuil*. He and a sketching friend, Robert Hawthorn Kitson (1873-1947), had travelled together on a number of trips to the Continent between 1903 and 1914 and were known to have been in Montreuil in 1905.

Brangwyn's connections with

Frank Brangwyn's etching and engraving tools.

Frank Brangwyn, R.A., R.W.S., R.B.A., Hon.V.P.R.S.M.A. (1867-1956) *The Ghent Gate, Bruges, Belgium*, etching.

scorpers were carefully stored in a leather suitcase stamped with his initials (see illustration). This artist's style has been described by Herbert Furst in *The Modern Woodcut*:

'His style in his best and most characteristic cuts is a short nervous stabbing of the wood with the graver …It is a style which is entirely his own. The design is in white line, roughly indicated, before the cutting, with chalk, but almost completely drawn in the cutting itself.'[10]

In 1926 *The Studio*, which had always been a staunch supporter of Brangwyn's artistic output, introduced his work to a worldwide audience and published *The Etchings of Frank Brangwyn – a catalogue raisonné*. It carried reproductions of over 330 etchings.

The dramatic example illustrated here relates to his birthplace, entitled *The Ghent Gate, Bruges*. It displays a powerful visual presence, coupled with the artist's confident belief in the scale of the composition. Towering, glowering buttresses guard the entrance to the medieval town of Bruges dwarfing the tiny figures which are not depicted in any great detail but rather serve to provide an indication of scale and help to animate the composition. Dramatic effects are gained through the massing of dark against light and this succeeds in conveying the grandeur of the overpowering medieval architecture. In 1936, Brangwyn presented Bruges with over 400 works which were to be housed in Arents House Museum. In return, Bruges bestowed upon the artist the distinction of a Grand Officer of the Order of Leopold II and made him a *Citoyen d'Honneur de Bruges*.

During his lifetime, Frank Brangwyn 'as a designer of stained glass, textiles and woven fabrics, metal work, and other ornamental accessories' combined an extrovert personality and ability for hard work.[11] However, his biographers note that towards the end of his life he became something of a recluse refusing to be entertained and to entertain and possessed an incessant commitment to his work:

'For nearly a generation he has been as good as dead to modern influences

Ireland may have been established through his friend and eventual patron, Lord Iveagh (d.1927). The latter signed an agreement with the artist in June 1926 '*to fill the space on the walls of the Royal Gallery … with decorative paintings representing various Dominions and Parts of the British Empire…*'[9] Brangwyn began work on this commission in 1925. It comprised sixteen large panels in total and were originally intended for the Royal Gallery, House of Lords, Westminster. However, they were refused because they were considered to be too colourful and full of life.

In 1912, Brangwyn again exhibited a number of works in the W.C.S.I. annual exhibition, *Brentford Bridge*, *Church of St. Austerlithe*, and *Traghetto, Venice*. As mentioned above the artist had always enjoyed his visits to Venice, and his links had been strengthened in 1905 when he was invited to design the 'English Rooms' for the Venice Biennale. Brangwyn's work was again on display in Dublin in March 1929 when an exhibition of original etchings organised by The Fine Art Society, London was held at Mills' Hall, 8 Merrion Row. Other contributors included William Walcot, F.R.I.B.A., Will Walcot, F.R.I.B.A., A.R.E., Sir Frank Short, R.A., P.R.E. and Oliver Hall, R.A., R.W.S., R.S.A., A.R.E.

Brangwyn joined the Royal Society of Painter-Etchers and Engravers in 1904. He enjoyed working closely with materials, whether it be a woodcut, a wood engraving or an etching. In particular the artist found the latter to be a lucrative market, and one which became a commercial venture with a ready market of buyers. Brangwyn's etching and engraving tools, which amounted to on average twenty-two gravers, tint tools and

Sir Nevile Rodwell Wilkinson A.R.E., R.M.S., K.C.V.O. (1869-1940) Bookplates: George Sidney Herbert; and Oliver St. John Gogarty, inscribed 'Designed and Drawn by his friend Major Sir Neville R. Wilkinson Ulster King of Arms' .

and the appreciation of his country-men, in fact the younger generation of his countrymen, if they were aware at all that he was still alive, thought of him as an Edwardian, or even (as William Rothenstein described him) a "Victorian".[12]

SIR NEVILE RODWELL WILKINSON A.R.E., R.M.S., K.C.V.O. (1869-1940)

As early as February 1913, Captain Nevile Wilkinson is listed as being a member of the W.C.S.I. committee. An enthusiastic member, he helped to organise the society's fifty-ninth exhibition, held in February 1913 at The Hall, 35 Dawson Street (along with his wife, Lady Beatrix, amongst others). Wilkinson served as a W.C.S.I. com-mittee member until October 15, 1937 and contributed to W.C.S.I. annual exhibitions from 1909 to 1939. Exhibits included mosaic panels, a design for stained glass, a substantial number of bookplates, headings, tail pieces and

armorial initial letters (executed for, amongst others, the Earl of Durham, the Earl of Donoughmore, and the artist's wife). Drawings relating to the work for which he is perhaps best remembered today, *Titania's Palace,* were placed on display at the W.C.S.I. annual exhibition held in 1922 and included a design for the reredos of Titania's chapel. Five years later, in 1927, he exhibited two more of his designs relating to *Titania's Palace:* the bathroom frieze and the miniature sleigh.

Sir Nevile Rodwell Wilkinson was born on 26 October, 1869 in Middlesex, son of Colonel Josiah Wilkinson, a barrister, and Alice Emma, daughter of Thomas Smith of Highgate. Educated at Harrow School, he entered the Royal Military College, Sandhurst in 1889 before being gazetted to the Coldstream Guards. He was stationed in Dublin in 1891. Soon afterwards he returned to London and became a member of the Chelsea Arts Club where he had ample opportunity to meet many leading artists of the day including American virtuoso portrait

painter, John Singer Sargeant, R.A., R.W.S. (1856-1925) and Sir John Everett Millais, P.R.A. (1829-1996) a founder of the Pre-Raphaelite Brotherhood. Wilkinson decided to train as an artist and enrolled at the National Art Training School where he studied engraving. Later he was to have the opportunity of studying the technique of etching under Sir Frank Short. When the Second Anglo-Boer War broke out in 1899, he served in South Africa with distinction. His marriage on 29 April, 1903 to Lady Beatrix Frances Gertrude Herbert (eldest daughter of the fourteenth Earl of Pembroke) brought him back again to Dublin. He and his wife went to live in Mount Merrion, Co. Dublin. They had two daughters, Gwendolene and Phyllis:

'...for it was during the summer of the year 1906 that my baby daughter called my attention to the appearance, or more correctly disappearance, of a being she described as a fairy, among the moss-covered roots of an old sycamore at Mount Merrion.'[13]

This event gave Wilkinson the idea of designing 'a special building…above ground. The Fairy Queen and her Court might be persuaded to transfer themselves and their treasures to the visible palace, so that all the children of the world might be invited to admire them.'[14]

He began to draw the plan of a miniature building, the total height being 27 inches and covering a space of 63 square feet. It contained sixteen rooms in all, built round a central courtyard and lit and heated throughout by electricity. The exterior was made by James Hicks of Dublin, the little belfry the work of architect, Sir Edwin Lutyens O.M., K.C.I.E., P.R.A., F.R.I.B.A. (1869-1944). Using an etcher's glass, Wilkinson successfully developed a technique for decoration which he described as 'mosaic painting'. These consisted of minute dots of watercolour, about one thousand to the square inch and all irregular in shape. During the next eighteen years and employing his new technique, Wilkinson used every minute of his spare time to design tapestries, mosaics, tiles frescoes, even a miniature Book of Hours (dated 1600) in order to create his *chef-d'oeure en miniature* which would be 'fit for the residence of Her Iridescence, Queen Titania, Her Consort Oberon, and the Royal Family of Fairyland'. The palace was exhibited all over the world and raised substantial amounts of money for under-privileged children, (it was sold in 1978 to Legoland, Denmark for £135,000).

In 1908 Wilkinson was appointed to succeed Sir Arthur Vicar as Ulster King of Arms, the latter having been forced to resign following the scandal of the theft of the Irish crown jewels in Dublin. Wilkinson was also Registrar of the Order of St. Patrick and was responsible in 1911 for designing the Sword of St. Patrick. Appointed an associate of the Royal Society of Painter-Etchers and Engravers in 1909, he assisted portrait, landscape and figure painter, Dermod O'Brien, P.R.H.A. (1865-1945) to organise a loan exhibition entitled *Art of Engraving* held the following year at the R.H.A. which was opened by the Lord Lieutenant, the Earl of Aberdeen.

Wilkinson's first works shown at the R.H.A. in 1907 had been a collection of four etchings. With the outbreak of war in 1914, he rejoined the army and served with distinction in both France and Gallipoli.

When the war was over, Wilkinson returned to his duties in Dublin. He was awarded a knighthood in 1920. During the next few years, Wilkinson was responsible for arranging the first opening of the parliament of Northern Ireland by George V in the Belfast City Hall in 1922. In return for his efforts, he was made a K.C.V.O. Wilkinson was also directly responsible for the design of the great seal of Northern Ireland which was exhibited in the sculpture gallery of the R.A. exhibition in 1924. He also designed and granted arms for each of the six counties of Northern Ireland. Despite working under difficult political circumstances during the 1920s and '30s, Wilkinson succeeded in ensuring the preservation of records making it possible for the new chief herald of the newly established Republic of Ireland to begin with registers dating back many centuries.

In 1921, Wilkinson was elected as Vice-President of the Royal Society of Miniature Painters and between 1927 and 1940 he showed eighteen works at the R.A. including a number of designs for the Guards' Chapel, Wellington Barracks. In 1931, Wilkinson exhibited two examples of mosaic painting in the W.C.S.I annual exhibition: *Mosaic for Titania's Palace* and *Mosaic, Dancing Figures*. A collection of over thirty bookplates was included in an exhibition of his work held at The Fine Art Society, London in 1937. Sir Nevile Wilkinson died on 22 December, 1940 in Dublin, secure in the knowledge that *Titania's Palace* had been enjoyed and admired by over one million children around the world.

MYRA KATHLEEN HUGHES, A.R.E. (1877-1918)

Etchings in both chalk and sepia (Class 6) were included in the first exhibition held in Lismore courthouse in May, 1871 organised by The Amateur

Drawing Society. Although not attracting a large entry, this class was to remain an integral part of W.C.S.I. exhibitions down through the years.

A critic writing in *The Studio* described the work of Myra Kathleen Hughes as an 'accomplished etcher'.[15] Their publication for June 1916 carried a number of the artist's etchings relating to Dublin in which the above, entitled *The Old Houses of Parliament, Dublin,* appeared.

A portraitist and miniaturist as well as being an etcher of landscapes and architectural scenes, Myra Kathleen Hughes was born at Polehore, Wexford on 9 September, 1877, one of five daughters and two brothers born to Sir Frederic Hughes, who had served in the 7th Madras Light Cavalry. In 1898 she was a student at Westminster School of Art where she studied under William Mouat Loudan (1868-1925) before completing her training at the Royal College of Art under watercolourist and engraver, Constance Mary Pott R.E. (1862-1957) and Professor of Engraving, Frank Short. A gifted teacher and President of the Royal Society of Painter-Etchers and Engravers (now known as The Royal Society of Painter-Printmakers) from 1910 to 1938, Sir Frank Short instilled in his students a feeling for purity of line and clean printing, together with a belief in high standards and serious craftsmanship.

Hughes began exhibiting at the W.C.S.I. in 1898 sending a view of the *Dean's Yard, Westminster* from 15, Onslow Gardens, London. She continued to exhibit with the Society until 1918, contributing a total of twenty-two exhibits. A keen traveller who sketched and painted in Norway, Iceland and Palestine, she contributed a number of landscapes relating to Co. Wexford, London, Oxford and Jerusalem to W.C.S.I. exhibitions together with a small group of portraits.

In February 1918 *The Studio* published an account of her travels and sketching trips in Palestine. She recalls her experiences of a woman sketching alone in the Holy Land around the beginning of the twentieth century:

'A boy came along and began making objections to the place I was sitting in – an unenclosed rough piece

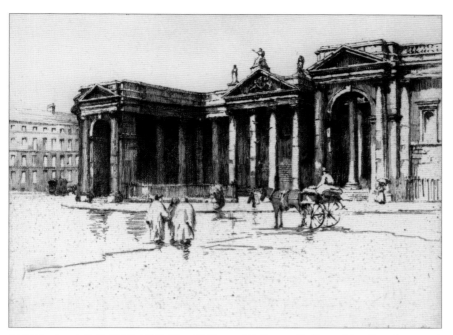

M.K. Hughes, A.R.E. (1877-1918) *The Old Houses of Parliament, Dublin,* etching. Signed in pencil
© V&A IMAGES, VICTORIA AND ALBERT MUSEUM

of ground which he said I had no right to be in, that he was in charge of it, and that it belonged to an order of priests who had buildings not very far off. I rather took the wind out of his sails by packing up my sketching things and interviewing one of the priests, who said the story was a fabrication, and I returned and finished my sketch.'[16]

Hughes exhibited for the first time at the Royal Academy in 1906 sending a view of houses in Silver Street, Notting Hill Gate, the theme being medieval buildings found in the city of London. The artist contributed a total of fifteen works at the R.A. until 1918. Also a keen participant in exhibitions organised by the Royal Society of Painter-Etchers and Engravers, London, Hughes was elected an Associate of the Society on 6 April, 1911.

The artist's links with the R.H.A. began in 1898 when she sent a view of Kew Bridge from Alexandra House, Kensington Gore, London. Hughes continued to exhibit at the R.H.A. submitting a number of portraits together with views in London, Dublin and Lincoln until 1915. A watercolour by this artist was included in the Cork International Exhibition, 1902. Hughes was also a member of The Dublin Sketching Club. A view in Norway, a

number of London scenes, together with a portrait (miniature), entitled *Miss Eleanor C. Hughes,* were included in their 1901 exhibition. A talented member of the Black and White Artists' Society of Ireland, examples of her work formed part of their exhibitions held in 1914 and 1916. The Society had been established by John Crampton Walker, A.R.H.A. in 1914 and embraced distinguished fellow artists such as Jack Butler Yeats, R.H.A., Rose M. Barton, R.W.S., Richard Francis Caulfeild Orpen, R.H.A., F.R.I.A.I, Oswald Reeves, A.R.C.A., and Dermod O'Brien, P.R.H.A. who acted as their President.

Writing in *The Dublin of Yesterday* (1929) the author, P.L. Dickinson regarded the output of Hughes as being of a high standard:

'Among those who used etching as their medium, Miss Myra Hughes, whose early death was a sad loss to Irish Art, was probably the best. Indeed much of her work takes a very high place, her draughtsmanship was adequate and decided, and her choice of subject always satisfactory for her medium- a quality only too often not found in etchers. She never went too far with her work and knew exactly how to get her effect with a minimum amount of line.'[17]

LADY MABEL MARGUERITE ANNESLEY (1881-1959)

Lady Mabel Annesley, wood-engraver and watercolourist, was the great grand-daughter of Sir Francis Grant, (1803-1878) President of the Royal Academy and eminent Victorian portrait painter. Daughter of Hugh Annesley, fifth Earl Annesley (1831-1908) and Mabel W.F. Markham, Countess Annesley (1858-1891), she received her early education from her governesses. In 1895, the young student enrolled to train in the School of Animal Painting which had been established the previous year under its principal and founder, Frank Calderon (1865-1943). Four years later, Lady Annesley was elected a member of the Belfast Art Society. She married Gerald Sowerby (1878-1913), Flag-Lieutenant to Admiral Prince Louis of Battenberg, on 14 January, 1904, and continued to exhibit with the Belfast Art Society until 1926.

Following her husband's death in 1914, the artist returned to Ireland to live at Castlewellan Castle, Co. Down built in the Scottish Baronial style to the design of architect, William Burn, (1789-1870) and completed in 1858. She had inherited the castle, sheltered by the Mourne mountains together with its famous gardens and arboretum, following the deaths of both her father and brother. She resumed her maiden name.

Lady Annesley turned to wood engraving in 1920 and enrolled at the Central School of Arts and Crafts, London for one year under teacher of book illustration, Noel Rooke (1881-1953). An exhibitor with the Society of Wood engravers between 1922 and 1939, she was elected a member in 1925.

The following year, in response to an invitation by members of the W.C.S.I. committee, the artist lent several examples of her wood cuts which were placed on screens for display at the 1926 annual exhibition. She also exhibited four of her watercolours that year in the W.C.S.I. annual exhibition: *Loughislandreavy; Mare and Foal; Study of Horses;* and *Design for a woodcut.*

During this period, Lady Annesley had established her own studio at 12,

Lady Mabel Marguerite Annesley (1881-1959) *In the Kingdom of Mourne Artist* 1926. A woodcut to accompany *Apollo in Mourne, A Play in One Act* by Richard Rowley.

dimensional style is similar to that of one of the most individual of English painters, a man who possessed a deep attachment for the countryside, Paul Nash (1889-1946). It would appear from her autobiography that she also greatly admired the work of New Zealand painter and one of the leaders of the romantic style, Frances Hodgkins (1869-1947) together with that of printmaker, writer and draughtsman, David Jones (1895-1974).

Lady Annesley died on 19 June, 1959 in Clare, Suffolk and was buried in Long Melford, Suffolk. A woman who disdained publicity, *The Times* in their obituary described her as possessing 'an incorruptible sense of duty and tradition, most strikingly combined with a passionate grasp of all that was most vital in the world of modern art…the fundamental inspiration of her inner life sprang from an intense and profound feeling for beauty in nature and in art.'[19]

HENRY PATRICK 'HARRY' CLARKE, R.H.A. (1889-1931)

Stained glass artist and illustrator Harry Clarke's contribution to The Water Colour Society of Ireland was in 1915 when he sent, from the family home – 33, North Frederick Street, Dublin – a design for a calendar *The Lady of Decoration* to be included in the Society's annual exhibition. The illustration, which 'shows a heavy-lidded, redheaded lady, clad in an elaborately swirling eighteenth century costume of turquoise, green and white set against a Venetian yellow back-ground', was executed during the week following his marriage to portrait, figure and landscape painter, Margaret Crilley, R.H.A. (1888-1961) on 31 October, 1914.[20] His exhibit was to serve as a calendar design for a friend of Clarke's father, John Duthie, who lived in Glasgow and supplied the Clarke Studio in Dublin with paint.

Henry Patrick Clarke was born on 17 March, 1889, second son of Joshua and Brigid (née MacGonigal, of Cliffoney, Co. Sligo – an aunt of Maurice MacGonigal P.P.R.H.A.). When he was eighteen, Joshua Clarke

Lombard Street, Belfast and began to lecture on wood-engraving. She also produced wood-engraved illustrations for the Golden Cockerel Press run by Co. Cork-born, Robert J. Gibbings M.A. (Hon), F.R.S.L., A.R.H.A., F.R.G.S., F.Z.S. (1889-1958). A collaboration between herself and Belfast figure and portrait painter, William Conor, (1881-1968) R.H.A., R.U.A., R.O.I. resulted in designs for costumes for the 1,500th anniversary of the landing of St. Patrick at Saul, Co. Down. The pageant to celebrate this event was staged at Castle Ward, Strangford, Co. Down in 1932. A year later, the Batsford Gallery, London mounted an exhibition of her wood-engravings, silverpoints and water-colours. In 1934, the artist was appointed an honorary member of the Royal Ulster Academy. Five years later, the Belfast Museum and Art Gallery accepted her generous gift, a collection of contemporary wood-engravings together with twenty of her own works.

Bombed out of her Belfast studio in 1942, Lady Annesley emigrated to New Zealand where she lived in Nelson and Takaka. Despite arthritis and family troubles, she continued to engrave, turning from box wood to soft lino. In 1953, she returned to England and retired to live in Suffolk.

In her autobiography, the artist wrote: 'It is the fascinating job of landscape painters not to imitate only but to study; to arrange and re-arrange, within a settled dimension, the glorious disorder of nature. I always want to know the distinctive features in a new bit of country; to learn the rhythm of the surface of the earth. I like to make imitative drawings on the spot, till my eye becomes accustomed to the character of the country. It is only after this preamble that I know whether I have something to say about it or not….'[18]

Always fascinated and interested in the patterns and shapes of the landscape, particularly her beloved Co. Down, her strong, expressionistic use of white line is displayed here in this little woodcut (illustrated) entitled *In the Kingdom of Mourne,* published to accompany *Apollo in Mourne,* a play in one act by Richard Rowley (1877-1947) published London, 1926. Her expressive two-

had arrived in Dublin from Leeds and spent a short time gaining experience with a firm of ecclesiastical suppliers before establishing his own church decorating business and stained glass studio at 33, North Frederick Street, Dublin. The family also lived at this address.

His young son, Harry, attended a number of schools which included the Model Schools in Marlborough Street and Belvedere College, close to his home. At school, the young boy was noted for his talents both as a draughtsman and caricaturist. Clarke left school in 1903, the year his mother died, and together with his elder brother, Walter, entered his father's business. There he was fortunate to receive instruction in stained glass design and technique from draughtsman and stained glass designer, William Flood Nagle (1853-1923). A year later, the Clarke Studios was awarded a prize in the 1904 Art Industries Exhibition held at Ballsbridge, Dublin. In 1906 Clarke began night classes at the D.M.S.A. under stained glass artist, and managing artist of The Tower of Glass, (*An Túr Gloine*), Alfred Ernest Child (1875-1939). However, his father was anxious that his son should receive further art training in London and at the same time become an apprentice in a reputable London glass firm. The latter did not materialise but Clarke did enrol for two months at the Royal College of Art in South Kensington. When he returned to Dublin for Easter 1906, Harry Clarke was, according to his biographer, Dr. Nicola Gordon Bowe, '…still undecided on his future career'.[21] He decided to resume his studies under Child in the evenings and assisted in his father's studios during the day. In May 1907, Clarke availed of the opportunity to see the work of a number of artists and book illustrators including Walter Crane R.W.S. (1845-1915), Sir Edward Coley Burne-Jones R.A. (1833-98), and Glasgow-born artist Annie French, (1872-1965). Their work was on display in the Palace of Fine Arts which formed part of the Irish International Exhibition held in Herbert Park, Dublin. Each summer, he found time

Henry Patrick 'Harry' Clarke, R.H.A. (1889-1931) *The Lady of Decoration* 1914. Pen, ink and watercolour design for a calendar. Signed bottom right.

to visit the island of Inishere in the west with fellow student, Austin Molloy who, like Clarke, was also a skilled black and white illustrator and stained glass artist.

Harry Clarke was awarded a scholarship in stained glass by the D.M.S.A. in 1910. This permitted him to attend on a full-time basis daily classes and to become a pupil in

Orpen's life drawing classes. During the years 1911, 1912 and 1913 he received the only gold medal awarded for stained glass design in the National Competition organised by the Board of Education.

As a student, Clarke had always been interested in book illustration and in 1913 persuaded his father to allow him to take a studio in London. Whilst there, the young artist applied himself diligently to his black and white illustrations, and also took the opportunity to visit a number of galleries including the V&A and the National Gallery. As Bowe noted: 'Clarke's earliest illustrations are eclectic in their reflection not only of Aubrey Beardsley, but only of Neilsen, Hoppe, Alastair, George Sherringham, Sime, Annie French, Jessie King, the MacDonald sisters, Erte and Bakst.'[22] In November of that year, the young artist was awarded a special travelling scholarship which commenced the following year. This provided Clarke with an opportunity to see and study stained glass in France.

Before returning to Dublin for Christmas, Clarke decided to seek commissions for his illustrating work. He called on publisher, George Harrap: 'He came into my room late in the afternoon, slim, pale and youthful, with the air of one who has had rebuffs. He opened his portfolio very shyly and with delicate fingers drew out his lovely drawings...'[23] The outcome of Clarke's visit was a commission to execute forty full-page illustrations (sixteen in colour) together with a number of headings, borders and decorative tailpieces for twenty-four of Hans Christian Andersen's *Fairy Tales*.

Harraps also commissioned four other works for illustration by Clarke. These included twenty-four black and white illustrations, as well as decorations for a deluxe edition of *Tales of Mystery and Imagination* by Edgar Allan Poe (1919), to be followed in 1920 by *The Year's at the Spring*. Dr. Thomas Bodkin, in his introduction to *The Fairy Tales of Charles Perrault* (1922) (which carried twelve colour, together with twelve black and white illustrations and other decoration by

Harry Clarke) strangely makes few references to the work of the illustrator. To supplement his income from Harrap, Clarke also executed a number of extra graphic commissions including the calendar design illustrated here and mentioned above. In 1914 at the R.H.A. exhibition, ten of his decorative illustrations were on display. Later, in 1924, Clarke was elected an associate of the R.H.A. and a full member the following year.

In Dublin the Rt. Hon. Laurence A. Waldron, P.C., a Governor of Harry Clarke's school, Belvedere College, had as early as 1913 provided the young artist with a commission to illustrate Pope's *Rape of the Lock* for which Clarke executed six pen and ink drawings. These drawings illustrate the same scenes as Beardsley and are highly derivative in style.

From 1918 until 1923, Clarke held a weekly class of graphic design and book illustration on Monday mornings at the Dublin Metropolitan School of Art. A student and later W.C.S.I. exhibitor, Nano Reid, recalls the scene:

'He taught in the Design Room and came and went without much talk or fuss. But it was wonderful to watch him draw when giving instruction. The ideas seemed to flow from the pencil like magic. He made drawings of the subject in hand, usually a poem. He always sat down and gave help by drawing himself and making a composition, leaving the choice of a poem or whatever to the student. He had his own particular style for water colouring which I've never seen since – on Bristol Board – using a special big flat brush to get an effect...'[24] In the view of Dr. John Turpin, Clarke's teaching contribution was vital: 'Clarke's many book illustrations and his teaching in the School established design for printed commercial purposes as an aspect of the curriculum.'[25]

In 1925 Harry Clarke was invited to join forces with two other book illustrators, Alan Odle (1888-1948) and John Austin (1886-1948), when their work was shown at the St. George's Gallery, London. A critic from *The Studio* remarked of Clarke's work:

'His drawings for book illustration

are distinguished by great technical mastery and are pre-eminent examples of the minute style of decorative composition. When he uses colour, he does so with a rare delicacy of feeling, and his work as a whole is remarkable for the depth and truth of its imaginative penetration.'[26]

The publication of an edition of *Faust* in 1925 saw the artist complete another commission for Harrap. His last recorded work as an illustrator was a series of black and white illustrations together with numerous decorations for *Selected Poems of Algernon Charles Swinburne* published in London (1928) by John Lane, The Bodley Head. In the N.G.I., there are six black and white drawings on card dated 1913 which the artist executed for a series of unpublished illustrations for Pope's *The Rape of the Lock*.

As previously mentioned, between 1916 and 1928 Harry Clarke had published nine sets of superb book illustrations which proclaimed his extraordinary originality and powerful imagination and his sheer technical skill. Clarke also found the time to translate his flair for design into such improbable objects as illustrating the Preference Stock Certificate of the Dublin United Tramway, handker-chiefs, textiles, bookplates, book wrappers, decorative schemes, Christmas and memorial cards. The book illustrations, although considered to be a vital and integral part of his career, might be considered something of an annexe to his contribution in the field of stained glass which became his central preoccupation throughout his tragically short life.

In 1926, Clarke became seriously ill. In October 1930, in orer to seek a cure, and accompanied by his friend, dramatist poet and theatre producer, Lennox Robinson (1886-1958) he set out for Davos, Switzerland. Returning from Davos in the New Year, he died at Coire on 6 January 1931. He was forty-one years old.

A retrospective exhibition was held in The Douglas Hyde Gallery, Trinity College in 1979 with a monograph-catalogue, entitled *Harry Clarke* written and compiled by his biographer, Dr. Nicola Gordon Bowe.

ELIZABETH 'BETTY' JOYCE RIVERS (1903-1964)

Following the death of W.C.S.I. member, Elizabeth Rivers, in 1964, distinguished stained glass artist, sculptor and painter, Patrick Pye wrote in a tribute to this artist's work:

'She would make the intellectual effort to enter into the vision of another...Her greatest encouragement was in the seriousness of her comment.'[27]

Since childhood Elizabeth Rivers had wanted to become an artist. Born at Sawbridgeworth, Hertfordshire on 5 August, 1903, she was the daughter of a well known nurseryman and gardener, Thomas Alfred Hewitt Rivers, F.R.H.A. (1863-1915). When she was eleven years old, her mother died: 'Thus during her formative years she did not have a close family life.'[28] Rivers began her art education at Goldsmiths College, London, enrolling for three years in 1921 and studying under Edmund J. Sullivan (1869-1933), a print-maker, illustrator and watercolourist. She also received lessons from influential wood-engraver and book illustrator, Noel Rooke, A.R.E (1881-1953). When Rivers left Goldsmiths, she gained employment in a commercial art studio.

In 1926, the artist was awarded a scholarship to the Royal Academy Schools and spent five years studying painting under a group of well known painters, including Sir Walter Westley Russell R.A., R.W.S. (1867-1949) and Walter R. Sickert (1860-1942). The latter was to have a profound influence on her work: 'I learned everything about painting from him'.[29] Rivers distinguished herself at the R.A. Schools by being awarded a number of medals and prizes. During this period, she managed to support herself by producing wood engravings, 'a tremendous bread and butter thing'.[30] The artist also embarked on a number of illustrations for publications such as Alfred, Lord Tennyson's *The Day-Dream* (1938) and Walter de la Mare's *On the Edge* (1930). When Rivers left the R.A. Schools in 1931, she spent three years in Paris studying under André Lhote, and collage and mural artist, Gino Severini (1883-1966), and

Elizabeth 'Betty' Joyce Rivers (1903-1964) *Far from the Madding Crowd* c.1930s. Wood engraving (third state). Inscribed 'EJR'.
COURTESY OF THE GORRY GALLERY, DUBLIN

as a student at the École de Fresque. Lhote introduced her to Synthetic Cubism (c.1912-1914), a style that would appear to have influenced River's work considerably, whilst Severini encouraged her to explore Divisionism. She also worked with Severini on several wall paintings gaining much practical experience. This was to stand her in good stead for the future when she was commissioned by the owners of the Zetland Hotel, Cashel, Connemara to design and complete a mural which would reflect the daily pattern of life in Conemara. Severini also taught Rivers how to produce cartoons from small preliminary sketches which was to assist the artist's work when she collaborated with Evie Hone H.R.H.A. (1894-1955) on a number of stained glass commissions.

In the mid-1930s, on the advice of a London picture dealer, Alex Reid (Lefevre Gallery), Rivers decided to seek a change in order to develop both her subject matter and her style. In 1935 she set out for the Aran Islands working on Inis Mór and recording scenes – the mackerel and seaweed harvests, hookers laden with turf, the Aran women shearing their sheep, Connemara ponies wandering desolately in search of a blade of grass – scenes which the painter gathered together for her one-man show held in London in February, 1939 and also her book *Stranger in Aran*.

Life on the island was not without danger. Recalling her first winter there, Rivers remembered how '...fascinated by a storm more tremendous that I had ever seen before, imagine my horror when I found myself cut off. I had to cling to a rock for eight hours with sea pouring over me every few minutes. It

was dusk when the tide receded. I struggled back to the shore, soaked to the skin.'[31]

Her friendship with Evie Hone began in 1946 and during the last nine years of her life, the stained glass artist was able to pass on her inch-scale designs to Rivers who developed them into full-size cartoons for stained glass windows. Rivers worked on the great eighteen-light window for Eton College chapel executed between 1949-1952 with Hone; it is interesting to note that little acknowledgement of this fact is made today by historians. Around this period there was a notable change in Rivers' approach to colour. From now on it was to become more dark and rich than in her previous work.

Following her election in 1940 as a member of the Society of Women Artists, three years later this artist began exhibiting with The Water Colour Society of Ireland, sending four works which included two nudes. On a somewhat irregular basis throughout the 1940s, '50s and '60s, this artist contributed a total of sixteen works to the Society's annual exhibitions including scenes painted in Provence (1950) and Gallilee (1960). Rivers continued to exhibit with the W.C.S.I. until the year of her death (1964).

In an interview with journalist, Marian Fitzgerald, for the *Irish Times* in 1962, and in response to the question - What do you get out of your work? Rivers replied:

'My work is a whole way of life. And my life is the food, the material out of which I make paintings and drawings and all the rest of it. I think all one's experience goes into a crucible and comes out. You have two selves, the one that experiences but there is also someone in the wings watching.'[32]

The artist spent the majority of her life living and working in Ireland with the exception of a short spell in Cornwall following the death of her close friend and fellow W.C.S.I. exhibitor, Evie Hone. Rivers' last one-woman exhibition was held at the Dawson Gallery, Dublin in May 1960 and included a number of designs for stained glass, possibly a tribute to her fellow painter.

In his introduction to her Memorial Exhibition held in Municipal Gallery of Modern Art in February 1966, Dr. James White, then Director of the N.G.I wrote: 'She seemed to reflect...this rhythm of shapes, the contours of life before her which seemed to be delicate contemplations of the finest side of people, devoid of cruelty, fear or hate...It might perhaps be said that she was primarily a draughtsman with a special gift for making the line conform to her mood...'[33]

DOCTOR ROBERT WYSE JACKSON M.A., LL.B., LL.D., Litt.D., D.D. (1908-1976)

In a tribute to the late Bishop, the Rt. Reverend, Dr. Robert Wyse Jackson, the Primate, the Most Reverend Dr. George O. Simms wrote:

'He had a warm-hearted personality with a friendly and spontaneous instinct for creating community. Often as Bishop of Limerick he would speak out for the whole community at a time when such a thing was rather unusual, calling for co-operation and a working together in way that was not passive... He was wonderful at bringing out the best in people and felt happiest when sharing in a project undertaken by many fellow workers. He spread confidence wherever he went.'[34]

Landscape painter and illustrator, Robert Wyse Jackson was born in Co. Offaly, the only son of Richard Jackson and his wife, Belinda Hester (née Sherlock). He was educated at the Abbey School, Tipperary, Bishop Foy School, Waterford and Drogheda Grammar School, Co. Louth. He graduated from T.C.D. in 1930 as a senior moderator in legal and political science, the following year the degree of LL.B was conferred. Whilst in College, Robert Wyse Jackson contributed a number of Indian ink drawings to issues of *The College Pen*, a college magazine of which he was an editor and a frequent contributor between 1929 and 1931. In 1932, he became a barrister-of-law in the Middle Temple. The following year he married Margaretta Nolan Macdonald. They had one son and one daughter.

It was while he was living in England that Robert Wyse Jackson decided to enter the church. He was ordained a deacon in 1934 and became a priest the following year. He was conferred with an M.A. followed by an LL.D. and a Litt.D. in 1939. Three years earlier, Robert Wyse Jackson had decided to return to Ireland. In 1942, he founded, together with a number of friends, the Limerick Arts Club while serving as Rector of St. Michael's Church, Limerick. Following his appointment as Dean of the Cathedral Church of St. John the Baptist and St. Patrick's Rock, Cashel in 1946, the club lapsed, only to emerge again in 1950 as the Limerick Art Society.

Elected a member of the W.C.S.I. at a meeting held at 19 Upper Mount Street on Thursday, 20 March, 1947, Robert Wyse Jackson exhibited one work that year entitled *Summer, Dunmore East*. He went on to contribute a total of forty-three works between 1947 and 1974. Exhibits included a number of portraits together with views in and around Cashel, Co. Tipperary, Co. Kilkenny, Achill, Wexford, Waterford, Mayo and the Dingle Penninsula.

Following the death of his wife in 1949, he married in 1952, Lois Margery Phair, a daughter of a former Bishop of Ossory, Dr. John Percy Phair. They had four sons and one daughter. In 1961, Robert Wyse Jackson was conferred with DD (jure dignitatis) and consecrated Bishop of Limerick, Ardfert and Aghadoe (1961-70). In the same year, he managed to find the time to paint and sent two exhibits to the W.C.S.I. annual exhibition: *St. Kevin's Kitchen* and *Ballyhack, Co. Wexford*. Despite a busy life, Robert Wyse Jackson continued to contribute to W.C.S.I. annual exhibitions throughout the 1960s and was also an exhibitor at the R.H.A. in 1971. He took an active part in the newly revived Limerick Art Society and was President until his retirement in 1970. Awarded a Freeman of the City of Limerick, Robert Wyse Jackson was the first Protestant to hold the honour since P.P.R.H.A. Dermod O'Brien in 1936. He retired to live at Greystones, Co. Wicklow and continued to write and publish widely.

Robert Wyse Jackson's articles in the *Church of Ireland Gazette* were

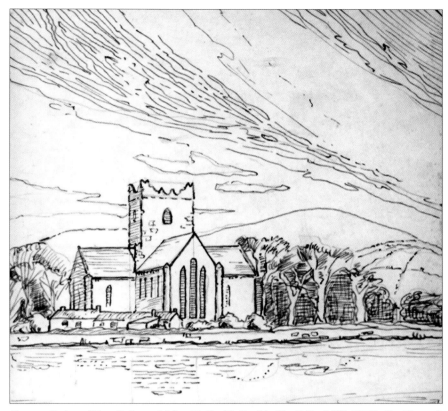

Doctor Robert Wyse Jackson M.A., LL.B., LL.D., Litt.D., D.D. (1908-1976) *St. Flannan's Cathedral, Killaloe, Co. Clare*, indian ink.

frequently accompanied by his own drawings. A recognised authority on literary figures including Oliver Goldsmith, (*Essays towards an Interpretation,* 1951), and in particular, Jonathan Swift (e.g. *Swift and His Circle,* 1945 reprinted 1970), he also made substantial contributions in the fields of local and Church of Ireland history — *Cathedrals of the Church of Ireland,* (1971) (text) with drawings by Mrs Donough Ó Brien, the history of silver, *An Introduction to Irish Silver* (1964) and law, e.g. *Pleadings in Tort,* (1933). Also a creative writer, Robert Wyse Jackson was the author of a number of novels including *The Journal of Corinna Brown.* He also wrote a play *Fair Liberty was all his Cry.*

When Robert Wyse Jackson retired, he did not sever his links with the Limerick Art Society. At the silver jubilee exhibition mounted by the Society in 1974 and opened by the President of Ireland, Erskine Childers, Robert Wyse Jackson submitted a number of works including *Across the Shannon* and *Limerick*. The previous

year, 1973, the artist held three one-man exhibitions: at the Molesworth Hall, Dublin; Thomond Antiques Gallery, Limerick (which included portraits of President Eamon de Valera and Bean de Valera, together with views of St. Mary's Cathedral, Limerick and the Augustine Abbey, Adare); and at the Cashel Palace Hotel, Co. Tipperary.

Affectionately known to his friends as 'Boney' he was a friendly, approachable and popular man throughout all his postings. A member of the Society of Antiquaries of Ireland, the R.I.A., the Friendly Brothers of St. Patrick, Dublin and a former president and an honorary life member of the Thomond Archaeological Society, Robert Wyse Jackson died on 21 October, 1976.

MARGARET MARY STOKES (1915-1996)

Wood-engraver, landscape and figure painter, Margaret Mary Stokes was elected a member of the W.C.S.I. at a

committee meeting held at 19, Upper Mount Street, Dublin on Thursday, February 22, 1940. Amongst the six committee members present was her first cousin, Mary Harriet ('Mainie') Jellett (1897-1944). From an early age, Stokes had been taught and influenced by Jellett who, living next door in Upper Pembroke Street, Dublin provided the young artist with art lessons. Margaret M. Stoke's great aunt was Margaret McNair Stokes, H.M.R.I.A. (1832-1900), a distinguished archaeologist and artist and considered to be '...an important scholar of early Christian art in Ireland and the first to consider its links with Europe'.[35]

Born into a well known Dublin medical family, her father, Henry, was a surgeon. The family lived at 32, Upper Pembroke Street, Dublin — the same house in which Margaret Stokes was to live until 1986. Between 1932 and 1935, Stokes was a student in the Royal Hibernian Academy Schools under Dermod O'Brien, P.R.H.A. Her fellow students included her lifelong friend, sketching companion, and fellow W.C.S.I. member, Helen Lillias Mitchell H.R.H.A. (1915-2000). In October 1935 Stokes registered as a student in the D.M.S.A. Later the artist went to London to study wood-engraving and drawing from life at the Grosvenor School of Modern Art in Pimlico, founded by painter and wood-engraver, Iain Macnab (1890-1967) and his wife, Helen Mary Tench. A representational artist, Macnab was more interested in the treatment of a subject than the subject itself and enjoyed to the full the limitations of wood-engraving. His style, which consisted of marrying modernism with tradition, would appear to have been adopted by the majority of his students including Stokes. Modernist in method and in the use of material, the design was always drawn, white line and black lines engendering one another, as seen here in Stoke's delightful woodcut of four mackerel swimming vigorously in the open sea.

Awarded the Purser Griffith Travelling Scholarship, this enabled the young artist to undertake a further period of study at Glasgow School of

Margaret Mary Stokes (1915-1996) *Mackerel*, woodcut, print 20 of 25. Inscribed in pencil 'To Petronelle & Peter. M. Stokes 1969'.

Art with distinguished art historian, Dr. Françoise Henry. Stokes continued her studies at the Edinburgh College of Art until she interrupted her art studies to become a nurse based in Edinburgh.

Whilst at the Edinburgh College of Art, Stokes worked under the supervision of teacher of printing and engraving, Joan Hassall (1906-1988). It would appear this artist preferred descriptive work to mere decoration and encouraged her students to draw no more than the outline on the surface to be engraved, the detail came from the burin. Stokes also had the opportunity to work closely with distinguished Scottish painter, Sir William G. Gillies (1898-1973), who, at that time, was a central figure in the artistic community of Edinburgh and was later to be appointed Principal of the Edinburgh College of Art in 1959. Gillies had studied in Paris under Cubist painter André Lhote but was later to be influenced by the Expressionist works of Symbolist Norwegian artist, Edvard Munch (1863-1944).

Following the artist's return to Dublin, Stokes organised her first solo show in 1944, which comprised a total of forty-seven works. It was held in the Grafton Gallery. There were twenty oils on display, seventeen watercolours and ten wood engravings.

As mentioned above, Stoke's links with the W.C.S.I. had begun as early as 1940. In the same year, the artist sent three landscapes to the Society's annual Exhibition. A consistent exhibitor, this painter exhibited a total of 149 works with the W.C.S.I. during the period 1940 to 1993. These included wood-engravings, book illustrations, together with figure and landscape studies featuring views in Crete, France, Italy and Connemara.

Employed as a teacher in the Froebel Department, Alexandra College, Earlsfort Terrace, Dublin, Stokes is fondly remembered by her past pupils. A small, petite woman, they marvelled at her extraordinary ability to wield heavy tools involved in the technique of wood-engraving. She also taught her students (generally on a one-to-one basis) how to select wood, explaining carefully how different grains produced different textures. A devoted and gifted teacher, she is remembered with affection by her many pupils.

Margaret M. Stokes exhibited at the R.H.A. and the Irish Exhibition of Living Art, (1943, and 1950). She was also a member of the Dublin Painters contributing to exhibitions throughout the 1950s. In an exhibition held in the Kennedy Gallery, Dublin in 1990, Stokes showed forty-four woodcuts, titles included *Monsoon Malindi*, *Lake Naivasha 11*, *Connemara Garden*, *Nude Wading* and *Bertraghboy Bay* together with thirty oil paintings.

Margaret M. Stokes died on 13 August, 1996. A year later in March, a retrospective exhibition took place in the Kennedy Gallery, Harcourt Street, Dublin. A large cross-section of the artist's work (78 exhibits) was on view comprising oils, watercolours, ink drawings, pastels together with a substantial collection of woodcuts. Reviewing this exhibition for the *Irish Times*, art critic Brian Fallon noted:

'Her basic idiom was "straight" and old-fashioned, at times conventional, with typical *plein air* effects and a good eye for light …she became highly adept at it; [woodcuts] …tree and animal studies are direct and strong and the female head *A Dubliner* is full of character.'[36]

Margaret M. Stoke's work is represented in the W.C.S.I. Permanent National Collection of the Water Colour Society of Ireland, University of Limerick, by a small woodcut entitled *The Connemara Garden* which she executed in 1984.

Chapter XVI

Water Colour Society of Ireland
Watercolourists Abroad

William Bingham McGuinness, R.H.A.
Lancelot Francis Sanderson Bayly
William Crampton Gore, R.H.A.
Beatrice Edith Gubbins

Letitia Marion Hamilton, R.H.A.
Margaret Murray Sherlock
**Arthur Gibney, P.P.R.H.A., Dip. Arch., F.R.I.A.I.,
R.H.A., Hon. R.A.**

WILLIAM BINGHAM McGUINNESS, R.H.A. (1849-1928)

The artist's name is mentioned for the first time in a catalogue relating to the twentieth exhibition held by the Irish Fine Art Society (later W.C.S.I.) at 35, Molesworth Street, Dublin in March-April, 1883. At that exhibition, Bingham McGuinness exhibited five works, four of which related to scenes in Bavaria, Brittany, Germany and Nassau. *Sketch in Limburg, Nassau; Street scene in Rothenburg, Bavaria; The Castle of Diez, on the River Lahn; Street Scene in Brittany*; and *Sketch in the Dargle Co. Wicklow.*

This painter was to become a prolific exhibitor with the Society contributing around 168 works and averaging three to four pictures each year in W.C.S.I. annual exhibitions. On occasions, Bingham McGuinness submitted as many as ten works. For example in 1910, landscapes included views along the banks of the Rhine, Venice, Holland, Belgium and France indicating a much travelled artist. In 1900 the artist's work caught the eye of the reviewer. *The Studio* commented: 'Mr. Bingham McGuinness deserves more than a passing mention. He is one of the most distinguished as well as one of the most facile of our water-colour artists, and showed several landscapes in which the skies were beautifully luminous, the effect being obtained without any apparent effort.'[1]

In March 1893, the W.C.S.I. catalogue for the thirty-eighth exhibition lists William Bingham McGuinness as being a member of the

W.C.S.I. committee. Other committee members included: Miss H. O'Hara, Miss H.K. Lynch, General Sir R.H. Sankey, K.C.B., Arland, A. Ussher, Miss M.A. Butler, Miss Keane, Miss Frances Keane, Miss Rose Barton, Miss Currey, and Secretary, Robert Clayton Browne (of Sandbrook, Tullow, Co. Carlow). However, the Society's minutes reveal that Bingham McGuinness was a somewhat irregular attendant at W.C.S.I. committee meetings and, apart from being a member of the Hanging Committee (from 1924 onwards), it would appear that this artist did not take an active part in the running of the Society's affairs, presumably due to his travels abroad.

Following the artist's death on 26 July, 1928 at 78, Grove Park, Rathmines, Dublin, W.C.S.I. members at their meeting held on 7 November, 1928 recorded:
'The committee stood while the following resolution of sympathy was read by the Chair, A.V. Montgomery, as drafted by Richard Caulfeild Orpen and passed unanimously: "The committee desires to convey to Mrs. McGuinness its sympathy at the loss of her husband, Mr. Bingham McGuinness, for many years a member of the committee, he was always a consistent contributor to the Society's exhibitions and assisted at the hanging of exhibits. The Society feels that it has lost a member whose work was always representative of the best traditions of Water Colour drawing."'[2]

In the early part of his life, William Bingham McGuinness was fortunate to be apprenticed to a Dublin architect,

John Skipton Mulvany, R.H.A. (1918-1870), the son of landscape and figure painter, Thomas James Mulvany, R.H.A. (1779-1845), which provided him with a sound sense of draughtsmanship and an ability to look at buildings with the eye of an architect/artist. Whilst working as an apprentice, he also attended evening classes at the R.H.A. He later travelled to Dusseldorf, Germany where he continued his studies concentrating, in particular on the medium of water-colour. Somewhat unusual among Irish artists of the period, Bingham McGuinness began to travel widely throughout the 1870s, particularly in Westphalia and Normandy. *The Tower of St Romain Church, Rouen, from Rue Horlogue,* illustrated here, was painted in 1878, a picturesque view of the tower of the late Gothic church of St. Romain. Later, this scene was to change dramatically. In 1944, due to the Allied liberation of the city, the tower was severely damaged. The picturesque timber-fronted houses and shops with their pretty, bright awnings which lined this attractive street, the Rue Horloge were also destroyed.

This type of accomplished picturesque view was highly popular in the nineteenth century. They were frequently transformed into print in order to satisfy a steady and lucrative market. Samuel Prout's, O.W.S. (1783-1852) *Sketches in France, Switzerland and Italy*, published in London in 1839, ensured a steady demand for scenes such as this: picturesque architecture, jostling streets and market places. Many influential English watercolourists, for example Richard Parkes Bonington (1802-1828),

William Bingham McGuinness, R.H.A (1849-1928) *The Tower of St. Romain Church, Rouen, from Rue Horloge* 1878, watercolour with white highlights. Signed and dated 'Bingham McGuinness 1878'. Inscribed: lower right 'Rouen St. Romain'.

Lancelot Francis Sanderson Bayly (1869-1952) *A scene in Tahiti* 1939, watercolour. Signed 'Lancelot Bayly 1939'.

his pupil Thomas Shotter Boys, N.W.S. (1803-1874), and in turn, his pupil and follower, William Callow, R.W.S. (1812-1908), produced watercolours and lithographs of picturesque views of European cities and towns throughout the nineteenth century on a regular, reasonably profitable and prolific basis.

A regular exhibitor at R.H.A. exhibitions from 1866, William Bingham McGuinness was elected an A.R.H.A. in 1882 and a full member in 1884. The following year, *The Dublin University Review* noted that 'Mr Bingham McGuinness is the only member of the Academy who has won his position as an exponent of this beautiful and delicate art...'[3] A hard worker, the artist appears to have held one man exhibitions throughout the 1880s in his studio, 6 St Stephen's Green, Dublin, which succeeded in attracting the attention of the press. Bingham McGuinness joined the Dublin Sketching Club in October

1874, the year of its foundation, and eventually was elected President. In 1895, the artist was made an honorary member of the Belfast Art Society.

In 1902 Bingham McGuinness was living in London and exhibiting at the Dudley Gallery, the Royal Institute of Painters in Watercolours and Agnew & Sons Gallery. He also exhibited his work further a field in Birmingham at the Royal Society of Artists and the Walker Art Gallery, Liverpool. At the invitation of Sir Hugh Lane, he participated in a prestigious exhibition of works by Irish artists held in 1904 at the Guildhall, London. A long-time friend, J.B. Hall wrote: '...his favourite theme, so to speak, was to be found in the old vistas of Continental cities...' In his view, he was 'a man of endearing qualities. He was of a singularly modest and retiring disposition, a kindly critic of others, and students of the Academy and amateurs ever found him a willing, earnest helper...'[4]

LANCELOT FRANCIS SANDERSON BAYLY (1869-1952)

Lancelot Francis Sanderson Bayly is first recorded as being a member of the W.C.S.I. committee at a meeting held at 61, Merrion Square, Dublin on 7 February, 1922 together with fellow committee members, Sir Nevile Wilkinson, Helen Colvill, Henrietta Lynch and W. Montgomery (Chair). From 1922 until 1930, Bayly's name frequently appears in the Society's minutes both as a committee member and member of the W.C.S.I. Hanging Committee. However, his links with the Society had begun as far back as 1910 when the artist exhibited two views, one of the bridge at Pont Aven, Brittany and the other near Vareve, Italy in the W.C.S.I. annual exhibition. Bayly became a keen supporter of the Society, exhibiting on average two to three watercolours per year until 1934, a total of 105 works.

When one looks at the catalogue titles, it is easy to see that here was a much travelled artist – scenes recorded in Munich, Tahiti, Rothenburg, Madeira and Martinique provide the evidence together with works painted in England and throughout Ireland.

Born on 16 October, 1869 at the family home, Bayly Farm on the outskirts of Nenagh, Co. Tipperary, Lancelot Francis Sanderson Bayly was the son of Lancelot Gilbert Alexander Bayly and Frances Katherine (née Luby). The couple had married on 26 June, 1869 and had three children, their eldest daughter, Violet, dying in infancy. Lancelot, together with his sister, Lydia, spent his early childhood on the family farm. After the tragic death of the young boy's father at the age of twenty-eight on 4 June, 1871, the family went to live in Dresden where the young boy attended school until the age of fourteen. He was then sent to Rugby but disliked it so much that after four terms he ran away. He returned to Dresden to complete his education.

Around the age of twenty, the family decided to live in Paris where as a young student Bayly attended the Paris Conservatoire and became part of a lively artistic and musical circle. He was both a talented amateur pianist and flautist and wrote about the latter in *Musical Opinion*.[5] He also enjoyed painting in watercolour. He remained in Paris until the death of his mother on 25 June, 1905. Always an enthusiastic traveller, the artist embarked on a world tour which was to last about three years during which time he wrote two science fiction books – *Across the Zodiac: A story of Adventure* (1896) and *Adventures of a Micro-Man* (1902?) – and a third relating to the South Pacific, *The Log of an Island Wanderer*, (1901), all under the pen name, Edwin Pallander.

Following his second marriage on 29 April, 1912 to Eileen Maude Bayly, daughter of Captain John Prittie Bayly and Annie Warburton, the couple spent part of their honeymoon on the island of Tahiti. Evidence of the artist's stay is expressed in this Tahitian watercolour illustrated here, where the artist employs bright, strong colours coupled with a skilful use of light and shade in order to capture this island paradise on a hot, cloudless day. Two further watercolours relating to the island were exhibited in the W.C.S.I. annual exhibition in 1915 (*Near Papeete, Tahiti*) and in the R H.A. exhibition held in the same year, *On the Beach, Tahiti*.

Before Bayly left Ireland to live in Wiltshire in 1930, he held an exhibition at Combridge's Galleries, Dublin. Five years later, the United Society of Artists exhibition included his Kerry coastal scene in their exhibition held in London in 1935. The artist died at the age of eighty-three on 4 December, 1952. His work is represented in the National Gallery of Ireland.

WILLIAM CRAMPTON CRAWFORD GORE, R.H.A. (1871–1946)

The name of interior, portrait, and landscape painter, William Crampton Gore is mentioned in the W.C.S.I. exhibition catalogue in 1904 and 1905 when the artist sent a total of five pictures from Glenbrook, Enniskerry, Co. Wicklow. The only son of Captain William Gore, 13th Hussars, of Fedney, Co. Down and Innismore Hall, Enniskillen, Co. Fermanagh, his mother, Dorothea, was the daughter of the Reverend J. Crampton, and the grand-daughter of well known Dublin surgeon, Sir Philip Crampton, Bart., F.R.S.

Gore (known to his friends as 'Ruddy Gore') read medicine at Trinity College, Dublin, qualifying in 1897. He practised until 1901 and then decided to abandon the medical profession and instead turned his attention to art. Gore had already spent four months studying with Henry Tonks at the Slade School of Fine Art, London in 1898. Two years later, he returned to the Slade and, in between painting, travelling abroad and receiving some art lessons in Paris, the artist spent a total of five years at the Slade.

From childhood, Gore had known and been a friend of the Orpen family and admired the work of Sir William Orpen. In December 1900 until March 1901, Gore rented a studio from a friend, Herbert Everett at 21 Fitzroy Street, Fitzroy Square 'which was known as The Newcombes…'.[6] Orpen, then around twenty years of age, was his neighbour and rented his own studio downstairs in the basement. Whilst Gore was attending the Slade in the mornings, Orpen asked if he might use Gore's studio. It was here that Gore was persuaded by Orpen to pose as the model for the doctor in *A Mere Fracture*: 'I posed twice for about 10 minutes. ….Orpen said to me, "Have a look at that leg, as if you were examining it for a fracture". No sooner had I started examining it than he cried, "Stay like that! That's magnificent!"'[7]

Despite his admiration for Orpen, Gore would appear to have been influenced to a greater extent by the work of Walter Osborne. Art critic Edward Sheehy noted this and wrote in *The Dublin Magazine* that Gore's work possessed 'a quiet and comfortable charm achieved through warmth of colour and smooth, apparently effortless painting' combined with 'a rich sense of colour somewhat reminiscent of Pissarro and at times of Osborne, especially in his interiors. There is a rightness and absence of strain in his compositions…'.[8]

Gore's interior, illustrated here, entitled *The Green Shutters*, depicts his wife, Yvonne Madeleine (only daughter of Leon Farine, late Lieutant and Adjutant 30 regiment d'artillerie), whom he had married in 1923, and daughter, Elizabeth ('Betty'). Painted at 44 Rue du General Potez, Montreuil-sur-mer, where he settled a year after his marriage in 1923, this interior possesses a quiet and comfortable charm achieved through warmth of colour and smooth, effortless painting.

Despite living abroad for the greater part of his life, Gore never severed his links with Ireland, contributing two works - *A Village Fair by Night* and *On the Sands* – to the Munster-Connacht Exhibition held in Limerick in 1906. A year earlier, he began exhibiting at the R.H.A., becoming an associate

William Crampton Crawford Gore, R.H.A. (1871-1946) *The Green Shutters*. 1921, oil. Interior with the artist's wife, Yvonne, Madeleine (née Farine) and young daughter, Elizabeth ('Betty'). Collection: James Adam & Sons, Dublin.

member in 1916 and a full member in 1918. He continued to exhibit at the Academy until 1939 contributing over one hundred works. The majority of pictures appear to have been despatched (in the 1920s) from his home in Montreuil-sur-Mer, France: *Snow at Montreuil* (R.H.A., 1927) *Springtime in Picardy* (R.H.A., 1927), *Interior–The Open Window* (R.H.A., 1930). A friend and relative of Dermod

O'Brien, P.R.H.A., Gore returned from France to spend a holiday in 1915 painting with O'Brien and George W. Russell, A.E. (1867-1935) in Co. Donegal. During World War I, the artist served as a captain in the Royal Army Medical Corps and as a member of the British Red Cross.

From 1932 onwards, Gore and his wife lived in Colchester, Essex. In that year, he despatched three paintings to

the Oireachtas Art Exhibition, including two flower pieces. Later, in the 1940s, Gore was to assist the R.H.S. in helping to organise one of the earliest known exhibitions of flower and garden paintings to be held in the Dublin Metropolitan School of Art.

Whilst living in England, the artist continued to paint and also found time to serve at the Military Hospital until 1940, when, due to injuries he received

from a road accident, he was forced to spend the rest of his life on crutches.

During his career, this artist saw his work hung in the Paris Salon, (*The Times* noting shrewdly that 'Mr William Gore has the genius to paint what he sees'), the Royal Academy (two works) and the Royal Scottish Academy (one work), together with a number of societies and commercial art galleries.[9] A composer, Gore also published various songs and incidental music, including *A Garden Pastoral* (based on the *Hesperides* of Herrick). The artist died aged seventy-five on 10 January, 1946 at the Essex County Hospital.

BEATRICE EDITH GUBBINS (1878-1944)

Landscape and figure painter, Beatrice Edith Gubbins travelled widely during her life-time – her watercolours record views in Italy, Corsica, Sicily, Spain, Avignon, Morocco, the West Indies, Algeria, Tunis and Portugal – and her travels are reflected in the titles of her pictures exhibited each year with the W.C.S.I. from 1913 to 1931, such as *Enkhinger* (1913), *Calir* (1927), *Corte* (1927), *Sorrento* (1928), *The Oudaija, Rabat* (1930). She also exhibited a total of thirty-six works at the R.H.A. beginning in 1897. It would appear from the R.H.A. titles that there was a larger entry relating to views recorded in Ireland and the south of England rather than on the continent.

Beatrice E. Gubbins was born at Dunkathel, Glanmire, Co. Cork. A handsome house built in the Palladian manner, it occupies a superb position on a hill facing south across the river Lee where it widens to embrace Lough Mahon. The youngest of two brothers and five sisters, her father, Thomas Wise Gubbins, had bought Dunkathal c.1883 when he took on the responsibility of running the Wise distillery at North Gate, Cork. Beatrice's family life was inextricably bound up with the church and the race track (her brother bred the winners of two Derbys). However, she also found time to record the everyday scenes she saw around her both in her watercolours and in her meticulously kept diaries.

However, the diaries reveal little about this artist's early art training but it is believed she may have studied at the Crawford School of Art, Cork. Gubbins travelled extensively during the period 1893-1911 (including three visits to Paris in the spring of 1901-1903) and, significantly, she made a visit to Barbizon in the summer of 1902, both sketching and recording.

The First World War found the artist undergoing intensive training as a nurse attached to the Tivoli Hospital, Cork. In January, 1917 Gubbins left for Exeter, Devon to take on the harrowing task of caring for the convoys of injured arriving daily. To keep up her spirits, she cycled all over the Devon countryside sketching and painting but longing for the day when 'this awful war is at an end'.[10]

Gubbins returned to Dunkathel in 1919 and, despite caring for her mother during the next seven years, she also managed to find the time to travel extensively. The painter's diaries provide a fascinating insight not only into the people and places she encountered but also record in minute detail the problems faced by a female traveller on the continent in the early part of the twentieth century. In Corsica in 1922, the artist tells how she took a motor tour around the island, (she being an avid motorist):

'We're very glad to be back safe and sound…having nearly been upset once to avoid a collision round a corner, nearly killing a dog, a goat and a man! Not a bad record for one day!'

Her visits to Avignon and Morocco in 1929 provided this painter with some of her most prolific works including many examples of the street life of Moroccan towns and villages together with a number of figure studies.

When studying Gubbins' prolific output, largely in watercolour, it is interesting to note that when this artist's work is placed alongside that of W.C.S.I. professional watercolourists such as Rose Barton or Mildred Anne Butler, she must be considered as a talented amateur watercolourist. Gubbin's style, charming, competent and attractive, was to remain consistent throughout her career with no clear stylistic development taking place. However, the artist's knowledge of how to explore and exploit the technical possibilities of the medium of watercolour for various effects is shown to advantage in her street scene composition illustrated here and titled on verso: *A sunny morning, Granada*, dated 'Dec. 1905'. Employment of simple washes provide various gradations of light which serve to enhance the various architectural elements and succeed in creating both interest and solidarity.

Unlike the W.C.S.I., which it would appear Beatrice Gubbins took no active part in running, she was an active and energetic member of the Queenstown Sketch Club. Appointed Hon. Secretary around the turn of the century, Gubbins ran a tight ship. Fines were strictly imposed: Rule 5 states that sketches 'were to reach the Hon. Sec. Before the 1st of the month for which they are intended. When no sketch is sent a fine of 6d to be paid'. Rule 7 made it clear that members 'may criticise and give a maximum of 3 votes to each sketch (their own excepted). Votes and criticisms to be signed with pseudonym'. Today, several watercolours by Beatrice Gubbins still retain the various pseudonyms which she used as a member of this sketch club, and are inscribed: 'Benjamin', 'Jessamine', 'Greyhound'.

Towards the end of her life, the artist tended to concentrate on domestic scenes and landscapes in and around her home, Dunkathel – harvest scenes, labourers at work, still-lives, cottage and garden scenes – many of which now form part of the collection housed in the Crawford Art Gallery. The artist was the first of her sisters to die. She passed away at the age of sixty-six years at Dunkathel on 12 August, 1944 and was buried on Little Island. An exhibition of Beatrice Gubbin's work was held at the Crawford Municipal Art Gallery (now known as the Crawford Art Gallery) Cork, in April/May 1986.

LETITIA MARION 'MAY' HAMILTON, R.H.A. (1878-1964)

Born on 20 July, 1878, landscape painter, Letitia Marion 'May' Hamilton

Beatrice Edith Gubbins (1878-1944) *A sunny morning,* Granada, 1905, watercolour. Inscription on verso '"A Sunny morning" by B.E. Gubbins Daunkathel Glanmire Co. Cork Granada Dec.1905'. PRIVATE COLLECTION

was a younger sister of Eva Henrietta Hamilton, another child in the large family of Charles Robert Hamilton, M.R.I.A. and his wife, Louisa, of Hamwood, Dunboyne, Co. Meath. She was educated at Alexandra College, Earlsfort Terrace, Dublin and like her sister studied under William Orpen at the Dublin Metropolitan School of Art, and with Frank Brangwyn at Chelsea Polytechnic, completing her studies at the Slade School of Fine Art It has been suggested that this artist was influenced not only by portrait painter and illustrator, John Butler Yeats, who taught her for a short period whilst she was still in her teens, but also by professional W.C.S.I. watercolourists such as her cousin, Rose Barton, and friend, Mildred Anne Butler.

Letitia Hamilton began exhibiting

with the W.C.S.I. in 1902 and sent just one entry that year, *An Old Garden*. In the early part of her career the artist was exhibiting under the name May Hamilton. On 8 April, 1925, proposed by Henrietta Lynch, and seconded by Helen Colvill, Letitia Hamilton was elected a member of the W.C.S.I. committee. A year later in March, she became a member of the hanging committee. Letitia Hamilton frequently acted as Hon. Secretary or took the Chair at meetings. Throughout her life, she remained an active and energetic member of the Society exhibiting a total of 235 works between 1902 and 1964, and frequently submitting up to eight pictures in any one year (e.g. 1926). W.C.S.I. titles provide evidence of an artist who travelled widely: *Montreuille* (1910), *The Flower Market, Amsterdam* (1916), *The Doge's Palace* (1924), *Florence from Fiesoli* (1926) , *La Charite sur Loire (*1931), *S. Pietro in Castello* (1934), *Riva Lake Garda* (1950), *A Canal in Venice* (1961). Until a few years before her death, Letitia Hamilton regularly attended meetings, her final contribution being made in December 1957.[11]

During early part of her career, this artist's work 'was typical of the lady amateur of the big house, cultivated, accomplished, constrained'.[12] In October 1907, Letitia Hamilton entered the Dublin Metropolitan School of Art. Between 1907 and 1920 the artist received a total of five years' training. Orpen's influence on this young student appears to have been less dominant than on that of her elder sister, Eva. Letitia Hamilton learned how to draw effectively employing a strong, confident line. She also learned how to examine buildings and nature with a new eye. At this stage in her career, Letitia Hamilton's watercolours remained reasonably conservative and saw her employing a simplification of forms and shapes together with the use of a limited palette.

Determined to progress beyond the boundaries of representation, the artist visited Montreuil in 1910, possibly in the company and under the guidance of her art teacher and W.C.S.I. exhibitor, Anne St. John Partridge,

R.I., R.B.A., S.W.A (fl.1888-1936). The latter taught at the Chelsea Polytechnic and each summer took her students to France in order to paint. (In that year, 1910, Anne St. John Partridge exhibited her own work for the first time at the W.C.S.I., sending a view of Montreuil). It has been suggested that around this period, Letitia Hamilton may also have become interested in impressionism. However, it would appear from her later work that although she did not study, as far is known, under contemporary French painters, such as Raoul Dufy, she was influenced by this artist and also by Irish painters such as landscape and portrait painters, Paul Henry, and Roderic O'Conor (1860-1940).

Following the death of her father in 1913, a major turning point in this artist's life, Letitia, together with her sisters, moved out of the family home, Hamwood, and into a house in Lower Dominic Street, Dublin. It is generally felt Letitia Hamilton's style reached maturity around the 1920s but this is difficult to establish as so many of her paintings are undated. A founder member of the Dublin Painters (1920), in 1922 her work *An Irish Town* was accepted and hung in the Royal Academy, London. At this point in her career, the artist possessed in the view of art historian, Dr. Hilary Pyle: '[a] professional way of working, sketching initially in oil on small boards, rather than using a sketchbook, and developing her scenes subsequently on canvas.'[13]

In February 1924, together with her elder sister, Eva, the artist exhibited a number of Venetian scenes in the Stephen Green Gallery, Dublin. Titles included *La Salute, The Courtyard of the Doge's Palace,* and *Palaces on the Grand Canal.* The sisters succeeded in capturing the attention of the critic of *The Studio:*

'Miss Eva Hamilton has hitherto been known principally as a clever portraitist, and Miss Letitia Hamilton as a sincere and able painter of somewhat sombre scenes in the Irish Midlands. These Venetian pictures were the first works of the kind which either of them has produced, and were warmly and deservedly admired.[14]'

The artist's visit to Venice in the company of sketching companion, Ada Longfield, Longueville, Mallow, Co. Cork, had created this new burst of creativity. The Longfield family were fortunate enough to own an apartment in Venice and allowed the two Hamilton sisters to make use of it together with a gondola studio. Eventually, Letitia Hamilton was to own her own studio in Venice. From 1924 onwards, Hamilton began to exhibit scenes set in Venice at the W.C.S.I. annual exhibitions. Titles included *Rialto Bridge* (1924), *The Bridge of Sighs, Venice* (1926), *Salute Venice* (1926), *A Venetian Arch* (1934), *Gondola* (1934), *The Grand Canal* (1936), *The Pink Bridge, Venice* (1937), *A Canal in Venice* (1961 & 1962).

The artist's Venetian scenes, executed in the 1920s and 1930s were, in Pyle's view:

'… her most exciting and accomplished work, here the artist was at ease, experimenting with colour, form and light…Her Venetian palette had original combinations of rich or pastel colours, her shadows and water reflections were often Munch-like in their idiosyncrasy. When she drew on canvas, she used her paint economically, and strengthened the charcoal line afterwards so that it contributes a soft, graphic effect to the whole…Venice was a challenge for her and truly captured her imagination.'[15]

The Venetian scene illustrated here displays bold, confident brushwork combined with the use of a palette knife in order to create a heavy impasto. The expressive manipulation of paint shows this artist handling the use of rich colour with assurance, the emphasis being placed on colour and light, factors which succeed in creating an exciting, atmospheric and imaginative work.

Following Hamilton's visits to Venice and having experienced the unique light of the city, her palette became more muted, the artist frequently employing soft pale colours, particularly when it came to watercolour seen in her depiction of the Irish landscape, or in her numerous recordings of Irish fairs, markets, hunt or race-meetings

Letitia Marion 'May' Hamilton, R.H.A. (1878-1964) *Venetian scene*, oil. PRIVATE COLLECTION

Letitia Hamilton's first solo exhibition was held in London in January 1926 and was highly successful, the artist being hailed as one of the most innovative painters. From 1925 to 1928 she exhibited at the Paris Salon. Whilst in Paris, Hamilton must have become aware of the work of Polish artist, Vladimir de Terlikowski (1873-1951), who was well known for executing his pictures with a palette knife only. However, she always stoutly maintained that she discovered this technique herself. 'Her own effect was achieved by laying her colours out on the palette, scooping them up with the knife and spreading them together in one sweep on the canvas.'

In 1944 *The Dublin Magazine* reviewing Hamilton's paintings which formed part of an exhibition entitled 'Recent Paintings of Ireland' held at the Waddington Gallery in October/November, 1943, recognised her technical achievements with the palette knife but felt she had overstepped the mark: 'Letitia Hamilton is technically accomplished as a painter... Her excessive use of the palette knife, a predilection for the most sugary tones and a superabundance of white, inevitably suggest the confectioner's.'[17]

A consistently hard worker, Letitia Hamilton exhibited each year at the R.H.A. from 1909 to 1919 submitting a total of over 200 works. At the Olympic Games art section in London in 1948, she was awarded the bronze medal for her work entitled *Meath Hunt Point-to-Point Races*. A frequent exhibitor with her sister, Eva at The Dublin Painters' Gallery from 1930, she also found time to exhibit her work at the Belfast Art Society (from 1927), the Oireachtas Art Exhibition (1920 onwards), the Irish Exhibition of Living Art (1943 onwards), the Beaux Arts Gallery, London, and at the Dawson Gallery, Dublin.

Her sister, Eva, exhibited at the W.C.S.I. for the last time in 1950. Letitia carried on painting, her work filled with vitality and life. The Dawson Gallery held an exhibition of the artist's work in March 1963, which was highly successful with every picture sold. In the year of her death, Letitia Hamilton sent two pictures to the annual W.C.S.I. exhibition. The artist died in hospital on 10 August, 1964.

In an appreciation published two days after her death, the *Irish Independent* commented: 'She really belonged to the world of Somerville and Ross, but she preferred to swap the hunting crop for palette knife and easel... She remained young at heart, and was able to take all the changes of life and custom that befell her in her stride.'[18]

MARGARET MURRAY SHERLOCK (née Ross) (1885-1966)

Margaret Murray Sherlock began exhibiting in 1913 with the W.C.S.I.,

Margaret Murray Sherlock (née Ross) (1886-1966) A *street scene in Srinagar, Kashmir* c.1917, watercolour.

PRIVATE COLLECTION

Clarinda Park West, Kingstown, Co. Dublin, Margaret Murray Ross was the daughter of William Ross of Ross and Walpole, iron and brass founders, engineers, and boilermakers, 65-67 North Wall Quay, Dublin. By 1903, the family had moved to Summerfield, Dalkey, Co. Dublin. In October, Margaret enrolled as a pupil of William Orpen at the Dublin Metropolitan School of Art. With the exception of October, 1904-July 1905, the artist attended the School until 1910, and was awarded several prizes. Three years later her work was shown for the first time at both the W.C.S.I. (see above) and the R.H.A.

Captain Sherlock was killed in Mesopotamia in 1917 and his wife was unable to return to Ireland until 1919. In 1926 the artist renewed her connections with the W.C.S.I. and exhibited two views, *Autumn, Kashmir* and *Snow Sketch, Switzerland*. A journey to India was undertaken in 1933 and again in 1936. A member of the Dublin Sketching Club, three of Sherlock's pictures were included in their 1937 exhibition: *Les Deuts de Midi, Morgins, Switzerland* and *Nauchandi Fair*.

During the last thirty or so years of her life, this artist's work tended to disappear from the Irish art scene. She died on the 7 January, 1966 at the Portobello Nursing Home, Dublin.

ARTHUR GIBNEY P.P.R.H.A., Dip. Arch., F.R.I.A.I., R.H.A., Hon. R.A. (1933-2006)

At the early age of seventeen, Dubliner Arthur Gibney was determined to become a painter and was reluctant to opt for the 'permanent, pensionable' culture of the 1950s. He studied architecture at the School of Architecture, Bolton Street, Dublin in the late 1950s and was successful in being awarded a number of prizes and a travelling scholarship. Almost from the beginning, Arthur Gibney seems to have been permanently to the forefront in the field of architecture. In the 1960s, together with the late Sam Stephenson, he won the Electricity Supply Board competition for the new Head Office, Fitzwilliam Street, Dublin. The designs

submitting two pictures (*Chungla Bazaar, Muree Hills* and *Brass Walah*) in the annual exhibition. The following year two views painted in India were on view (*At Muree, India* and *Balum Bazaar, India*).

In 1910 Margaret Murray Ross had married Captain Charles Sherlock from the Army Medical Corps and they left Ireland to live in India. True to tradition, summer was spent in the hills and winter on the plains. The artist had a particular liking for Kashmir and recorded in watercolour the meadows filled with wild flowers, the attractive

temples, house-boats anchored on the still lakes surrounded by lilies and street scenes, such as the one illustrated here, recorded in the capital, Srinagar, the Lake City. This watercolour, executed around 1917, demonstrates the artist's ability to carefully arrange planes of light and shadow which succeed in articulating this street scene to great effect. Within this framework, colours are loosely and delicately applied, the figures contributing to the sense of a busy, bustling street in the capital.

Born on 1 November, 1885 at 17

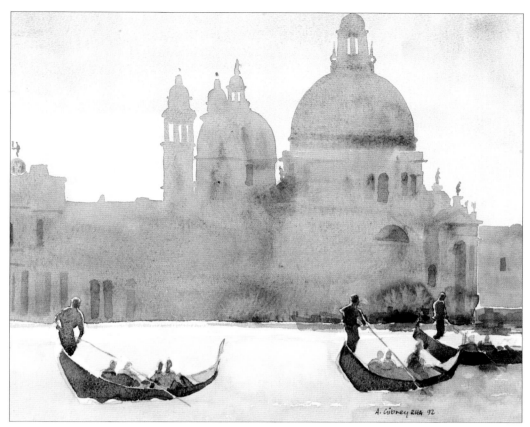

Arhtur Gibney, P.P.R.H.A., Dip. Arch., F.R.I.A.I., R.H.A., Hon. R.A. (1933-2006)
Morning Light, Venice 1992, watercolour. Signed 'A. Gibney RHA '92'. This work was exhibited in the 1992 W.C.S.I.
annual exhibition (cat. no. 76).

were exhibited in the R.H.A. in 1963.

Assistant to architect Michael Scott between 1958–61, he became a partner in Stephenson Gibney and Associates in 1961. Amongst his many prestigious commissions was the Irish Management Institute, Sandyford, south Co. Dublin for which he was awarded the R.I.A.I. Triennial Gold Medal in 1974.

Two years after his marriage to distinguished stained glass artist Phyllis Burke in 1961, he founded his own practice. He completed a number of substantial projects abroad, including a hotel in Dharan, Saudi Arabia and the Irish Embassy in Riyadh. Amongst his well known commissions in Dublin was the elegant refurbishment of Dr. Steevens' Hospital for which he was awarded the Europa Nostra Award for Conservation (1994). Other commissions included the relaxed, comfortable interior he created for the Patrick Guilbaud restaurant, Merrion Hotel, Dublin.

In the 1980s Arthur Gibney was elected president of the R.I.A.I.; he served as a member of the Arts Council and as a member of the board of the N.G.I. In the 1990s he was elected President of the R.H.A. His obituary in *The Irish Times* records:

'Every year in the election to the Council of that body, he comfortably headed the poll. Similarly the fact that he was president of the R.H.A for nine consecutive years emphasised not only the measure of the regard in which he was held, but also the practical gifts that he brought to the running of such a body.'[19]

Arthur Gibney's love of painting in watercolour stayed with him all his life, his urban landscapes being largely executed in watercolour and his figurative work in oil. A pupil of Maurice MacGonigal at the N.C.A.D. between 1961-63, he returned there again in the latter part of his career to study sculpture (2005). Elected a member of the W.C.S.I. in 1984, he began exhibiting the same year with two entries: *Quayside, Venice* and *Orvieto*. During the next ten years he exhibited a total of twenty-two works, including four Venetian views, a number of scenes in Kerry, studies of Trinity College, Dublin, together with a portrait and a nude. 'His painting was, in its apparent simplicity and beauty on much the same lines as his architecture and no matter how many times he painted the church of Santa Maria delle Salute in his beloved Venice, he always found something new.'[20]

Perhaps being able to bring about change in whatever field he chose to tackle was Arthur Gibney's greatest legacy.

Chapter XVII
Water Colour Society of Ireland
Stained Glass Artists

Beatrice, Lady Glenavy, R.H.A. (née Moss Elvery)
(Mrs Beatrice Campbell)
Evie Sydney Hone, H.R.H.A.

BEATRICE, LADY GLENAVY, R.H.A. (née Moss Elvery) (Mrs Beatrice Campbell) (1881-1970)

'When I gave up going to the School of Art, Sarah Purser, who was already ready to help young artists, built a corrugated-iron studio in the yard of her Stained Glass Works… Sarah Purser suggested that I should do stained glass. Orders were pouring in and she wanted workers. She had imported a stained glass artist from London and made him her manager… I became an employee at the Stained Glass Studio at a wage of nine pence an hour. I put away my clay and my modelling-stands and used my tin studio as a place for drawing cartoons for windows; all the other parts of window-making I did in the large Stained Glass Studio across the yard… I did many windows during my years at the Stained Glass Studio. I think my best ones are a Good Samaritan in Carrickmines and a Crucifixion in a tiny church on Tory Island. They are rather like colour illustrations to a child's book.'[1]

Beatrice, Lady Glenavy was elected a member (Mrs Beatrice Campbell) of the W.C.S.I. at the Society's committee meeting held on 27 April, 1921 and began exhibiting her work in the same year.

Beatrice Moss Elvery, the second of seven children of a wealthy Dublin businessman, (John) William Elvery (d.1934), spent part of her early childhood on the outskirts of Dublin, namely Carrickmines an area which she described in her autobiography as being 'a wild and lonely place'.[2] The Elvery family were somewhat frowned upon by their neighbours, as, 'being in trade' they were considered to be not quite up to the mark: 'A little girl said to me, "We are not allowed to play with you because your father has a shop".'[3] Beatrice Elvery's mother, Theresa Moss (d.1925) may have been a pupil in the Dublin Metropolitan School of Art. Two daughters, Dorothy (Kay) and Beatrice, both became D.M.S.A. students. Beatrice Moss Elvery entered the D.M.S.A. in October 1899 and was to spend in all a total of five years there becoming a pupil of the Instructor in Modelling at the School, sculptor John Hughes, R.H.A. (1865-1941). She was awarded the first studentship for modelling and was also awarded a number of prizes and scholarships which enabled her to study at the National Art Training School, South Kensington. When this young, imaginative, strong-willed student arrived in the School, Sir William Orpen was completing his final year. He was to remain a lifelong friend and admirer: 'There was one [artist] who stood out alone – Beatrice Elvery, a young lady with many gifts, much temperament, and great ability.'[4]

During a period when 'sculpture in Dublin was almost negligible'.[5] Beatrice Elvery's success in this field was outstanding. In 1901, she was awarded the Taylor Scholarship for a statuette entitled *A Bather*. The following year, the artist began exhibiting at the R.H.A. with a statuette of a boy. She was elected an R.H.A. in 1933 and her links with the Academy continued until 1969. Beatrice Elvery was again awarded the Taylor Scholarship in 1902 and for a third time in 1903. In 1902, Elvery had begun exhibiting with the Young Irish Artists and she also participated in the Arts and Crafts Society exhibitions beginning in 1904 showing a panel in relief together with some small statuettes.

In that same year, (1904) together with her sister, Dorothy, friends Estella Solomons, H.R.H.A. (1882-1968) and 'Cissie' Beckett (Frances), (1880-1951), and armed with a scholarship, Elvery travelled to Paris. She enrolled as a student at Académie Colarossi in order to study drawing from life. In the summer of 1904, she returned to Dublin and was invited to teach at the D.M.S.A. summer school.

Sarah Purser admired Elvery's talent and persuaded the young artist to join An Túr Gloine (Tower of Glass), a stained glass co-operative which she had founded. It had opened in January 1903. Before embarking on this new aspect of her career, Elvery enrolled at the D.M.S.A. in order to learn about the craft of stained glass. A pupil of A.E. Child (who had formed a stained glass class shortly after his arrival at the D.M.S.A. in September 1901, he was also manager of An Túr Gloine), Elvery learned from Child a technique and practical approach to the making of a window based on a style derived from pre-Raphaelitism.

In her autobiography, the artist always maintained that 'making stained-glass windows [was] an activity which never gave me any pleasure…'[6] Beatrice Elvery spent a relatively short period on stained glass, and in the view of the late Dr. Michael Wynne this did not give the artist sufficient time to develop a particular stained glass talent of her own. However, art historian Dr. N. Gordon Bowe has written:

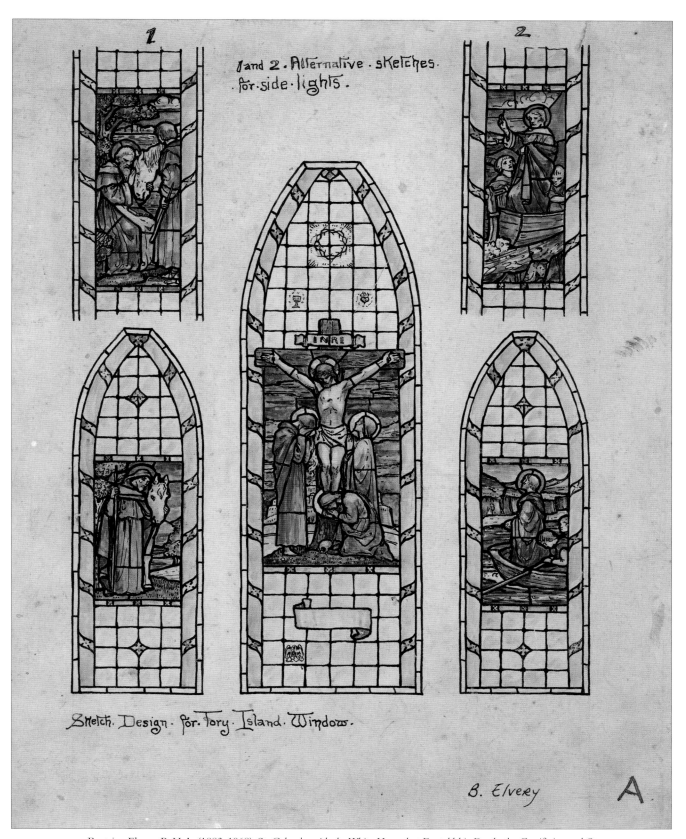

Beatrice Elvery, R.H.A. (1883–1968) *St. Columba with the White Horse that Foretold his Death, the Crucifixion and St. Columba Arriving at Tory Island*, (for a 3-light window in Tory Island Church, County Donegal, 1910, with alternative side-lights. Ink, graphite and watercolour on board. COURTESY NATIONAL GALLERY OF IRELAND

'Over the next 15 or so years she dashed off some 26 first-rate stained glass windows all over Ireland which was, like her sculpture, in a fundamentally English Arts and Crafts idiom. She favoured rich, flowing colours delightful, fluidly painted narrative compositions and the engaging details which are a hallmark of this period.'[7]

Beatrice Elvery's first commission, six windows for the Convent of Mercy chapel, Enniskillen, Co. Fermanagh (1905) was on the verge of completion just a year after her arrival in An Túr Gloine. This was followed by such notable commissions as *Christ among the Doctors,* 1907 (St. Stephen's Church, Mount Street, Dublin) and *Good Shepherd; Good Samaritan* (St. Nicholas's Church, Carrickfergus). Her three-light *St. Columba and the Crucifixion* (1910) was considered to be one of her favourite commissions. It was made for progressive English architect and designer, Edward William Godwin's (1833-1886) small Roman Catholic church designed in a severe Gothic style between 1857-61 on Tory Island, Co. Donegal. The cartoon (illustrated here) was executed on a small scale in ink, graphite and watercolour on board. In the artist's opinion, the design was '… rather like coloured illustrations to a child's book'.[8] A reluctant convert to the art of stained glass, Beatrice Elvery's inspiration followed the English Arts and Crafts tradition and always in the best Irish tradition the artist used richly coloured glass in well designed, effective compositions as demonstrated here.

In 1910, on the advice of Orpen, Elvery travelled to London to spend a year at the Slade School of Fine Art studying under Henry Tonks and Steer. On her return to Dublin, she again taught for a brief period at the D.M.S.A. In 1912 she married barrister and politician, Gordon Campbell. During the war, they remained in London, their home becoming an artistic milieu for such literary friends as D.H. and Frieda Lawrence, George Bernard Shaw and Katherine Mansfield. When the war ended, the family returned to Dublin and led a busy life raising their three children. However, the artist still found time to exhibit sending four portraits to the W.C.S.I. annual exhibition in the first year of her election (1921). Until 1925 she continued to exhibit largely portraits with the W.C.S.I., including one of the writer, James Stephens. In 1931, her husband succeeded to his father's title becoming Lord Glenavy, second Baron Glenavy. In the same year, Lady Glenavy exhibited an imaginary scene entitled *The Intruder* at the R.H.A. and a year later this was hung on the line at the Royal Academy. During this period, the artist was not only painting imaginary scenes but 'was also getting great pleasure out of painting still-life arrangements with romantic backgrounds of forests and distant figures. I would have liked to have painted still-lifes like some of Gertler's pictures.'[9]

Beatrice Glenavy held her first solo show at 7, St. Stephen's Green in 1935, a year after she had been elected a full member of the R.H.A. Despite her growing family, she also found time to illustrate books, design posters and Christmas cards for the Cuala Press, design furniture and create plaster plaques – many of which appeared in her later paintings. Involved with the Dublin Drama League, she assisted Shelagh Richards in the production of two plays in 1936. Always at the centre of a wide artistic circle, the Glenavys welcomed many musicians, artists and writers to their lovely home, Rockbrook, Tibraden at the foot of the Dublin mountains for their well known 'Sunday evenings'. Lady Glenavy died on 21 May, 1970.

In 'An Appreciation', the late Dr. Monk Gibbon recalled: 'Only those who knew her well, knew her at all; and even to them she remained a mystery. She was ageless and although one could get extraordinarily angry with her one never offered her that supreme insult of treating her as an old lady… She took her own painting most seriously but could not bear to have it praised. She was outspoken and could be quick tempered but basically I think it would be true to say of her that she was fundamentally gentle and even perhaps timid.'[10]

EVIE SYDNEY HONE H.R.H.A. (1894-1955)

Dr. James White, in his introduction to the memorial exhibition of drawings, paintings and stained glass organised to honour the distinguished stained glass artist and craftswoman, Evie Sydney Hone held in the Great Hall, University College, Earlsfort Terrace, Dublin in 1958, declared the artist to be 'an outstanding religious painter of modern Ireland and a stained glass artist of international stature'.[11] Evie Hone's dedication to her art in all its forms was underpinned by a deeply held religious conviction which was at the centre of this artist's practical life and one which was expressed in her sketches, pictures, cartoons and stained glass.

It was not until she was thirty-eight years old and a professional painter in both oil, gouache and watercolour that Hone began to turn her attention to glass. Her earliest family links with the world of stained glass might be traced back to the sixteenth-century Flemish craftsman, Galyon Hone. Born in the Netherlands, Hone had trained as a glazier in Antwerp but had settled in England by 1510 and was working on projects which included Eton College, Hampton Court and Whitehall Palace.[12] Galyon Hone succeeded the King's (Henry VIII) glazier, Barnard Flower in 1517 and in this role completed the great east window and others for King's College Chapel, Cambridge. Evie Hone was also a direct descendant of Joseph Hone, a brother of the portrait painter, Nathaniel Hone, R.A. (1718-84), and father of portrait painters, John Camillus Hone (1759-1836) and Horace Hone A.R.A. (1756-1825).

Evie Hone was born in 1894 at Roebuck Grove, Donnybrook Co. Dublin. Her father, Joseph Hone (1850-1908), was a maltster who founded the firm of Minch and Co.; he was also a director of the Bank of Ireland. Her mother, Eva Eleanor (d.1894), daughter of Sir Henry Robinson, K.C.B. died two days after the artist's birth. At the age of twelve, Evie Hone contracted infantile paralysis which shadowed her life and left her lame. It also affected her hand.

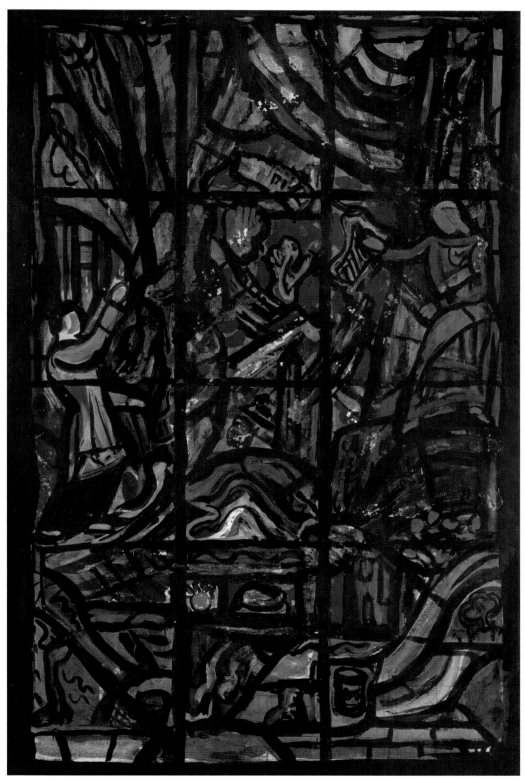

Evie Sydney Hone H.R.H.A. (1894-1955). *My Four Green Fields* (Provisional Design for a Glass Panel, now at Government Buildings, Dublin) 1938. Gouache on board. Note: The stained glass panel *My Four Green Fields* was commissioned by the Department of Industry and Commerce for the Irish Pavilion at the New York World Fair. The panel was completed 30 January, 1939 and dispatched 15 February, 1939. A sketch design relating to this panel was exhibited by the artist at The Watercolour Society of Ireland's annual exhibition, 1939, (cat no: 76).

Its course was to determine her early education and her working life. After a succession of medical treatments in Ireland, she travelled, together with her governess, to Ouchy, Switzerland in order to try and seek medical assistance, Evie Hone always possessing 'heaps of courage and never mention[ing] her disabilities'.[13] After a relatively short period, she decided to return to London to study art and to seek further medical help.

Both Evie Hone and her life-long friend, Mainie Jellett, became pupils around 1917 of Walter R. Sickert (1860-1942) at the Westminster School of Art, London. Hone also attended the Byam Shaw School of Art in order to study composition. She then moved to the Central School of Arts and Crafts in Red Lion Square, London where she found the teaching of outstanding figurative artist and landscape painter, Bernard Meninsky (1891-1950) inspirational and always spoke of him throughout her life with admiration. Later, it was Meninsky who advised his young student to continue her studies in Paris.

In the autumn of 1920, Hone left for Paris; Mainie Jellett joined her there the following February. For the next eleven years, both girls studied together in France. The first year was spent in the studio of cubist painter, André Lhote, but the following year they plucked up enough courage to knock on the door of Albert Gleizes (1881-1953). A painter totally absorbed in purely abstract painting, Gleizes' early work had been impressionist in style but in 1909 he had embraced cubism. In 1912, he published, together with French painter and writer, Jean Metzinger (1883-1956), the first book relating to the movement entitled *Du Cubism* (1912, tr.1913) which presented the philosophical basis of the cubist aesthetic.

Both Irish students worked with Gleizes between 1921 and 1931, spending four or five months each year in Paris or in the Ardèche country. They also visited Spain where El Greco (together with Giotto's influence gained from an early visit by Evie Hone to Italy in 1914) obviously penetrated Hone's attitude towards her approach. In the early thirties, this was to be marked by the influence of French Fauvist and Expressionist painter and print-maker, Georges Rouault (1871-1958) whom she often quoted: 'I have painted by opening my eyes day and night on the perceptible world, and also, by closing them from time to time, that I might better see the vision blossom and submit itself to orderly arrangement. Art is choice, selection and especially an interior hierarchy.'[14]

Rouault had been apprenticed to a stained-glass maker and had worked on the restoration of medieval glass: the vivid colours and strong outlines characteristic of the medium had left a strong imprint on his compositions. In the early 1890s, Rouault had become a fellow pupil of Henri Matisse (1869-1954) under Gustave Moreau (1826-1898) at the École des Beaux-Arts. However, he did not adopt the brilliant colour or subject matter of the Fauves (as this group were later called) but rather turned to religious art which was governed by an underlying abstract design. This appealed to the Irish artist.

Hone now began to study the problems of stained glass and visited Chartres and Le Mans. She also presented three designs for small panels to Sarah Purser at An Túr Gloine who suggested that she should join the class run by A.E. Child in the Dublin Metropolitan School of Art. Following a short period spent there, Hone paid a visit to English book illustrator, Arthur Rackham (1867-1939) in London who advised her to find a craft worker. Stained glass artist, Wilhelmina Margaret Geddes (1887-1955) came to her assistance and in her kiln, Evie Hone converted her designs for the first time into glass. Finally permitted by Sarah Purser to join An Túr Gloine in 1935, Evie Hone worked alongside Irish stained glass artist, Michael Healy (1873-1941) who gave her substantial technical assistance and increased her knowledge in this area.

The first five years of Hone's devotion to stained glass saw this artist execute one of the most important commissions of her career. The fusion of symbol and abstract expresses itself to the full in the free development found in the great panel *My Four Green Fields*, which was an important commission not only for the artist but for An Túr Gloine. One of several sketch designs for this work was exhibited in the W.C.S.I. Exhibition in 1939. The final composition is believed to be more abstract and precise than the early drawings with the emblems of the four provinces of Ireland standing out in a clear, straightforward, representational way. Defined in themselves, they are bound together within this large window by the discipline of abstract composition. A skilful use of space together with strong forms, shapes and colour produces a quality of grandeur which is prevalent in this artist's work throughout her career. Commissioned by the Irish Government for the Irish Pavilion at the New York World Fair, the artist was awarded first prize which in turn brought her international recognition.

The Reverend Dónal O'Sullivan, S.J. paying tribute to Evie Hone in the Irish Exhibition of Living Art (1955) refers to this great work and commented:

'Colourists and in particular with the modern French school…The amazing freedom of her mature work …and on a lesser scale, the panel of *My Four Green Fields* was no hazard product of some inspired morning in her studio but the freedom of the city of colour and form won by right of patient and dedicated discipleship… few artists have expressed themselves more fully.'[15]

Together with her friend, Mainie Jellett, Evie Hone joined the ranks of the W.C.S.I. on 20 November, 1930 at a meeting held at 61, Merrion Square, Dublin. Unlike Jellett, Hone does not appear to have taken an active part in the administrative affairs of the Society or become a committee member. Evie Hone began to participate in W.C.S.I. annual exhibitions in 1931 sending two untitled paintings together with a view entitled *Barnaculla* that year. She continued to exhibit with the Society until 1946 exhibiting a total of forty-three works which included designs for stained-glass panels, designs for stained glass windows e.g. King's Hospital,

Dublin (1938), the Methodist Church, Sandymount (1944) together with a number of landscapes, largely relating to her home Marlay, Rathfarnham, Co. Dublin and surrounding areas.

As a result of An Túr Gloine being formally dissolved as a co-operative in 1944, Evie Hone decided to open a studio at her home, The Dower House, Marlay, Rathfarnham, Co. Dublin. Constantly receiving commissions and working at a furious pace despite her physical handicap, the climax of her career came in 1949 when her name was put forward for the replacement for one of the great windows in Eton College Chapel which had been destroyed in 1940 by a bomb. Begun in 1949 and installed early in 1952, Evie Hone's masterpiece, is now recognised as one of the most outstanding modern windows of Europe. Divided into two great horizontals, the Crucifixion occupies the upper space; beneath it, the Last Supper, flanked with the impressive figures of Melchizedek and Abraham, the entire surmounted by tiers of tracery and a host of symbolic imagery. It was a remarkable *tour de force* by a woman who was in poor health, and who had only a small number of glaziers together with artist, Elizabeth J. Rivers (1903-64) to assist her.

Evie Hone's career came to a sudden end on 13 March, 1955. Whilst she was walking into her parish church, St. Joseph's Rathfarnham, she collapsed. She was buried in St. Maelruain's Church, Tallaght, Co. Dublin.

During a period of no longer than twenty years of work in the field of stained glass, Evie Hone is believed to have executed over fifty stained glass commissions throughout Ireland and abroad. Her work was exhibited at the Oireachtas Art Exhibition, the Irish Exhibition of Living Art, (a small memorial exhibition was held in conjunction with the 1955 exhibition), the R.H.A. (from 1931-1937 with the exception of 1937), the White Stag Group, the Dublin Painters and at the Dawson Gallery. Three years after her death, a memorial exhibition was held in the Great Hall, University College, Earlsfort Terrace, Dublin (1958), and at the Tate Gallery, London.

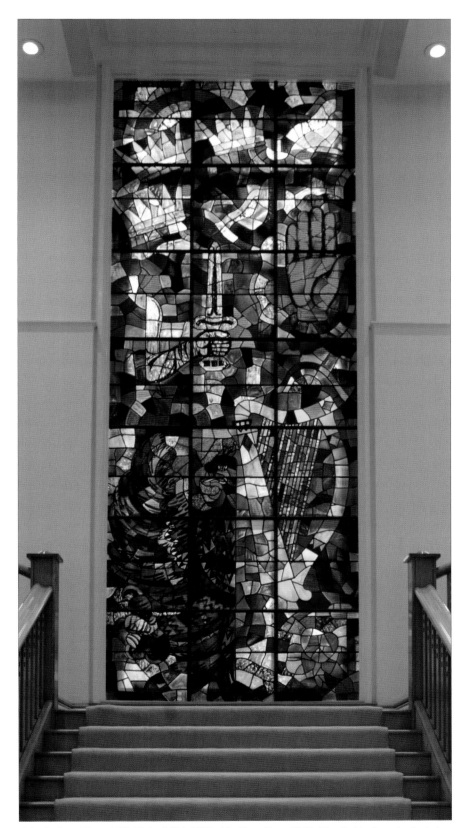

Evie Sydney Hone H.R.H.A. (1894-1955) *My Four Green Fields.* The finished work, depicting the emblems of the four provinces of Ireland, is set in the entrance hall above the ceremonial staircase, Government Buildings, Upper Merrion Street, Dublin.

Chapter XVIII

Water Colour Society of Ireland
Military Painters

LADY ELIZABETH BUTLER
(née Southerden Thompson). R.I.
(1846–1933)

In the second half of the nineteenth century, Lady Elizabeth Butler experienced dazzling success for a relatively brief period, becoming England's leading battle painter and foremost war artist of the mid-Victorian age. Between 1874 and 1881 each of her major works exhibited at the R.A. was received with admiration and applause and almost single-handedly the artist succeeded in revising interest in what was looked upon as a masculine genre. However, throughout her life she always stressed that she did not wish to portray the glories of war but rather its pathos and heroism.

The daughter of unconventional parents, Thomas J. Thompson (1812-81) and Christiana Weller (1825-1910), Elizabeth was born at Villa Claremont, Lausanne, Switzerland in 1846. Her father, accompanied by novelist Charles Dickens, had met her mother, Christiana, an accomplished concert pianist, at a concert in Liverpool. They were married in 1845 and had two daughters, Elizabeth 'Mimi' and her sister, Alice 'Babe', who became the socialist poet and critic, Alice Meynell. Both parents became directly involved in their daughters' schooling, teaching them how to play the piano, providing them with drawing lessons and her father, in particular, becoming involved in the more routine aspects of their education

When she was nineteen years old, Elizabeth embarked on an intensive three-year course at S. Kensington Female School of Art where she quickly distinguished herself. She also availed of the opportunity to study in

Florence under painter, Giuseppe Bellucci (1827-1882):

'I became the pupil of a very fine academic draughtsman, though no great colourist, Giuseppe Bellucci. On alternate days to those spent in his studio, I copied in careful pencil some of the exquisite figures in Andrea del Sarto's frescoes in the cloisters of the SS Annunziata'.[1]

When she graduated in 1869 from South Kensington, the young painter was already devoting a good deal of her time to military history and military subjects. Her first battle watercolours achieved a moderate degree of success and revealed her love of a pre-Raphaelite exactness of detail. Elizabeth appears to have realized from an early stage in her career that the subject of military painting was 'non-exploited' and, despite her family having no direct military connections or any first-hand knowledge of battle, the young painter decided to pursue this particular subject area. Her first success came in 1873 when her oil painting entitled *Missing* portraying an imaginary scene from the Franco-Prussian War (1870) went on display at the R.A. Following the success of this work, the artist rented her own studio and began work at the end of December (1873) on *Calling the Roll after an Engagement in the Crimea*, which became more popularly known as *The Roll Call*. Exhibited at the R.A. (1873) the following year (1874), the work was purchased by Queen Victoria. It had been commissioned by Manchester industrialist, Charles Galloway, who, it was said, reluctantly agreed to cede it to the Crown. When the painting went on tour, it attracted huge audiences which brought the artist international fame and succeeded in establishing her reputation as a military painter. In the same year,

Elizabeth was elected a member of the Royal Institute of Painters in Water Colours. However, she never succeeded in being elected to the R.A.

Following the success of *The Roll Call*, in the summer of that year, Elizabeth Thompson, who had converted to Roman Catholicism in 1873, met her future husband, Irish Catholic, Major William Francis Butler (1838-1910; later General Sir William Butler GCB., K.C.B.) at a private viewing (which included one of her works) organised by the Fine Art Society in Bond Street. They were married in London on 11 June, 1877. Somewhat unusual for the period, the bride was more well known and independent than her husband, having already succeeded in establishing herself as a well known artist with a busy and successful career.

Elizabeth was given a choice of spending the honeymoon either in the Crimea or in Ireland. Wisely, she opted for the latter. Ireland captivated this young painter's imagination and later in her autobiography, she recalled '…its freshness, its wild beauty its entrancing poetry, and the sadness which, like the minor key in music, is the most appealing quality in poetry'.[2] The Butlers spent sometime in Kerry staying in Glencar and it was here that the artist made sketches of two local men who were later to become the models portrayed in Butler's famous *Listed for the Connaught Rangers*. This painting was exhibited at the R.A. in 1879.

Pursuing her roles as both mother, wife, and military hostess, Elizabeth accompanied her husband to various stations both at home and abroad which ranged from Aldershot to South Africa. It was while living in Delgany, Co. Wicklow that she began her most famous work *An Eviction in Ireland,* a

314

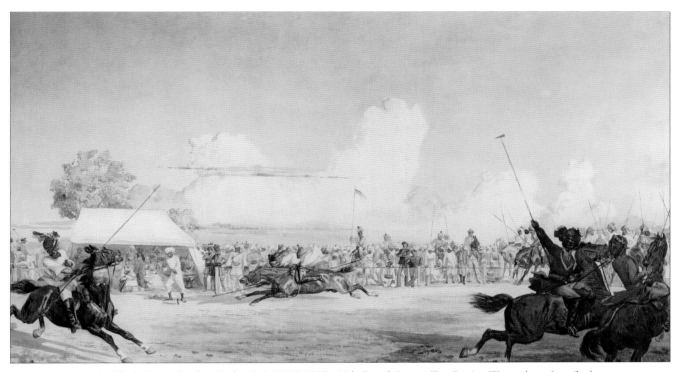

Lady Elizabeth Southerden Butler R.I. (1846-1933) *10th Bengal Lancers Tent-Pegging*. Watercolour, Inscribed: 'Elizabeth Thompson 1873'. The painting was presented to the Indian Army Museum by the regiment in 1956. An oil with the same title was exhibited in the Royal Academy in 1902. This work was also exhibited in the Society of Lady Artists Exhibition, 1874 (cat. No. 247) under the title *Tenth Bengal Lancers at Tent Pegging*.

COURTESY NATIONAL ARMY MUSEUM, CHELSEA

strong expression of nationalism which is somewhat startling coming from the wife of a general in the British army, but explained to some extent by the fact that the Butlers were a Catholic family. When it was exhibited at the R.A. in 1890 and two years later at the R.H.A., the painting caused a certain degree of controversy. It depicts a woman, bare-footed and bare-headed, standing starkly in front of the gable walls of her razed cottage. Her strong face is upturned to the light. The surrounding scenery of mountains appear to emphasize the woman's strength. In the far distance may be seen the receding figures of a police patrol, the eviction party who carried out the brutal violation. The artist herself takes up the story:

'Being at Glendalough at the end of that decade, [1880s] and hearing one day that an eviction was to take place some nine miles distance from where we were staying for my husband's shooting, I got an outside car and drove off to the scene, armed with my paints.

I met the police returning from their distasteful "job", armed to the teeth and very flushed. On getting there I found the ruins of the cabin smouldering, the ground quite hot under my feet, and I set up my easel there. The evicted woman came to search amongst the ashes of her home to try and find some of her belongings intact... I studied her well, and on returning home at Delgany I set up the big picture which commemorates a typical eviction in the black 'eighties... What storms of wind and rain, and what dazzling sunbursts I struggled in, one day the paints being blown out of my box and nearly whirled into the lake far below my mountain perch! My canvas, acting like a sail, once nearly sent me down there too.'[3]

When General Sir William Butler retired in 1905, the Butlers decided to move to Ireland to live at Bansha Castle sited on the edge of the Suir valley, Co. Tipperary and not far from her husband's family home. Two years later, on 12 July 1907 on the recommendation of the

Director of the N.G.I. Sir Walter Armstrong (1850-1915), she was appointed the first woman member of the Board of Governors and Guardians of the National Gallery of Ireland. Unlike the next woman member of the Board, Sarah Purser R.H.A. (1848-1943), she appears to have attended few meetings and resigned in 1912.

Elizabeth had already established her art connections with Ireland by exhibiting at the R.H.A. as early as 1892. Three years after settling into their home in Tipperary, Elizabeth Butler began exhibiting with the W.C.S.I. (1908). She sent just one work that year which had been painted in Egypt in the early 1890s, *The English General's Syces, Cairo*. When she and her husband visited Egypt they had made full use of the opportunity to travel outside that country, the couple visiting several Napoleonic battle sites including Austerlitz. They also joined a pilgrimage to Palestine at Easter 1891, Elizabeth recalling the event as being 'the most memorable journey of our lives'.[4]

Although listed as a member of the W.C.S.I. committee for the Society's fifty-ninth exhibition, (February, 1913), which took place at The Hall, 35, Dawson Street, Dublin, it was not, in fact, until 1918, that a further five works were shown by this artist in a W.C.S.I. annual exhibition. These included *Site of the Birthplace of St. John the Bapist* and *First View of the Lake of Galilee*. In 1903, Butler's *Letters from the Holy Land* had been published and carried sixteen full-page illustrations by the artist in watercolour. A total of eight works were shown by Elizabeth Butler between 1926 and 1932 at W.C.S.I. annual exhibitions and included *Reveille before battle: A Trumpeter of Napoleon's Cuirassiers* (1929) and military portraits such as a *New Zealand Trooper in the Great War* (1929) together with *A Drummer of the 5th Royal Irish Lancers, 1914* (1931).

In her autobiography, the author provides an indication of how and when she used the medium of watercolour in relation to her battle paintings:

'I was asked, as the war developed, if I had been inspired by it, and this caused me to return my attention pictorially that way. Once I began on that line I went at a gallop, in water-colour at first, and many a subject did I send to the Dudley Gallery and to Manchester, all the drawings selling quickly, but I never relaxed the serious practice in oil painting which was my solid foundation.'[5]

After her husband's death on 7 June, 1910, Elizabeth decided to live on at Bansha Castle for the next twelve years. During the Irish Civil war her home was occupied by republican and then by state forces. Aged seventy-five, she decided to leave and went to live with her daughter, Eileen, Viscountess Gormanston at Gormanston Castle, Co. Meath.

A friend recalls how the artist appeared in her latter years: 'After dinner, I was taken to see Lady Butler. I found a frail little lady in black – the ghost of the energetic woman in neat tailored clothes that I remembered at Farnborough…More than once, Lady Butler invited me to her studio where she continued to paint regularly. One of the last things I saw on her easel was a watercolour, fresh and vigorous, of an Inniskilling Dragoon. She painted uniform and accoutrements, of which she had a unique collection, with meticulous regard for detail. She had a tremendous capacity for hard work. A hard and fast rule…was to take exercise every morning before going to her studio… I often came upon her on her solitary walks in the sunny walled-in gardens. She was a woman of high courage content to lead a secluded life of great simplicity that was such a contrast to the brilliant years of her success as an artist and her role as the wife of an officer of high rank.'[6]

Following the artist's death on 2 October, 1933, a W.C.S.I. committee meeting was held at 13, South Fredrick Street, Dublin, on 31 October:

'The Chairman opened the meeting by paying a tribute to the memory of the late Lady Butler who had been a very valued member of the Committee…whose loss was felt not only in Ireland but throughout the artistic world where Lady Butler held a very distinguished place. A vote of sympathy was passed, the Committee standing in silence.'[7] She was buried close to her daughter's home at Stamullen, Co. Meath.

List of the Water Colour Society of Ireland Presidents/Chairmen, Secretaries and Treasurers from 1921 to 2009

Presidents/Chairmen

1921–1940	Mr. A.V. Montgomery
1941	Miss Alice M. Boyd
1942–1947	Major Nolan Ferral
1948–1961	Mr Frederick G. Hicks
1962–1981	Mrs Kitty Wilmer O'Brien
1982–1993	Mr James Nolan
1994–1998	Mrs Kay Doyle
1999–2001	Mr George McCaw
2002–2004	Mrs Nancy Larchet
2005–2007	Mrs Pauline Scott
2008 –	Mr Vincent Lambe

Secretaries

1921–1922	Miss Charlotte Dease
1923–1936	Mrs Ellice Pilkington
1937–1972	Mrs Eileen Reid
1973–1977	Mr Ciarán MacGonigal
1978–1983	Mrs Dorothy Glynn
1984–1998	Mr George McCaw
1999–2004	Mrs Pauline Scott
2005–2008	Mrs Pauline Doyle
2009–	Dr Patricia McCabe

Treasurers

1978–1981	Mr Brendan O'Brien
1982–1996	Mr Brian K. Reilly
1997–2001	Mr Brian Doyle
2002–2007	Dr. Thomas Wilson
2008–	Ms Gráinne Dowling

Index of the Water Colour Society of Ireland Committee, Trustees and Members (2010)

Appendix III

CHEMICAL DEVELOPMENTS

Until the mid eighteenth century, it was usual for artists to prepare and mix their own colours, grinding, washing and then mixing them with pigments to which was added the requisite amount of gum Arabic. What almost amounted to a technical revolution in the development of the medium was mounted towards the end of the eighteenth century by two brothers, William and Thomas Reeves, in their little shop close to Holborn Bridge, London. Their 'revolution' ensured that artists no longer had to mix their own colours. The brothers prepared the watercolours, moulding them into the form of moist cakes on which their name was impressed and sold them to an ever increasing and demanding public.

In 1801, advertisements by the firm of Rudolph Ackermann for watercolour artists' materials began appearing with increasing frequency in newspapers and journals. The company, from their Repository of the Arts in the Strand, London, declared in 1801 they could provide their customers with all necessities for painting in watercolour: a variety of paper, brushes, crayons and paint-boxes and a choice of at least sixty-nine different colours stamped with the Ackermann trademark. Mahogany boxes suitable for outdoor use containing cakes of watercolour together with a marble palette were now on offer for the enthusiastic watercolourist. Artists could also choose from a wide range of instructive manuals together with a variety of prints which it was possible to hire for copying purposes. The company's success was widespread and the technical advances made by both Reeves and Ackermann undoubtedly led to the ever increasing popularity of watercolour painting on both a professional and amateur level throughout England and Ireland.

Further technical developments were carried out by William Winsor and H.C. Newton who, in 1832, invented

The trade card of William Reeves who established his business with his brother, Thomas at 'the sign of The Blue Coat Boy and King's Arms', Holborn Bridge, London. PRIVATE COLLECTION

The trade card of James Hawkesworth, carver and gilder of No. 14, Duke Street, Dublin. COURTESY OF THE IRISH ARCHITECTURAL ARCHIVE

colours which were more moist than previously on offer. These were contained in small pans 'Japanned Tin Sketching Boxes for the Pocket, with 6, 8, or 12 Colours, Pencils, Bottle, Cups etc., complete'. Around 1846, metal tubes containing moist watercolours were introduced by the same firm. One disadvantage lay in the fact that they were not very suitable for outdoor sketching, the tubes being heavy and cumbersome to carry.

BRUSHES

Until around 1850, the finest artists' brushes were called 'pencils'. Watercolour brushes are made from red sable, the less expensive coming from camel or, more frequently, squirrel's hair. Until the mid-nineteenth century, the bristles were set in quills according to size. Goose, duck, lark, crow and swan were frequently used. They were superseded by handles made from wood with an aluminium or nickel ferule.

Page from Winsor & Newton Catalogue, 1849, showing the combination sketch seat and easel. By the late nineteenth century advertisers were targetting the large number of professional and amateur women artists. COURTESY WINSOR & NEWTON MUSEUM

Cornelius Varley (1781-1873) *Artist sketching with a Camera Lucida* (detail) c.1830. Engraving
COURTESY GERNSHEIM COLLECTION, HARRY RANSOM HUMANITIES RESEARCH CENTRE. UNIVERSITY OF TEXAS AT AUSTIN

CAMERA OBSCURA

Devices to aid the artist record the landscape before him included the *camera obscura* which had been introduced as far back as the sixteenth century. The image was transmitted through a series of lenses onto the sheet of paper on which the painter hoped to produce the drawing. As time went on, these became smaller and more portable and remained popular until well into the eighteenth century.

The *camera lucida* patented in 1807 possessed a wider field of vision than its predecessor and four years later, watercolourist Cornelius Varley introduced his 'Graphic Telescope' (A *Treatise on Optical Drawing Instruments*, 1845) which had a far greater power of magnification and was small, compact and easily adjustable.

Paul Sandby, R.A. (c.1730-1809) *Lady Frances Scott, drawing from a camera obscura, with Lady Elliott*, c.1770. Pencil and watercolour. COURTESY MANCHESTER UNIVERSITY

Paul Sandby, R.A. (c.1730-1809) *Mr. Whatman's Paper Mills near Maidstone*, c.1793. Graphite on woven paper Countermark: J WHATMAN. Inscribed, lower right: 'Mr. Whatman's Paper Mills near Maidstone'. The Whatman paper mill known as the Turkey Mill was sited close to the town of Maidstone, Kent. In the second half of the eighteenth century, the Turkey Mill was considered to be the largest paper mill in these islands supplying countless Irish and English artists with high quality paper.

PAPER

As mentioned in Chapter II, vellum (fine parchment) was the traditional painting surface for both manuscript illuminators and map-makers of the Middle Ages. Machine-made paper was introduced in the early nineteenth century, the paper being derived from boiled rags and linen which, after being reduced to a white pulp by boiling and starching, were laid onto flat moulds, then pressed, and allowed to dry out. The sheets of paper were then covered with a thin layer of vegetable glue or size which, once it had dried prevented washes, watercolours or ink from sinking into the paper. Watercolour being a transparent medium meant that the lines of the wires of the mould in which the paper was made tended to show through. James Whatman, in the 1780s, invented a 'wove' watercolour paper which did away with the 'chain lines' seen on old traditional paper and provided the artist with a smooth and even surface on which to draw and colour.

Attributed to a member of the Brocas family. *View of a papermill beside the R. Dodder at Clonskeagh Dublin*, Ireland.

Glossary of Technical Terms

WATERCOLOUR PAINTING

Watercolour: In the strict sense of the word, watercolour is a medium in which water is used as the 'vehicle' for the pigment together with a binding material. That binding material is generally gum Arabic (a soluble gum obtained from the acacia tree) or, in the case of the medieval illuminator, glair (egg white). When dissolved in water these materials not only disperse the insoluble grains of pigment but actually increase the luminosity of the colours. A more dense colour can be achieved by mixing pigment with an opaque white such as 'Chinese white' (a pigment based on zinc oxide, introduced by Winsor & Newton in 1834), and this is known as body colour or gouache. Body colour conceals what is underneath, but the transparent medium is unable to do this, the painted surface becoming a series of colour filters which allow the light to pass through them and reflect off the white surface beneath. The greater the degree of translucency achieved, the purer the colours will appear.

Wash: Using generous amounts of water and applied with a brush, an even covering of liquid watercolour or dilute ink may be applied to the paper. Successive transparent washes are applied resulting in what is known as pure watercolour.

Wet Method: The entire paper is soaked in water. Washes are then applied together with blobs of colour which are carefully dripped onto the wet surface. A method of watercolour which was invented by Scottish painter, Arthur Melville (1858-1904).

Stopping-out: Highlights may be achieved in watercolour by skilfully lifting colour from washes which have already been applied. The method employed is to drop blobs of water on the relevant section required to lift. The colour is removed with blotting-paper, breadcrumbs or a piece of cloth. The will succeed in leaving the precise shape of the drop of water as a light area.

Foxing: This is a fungus which appears as tiny brown spots on paper. Warm, damp conditions encourage it to thrive. It may be removed by sterilisation and bleaching.

DRAWING MEDIA

Bistre: A brown pigment made from beechwood soot; often referred to as pen and brown wash or pen and brown ink.

Chalk Black: This is a mineral which is indelible and adhesive to paper.

Chalk Red: Subtle gradations of tone may be introduced by rubbing with the finger or brush.

Charcoal: Easy to manufacture and cheap to buy, this was and is a popular medium in drawing.

Conté (crayon): The conté crayon is a mixture of clay and refined graphite, invented in 1790 by Nicholas-Jacques Conté (1755-1805).

Ink: Indian and Chinese ink are made from lampblack (soot) mixed with gum and hardened by baking. Iron-gall writing ink was used until the present century. It is made from tannin obtained from oak galls and treated with ferrous sulphate.

Pastel: A wide variety of coloured chalks is used in pastel drawing. In eighteenth-century France another term used for pastel was 'crayon'.

Pen and Wash: Often the quill feathers of a bird's wing were used for pens. Wash indicates an area of tone applied with the brush.

Pencil: Piece of graphite enclosed in a cylinder of wood or contained in a metal case with tapering end.

Plumbago: The Latin word for lead ore, now denoting black lead which is, in fact graphite. Sharpened pieces were used for drawing.

Sepia: A dark brown pigment derived from the black fluid of the cuttlefish. The name is frequently used as a general term for a dark brown colour.

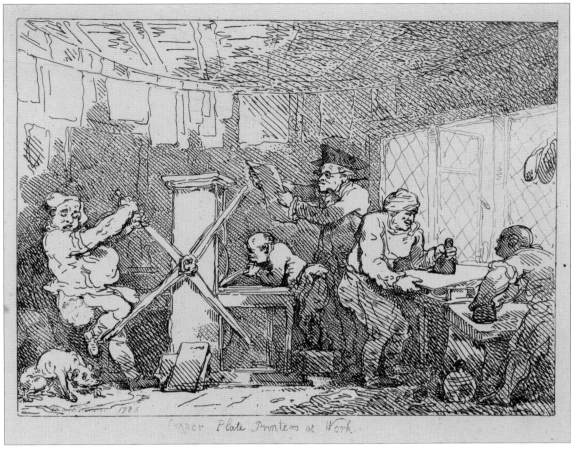

Thomas Rowlandson (1756-1827). *Copper Plate Printers at Work* 1785 Etching. Printers can be seen inking and printing on the rolling press.

PRINTING TECHNIQUES

Aquatint: This method involves covering the plain surface of the steel plate with sand or other grainy matter. The plate is then applied to heat, acid or other agents which cause the surface to become mottled.

Engraving: The art of drawing or writing on any substance by means of an incised line. Materials usually used as the plate substance are: stone, wood, zinc, iron, silver, steel, brass, pewter and in later times man-made fibres. The line is incised on the surface by a variety of sharp tools. Scrapers with two cutting edges are also used to remove larger areas of the surface so that the paper or other material being printed received no impression in the area in question.

Etching: Instead of cutting into steel plate substances with a tool, as in the case of engraving, the line is obtained by corroding or 'eating into' the plate with acid or mordant. In this technique, the plate is covered with an acid-resistant surface which is then cut into by the special tools. This is then exposed to acid or mordant which eats the line where the acid-resistant surface has been removed.

Lithography: The process of writing or drawing on a stone with a composition of wax and lampblack (substances of a more sophisticated type were later developed). The stone is then wetted but the drawn or written line, being greasy, resists the mater. A roller covered with printing ink is then applied to the stone, but only the drawn or written line picks up the ink and this is then pressed on to paper in the usual method.

Mezzotint: This is a process of working out light portions of ground by eating into the steel plate with a rocker or other toothed or serrated edge which breaks up the plain surfaces.

Printing: Printers' ink is laid on the prepared plate and dabbed into the lines, incisions or crevices. The superfluous ink is then removed. Paper is placed damp against the plate in a copper-plate press or other pressure method to force the paper into the hollows and so gain the impression of the ink.

Stipple: Work in stipple is produced by a skilful arrangement of dots pecked into the metal plate.

Endnotes

Chapter I

1. Strickland, 1968, Vol II, p. 651.
2. *Art Journal*, 23, 1861, p. 161.
3. 'Art Exhibition in Lismore', *Clonmel Chronicle, Tipperary Express and Advertiser*, Saturday evening, 13 May, 1871.
4. Blacker, S., in *The R.D.S Report of the Third Distribution of Premiums...in the Drawing and Modelling Schools*, 18 December, 1844, p.22.
5. Scrapbook of the Dublin Sketching Club (no page nos.).
6. Strickland, 1968, Vol. II, p. 651.

Chapter II

1. Butler, P., 'The Ingenious Mr. Francis Place' *G.P.A. Arts Review*, Vol. 1, No. 4, Winter 1984, p.40.
2. As quoted in Harbison, P. (ed.), 1998, p.24.
3. As quoted in Turpin, J., 'The Dublin Society's School of Architectural Drawing' in *The Irish Georgian Society's Bulletin*, Vol. XXVIII, 1985, p.1.
4. McParland, 1973, p.2.
5. Ibid., p.7.
6. *The Irish Builder*, 15 May, 1870 (no page nos.).
7. Ibid.
8. Goodman, T., 'Water-Colours & Contemporary Pictures' in *Commentary*, 1943, Vol. 1, no. 8, p.12.

Chapter III

1. *Faulkner's Dublin Journal*, 14–18 May, 1746.
2. As quoted in Turpin, 1995, p.333.
3. Ibid.
4. Ibid., p.65.
5. An Address given by Dr. John Turpin *The R.D.S. School of Landscape and Ornament*, read at the opening of the Annual Exhibition of the Water Colour Society of Ireland, Monday, 24 June, 1985.
6. As quoted in Potterton, H., 1983, p.xxiii.
7. Ibid.
8. Turpin, 1995, p.128.
9. Bate, 2003, p.307.
10. Turpin, 1995 p.128.
11. As quoted in Turpin, 1995, p.128.
12. Strickland, 1969, Vol. 1, p.151.
13. Ibid., p.150.
14. Adams, 1973, p.115.
15. Murray, 2004, p.48.
16. Blacker, S., in *The R.D.S Report of the Third Distribution of Premiums...in the Drawing and Modelling Schools*, 18 December, 1844, p.18.
17. Strickland, 1969, vol. 1, p.131.
18. Strickland, 1969, vol. 1 pp.130-131.
19. Letter from George Eliot, The Priory, 21, North Bank, Regent's Park to Sarah Sophia Hennell, London, dated 30 April, 1864, from Haight, (ed.), 1956, Vol. IV, p.147.
20. Gregory, 1974, p.150.
21. Potterton, H., 'A Director with Discrimination: Sir Frederic Burton at the National Gallery' in *Country Life*, vol.C1V, 9 May, 1974, pp.1140-41.

Chapter IV

1. Smith, G., 2001, p.104 (exhibition catalogue).
2. Ibid., p.194.
3. As quoted in Fenwick, 2004, p.18.
4. Ibid., p.22.
5. *Faulkner's Journal*, 15-19 January, 1765.
6. Strickland, 1969, Vol. II, p.599.
7. Unknown Diarist, *A Journal, Vol. V, 1 Feb. 1801– 19 Sept. 1801*, entry for 6 July.
8. Kennedy, S.B., 1990, p.viii.
9. *Freeman's Journal*, Tuesday, 12 January, 1802, advertisement, p.1.
10. Unknown Diarist, *A Journal, Vol. V 1, 19 Sept. 1801–9 May 1805*, . p.112.
11. p.iii of 'Prefatory Matter, Part 1. Historical, and treating of the Origin, Institution, and Foundation of the Academy' in the catalogue of *The Exhibition of the Royal Hibernian Academy*, MDCCCXXV, Dublin: N. Clarke.
12. Ibid.
13. Ibid., pp.8-9.
14. Turpin, 1991, p.201.
15. Ibid., p.208.
16. Strickland, 1969, Vol. II, p.658.
17. Ibid., p.659.
18. 'No. 2. Rules & Regulations & Instrument Constituting The Art Union' in *Report of Art Union Committee for 1915*, p.10.
19. Ibid., pp.12-13
20. The Lord Lieutenant of Ireland as quoted in Sproule, J., (ed.), 1854, p.14.
21. Address of the Governors and Guardians of The National Gallery of Ireland, p.1 (no date). N.G.I. Archives.
22. Strickland, 1969, p.642.
23. J. Sproule (ed.), 1854, p.98.
24. 'Opening of the International Exhibition by His Royal Highness, The Prince of Wales', *Freeman's Journal*, 10 May, 1865, p.5.
25. Strickland, 1969, Vol. II, p.617.

Chapter V

1. Strickland, 1969, Vol. II, p.651.
2. *Faulkner's Dublin Journal*, 6 May, 1746.
3. Turpin, 1995, p.44.
4. As quoted in Strickland, 1969, Vol. II, pp.260-261.
5. As quoted in Strickland, 1969, Vol. II, pp.264-265.
6. As quoted in Strickland, 1969, Vol. I, pp.399-400.
7. Blackburn, (ed.), 1888, p.51.
8. Wornum, (ed.), 1848, p.248.
9. Lovell Edgeworth, M. and R., 1798, p.542
10. Murphy, D., 2010, p.91.
11. Shee, 1805, p.30.
12. Ward, 1888, p.118
13. Somerville and Ross, 1918, p.47.
14. Clayton, E., 1876, p.152.
15. Carter, F., 1943, p.57.
16. Lamour, 1992, p.35.
17. 'Some Exhibits of the Home Arts and Industries Association, at the Royal Albert Hall', *The Queen*, June 25, 1891, p.1061.
18. Cole, Alan, S., *Two Lectures on the Art of Lace Making*, Science and Art Department, South Kensington. Published in Dublin, 1884. [This is a pamphlet]
19. Keane, H.E., 1888, p.197.
20. Aberdeen, 1886, p.7.
21. Cole, A.S., *A Renascence of the Irish Art of Lace-Making*, London, 1888. (no page nos.)
22. Authors: Bowe and Cumming, 1998, p.88
23. 'Irish Home Industries – Irish Lace' in *The Irish Builder*, Vol. 25, 1 July, 1883, p.210.
24. 'Exhibition and Sale of Irish Handiwork', *The Queen*, 11 March, 1893 p.393.
25. Aberdeen, 1893, p.14 *Guide to the Irish Industrial Village and Blarney Castle*. The exhibit of *The Irish Industries Association at the World's Columbian Exposition, Chicago*. President, The Countess of Aberdeen. Published 1893.
26. *Lady's Pictorial*, 25 February, 1888, p.194.
27. Symondson, 1994, p.126
28. *The Building News*, 22 June, 1888, p.872.
29. Aberdeen, 1893, p.11.
30. 'The Mallow Amateur Art Exhibition', *The Cork Constitution*, Friday, 21 May, 1886, p.2, col.8.

Chapter VI

1. Armstrong Duffy, 1987, p.14.
2. Gray, 1904, p.91.
3. *Belfast News-Letter*, 'The Ramblers' Exhibition', 11 November, 1885, p.5.
4. The author is most grateful to Francis Russell for information relating to the Queenstown Sketching Club.
5. Dublin Sketching Club, Rules, 1874-1904. Dublin Sketching Club Archives, National Library of Ireland.
6. *A Catalogue of Exhibition of Paintings by members of The Dublin Sketching Club held in the hall of the Friends' Institute, 35 Molesworth street from 4 November to 30 November, 1901 (the Twenty-eighth season, 1901-1902)*. Dublin Sketching Club Archives, N.L.I.
7. Scrapbook of the Dublin Sketching Club, (no page nos.), N.L.I.
8. 'The Dublin Sketching Club' *The Irish Times*, 1 December, 1884, p 2.
9. As quoted in Sutton, 1963, p.64
10. As quoted in Pennell, 1908, pp.35-36.
11. Ibid. p.36.
12. Dublin Sketching Club Minute Book, Dec. 1885-Dec.1891. Minutes dated 28 Oct.1885, Dublin Sketching Club archives, N.L.I.
13. Booklet, Dublin Sketching Club, Nov. 1898. Dublin Sketching Club archives, N.L.I.
14. The Dublin Sketching Club Hon. Secretary's Report (A.B.Wynne), dated 3 October, 1888. Dublin Sketching Club Minute Book Dec. 1885-Dec. 1891. Dublin Sketching Club Archives, N.L.I.
15. Boylan, 1988, see dust jacket, (inside flap).

Chapter VII

1. Mr M.A. Titmarsh [W.M. Thackeray], 1843, p.93
2. Strickland, 1969, p.651.
3. Somerville and Ross, 1923, p. 205.
4 Ibid., p.204.
5. Scrapbook of the Dublin Sketching Club, N.L.I.
6. Lismore Castle Papers, collection list no.129, N.L.I.
7. Solly, 1873, p.158.
8. Ibid., p.173.
9. 'Royal Hibernian Academy Opening of the Exhibition' in *Daily Express* (Dublin), 4 March, 1895, p.5.
10. *The Queen*, 28 November, 189, p.855.
11. *The Lady of the House*, January, 1893, pp.11-12.
12. Letter to Edith Somerville dated Tuesday, 20 August, 1889 from Martin Ross as quoted in Lewis (ed.), 1989, p.140
13. The author is most grateful to Mrs E. Villiers-Stuart for supplying information about her relative, the Baroness Pauline Prochazka.
14. *The Tangled Tale of the Three Paulines*, p.6. Unpublished manuscript. For private circulation. (kindly lent to the author by Mrs E. Villiers-Stuart).
15. *The Clonmel Chronicle, Tipperary Express and Advertiser*, 28 October, 1871 p.2.
16. The author is most grateful to the late Captain A.C. Tupper and to Mrs E. Villiers-Stuart for information relating to their families. Also see Baroness Pauline Prochazka's obituary in *The Times*, Monday, 12 May, 1930; p.23.
17. *The Irish Times* Monday, 8 March, 1875, p.5, col. 4.
18. 'Water Colours' in *The Clonmel Chronicle, Tipperary Express and Advertiser*, 28 October, 1871, p.2.
19. 'Irish Amateur Drawing Society (Second Notice)' in *The Irish Times*, Tuesday, 9 March, 1875, p.5, col. 5.
20. *Burke's Peerage & Baronetage*, 2003, p.2843.
21. Visitors' Book, Tourin, Cappoquin, Co. Waterford - January, 1873 - 30 June, 1902. The author is most grateful to Andrea Jameson for bringing this to her attention.
22. See Mark Girouard, 'Stamped, addressed and Illustrated. Irish Decorated Envelopes of the Victorian Era' in *Country Life*, 30 July, 1970, pp.290-1.
23. Letter from Miss Nancy K. Sandars to the author dated 5 June, 2006, granddaughter of Colonel Ramsay Weston Phipps, R.A. (1838-1923).
24. Phipps, 1894, (no page nos.).
25. Information kindly supplied by letter to the author by Colonel Ramsay Weston Phipp's descendant, Miss Nancy K. Sandars.
26. Phipps, 1894, (no page nos.).
27. Ibid.
28. Ibid.
29. The author would like to thank Fenella Tillier, great-great-great-granddaughter of Anna Phipps, Henrietta Phipps' mother, for much additional

information relating to the Phipps family.
30. In a letter to the author from Miss Nancy K. Sandars dated 15 May, 2006.
31. *The Art Journal*, 1 May, 1851, p.179.
32. *The Clonmel Chronicle, Tipperary Express and Advertiser*, 25 October, 1871, p.2., cols. 3&4.
33. 'Catalogue of the Cork Industrial Exhibition, 1883, LACE-Medals' in the *Report of Executive Committee. Awards of Jurors and Statement of Accounts*, Cork 1886, p.427.
34. Blackburn (ed.), 1888, p.18.
35. 'Irish Fine Art Society' in *The Cork Examiner*, Thursday morning, November 15, 1883, p.2. col.4.

Chapter VIII
1. Wragg, 2000, p.175.
2. *The Clonmel Chronicle, Tipperary Express and Advertiser,* Saturday evening, 13 May, 1871. (no pages nos.)
3. Ibid.
4. *The Clonmel Chronicle, Tipperary Express & Advertiser,* Wednesday evening, 10 May, 1871.
5. *The Irish Times*, Monday, 8 March, 1875, p.5, col. 4.
6. Turpin, 1995, p.171.
7. *The Clonmel Chronicle, Tipperary Express and Advertiser*, 13 May, 1871.
8.–16. Ibid.
17. *Clonmel Chronicle, Tipperary Express and Advertiser.* August 12, 1871.
18. Ahern, M., 'Clonmel Mechanics' Institute' in *Tipperary Historial Journal*, p.159.
19. *Free Press & Clonmel General Advertiser.* Saturday, 28 October, 1854. p.3. Col.2
20. *The Clonmel Chronicle, Tipperary Express and Advertiser* Wednesday evening, 25 October, 1871.
21. *The Clonmel Chronicle, Tipperary Express and Advertiser*, 21 October, 1871.
22. *The Clonmel Chronicle, Tipperary Express and Advertiser,* Wednesday evening, 25 October, 1871.
23. *The Clonmel Chronicle, Tipperary Express and Advertiser*, 21 October, 1871. If a catalogue was printed, it would appear that no catalogue relating to this exhibition has survived.
24. Ibid.
25. Ibid.
26. *The Clonmel Chronicle, Tipperary Express and Advertiser*, 25 October, 1871.
27. *The Clonmel Chronicle, Tipperary Express and Advertiser*, 1 November, 1871.
28. Ibid.
29. *The Clonmel Chronicle, Tipperary Express and Advertiser*, Wednesday evening, 25 October, 1871.
30. Ibid.
31. Ibid.
32. Ibid.
33. Ibid.
34. O'Brien, (ed.), *County Carlow Football Club, Rugby History, 1873-1977*, p.51.
35. Ibid., p 52.
36. *The Carlow Sentinel*, 11 May, 1872.
37. Ibid.
38. *The Irish Times* Monday, 8 March, 1875. col. 4.
39. 'Irish Amateur Drawing Society Judges' Report' in *The Irish Times*, Friday, 2 April, 1875, col. 5.
40. Ibid.
41. Irish Amateur Drawing Society (Second Notice) in *The Irish Times*, Monday, 20 March, 1876, col. 2.
42. Irish Amateur Drawing Society Ninth Exhibition (First Notice) in *The Irish Times,* Monday, 13 March, 1876, col. 5.

43. 'Exhibition of Society of Painter-Etchers, New Bond Street' in *The Athenaeum*, no. 2789, 9 April, 1881, pp. 497-8.

Chapter IX
1. Murray, 1991, p.ix.
2. Maguire, 1853, p.289.
3. Maguire, 1853, p.284
4. Murray, 1993, p.841, in Buttimer and O'Flanagan (eds.), 1993.
5. Ibid., p. 865.
6. As quoted in ibid., p.846.
7. Turpin, 1995, p.169.
8. St. Leger, 2005, p.24
9. Ibid., p.26.
10. *Cork Examiner*, Tuesday morning, 1 October, 1878.
11. Ibid.
12. Ibid.
13. *Cork Examiner*, 5 October, 1878, p.2.
14. Ibid.
15. Ibid.
16. Ibid.
17. Casey, 2005, p.531.
18. *Cork Examiner*, 5 November 5, 1879.
19. First Report of the Committee of the Art-Union of Ireland 1858-59, p.31.
20. *Cork Examiner*, 5 November, 1879.
21. The Irish Fine Art Society Catalogue of the Fifteenth Exhibition held at 35, Molesworth Street, Dublin, March, 1880.
22. *Cork Examiner*, 25 October, 1881, p.2.
23. *Cork Examiner*, Monday Morning, 7 November,. 1881, p.2.
24. *Cork Examiner*, 14 November 1881 p.2.
25. *The Cork Constitution,* 25 October, 1881, p.3, col. 3.
26. Scrapbook of the Dublin Sketching Club (no page nos.).
27. *Daily Express* (Dublin), 15 March, 1883, p.6.
28. *Daily Express* (Dublin), Monday, March 19, 1883 (no page nos.).
29. Ibid.
30. Letter to the Editor, *Daily Express* (Dublin), dated 26 March, 1883, from P. Chenevix Trench.
31. Ibid.
32. James Brenan, R.H.A. 'Cork School of Art. Report on the Fine Art Department', *Report of Executive Committee, Awards of Jurors and Statement of Accounts*, Cork 1886, pp.272-275.
33. *Cork Examiner*, 15 November, 1883, p 2.
34. *Cork Examiner,* Thursday, 22 November, 1883.
35. Ibid.
36. Scrapbook of the Dublin Sketching Club.
37. *Daily Express* (Dublin), 19 March, 1896.
38. 'Water Colour Society Conversazione', *The Irish Times*, 19 March, 1896.
39. *Daily Express* (Dublin), Tuesday, 11 March, 1884.
40. *Cork Examiner,* Friday morning, 14 November, 1884.
41. *Cork Examiner,* 27 November, 1884, p.2.
42. *Cork Examiner*, 14 November, 1884, p 2
43. *Cork Examiner*, 15 November, 1884.
44. *Daily Express* (Dublin), 12 March, 1888, p.3, col. 1.
45. Ibid.
46. *The Irish Times,* Tuesday, 13 March, 1888, p.5.
47. *Daily Express* (Dublin), 12 March, 1888, p.3, col. 1.
48. Scrapbook of the Dublin Sketching Club.

49. *Daily Express*, (Dublin), Monday, 11 March, 1889, p.5, col. 7.
50. 'The Water Colour Society of Ireland. Opening Today', *The Irish Times,* Monday, 11 March, 1889, p.5.
51. *Daily Express* (Dublin), Monday, 11 March, 1889 p.5, col. 7.
52. 'The Water Colour Society of Ireland. Opening Today', *The Irish Times,* Monday, 11 March, 1889, p.5.
53. Ibid.
54. *Daily Express* (Dublin), Monday, 11 March, 1889, p.5, col. 7.
55. 'The Water Colour Society of Ireland. Opening Today', *The Irish Times,* Monday, 11 March, 1889.
56. Williams, 1994, pp.30-31.
57. *The Northern Whig,* 22 September, 1883.
58. *The Belfast News-Letter* Monday, 15 October, 1888.
59. Ibid.
60. Ibid.
61. Scrapbook of the Dublin Sketching Club.
62. Ibid.
63. Ibid.
64. Ibid.
65. Ibid.
66. *The Irish Times,* 7 November, 1890.
67. Ibid.
68. Ibid.
69. Hand-written letter from The Castle, Dublin dated 14 March, 1892 from the Lord Lieutenant, Lord Langford, W.C.S.I. archives. N.G.I.
70. Hand-written letter dated 15 March 1892 from 30 Kildare Street marked 'Copy' to The Lord Langford, Dublin from Philip Chenevix Trench, W.C.S.I. archives. N.G.I.
71. Hand-written letter dated '18th' (no year given), The Castle, Dublin from The Lord Lieutenant, Lord Langford, W.C.S.I. archives. N.G.I.
72. Hand-written letter dated 20 March from 30 Kildare Street. from Philip Chenevix Trench, W.C.S.I. archives.
73. 'The Forty Ninth Exhibition', *The Irish Times,* Wednesday, 18 February, 1903.

Chapter X
1. Cook and Wedderburn (eds.), 1903-12, Vol. XV, p.138
2. W.H. Pyne in the *Somerset House Gazette*, 1823-24, Vol. 1, p.67.
3. 'Irish Amateur Drawing Society. Ninth Exhibition (First Notice)' in *The Irish Times*, Monday, 13 March, 1876, col. 5.
4. *Cork Examiner*, 1 October, 1878, p.2.
5. *Daily Express* (Dublin), 18 March, 1888, p.3, col. 1.
6. Csteras and Denney (eds.), 1996, p.viii.
7. *The Ladies Field*, December 1900, p.41
8. 'Obituary - Rose Barton', *The Times*, 12 October, 1929.
9. 'Distinguished Irish Women' in *The Lady of the House* January, 1896, p.3.
10. Barton, 1904, p.41.
11. As quoted in Rebecca Rowe 'The Paintings of Rose Barton', from a catalogue *Rose Barton. R.W.S. (1856-1929) Exhibition of Watercolours and Drawings,* Crawford Municipal Art Gallery, Cork, 1989.
12. Charles Nugent in exhibiton catalogue, *Rose Barton. R.W.S. (1856-1929) Exhibition of Watercolours and Drawings*, Crawford Municipal Art Gallery, Cork, 1989.
13. W.C.S.I. Minutes dated Tuesday, 19 November, 1929. Signed A.V. Montgomery.

14. Fox and Greenacre, 1979, p.210, exhibition catalogue for *Artists of the Newlyn School (1880-1900).*
15. Ibid. p.209.
16. Norman Garstin's introduction to the Spring Exhibition, 1902, Whitechapel Art Gallery, as quoted in Patrick Heron, introduction to the *Norman and Alethea Garstin* exhibition catalogue, 1978.
17. C. Lewis Hind, 'Stanhope A Forbes R.A.' *Art Journal*, 1911, p.10.
18. Quoted by Michael Canney in his introduction to *Norman and Alethea Garstin* exhibition catalogue, 1978, p.17 .
19. Dr. Hilary Pyle, *Mildred Anne Butler 1858-1941,* exhibition catalogue, Crawford Municipal Art Gallery, Cork 25 August -30 September, 1987. (no page nos).
20. *The Queen,* 6 June, 1891, p.901.
21. *Year's Art,* 1899, p.349. (advertising section).
22. *Daily Express* (Dublin) Monday., 25 March, 1889 p.5, col. 7.
23. *Belfast Newsletter* 11 November, 1893.
24. *Belfast Newsletter,* 8 November, 1895.
25. W.C.S.I minutes dated 17 February, 1932 relating to a meeting held on 30 October, 1931 at 61, Merrion Square, Dublin, (Secretary, A.V. Montgomery).
26. Somerville and Ross, 1932, p.208.
27. 'The Society of Painters in Water Colour' in *The Athenaeum*, 8 May, 1897, p.622.
28. Gearóid óBroin, *Jacob Poole of Growtown - and the Yola Dialect, Manuscript,* 1996, p.1.
29. Snoddy, 2002, p.11
30. *Cork Examiner,* 7 June, 1883, p.2.
31. Dublin Sketching Club scrapbook (no page nos.), Printed notice (no title given).
32. Dublin Sketching Club Minute Book 1895-1905, Secretary, Alexander Williams, R.H.A., p.92.
33. Snoddy, 2002, p.12
34. Minutes of the Dublin Sketching Club A.G.M. held on Wednesday, 19 October, 1898, p.97.
35. Crookshank and Glin, 1994, p.265
36. Ibid., p.265.

Chapter XI
1. W.C.S.I. Minutes dated 8 April, 1925.
2. W.C.S.I. Minutes dated 4 March, 1927.
3. W.C.S.I Minutes dated 27 November, 1934.
4. W.C.S.I Minutes dated 22 February, 1935.
5. W.C.S.I. Minutes dated 10 December, 1936.
6. W.C.S.I. Minutes dated Friday, 8 December, 1944.
7. W.C.S.I Minutes (no date), signed 'Major Nolan Ferrall'.
8. W.C.S.I. Minutes (no precise date), March, 1945.
9. Ibid.
10. Ibid.
11. W.C.S.I. Minutes dated 11 March, 1946.
12. W.C.S.I. Minutes dated 3 December, 1957.
13. W.C.S.I. Minutes dated 12 December, 1960.
14. W.C.S.I. Minutes dated 9 February, 1970.
15. W.C.S.I. Minutes dated 7 February, 1973.
16. W.C.S.I. Minutes dated 24 January, 1974.
17. W.C.S.I. Miunutes dated 6 February, 1984.
18. Ibid.

19. George A. McCaw (ed.), W.C.S.I. Newsletter, January, 1985.
20. W.C.S.I. Minutes dated 30 October, 1986.
21. W.C.S.I. Minutes dated 30 October, 1986, and 27 January, 1987.
22. W.C.S.I. Minutes dated 27 January, 1987.
23. Written information received from W.C.S.I. Past President, James Nolan, R.H.A., A.N.C.A to the author dated 28 May, 2007.
24. W.C.S.I. Hon. Secretary, George McCaw's report (1988) on progress to date of W.C.S.I. over the last few years. See p.2.
25. Ibid., p.3.
26. W.C.S.I. Minutes dated 27 January, 1987, p.2.
27. W.C.S.I. Minutes of General Meeting, 9 February, 1988.
28. George A. McCaw (ed.), W.C.S.I. Newsletter 1989-90.
29. George A. McCaw (ed.), W.C.S.I. Newsletter, February 1993, p.1.
30. George A. McCaw (ed.), W.C.S.I. Newsletter 1989/90, 15 December, 1989, p.2
31. Letter dated 8 March, 1990 from Dr. Edward M. Walsh, President, University of Limerick to James Nolan, R.H.A., A.N.C.A President, Water Colour Society of Ireland.
32. Address/Response by the President of the W.C.S.I. James Nolan, R.H.A., A.N.C.A. to the Minister of State, Department of Justice, Mr. Willie O'Dea, T.D.
33. Ibid.
34. George A. McCaw (ed.), W.C.S.I. Newsletter dated March 1995.
35. W.C.S.I. Press Release dated Tuesday, 15 February, 1994. 'Well-Known Artist New President of Water Colour Society of Ireland'.
36. George McCaw, W.C.S.I. report for years 1996, 1997 & 1998. See p.2.
37. Ibid., p.3.
38. Letter from George A. McCaw, President, W.C.S.I. Dated 20 April, 2002 to Nancy Larchet, W.C.S.I. Committee Member.
39. The Water Colour Society of Ireland 150th Exhibition - A Celebratory Display of Paintings by Past Members (exhibition catalgoue) 6 October-12 December, 2004.

Chapter XII
1. As quoted in Gordon T. Ledbetter, 'Alexander Williams (1846-1930): Sidelights on a Victorian Painter' In *The Irish Ancestor*, No. 2, 1975, p.86.
2. Gordon T. Ledbetter, 'A Painter on Achill' in *Irish Arts Review*, Winter 2006, p.109.
3. As quoted in Gordon T. Ledbetter, 'Alexander Williams (1846-1930): Sidelights on a Victorian Painter' in *The Irish Ancestor*, No. 2, 1975, p.83.
4. Ibid., p.85.
5. Alexander Williams *Achill Natural History Notes and Diary* (no page nos). I would like to thank Gordon T. Ledbetter for drawing my attention to the painter's diary entries and for providing so much valuable information in connection with the life of the artist.
6. Thomas MacGreevy, 'Fifty Years of Irish Painting', *Capuchin Annual*, 1949, pp.502-3.
7. Hardie, 1966-8, Vol. 3, p.156.
8. Catalogue of the Belfast Art Society's Annual Exhibition, the 28th Year, 1909. For a list of 'Artists Exhibiting by Special

Invitation' see p.19.
9. Hardie, 1966-8, Vol. 3, p.159.
10. Brian Fallon, *Irish Times,* 19 August, 1982, p.8.
11. As quoted in Oliver Nulty's Introduction to exhibition catalogue (no page nos.) *Exhibition of Watercolours by Percy French (1854-1920)*, The Oriel Gallery, 17 Clare St., Dublin, 19 June-7 July 1979.
12. As quoted in ibid., 'Introduction' by Oliver Nulty.
13. *Irish Times*, 27 January, 1920, p.6.
14. Price (ed.), 1982, Vol. II, pp.6-7.
15. Kennedy, 2003, 'Director's Foreword' by R.Keaveney, (no page no.).
16. Henry, 1951, p.18.
17. Pennell, E.R. & J., 1908, p.232.
18. Kennedy, 2007, p.141
19. Unidentified press cutting, as quoted in Kennedy, 2007, p.141.
20. Henry, 1951, 'Foreword' by Sean O'Faolain, p.viii.
21. Leslie, 1940, p.46
22. W.C.S.I. Minutes dated 20 October, 1932, A.V. Montgomery, Chairman.
23. Mrs R. Wilkins, 'The Work of Educated Women in Horticulture and Agriculture' [Sept. 1915] in *The Journal of the Board of Agriculture*. Vol. XXII, April 1915-March 1916, p.558.
24. Frost (ed.), 1957, p.76.
25. The author is most grateful to Jim O'Callaghan, Education Department, N.G.I for this information.
26. Review of *Vanishing Dublin*. Editor: Allen Figgis in *Ireland of the Welcomes*. Sept-Oct.1966.
27. Ibid.
28. 'Nostalgic Scenes of Dublin' Signed 'N.L.' in the *Irish Independent*, 3 September, 1959, p.6.
29. Kennedy, 1993, p.16.
30. *The Studio*, Vol. 86, No. 369, pp.302-309 (no title).
31. Ibid.
32. 'Frank McKelvey, R.H.A. An Appreciation' in *The Irish Times*, 4 July, 1974
33. E. Kehoe 'Maurice McGonigal' in *The Sunday Press*. 4 February, 1979, p.11
34. R.T.E broadcast interview c.1972 Maurice MacGonigal and Tom McGurk. Quoted in *Maurice MacGonigal, R.H.A. 1900-1979* by Katharine Crouan, The Hugh Lane Municipal Gallery of Modern Art, Charlemont House, Parnell Square, Dublin 1. 12 July-25 August 1991 (exhibition catalogue).
35. *The Dublin Magazine*, April-June 1958, pp.35-36.
36. As quoted in Snoddy, 2006, p.379.
37. Brian Fallon, 'An Appreciation. Art and Epoch Pass Together' in *The Irish Times,* 1 February, 1979, p.7.
38. Professor Anne Crookshank from 'Introduction' to the *Norah McGuinness Retrospective Exhibition*, Exhibition Hall, New Library, T.C.D. 11 October -2 November, 1968, p.6.
39. Kennedy, 1991, p.55.
40. Susan Butler, 'It has taken thirty-three years!' in *Kilkenny People*, Friday, 3 December, 1976, p.9.
41. 'George Pennefather. An Appreciation' in *The Irish Times*, Thursday, 13 April, 1967, p.7.
42. 'A Provincial View of the R.H.A.' by T. MacS. in *Commentary*, Vol. 1, No. 8, July 1942.
43. S.B. Kennedy, *The White Stag Group* (exhibition catalogue) Irish Museum of Modern Art 6 July-4 October, 2005, p.5.

44. Ibid., pp.12,13.
45. Kenneth Hall, 'Exhibition of Watercolours by Basil Rákóczi' in *Commentary*, Vol. ?, No. 7, 1 June 1942, pp.15,16
46. Catalogue. Irish Art Auction (including the Studio of Tom Nisbet R.H.A) de Veres Art Auctions held on Monday, 13 November, 2006 at 5.30 p.. in the R.H.A. Foreword by Thomas Ryan, Past President of the R.H.A. p.1.
47. 'Obituary: Tom Nisbet' in *The Irish Times*, Saturday, 19 May, 2001, p.18.
48. Introduction by Dr. Brendan O'Brien from exhibiton catalogue *Kitty Wilmer O Brien R.H.A.* Taylor Galleries, 6 Dawson Street, Dublin, 2. 1983.
49. Dr. Brendan O'Brien from exhibition catalogue *Kitty Wilmer O Brien R.H.A.* Taylor Galleries, 6 Dawson Street, Dublin, 2. 1983.
50. The author would like to thank Anthony O'Brien for his help and assistance in compiling this entry.
51. The author is grateful to a friend of the artist, Pamela Robinson (née Mathews), for this information.
52. James Nolan, R.H.A., A.N.C.A. President The Water Colour Society of Ireland. Letter to The Editor, *The Irish Times*, D'Olier Street, Dublin, 1 dated 24 February, 1982.
53. Ibid.
54. Brian Fallon, 'Belfast Artist exhibits work in Dublin' in *The Irish Times,* Saturday, 19 September, 1970, p.3.
55. As quoted in T.P. Flanagan 'Tom Carr, An Appreciation' in the exhibition catalgoue for *Tom Carr Retrospective*, Arts Council Northern Ireland, 1983. (no page nos.)
56. Ibid.
57. *Irish Independent,* Friday, 4 October, 1940, p.4.
58. Kennedy, 1991, p.62.
59. Stephen Rynne, 'A Square Peg' in *The Leader,* 12 October, 1940, p.852.
60. Edward Sheehy 'Art Notes' in *The Dublin Magazine*, Vol. XX1, No.1. January-March, 1946, p.52.
61. Kennedy, 1991, p.63.
62. W.C.S.I. Minutes dated 5.4.54, F.G. Hicks.
63. W.C.S.I. Minutes dated 14.12. 54, F.G. Hicks.
64. W.C.S.I. Minutes dated 24.3.61, F.G. Hicks.
65. Gerald Dillon, Chapter One *Growing up* pp.13-17 in (exhibition catalogue) *Gerard Dillon. A Retrospective Exhibition 1916-1971*. Ulster Museum, Belfast, Nov.-Dec. 1972. Municipal Gallery of Modern Art, Dublin, Jan.-Feb. 1973.
66. Haughton, 1982, p.79.
67. W.C.S.I. Minutes dated 13.1.50.
68. Frederick Parkinson, critic & editor of *The Artist,* quoted in *Newsletter* Friday, 11 February, 1966 p.8.
69. Ibid.
70. Haughton, 1982, p.49.

Chapter XIII
1. *Clonmel Chronicle* etc., Wednesday evening October 25, 1871.
2. Hare, 1893, Vol. I, p.153.
3. Dante Gabriele Rossetti in a letter to his mother dated 'Sunday night, 1st July 1855', in Rosetti (ed.), 1899.
4. Letter to Lady Waterford from John Ruskin dated '27 January [1858], W. 13.', in Rosetti (ed.), 1899.
5. Letter from Lady Waterford to Mrs Bernal Osborne dated '22 February, 1865.

Ford Cottage' in Hare, 1893, Vol. III, p.14.
6. O'Grady, 1996, p.27.
7. 'Irish Fine Art Society' in the *Daily Express* (Dublin), Wednesday, 17 March, 1889.
8. O'Grady, 1996, p.41.
10. Purser, 2004, p.64.
11. Ibid., p.187.
12. O'Grady, 1996, p.139.
13. *The Studio*, December, 1900.
14. Snoddy, 1969, p.696.
15. As quoted in ibid., p.697
16. Bodkin, 1987, p.34.
17. Gregory, 1973, p.45.
18. Bodkin, 1987, p.38.
19. Mary Swanzy, 16 September, 1958. T.C.D. Ms.3549.
20. Pyle, 'Clare Marsh Remembered' in *The GPA Irish Arts Review Yearbook 1988*, p.89.
21. As quoted in ibid.
22. Ibid.
23. Thomas MacGreevy in *The Capuchin Annual* 1949, p.504.
24. W.C.S.I. Minutes, 19 March, 1951, 19 Upper Mount Street, Dublin, signed 'Eve H. Hamilton Dec. 10th 1951'.
25. 'Studio-Talk' in *The Studio*, No. 56, 1912, p.317.
26. Ryan-Smolin, 1987, p.110.
27. Dr. John Turpin, 'William Orpen as Student and Teacher' in *Studies* Vol. LXVIII, No. 271, Autumn 1979, pp.173-192.
28. Frank Rutter, 'Orpen's Self Portraits', in *The Studio*, Vol. LXXX, May 1903.
29. As quoted in Turpin, 1979, p.173.
30. Letter from William Orpen to the Adelaide Public Library Board, 15 August, 1914 as quoted in Arnold, p.290.
31. Letter from Dr Bruce Arnold to the author, dated 24 January, 2009.
32. *Some Memories of Lilian Davidson, A.R.H.A. A appreciation of the Art Classes given by Lilian Davidson, A.R.H.A.* Typescript, 1986. (no page nos. now). W.C.S.I. Archives, C.S.I.A. N.G.I.
33. Cahill, 1999, p.36.
34. Ibid., pp.36, 37.
35. White, 1972, p.18.
36. Cahill, 1999, p.44.
37. 'The Water Colour Society of Ireland. The Fiftieth Exhibition', *The Irish Times*, Wednesday, 24 February, 1904.
38. *Fáinne an lae* (Dublin) Vol. 1, No. 19, 14 May, 1898, p.5.
39. 'Art in Belfast' in *The Nationalist* (Dublin), 2 November, Vol. 1. No. 7, p.111.
40. W.C.S.I. Minutes, A.V. Montgomery, 27 November 1934.
41. Tom Nisbet, R.H.A. 'Eileen Reid An Appreciation' in *The Irish Times,* Thursday, 23 April, 1981 p.11.
42. Ibid.
43. As quoted in Arnold, 1991, p.25.
44. Ibid., p.12.
45. Ibid., p.19.
46. Ibid., p.22.
47. As quoted in Purser, 2004, p.174.
48. Frost (ed.), 1957, quotation from frontispiece.
49. Ibid., p.48.
50. Purser, 2004, p.175.
51. Ibid.
52. Bruce Arnold, 1976, in exhibition catalogue *Mainie Jellett 1897-1944* at The Neptune Gallery, 42 South William St., Dublin, 2.
53. W.C.S.I minutes dated 9 March 1939. Signed A.V. Montgomery.
54. Elizabeth Bowen in Frost (ed.), 1957, p.5.
55. W.C.S.I minutes dated 6 October,

1944. Signed H. Nolan Ferrall.
56. Arnold, 1991, p.vii.
57. Patrick Swift, 'Contemporary Irish Painters (No.4.) Nano Reid' in *Envoy*, Vol. 1, No. 4, March, 1950, pp.26-35.
58. As quoted in Mallon, 1994, p.79.
59. Swift, 1950, p.33.
60. Elizabeth Curran, 'The Art of Nano Reid' in *The Bell*, Vol. 3, No. 2. November, 1941, pp.128-131.
61. Mallon, 1994.
62. Curran, 1941, p.127.
63. 'International Art News: Ireland' in *The Studio* 1937, Vols. 13-14, p.163.
64. E.A. McGuire writing in ibid. p.163.
65. Dr. Jeanne Sheehy writing in ibid., p.6.
66. John Ryan, p.5 in the exhibition catalogue for *Dubliners Portraits* by Harry Kernoff, R.H.A. Godolphin Gallery, 20 Clare Street, Dublin, 2, February 1975.
67. Foreword by Harry A. Kernoff in the exhibition catalogue for *Paintings by Harry A. Kernoff* at the Gieves Gallery, 22, Old Bond Street, London W1, March, 1931.
68. As quoted in Snoddy, 1969, p.311.
69. Edward Sheehy 'Art Notes' in *The Dublin Magazine*, Vol. XX, No. 1, Jan-March, 1945, p.41.
70. Press cutting: December 1937, Kernoff to critic, Sean O'Meara, N.L.I. MS. 20919(ii).
71. Brigid Ganly interviewed by Barbara Dawson 12 March, 1998, p 28 in exhibition catalogue, *Brigid Ganly Retrospective*, Hugh Lane Municipal Gallery of Modern Art, 1998.
72. Brigid Ganly as quoted in Turpin, 1995, p.250.
Brigid Ganly interviewed by Barbara Dawson 12 March, 1998, p.18 in exhibition catalogue, *Brigid Ganly Retrospective*, Hugh Lane Municipal Gallery of Modern Art, 1998.
74. Daire O'Connell. p.6 in the Introduction to exhibition catalogue, *Brigid Ganly Retrospective*, Hugh Lane Municipal Gallery of Modern Art, 1998.
75. Mainie Jellett, 'The RHA and Youth' in *Commentary*, May 1942 pp.5-7.
76. Brigid Ganly, 'The RHA, 1943' in *Commentary*, May, 1943, pp.5-6.
77. W.C.S.I Minutes, sgned A.V. Montgomery, dated 21st February, 1928.

Chapter XIV
1. W.C.S.I Minutes dated 5 December, 1921 Signed W. Montgomery.
2. W.C.S.I. Minutes dated 14 June, 1922. Signed W. Montgomery.
3. W.C.S.I. Minutes dated 3 March, 1950 Signed E.M. Mooney.
4. *May Guiness*, exhibition catalogue, Eldar Gallery, London, 1920 (no page nos.).
5. Selina Guinness, 'Introduction to *The Bombardment of Vadelaincourt* by May Guinness', p.52, *Dublin Review*, No. 25, Winter 2006-7, (pp.52-65).
6. *Sphere Magazine*, 17 October, 1925, p.240.
7. Selina Guinness, 'Introduction to *The Bombardment of Vadelaincourt* by May Guinness', p.52, *Dublin Review*, No. 25, Winter 2006-7, (pp.52-65).
8. Sir Frederick Moore's correspondence, The Library, National Botanic Gardens, Glasnevin, Dublin.
9. Snoddy, 2002, p.141.
10. White, 1943.
11. Ibid., p.40.
12. 'New Irish Salon, Work of Modern School of Irish Artists' in *The Irish Times*, Monday, 5 March, 1923, p.4.
13. Brian Fallon, 'Moyra Barry paintings at

the Gorry Gallery' in *The Irish Times*, 29 September, 1982.
14. Edward Sheehy, 'Exhibition of Paintings by Caroline Scally at The Dublin Painters' Gallery' in Art Notes, p.41 in *The Dublin Magazine*, Jan-March, 1953, Vol. XXVIII, No.1 (pp.39-41).
15. Dr. S.B. Kennedy, Introduction to retrospective exhibition *Caroline Scally*, The Frederick Gallery, Dublin. 9th March - 23rd March, 2005.
16. Arland Ussher, 'Art Notes: Review of Exhibition The Dublin Painters No. 7 St. Stephen's Green', p.57, in *The Dublin Magazine*. July-September, 1957 (pp.48-51).
17. Brian Fallon in *The Irish Times*, 23 July, 1965.
18. Brian Fallon in *The Irish Times*, 30 May, 1970.
19. Kennedy, 1991, p.68.
20. 'Society of Black and White Artists. Second Annual Exhibition', *The Irish Times*, 13 April, 1914.
21. Kennedy, 1991, p.68
22. J. Crampton Walker, 1926, dedication page
23. 'Book Reviews', p.73 in *The Dublin Magazine* January-March 1927, Vol.11, No.1.
24. Molly Keane, 'Joan Jameson & Norah McGuinness. Two Painters in Ardmore' in *The Ardmore Journal*, p.1. Waterford County Museum.
25. *Throne and Country*, 1 May, 1911.
26. *Dublin Evening Mail*, 23 October, 1934.
27. Edward Sheehy, 'Art Notes: Irish Exhibition of Living Art' in *The Dublin Magazine*, Sean O'Sullivan p.43. Vol. XX. No. 4. October-December, 1945.
28. (Dr.) J. White in *The Bell*. Vol. XVII. No. 6. September, 1951, p.60 (pp59-61).
29. *The Irish Times*. 4 October, 1943.
30. *The Irish Times* 4 October, 1989.
31. Molly Keane, *Joan Jameson & Norah McGuinness - Two Painters in Ardmore*. Waterford County Museum. February, 2004.
32. George McCaw 'Appreciation. Phoebe Donovan', *The Irish Times*, Thursday, 2 July, 1998, p.17.
33. As quoted in ibid.
34. Aidan Dunne 'Woman of Strength' in *The Irish Times*, Saturday, 24 March, 2001.
35. Ibid.
36. George McCaw 'Appreciation. Phoebe Donovan', *The Irish Times*, Thursday, 2 July, 1998, p.17.
37. 'Art Notes', *The Dublin Magazine* Vol. XXXII, No.2, April-June, 1957, p 28 (pp 26-29).
38. Brian Fallon, 'Obituary. The Reverend Father J. Hanlon' in *The Irish Times*, Tuesday, 13 August, 1968, p.9.
39. John Coleman, 'A Painter of Living Art: Jack P. Hanlon (1913-1968)', *Irish Arts Review Yearbook*, 1988, p.224
40. (Dr.) James White *Father Jack Hanlon 1913-1968 Paintings and Watercolours*. Pantheon Gallery. 6 Dawson Street, Dublin, 2.
41. Coleman, 1988, p.225.
42. Lillias Mitchell, 'Remembering Mother and Miss Yeats' in Irish Arts Review, Vol.3, No.1, Spring 1986, p.42 (pp.41-42).
43. *Irish Press* Wednesday, 10 January, 1979, 'Weaving Strands of a Craft Revival' Interview with Sheila Walsh.
44. D.A. Levistone Coone, 'Threads in a Tapestry: The Story of the Mitchell Family' in the *Dublin Historical Record*, Vol.

L1, No.1, Spring 1998, p 42. (pp 25-50).
45. Ibid. p.47.

Chapter XV
1. Lewis, 1987, p.17.
2. Somerville and Ross, 1932, p.212.
3. Bodkin, 1948, p.9
4. As quoted in Snoddy, 2002, p.643.
5. J.S. Little, 'Frank Brangwyn and his Art' in *The Studio*, October, 1897, p.8.
6. As quoted in Horner, 2006, p.31 [As quoted by Libby Snoddy Chapter 1 Biography *Frank Branguyn 1867-1956* etc.]
7. Jacomb-Hood, 1925, p.73.
8. *Irish Times*, Wednesday, 28 February, 1912, 'The Water Colour Society of Ireland. The 58th Exhibition.'
9. Quoted in Boswell, 2006, p.182.
10. Furst, 1924, p.122
11. 'A Room decorated by Frank Brangwyn', in *The Studio*, March, 1900, p.178.
12. Galloway, 1962, p.11.
13. Wilkinson, 1925, p.274.
14. Wilkinson, 1926, pp.3-4.
15. *The Studio*, Vol. 68, June 1916, p.113
16. M.K. Hughes, 'Impressions of Palestine' in *The Studio*, February 1918, Vol. 73, p.6.
17. Dickinson, 1929, p.43.
18. Annesley, 1964, p.46.
19. Obituary for Lady Mabel Marguerite Annesley (1881-1959) in *The Times*, 26 June, 1959.
20. Quoted in Bowe, 1989, pp.40-41.
21. Bowe, 1989, p.14.
22. Ibid., p.18.
23. George Harrap as quoted in Bowe, 1989, p.18.
24. Quoted in Turpin, 1995, p.215.
25. Ibid, p.205.
26 'An Exhibition by Three Book-Illustrators: John Austen, Harry Clarke and Alan Odle' in *The Studio*, Vol. 89, 15 January, 1925, p.261.
27. 'Elizabeth Rivers', An Appreciation by Patrick Pye, *Irish Times*, 2 September, 1964.
28. Brian Kennedy, 1989 catalogue for *Elizabeth Rivers 1903-1964, A Retrospective View*, p 12, Gorry Gallery. Dublin 26 May-8 June, 1989.
29. Ibid., p.12.
30. Kennedy, 1989, exhibiton catalogue, *Elizabeth Rivers 1903-1964, A Retrospective View*, The Gorry Gallery, 20 Molesworth Street, Dublin, p.12.
31. 'Pictures from the Aran Islands. Miss River's London Exhibition held at Nicholson Galleries' in the *Irish Times* Thursday, 9 February, 1939.
32. Elizabeth Rivers in conversation with Marian Fitzgerald reprinted for the *Irish Times*, 11 August, 1962.
33. James White, 1966 catalogue for *Elizabeth Rivers Memorial Exhibition*, February 1966. p.5, Municipal Gallery of Modern Art. Dolmen Press.
34. Obituary for Bishop Wyse-Jackson in *The Church of Ireland Gazette* by the Primate, the Most Reverend Dr. George Otto Simms, 29 October, 1976, p.2.
35. Snoddy, 2002, p.282.
36 .Brian Fallon, 'Margaret Stokes 1915-1996, Kennedy Gallery' in the *Irish Times*, 27 March, 1997.

Chapter XVI
1. 'Studio-Talk' in *The Studio*, March 1900, p.116.
2. W.C.S.I. Minutes. Signed: A.V. Montgomery, 21 March, 1929.

3. *The Dublin University Review*, Illustrated Art Supplement dated March 1885. Title: 'Watercolours' (from a Review of the R.H.A. Exhibition opened 2 March, 1885).
4. A friend of the artist, J.B. Hall, as quoted in Snoddy, 2002, p.384.
5. *Musical Opinion* September, 1889; August, 1890; and September, 1890.
6. 'A Mere Fracture', letter to *The Times*, April 19, 1943 from William Crampton Gore, 21 Creffield Road, Colchester.
7. Ibid.
8. Sheehy, Edward, 'Art Notes: The Slack Season' in *The Dublin Magazine*, October-December, 1940, Vol. XXI, No.4, pp.45-46.
9. *The Times*, Friday, 1 May, 1914, 'Paris Salon des Artistes Français'.
10. As quoted in the exhibition catalogue, *Beatrice Gubbins of Dunkathel, Co. Cork* (1878-1944), Crawford Municipal Art Gallery, April 17-May 13, 1986, p.5.
11 W.C.S.I. Minutes dated 4 March, 1958. Signed: Kitty O'Brien.
12. Pyle, Hilary, 'The Hamwood Ladies: Letitia and Eva Hamilton' in the *Irish Arts Review*, 1997, Vol. 13, p.124.
13. Ibid. p.131.
14. *The Studio*, Volume 87: January-June (inclusive), March 1924, p.169
15. Pyle, 1997, p.131.
16. Ibid. p.132.
17. Sheehy, Edward, 'Art Chronicle' in *The Dublin Magazine*, January-March 1944., Vol. XIXM, No. 1, p 44.
18. *The Irish Independent*, Wednesday, 12 August, 1964, p.11, col. 8.
19. *Irish Times*, Saturday, May 27, 2006, Obituary, p.12.
20. Ibid.

Chapter XVII
1. Glenavy, 1964, p.38
2. Ibid. p.13
3. Ibid. p.13.
4. Orpen, 1924, p.69.
5. Dickinson, 1929, P.43.
6. Glenavy, 1964, p.38.
7. Bowe and Cumming, 1998, p.132.
8. Glenavy, 1964, pp.35-43.
9. Glenavy, 1964, p.148.
10. *The Irish Times*, Monday, 25 May, 1970, p.3.
11. Dr. James White in the Introduction to the exhibition catalogue for *Evie Hone, Memorial Exhibition*, 29 July-5 September, 1958. Great Hall, U.C.D. Earlsfort Terrace, Dublin, 1958 (no page nos.).
12. Hicks, 2007, p.125.
13. Mary Swanzy, as quoted in Snoddy (2nd edition), 2002, p.262.
14. E. Hone, 'Georges Rouault' *Irish Ecclesiastical Record*, 5th Ser., Vol.61, February, 1943, p.135.
15. O'Sullivan, Dónal in the catalogue of the *Irish Exhibition of Living Art*, 18 August-16 September, 1955. National College of Art, Kildare Street, Dublin.

Chapter XVIII
1. Butler, 1922, p.60.
2. Ibid. p.169.
3. Ibid. p.200.
4. Butler, 1909, p.86.
5. Ibid. pp.96-97.
6. O'Byrne, M.K., 'Lady Butler Painter of the Roll Call' in *The Irish Monthly*, Vol. LXXVIII, No. 930, December 1950, p.592.
7. W.C.S.I Minutes dated 23 February, 1934. Signed: R. Caulfeild Orpen, Chairman.

Bibliography

BOOKS

Adams, Eric, *Francis Danby: Varieties of poetic landscape*. New Haven & London 1973.

Andrews, J.H., *A Paper Landscape: The Ordnance Survey in nineteenth-century Ireland*. Oxford 1975.

Anglesea, Martyn, *The Royal Ulster Academy of Arts*. Lisburn 1981.

Annesley, Mabel M., *As the Sight is Bent*. London 1964.

Arnold, Bruce, *Mainie Jellett and the Modern Movement in Ireland*. Yale University Press, New Haven & London 1991.

Arnold, Bruce, *A Concise History of Irish Art*. London 1969.

Arnold, Bruce, *Orpen: Mirror to an Age*. London 1981.

Backhouse, Janet, *The Illuminated Manuscript*, Reprint, 7th edition. London 2006.

Bagenal, Philip Henry, *The Life of Ralph Bernal Osborne, MP.* London 1884 (for private circulation).

Baile de Laperriere, Charles, *The New English Art Club Exhibitors 1886-2001*. Calne, Wiltshire 2002.

Barret, George [the Younger] *The Theory and Practice of Water Colour Painting elucidated in a Series of Letters*. London 1840.

Barton, Rose, *Familiar London* with 61 illustrations by the author. London 1904.

Bate, Jonathan, *John Clare, a biography*. New York 2003.

Beck, Hilary, *Victorian Engraving*. London 1973.

Bence-Jones, Mark, *A Guide to Irish Country Houses*. Revised Edition, London 1988.

Bénézit, Emmanuel, *Dictionnaire critique et documentaire des peintres, sculpteurs, dessinateurs et graveurs*, 10 vols. New edition, Paris 1976.

Pownoll, W. Phipps, *The Life of Colonel Pownoll Phipps*. Printed for private circulation by Bentley, Richard and Son, London, July, 1894.

Bernal Osborne, Catherine Isabella (ed.), *Memorials of Lady Osborne: The life and character of Lady Osborne and some of her friends [letters]*. 2 vols., Dublin 1870.

Black, Eileen, *Art in Belfast 1760-1888 Art Lovers or Philistines?* Dublin and Portland, Oregan. 2006.

Blackburn, Helen (ed.), *A Handy Book of Reference for Irishwomen*. Preface by Mrs Power Lawlor. London 1888.

Blacker, Stewart, *Irish Art and Irish Artists*. Dublin 1845.

Blakesley, Rosalind, *The Arts and Crafts Movement*. London 2006.

Bodkin, Thomas, *The Noble Science. John Leech in the Hunting Field*. Introduction by Sir Alfred Munnings. P.R.A. London 1948.

Bodkin, Thomas, *Four Irish Landscape Painters*. 2nd edition. Dublin 1987.

Borzello, Frances, *A World of Our Own: Women as Artists*. London 2000.

Bourke Marie, *The Aran Fisherman's Drowned Child by Frederick William Burton*. Dublin 1985.

Boylan, Henry, *A Dictionary of Irish Biography*. Second Edition. Dublin 1988.

Boylan, Patricia, *All Cultivated People – A History of The United Arts Club, Dublin*. Gerard's Cross, Bucks. 1988.

Brandon, Ruth, *Other People's Daughters: The Life and Times of the Governess*. London 2008.

Breeze, George, *Society of Artists in Ireland: Index of Exhibits 1765-80*. Introduction by Dr. M. Wynne. Dublin 1985.

Brooke, Raymond F., *The Brimming River*. Dublin 1961.

Brookner, Anita, *Watteau*. London 1967.

Brown, Terence, *Ireland: A Social & Cultural History 1922-2002*. Dublin 2004.

Bryan, Michael, *Bryan's Dictionary of Painters and Engravers* 5 vols., Revised edition. London 1903-05.

Burbidge, Frederick W.T., *The Art of Botanical Drawing*. London 1873.

Butler, Elizabeth, *An Autobiography*. London 1922.

Butler, Elizabeth, *From Sketch-Book and Diary*. London 1909.

Butler, Henry, *South African Sketches: Illustrative of the Wildlife of a Hunter on the Frontier of the Cape Colony*. London 1841.

Butler, Patricia & O'Kelly, Pat, *The National Concert Hall at Earlsfort Terrace, Dublin. A History*. Dublin 2000.

Butler, Patricia, *Irish Botanical Illustrators and Flower Painters*. Woodbridge, Suffolk, 2000.

Butler, Patricia, *Three Hundred Years of Irish Watercolours and Drawings*. London 1990. Reprint 1994.

Buttimer, Cornelius G., and O'Flanagan, Patrick, *Cork History & Society*. Dublin 1993.

Caffrey, Paul, *Treasures to Hold: Irish and English miniatures 1650-1850 from the National Gallery of Ireland Collections*, Dublin 2000.

Caird, Mona, *Romantic Cities of Provence* Illustrations from sketches by Joseph Pennell and Edward M. Synge. London 1906.

Casey, Christine, *Pevsner Architectural Guides: The Buildings of Ireland. Dublin: The City within the Grand and Royal Canals and the Circular Road with the Phoenix Park*. Yale University Press, 2005.

Chadwick, Whitney, *Women, Art, and Society*. Fourth edition, London 2007.

Chilvers, Ian, (ed.), *Oxford Concise Dictionary of Art & Artists*. Third edition,.Oxford 2003.

Clayton, Ellen C., *English Female Artists*. 2 vols. London 1876.

Cole, Alan S., *A Renascence of the Irish Art of Lace-Making*. London 1888.

Cole , Alan S., *Two Lectures on the Art of Lace Making*. Dublin 1884. [Pamphlet]

Cook, E. & Wedderburn, A. (eds.), *The Works of John Ruskin*, Vol. XV. London 1903-12.

Corbet Yeats, Elizabeth, *Brush Work Studies of Flowers, Fruit and Animals*. London & Liverpool 1898.

Corporation of Dublin, *A Book of Dublin*. With illustrations by Flora Mitchell, M. McGonigal, Dublin 1929.

Cox, David, *A Series of Progressive Lessons intended to elucidate the art of painting in Watercolour*. London 1841.

Cox, David, *Treatise on Landscape Painting and Effect in Watercolour*. London 1814.

Coyne, W.P., *Ireland: Industrial and Agricultural*. Dublin 1902.

Craig, Maurice, *Dublin 1660-1860*. Dublin 1969.

Craig, Maurice, *The Architecture of Ireland*. 1982.

Crampton Walker, J., *Irish Life and Landscape*. Dublin [1926].

Cromwell, Thomas Kitson, *Excursions through Ireland*. 3 vols. London 1820-21.

Crookshank, Anne and Glin, Knight of, *Ireland's Painters 1600-1940*. Revised edition, New Haven & London 2002.

Crookshank, Anne and Glin, Knight of, *The Watercolours of Ireland*. London 1994.

Crookshank, Anne, *Mildred Anne Butler*. Dublin 1992.

Csteras, Susan P. and Denney, Colleen (eds.), *The Grosvenor Gallery, A Palace of Art in Victorian England*. New Haven & London 1996.

Cullen, Fintan, *Sources in Irish Art A Reader*. Cork, 2000

Dalby, Richard, and Hughes, William, *Bram Stoker: A Bibliography.*, Essex 2004.

de Hamel, Christopher, *A History of Illuminated Manuscripts*. Reprint, London 2006.

Desmond, Ray, *Dictionary of British & Irish Botanists and Horticulturists*. Revised second edition, London 1994.

Dickinson, P.L., *The Dublin of Yesterday.*, London 1929.

Dolan, T.P. & O Muirithe, Diarmaid, *The Dialect of Forth and Bargy, Co. Wexford, Ireland*. Blackrock, Co. Dublin 1996.

Duff, Johanes, and Meyer Lausanne, Peter, *The Irish Miniatures in the Library of St. Gall.*. 1954.

Fehrer, Catherine, *The Julian Academy, Paris 1865-1939*. New York 1989.

Fenwick, Simon, *The Enchanted River. Two Hundred Years of The Royal Watercolour Society*. Bristol 2004.

Flint, Kate, *The Victorians and the Visual Imagination*. Cambridge 2000.

Foster, Vere, *Simple Lessons in Landscape Painting*. London, Glasgow, Edinburgh & Dublin 1884.

Frost, Stella (ed.) *A Tribute to Evie Hone and Mainie Jellett*. Dublin 1957.

Furniss, Stephen & Booth, Tony, *Paul Jacob Naftel. 1817-1891: A Biography*. Jersey, Channel Islands 1991.

Furst, Herbert, *The Modern Woodcut: A Study of the Evolution of the Craft*. London 1924.

Galloway, Vincent, *The Oils and Murals of Sir Frank Brangwyn R.A.* Leigh-on-Sea 1962.

Gascoigne, Bamber, *How to Identify Prints*. Reprint, London 1988.

George Boyce, D., *Nineteenth Century Ireland. The Search for Stability*. (New Gill History of Ireland 5) Revised edition. Dublin 2005. .

Gerard, Frances & Barton, Rose, *Picturesque Dublin Old and New*. (Illustrations only). London 1898.

Gilbert, Sir John. T., *History of the City of Dublin*. 3 Vols., Dublin 1854-59, new edition, Dublin 1903.

Gleizes, Albert, and Metzinger, Jean, *Du Cubism*. Paris 1912.

Glenavy, Beatrice, *Today we will only Gossip*. London 1964.

Gordon Bowe, Nicola and Cumming, Elizabeth, *The Arts & Crafts Movement in Dublin & Edinburgh. 1885-1925*. Dublin 1998.

Gordon Bowe, Nicola, *The Life and Work of Harry Clarke*. Blackrock, Co. Dublin 1989.

Gordon Bowe, Nicola, *Harry Clarke, His Graphic Art*. Mountrath, Ireland & Los Angeles 1983.

Graves, Algernon, *A Dictionary of Artists who have exhibited works in the principal London exhibitions from 1760 to 1889*. London 1884, New and enlarged edition, 1895.

Graves, Algernon, *The Royal Academy of Arts; a complete dictionary of contributors and their work 1769-1904*, 8 Vols. London 1905-6; reprint, London 1971.

Graves, Algernon, *The Society of Artists of Great Britain … the Free Society of Artists*. London 1907.

Gray, William, *Notes on the Educational Agencies for promoting Science and Art in Belfast during the past fifty years*. Belfast 1904.

Greene, David H., and Stephens, Edward M., *J.M. Synge, 1871-1909*. New York 1959.

Gregory, Lady, *Seventy Years: Being the autobiography of Lady Gregory*. Edited and with a foreword by Colin Smythe. New York: Macmillan, 1976.

Gregory, Lady, *Hugh Lane's Life and Achievement, with some account of the Dublin Galleries*. London: Augusta 1921.

Grosart, Rev. A.B. (ed.), *Autobiographical Notes, Remembrances & Diaries of Sir Richard Boyle, First and 'Great' Earl of Cork*. London 1886.

Haight, George S. (ed.), *The George Eliot Letters.* 7 vols., London 1956.

Halsby, Julian, *Scottish Watercolours 1740-1940*. London 1986.

Harbison, Peter, *Beranger's Antique Buildings of Ireland*. Dublin: N.L.I. 1998

Hardie, Martin, *Water-colour Painting in Britain*. 3 vols., London 1966-8.

Harding, James Duffield, *Principles and Practice of Art*. With illustrations drawn and engraved by the author. London 1845.

Hare, Augustus J.C. , *The Story of Two Noble Lives being Memorials of Charlotte, Countess Canning and Louisa, Marchioness of Waterford*. Vols. I-III. London 1893.

Harrison, Richard, *A Biographical Dictionary of Irish Quakers*. Dublin 1997.

Haughton, Wilfred J., *Brush Aside*. Ballycastle 1982.

Hayes, Alan, and Urquhart, Diane, *Irish Women's History*. Dublin and Portland, Oregan 2004.

Helland, Janice, *British and Irish Home Arts and Industries 1880-1914. Marketing Craft, Making Fashion*. Dublin and Portland, Oregon. 2007.

Henry, Paul, *An Irish Portrait. An autobiography of Paul Henry, R.H.A.* Dublin 1951.

Hewitt, John, *Art in Ulster: 1*, Biographical notes by Theo Snoddy. Belfast 1977.

Hicks, Carola, *The King's Glass: A Story of Tudor Power and Secret Art*. London 2007.

Hocking, Charles, *Dictionary of Disasters at Sea during the age of steam 1824-1962*. 2 vols., London 1989.

Holland, Patrick, *Tipperary Images: The photography of Dr. William Despard Hemphill*. Cahir, Co. Tipperary 2003.

Holman Hunt, W., *Pre-Raphaelitism and the Pre-Raphaelite Brotherhood*. London 1914.

Hone, J., *The Life of Henry Tonks*. London 1939.

Hopkinson, Martin, *No Day Without a Line. The History of the Royal Society of Painter-Printmakers, 1880-1999*. With a list of the Diploma Collection by Clare Tilbury, Oxford 1999.

Hoppen, K.T., *The Common Scientist in the Seventeenth Century. A Study of the Dublin Philosophical Society, 1683-1708*. London 1970.

Houfe, Simon, *The Dictionary of British Book Illustrators & Caricaturists 1800-1914*. Revised 2nd edition, Woodbridge, Suffolk 1981.

Huish, Marcus B., *British Water-Colour Art in the First Year of the Reign of King Edward the Seventh*. London 1904.

Jacomb-Hood, G.P., *With Brush and Pencil*. London 1925.

Jarman, Angela, *Royal Academy Exhibitors, 1905-1970*. Calne, Wiltshire 1987.

Jellett, Mainie, *My voyage of discovery – The artist's vision. Lectures and essays on art*. Dundalk 1958.

Johnson, J. & Greutzner, A., *The Dictionary of British Artists 1880-1940*. Woodbridge, Suffolk 1976.

Keane, Maureen, *Ishabel, Lady Aberdeen in Ireland*. Newtownards, Co. Down 1999.

Kennedy, S.B., *Paul Henry*. With an essay by Síghle Bhreathnach-Lynch. Yale University Press 2003.

Kennedy, S.B., *Frank McKelvey R.H.A., R.U.A., A Painter in His Time*, Blackrock, Co. Dublin 1993.

Kennedy, S.B., *Irish Art and Modernism. 1880-1950*. Belfast 1991.

Kennedy, S.B., *Paul Henry with a Catalogue of the Paintings, Drawings and Illustrations*. Yale University Press 2007.

Lambourne, Lionel and Hamilton, Jean, *British Watercolours in the Victoria and Albert Museum*. London: V&A 1980.

Larmour, Paul, *Belfast: An Illustrated Architectural Guide*. Belfast 1987.

Larmour, Paul, *The Arts & Crafts Movement in Ireland*. Belfast 1992

Lecane, Philip, *Torpedeod! The R.M.S. Leinster Disaster*. Penzance, Cornwall 2005.

Leslie, Reverend James B., *Ardfert & Aghadoe Clergy and Parish*. Dublin 1940.

Lewis, Gifford (ed.), *The Selected Letters of Somerville and Ross*. London 1989.

Lewis, Gifford, *Somerville and Ross: The World of the Irish R.M.* London 1986.

Lindsey, Ben, *Irish Lace: Its Origins and History*, Dublin 1886.

Lovell Edgeworth, Maria and Richard, *Practical Education 1798*. London 1801.

Maas, Jeremy, *Victorian Painters*. London 1969.

Maguire, John Francis, *The Industrial Movement in Ireland as illustrated by the National Exhibition of 1852*. Cork 1853.

Malcomson, A.P.W., *The Pursuit of the Heiress. Aristocratic Marriage in Ireland, 1740-1840*. Belfast: Ulster Historical Foundation 1982.

Mallalieu, Huon L., *The Dictionary of British Watercolour Artists up to 1920*. Woodbridge, Suffolk 1976.

Mallon, Declan, *Nano Reid*. Drogheda, Co. Louth 1994.

Malton, James, *A Picturesque and Descriptive View of the City of Dublin displayed in a series of the most interesting scenes taken in the year 1791 etc*. London 1792-9.

McConkey, Kenneth, *The New English. A History of The New English Art Club*. London: Royal Academy of Arts 2006.

Meenan, James, & Clarke, Desmond, *The Royal Dublin Society, 1731-1981*. Dublin 1981.

Meyer, Jonathan, *Great Exhibitions: London-New York-Paris-Philadelphia, 1851-1900*. Woodbridge, Suffolk 2007

Milton, T., *A Collection of Select Views from the Different Seats of the Nobility & Gentry in the Kingdom of Ireland, engraved by T. Milton, drawings by the best artists*. 24 plates. London 1783-93.

Mitchell, Flora H., *Vanishing Dublin*. Dublin 1966.

Mitchell, Lillias, *Irish Weaving Discoveries and Personal Experiences*. Dundalk 1986.

Mosley, Charles (ed.), *Burke's Peerage & Baronetage*. Vols. I & II. 107th edition, Delaware 2003.

Muir Mackenzie, Therese [T. Villiers-Stuart] *Dromana: The Memoirs of an Irish Family*. Dublin 1916.

Murray, L. and P., *The Penguin Dictionary of Art and Artists*. 1978 edition. London 1978.

Murray, Peter, *George Petrie (1790-1866). The Rediscovery of Ireland's Past*. With essays by Joep Leerssen and Tom Dunne. Cork: Crawford Municipal Art Gallery 2004.

Musgrave, Sir Richard, *Memoirs of the different Rebellions in Ireland...* First published 1801. Reprinted, Fort Wayne, USA 1995.

Newall, Christopher, *The Grosvenor Gallery Exhibitions. Change and continuity in the Victorian art world*. Series: *Art Patrons and Public*. Cambridge 2004.

Nicolson, Francis, *The Practice of Drawing and Painting Landscape from Nature, in Water Colour*. London 1820.

Norris Brewer, James, *The Beauties of Ireland*. 2 vols., London 1825-26.

Ó Gallchoir, Cliona *Maria Edgeworth: Women, Enlightenment and Nation*. Dublin 2005.

O'Brien, Thomas J. (ed.), *County Carlow Football Club, Rugby History, 1873-1977*. Carlow [c.1977].

O'Broin, Gearóid, *Jacob Poole of Growtown – And the Yola Dialect* 1996.

O'Byrne, Robert, *Hugh Lane 1875-1915*. Dublin 2000.

O'Donovan, Donal, *God's Architect. A Life of Raymond McGrath*. Dublin 1995.

O'Dowda, Brendan, *The World of Percy French*. Belfast 1981.

O'Grady, John, *The Life and Work of Sarah Purser*. Dublin 1996.

O'Sullivan, Melanie & McCarthy, Kevin, *Cappoquin: A Walk through History*. c.2000 (no publication date given).

Orpen, Sir William, *Stories of Old Ireland and Myself*, London 1924.

Pallander, Edwin, [L.F.S. Bayly] *Across the Zodiac: A Story of Adventure*. London 1896.

Pennell, E.R. and J., *The Life of James McNeill Whistler*. Vol. 11. W. Heinemann, London; Philadelphia, J.B. Lippincott Company (1908).

Petteys, C., *Dictionary of Women Artists: an international dictionary of women artists born before 1900*. Boston, Mass. 1985.

Power, Patrick, C., *History of Waterford City and County*. Cork 1990.

Price (ed.), Alan, *J.M Synge. Collected Works. Vol. II Prose*. Gerard's Cross 1982.

Prout, Samuel, *Sketches in France, Switzerland and Italy*. London 1839.

Pryke, Richard, *Norman Garstin: Irish Man and Newlyn Artist*. Reading 2005.

Purser, Michael, *Jellett, O'Brien, Purser and Stokes. Seven Generations, Four Families*. Dublin 2004

Rákóczi , Basil, *Three Painters: Basil Rákóczi, Kenneth Hall, Patrick Scott*, Dublin 1945.

Redgrave, G.I.R., *A History of Watercolour Painting in England*. (Illustrated London Books of Art) London 1892.

Reksten, Terry, *The Dunsmuir Saga*. Vancouver BC 1991. Paperback ed. 1994.

Reynolds, Sir Joshua, *Discourses on Art*. New Haven and London 1975.

Roget, John Lewis, *A History of the 'Old Water-Colour' Society, now the Royal Society of Painters in Watercolours. With biographical notices of its older and of all deceased members & associates, preceded by an account of English water-colour art and artists in the eighteenth century*. 2 Vols. London 1891, revised edition, Woodbridge, Suffolk 1972.

Rossetti, W.M. (ed.) Maddox Brown's Diary. Ruskin, Rossetti: Pre-Raphaelitism, London 1899.

Rowbotham, Thomas L.S., and Rowbotham, Thomas C.L., *The Art of Landscape Painting in Water-Colours*. Winsor & Newton, London 1872.

Rowley, Richard, *Apollo in Mourne. A Play in One Act*. Woodcuts by Lady Mabel M. Annesley, London 1926.

Ruskin, John, *The Elements of Drawing*. London 1857.

Ruskin, John, *The Elements of Perspective*. London 1859.

Sandby, Paul, *The Virtuosi's Museum, containing select views in England, Scotland and Ireland drawn by Paul Sandby, R.A.* London 1778-81.

Shaw Sparrow, Walter, *Frank Brangwyn and His Work*. London 1910.

Shea, Patrick, *A History of the Ulster Arts Club*. Belfast 1971.

Sheehy, Jeanne, *The Discovery of Ireland's Past: The Celtic Revival, 1830-1930*. London 1980.

Sheehy, Jeanne and Osborne, Walter, *Walter Osborne* Ballycotton, Co. Cork 1974.

Smith, Hammond, *Peter De Wint 1784-1849*. London 1982.

Snoddy, Theo, *Dictionary of Irish Artists 20th Century*. Second edition, Dublin 2002.

Solly, N. Neal, *Memoir of the life of David Cox*. London 1873.

Somerville, E. & Ross, M., *An Incorruptible Irishman being an account of Chief Justice Charles Kendal Bushe and his wife, Nancy Crampton, and their times 1767-1843*. London 1932.

Somerville, E. & Ross, M., *Irish Memories*. Fourth edition, London 1918.

Somerville, E. & Ross, M., *Wheel-Tracks*. London 1923.

Somerville, E., *Slipper's A.B.C. of Fox Hunting*. London 1903.

Somerville-Large, Peter, *1854-2004. The Story of the National Gallery of Ireland*. Dublin: N.G.I. 2004.

St. Leger, Alicia, *Melodies and Memories 150 Years at Cork Opera House*. Cork 2005.

Stewart, Ann M. (ed.), *Irish Art Loan Exhibitions 1765-1927*. Introduction by S.B. Kennedy. Dublin 1990.

Stewart, Ann M. (ed.), *Irish Art Societies and Sketching Clubs. Index of Exhibitors 1870-1980*. Foreword, Anne Crookshank and Desmond FitzGerald, Knight of Glin. Dublin 1997.

Stewart, Ann M. (ed.), *Royal Hibernian Academy of Arts. Index of Exhibitors and their Works, 1826-1979*. Summary history of the R.H.A. by C. de Courcy. Dublin 1985.

Strickland, Walter G., *A Dictionary of Irish Artists*. 2 vols. Second edition, Shannon 1969.

Sutton, Denys, *Nocturne – The Art of James McNeill Whistler*. London 1963.

Thornton, Alfred, *Fifty Years of the N.E.A.C. 1886-1935* London 1935.

Titmarsh, M.A., [W.M. Thackeray], *The Irish Sketch-Book*, Vol. I. London 1843.

Turpin, John, *A School of Art in Dublin Since the Eighteenth Century: A History of the National College of Art and Design*. Dublin, 1995.

Twyman, M., *Lithography 1800-1850*. London 1970.

White, James, *Irish Art Handbook – Independent Painters – A Short Review of some Contemporary Irish Artists*. Dublin 1943.

White, James, *John Butler Yeats and the Irish Renaissance*. Dublin 1972.

Whitley, W. T., *Artists and their Friends in England 1700-1799*. London 1928.

Wilkinson, Major Sir Nevile, *Titania's Palace. An Illustrated Handbook*. London 1926.

Wilkinson, Major Sir Nevile, *To All and Singular*. London 1925.

Willemson, Gitta, *The Dublin Society Drawing Schools, 1746-1876*. Dublin 2000.

Williams, Iolo, *Early English Water-colours*. London 1952. Reprint, Bath 1970.

Williams, Jeremy, *A companion guide to Architecture in Ireland. 1837-1921*. Foreword by Mark Girouard. Dublin 1994.

Wilton, Andrew, *British Watercolours 1750-1850*. Oxford 1977.

Wood, Christopher, *The Dictionary of Victorian Painters with Guide to Auction Prices and Index to Artists' Monograms*, Woodbridge, Suffolk 1971.

Wood, Christopher, *Victorian Painters* Woodbridge, Suffolk. 1995. Reprint, Woodbridge, Suffolk 1998.

Wornum, Ralph N. (ed.), *Lectures on Painting*. With essays by Barry, Opie and Fuseli. London 1848.

Wragg, Brian, *The Life and Works of John Carr of York*. York 2000.

Wright, C., with Gordon, C., and Peskett Smith, M., *British and Irish Paintings in Public Collections*. New Haven and London 2006.

Wright, Rev. George N., *Ireland Illustrated, from original drawings by G. Petrie, R.H.A, W.H Bartlett & T. M. Baynes (With descriptions by G.N. Wright)*. London 1831.

Wylie, J.C.W., *Irish Land Law*. Third edition, Dublin 1997.

Wyse Jackson, Rt. Rev. Robert, *Cathedrals of the Church of Ireland*. Dublin 1971.

UNPUBLISHED MANUSCRIPTS

Unknown Diarist, Royal Irish Academy ms. 24K. 14/15, 2 vols. (1801-3).

Lismore Castle Papers. Collection List No. 129. N.L.I. Compiled by Stephen Ball (2007).

'Observations made on his tour in Ireland and France, 1675-80', Thomas Dineley. N.L.I. Ms. No. 392.

'Slade School Archive Reader 1868-1975', Stephen Chaplin, archivist, Slade School of Fine Art 1990-1997.

'Achill Natural History Notes and Diary' Alexander Williams RHA (1846-1930).

'Some Memories of Lilian Davidson, A.R.H.A. An appreciation of the Art Classes given by Lilian Davidson, A.R.H.A.' Typescript, 1986.

Stained Glass in Ireland principally Irish Stained Glass 1760-1963. Michael Wynne Thesis. Trinity College, Dublin (get full details).

Sketching Clubs Membership in Ireland 1872-93. Shirley Armstrong Duffy. Unpublished M/s 1985.

'The Tangled Tale of the Three Paulines'. (No author or date). Villiers-Stuart archives.

JOURNALS, NEWSPAPERS, NEWSLETTERS, MINUTES

W.C.S.I. Minutes from Dec.5, 1921 onwards. W.C.S.I Archives, C.S.I.A., National Gallery of Ireland.

W.C.S.I Newsletter from Jan., 1985 onwards. W.C.S.I Archives, C.S.I.A., National Gallery of Ireland.

Dublin Metropolitan School of Art Index Register (NIVAL)

Art-Journal, May, 1851, 1861, 1880, 1881, 1911, Sept. 1925.

Belfast News-Letter, 11 Nov., 1885, Oct., 15, 1888, 11 Nov., 1893, 8 Nov. 1895.

Carloviana: Journal of The Old Carlow Society. Vol. 1, Series New, no. 18 pp 8-11, Dec., 1969.

Cork Examiner. Oct. 1, 1878, Oct., 5, 1878, 20 Oct., 1879, , Nov., 5, 1879, Sept., 7, 1880, 25 Oct., 1881, Nov., 7, 1881, , Nov., 14, 1881, 7 June., 1883, Nov., 15, 1883, Nov. 22., 1883, 14 Nov., 1884, 15 Nov., 1884, 20 Nov., 1884, 27 Nov., 1884, 4 Nov., 1895.,

Daily Express (Dublin), Mar., 15, 1883, Mar.,, 19, 1883, Mar., 26, 1883, Mar., 28, 1883, Mar., 11, 1884, Dec. 7, 1885, Feb., 14, 1888, Mar., 12, 1888, Mar. 18, 1888, Mar., 11, 1889, Mar. 17, 1889, Mar. 25, 1889, Mar., 4, 1895, , Mar., 19., 1896.

Drogheda Independent, Jul., 18, 1980.

Dublin University Magazine, Vol. LV, pp 364-370 Mar., 1860. Mar., 1885.

Irish Times, Mar., 8, 1875, Mar., 9, 1875, April 2, 1875, Mar.13, 1876, Mar., 20, 1876, Dec., 1, 1884, Mar., 13, 1888, Mar., 9, 1889, Mar. 11, 1889, Nov., 7, 1890, Mar., 5, 1891, Mar., 19, 1896, Feb., 18, 1903, Feb., 24, 1904, 28 Feb., 1912, 27 Jan., 1920, 5 Mar. 1923, Feb., 21, 1924, Feb., 9, 1939, 3 June, 1939, 28 Aug., 1941, 4 Oct. 1943, Jan., 14, 1946, 11 Aug., 1962, 2 Sept., 1964, April 13, 1967, Aug., 13, 1968, 3 Oct., 1969, 25 May, 1970, 30 May, 1970, Sept., 19, 1970 4 July, 1974, Feb., 1, 1979, April 23, 1981, 24 Feb., 1982, 19 Aug., 1982, 29 Sept., 1982, April, 1988, 4 Oct., 1989, 27 Mar., 1997, Jul., 2, 1998, 24 Mar. 2001 May 14, 2001, May 27, 2006.

Irish Independent, Oct., 4, 1940, Sept., 3, 1959, 12 Aug., 1964.

Faulkner's Dublin Journal, 6 May, 1746, 14-18 May, 1746, 15-19 Jan., 1765,

Freeman's Journal, Tuesday, 12 Jan., 1802, 10 May, 1865.

Free Press & Clonmel General Advertiser, 28 Oct., 1854.

Fraser's Magazine, 1855.

Journal of the Board of Agriculture, Vol. XXll. (April, 1915-March, 1916.

Journal of the R.D.S., Vol. 111 pp. 94-96, Jul., - Oct., 1860.

Kilkenny People, Jan., 8, 1916, Dec. 3, 1976.

Lady's Pictorial, Feb., 25, 1888.

Morning News (Belfast), Nov., Dec., 1889.

Musical Opinion, Sept. 1889, Aug., & Sept., 1890.

Newsletter, Feb., 11, 1966.

Sphere, 17 October, 1925.

Studio, 1929 (famous water colour painters series: Peter de Wint by Martin Hardie)

The Northern Whig, 22 Sept., 1883.

The Amateur, Nov., 1849-Jan., 1850.

The Artist, June, 1956, Feb., 11, 1966,

The Art Journal, 1 May, 1851

The Art-Union, Vol. V–X London 1843-1848, continued as the *Art Journal* 1849-1912. Vol. X1-

The Atheneaum, April 9, 1881, May 8, 1897.

The Building News, June 22, 1888.

The Carlow Sentinel, May 4, 1872. May 11, 1872.

The Church of Ireland Gazette, Oct., 29, 1976.

The Clonmel Chronicle, Tipperary Express and Advertiser, May 10, 1871, May 13, 1871, Aug., 12, 1871, Oct., 21, 1871, Oct., 25, 1871, Oct., 28, 1871, Nov., 1, 1871.

The Cork Constitution, Oct., 25, 1881, May 21, 1886.

The Dublin Magazine. Vol. XXV111 No.1. Jan. - Mar. 1953. Art Notes by Edward Sheehy; Art Notes by Edward Sheehy. Oct. Dec.1940. Vol. XX1 No.4; July-Sept.1957. Art Notes by Arland Ussher pp 48-51; Vol. XlXm, No. 1, January-March, 1944; Vol. XX. No. 1 Jan-March, 1945. Art Notes by Edward Sheehy p 41; Vol. XX1-No. 1 January - March, 1946. Art Notes by Edward Sheehy; Vol. XVll, No. 2, April-June, 1943.

The Irish Ancestor, No. 2. 1975.

The Irish Builder, May 15, 1870., July 1, 1883.

The Irish Monthly, Vol. LXXVlll, No. 930, Dec., 1950.

The Irish Quarterly Review, Vol. 1. pp 318-340. Jun., 1851.

The Ladies Field, Dec., 1900.

The Lady of the House, Jan., 1893, Aug., 1895, Jan., 1896,

The Leader, Oct.12., 1940.

The Queen, the Lady's Newspaper and Court Chronicle, Mar., 21, 1891, Jun., 6, 1891, Jun., 25, 1891, Nov. 28, 1891, 11 Mar. 1893,

The Royal Irish Art-Union, Report of the committee, 1839-40.

The Studio, April, 1893, Oct. 1897, Mar. 1900, Dec. 1900, May, 1903, June, 1916, Feb., 1918, Mar., 1900lDec. 1923, Mar., 1924, 15 Jan., 1925, Jan., 1949.

The Times, May 1, 1914, May 29, 1919, 12 Oct.,, 1929, May 12, 1930, April, 19, 1943, Jun., 26, 1959.

Tipperary Free Press & Clonmel General Advertiser, 28 Oct., 1854.

The Woman's World, Vol. 11. London. 1888.

Somerset House Gazette, Vols. 1 & 11. W.H. Pyne, editor and writer, 2 vols. 1823-'24.

Sunday Press, Feb. 4, 1979.

Tipperary Free Press & Clonmel General Advertiser, Vol. XXXV111. Oct., 28, 1854.

Weekly Irish Times (last ed.), Vol. 46. No. 2,401. Dublin, Sat., 19, 1918.

Year's Art, 1899 (advertising section)

White, James *The Bell*. Vol. XV11. No. 6 Sept. 1951 pp 59-61.

REPORTS

'The R.D.S. Report of the Third Distribution of premiums… in the Drawing and Modelling Schools', 18 December, 1844. Stewart Blacker. Dublin. 1845.

'First Report of the Committee of the Art-Union of Ireland' 1858-59.

'Cork School of Art. Report on the Fine Art Department' Report of Executive Committee, Awards of Jurors and Statement of Accounts', Cork. 1886.

'W.C.S.I. Report of Art-Union Committee, 1915'. W.C.S.I Archives, C.S.I.A., National Gallery of Ireland.

ARTICLES AND PERIODICALS

Ahern, Michael. 'Clonmel Mechanics' Institute in Tipperary Historical Journal' published by The County Tipperary Historical Society, County Library, Thurles, Co. Tipperary 1991. pp.159-162

Armstrong Duffy, Shirley. 'The Role of Women in Irish Sketching Clubs in the late Nineteenth Century' (pp. 12-14) in *Irish Women Artists From the Eighteenth Century to the Present Day*. Catalogue. N.G.I and the Douglas Hyde Gallery, Trinity College, and the Hugh Lane Municipal Gallery of Modern Art, Dublin. July–August 1987.

Black, Eileen. 'Practical Patriots and True Irishmen. The Royal Irish Art Union 1839-59' in the *Irish Arts Review Yearbook 1998*. Vol. 14. 1998 pp.140-146

Bourke, Marie. 'Frederic William Burton (1816-1900) Painter and Antiquarian in Eire-Ireland'. *A Journal of Irish Studies. The Irish American Cultural Institute*. Autumn 1993 pp.47-51.

Butler, Patricia. 'The Ingenious Mr Francis Place' *Irish Arts Review*, Vol. 1. No. 4 Winter, 1984 pp.38-40.

Butler, Patricia. 'An Irish Watercolourist – Beatrice Gubbins (1878-1944) at Dunkathel' in GPA Music in Great Irish Houses Festival Programme, June 9-20, 1992 pp.5-7

Butler, Patricia. 'A Victorian Watercolourist – Louisa Anne, Marchioness of Waterford (1819-1891).' *Irish Arts Review Year Book*. Vol. 10. 1994 pp.157-162.

Butler, Patricia. *The Water Colour Society of Ireland 150th Exhibition (2004)* N.G.I. Catalogue. Foreword: A Celebration – The Water Colour Society of Ireland. (no page nos).

Butler, Patricia. 'Introducing Mr. Brocas. A Family of Dublin Artists' in *Irish Arts Review Yearbook*. Vol. 15. Autumn, 1999 pp. 80-86.

Butler, Patricia. 'Mary Herbert of Muckross House, 1817-1893. A Nineteenth Century Watercolourist'. (pp.9-14) Foreword by John Kennedy, Chairman, Trustees of Muckross House, Killarney, Co. Kerry. Catalogue entries and text by Sinéad McCoole and Carla Briggs. Sept. 1999.

Butler, Patrick, 'Baron Dunboyne. The Butler Family History'. *Butler Society Journal*. 1972 p 21.

Caffrey, Paul. 'Samuel Lover's Achievement as a Painter' in the *Irish Arts Review* Vol 3 No 1 Spring, 1986 pp.51-54.

Cahill, Katherine. 'In the Mainstream of Irish Naturalism. The Art of Lilian Lucy Davidson, 1879-1954' in the *Irish Arts Review Yearbook 1999*. Vol. 15 pp 34-45.

Campbell, Julian. 'Irish Painters in Paris, 1868-1914.' *Irish Arts Review*. Vol. II. 1995 p.163.

Coleman, John. 'A Painter of Living Art: Jack P. Hanlon (1913-1968)'. *Irish Arts Review Yearbook*. *1988* pp.222-228.

Cooney, Leviston, D.A. 'Threads in a Tapestry: The Story of the Mitchell Family' in *Dublin Historical Record*. Vol. L1. No. 1 Spring, 1998. pp.25-50. Paper read to The Old Dublin Society, Feb. 25, 1998.

Crosbie, M.A. 'The Training of a Lady Gardene'r' in *Irish Gardening* January 1912. Vol. V11 No. 71.

Curran, Elizabeth. 'The Art of Nano Reid' in *The Bell*. Nov. 1941. Editor: Sean O'Faoláin, Vol. 3. No. 2. Nov. 1941 pp.128-131

Fehrer, Catherine, 'Women at the Academie Julian in Paris' pp.752-757 *Burlington Magazine*, Vol. CXXXV1. No. 1100, November, 1994.

Ganly, Brigid. A.R.H.A. 'The RHA, 1943' in *Commentary*, May, 1943, pp.5-6.

Girouard, Mark 'Stamped, addressed and illustrated. Irish Decorated Envelopes of the Victorian Era'. *Country Life*. July 30, 1970. pp.290-291.

Guinness, May. 'The Bombardment of Vadelaincourt' in *Dublin Review*. Introduction by Selina Guinness pp.52-65. Number twenty-five. Winter, 2006-7.

Hartigan, Maianne. 'The Commercial Design Career of Norah McGuinness', *Irish Arts Review*. Vol. No. 3. Autumn 1986.

Hone, Evie. 'Georges Rouault' in *Irish Ecclesiastical Record* 5 th Series. Vol. 61. Feb. 1944.

Jellett, Mainie. 'The RHA and Youth' in *Commentary*, May, 1942, pp.5-7.

Keane, Molly. 'Joan Jameson and Norah McGuinness. Two Painters in Ardmore.' *The Ardmore Journal*. Waterford County Museum. February, 2004.

King, John. 'The Rowbotham Family' in *Watercolours, Drawings and Prints*. Vol. Eight. Number one, Winter, 1993 pp.11 - 14

Larmour, Paul. The Art-Carving Schools in Ireland. in GPA Irish Arts Review Yearbook 1989-1990 pp.151-157

Ledbetter, Gordon T. 'A Painter on Achill: Alexander Williams.' *Irish Arts Review* Winter 2006 pp.106-111.

Ledbetter, Gordon T. 'Alexander Williams (1846-1930) Sidelights on a Victorian Painter' in *The Irish Ancestor*. No. 2. 1975. pp.83-86.

Love, Walter D. 'The Hibernian Antiquarian Society.' in *Studies*. Vol. L1 No. 203 Autumn, 1962.

MacCarthy, Robert B. 'The Diocese of Lismore, 1801-69'. *Maynooth Studies in Local History,* Number 81. Series Editor: Raymond Gillespie. Dublin, 2008.

MacGreevy, Thomas. 'Fifty Years of Irish Painting'. *Capuchin Annual*, Dublin. 1949.

McCabe, Patricia 'William Percy French (1854-1920)' in W.C.S.I Annual Exhibition Catalogue, September, 2009.

McParland, Edward, 'Thomas Ivory, Architect'. *Gatherum Series*, no. 4, Ballycotton: Gifford & Craven. 1973.

Murphy, Derville. 'Margaret Allen - Social Commentator' in the *Irish Arts Review*, Spring, 2010 pp.89-91.

Murray, Peter. 'Art Institutions in nineteenth-century Cork' in *Cork History and Society. Interdisciplinary Essays on the History of an Irish County*. Editors: Patrick O'Flanagan Cornelius G. Buttimer. Dublin 1993. pp.813-872.

Murray, Peter. 'Artist and Artisan: James Brenan as Art Educator' in *America's Eye: Irish paintings from the Collection of Brian P. Burns Boston College Museum of Art*. Edited by A.M. Dalsimer and V. Kreilkamp. 1996. pp.40-46.

O'Byrne, M.K. 'Lady Butler Painter of the Roll Call' in *The Irish Monthly* Vol. LXXV111. No. 930. Dec. 1950 pp 590-592.

Potterton, Homan. 'A Director with Discrimination: Sir Frederic Burton at the National Gallery'. *Country Life*, Vol. C1V, 9 May, 1974 pp. 1140-41.

Pyle, Hilary. 'Clare Marsh Remembered in' *GPA Irish Arts Review Yearbook 1988*. (No Vol. No.) pp 89-92.

Pyle, Hilary. 'The Hamwood Ladies: Letitia and Eva Hamilton' in *Irish Arts Review* Vol. 13, pp 123-134. 1997.

Snoddy, Oliver. 'An Unlisted Item of Carlow Printing' in *Carloviana Carlow Journal*. Dec. 1969 pp.8-11 & p 22.

Swift, Patrick, 'Contemporary Irish Painters (No.4.). Nano Reid' in *Envoy*. Vol. 1 No 4, March, 1950 pp.26-35.

Symondson, Anthony, SJ. 'Art Needlework in Ireland'. *Irish Arts Review Yearbook*, Vol. 10. 1994. pp.126-135

Turpin, John 'The Dublin Society's School of Architectural Drawing' *The Irish Georgian Society's Bulletin*, Vol. XXXV111, 1985.

Turpin, John. 'The Metropolitan School of Art. 1900-1923 (part 3).' *Dublin Historical Record*. Vol. XXXV111, no. 3, June, 1985 .

Turpin, John. 'William Orpen as Student and Teacher'. *Studies*, Vol. LXVIII, Autumn 1979. No. 271.

Turpin, John. 'Irish Art and Design Education from the Eighteenth Century to the Present.' *Irish Arts Review Yearbook 1994*. Vol. 10 pp.209-216.

Turpin, John. 'The Royal Hibernian Academy Schools. The first eighty years, 1826-1906'. *Irish Arts Review Yearbook 1991-1992*, pp.198-209.

Turpin, John. 'The School of Ornament of the Dublin Society in the 18th century.' *Journal of the Royal Society of Antiquaries of Ireland*. Vol. 116. 1986 pp.38-50.

Turpin, John. 'The Dublin Society's School of Architectural Drawing', in *The Irish Georgian Society's Bulletin*. Vol. XXXV 111, 1985.

Turpin, John. 'The Masters of The Dublin School of Landscape and Ornament, 1800-1854'. *Irish Arts Review*, Vol. 3. No. 2. Summer, 1986 pp.45-52.

Wynne, Michael. 'The Charlemont Album' in *The Irish Georgian Society's Bulletin*, January-June, 1978 pp.1-6

CATALOGUES

A Century of Watercolours at Lismore (an exhibition of watercolours held in association with the Crawford Municipal Art Gallery, Cork). Foreword, Peter Murray, Director, Crawford Gallery, Cork. Introduction Professor Anne Crookshank and Desmond Fitzgerald, Knight of Glin, catalogue entries by Susan Wingfield, Patricia Martin - The Lismore Arts Centre, Dromroe, Cappoquin, Co. Waterford. 25-26 April, 1998.

Anglesea, Martyn Portraits and Prospects. Catalogue of an exhibition of watercolours from the Ulster Museum in association with the Smithsonian Institution. Belfast 1989.

Aonac Tailteann Teasbantas ealadan eireannac. Exhibition of Irish Art. D.M.S.A. Kildare Street, Dublin. June 18-July 10, 1932.

Arnold, Bruce & Kennedy, S. Brian. The White Stag Group. Exhibition catalogue, S.B. Kennedy with an essay by Bruce Arnold. Foreword Enrique Juncosa, Director, Irish Museum of Modern Art (no date).

Arnold, Bruce. Mainie Jellett. The Neptune Gallery, 42 S. William Street, Dublin, 2. 1976.

Art on the Line. The Royal Academy Exhibitions at Somerset House, 1780-1836. Edited by David H. Solkin. Exhibition catalogue. Oct. 2001-January, 2002. Courtauld Institute. London. Publishers: Yale University Press, New Haven and London.

Artists of the Newlyn School (1880-1900) Exhibition, Newlyn, Penzance, and Bristol (1979). Catalogue by Caroline Fox and Francis Greenacre.

Baily, Michelle. George Campbell 1917-1979. Droichead Arts Centre, Bellscourt, Drogheda, Co. Louth. Retrospective exhibition. June 5-July 5 (no year given).

Bea Orpen, H.R.H.A. 1913-1980. Exhibition catalogue. The Gorry Gallery, Molesworth Street, Dublin, 2. 1981.

Beatrice Gubbins of Dunkathel, Co. Cork (1878-1944) Preface by Director, Peter Murray. Essays by Francis Russell and Shirley Armstrong Duffy. Crawford Municipal Art Gallery, Cork April 17-May 13, 1986.

Black, Eileen, (Ed.) Drawings, paintings and sculptures: the catalogue. Belfast, 2000.

Bowe Gordon, Nicola. Harry Clarke. Monograph and catalogue published to coincide with the exhibition, Harry Clarke, 12 Nov.-8.Dec.1979, Douglas Hyde Gallery, Trinity College, Dublin.

British Vision Observation and Imagination in British Art 1750-1950. (Ed.) Robert Hoozee. Introductory essays John Gage and Timothy Hyman. Museum voor Schone Kunsten, Ghent. 5 Oct 2007-Jan.2008

Campbell, Julian The Irish Impressionists. Irish Artists in France and Belgium 1850-1914. N.G.I. Exhibition catalogue 1984. Ulster Museum, Belfast 1985.

Catalogue of Irish Topographical Prints & Original Drawings. Rosalind M. Elmes. N.L.I. Dublin, 1943. Reprint, N.L.I. Dublin, 1975.

Catalogue of Paintings: Exhibiting several fine Works by the Masters and a Collection of Pictures, by the Artists and Amateurs of Limerick. 1821.

Catalogue of The Exhibition of the Royal Hibernian Academy MDCCCXXV1. The first (3rd) edition. Published by N. Clarke, Printer, No. 50 Great Britain Street, Dublin.

Catalogue of the Exhibition of Works by Irish Painters. Hugh P. Lane, Honorary Director. With descriptive and biographical notes by A.G. Temple, F.S.A., Director of the Art Gallery of the Corporation of London. London 1904.

Catalogue of the First Exhibition, 1895. The Arts and Crafts Society of Ireland. Dublin. 1895.

Catalogue of the Loan Collection of Works of Art, and Historical Memorials of Belfast. Belfast 1888.

Catalogue for the exhibition of the Society for Promoting the Fine Arts in the South of Ireland, Patrick Street, Cork. 1833.

Catalogue of the First Exhibition of The Society of Native and Resident Artists, 1835. Cork.

Catalogues for: The Amateur Drawing Society, the Irish Amateur Drawing Society, the Irish Fine Art Society, the Water Colour Society of Ireland.

Complete Illustrated Catalogue. National Portrait Gallery, London. Edited by David Saywell and Jacob Simon. London. 2004.

Cork Industrial Exhibition, 1883. Report of Exhibition Committee, Awards of Jurors and Statement of Accounts. Cork. 1886.

Cronan, Katharine. Maurice MacGonigal , R.H.A. 1900-1979 . Exhibition catalogue. The Hugh Lane Municipal Gallery of Modern Art, Parnell Square, Dublin 1. 12 July - 25 August 1991.

Crookshank, Anne and the Knight of Glin, Mildred Anne Butler (1858-1941). Exhibition catalogue- Kilkenny Art Gallery Society, Kilkenny Castle, Kilkenny, 1981, Bank of Ireland, Baggot St., Dublin and Christies, King Street, London, 1981. Published Freshford, Kilkenny, 1981.

Crookshank, Anne, Introduction to Norah McGuinness Retrospective Exhibition, Exhibition Hall, New Library, T.C.D. Oct.11-Nov.2, 1968, Crawford Municipal Art Gallery, Cork 1968 and the Brooke Park Gallery, Derry 1969.

Dawson, Barbara. Brigid Ganly Retrospective. Hugh Lane Municipal Gallery of Modern Art, Dublin, 1998. Brigid Ganly interviewed by Barbara Dawson, Director, Hugh Lane Municipal Gallery of Modern Art, Dublin. Introduction by Daire O'Connell.

Dublin Sketching Club archives, Manuscript collection, N.L.I. (un-catalogued)

Dubliners Portraits by Harry Kernoff, R.H.A. Foreword by John Ryan. Godolphin Gallery, 20 Clare Street, Dublin, 2. February, 1975.

Dubliners' Portraits by Harry Kernoff, R.H.A. Godolphin Gallery, 20 Clare Street, Dublin, 2. Foreword by John Ryan. February, 1975.

Edinburgh International Exhibition. 1886. Women's Industries Section. Guide to Irish Exhibits. Compiled by Her Excellency, The Countess of Aberdeen, Dublin. Second edition.

Elizabeth Rivers. Memorial exhibition catalogue Appreciation by Patrick Pye. Introduction by (Dr.) James White, Director, N.G.I. Municipal Gallery of Modern Art February, 1966.

Evie Hone Memorial Exhibition 29 July-5 Sept. 1958. Introduction by the Hon. Secretary, James White. The Great Hall, U.C.D. Earlsfort Terrace, Dublin. 1958. Tate Gallery, London 2 Jan-15 Feb, 1959.

Evie Hone, Memorial Exhibition. 29 July - 5 Sept., 1958, Great Hall, U.C.D. Earlsfort Terrace, Dublin, 1958. Foreword by James White.

Exhibition of Flower & Garden Pictures. Organized and arranged by J. Crampton Walker, A.R.H.A. Mills' Hall, 8 Merrion Row, Dublin. 12-28 February, 1931.

Exhibition of Pictures, Flowers, and West of Ireland Landscapes. Mills' Hall, 8, Merrion Row, Dublin. Tuesday 3 - Friday 14 June, 1929.

Exhibition of watercolours by Percy French (1854-1920) at The Oriel Gallery, 17 Clare Street, Dublin, 2. June19th - July 7th. 1979. Introduction by Oliver Nulty.

Exhibitions of watercolours by Percy French (1854-1920). The Oriel Gallery, 17 Clare St., Dublin, 2. July 19th - July 7th, 1979. Introduction by Oliver Nulty.

First Annual Exhibition of Fine Art at The Goodwin Galleries, Limerick. March 9-18, 1944.

First Munster Exhibition of Original Pictures in Oil and Watercolours, Pencilling, Crayons. (no date) . Cork.

Flanagan, T.P. Tom Carr Retrospective. Ulster Museum, Belfast. 16 Nov. - 31 Dec. 1983. Douglas Hyde Gallery, Trinity College, Dublin 10 - 28 Jan. 1984

Frank Brangwyn 1867-1956. Editors Libby Horner and Gillian Naylor. Leeds City Art Gallery, 6 April-11 June, 2006. Arents House, Bruges, 8 July-17 Sept. 2006. Glynn Vivian Art Gallery, Swansea, 13 Oct.-7 Jan,2007.

Guide to the Irish Industrial Village and Blarney Castle. The Irish Industries Association at the World's Columbian Exposition, Chicago. 1893.

Hardie, Martin. Memorial Exhibition of Original Etchings by Edward Millington Synge. London, 1913.

Illustrated Summary Catalogue of Drawings, Watercolours and Miniatures. Compiled by Adrian Le Harivel. Introduction, Homan Potterton, Director, N.G.I. Dublin. 1983.

Illustrated Summary Catalogue of Prints and Sculpture. Edited by Adrian Le Harivel. Compiled by Susan Dillon, Frances Gillespie, Adrian Le Harivel and Wanda Ryan-Smolin. Foreword by Homan Potterton, Director, The N.G.I. Dublin 1988.

Illustrated Summary Catalogue of The Crawford Municipal Art Gallery incorporating a detailed chronology of art in nineteenth-century Cork and biographies of those Cork artists represented in the collection. Compiled by Peter Murray. 1991. Published City of Cork Vocational Education Committee.

Irish Art Auction (including the Studio of Tom Nisbet R.H.A.) de Veres Art Auction, Monday, 13 Nov. 2006. Foreword by Thomas Ryan, P.P R.H.A.

Irish Exhibition of Living Art. 18 August-16 Sept., 1955. N.C.A, Kildare Street, Dublin.

Irish Women Artists From the Eighteenth Century to the Present Day. Catalogue co-0ordinated by Wanda Ryan-Smolin, Jenni Rogers and Patrick T. Murphy. Exhibition co-ordinated by Kim-Mai Mooney, Wanda Ryan-Smolin, Jenni Rogers and Patrick T. Murphy. N.G.I and the Douglas Hyde Gallery, Trinity College, Dublin. July-August, 1987. Dublin, 1987.

J.H. Campbell 1757-1828 and his School, John Henry Campbell 1757-1828. Cecilia Margaret Campbell 1791-1857 School of Campbell. Irish Landscape Watercolours. Introduction by (Dr) Bruce Arnold. Neptune Gallery 136 St. Stephen's Green, Dublin. 1967.

Jordan, Peter. Waterford Municipal Art Collection. A History and Catalogue. Waterford Institute of Technology and Waterford City Council. 2006.

Kennedy S. Brian. Basil Ivan Rakoczi (1908-1979) A Symbolist and Expressionist painter with Irish connection. Introduction and catalogue by S.B. Kennedy. The Gorry Gallery 30 May - 12 June, 1996.

Kennedy, Brian A Concise Catalogue of the Drawings, Paintings & Sculptures in the Ulster Museum. Editor, Brian Kennedy, Assistant Keeper, Art Department, Ulster Museum. Published by Ulster Museum, Botanic Gardens, Belfast, 1986.

Kennedy, S. Brian. Caroline Scally. Retrospective exhibition. The Frederick Gallery, Dublin. 9 Mar.-23 Mar. 2005.

Kennedy, S. Brian. Elizabeth Rivers. 1903-1964. The Gorry Gallery, Dublin. 1989.

Kernoff, Harry. Paintings by Harry A. Kernoff. Gieves Gallery, 22 Old Bond Street, London W.l. March, 1931.

Kitty Wilmer O Brien R.H.A. Introduction by Brendan O'Brien. Taylor Galleries, 6 Dawson Street, Dublin, 2. 1983.

Lillias Mitchell Exhibition, The Kennedy Gallery, 1-2 Harcourt Street, Dublin 2 Mar. - 13 Mar. 1993.

Macavock, Jane, Flora Mitchell View of Dublin. Research: K. Lumme. Catalogue published to accompany exhibition held 15 October - 12 December, 1999, N.G.I. Dublin.

Margaret Stokes 1915-1996. Retrospective exhibition 4 Mar.1997-15 Mar.1997. Exhibition opened by Professor A. Crookshank. The Kennedy Gallery 12 Harcourt Street, Dublin, 2.

Moyra A. Barry 1886-1960. Exhibition catalogue of Paintings, Watercolours and Drawings. 24 September - 8 October, 1982. The Gorry Gallery, Dublin.

Murray, Peter. Joan Jameson 1892-1953. Exhibition held Crawford Municipal Art Gallery, Cork. Introduction by Dr. Peter Murray, Director, Crawford Municipal Art Gallery, Cork. Sponsored by Sothebys, London. 2 Sept.-23 Sept. 1989. R.H.A. Gallagher Gallery, Dublin. 28 Sept.-11. Oct. 1989.

Nano Reid and Gerard Dillon. Exhibition catalogue. Curated by Riann Coulter. 6 Nov. 2009-Jan. 10, 2010. Highlanes Municipal Art Gallery, Drogheda, Co. Louth.

Nano Reid. A Retrospective Exhibition. The Arts Council of Northern Ireland/An Chomhairle Ealaion/The Arts Council. Municipal Gallery of Modern Art, Parnell Square, Dublin 1974. Ulster Museum, Belfast, 1975. Introduction by Sean O'Faolain.

O'Brien, Brendan. Introduction Exhibition catalogue Kitty Wilmer O Brien R.H.A. Taylor Galleries, 6 Dawson street, Dublin, 2. 1983.

Official Guide to the World's Columbian Exposition, Chicago, 1893. The Art Gallery. Editor: Charles M. Kurtz. Philadelphia 1893.

Paintings by Harry A. Kernoff. Gieves Gallery, 22 Old Bond Street, London W.1. March, 1931. Foreword by Harry A. Kernoff.

Phoebe Donovan. Lithographs. The Print Gallery, Wexford Arts Centre, Cornmarket, Wexford, April, 2001.

Pyle, Hilary. Mildred Anne Butler 1858-1941. Exhibition catalogue, Crawford Municipal Art Gallery, Cork 25 August-30 September, 1987.

Rowe, Rebecca and Charles Nugent Rose Barton RWS, Exhibition of Watercolours and Drawings, exhibition catalogue, Crawford Gallery, Cork; Fine Art Society, London; Ulster Museum, Belfast and the Butler Gallery, Kilkenny 1987.

Something about Achill. Alexander Williams. Catalogue of the 11th exhibition of pictures & original sketches in oil and water-colour of Irish scenery; Achill Island, Lough Conn, Letterfrack and County Dublin by A Williams, R.H.A. Leinster Lecture Hall, 35 Molesworth st. Dublin, January 28, 1897.

The Brocas Collection. An illustrated selective catalogue of original watercolours, prints and drawings in the National Library of Ireland with an account of the Brocas family and their contribution to the (Royal) Dublin Society's School of Landscape and Ornament Drawing. Patricia Butler. N.L.I. Dublin. 1997.

The Dublin Exhibition of Arts, Industries and Manufactures, and Loan Museum of Works of Art. Dublin. 1872.

The Dublin Exhibition of Arts, Industries, and Manufactures, and Loan Museum of Works of Art. Official Catalogue. 1872.

The following catalogues are missing from both collections: 1871-1876, 1878, 1885-1888, 1890-1892, 1894, 1896, 1900, 1903, 1907, 1960, 1961, 1962 .

The French Influence – An exhibition of Irish, British and French Paintings from the 19th and 20th Centuries. Introductory Essay by Dr. J. Campbell pp 2-11. The Gorry Gallery, Dublin 5 May – 15 May, 2004.

The Great Age of British Watercolours 1750-1880. Andrew Wilton and Anne Lyles. Exhibition catalogue. London and National Gallery of Art, Washington, U.S.A. 1993.

The Irish Industrial Exhibition of 1853. A detailed catalogue of its contents. Editor, J. Sproule. Dublin, 1854.

The National Self-Portrait Collection of Ireland. Vol. 1. 1979-1989. Sarah Finlay. Limerick and Dublin. 1989.

The Water Colour Society of Ireland. 150th Exhibition, 2004. A celebratory display of paintings by past members. Preface by Raymond Keaveney, Director, N.G.I. Foreword by Patricia Butler. Editor, Anne Hodge, biographical entries by Anne Hodge and Niamh MacNally. N.G.I. 6 October – 12 December, 2004.

The Water Colour Society of Ireland National Collection. University of Limerick. Preface Dr. Edward M. Walsh, President, University of Limerick. Introduction, James Nolan, R.H.A., A.N.C.A. President, W.C.S.I Compiler, Erica Loane.

The Water Colour Society of Ireland Exhibition List 1872-1994. Compiled by B.K. Reilly. Dublin. 1995.

The Water Colour Society of Ireland National Collection. Editor Yvonne Davis. Research and cataloguing, Mary Healy. Photography Eoin Stephenson. University of Limerick Press, Limerick, 2009.

The White Stag Group in Ireland Exhibition catalogue. S.B. Kennedy. Essay by Bruce Arnold. Exhibition curated by S.B. Kennedy and Bruce Arnold. Editor: Sean Kissane Curator of Exhibitions, Irish Museum of Modern Art. 6 July – 4 October, 2005.

Venice. Eva H. Hamilton and Letitia M. Hamilton at The Stephen's Green Gallery, 7, St. Stephen's Green, Dublin. Feb. 11-23, 1924.

W.C.S.I. Catalogues: W.C.S.I. Archives , Centre for the Study of Irish Art, N.G.I. 1893-1981.

W.C.S.I. Catalogues:. N.L.I. 1877, 1879, 1880, 1882, 1883, 1889, 1893, 1904, 1905, 1913, 1914, 1916, 1928-1933.

Waterford Municipal Art Collection. A History and Catalogue. Peter Jordan. Published by Waterford Institute of Technology and Waterford City Council. 2006.

Watts Memorial Exhibition catalogue R.H.A. 1906.

White, James. Father Jack Hanlon 1913-1968. Paintings and Watercolours. Pantheon Gallery. 6, Dawson Street, Dublin, 2.

White, James. John Butler Yeats and the Irish Renaissance with Pictures from the Collection of Michael Butler Yeats and from The National Gallery of Ireland. Dublin, 1972.

Index

Page numbers in **bold** type refer to illustrations and captions.

'75' Gallery, Limerick, 213
'AE' see Russell, George
Abbey of Saint-Gall, Switzerland, 20; **19**
Aberdeen, Earl of, (Lord Lieutenant of Ireland), 288
Aberdeen, Ishbel, Countess of (née Marjoribanks), 72, 75, 76; **74**
Académie Carmen, 223; see also Whistler, James Abbott MacNeill
Académie Colarossi, 282, 308; **68**
Académie de la Grande Chaumière, 232, 258, 282
Académie Julian, 71, 92, 223, 244, 245, 274; **69, 94, 147**
Académie Montparnasse, 230, 280
Académie Royale des Beaux Arts, 246
Academy of Artists, Dublin, 52; see also Society of Artists in Ireland
Achill Island, Co. Mayo, 218, 219, 226, 232, 233, 276, 294; **219, 225**
Adam, Robert, 30; **29**
Addey, Eliza, 'Lizzie', (née Poole), see Poole, Eliza
Addey, George, 179
Addey, Jane, **181**
Addey, Joseph Poole, 150, 156, 160, 179-187; **160, 179-187**
Addey, Keith, **181**
Addey, Maria Louisa, (née Dixon), see Dixon, Maria Louisa
Addey, Robert, 179
Addey, Sarah, 179
Affane graveyard, 107; **107, 117**
Agnew and Son, 114, 299; **47**
Albert, Prince, 60, 110, 132; **59**
Alcock, P., 133
Alexandra College, Dublin, 95, 245, 248, 249, 276, 282, 296, 303
Alexandra, Queen, 176
Algeria, 302
Allen, Margaret, 55, 66
Allen's, 52, 53
Amateur Drawing Society (later W.C.S.I.), 15, 49, 61, 62, 74, 78, 79, 88, 89-117, 118-135, 136; **16, 89-117, 118-135**; see also Irish Amateur Drawing Society; Irish Fine Art Society
An Túr Gloine (Tower of Glass), 244, 291, 308, 310, 312, 313,
Anglo-Boer War, second, (1899), 287
Annesley, Hugh, Earl of, 289
Annesley, Mabel Marguerite, Lady, 282, 289-290; **290**
Annesley, Mabel W.F. Markham, Countess, 289
Antwerp, 172, 219, 246, 310; **111**
Aonach Tailteann (exhibition), 252
Aran Islands, 47, 233, 293; **45**
Ardilaun, Lady, 144, 168; **163**
Ardilaun, Lord, **135**
Argentina, 222
Armstrong, Arthur, 206, 234
Armstrong, Walter, Sir, 315
Art Industries Exhibition, Dublin (1904), 291
Art Union of Ireland, 58, 141, 158; **55, 144**; see also Water Colour Society of Ireland Art Union
Arthur, Prince, 1st Duke of Connaught and Strathearn, 132; **143**
Arts and Crafts, 76, 258, 261, 285, 289, 308, 310, 312; **78, 194**
Arts Council Prize, 280
Arts Council, 201, 236, 259, 307
Ashbourne, Baron (Edward Gibson), **248**
Ashford, William, 54, 55; **26, 53, 104**
Australia, 222, 231, 234, 262; **195**
Avignon, 302
Bagenal, K., 72, 133
Bagenal, Philip Henry, 113, 135, 141, 154
Bagwell, Emily, Miss, 112, 121, 125, 133
Bagwell family, 112, 126

Bagwell, Harriette, (Mrs Robert Bagwell) 72, 106,
Bagwell, Lilla M. (Mrs John Perry), 71; **193**
Bagwell, Robert, 130
Bailward, Miss, 156
Baldwin, Vivienne, 208
Balearic Islands, 226
Bandon, Earl of, 139
Bank of Ireland, 47, 205, 206, 207, 208, 310
Bankside Gallery, London, 52
Bantry, Countess of, 154
Barbados, 280
Barbizon, 83, 302; **147**
Barret, Senior, George, 35, 44, 187
Barret, the Younger, George, 51
Barry, Jayne, 318; **217**
Barry, Moyra A., 263, 270; **197, 271**
Barton, Augustine, 168
Barton, Emily Alma, 71, 168
Barton family, 126
Barton, John G., Sir, 58
Barton, Rose Mary, 13, 71, 91, 120, 133, 140, 141, 144, 150, 153-171, 154, 155, 163, 164, 173, 176, 179, 189, 249, 263, 268, 289, 297, 302, 303; **146, 148, 160-170**
Bastien-Lepage, Jules, 168, 244
Battle of the Boyne, 113
Bavaria, 110, 297; see also Maximillian II of Bavaria, King
Baxter, Herbert, **147**
Baxter, William Giles, **148**
Bayly, Lancelot Francis Sanderson, 297, 299-300; **79, 196, 299**
Beardsley, Aubrey, 292; **164**
Beaux Arts Gallery, London, 305
Beckett, Frances, 'Cissie', 308; **195**
Behan, Brendan, 234, 260
Belfast, 75, 80-81, 90, 136-159, 179, 227, 233, 236, 239, 240, 253, 277, 290; **254**; see also Ulster Museum; Ulster Watercolour Society; W.C.S.I. exhibitions, Belfast
Belfast Art Society, 82, 103, 176, 220, 223, 224, 253, 254, 263, 289, 299, 305; **80, 159**; see also Belfast Sketching Club; Belfast Ramblers' Sketching Club; Ulster Arts Club; Ulster Academy of Artists; Royal Ulster Academy of Arts
Belfast Castle, 157
Belfast City Hall, 288
Belfast College of Art, 234, 237
Belfast Free Public Library, 156, 220; **153**
Belfast Museum and Art Gallery, 290
Belfast Ramblers' Sketching Club, 81, 157; **80,**
Belfast School of Design, 66, 156
Belfast Sketching Club, 80,
Belgium, 172, 265, 280, 285, 297; **286**
Bell Gallery, Belfast, 206
Bellucci, Giuseppe, 314
Belvedere College, Dublin, 278, 291, 292
Bennett, C., 133
Benson, John, Sir, 138
Benson, Mary Kate, 88, 140
Bentley, Joseph Clayton, 60
Beranger, Gabriel, 24, 52; **15, 22**
Berenson, Bernard, 236
Bernal, Ralph, M.P. see Osborne, Ralph Bernal
Betjeman, John, Sir, 195; **197**
Bettwys-y-Coed, 92
Bianconi, Charles, 109, 123
Bing, Siegfried 'Samuel', 285
Birmingham, 57, 94, 226, 299
bistre, 322
Black and White Artists' Society of Ireland, 274, 289
Blacker, Stewart, 144
Blackham, Dorothy Isabel, 229, 232, 237, 263, 276-277; **276**

Blackwater, river, 99, 105, 106, 107, 113, 231; **17, 102, 104, 108, 115, 166**
Blaker, Miss, 154
Blanche, Jacque Emile, 168; **164**
Bloomsbury Group, 232
Bodkin, Thomas, 246, 283, 292
body colour (gouache), 21, 33, 161-163, 322; **23, 43, 45, 163, 166, 170, 177**
Bonington, Richard Parkes, 297
Bonnard, 265
Borrer, Dawson, Mr and Mrs, 154
Botanic Garden, Trinity College, Dublin, 95, 156; **152**
Botticelli, 60
Bourn Vincent Gallery, University of Limerick, 210
Bouveret, Pascal-Adolphe-Jean-Dagnan, 282
Boyd, Dr., 156
Boyd, Alice, 200, 229, 237, 263, 317
Boydell, Brian, 232
Boyer, Miss, 156
Boys, Thomas Shotter, 109, 299; **111**
Brandon, Edouard, **191**
Brandt, Ruth, 32, 206
Brangwyn, Guillaume François, 'Frank', 282, 285-286, 302; **193, 285-286**
Braque, 230, 265
Brash, Richard Rolt, 144
Bray, 112, 144, 247, 252, 278; **51, 143**
Brenan, James 119, 121, 136, 138, 150, 252; **74, 118**
Breslau, Louise, **70**
Brewer, J.N., 43
Brighton, 99, 232; **99**
Brighton School of Art, 232
Bristol board, 292
Bristol, 41, 268
British Museum, **23, 46, 50, 65, 284, 287, 321, 323**
Brocas family, **321**
Brocas, Henry, Junior, 14, 35
Brocas, Henry, Senior, 14, 35, 45
Brocas, James Henry, **33**
Brocas, William, 37; **40**
Brown, Frederick, Prof., 172, 187
Browne, Robert, 132
Browne, Robert Clayton, 141, 155, 297; **116**
Bruce, Harriet C., 144
Bruen, Gerald, 202
brushwork, 37, 65, 163, 169, 223, 228, 232, 236, 243, 246, 256, 259, 262, 265, 268, 274, 275, 278, 292, 304, 322
Buck, Adam, 187
Buller, Miss, 154
Burbidge, Frederick W.T., 156; **152**
Burghley, Lord, 27
Burke, Augustus, 83, 134
Burke, Phyllis, 307
Burma, 266, 267; **196**
Burne-Jones, Edward Coley, Sir, 48, 243, 291; **48, 90, 150**
Burney, Edward Francis, **62**
Burton, Frederic William, Sir, 45-48, 61, 150; **45-48**
Bushe, C., Miss, 133
Bushe, Charles Kendal, Rt. Hon., 69, 282
Bushe, Letitia, 69
Butler-Stoney, T., 120, 126
Butler, A., Mr., 154
Butler, Elizabeth, Lady (née Southerden Thompson), 79, 189, 314-317; **315**
Butler, Henry, Captain, 172
Butler, Isabel, 'Issy', 178
Butler, Mildred Anne, 91, 155, 156, 157, 160, 167, 171-179, 221, 225, 264, 268, 297, 302; **146, 160, 170, 174-177**
Butler, Patricia, 13, 217
Butler, William, General Sir, 314, 315
Byam Shaw School of Art, 312
Byrne, Anne Frances, 51-52

Byrne, Kathleen Byrne, 234
Cabanel, Alexandre, 168, 282
Cahill, Katherine, 252
Caird, Mona, 284
Calderon, William Frank, 172, 289; **171**
Callow, William, 60, 299
Callwell, Annie, 47
Camarasa, Hermenegildo Angladam, 264
Cambridge, 274; see also Fitzwilliam Museum, Cambridge
Cambridge School of Architecture, 206
Cambridge University, 90, 237, 284, 310; **183**
Campbell, George, 234, 240, 258; **204**
Campbell, John Henry, 39-40; **41**
Canada, 106, 110, 221, 227, 234, 246; see also National Gallery of Canada
Canaletto, 58
Cannes, 268
Canova, 136
Cappoquin House, 112-114; **73, 114-115**
Cappoquin, 74-76, 89, 99, 105, 106, 107, 112-115, 119, 120-121, 212, 274-275; **73, 107, 115**
Carlisle, Earl of (Lord Lieutenant of Ireland), 139; **60**
Carolin, Edward, 55; **53**
Carpenter, Dora, 154
Carr, John, of York, 16, 118
Carr, Tom, 14, 206, 218, 236-7; **204, 237**
Carracci, 54
Carraciolo, Niccolo, 206
Carter, Frederick, 71
Carver, Robert, 35
Castle season, **165**
Cathedral of St. Paul, Minnesota, 76; **78**
Cattermole, 150
Catterson-Smith, Stephen, Junior, 68
Catterson-Smith, Stephen, the Elder, 116; **126**
Central School of Arts and Crafts, London, 258, 289, 312
ceramics, painting on, 35, 58, 71, 103, 140, 142, 158, 189, 144; **142**
Cezanne, 269
Chalfant, Jefferson Davis, **69**
chalk, 45, 47, 52, 58, 65, 71, 119, 121, 132, 133, 135, 158, 171, 189, 208, 244, 246, 286, 288, 322; **36, 46, 126, 170**
Chambers, William, Sir, 30
charcoal, 32, 129, 173, 223-224, 244-245, 304, 322; **69, 223, 259**
Charles II, 94
Charnley, I., 133
Chearnley, Anthony, **89**
Chearnley, T., Miss, 120, 121, 133
Chelsea Arts Club, 287
Chelsea Polytechnic, 258, 303, 304
Child, Alfred Ernest, 291, 308, 312
Childers, Erskine, 295
Chinese white, 161, 322
City of Dublin Technical Schools, 72
Clarke, Austin, **200**
Clarke, Carey, 206
Clarke, Eoghan, **217**
Clarke, Henry Patrick, 'Harry', 210, 228, 229, 250, 258, 260, 282, 290-292; **197, 291**
Clarke, Margaret, 261
Claude, 36, 41
Clausen, George, Sir, 246, 251
Clifford Gallery, 168
Clifford, C.E., 168
Clonmel, 106-109, 121, 123, 125, 126, 129, 242; **106, 109-111, 113, 122, 123, 128, 193**; see also W.C.S.I. exhibitions, Clonmel
Clonmel School of Art, 123, 125; **125**
County Antrim, 157, 182, 223, 227, 240, 241, 253, 267
County Armagh, 224, 263; **159**
County Carlow, 106, 120, 132, 264, 297; **116, 129, 131**; see also W.C.S.I. exhibitons, Carlow

County Cavan, 40, 221; **41**
County Clare, 24, 235, 255, 276; **22, 295**
County Cork, 63, 78, 120, 232, 268, 282, 290, 302; **81, 82, 138, 147, 181, 303**; see also Cork city; W.C.S.I. exhibitons, Cork
County Donegal, 182, 223, 224, 227, 229, 253, 254, 256, 265, 276, 301, 310; **200, 222, 309**
County Down, 30, 40, 157, 213, 224, 236, 289, 290, 300
County Dublin, 17, 47, 183, 214, 217, 227, 237, 244, 249-252, 262-263, 265, 269-271, 278, 287, 306, 313; **152, 180, 215, 216, 264**; see also Dublin; W.C.S.I. exhibitions, Dublin
County Fermanagh, 300, 310
County Galway, 45, 113, 216, 223, 229, 235, 237, 274
County Kerry 140, 187, 223, 224, 225, 228, 255, 260, 271, 274, 300, 307, 314; **35, 122, 229, 238**
County Kildare, 40, 251; **77, 199**
County Kilkenny, 24, 90, 99, 100, 103, 120, 172, 176, 178, 206, 231, 265, 267, 294; **78, 100, 171, 176, 177**
County Laois, **26**
County Limerick, 74, 172, 224, 229, 260, 261, 262; **71, 79**
County Londonderry, 13,182, 183; **184**
County Louth, 218, 260, 294
County Mayo, 112, 218, 223, 226, 229, 232, 235, 236, 239, 258, 271, 294; **219, 235**; see also Achill Island
County Meath 30, 206, 249, 250, 261, 274, 303, 305, 316; **29**
County Monaghan, 206, 218; **159**
County Offaly, 294
County Roscommon, 221; **64**
County Sligo, 290.
County Tipperary, 16, 106, 107, 111, 120-121, 168, 224, 243, 294, 300, 315; **106, 109, 110, 118, 122-125, 128, 193, 196**
County Tyrone, 206
County Waterford, 15, 24, 25, 27, 32, 60, 75, 90, 94, 99, 102, 105-108, 112-115, 118, 120, 123, 126, 176, 179, 212, 215, 223-224, 229, 242, 244, 267, 274-276, 294; **14-16, 21, 30, 66, 72, 73, 89-91, 95, 97, 99-100, 103-105, 107-108, 115-118, 120, 125, 134, 166, 192, 214, 222, 231**
County Westmeath, 40
County Wexford, 40, 179, 206, 267, 277, 278, 288, 294
County Wicklow, 25, 39, 40, 43, 53, 112, 144, 182, 183, 222, 223, 225, 229, 234, 247, 252, 255, 270, 278, 284, 294, 297, 300, 314; **26, 143, 224, 234**
Coburn, Ivor, 318; **217**
Coghill, Egerton B., 282; **147**
Coghill, Hildegarde, **147**
Coghill, John Joscelyn, Sir, 61, 135, 141, 144, 154; **134**
Coghill, Josiah, Sir, 282
Coláiste na Rinne, 102; **103**
Coldstream, William, Sir, 236
Cole, Alan S., 74
Coleridge, F.G., 156
Colles, Alexander, 274
Colles, Lillie, 72
Colnaghi, Domenic, 43
Colomb, Mr., 156
Colquhoun, Miss, 154
Colthurst, Miss, 151
Column, Mary, 88
Column, Pádraic, 88
Colvill, Helen, 13,142, 189, 193, 200, 229, 254, 263-264, 299, 304; **152, 264**
Comerford, John, 45; **53**
Comper, Ninian, Sir, **77**
Connell, Liam, 199
Connell, W., Mrs, 63
Connemara, 45, 223, 228, 235, 236, 240, 253, 255, 268, 293, 296
Conor, William, 290
Constable, John, 43, 227
conté, 322
conversazione, 80, 144, 151, 153; **150**

Cooper, Richard, 38
Cope, Charles West, **161**
Cork city, 30, 63, 75, 78, 82, 179, 182-183, 231, 268, 302; **31, 126, 139, 142**; see also County Cork; W.C.S.I. exhibitions, Cork
Cork Harbour, **179**
Cork Industrial and Fine Art Exhibition (1883), 114-115, 149, 182
Cork Industrial Exhibition (1910), 220, 285
Cork International Exhibition (1902), 289
Cork National Exhibition (1852), 43, 138
Cork School of Art, 119, 138, 144, 150, 247, 268; **118**
Cork School of Design, 66, 179; see also Cork School of Art
Cork Society for Promoting the Fine Arts, 136
Cornwall, 109, 172, 173, 247, 264, 294; **174**
Correggio, 58, 121
Corsica, 302
Cot, Pierre-Auguste, 92
Cotman, John Sell, 41
Coulson Academy, 254
Coulson Exhibition (1910), 254
Council of the Friends of the National Collections of Ireland, 280
Count D'Orsay, Alfred, **125**
County Hall, Dun Laoghaire, 17, 214, 217; **216-217**
Courcell, A., 25; **26**
Courthouse, Lismore, 16, 103, 119, 123, 129, 135, 136, 212-213, 288; **118, 120**
Cowan, Edward Porter, Sir, 157
Cowan, George, 33
Cowan, Lady, 157, 158
Cowper, Katrine, Countess, 75
Cox, David, 91-92, 172, 219; **65, 94**
Coyle, Brian, 199
Craig, J. Humbert, 228
Crampton, John Fiennes Twistleton, Sir, **131**
Crane, Walter, 291
Crawford Art Gallery (Crawford Municipal Art Gallery), 136, 270, 276, 284, 302; **56, 68, 74, 126, 137-142, 178**; see also Crawford School of Art
Crawford School of Art (Crawford Municipal School of Art), 136, 158, 302; **137, 140**; see also Crawford Art Gallery
Crawford William Horatio, 136, 153
Crawford, Sharman, Mrs, 140-141
Crilley, Margaret (Mrs Harry Clarke), 290; **197**
Crimean War, 108
Cristall, Joshua, 51
Cromwell, Thomas Kitson, **44**
Crookshank, Anne, 35, 187, 195, 213, 230; **214**
Crookshank, Miss, 94
cubism, 16, 230, 233, 256, 262, 265, 269, 280, 293, 296, 312
Cuffe, Charles F. Wheeler, Sir, 99-100, 120; **100**
Cuffe, Charlotte Isabel Wheeler, Lady (née Williams), 100, 263, 265-267; **100, 196, 266**
Cuffe, Otway Fortescue Luke Wheeler, Sir, 100, 265, 267
Culverwell, Celia, 156
Cuming, William, 54; **41**
Curaçao, 280
Curran, Elizabeth, 258
Currey, A., Miss, 156
Currey, Anna Matilda, (née Hamilton), 90
Currey, Benjamin, 90
Currey, Chetwode Hamilton, 121; **92**
Currey, Frances Wilmot, 'Fanny', 15, 71, 72, 74, 89-97, 103, 106, 107, 116, 119, 120, 121, 125, 126, 129, 130, 132, 133, 135, 140-142, 144, 150, 151, 154, 155-157, 167, 242, 297; **16, 91-92, 95-98, 111, 114, 116, 122, 146**
Currey, Francis Edmond, 90-91; **90-92, 95, 120**

Cusack, Ralph Desmond Athanasius, 16, 218, 232, 237-238; **238**
Cuyp, Aelbert, 54, 129
d'Ott, Pauline Theresia (Lady Stuart de Decies), 99
Danby, Francis, 40-43; **42-43**
Danby, Thomas, 187
Dargan, William, 58; **126**
Dargle, river, 25, 40, 53, 187, 297; **26**
Darragh, William, 253
David Hendriks Gallery, Dublin, 236
Davidson, Jennifer, 239
Davidson, Lilian Lucy, 151, 200, 237, 242, 252-253; **201, 253**
Dawson Gallery, Dublin, 280, 294, 305, 313
de Blacam, Una, (née Craddock), 207; **207**
de Burca, Michael, **34**
de Langillière, Nicolas, 126
de Montmorency, Mrs, 133
de Terlikowski, Vladimir, 305
de Valera, Bean, 295
de Valera, Eamon, 223, 295
De Wint, Harriet, 36
De Wint, Peter, 14, 36-38, 61; **38**
Deane, Lady, 63
Deane, Miss, 88
Degas, 236, 244; **164**
Delane, Solomon, 35
Denny, Abraham, 106
Derg, lough, 224, 278; **277**
Dermody, Frank, **203**
Desmond McLoughlin, 208, 212, 215; **213**
Deverell, Leah, **217**
Devonshire, Duke of, 5th, 16, 118
Devonshire, Duke of, 6th, 75, 90, 91; **74, 91, 120**
Devonshire, Duke of, 7th, 90; **120**
Dickens, Charles, 314
Dickey, E.M. O'Rorke, 236
Dillon, Gerard, 218, 239-240, 258, 267; **240**
Dineley, Thomas, (or Dingley), 23
Divisionism, 293
Dixon, Maria (née Keville), 182
Dixon, Maria Louisa (Mrs Joseph Poole Addey), 182-183; **182, 186**
Dixon, Thomas Henry, 182
Dobbin, Alfred Graham, Sir, 268
Dobbin, Kate, Lady (née Wise), 263, 268; **137, 268**
Donnelly, Gerald, 202
Donoughmore, Countess of, 126, 130
Donoughmore, Earl of, 287
Donovan, Phoebe, 13, 32, 202, 206, 214, 235, 263, 277-278; **203, 277**
Doolan, Jim, **217**
Doran, Patrick F., Professor Dr., 210; **212**
Douglas Hamilton, Hugh, 187
Douglas Hyde Gallery, Trinity College, Dublin, 236, 292
Douglas Hyde Gold Medal, 236, 259, 280
Douglas, Jessie Ogston, 242, 253-254; **254**
Dowling, Gráinne, **217**
Downes, Margaret, Dr., 199
Doyle, Brian, 215, 216; **213**
Doyle, Henry Edward, **48**
Doyle, Kay, 208, 210-212, 214-216; **211-213**
Doyle, Pauline, 208; **217**
Dresden, 235, 300
Drew, A., 133
Dromana (house), 99-100, 103, 120; **99, 101, 102, 192**
Drury, Franklin, 63
Drury, Susannah, 63; **64**
du Noyer, George Victor, 27, 61; **30**
Dublin, 14, 16, 17, 19, 20, 21... passim; see also County Dublin; Irish Industrial Exhibition; W.C.S.I. exhibitions, Dublin
Dublin Amateur and Artists' Society, 88
Dublin Art Club, 88, 164, 246
Dublin Bay, 252
Dublin Castle, 17, 157, 158, 168, 212, 218, 281; **165**
Dublin City Gallery, The Hugh Lane

(Municipal Gallery of Modern Art), 17, 204-205, 245, 260-261, 263, 294; **163, 203, 244, 248**
Dublin Diocese Commission for Sacred Art and Architecture, 280
Dublin Drama League, 310
Dublin Exhibition of Art Industries (1904), 291
Dublin Exhibition of Arts, Industries and Manufactures (1872), 114; **73**
Dublin Glee and Madrigal Union Quartet, 218
Dublin International Exhibition of Arts and Manufactures (1865), 144, 150; **128**
Dublin Metropolitan School of Art (D.M.S.A.), 32, 138, 187, 202, 227, 228, 229, 234, 244, 245-247, 249-252, 255, 256, 258, 260-261, 264, 269-270, 273, 274, 276, 278, 291, 292, 295, 301, 303, 304, 306, 308, 310, 312; **34, 118, 198** see also National College of Art and Design
Dublin Painters, 235, 250, 269, 275, 280, 296, 304, 313
Dublin Painters' Gallery, 200-201, 226, 238-239, 252, 262, 271, 273, 275, 305
Dublin Philosophical Society, 24
Dublin Photographic Society, 135; **134**
Dublin Sketching Club (Dublin Painting and Sketching Club), 82-84, 88, 144, 151, 155, 183, 187, 216, 218, 223, 224, 234, 246, 248, 263, 270, 274, 278, 289, 299; **82-84, 180**
Dublin Society's House, Grafton Street, Dublin, **32**
Dublin Society's House, Hawkins Street, Dublin, **32**
Dudley Gallery, London, 94, 158, 164, 176, 221, 299, 316
Dufy, Raoul, 230, 265, 280, 304
Dun Laoghaire (Kingstown), 17, 40, 48, 214-215, 222, 262, 270; **214-215**
Duncan, Ellen, **87**
Dunne, Berthold, 212
Dunsmuir, Jessie Sophia, 106, 274
Dunsmuir, Robert, Hon., 106
Eadfrith, Bishop of Lindisfarne, 20
Eagle, Edward, 156
Ecole de Fresque, 293
Ecole des Beaux-Arts, 71, 92, 94, 168, 282, 312
Ecuador, 270
Edgeworth, Maria Lovell, 64, 69; **64**
Edgeworth, Richard Lovell, 64
Edinburgh College of Art, 206, 296
Edward VII, King, 176
Edwards, Lionel D.R., 172
Egerton, Louisa, Lady, 133
Eliot, George, 48; **46**
Elizabeth I, Queen, 27
Elrington, Mrs, 133
Elvery, Beatrice Moss, (Mrs Campbell; Lady Glenavy), 88, 308-310; **87, 195, 309**
England, 25, 37, 49, 63, 70, 79, 121, 144, 154, 172, 187, 211, 219, 221, 227, 232, 237, 242, 246, 252, 253, 255, 263, 265, 290, 294, 301, 302, 310, 314, 319; **142, 245**
etching, 25, 58, 74, 119, 121, 129, 132, 135, 158, 176, 189, 208, 282-296, 323; **189, 193, 284-296, 323**
Ethilwald, Bishop of Lindisfarne, 20
Eton College, 294, 310, 313; **199**
Europa Nostra Award for Conservation (1994), 307
European Association of Water Colours, 216
Evans, Helen, 43
Everett, Herbert, 300
'exhibition' watercolour, 160-187; **220**
Expressionism, 236, 258, 262, 290, 296, 312
Fairholm, Katherine, 156
Fallon, Brian, 221, 229, 236, 270, 273, 275, 296
Farmar, Elizabeth M., 71, 72
Faucit, Helen, 47
Faulkner, Maud, 71
Fauvist, 264, 280, 312

Female School of Art and Design, London, 314; see also South Kensington
Ferrall, Nolan, Major, 200, 229, 237
Fielding, Anthony Vandyke Copley, 36, 38, 63
Fine Art Society, London, 17, 61, 74, 80, 82, 88, 94, 114, 154, 176, 267, 268, 274, 286, 288, 314; **81**, **173**
First World War, 103, 106, 227, 246, 250, 252, 260, 264, 267, 285, 301, 302, 316
Fisher, Jonathan, 52
Fitzgerald, C.E., 83
Fitzgerald, Desmond, see Glin, Knight of,
Fitzgerald, Geraldine (Frances A. Gerrard), 168
Fitzgerald, Marian, 294
Fitzgerald, Miss, 63
Fitzwilliam Museum, Cambridge, 120; **111**
Flack, James, 212
Flood, Edythe, 208, 211
Foley, John Henry, **49**
Forrester, James, 35
Foster, Myles Birket, 121
Foster, Vere, 65, 75, 222; **64**
fox-hunting, 70, 282, 283, 304, 305; **283**
foxing, 322
frame, 71-72, 74, 155, 162, 171, 176, 189, 209, 219, 240, 285; **161**, **162**
France, 35, 37, 43, 58, 60, 63, 104, 110, 121, 126, 168, 172, 216, 229, 232, 236, 237, 242, 245, 246, 248, 253, 256, 263, 264, 265, 270, 276, 278, 280, 282, 288, 292, 296, 297, 301, 304, 312, 322; **153**
Franco-Prussian War (1870), 314
Fraser, Florence, **79**
Freeney, John, 212
French, Annie, 291, 292
French, Lady, 172
French, Marjorie Hariette, **82**
French, Phoebe, 120, 121
French, William Percy, 13, 83, 88, 182, 218, 221; **130**, **221**
fresco, 243, 262, 288, 314
Friendly Brothers of St. Patrick, Dublin, 295
Fripp, Alfred Downing, 120
Frost, Stella Noel, 218, 225-226; **225**
Furniss, Harry, **154**
Gaisford, E., 133
Ganly, Rose Brigid, 13, 33, 242, 261-262; **198**, **261**
Garstin, Norman, 172-173, 247, 256, 264
Gautier, Theophile, 43
Gaven, George, 63
Geddes, Wilhelmina Margaret, 312
Geological Survey of Ireland, 27; **30**
George IV, King, 136
George V, King, 288
Gerome, Jean-Leon, 282
Gerrard, Frances A., see Fitzgerald, Geraldine
Gersch, Leopold, Captain, 99
Gersch, Leopoldine, 99
Gervex, Henri, 168; **164**
Gibbings, Robert, 290
Gibbon, Monk, Dr., 310
Gibney, Arthur, 33, 206, 297, 306-307; **307**
Gilbert, John, Sir, 144, 151; **49**, **142**
Gilchrist, Mr., 156
Gillies, William G., 296
Giorgione, 60
Girtin, Thomas, 36, 37, 41, 44; **37**
Gladstone, William, 48; **48**
Glasgow, 290; **64**
Glasgow Exhibition (1938), 258; **198**
Glasgow Institute of Fine Arts, 94, 284
Glasgow School of Art, 295-6
Gleizes, Albert, 256, 312
Glenavy, Lady, see Elvery, Beatrice Moss
Glenavy, Lord, (Gordon Campbell), 310
Glenshelane (house), 114-115; **72**, **73**, **115**
Glin, Knight of (Desmond Fitzgerald), 35, 187, 213; **214**

Glynn, Dorothy, 206
Godwin, Edward William, 310
Goggin, Muriel Byrne, **217**
Golden Fleece, The Helen Lillias Mitchell Artistic Fund, 281
Goldsmiths, University of London, 276, 293
Goodall, Frederick, 120
Goodman, Theodore, 30
Gordon, John, Sir, 139
Gore, William Crampton, 'Ruddy', 297, 300-302; **190**, **301**
Gorman, Amy F., 72
Gormanston, Eileen, Viscountess, 316
Gorry Gallery, Dublin, 263, 270; **17**, **51**, **96-98**, **125**, **145**, **149**, **152**, **167**, **179**, **186**, **221**, **227**, **237**, **247**, **264**, **293**
Gothic, 297, 310; see also Hindu-Gothic
Gough, Mary, 121
Goupil Gallery, London, 283
Government of Saorstát Eireann, 193; **194**
Government Schools of Design, 66, 68, 136
Graham, D., 133
Graham, Henry, 33
Grant, Francis, Sir, 242, 289; **128**
graphite, 37, 183, 310, 322; **38**, **45**, **49**, **50**, **163**, **219**, **229**, **260**, **266**, **267**, **309**, **321**
Graves, H., 133
Great Exhibition, London (1851), 110
Greece, 121, 262
Grenville, Manton, G., **150**
Grey, Alfred, 83
Grey, Charles, 133; **133**
Grierson, Mr, 156
Grogan, Nicholas, 150
Grosvenor Gallery, London, 94, 148, 167, 227; **146**
Grosvenor School of Modern Art, London, 295
Gubbins, Beatrice Edith, 82, 297, 302; **81**, **303**
Guercino, 54
Guernsey, 91, 172; **93**
Guernsey Museums & Galleries, **93**
Guildhall Art Gallery, London, 187, 220, 247, 249, 299; **184**
Guildhall Library, London, **168**
Guinness, May Catherine, 16, 71, 156, 172, 254, 263, 264-265, 269; **173**, **265**
Guinness, Noel, 246
Hackett, Jennie, 151
Haden, Francis Seymour, Sir, 284
Haines, Charles Yelverton, Dr., 139
Hall, J.B., 299
Hall, Kenneth, 232, 237, 239
Hall, Oliver, 286
Hallmark International Art Award (1955), 280
Hamilton, Alexander, Rector of Thomastown, 90
Hamilton, Ethel, 249
Hamilton, Eva Henrietta, 200, 229, 237, 242, 249-250, 280, 303-304; **249**
Hamilton, Letitia Marion 'May', 200, 248-9, 250, 267, 269, 278, 280, 297, 302-305; **305**
Hamilton, Mrs Charles (Violet), 249; **249**
Hampton Court, 310
Hanlon, John 'Jack' Thomas, Rev., 13, 263, 265, 267, 269, 278-280; **279**
Harbison, Eleanor, 213
Harding, James Duffield, 161
Harman, Anne S. King, 202, 262
Harrap, George, 292
Harrison, Sarah Cecilia, 236
Harvey, Miss, 156
Hassall, Joan, 296
Haughton, J., 133
Haughton, Wilfred James, 13, 14, 218, 240-241; **241**
Haussman, Baron, 71
Hayes, Edwin, 150, 156
Hayes, Claude, 218, 219-220; **220**
Hayes, Ernest, **34**

Hayes, Michael Angelo, **54**
Headfort House, Co. Meath, 30; **29**
Healy, Henrietta, 278
Healy, Michael, 312
Healy, Mr. (Master of the Clonmel School of Art) 123
Hederman, Carmencita, Dr., 199
Henry VIII, King, 310
Henry, Françoise, Dr.
Henry, Grace, 248, 269
Henry, Mabel (née Young), 227
Henry, Paul, 13, 14, 218, 223, 228, 248, 250, 304; **223**
Hepworth, Barbara, 258
Herbert, Beatrix Frances Gertrude, Lady, 187
Herbert, Mary, **122**
Hereford, 40, 224
Herkner, Friedrich, Professor, 280
Hibernian Antiquarian Society, 24
Higgins, F.R., **34**
Hill, Cassandra M., 63, 144, 154
Hillery, Patrick, Dr., 207
Hillyard, W.H., 58
Hindu-Gothic, 99
Hodder, Captain, 151
Hodge, Anne, 217
Hodgkins, Frances, 290
Hodson, George Frederick, Sir, 61, 144; **143**
Hogan, John, 60; **56**
Holland see Netherlands, The
Holland, Francis, 278
Hollar, Wenceslaus, 44
Holman Hunt, William, 48, 61, 133, 243
Holman, A., 133
Home Arts and Industries Association, 72, 74; **71**
Hone, Evie Sydney, 13, 16, 210, 226, 232, 256, 265, 267, 269, 275, 278, 293, 294, 308, 310-313; **199**, **311**, **313**
Hone, Evie, Memorial Exhibition, **199**
Hone, Galyon, 310
Hone, Horace, 21, 310; **25**
Hone, John Camillus, 310
Hone, Joseph, 310
Hone, Nathaniel, 83, 192, 210, 274, 310; **191**
Hope, Alan, 201
Hospitalfield, Arbroath, 20
House of Lords, London, 90, 286
Howet, Marie, 238
Howse, George, 60
Hughes, John, 236, 247, 308; **192**
Hughes, Myra Kathleen, 282, 288-289; **289**
Huish, Marcus Bourne, 176
Hungary, 102, 216, 232
Hunt Museum, 208
Hunt, John, 208
Hunter, Anne, 63
Hunter, John, 63
Hunter, Robert, 52
illustrator, 72, 157, 168, 206, 229, 238, 248, 254, 282-296, 303, 312; **130**, **147**, **189**, **203**
Impressionism, 91, 168, 228, 229, 244, 256, 304, 312; **94**
India, 107, 109-110 242-243, 266, 306, 315
Ingles, Johnston J., 154
Inis Mór, 293; **43**
Inishere, 291
ink, 24, 25, 30, 47, 58, 106, 158, 161, 189, 208, 226, 232, 233, 261, 283, 292, 294, 296, 310, 321, 322-323; **20**, **21**, **31**, **49**, **50**, **104**, **111**, **143**, **160**, **184**, **188**, **230**, **233**, **240**, **291**, **295**, **309**, **323**
Ireland, John, Archbishop, 76; **78**
Irish Amateur Drawing Society (later W.C.S.I.), 16, 61, 71, 74, 102, 106, 113, 130, 132, 134-135, 221; **71**, **129**, **130-5**, **141**, **147**, **163**; see also Amateur Drawing Society; Irish Fine Art Society
Irish Architectural Archive, **31**, **79**, **176**
Irish Association for Promoting the Training and Employment of Women, 72

Irish Embassy, Riyadh, 307
Irish Exhibition at the Edinburgh International Exhibition (1886), 76
Irish Exhibition of Living Art, 226, 229, 232-233, 240, 270-271, 275, 278, 280-281, 284, 296, 305, 313
Irish Exhibition, London (1888), 76, 114, 220
Irish Fine Art Society (later W.C.S.I.), 17, 61, 74, 82, 92, 103, 119, 135, 136, 138-139, 141, 144, 148, 150-151, 154-155, 164, 176, 218, 242, 244, 263, 282, 297; **81**, **129**, **139**, **141**, **143**, **145**, **147-149**, **191**; see also Amateur Drawing Society; Irish Amateur Drawing Society
Irish Government, 245, 312; see also Government of Saorstát Eireann
Irish Guild of Spinners, Weavers and Dyers, 281
Irish Industrial Exhibition, Dublin (1853), 58-60; **57**, **59**
Irish Industries Association, 72, 74-75
Irish International Exhibition (1907), 220, 254, 291; **192**
Irish Lace Depot, 75
Irish National Teachers' Organisation, 65
Irish Republican Brotherhood, 261
Irish Society of Design and Craftwork, 280
Irwin, Captain, 144
Irwin, Clara, 154; **159**
Italy, 35, 37, 58, 60, 100, 102, 104, 106, 118, 120, 129, 172, 216, 229, 236-237, 262, 263, 265, 276, 280, 284, 296, 297, 299, 302, 312; **133**
Iveagh, Lord, 286
Izod, E., 133
Jackson, Robert Wyse, 282, 294-295; **295**
James II, King, 113
Jameson, Joan Moira Maud (née Musgrave), 263, 271, 274-276; **275**
Jameson, Mrs William, see Mitchell, Flora Hippisley
Jameson, William, 226
Japan, 87, 144, 176
Japanese Gallery, London, 167
Jellett, Mary, 'Mainie', 13, 14, 16, 225-226, 229-230, 232, 237, 239-240, 242, 255-258, 265, 267, 269, 275, 278, 280, 295, 312; **198-199**, **257**
John, Augustus Edwin, 187, 251, 269; **164**
Johnson, James F., 158
Johnson, Mr, 192
Johnston, Francis, 55; **54**, **53**
Jones, David, 290
Jones, Owen, 139
Jones, Thomas Alfred, Sir, 83, 116, 134, 154; **58**
Jorgensen Fine Art Gallery, Dublin, **169**, **230**
Julian, Rodolphe, 71; **94**; see also Académie Julian
Kavanagh, Patrick, 234
Kay, Dorothy (née Elvery), **195**
Keane family arms, **115**
Keane, Eleanor, Lady, 72, 75, 76, 120, 126; **133**
Keane, Frances Annie, 15, 72, 74, 89, 107, 112-117, 119, 126, 132, 135, 141, 151, 242, 297; **16**, **72-73**, **114-115**, **122**, **133**
Keane, Frederick H., 112
Keane, George Wilfred, 112
Keane, George, 113
Keane, Harriet Edith, 'Miss Keane', 15, 72, 74-75, 89, 107, 112-117, 119, 125, 126, 132, 135, 141, 150, 155, 242, 297; **16**, **72-74**, **114-117**, **119**, **121-122**, **133**
Keane, John Henry, Sir, 126
Keane, Laura Ellen Flora, 112
Keane, Molly, 103, 274, 276
Keane, Richard Francis, 112, 113
Keating, Richard, Rt. Hon., 112
Keating, Seán, 32-33, 195, 205, 228, 234, 258, 260-261, 271, 273, 278; **34**
Keaveney, Raymond, 199, 216-217
Kelly, Frances, 259, 269

Kelly, John F., Professor, 206
Kenmare, 138
Kennedy Gallery, Dublin, 281, 296
Kennedy, Jean, 199
Kennedy, S.B., Dr., 223, 228, 230, 238, 274
Keogh, Miss, 156
Kernoff, Harry, 33, 234, 242, 260-261, 267; **34**, **260**, **262**
Kilkenny Art Gallery Society (Society for the Encouragement of Art in Kilkenny), 231
Killarney, **35**, **42**, **122**; 41, 138, 225
Kilmurry (house), 172, 176, 178; **176**, **177**
Kilroy, Patricia, 207; **207**
King, I., 133
King, Mrs, 120
King, T., 133
Kingsmill Moore, T.C., 195
Kinsale, 138
Kirkwood, Grace Harriet Sara (née Jameson), 239, 263, 269-271, 280; **269**
Knee, Howard, **198**
Knox, George J., 142
Labourers' Cottages and Allotments Bill, 102
lace, 72, 74-76, 114-116, 136, 138, 253; **73-75**
Lagan, river, 236; **237**
Laird, William, 253
Lambe, Vincent, 13, 212; **216**, **217**
Langford, Lord (Lord Lieutenant of Ireland), 158
Langrishe, Grania, **217**
Langrishe, Hercules, Sir, 265
Larchet, John, 217
Larchet, Nancy, 13, 215, 216, 281; **212**, **213**, **215**
Laver, Grahame, **197**
Lawless, Frederick, Hon., 84
Lawlor, Mary Power, 74, 114
Lawrence, D.H., 310
Lawrence, Frieda, 310
Lawrence, Thomas, Sir, 54
Le Brocquy, Louis, 206, 280
Le Harivel, Adrian, 199
Leavey, Anna Marie, 212
Lee, Ida, 151
Lee, river, 82, 302
Leech, John, 283
Legross, Alphonse, 172
Lely, Peter, Sir, 150
Leonard, Pamela, 208, 212; **207**, **212**, **213**
Leonardo, 48
Léopold I, King of the Belgians, 58
Leyrath, 99, 100, 120, 265; **100**
Lhote, André, 230, 236, 256, 262, 265, 269, 278, 280, 293, 296, 312
Lillias Mitchell Prize, 281
Limerick Art Society, 294
Limerick Arts Club, 294
Limerick City Gallery of Art, **34**
Limerick city, 63, 125, 213, 225, 224, 267, 294, 295, 300; **20**, **34**; see also County Limerick; University of Limerick
Lindisfarne (Holy Island), 19
Lindisfarne Gospels, 19; **18**
Lindsay, Blanche, Lady, 167; **146**
Lindsay, Coutts, Sir, 167; **146**
Lindsay, Tomas Mitchner, 156
Linnell, John, **35**
linocut, 276, 277
Lismore, 14-17, 27, 89-91, 94-95, 97, 99, 103, 107, 110, 112-113, 118-120, 135, 136, 213, 288; **14-17, 89-92, 95, 97, 99, 118-120, 125, 134**; see also Lismore Castle; Lismore Heritage Centre; Lismore Arts Centre; the Courthouse, Lismore
Lismore Arts Centre, 212
Lismore Castle, 12, 89-91, 120, 155, 212; **16, 89, 91-92, 120, 166**
Lismore Heritage Centre, 16, 118, 212; **120, 214**; see also the Courthouse, Lismore
Lithuania, 258
Liverpool, 94, 134, 176, 179, 284, 299, 314
Lodder, Charles A., 144
Londonderry School of Art, 182

Londonderry, Marchioness of (Theresa Susey Helen Vane-Tempest-Stewart), 75, 154-155, 157; **151**
Londonderry, Marquis of, 6th, 133, 154-155; **151**
Longfield, Ada, 304
Longfield, J., Miss, 141, 150, 153, 156
Longfield, Mrs, 151, 153
Longford, Lord, 85, 88
Loudan, William Mouat, 284, 288
Louis XVIII, King, 242
Lover, Samuel, 45
Ludwig I, King, 48
Luke, Eric, **212**
Luke, John, 237
Lutyens, Edwin, Sir, 288
Lynch, Henrietta K., 155, 156, 184, 193, 263, 297, 299, 304
Lynch, J.H., **54**
Lyne, Robert Edwin, 125; **126**
Lynn, William Henry, 30, 157; **31**, **153**
Macaulay, Rosemary, 211; **213**
Macauley, Miss, 156
MacCalmont, Major, 171
MacGonigal, Ciarán, 204-205, 208
MacGonigal, Maurice, 13, 32, 204-205, 218, 228-229, 234, 260, 290, 307; **198, 200, 203, 210, 229**
Mackmurdo, Arthur Heygate, 285
Macleod, Norman, 61
MacLiammoir, Michael, 88
Maclise, 150
Macnab, Iain, 295
MacNally, Niamh, 217
Madeira, 300
Maffey, Lady, 200
Maguire, Myra, 208, 215; **207**
Maguire, P., 126, 133
Malton, James, 25; **27**
Malton, Thomas, 25
Manahan, Rosita, **217**
Manchester City Art Gallery, 94
Manchester University, **320**
Manchester, Duchess of, 130
Manchester, Duke of, 126, 130
Manet, 172; **164**
Mansfield, Katherine, 310
Marescaux, Kathleen Louisa Rose (née Dennis), 263, 267; **267**
Markieviez, Casimir, 88
Markieviez, Constance, 88
Marlfield (house), 106, 112, 121; **193**
Marlfield Cottage Industries, 106
Marsh, Clare, 242, 247-249; **248**
Martin, H&J, **153**
Martin, Patricia, 212
Martin, Violet, 97, 282-284, 305
Martinique, 300
Masaccio, 60
Mashkov, Ilya Ivanovich, 269
Massy-Hewson, Frances, 280
Massy, Lord, 156
Massy, Mary Elizabeth, **79**
Massy, Mrs, **79**
Matisse, Henri, 230, 265, 280, 312
Maughan, Gemma, 217
Maximillian II of Bavaria, King, 47
May, Princess (Queen Mary), 176
Mayo, Earl of, 192
McCabe, Patricia, Dr., 13, 208, 210, 211; **217**
McCalmont, J., Mrs, 72
McCarthy, Miss, 63
McCaw, George, 13, 206, 207, 208, 214-216; **209, 212-214**
McCaw, Maureen, 215
McCurdy, John, 100; **100**
McDonnell, Samuel, **139**
McDowell, Sandra, 210
McGoogan, Archibald, **36**
McGrath, Raymond, 31
McGreevy, Thomas, 195
McGuinness, William Bingham, 144, 189, 221, 263, 297-299; **145, 298**
McGuinness, Norah, 16, 218, 229-230, 239, 259, 269, 271, 275, 278; **230**
McGuire, Edward A., 259
McKelvey, Frank, 218, 227-228; **198, 227**
McManus, Jack, **211**
McParland, Edward, 30
Mechanics' Institute, Clonmel, 123, 125, 242; **123, 125, 128**

Meninsky, Bernard, 258, 312
Metropolitan Museum, Tokyo, 211
Metzinger, Jean, 312
Middleton, Colin, 234
Miller, Liam, 195, 278
Millet, 172
Milton, Thomas, 25; **26**
Mina, Ann, **217**
Minch, Janet McGloughlin, 206
miniature, 19-21
Mitchell, Flora Hippisley, 218, 226-227; **226** (Mrs William Jameson),
Mitchell, Helen Lillias, 208, 252-253, 263, 279, 280-281, 295; **281**
Model Schools, Dublin, 291
model, 71, 83, 187, 232, 243, 252, 300, 314; **69**
modelling, 32, 58, 66, 158, 189, 256, 261, 308
modernism, 226, 228, 232, 236, 238, 262, 265, 278, 295
Mogford, Thomas, **93**
Molloy, Austin, 291
Monro, Thomas, Dr., 36,
Montgomery, Archibald V., 176, 189, 192, 237, 297
Montgomery, Charles, 36
Montgomery, W., 263, 299
Montizambert, C.E., 71, 133
Moore, George, 244
Moore, Henry Spencer, 202, 258
Moore, James Butler, Dr., 83
Moreau, Gustave, 312
Morgan, Miss, 156
Morocco, 94, 172, 302; **190**
Morris, William, 285; **90**
Moscow, 269
Moseiwitch, Tanya, **200**
Mount Temple, Dublin, 280
Mountgarret, Viscount, 172
Mulcahy, Richard, General, 281
Muldowney, Patrick, 208
Mulready, William, 187
Mulvany, George Francis, 59; **58**
Mulvany, John Skipton, 297
Mulvany, Thomas James, 297
Munich Secession (1893), 285
Munich, 270, 285, 300
Munster Exhibition, 136
Munster Fine Art Club, 268
Munster-Connaught Exhibition, 224, 300
Murphy, Barry, 199, 212
Murphy, Derville, 66
Murphy, Seámus, 276
Murray, Peter, Dr., 43-44, 136
Musgrave, Anna Frances, 'Fanny', 15, 72, 74, 89, 103-107, 119, 120, 126, 135; **104-107, 114, 117**
Musgrave, Christopher, 105
Musgrave, Edith Melesina Lovett, 106, 120, 126
Musgrave, Florence Sophia (known as 'Margaret'), 106-107, 120, 126; **107**
Musgrave, Frances Mary, Lady (née Ashton Yates), 106, 120, 126
Musgrave, Maria, 106, 120, 126
Musgrave, Richard John, Sir (5th Bart.), 106, 120, 126, 274; **105**
Musgrave, Richard, of Yortley, 105
Musgrave, Richard, Sir (1st Bart.), 105
Musgrave, Richard, Sir (4th Bart.), 106, 120, 126
Na Fianna Eireann, 228
Naftel, Maud, 142
Naftel, Paul Jacob, 61, 91-92, 156, 168, 172-173; **93**
Nagle, William Flood, 291
Napoleon III, Emperor, 71
Nash, Paul, 187, 238, 290
Nassau, 297
National Art Training School, London (Royal College of Art), 138, 156, 179, 252, 308; see also South Kensington
National College of Art and Design, Dublin, (N.C.A.D.), 32, 199, 205, 207, 211, 216, 281, 307; **34, 198, 214**; see also Dublin Metropolitan School of Art; National College of Art
National College of Art, Dublin, 32, 200, 228, 280-281; see also Dublin Metropolitan School of Art; National College of Art and Design

National Gallery of Canada, 43
National Gallery of Ireland (N.G.I.), 35, 48, 59-60, 171, 178, 195, 199, 204, 206, 208, 211, 216-217, 227, 245-246, 265, 270-271, 277, 292, 294, 300, 307, 315; **25, 35, 38, 39, 41, 44, 45, 46, 53, 55, 57-61, 117, 126, 129, 144, 165, 170, 174, 190-192, 194, 196-200, 205-216, 223, 226, 229, 245, 253, 260, 269, 279, 298, 309, 311**
National Library of Ireland (N.L.I.), **20, 26, 33, 36, 40, 44, 52, 54-55, 57, 63-64, 66, 71, 73, 76, 78, 80-83, 85, 89, 94, 97, 99, 104-105, 115, 118, 129, 131, 132, 146-149, 153-155, 163, 183-184, 194-195, 199, 200, 204-205, 262, 283, 290, 321**
National Museums, Northern Ireland, **31, 64, 80, 130, 148, 159, 239-240, 254**
National Self-Portrait Collection, University of Limerick, 206
naturalism, 35, 236, 244, 246, 253, 278, 282
neoclasscism, 187
Neptune Gallery, Dublin, 277
Netherlands, The, 16, 35, 58, 228, 245, 246, 253, 264, 267, 276, 297, 310
New English Art Club, 252, 273; **247**
New Gallery, 94, 176
New Irish Salon, 269, 273
New Society of Painters in Miniature and Watercolour (N.W.S.), 51, 121
New Zealand, 222, 290, 316
Newlyn Harbour, 173; **174**
Newlyn School, 172-173, 264; **172**
Newport, Kathleen, 71
Newton, Emily (Mrs Trant), 102, 132; **133**
Newton, H., 133; **133**
Newton, M., 72
Newton, Philip Jocelyn, 106, 132; **131**
Newtown Anner (house), 106-109, 120-122, 126, 242; **109, 111-112, 128**
Newtown School, Waterford, 179
Nicholl, Erskine, 150
Nicholson, Ben, 187, 258
Nicholson, Francis, 35, 38, 51, 63
Nicholson, Miss, 156
Nicolet, Gabriel Emile-Edouard, 282
Nisbet, Tom, 33, 202, 218, 233-234, 255, 278; **234**
Nixon, Mrs, 133
Nolan, James, 13, 205-211, 215, 236; **205, 207, 209-210, 212-213**
Norfolk, 226, 237
Norway, 41
Nugent, Frances, **79**
Nugent, Lady, 120
O'Brien, Brendan, Dr., 202, 235
O'Brien, Dermod, 192, 195, 202, 235, 250, 261, 280, 288-289, 294-295, 301; **87, 191, 198**
ÓBrien, Donough, Mrs, 295
O'Brien, William Smith, 261
O'Connell, Daire, 262
O'Sullivan, Dónal, Rev., 312
O'Brien, Anthony, **202**, **235**
O'Brien, Kitty Wilmer, 13, 202, 204, 210, 218, 234, 235-236, 253, 278; **198, 202, 235**
O'Callaghan, Lucius, 193
O'Clery, Ann, **217**
O'Connell, Terence, **217**
O'Connor, Frank, **34**
O'Connor, James Arthur, 41
O'Connor, Ulick, 195
O'Conor, John, Dr., 199
O'Conor, Roderic, 304
O'Dea, Willie, T.D., 210; **209**
O'Doherty, Miss, 71
O'Faolain, Seán, 224
O'Grady, Elizabeth, 74; **71**
O'Grady, John, Dr., 244
O'Hara, Helen Sophia, 71; **17, 125, 134**
O'Herlihy, Liam, 215; **212**
O'Neill, Dan, 258
O'Nolan, Brian, 234
O'Reilly, Rosemary, 207
O'Ryan, Fergus, 234
O'Sullivan, Sean, 261, 275; **34**

Oaklands (house), 107-108, 112; **110, 113**
Odle, Alan, 292
Oireachtas Art Exhibitions, 223, 235, 236, 246, 252, 259, 270, 280-281, 301, 305, 313; **271**
Old Masters, 35, 48, 54, 58-60, 63, 150, 256; **48**
Oniton, Miss, 156
Oon-a-Shad, river, 95
Ordnance Survey, 27, 44
Orpen, Bea (Mrs C.E.F. Trench), 13, 32, 202, 239, 253, 267
Orpen, Richard Francis Caulfeild, 13, 83, 113, 188, 193, 250, 254, 274, 279, 289, 297; **71, 114, 194**
Orpen, William Newenham Montague, Sir, 13, 14, 88, 113, 187, 210, 242, 249, 251-252, 255-256, 261, 271, 273-274, 290-291, 300, 303-304, 306, 308, 310; **34, 114, 194-196, 251**
Osborne family, 242; **128**
Osborne, Catherine Isabella, 107, 109, 130
Osborne, Edith Bernal (Lady Edith Blake), 106, 108, 110, 126, 130; **16, 106**
Osborne, Grace Bernal, (Duchess of St. Albans, 10th), 75, 106, 108, 110, 120-121, 126, 130; **16, 111, 125, 127**
Osborne, Ralph Bernal, M.P., 108, 123, 126; **125,**
Osborne, Walter Frederick, 13, 14, 66, 246-247, 300; **67, 192, 247**
Ostade, 54
Oulton, Desmond Calverley, 255; **202**
Oulton, Eileen Florence Beatrice, see Reid, Eileen Florence Beatrice
Oulton, George Nugent, 254
Oulton, William, Major, 255; **255**
Oxford University, 108, 109, 183; **135**
Oxford, 288
paintings on china (burnt in), see ceramics, painting on
Palestine, 114, 288, 315
Palliser, Grace, 243
Partridge, Anne St. John, 304
Pasmore, Victor, 236
Pastel Society of Ireland, 216
pastel, 33, 58, 135, 145, 157, 158, 189, 208, 234, 236, 244, 246, 249-251, 260, 296, 304, 322; **67, 191, 203, 241, 244-245, 250, 260**
Patterson, Nina, 212
Patton, Eric, 206
Paul Collin School of Theatre Design, Paris, **200**
Payne, William, 39-40
Payne's grey, 39-40
Pearsall, William Booth, 82-84, 87, 144; **84**
Peel, Maud J., 154, 156
pen and ink wash, **20-21**
pen and ink, 58, 106, 158, 161, 189, 208, 232, 261, 292; **49, 50, 160, 184, 233**
pen and wash, 65, 322, 251
pen, pencil, ink and watercolour, **104, 160**
pencil and gouache, **101, 112, 143**
pencil and ink, 47
pencil and sepia, 43
pencil and watercolour, 37, 41, 277; **29, 39-40, 42, 59, 64, 70, 102, 110, 115, 122, 162, 166-167, 177, 180, 191, 194, 249, 257, 320**
pencil, 58, 65, 68, 132, 135, 136, 158, 183, 189, 208, 221-222, 226, 266, 280, 292, 314, 319-320, 322; **33, 36, 45, 113, 182, 194, 196-197, 210**
pencil, gouache and watercolour, **116, 192, 199, 201**
pencil, ink and wash, 83
Pennefather, George, 218, 231-232, 259; **231**
Pennefather, Helen, 218 , 231-232, 259
Pennell, Joseph, 284
Penrose, James, 141
Perrin, H., Miss, 72
Perrin, M., 133
Perrott, Frida, **195**
Perrott, W. Hyde, 115
Perry, Lilla (Mrs John Perry), see Bagwell, Lilla

Petrie, George, 41, 43-45; **44-45, 126**
Petrie, James, 43; **44**
Phibbs, Geoffrey (Geoffrey Taylor), 230
Phillips, Thomas, 23; **20**
Philp, James George, 109
Phipps, Anna Pownoll (née Smith), 107-110, 112; **112**
Phipps family, 126
Phipps, Henrietta Sophia (Mrs William Francis Smith), 15, 89, 107-113, 119, 125, 129; **16, 109-112, 114**
Phipps, Pownoll William, 108-110, 112
Phipps, Pownoll, Colonel, 107-110, 112; **110, 113**
Phipps, Ramsay Weston, Colonel, 108; **113**
Picasso, 265
Pielou, Florence Josephine (née Gillespie), **201**
Pike, Florence L., 71, 72
Pilkington, Mrs, 193
Piper, John Egerton, 202
Pius VII, Pope, 136
Place, Francis, 24, 44; **20-21**
plein air, 35, 65, 168-169, 172-173, 187, 219, 244, 246, 262, 268, 296; **147, 173, 205**
plumbago, 322
Plunket, Emmeline, Hon., 72, 133
Plunket, John (3rd Baron), **147**
Plunket, Katherine Frances, Hon., **147**
Plunket, Lady, 71
Pocock, Nicholas, 38
Pollard, Miss, 154, 156
Pollen, John Hungerford, 76
Poole, Eliza 'Lizzie' (Addey), 179
Poole, Jacob, 179
Poole, Mary, 179
Pope, Alexander, 292
porcelain, see ceramincs, painting on
Portugal, 276, 302
Post-Impressionism, 229, 248, 265
Potterton, Homan, 48, 195
Poussin, 54, 58, 150
Power, Arthur, **198**
Power, L., Miss, 121
Power, Mr, 130
Powerscourt, 7th Viscount (Mervyn Wingfield), 133, 144, 155; **48, 143**
Poynter, Edward, Sir, 187
Praeger, Rosamond, 254
Praval, Charles, 63
Pre-Raphaelitism, 243
print, 25, 35, 40, 43, 52, 63, 65, 109, 168, 179, 193, 206, 217, 219, 264, 265, 277-278, 282, 285, 288, 290, 292-293, 296, 297, 319, 312, 323; **296, 323**
Prix de Rome, 92
Prochazka, Harry, 99
Prochazka, Ottocar, Colonel Baron, 97
Prochazka, Pauline Harriet 'Polly', Baroness, 15, 72, 75-78, 89, 97-103, 107, 119, 126, 133-133, 242, 266; **76, 77, 78, 99-104, 114, 192**
Protestant, 66, 113, 294
Prout, Samuel, 37
Purcell, Edward, 63
Purser Griffith Travelling Scholarship, 295
Purser, Sarah, Prof., 13, 14, 68, 71, 83, 142, 150-151, 157, 242, 244-245, 250, 253, 308, 312, 315; **67, 70, 84, 129, 145, 244, 253**
Pyle, Hilary, Dr., 248, 304
Quaker, 179, 245
Queen's College, 157, 245
Queen's Theatre, Dublin, 221
Queen's University, Belfast, 277
Queen's Institute for the Training and Employment of Educated Women, 71, 245
Queenstown Sketch Club, 82, 302; **81**
Queenstown, 120; **81, 82**
R.H.A. Gallagher Gallery, 205
R.M.S. *Leinster*, 107; **107**
Rackham, Arthur, 312
Rákóczi, Basil Ivan, 16, 218, 232-233, 237, 239, 267, 276; **203, 233**
Ramsay, Allan, 126
Ramsay, James, Rev., 107
realism, 30, 32, 37, 172, 220, 228, 251, 256, 261, 264

Reeves, Dr., Bishop of Down, Connor and Dromore, 157
Reeves, Frances Angel, **135**
Reeves, Mary, 141, 144, 150, 156, 157; **141**
Reeves, Percy Oswald, 229, 289
Reeves, Robert, **135**
Reeves, William and Thomas, Messrs, 33-35, 319; **319**
Regent Street Polytechnic, London, 278
Regional Hospital, Waterford, 215
Regnault, Henri A.G., 168
Reid, Eileen Florence Beatrice (née Oulton), 195, 201-202, 204, 229, 237, 242, 254-255; **198, 202, 255**
Reid, Alex, 293
Reid, Anne Margaret, 'Nano', 16, 232, 242, 258-260, 269, 271, 292; **205, 259**
Reid, Chris, Mrs, 202; **207**
Reid, Hugh C., 255
Reilly, Brian K., 208, 211, 215; **207, 212-214**
Rembrandt, 58, 60
Reynolds, Joshua, Sir, 49, 58, 242, 246; **49**
Riall, A., Mrs, **123**
Riall family, 112, 126
Riall, Miss, 130, 168
Riall, W., Mrs, 130
Richards, Shelagh, 310
Richardson, Edward M., 121
Ring Agricultural College, 102; **103**
Rivers, Elizabeth Joyce, 'Betty', 271, 278, 282, 293-294, 313; **203, 293**
Rivers, Elizabeth, Memorial Exhibition, **202**
Robert-Fleury, Tony, 92, 244, 245
Roberts, Morfudd, 281
Roberts, Thomas Sautelle, 25, 53-54; **26, 51**
Roberts, Thomas, 35
Robertson, Daniel, **131**
Robertson, Keith, **184**
Robinson, Lennox, 88, 292
Robinson, Mary, President of Ireland, 199, 212; **213**
Robinson, Webb, Mrs, 154
Robson, George Fennel, 43
Rogers, Claude, 236
Rogers, Edward J., 191
Rogers, J.E., 83
Roman Catholic, 310, 314-315
Rome, 37, 225, 236, 240, 262, 271, 278, 284; **40**
Romney, 60
Rooke, Noel 289
Ross, Florence Agnes, 218, 222-223; **222**
Ross, Lady, of Bladensburgh, 189
Ross, Martin (Violet Ross), see Martin, Violet
Rossetti, Dante Gabriel, 48, 242-243
Rothenburg, 297, 300
Rothenstein, W., 251, 287; **164**
Rothwell, T., 133, 312
Rouault, Georges, 265, 280
Rowan, Alistair, 199
Rowbotham, Thomas Charles Leeson, 61, 102
Rowlandson, Thomas, **50, 232**
Rowley, Richard, 290; **290**
Royal Academy of Arts, London, 25, 29, 47, 49, 51, 54, 56, 68-69, 80, 94, 125-126... *passim*
Royal College of Art, London, 291; see also National Art Training School
Royal Cork Institution, 136, 139
Royal Drawing Society, 279
Royal Dublin Society (formerly the Dublin Society), 14, 17, 24, 27, 29, 32-48, 53-54, 58, 199, 213-215, 218, 244, 279, 281; **32-48, 55**
Royal Dublin Society Schools, 32-48, 61, 63, 65-66 71, 119, 125, 138, 244; **32-48**
Royal Hibernian Academy of Painting, Sculpture and Architecture, 14, 17, 40, 43-47, 53-57, 60-63, 66, 68, 80, 88-89... *passim*
Royal Institute of Oil Painters, 94, 285

Royal Institute of Painters in Watercolours, 94, 109, 158, 254, 299, 314
Royal Irish Academy of Music, 254
Royal Irish Academy, 44, 295
Royal Irish Art Union, 44, 47, 56-57; **54, 55**
Royal Irish Institution, 54; **52**
Royal Irish School of Art Needlework, 75-76, 100; **76-78**
Royal Scottish Academy, 254, 302
Royal Society of Artists Birmingham, 94
Royal Society of British Artists, 94, 246
Royal Society of Miniature Painters, 288
Royal Society of Painter-Etchers and Engravers, 284, 286, 288-289
Royal Ulster Academy of Arts, 211, 216, 241, 290
Royal Watercolour Society, 52, 163-164, 178; **38, 40, 163**
Rubens, 54, 58, 150
Ruskin, John, 48, 84, 161, 228, 242-243; **48**
Russell, George W. ('AE'), 256, 301
Russell, Walter Westley, Sir, 293
Ruttledge, H., 133
Ruttledge, K., 133
Ryan-Smolin, Wanda, 250
Ryan, Thomas, 195, 212, 233
Ryland, E., 133
Sadlier, Anne, **212**
Saint Germans, Earl of (Lord Lieutenant of Ireland), 57
Saint-Gall Gospel, 20
Salisbury, Marquis of, **16, 19, 99, 112, 123, 127**
Salon de Monaco, 237
Salon, Irish, see New Irish Salon
Salon, Paris, 84, 92, 153, 168, 285, 302, 305
Salon, Union des Femmes Artistes, 71
Sandars, Nancy K., 107-108
Sandby, Paul, 25, 38, 44; **23-24, 320-321**
Sandby, Thomas, 29
Sankey, General, 155, 156, 297
Sankey, Lady, 153
Sargent, John Singer, 246
Saudi Arabia, 307
Scalé, Bernard, 27; **14**
Scally, Caroline M. (née Stein), 202, 263, 267, 270-272; **272**
Scharf, George, **162**
School of Animal Painting, 172, 289; **171**
School of Design, Belfast (1870-1906), 156
School of Design, Dublin, 65-66
Scotland, 16, 38, 41, 104, 113, 225, 248, 267, 268; **77, 133, 184**
Scott, Basil, Sir, **192**
Scott, Edwin, 264
Scott, Josephine, 208
Scott, Patrick, 215, 217; **213**
Scott, Pauline, 208
Scully, T., **82**
Second World War, 232, 236, 240
sepia, 43, 135, 158, 189, 288
Severini, Gino, 293
Sex, Susan, **216**
Shaw, George Bernard, 88; **200**
Shawcross, Neil, 212
Shee, Martin Archer, Sir, 54, 69; **68**
Sheehy, Edward, 238; **259**
Sheehy, Jeanne, Dr., 246
Sheppard, Oliver, 247, 261; **198**
Sherlock, Margaret Murray, 297, 305-306; **306**
Shivnen, Angela, **217**
Short, Frank, Sir, 284, 286, 287, 288
Sicily, 302
Sickert, Walter, 236, 251, 255, 256, 293, 312; **164**
Siddons, Sarah, 21; **24**
Sigerson, Dora Mary (Mrs Shorter), **245**
Skeffington, Sheehy, Dr., 195
Skerrett, Palm, 202, 208; **207**
sketch, *passim*
sketching clubs, 14, 61, 78, 79-88; see also Queenstown Sketching Club; Belfast Sketching Club; Dublin Sketching Club

Slade School of Fine Art, 172, 187, 202, 235, 236, 239, 249, 251, 252, 269, 270, 300, 303, 310; **180**, **182-183**
Smith, C., 89
Smith, Jean Kennedy, 199
Smith, William Francis, Mrs, see Phipps, Henrietta Sophia
Smith, William Francis, Lieutenant. Colonel, 112; **112**
Societé Nationale des Beaux-Arts, 168
Society for Creative Psychology, 232
Society for Promotion of the Fine Arts in the South of Ireland, 63
Society for the Encouragement of Art in Kilkenny (SEAK), see Kilkenny Art Gallery Society
Society of Antiquaries of Ireland, 295
Society of Artists in Ireland, 52, 54, 63
Society of Female Artists, 70; see also Society of Lady Artists; Society of Women Artists
Society of Lady Artists, 70, 167, 176; **315**; see also Society of Female Artists; Society of Women Artists
Society of Painters in Water Colour (often referred to as the Old Water Colour Society, 'O.W.S.'), 49-52, 61
Society of Women Artists, 94, 254, 294; see also Society of Female Artists; Society of Lady Artists
Sohn, Carl Rudolph, 282
Solomons, Estella, 308; **195**
Somerville, Edith Œnone, Dr., 71, 89, 97, 154, 168, 282-284, 305; **68**, **147**, **149**, **283**
South Africa, 172, 234, 287, 314
South Kensington 'system', 32, 65, 123, 252; see also National Art Training School
South Kensington, Female School of Art and Design, 68, 314
South Kensington, Department of Science and Art, 61, 74, 123, 138, 156
South Kensington, Government Museum, 61, 109, 123, 150, 182; **110**
South Pacific, 262, 300, 302, 312
Sowerby, Gerald, 289
Spain, 172, 216, 263, 284
Spencer, Countess of, 144
Spencer, Earl of (Lord Lieutenant of Ireland), 144
Spencer, Stanley, 187
'Spy' (Vanity Fair), **85**
St. Albans, Duchess of, see Osborne, Grace Bernal
St. Columba's, Dublin, 47
St. Carthage's Cathedral, Lismore, 89, 95; **89-90**
St. Columba, 262
St. Cuthbert, 19
St. Gall, see Abbey of Saint-Gall
St. John, 316
St. Luke, 207
St. Mark, **18**
St. Martins College of Art, London, 205; **214**
St. Matthew, 20; **19**
St. Patrick's Cathedral, 24, 218, 265; **22**
St. Patrick's Day, **165**
St. Paul's Cathedral, Minnesota, see Ireland, John, Archbishop
stained glass, 76, 226, 228-229, 243, 245, 286-287, 290-294, 307, 308-313; **90**, **199**, **204**, **309**, **311**, **313**
Stannus, Anthony Carey, 81, 157
Steer, Wilson, 236, 251, 310
Stephens, James, 88, 310
Stephenson, Eoin, **208**
Stephenson, Sam, 306
Stewart, Ann M., 208, 211; **213**
Stewart, H., Mrs, 63
Stoker, Abraham, 'Bram', 83; **84**
Stoker, Lucy, **192**
Stokes, Margaret Mary, 202, 282, 295-296; **296**
Stokes, Margaret McNair, 295
Stokes, Whitley, Dr., 48
Stopford, Robert Lowe, 150; **126**, **138-139**
stopping-out, 162, 322

Strickland, Walter George, 17, 39, 45, 52, 58, 61, 103, 119, 169; **55**
Stronge, Miss, 156
Stuart, Charles, Sir, 242
Sullivan, Edmund J., 293
surrealism, 16, 232, 238
Swan, Miss, 151
Swanzy, Mary, 247-248, 265
Swift, John, 259
Swift, Jonathan, 295
Swift, Patrick, 258
Switzerland, 20, 37, 43, 224, 244, 292, 297, 306, 312, 314
symbolism, 16, 296; **203**
Synge, Edward Millington, 282, 284-285; **284**
Synge, Elizabeth, 222
Synge, Freda, 285
Synge, John Millington, 222-223
Synge, Kathleen, 222
Tahiti, 300; **299**
Talbot, Earl of, Viceroy, 54
Tanner, Lily, Miss, 140
Tate Gallery, 176, 313; **49**, **86**, **175**
Taunton, 138
Taylor Art Scholarship, 202, 228, 235, 246, 256, 260-261, 271, 279, 281, 308
Taylor, Ernest E., 80
Taylor, George Archibald, Captain, 59-60; **58**
Taylor, Jane, 71
tempera, 262
Tench, Helen Mary, 295
Tennyson, Alfred, Lord, 293
Thackeray, William Makepeace, 89; **122**
Thomond Archaeological Society, 295
Tintoretto, 48
Tisdall, Henry C.W., 200
Titian, 54, 60
Todhunter, John, 83
Tonks, Henry, 187, 236, 300, 310; **182**
Topham, Francis, 120
Tory Island, Co. Donegal
Tottenham, F., Miss, 71
Tottenham, S., Miss, 133
Tourin (house), 104, 106, 119, 274; **104**
Tower of Glass, see An Túr Gloine
Towne, Francis, 49
Townshend, Harriet Hockley, 242, 250-251; **250**
Trant, Miss, 156
Trant, Mrs, see Newton, Emily
Trayer, Miss, 130
Trayer, Mrs, 133
Trench, Philip Chenevix, 106, 148, 155, 158; **108**, **135**
Trench, Richard Chevenix, Archbishop, **135**
Trench, C.E.F., Mrs, see Orpen, Bea
Trinity College, Dublin, 27, 95, 152, 156, 172, 195, 221, 230, 236, 274, 283, 284, 292, 300, 307; **19**
Trobridge, George, 156
Tunisia, 302
Tuohy, Patrick, 228-229, 260-261
Turner, Joseph Mallord William, 41, 58, 61, 162, 168, 185; **37**
Turpin, John, Dr., 35, 56, 138, 199, 251, 292
Ulster Arts Club, **80**,
Ulster Museum, Belfast, 236, 260
Ulster Watercolour Society, 206, 241; **206**
Underwood, Jane, Miss, 168
Union des Femmes Artistes, Paris, 71
United Arts Club, Dublin, 88, 216, 235; **87**
United Kingdom, 25, 89, 94, 156, 172, 234, 244, 226
United States of America, 84, 223, 224, 226, 236, 248, 264, 270, 282, 284, 287
University College, Dublin, 76, 199, 278, 310, 313; **78**, **199**
University College, Galway, 216
University College, London, **183**
University of Limerick, 13, 206, 208-211, 255, 262, 281, 296; **202**, **208-210**, **212**, **214**, **234**, **261**, **277**, **281**, **307**
Empey, Valerie, 'Moffy', **217**
Vallancey, Charles, 24

van Dongen, Kees, 264
van Dyck, 54, 60, 94, 150
van Gogh, 236
van Stockum, Hilda, 260; **199**
Vance, Adelaide Sidney, 113, 135
Vance, John, M.P., 113, 135
Vanston, Dorothy, 232
Vanston, Dairine, 273
Mildura Arts Centre, **195**
Varley, Cornelius, 35, 51, 320; **320**
Varley, John, 35-36, 38, 44, 51, 163; **35**
Venezuela, 280
Venice, 243, 263, 274, 285-286, 297, 304, 307; **40**, **307**
Venice Biennale, 259
Verlat, Charles, 172, 220, 246
Veronese, 54, 58
Vesey, Mrs, 133
Victoria and Albert Museum, 40, 193, 219; **41**, **62**, **124**, **131**, **162**, **243**, **289**
Victoria, Queen, 58, 60, 110, 132, 156, 314; **59**
Vienna Secession (1897), 285
Villa i Tatti, 236
Villiers-Stuart, Gertrude, **190**, **192**
Villiers-Stuart, Henry (Lord Stuart de Decies), 99, 102
Villiers-Stuart, Henry Windsor, 99, 120
Villiers-Stuart, Pauline, 99-100; **100**
Villiers-Stuart, Windsor, the Hon. Mrs, 120
Society of Native and Resident Artists, 63
Viliers-Stuart family, 102, 126; **103**
Vinycomb, John, 81; **80**
Vlaminck, Maurice, 230
Watercolour Society of Ireland (W.C.S.I.), *passim*
Water Colour Society of Ireland Art Union, 58, 158, 193, 195; **55**
W.C.S.I. 150th exhibition, 102, 216-217, 277; **117**, **216**
W.C.S.I. Centenary Exhibition, 171, 192, 195, 202, 204, 235, 247, 254; **181**, **192**, **251**
W.C.S.I. emblem, 206; **207**
W.C.S.I. exhibitions, Belfast, 136-159; **136-159**
W.C.S.I. exhibitions, Carlow, 15, 16, 113, 115, 130, 133, 164; **131**, **133**, **163**
W.C.S.I. exhibitions, Clonmel, 15, 16, 17, 102, 103, 109, 112, 119, 121, 123, 125, 129, 130, 133; **110**, **118**, **125**, **126**, **128**
W.C.S.I. exhibitions, Cork, 17, 43 136-159; **136-159**
W.C.S.I. exhibitions, Dublin, 16-17, 74, 94, 116, 134-135, 136-159, 182, 189, 208, 212-214, 226, 242, 244, 252, 253, 282-3, 297, 316; **135**, **136-159**, **191**, **212-213**
W.C.S.I. Permanent National Collection, University of Limerick, 206, 208, 210-214, 255, 262, 281, 296; **202**, **208**, **209**, **210**, **212**, **234**, **277**, **281**, **307**
Waddington Gallery, Dublin, 305
Walcot, William, 286
Waldron, Eithne, 204
Waldron, Laurence A., Rt. Hon., 292
Wales, 38, 43, 61, 92, 107, 136, 239, 268, 280-281; **107**
Walker Art Gallery, Liverpool, 94, 176, 284, 299
Walker's Gallery, London, 283
Walker, John Crampton, 268-269, 273-274, 289; **163**, **200**, **263**, **273**
Wallace, Patricia, (Mrs Griffith), 218, 239, 253, 269, 276; **239**
Walsh, Edward, Dr., 13, 208-210; **209**, **210**, **212**
Walsh, Stephanie, **210**
Walsh, Sheila, 280
War of Independence, Ireland, 118, 228, 315, 316
Ward, Mary, 69
Warren Nursery, Lismore, 95; **97**
wash, 23, 25, 27, 30, 36, 37, 65, 91, 161, 172, 173, 219, 223, 232, 245, 256, 259, 267, 302, 319, 321, 322; **39**; see also pen and wash; pen and ink wash; pencil, ink and wash

Ward, James, 274
Waterfield, Aubrey, 236
Waterford Central Technical Institute, 66
Waterford School of Art (School of Practical Art and Design), 66; **66**
Waterford, Dungarvan and Lismore Railway Company, 112
Waterford, Louisa Anne, Marchioness of, 75, 126, 130, 132, 144, 156, 167, 242-243; **124**, **128**, **146**, **243**
Watkins, Bartholomew Colles railway, 58, 90, 94, 106, 112, 125; **126**
Watteau, Antoine, 'Jean', 185
Webb Robinson, Mrs, 154
Webb, Josephine, 242, 245-246; **245**
Webb, George, Webb, 58
Webb, Miss, 156
Webb, Richard Davis, 179
Welch, W.S., 152
Werner, Louis, 206
West Indies, 107, 110, 221, 302
West, Robert (d.1770), 32
West, Robert Lucius, 46
Westminster School of Art, 172, 256, 284, 288, 312
Wexford Arts Centre, 278
Whall, Christopher W., 76
Whelehan, Ann, 208; **212**
Whistler, James Abbott MacNeill, 84-87, 168, 223-224, 246, 251, 282-283; **85-86**
white pigment, 21, 161, 163; see also body colour
White Stag Group, 232, 237, 239, 276, 313
White, James, Dr., 204, 269, 275, 294, 310
Black & White Artists' Society of Ireland, 274, 289; **200**
White, Terence De Vere, 195
Whyte's Auctioneers, 217; **219**, **224**, **255**
Wicklow, William Howard, 8th Earl of, 195
Wilde, Oscar, 74; **73**, **164**
Wilkinson, Neville Rodwell, Sir, 189, 192, 263, 282, 287-288, 299; **189**, **191**, **287**
William III, King, 133
Williams, Lily, **195**
Williams, Alexander, 144, 151, 154, 156, 218-219; **191**, **219**
Williams, Hugh William, 'Grecian', 58
Williams, Jeremy, 157
Wilson, Richard, 44, 227
Wilson, George, 132
Wilson, T.G., Dr., 216
Wilson, Thomas, Dr., 216; **217**
Wingfield, Susan, 212
Wingfield, Leslie, 141
Wingfield, Mervyn, see Powerscourt, Viscount
Winsor & Newton, 319, 322; **320**
wood-carving, 58, 66, 72-74, 102, 116, 136, 157, 158, 189; **72**
woodcut, 261, 276, 286, 289, 290, 295; **290**
Woodhouse, E.E., Mrs, 285
Woodhouse, John, 83
Wragg, Brian, 118
Wright, G.N., Rev., 43
Wright, Joseph, of Derby, 126
Wyatt, Matthew Digby, 138
Wynne, A.B., 88
Wynne, A.R., 156
Wynne, Edith Gladys, 218, 224-225; **224**
Wynne, Michael, Dr., 308
Wynne, Geoffrey, 202, 235
Wysard, Anthony, **143**
Yeats, Anne, **200**
Yeats, Grainne, **198**
Yeats, Elizabeth C., 280
Yeats, John Butler, 'Jack', 248, 280; **188**, **198**
Yeats, William Butler, 244, 280; **200**, **244**,
York, Duke of, 176
Yugoslavia, 226
Zadkine, Ossip, 232

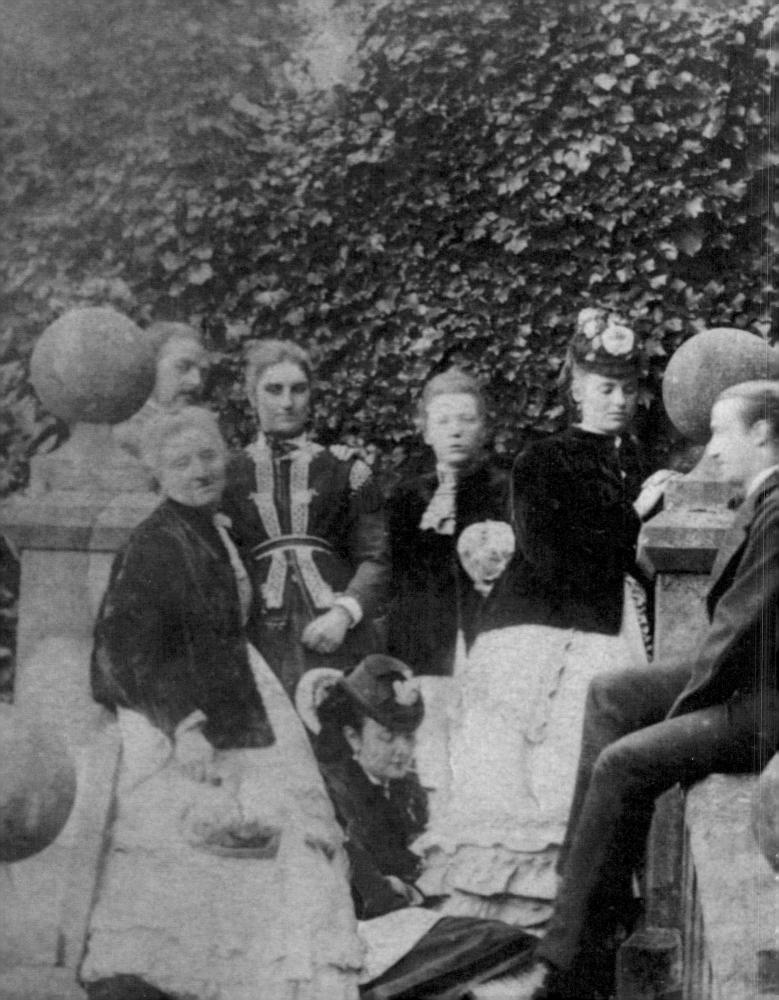